Contents

Editors
Miquel de Moragas Spà, Carmelo Garitaonandía, Bernat López

Authors
Peter Arvidson, Sylvie Bardou-Boisnier, Pedro Jorge Braumann, Enric
Castelló, Suzy Collard, Mike Cormack, Hans Heinz Fabris, Carmelo
Garitaonandía, Ellen Hazelkorn, Nicholas W. Jankowski, Hans J.
Kleinsteuber, Bernat López, Miquel de Moragas Spà, J.-M. Nobre-Correia,
Isabelle Pailliart, Roy Panagiotopoulou, Renato Porro, Giuseppe Richeri,
Jaume Risquete, Francisco Rui Cádima, Monique K. H. Schoorlemmer,
Gabriele Siegert, Barbara Thomaß, Thomas Tufte, Tapio Varis.

Co-ordination and documentation
Jaume Risquete, Marta Civil

Acknowledgements
The research on which this book is based has been supported by DGICYT
(Spanish Ministry of Education and Culture) and CIRIT (Catalan
Government). The Federation de Organismos de Radio y Televisión
Automicos (FORTA, Spain) has sponsored the spanish edition of this book.
The Consell de l'Audiovisual de Catalunya and the Ufficio di Presidenza
del Consiglio della Provincia Autonoma di Trento (Italy) have contributed
to the publication of this book.

Television on your doorstep
Decentralization experiences in the European Union

Television on your doorstep

Decentralization experiences in the European Union

Editors: Miquel de Moragas Spà, Carmelo Garitaonandía, Bernat López

UNIVERSITY
OF LUTON

press

British Library Cataloguing in Publication Data
A catalogue record for this book is available from the British Library

ISBN: 1 86020 547 X

Published by
University of Luton Press
University of Luton
75 Castle Street
Luton
Bedfordshire LU1 3AJ
United Kingdom

Tel: +44 (0)1582 743297; Fax: +44 (0)1582 743298
e-mail: ulp@luton.ac.uk
www.ulp.org.uk

Cover Design by Gary Gravatt, Morgan and Gravatt Design Consultants
Typeset in Palatino
Printed in Great Britain by Whitstable Litho, Whitstable, Kent

Preface

Just before this book was published, we were very sad to learn about our colleague Renato Porro's death. Renato Porro, one of the main promoters of this research and co-author of the report about Italy, was a Sociology Lecturer at the University of Trento and Chairman of Coordinamento Nazionale Comitati Regionali per i Servizi Radiotelevisivi (national co-ordination of regional committees for radio and television broadcasting services in Italy). As Chairman of the Coordinamento, he did an extremely effective and intensive job of promoting research into and intellectual debate about the role of radio and television in regional development. This book is dedicated to his memory.

This book contains the results of the second research project undertaken by a group of communications experts from the 15 member States of the European Union led by Professors Miquel de Moragas Spà (Autonomous University of Barcelona, UAB) and Carmelo Garitaonandía (University of the Basque Country) within the framework of the Institut de la Comunicació, InCom (UAB).

Created in 1992, this group specialises in studying the decentralisation processes of television systems in Europe. The first research project to be published was entitled *Decentralization in the Global Era* (Moragas and Garitaonandía, eds. London: John Libbey, 1995). An abridged version of this research project was published in Spanish in issue 45 (April 1996) of the *Telos* magazine (Fundesco), and another version in Catalan in issue 17 of the *Anàlisi* magazine (Departament de Periodisme i Ciències de la Comunicació, UAB). An advance of the research entitled *The role of regional television stations* was presented to the European Parliament (Brussels) at a public hearing held in March 1993 (Parliamentary Document: PE.208.155).

In those initial studies, which pioneered research in this field, the complex experiences of the decentralisation of television systems of the "Europe of 12" were analysed and evaluated. Those experiences went from an initial situation of marked centralisation, in which there was little room for urban or regional audio-visual expression, to a new, much more complex one characterised by a whole range of decentralising experiences.

Its conclusions highlighted the fact that the 1990s would mark the beginning of a new stage of further decentralisation of television. In a context characterised by the continuity of transformations that had begun in the 80s, emphasised by the initial signs of the "digital revolution", the consolidation of existing regional and local broadcasts could already be appreciated, as could a proliferation of new experiences. Despite the persistence of some difficulties and legal and political resistance, the emergence of new technological resources, renewed institutional interest in these matters and the consolidation of regional and local advertising markets bore witness to the fact that the "information society" was both global and local at one and the same time, and that there was indeed room for "proximate communication" in it.

Faced with this situation we decided to promote further research with the aim of examining the state of the question in greater depth and building on the findings of the first phase to do a detailed analysis of some of particularly relevant aspects of proximity television experiences. So, on the one hand, this led to the data being updated and the scope of analysis being extended to local-urban television, in addition to the inclusion of reports about the new EU countries (Austria, Finland and Sweden). On the other hand, emphasis was placed on small-scale TV programming and audiences, and its interaction with major technological innovations in the audio-visual sector (digitalisation and the creation of integrated communications networks).

The chapters in this book are monographic reports for each EU country written by local experts. All of them followed common guidelines to make comparison between countries easier and more accurate. Each report starts off with a brief description of the country's regional system followed by a presentation of television's legislation and structure. It then goes on to describe the regulatory framework and the different types of regional and local television. After that it analyses the programming of some channels and assesses the conditions for small-scale television's viability, based on the financial, technological and sociocultural factors affecting its development.

An analytical chapter emerged from the study of all this material. In it we aim to establish a blueprint for the state of the question, to analyse the main similarities and differences between one country and another, to run through the existing types of regional and local television and to analyse the conditions for their viability and future development.

This research and this book are the end-products of co-operation between a large team of European communication experts (the full list of authors is contained in the credits), who have contributed their knowledge about their respective countries. As the editors of this book, we would like to express our gratitude to each and every one of them and to acknowledge the intellectual and social interest that has guided their collaboration.

We would like to acknowledge as well the publication coordinating team at the Institut de la Comunicació, InCom (Autonomous University of Barcelona), formed by Marta Civil and Jaume Risquete, in recognition of their liaison, documentation and technical support work. We would also like to thank the following people who were involved in the translation of the reports contained in this book: Matilde Delgado, Mercè Díez, Rhoda Justel, Steve Norris, Carme Padilla, Joan Ramon Rodríguez, Oriol Solé and Servei de Traducció de la Facultat de Traducció i Interpretació at the Autonomous University of Barcelona.

Finally, we would like to express our gratitude to the institutions that have lent their support to this project. DGICYT (Ministerio de Educación y Cultura) and CIRIT (Generalitat de Catalunya) provided basic funding for the research. FORTA (Federación de Organismos de Radio y Televisión Autonómicos), the Consell de l'Audiovisual de Catalunya (CAC), the Ufficio di Presidenza del Consiglio della Provincia Autonoma di Trento (Italy) and the Fundació Jaume Bofill lent their support to the publication of this book in several languages.

Miguel de Moragas Spà
Carmelo Garitaonandía
Bernat López
June 1999

NOTE

1 Euro =

1.045	US Dollars
0.578	English Pounds
166.386	Spanish Pesetas
1.95583	German Marks
1,936.27	Italian Lire
6.55957	French Francs
200.482	Portuguese Escudos
0.787564	Irish Punts
2.20371	Dutch Guilders
13.7603	Austrian Schillings
40.3399	Belgian Francs
40.3399	Luxembourg Francs
5.94573	Finnish Markka

Regional and Local Television in the Digital Era: Reasons for optimism

Miquel de Moragas Spà, Carmelo Garitaonandía, Bernat López

1. Introduction

Over the last few years, the media in different EU countries – and their audio-visual systems in particular – have undergone major transformation. Such transformation has affected the technologies they use as well as their organisation, funding, contents and social influence. Most analyses of these changes have concentrated on two of the most obvious dimensions: deregulation (especially privatisation) and internationalisation (or globalisation). More recently, and as a result of digitalisation, a new expression of the phenomenon has come to the fore: the convergence of television, computers and telecommunications.[1] However, there is a further dimension which is equally as influential, but which has so far received less attention from researchers: the process of decentralisation which – as we shall see later – forms part of the major mutation of modern audio-visual systems.

In today's debate about communication in Europe, time and time again one comes across the idea that the most visible aspects of the media's transformation (deregulation/privatisation, internationalisation and convergence) are processes which oppose or jeopardise small-scale communications experiences, and that the *digital revolution* will only aggravate the delicate situation that local or regional media find themselves in. According to this viewpoint, the emergence of large

1

international multimedia groups, digital platforms and the scope of satellites will necessarily lead to small regional or local television networks or stations being left out.

Nonetheless, although the difficulties and contradictions cannot be denied, it is possible to assert that the last 15 to 20 years have been a period of decentralisation of television in Europe. In virtually every European Union country, regional or local audio-visual systems have emerged or been consolidated. That does not of course mean that the future of this broadcasting level is free from uncertainties or that its current state is good and flourishing in all EU countries and regions.

To make an accurate diagnosis of the situation it is worth examining the range of experiences in EU countries one by one. This book looks into the communication policies and decentralisation processes of a number of national audio-visual spaces that are virtually all characterised by their heavily centralised origins.

2. Decentralisation in the global era: The rise of regional and local spaces in a united Europe

The most important and visible political phenomenon in Europe at the end of the twentieth century is undoubtedly the unification process, the construction of a united Europe. Such unification is taking place in a context of ever-increasing economic, political and cultural globalisation. And it goes without saying that communication plays a decisive role in those processes.

However, this phenomenon of globalisation must not be allowed to overshadow another parallel process which is equally as significant: the rise of local and regional economic, political and cultural spaces. From a political viewpoint, most European States have made major institutional reforms in the last 20 to 30 years which have led to the emergence or consolidation of regional levels of government. This phenomenon is particularly visible in large States with a centralist tradition (France, Spain, Italy and the United Kingdom; Germany has had a federal regime since the end of the Second World War), though it is also apparent in States with medium-sized or small territories (mainly Belgium, though Holland, Denmark, Greece, Sweden, etc. can also be included). Reinforcement of the regional level of government is reflected by the recent emergence of regional lobbying before the EU authorities in Brussels. Examples of this are the Assembly of European Regions, the Council of European Municipalities and Regions and the Committee of the Regions, the latter being an organisation instituted by the Maastricht Treaty as an integral part of the EU organisation chart. At the same time, the local level of government has been reinforced in many States. Municipalities have gone beyond their former status as administrators of central power delegation with no political autonomy and have become responsible for many

functions that used to be alien to local administration. A special case of taking on new powers will take place in the area of communications, particularly in the telecommunications sector.

The new protagonism of regional and local levels can be put down to structural change and the transformation of the welfare State, which forces governments to pass some powers and responsibilities down to levels of government that are closer to individuals. These processes, which wholly affect communication policies in the *broadcasting era*, will become even more important in the new stages of the *information society*'s development.

The cultural causes of political decentralization are equally as significant. They bear witness to the rebirth of "minority" cultures and languages. The EU is a patchwork of cultures and languages (there are approximately 30 autochthonous languages) which, for many decades, have been quelled by the homogeneization attemps of hegemonic cultures. Their resurgence is due to action taken by communities set on recovering their languages and traditions. This factor also wholly affects the process of strengthening the regional and local communication systems in Europe. Many formerly *peripheral* communities, such as the Welsh or Scottish in the United Kingdom, the Catalans, Basques or Galicians in Spain, the Frisians in Holland, the Bretons or Corsicans in France, the Gaelic-speaking community in Ireland and many others, are now the protagonists of a culture and language revival and standardisation process to which the media and television in particular make a decisive contribution.

This revival of *minority* or *lesser-used* languages and cultures is connected with cultural globalisation. As cognoscitive and symbolic horizons beyond the State-nation reference are opened out to the world, people look for their own genuine signs of identity in their most immediate communities to help them cope with greater complexity and hybridisation.

For their part, the economic changes originated by the development of so-called *tardy capitalism* have placed a new value on regional and local spaces as areas best-suited to the adaptability and decentralisation of production (small and medium-sized units). From a market viewpoint, growing competition means that marketing must take the peculiarities and tastes of different human communities into account, with the personalisation of products down to local level in some cases. Production is designed globally, but products are made and sold locally.

In short, as many analysts have pointed out, the opposite side of the economic, political and cultural globalisation coin is decentralisation and localisation. Nation state cede protagonism to old and new territorialities and identities: Europe, the regions and municipalities. However, that does not, in any way whatsoever, mean the disappearance of the State as a political reality or a symbolic and cultural reference. In reality, new territoriality is characterised by a complex superimposition of different

levels, the mobility of frontiers and the hybridisation of identities. The single, centralised reference framework of the nation state has been replaced by a plural, dynamic one. The region does not replace the State; it is complementary to it, sometimes competing against it and sometimes cooperating with it (it should not be forgotten that the political-administrative region forms part of the State structure itself) in a context of complex interaction with other regions and States, with the EU and with municipalities. Neither is the region a homogenous reality. In fact it is quite the opposite. The frontiers of economic, political and cultural-language regions rarely coincide. An economic region may include several political regions, even located in different countries. The same goes for some language regions, though the reverse may well indeed apply: a political region may include several cultural communities. That is also the reality that globalisation – a united Europe – brings out into the open. To give just one example, regional reality in Germany's case is at a lower level than the *länder* and only coincides with them in the three city-States of Berlin, Hamburg and Bremen, and in the small *land* of Saar.

Such complexity is necessarily reflected by the proliferation, superimposition and hybridisation of communication spaces, in the sense that these are both the reflection of and drive behind the different territories and cultural identities.

3. Old and new ways of interpreting the decentralisation of television

The concepts used in the *broadcasting era* to analyse the different television models are gradually becoming outdated as new and much more complex realities emerge from the proliferation of channels, the fragmentation of audiences and the globalization/decentralization of communications. In this sense we have to acknowledge that the concept of "communication space" (Moragas, 1988) was useful when analysing the old scenario of over-the-air television, since it allowed us to interpret different television models by geographical coverage area: cross-frontier, national, regional and local-municipal. But the previously-mentioned contradictions and complexities, aggravated by the influence of technological transformations, highlight the shortcomings of the concept of communication space when attempting to express television experiences from a cultural-territorial viewpoint.

For that purpose we must use a set of concepts, including several new ones, whose scope never really fully meets the analytical demands of a phenomenon characterised by such complexity and diversity. These terms are *decentralisation of television, regional television, television in the regions, "proximity television", local television, urban television, small-scale television*, etc, some of which have different meanings depending on the language used.

The first concept that appears frequently throughout this book is *decentralisation of television*, which can be used in two ways. Firstly, it deals

with different realities that can be identified by any of the other labels, from "autonomic" broadcasters in Spain to the local television stations of the TV Danmark network. Secondly, it gives a new, evolutive, historic perspective by placing emphasis on the process of transition from the initial, highly-centralised forms of organisation of television systems towards situations giving greater protagonism to regions and cities. However, this concept does not allow us to refer to particular realities emerging from the same process. Instead, it only allows us to refer to the framework of their transformation.

Perhaps the most widespread concepts in this field of study are *regional television* and *local television*. The first one defines those television activities having a specific, deliberately regional coverage (less than national coverage and greater than local coverage), in a double geographical and journalistic content sense.[2] The second one refers to local coverage broadcasts (generally of urban or metropolitan scope).[3] Nonetheless, in Europe, *regional television* is generally understood as being off-the-network or disconnected broadcasts by regional centres belonging to or ascribed to national channels: regional news disconnections broadcast by some national channels such as RAI-3, France Régions 3 (now called France 3), the BBC or RTVE, along with some magazine-type programmes in the best of cases. However, some independent broadcasters – whose coverage is specifically and exclusively regional – emerged in the 1980s and 1990s who reject the *regional television* label as a description of their activities because they consider it to be lacking and in some ways pejorative. Consequently, the expression *television in the regions*, or *regional-scale television*, which is more descriptive, also appears to be better suited to the diversity of experiences in this field. However, these expressions do not cover the local television experiences, which do however share with the latter the fact of basing their existence on the physical and referential proximity of their viewers.

Given these conceptual difficulties, in earlier stages of our research we proposed to adopt the French term "télévision de proximité" to refer generally to all small and medium-scale broadcasting experiences. This name was initially given to the new urban windows of the French national public service channel France 3 in the late 1980s. In our research we suggest it be taken as a conceptual innovation aimed at overcoming the contradictions posed by the previously-mentioned terminology, which concentrates more on the geographical idea of communication spaces than on the idea of contents or social uses. This term is easy to translate into any other Latin language, but its English version poses a major problem, as it is quite difficult to translate into that language without losing its expressive power. Indeed, "proximity television" is not grammatically correct, and the other possible translations ("small-scale television", "close area television" and other similar ones) do not fully transmit the idea of both physical and cultural proximity that this term conveys. To overcome

this problem in the title of the book, we have used the metaphor "television on your doorstep", but obviously it doesn't work as a discourse concept. Thus, in this English version of our research we have had to avoid the term "proximity television", or to use it in quotation marks, but only exceptionally; the *old* concepts of "regional and local television" or "small-scale television" are used instead.

The concept of *proximity* applied to television refers to the idea of a scenario of experience shared by broadcaster and viewer alike. This is something which is reflected by the content of programmes. The main feature of this "proximity pact" or complicity between the audience and the broadcaster is the preferential attention paid to news contents concerning the territory of reference by small-scale television stations. However, this attention goes much further than traditional newscasts and spills over into other types of programmes such as reports, interviews, discussions, debates and talk-shows, documentaries, magazines, etc. For their part, viewers reward such proximity with high audience figures, as can be seen in the case of France 3's regional broadcasts: 7.10 p.m. to 7.30 p.m. regional and local news have experienced continued audience growth, so much so that the mean share in 1997 was 42 per cent in that timeblock.

Over the last few years, the demand for proximate contents, which had basically been covered by non-fiction programmes, has spread towards soaps, whose high cost and "entertainment" value meant that until very recently they were the exclusive domain of national broadcasters and audio-visual multinationals. For example, the most successful programme on Catalan television, TV3-Televisió de Catalunya, in 1997-98 –14 years after its creation – was the home-produced soap opera *Nissaga de Poder*. It was broadcast daily in the early afternoon timeblock and was based on the intrigues of a rich Catalan family of "cava" (Catalan champagne) producers. Something similar happened on the Welsh channel S4C, whose most popular Welsh-language programme is the long running serial *Pobol y Cwm*, produced by BBC Wales.

With the growth of supply and technological innovation, television is beginning to show that it too can do something that until very recently appeared to be the exclusive domain of *lighter* media like the press and radio: it can interpret a reality on the basis of certain cultural values shared by a small community.

4. Decentralisation of television in Europe: Historical evolution and main stages

In its initial stages television in Europe was heavily centralised. It began operating in capital cities (London, Paris, Rome, Madrid, etc) and then radiated out to the "provinces"; the broadcasts were the same for all territories, mostly (though not exclusively) produced in the headquarters of the broadcasting organization. The first manifestations of

decentralisation generally date back to the 1960s with some exceptions in the 1950s as far as the United Kingdom is concerned, where television centres were set up in the main "provincial" towns. Those centres acted as newsrooms and technical delegations of the central organisation, and also began to broadcast short regional news bulletins in windows. However, these activities were clearly secondary to the strategic projects of the large public service radio and television broadcasting corporations which were much more interested in "nationalisation" than decentralisation. It was precisely to avoid that function of national reaffirmation that the Allied Forces imposed a federal structure on Germany with a corresponding broadcasting system that was highly decentralised (see the article by Hans Kleinsteuber and Barbara Thomass in this book).

The historic development of the decentralisation of television in Europe can be divided into four main stages, including the current stage of major transformation.

At the end of the 1960s, and particularly in the 1970s, the creation of second and third channels by large public service broadcasting corporations encouraged an initial gateway towards regional and local realities. The large public service corporations (BBC in the United Kingdom; RTF-ORTF in France; RTVE in Spain, etc) created their own regional structures. After attaining institutional and business solidity thanks to the benefits and profits gained from their position as monopolies and from public funding, and having reached full coverage of their respective countries as a whole with one or two channels, they started setting up centres or delegations in the main cities and regions of national territory. It was a process that could be considered "natural" in the sense that these corporations were trying to strengthen their areas of coverage from the centre out.

However, these regional centres clearly played a secondary role. They contributed to the news programming of national channels by acting as local newsrooms (and very rarely as programme producers, a role which was allocated to the central headquarters of broadcasting corporations) and were allowed short daily disconnetcions to broadcast regional information. Their off-the-network programming schedules expanded very slowly in terms of time and programme range.

The United Kingdom spearheaded the application of a large-scale television decentralisation policy with the creation of one of the earliest commercial channels in Europe, ITV, on the basis of a structure of independent regional companies (see the article by Mike Cormack in this book). Germany is an exceptional case given that it has had a highly-decentralised federal audio-visual system since the very beginning.

Between the mid 1970s and mid 1980s, general criticism was levelled at the public service television monopoly. This reformist movement had several fronts, one of which was territorial decentralisation of audio-visual

structures. At the same time, technological innovation in the audio-visual sector made production and broadcasting costs cheaper and laid the foundations for "small-scale television". Reformist debate was particularly heated in France and Italy, though it was also present in the United Kingdom, Germany, Holland, Denmark, Belgium, etc. During this period the first local television stations emerged, some of which were based on the "open channel" model, and the regional structures of public service corporations were reinforced. The most obvious manifestation of the latter came with the creation of region-based third channels in France (FR3) and Italy (RAI3). In Spain, this period coincided with political transition from dictatorship to democracy. One of the fundamental principals of that transition was the decentralization of the Spanish State, with the creation of 17 autonomous communities. Consequently, the foundations were laid for the creation of the second most developed and wide-ranging regional audio-visual system in Europe after the German system.

From the mid 1980s to the beginning of the 1990s, debate and reform concentrated on the deregulation/privatisation and globalisation of television. To optimise their commercial revenue, the new private channels fought to get the highest possible audience figures and dragged the old public service corporations into a competitive arena. Consequently, the private channels were not interested in limited regional or local coverage, but in national and international coverage. In the competitive race, the public broadcasting organizations were weighed down by heavy structures stemming from their public service mission, among which "regional obligations" were included. As a result, many corporations chose to freeze or cut back their decentralized activities (RAI, FR3, TVE, etc). The repercussions of all these processes meant that the "proximity factor" faded into the background as commercial channels and entertainment programming proliferated. At this stage it had not yet been perceived as an area of strategic interest for either public or private television networks.

In the 1990s, at the height of transition towards the *digital era*, the processes of privatisation and technological transformation have been the deciding factors that have led to an extremely important change for the audio-visual sector: the multiplication and diversification of television channels. Faced with this new situation, and as the processes of deregulation and innovation matured, small-scale television began to acquire a new importance. The old off-the-network initiatives regained their protagonism while new regional and local experiences emerged. Numerous examples of this new reality can be found in this book. Some national public networks strengthened their regional structures and became receptive to "proximity programming" as a global competitive strategy (the most obvious example is France 3). The Spanish "autonomic" television networks made a sound recovery in terms of audience figures and revenue despite the exponential multiplication of audio-visual supply in Spain (similar in some ways to what happened with the Welsh channel S4C).

On a local scale, more and more cities set up their own channels, whether public, private or mixed. Even large national private networks became interested in this phenomenon and began to place their bets on more regional or local windows. This is the case, for example, of the Spanish channels Antena 3 TV and Tele Cinco, or the British channel ITV. In Denmark, the commercial channel TV2 has a network of eight regional centres that broadcast daily off-the-network programming to their respective territories (see the article by Thomas Tufte in this book). Something similar happens with the private Swedish channel TV4, which broadcasts 15 local windows on a daily basis through the same number of associated local television stations. In Germany, the national private channels SAT.1 and RTL broadcast regional disconnections, though it must be said that they do so by legal obligation rather more than by their own desire to do so.

So, rather than exclude the existence of local and regional television, the advent of the "digital era" appears to have the opposite effect.

5. Types of regional and local television experiences

Unlike the initial stages of television's implantation, the local and regional television scenario in Europe is far from being homogenous or uniform. What we find today is a multiplicity of television forms and models that attempt to adapt and respond to a great deal of regional and local diversity (cultural, linguistic, political, demographic, geographic).

By its very nature, small-scale television is diversity television. That is why we proposed definitions of types in our previous book (*Decentralization in the Global Era*) in order to describe and classify regional television into seven models which, to a large extent, are still valid.

(a) Regional delegated production centres

This refers to regional centres that produce programmes for a national television network, to which they belong. They do not generally broadcast to the city or region they are located in, their production is small and is subject to directives issued by the network central headquarters. They act usually as local newsrooms for the latter. In our previous research we quoted ERT in Salonika (Greece) and RTP in Oporto (Portugal) as examples of this category, though the latter can now be classified under type 2 below. Over time this category has become a residual one since all regional centres now tend to offer some type of disconnected programming.

(b) Decentralised television

This category includes regional centre structures that are dependent on a national network. These regional centres produce and broadcast a daily news programme for their respective areas lasting for 15 to 30 minutes.

They also take part in the production of news and reports for the central newsroom. This is the case, for example, of the regional centres of TVE (Spain), RAI (Italy), TV2 (Denmark) and ORF (Austria).

(c) Regional off-the-network television

This model is similar to type 2 above but is rather more advanced. It refers to the regional centres of a national television station that broadcast in windows of one hour or more per day and have minimally diversified programming schedules. In addition to regional news, they offer reports, cultural programmes, debates, game shows and sport. In some cases these regional "mini-schedules" include regional advertising. They often have a certain degree of autonomous production capacity that they use to meet their own programming needs or to make programmes for national broadcast (some of these delegations have been, are or could become large programme production centres for national broadcast). Some examples of this type are regional centres of some large public service channels located in regions which clearly have their own identity, like BBC Scotland and BBC Wales in the United Kingdom, or TVE Catalunya and TVE Canarias in Spain.

(d) Federated television

This category refers to a set of legally independent regional television organisations that cooperate in a common organization in order to manage and produce programmes for a common national TV network. In addition, they use their territorial settlement to produce and broadcast specific programming for the respective region. Included in this classification are the public broadcasting organisations of the German *länder* and the regional private companies of Channel 3 (formerly ITV) in the United Kingdom.

(e) Independent television with specific regional coverage

This category refers to independent regional stations that produce and broadcast a complete, general programming schedule all day or for a large part thereof in their respective regions. Examples of this type are the "autonomic" television networks in Spain, Omrop Fryslân in Holland and S4C in Wales.

(f) Regional independent television with supra-regional, national or international coverage

This refers to independent regional stations like the ones above which, besides broadcasting in their regions, cover larger territorial units (several regions, the whole State or even beyond State frontiers). Until very recently this type was a minority one, but it has since proliferated as a result of digital compression, satellite broadcasting and distribution via digital

platforms or cable systems. Several German regional terrestrial channels are rebroadcast by satellite (West 3, N3, Bayern 3, MDR 3) and all Spanish "autonomic" television channels have their satellite versions. The latter can be picked up all over Europe and in some cases in America. Belgian television networks, both public and private, are "regional" in the sense that they are aimed at one of the two large, territorially-defined language communities (Flemish and Walloon), though all of them can be picked up throughout the country and beyond by cable broadcast.

(g) Local television with a regional outreach

Although they cannot really be described as "regional television", we consider that some over-the-air (so far) television stations whose broadcasting area and scope reaches out to large part of the region they are located in fit into this category. Examples of this type of television are Télé Lyon Métropole in Lyon (France), Rete 7 in Bologna (Italy), Puls TV in Berlin (Germany), etc.

6. Other transversal classifications

Small-scale television is a complex reality, as it includes the regional dimension as well as local and urban ones. So, in order to define them better, seven-category classification above described needs to be refined by using other approaches.

6.1. Communicative function: "Mirror Television" and "Window Television"

A type defined by Pierre Musso (1991) is taken up here once again. It distinguishes between "mirror television" and "window television". From the viewpoint of a region or city, a television station may act like a "mirror" by reflecting local reality with a complete, independent programming schedule, or like a "window" by inserting disconnected programming into nation-wide programming schedules aimed at the region or city in question.

The latter of the two categories includes off-the-network programming inserted in national networks, which allow for specifically regional broadcasts aimed at different territories simultaneously. These broadcasts are produced by the delegations of central television organisations or by independent local broadcasters who join forces to produce a common nation-wide channel, in which they insert windows they themselves produce. These windows last for half an hour to one and a half hours per day and are based in regional news and current affairs (so, they may include "hard news", reports, debates, talk-shows, documentaries, live transmissions, etc). Some examples of this type are the regional windows of the BBC (United Kingdom), RAI (Italy), TVE (Spain), France 3 (France), ARD (Germany), ITV (United Kingdom), Antena 3 TV (Spain), RTL (Germany), TV2 (Denmark) and ORF (Austria).

"Mirror" television refers to stations who broadcast complete programming schedules aimed specifically at certain regions of a State. These schedules are designed by regional or local-metropolitan television organisations which are not dependent on nation-wide broadcasters. These channels often tend to imitate the programming models of the large, general, national and international television networks, and even include externally produced or imported programmes (telefilms, documentaries, feature films, soaps, etc). But, as the term "mirror television" suggests, the main objective of these stations, unlike nation-wide ones, is to reflect the reality of a region or city through home-produced programmes specifically designed to satisfy the tastes and meet the needs of viewers through contents which are close to their daily experiences.

The 10 autonomic channels in Spain, S4C in Wales, the regional channels of the German *länder* corporations and a large number of local, urban and metropolitan channels in virtually all EU countries can be included in this category.

6.2. Classification according to language use

Analysis of regional and local television's language use can be the basis for another classification. This criterion allows us to distinguish between the following:

• Television stations that basically broadcast in a language specific of the region in which they operate, which is different to the majority language of the State where they are located. This model is virtually exclusive to Spain, where there are a whole host of examples: both of Televisió de Catalunya'a channels, Euskal Telebista's first channel, both of Televisió Valenciana's channels, Televisión de Galicia and TVE's regional centres in Catalonia, the Balearic Islands and Galicia. There is one case in the United Kingdom, which is S4C. Even though 75 per cent of its programming schedule consists of programmes in English taken from Channel 4, it can be included in this category because most of its prime time programmes are broadcast in Welsh.

• Television stations in the regions that only broadcast in the majority language of the State. This is the most widespread model, especially (as to be expected) in those regions that do not have their own particular language.

• Television stations that basically broadcast in the majority language of the State, yet have regular broadcasts (from several hours a month to several hours a day) in the language of the territory they broadcast in. This type is particular to the regional centres or delegations of national channels located in regions where a language is spoken that is different to the majority one of the State. For example: France 3 Bretagne-Pays de Loire (Breton), RAI Bolzano (German and Ladin), and BBC Scotland (Gaelic).

6.3. Territorial coverage

Ten years ago this classification would have been relatively admissible, but today it is complicated by technological innovations and the combination of different broadcasting methods (over the air, cable and satellite). The geographical coverage areas of different channels change quite rapidly and often does not coincide with "legal" (theoretical) or real coverage. Real coverage is usually much wider because of hertzian overspill or "uncontrolled" cable network broadcasting. So, a possible classification for the coverage area type could include the following levels: neighbourhood television, local or urban television, metropolitan television, county/provincial television, regional television, regional television with real national coverage and regional television with real international coverage. The boundaries between these types are becoming less and less defined, and in fact the most financially powerful channels (the Spanish "autonomic" ones, the *Länder*-corporations, Paris Première, etc) are tending to expand their coverage even beyond the frontiers of the countries they are located in, to reach out to those people originating from the region or city who live outside it, or simply to those viewers who have some type of interest in contents referring to that city or region.

7. Factors leading to the decentralisation of television in Europe

Comparative analysis reveals four large groups of factors that go to explain the decentralisation of television: political factors, cultural and language factors, technological factors and specific media factors (those generated by television's structure and funding). Far from acting in an isolated way, these factors combine to produce positive results, or to sometimes restrict the development of regional or local television.

7.1. Political factors

Analysis of the different experiences described in this book shows that one of the most influential factors of decentralisation of television – encouraging or discouraging it – is the political one. This weight is reflected in three particular dimensions which are all closely related: the obvious parallels between political-administrative regionalisation of States and the decentralisation of television, the influence of political parties and lobbies on small-scale television and the prevalence of the public initiative in this sector. Finally, a fourth political dimension that ought to be taken into account now more than ever is internationalisation or, to be more precise, the cession of State sovereignty to the European Union.

7.1.1. Political-administrative regionalisation and the decentralisation of television

The political-administrative decentralisation processes have direct, immediate consequences for radio and television broadcasting systems. This is particularly obvious in the large countries with a centralist tradition

whose television came into being under direct tutelage of the State. This is case for Spain, France and Italy, where, even before the most recent decentralising reforms, the link between regional television and territory management was evidenced by the creation of national networks' delegations and regional windows.

In Italy, the creation of the regions between 1972-1977 received a virtually immediate response with the launch of the regionalised channel RAI 3 in 1979 (see the article by Renato Porro and Giuseppe Richeri in this book). In Spain, the 1978 Constitution, which broke with centuries of hard centralism and paved the way to an "autonomic" regime, allowed "autonomic" television stations to come into being as from 1982 and stimulated RTVE's decentralisation (see the article by Bernat López, Jaume Risquete and Enric Castelló in this book). In France, the 1982 decentralisation Act (see the article by Sylvie Bardou-Boisnier and Isabelle Pailliart in this book) was accompanied by audio-visual reform which, among other things, provided for the fragmentation of FR3 into 12 independent regional television companies that allowed a spectacular increase in regional production and broadcasting to take place (though later these provisions ended up as minor regionalising reforms). Germany, as already mentioned, represents the model with the highest degree of decentralisation, as the federal government does not have powers over broadcasting issues: the powers are in the hands of the *länder*, which have created independent regional broadcasting corporations that together form the public German audio-visual system. Austria did not go as far with the decentralisation of its audio-visual system despite the fact that occupying forces after the Second World War also reorganised the State on a federal basis. However, the ORF is a central, national organisation which has delegations in each of the Austrian *länder* (see the article by Hans Heinz Fabris and Gabriele Siegert in this book).

The British case is special in that a long time before the steps towards political-administrative devolution were promoted by the Labour government as from 1997, some measures had been taken to assure a certain degree of decentralisation of television, the greatest expression of which was the creation of regional television in Wales by the Thatcher government in 1982, apparently contradicting the neo-liberal principles of the *Iron Lady*. The political nature of this and other decentralising decisions that affected the BBC and ITV seems clear: the objective was to create channels of expression particular to non-English peripheries, especially in the case of the national minorities of Scotland and Wales, with the aim of minimising incipient autonomist tension arising in these nationalities. Finally, another outstanding case of the influence of political regionalisation on audio-visual decentralisation is that of Belgium, whose initially single-television system became federalised as the Belgian State progressed towards the separation of the two regions/dominant cultural communities: the Flemish and the Walloons (see the article by J-M Nobre-Correia and Suzy Collard in this book).

These transformations are not free from contradiction or conflict, basically between the central State and regional institutions. In fact, the most competitive regional television projects, those which have attained a more influential cultural and communicative presence and a sounder financial position, are the end-product of political fights, some of which lasted for a long time and were connected with claims of wide-ranging autonomy as in the case of Wales (12 million inhabitants) and Catalonia (6 million inhabitants).

Contrary to that, the State has often tried to limit the scope of the decentralisation of television by promulgating Acts and Regulations containing restrictions on the development of regional and local television. It has occasionally gone to extent of deliberately not regulating the sector to impede an orderly, sound growth (as was the case for local television in Italy and Spain until the beginning of the 1990s). Among these restrictions, it is worth referring to the limitations placed on the creation of local and regional television stations in some States' regulations (the strict control exercised by the CSA in France; private regional television matters or the concession of autonomic channels in Spain), the precariousness or short duration of licences granted (in France, local television licences are granted for four or five years only; in Spain, the local television Act imposes burdensome obligations on local channels) and the restrictions placed on local and regional advertising. Most of these limitations do not affect nation-wide television stations, whether public or private.

7.1.2. Influence of political parties and the political elite on the decentralisation of television

As a logical result of the political nature of the centre-periphery struggle which is the basis for many regional and local television experiences, the political elite and political parties have had and still have a considerable degree of influence over the existence and development of such stations. For example, in the cases already mentioned, the regional elite has practically always tried to influence the incipient regional broadcasting structures and has occasionally gone to the extreme of clear-cut control over them in order to use them as ideological influence instruments in relation to the central State and even against its internal political opponents. But this phenomenon also has its reverse side: in other cases the central State has tried to control or soften regionalist demands or feelings through the regional structures of public broadcasting organisations under its control, or to instrument them in party struggles. In France, for example, ORTF's regional structure, which later led to the creation of France Régions 3, was the result of a deliberate strategy by Gaullist governments to create central-power communication resources in the regions to put the brakes on the major influence of the French regional press which often backed the government's political rivals. In

Spain we have also seen how TVE's regional centres tried to put the brakes on the rise of the new "autonomic" television stations, which in turn were sometimes controlled by regional political parties.

7.1.3. Proximity as a public service function

One of the most visible results of such political influence over the decentralisation of television is the clear protagonism of public initiatives in the local and regional television sector. Small-scale television experiences promoted by the public sector are the rule, whereas those linked to the private sector are the exception.

Determiners particular to the economy of television must be added to that, given its service nature which depends very much on economies of scale (the cost of expanding its market, through coverage spreading, is low compared to the increase in advertising "impacts" to be offered to advertisers). So, the programming of private television stations, whose intention is to reach the largest possible number of viewers, generally offers deterritorialised products, successful programmes bought in from the external market or its own productions without any particular sociocultural reference except for the reproduction of certain successful international formats. In the immediate future and faced with the fragmentation of television supply in general, it remains to be seen if these companies discover the "proximity factor" as a new competitive value, as is the case for M6's local disconnections in France and Antena 3 TV and Tele Cinco regional windows in Spain.

7.1.4. Political internationalisation: The new EU reference

The European Union's communications policy has taken on an extraordinary degree of protagonism in the last 10 years by integrating member States into a new, wider regulatory framework involving the cession of powers in a field, the media and telecommunications, that is so strategic for national sovereignty.

In this new EU context, the core project consisted of creating a common market for communications infrastructures, goods and services (especially in the audio-visual and telecommunications sectors) capable of assuring the survival of European identities and the competitiveness of autochthonous cultural and information industries (Vasconcelos *et al*, 1994). EU communication policies are therefore defined as a form of resistance against large cultural and technological powers (United States, Japan) and that is why they incorporate a large protectionist component. But, at the same time, they play heavily on the liberalisation of the internal market and the breakdown of the different national television and telecommunications monopolistic markets, tipping the scales in favour of a neo-liberal-privatising approach over and above the protectionist-interventionist one (Collins, 1994). This powerful liberalising component is

balanced out by a series of political intervention lines which are generally "softer", such as:

- Encouraging debates about the effects of concentration on media plurality;
- Supporting European audio-visual production (MEDIA programme);
- Supporting public service television under certain conditions;
- Adopting programmes and measures to stimulate the social spread of information and communications technologies (EU discourse about the "information society"; defence of the "universal service" principle, etc).

The effect of this partial transfer of sovereignty in the field of communications to the European Union on the decentralisation of television is limited and, in any event, indirect. It is a well-known fact that the EU has adopted the principle of subsidiarity as a guide in its relations with member States and, by extension, with the regions. So, European regional policy is one that basically redresses economic and structural imbalance, and does not intervene in areas to which the sovereignty of the State or region applies. In other words, regional organisation is the power of the States and regions themselves, and European policy only affects it as a large reference framework on a "macro" scale. Therefore, as far as audio-visual matters are concerned, European policy has not directly affected regions or cities, though it has done so indirectly and ambivalently, in the sense that it has stimulated deregulation and privatisation on the one hand, and the alteration of rigid "statalist" regulatory frameworks on the other, giving rise to new opportunities for other actors (companies, as well as regions and cities). Furthermore, EU discourse protecting, promoting and defending the major philosophical principles of the public service concept is directly connected with values of cultural diversity, proximity and the citizen, as well as authenticity in things local which, needless to say, are inherent to small-scale television.

7.2. Cultural and language factors

The cultural and language factors of the decentralisation of television are closely linked to political factors. In fact, they strengthen them in the sense that cultural minority claims are often politically articulated in the form of demands for autonomy which may be more or less advanced.

The influence of those cultural and language factors are clearly reflected in the case of television stations located in regions which have a different language from the rest of the State: Televisió de Catalunya, Euskal Telebista, Televisión de Galicia and Televisió Valenciana in Spain, S4C in the United Kingdom and Omrop Fryslân in Holland (see the article by Nick Jankowski and Monique Schoorlemmer in this book). In all other cases, for regional television stations that broadcast all or some of their

programmes in a "minority" language, the language factor was not the main or decisive reason behind their creation, since they are regional delegations of national channels forming part of a structure of centres spread out over the territory. "Minority" language broadcasts are generally accessory and/or sporadic in this type of regional centre, with the exception of TVE's centres in Catalonia, the Balearic Islands and Galicia, which wholly broadcast in languages different from the majority one in Spain (in Catalan in the first two cases and Galician in the second). So, for example, the figures for broadcasts in minority languages for France 3 and RAI 3 are minimal in comparison to the overall volume of regional broadcasts. In Scotland, where 65,000 people speak Gaelic (out of a population of over 5 million inhabitants), the first regional broadcasts in this language came considerably after the creation of BBC Scotland and Scottish ITV companies, and are quite scarce altogether. So, in these cases the existence of a minority language cannot be considered as a fundamental motor of the decentralisation of television.

On the contrary, cultural and language factors may restrict the development of regional or local television projects. These must respond to an audience demand in order to become consolidated. The greater the degree of cultural and language difference and awareness of the community in question, the greater the demand. As Dominique Wolton asserts, communication is not given, but is generally conquered in a context of conflict (Wolton, 1989). At a time marked by growing demobilisation of the general public and lack of civilian initiatives, there is a risk of new local and regional television stations emerging which are exclusively connected with political party or business interests. This means that they may be lacking in social approval and therefore in hold and soundness. Or, even worse, new stations may not be created for that very same reason.

7.3. Technological transformation: The "Digital Revolution" and changes in communication's territoriality

Technology stimulates movements and changes in communications (although sometimes the reverse occurs, as changes require technological innovation to meet the demand they generate). Indeed, among the combined causes of TV decentralization, the influence of different stages and aspects of technology are to be mentioned.

Without the advances made in the 1970s and 1980s in the area of production technology (video, lightweight cameras, ENG equipment) and in the area of broadcasting (terrestrial transmission networks, cable networks, etc) local and regional channels would not have emerged and regional centres of national channels could not have been equipped at a reasonable cost. In other words, the lower cost of equipment and the multiplication of available frequencies resulting from the application of

new broadcasting techniques gave rise to the proliferation of small and medium-scale audio-visual experiences.

This early influence has considerably expanded with the opportunities offered by digital technologies in the 1990s. This is basically due to digitalisation and the implantation of broadband networks. It could be said that these technologies actually favour the processes of decentralisation to a large extent, in the sense that they reduce transmission costs by multiplying the number of channels. Digitalisation marks the end of the "broadcasting era" and is paving the way towards a new stage of communication in which – although somewhat paradoxically – the value of everything local is being recovered, in both "traditional" audio-visual spaces and the new framework of technological and communications convergence or "cyberspace" (the Internet). In this sense, some experts have spoken of the "glocal" communication era, that is, local production and contents for global diffusion.

In contrast to that, the new situation of world-wide competition is forcing a constant increase in audio-visual production costs. This context, characterised by the contradiction between a multiplication of channels and an increase in production costs, generates the effect of transforming local communication logic, which is no longer as conditioned by broadcasting space or area as it was in the "broadcasting era". Instead, it will be conditioned by the sociocultural and geographical references of content production. The paradigm of this new situation is the Internet, where local contents have world-wide diffusion (Moragas, 1997a: 153 and 1997b: 88).

In any case, with the more channels, cheaper production and broadcasting technologies, any human community of a reasonable size will have the opportunity to set up its own television channels. In short, it will be able to "audiovisualise" its collective existence. Furthermore, in the new ultra-competitive context, regional and local television stations have an important trump card available to them: their interdependence on the territory, the culture and the interests inherent to the communities for whom they broadcast.

7.4. Structural and financial factors of media systems

In some countries, regional and local broadcasts act like initial "pressure valves" for deregulation. The most obvious case is the Italian one, where the local television boom is the "crack" through which large private interests in the field of television permeate. Something very similar occurred in Greece some 20 years later. But in France, Spain and Denmark, too, decentralisation was the prelude to the deregulation of audio-visual systems. In the United Kingdom, regionalisation and private television came into being simultaneously and were combined to form a single structure, ITV. More recently, in some countries local television has acted like a useful niche

allowing large companies in the sector to penetrate audio-visual markets dominated by an oligopoly of public and private channels. In Germany, urban television came into being in the 1990s as a new area into which German and international media giants could expand, such as Time Warner, which has a shareholding in the metropolitan channels of Berlin (PulsTV) and Hamburg (Hamburg 1), or the Kirch group, which owns 40 per cent of TV München's shareholding. In France, the Compagnie Générale des Eaux has tried to make a place for itself in the audio-visual system through its shareholdings in the local-regional channels Télé Toulouse, Télé Lyon Métropole and Télé Montecarlo.

These contradictions prevent us from always attributing regional and local television with a decentralisation value. In line with our terminology, we could say that not all local stations are true "proximate" TV stations. On the contrary, some may exclusively act in favour of globalisation, by merely becoming local rebroadcasters of imported products, most of which are North American.

In reality, it can be said more rightly that the structural and economic factors inherent to the recent evolution of European media systems have acted against the decentralisation of television.

Firstly, and from a legal-organisational viewpoint, the model of the national television organisation with regional delegations contains the limits of decentralisation within itself. Historically these centres have played a secondary role in the organisation chart and programming schedules of this type of national networks. Programming for national broadcast is mainly produced in the capital (and in two or three major "provincial" cities in some cases) and regional windows account for a small proportion of national channels' programming schedules (generally either side of prime time viewing). This is unlikely to change in the short term at least, basically because of the high costs that a highly decentralised production system would involve and the lack of advertising profitability for regional windows. In some cases, deregulatory tension has even led to backward steps being taken by national channels in their approach towards decentralisation (this was the case for France 3 in France and RAI 3 in Italy in the mid-to-late 1980s). So, in most cases it is very unlikely that regional centres will be able to considerably expand their windows programming or produce more for national broadcast. However, the digital, multi-channel future provides these centres with new prospects. Many of the centres have enough equipment and staff to be able to substantially increase their production if there is enough demand to justify it. In other words, the delegations of national channels are potential audio-visual producers who could employ their capacity to provide regional audio-visual industries with a dynamic boost.

Secondly, as discussed in the next section, deregulation has generally acted to the detriment of the decentralisation of television, though this assertion needs deeper analysis.

7.4.1. Deregulation and decentralisation: complementary or contradictory processes?

One of the most widespread theoretical assumptions in the field of media studies is that deregulation of communication (which includes processes of privatisation, even though those are not the only ones) and decentralisation of television are incompatible or contradictory.

Actually, the complexity of the deregulatory changes goes far beyond a pure and simple privatising movement and includes phenomena as diverse as the end of public service broadcasting monopolies, the gradual reduction of the State's protagonism in communications activities, the recomposition of broadcasting areas, the massive influx of private interests into broadcasting and the questioning of the traditional "enlightened" values associated with public service broadcasting. At virtually the same time, similar processes have affected telecommunications, which are becoming more and more linked to the audio-visual sector as a result of technological innovation.

However, as said above, until very recently most initiatives in the area of regional and local television were taken and maintained by the public sector. The private sector has been very reticent in this area, and it has been much more interested in competing with public television for large national and international markets for obvious reasons connected with business opportunities and growth. This lack of "natural" interest has, in some countries, been supplemented by the existence of centralist-style regulations which have directly or indirectly put obstacles in the way of the private sector's participation in small-scale television, as mentioned previously.

So, it can be asserted that there are different aspects of major changes in European audio-visual systems (transnationalisation of communication, homogenisation of cultural products, deregulation and a commercial approach to the audio-visual sector, etc), which have resulted in negative consequences or restrictions on the decentralisation of television. At the end of 1980s, regional television went into recession throughout virtually all the large EU countries (the most noteworthy exception was Spain), basically because of the defensive reaction of public broadcasting organisations faced with the proliferation of commercial channels. In the case of national broadcasters, that reaction consisted of concentrating their efforts and resources on "popular" national broadcasts, while in specifically regional channels (like the "autonomic" ones in Spain), programming lost local specificity in order to compete with the growing national and international supply. In most of the countries analysed (with the exception of the United Kingdom) there was a quantitative drop in regional off-the-network broadcasts over this period. In some cases this was accompanied by a parallel drop in the regional centres' overall activity. In some countries there was even talk of privatising them or directly

closing them down. Let's see, in the case of large countries, how this crisis of the decentralisation of television resulting from deregulatory pressure manifested itself:

• In France, the conservative government that came into power in 1986 looked into the possibility of privatising FR3, in addition to TF1, although this option was thrown out in 1989-90. Meanwhile, FR3's regional programming went down considerably (from 739 hours in 1984 to 388 hours in 1986).

• In Italy, RAI's third, regionally-based channel was converted into a basically national channel in 1987, with a great deal of programmes for large audiences, within the context of RAI's global competition strategy against Berlusconi's three private networks. Until then it had survived as a very minority channel without any clear identity in which the regional component had not gone any further than playing a marginal role despite the channel's initial decentralising vocation.

• In Spain, the deregulation of television came later than in other European countries. After the major boost that TVE's regional structure received in the 1980s partially in response to the mandate of the Radio and Television Statute Act (1980) though basically as a result of the public organisation's financial bonanza and desire to compete with "autonomic" televisions in their own territories, by 1993 the pressure of the new ultra-competitive market meant that the organisation's management had cut back the activities of regional centres to a minimum (at the same time however, "autonomic" TV stations multiplied and consolidated their positions).

• In Germany, deregulation led to a reduction in the "visibility" of the regional factor in television programmes as a whole. As a result of the competitive pressure stemming from the consolidation of private stations, in 1993 the ARD (a channel managed jointly by the *länder*'s nine broadcasting corporations) unified the timeblock from 5.00 p.m. to 8.00 p.m. with the same national programming which replaced the former, territorially-fragmented programming schedule in which each corporation used to broadcast its own programmes. The basic reason for this unification was the desire to offer advertisers a single national programming schedule instead of several different regional schedules to increase advertising revenue (this timeblock is the ARD's only one to carry advertising). On the basis of that decision, the regional programmes that used to be broadcast on the first channel were transferred to the third channels, which have smaller audiences than the first one and cannot broadcast advertising. As a result, regional presence on the first channel was limited to a daily 10-minute news bulletin.

However, in this process of deregulatory change some positive signs for the development of small-scale television were also found. The inconsistent and

complex nature of structural changes in the audio-visual sector in Europe was borne out by the growing interest of private initiatives in regional and local television after the initial crisis stage had been overcome.

Indeed, deregulation and the new ultra-competitive situation of the audio-visual sector have also produced an opposite reaction to the one described previously in public television networks with greater implantation: some of them have decided to place greater emphasis on regional programming as a "brand" feature to personalise and differentiate them from private supply which is basically of national or international reference. The clearest example is France 3 which, in 1990-91, entered a new phase marked by the growing protagonism of its decentralised structure, a quantitative increase in regional programming and regional production for national broadcast, and a further step towards its "proximity strategy", with the creation of urban news disconnections in small and medium-sized cities by taking advantage of its dense network of sub-centres and newsrooms. In the United Kingdom, despite the negative omens stemming from the 1990 Broadcasting Act, which was of an eminently deregulatory nature, ITV's regional programming increased between the early and mid 1990s, and its decentralised production organisation was maintained and strengthened. In the case of ITV, it is clear to see that decentralisation is a brand image which makes it different from the other terrestrial and satellite channels (however, its business reality has been marked by an ongoing process of concentration of the different regional companies. So, the 1990 reform is ambivalent from the a decentralisation viewpoint). For its part, the BBC also increased its regional broadcasts by 32 per cent between 1990 and 1994 (López, 1998).

But the large public channels, or those with public service obligations, like the ones mentioned in the previous paragraph, were not the only ones to begin to reconsider the competitive potential of proximity; some private channels also opted for approximation. On occasions it was a response to legal requirements and therefore not necessarily voluntary, as was the case for the German channels SAT.1 and RTL, or the expression of an incipient awareness of the benefits of decentralisation in terms of implantation, popularity and audience, as reflected by the cases of the Spanish channels Antena 3 TV and Tele Cinco and the French channel M6. In other countries, government policy has designed commercial television in such a way that it has a direct, unavoidable relation with regionalisation, like the cases of TV2 in Denmark and TV4 in Sweden (or even ITV in the United Kingdom), as part of the public service obligations of new private channels.

As from the 1990s, one of the areas of small-scale television in which private initiatives have had the clearest "spontaneous" protagonism is local television. Two types of initiative were found in this field: large metropolitan area stations and small and medium-scale city channels. The private sector's interest in metropolitan television can be explained by the concentration of

audiences in very small geographical areas with common interests and by reasonable distribution costs (over the air or cable). A paradigmatic case is Paris Première, a channel which, in its early stages, only broadcast to the French capital with contents centred around it. But, in the last few years, it has been broadcast to the whole country and internationally since its incorporation into satellite digital platforms. Without losing its Parisian roots, the channel now appeals to international audiences interested in "la ville des lumières". Another important reason behind the private sector's interest in local (metropolitan) television originates from the fact that national audio-visual spaces have already been occupied by large public and private conglomerates, yet local space is still practically virgin. The latter offers them a niche in the market for business opportunities based on local and regional activity while they get themselves ready to make the jump to national or international markets. This appears to be the case for some metropolitan channels in Germany, where the Time Warner group has shareholdings in PulsTV and Hamburg 1, and in France, where the Compagnie Générale des Eaux controls Télé Lyon Métropole and Télé Toulouse. In Greece, national and regional press companies are trying to make a place for themselves in the audio-visual system by launching regional television stations (see the article by Roy Panagiotopulou in this book).

For their part, in private television stations of some small and medium-sized cities different actors, from private ones with commercial objectives to local public authorities, are involved, which gain "social" and image benefits from their investments. However, small-scale local television is still a not-for-profit undertaking to a large extent, which counts on the financial support of municipalities and other local institutions, or is based on work done by volunteers from civilian organisations.

It should be pointed out, however, that these cases are rather exceptional in the European context. However stimulating the prospect of the private sector becoming involved in regional and local television in a significant way may be, the financial imperatives of the audio-visual business mean that such activity is still a domain preferred by the public sector. As discussed later, this does not mean that public initiatives can maintain regional and local television alone indefinitely, or that private initiatives are going to withdraw from that area: in the new communication ecosystem that is emerging from the new digital landscape, the real formula for this type of television's viability is a mixed public and private funding regime.

8. Future prospects: small-scale television and global development in the "Information Society"

8.1. The tough issue of viability: Towards a mixed public – private model

Previously it was argued that the public sector is and will be decisive in terms of the survival and development of regional and local television. But

it would be impossible to imagine this support without considering new approaches to television's funding and marketing in the new institutional and political context marked by deregulation. In the future, it will no longer be possible to rely wholly on public funding of television in any area. Current debate about the funding of the large public broadcasting corporations and its new strategies of participating in digital multichannel television marks the beginning of a journey of no return as far as the organisation of public television in Europe is concerned.

The future of small-scale TV stations now depends on several factors and synergies they are capable of creating in their favour. It depends, of course, on public policies, on the survival of the public service in this sector, but also on the ability to market their supply of programmes and on a possible increase in demand for proximate contents as an indirect response to globalisation.

The European experience shows that the viability of these small and medium-scale television stations – essential to the social and cultural development of Europe – depends on recourse to a mixed system of backing: public funding and market implantation, as neither of the two sources of funding alone appears to be sufficient to guarantee long-term survival. There are more and more examples that go to illustrate the benefits of this balance between public and commercial funding: the "autonomic" television networks in Spain, S4C in Wales and the local television stations associated to TV4 (Sweden), among others.

Public support for mixed systems is therefore required, combining public subsidies and commercial initiatives, in the different areas of production, broadcasting and marketing of proximate audio-visual products. That means creating global communications policies which are capable of embracing all the areas – local, regional, national and EU-wide – to take advantage of all possible synergies in this sector and, of course, of getting rid of restrictive legislation which, unfortunately, still exists in some European countries.

Local and regional authorities should be able to contribute to the direct or indirect funding of television stations within their areas, as States with national public television networks have done so far. However, some "liberalisation" will be necessary to be able to do that, this time in a decentralising sense, which removes barriers that still persist and allows these experiences to be consolidated without restrictions as absurd as the limitations placed on broadcasting commercials on a local and regional scale, for example (in force in some European countries' current legislation).

Faced with the new communicative landscape, EU media policy comes up against an apparent contradiction between the need to promote a common market, including the audio-visual industry, and the discovery that one of the most important assets of that industry is in fact cultural diversity.

Unification of the market is undoubtedly advantageous for numerous areas of communication, particularly technology, where homogenisation of technical requirements is vital to European competitiveness. The size of the market also needs to be increased for high-budget audio-visual production in order to offset costs and generate economies of scale. But the purely commercial logic of removing barriers and homogenising things for a new, large common market is not as appropriate from a cultural viewpoint. Or should the range of languages that exist in Europe carry on being considered as an obstacle in the way of the development of cultural industries instead of being considered as a potential asset? Is speaking in Galician or Breton a problem or a trump card, once again from a financial viewpoint? In our opinion there can only be one answer in the long term: diversity is wealth, not just cultural but also financial. In the "post-broadcasting era", diversity cannot continue to be considered as a financial obstacle. Instead, it should be considered as a wealth source, especially if advantage is taken of all the opportunities stemming from the convergence of different communications sectors and services.

European cultural and audio-visual policy should stop considering decentralisation as an obstacle or a necessary evil in the defence of identity and see it as a new opportunity for the European audio-visual market. To make compatible the "identity space" and "cultural market" binomial is now the main challenge for communications policies in Europe in every sense.

8.2. Regional and local television in the "Digital Revolution"

But all of this is happening at a time that can be described as the final stage of the "broadcasting era". The future of regional and local television must now be interpreted in the light of changes that are taking place in the communications system in its transition towards the "information society" or the "digital society".

In this stage, the influence of the audio-visual sector and communications in general has already gone beyond the traditional scope of politics, culture and education. Now it affects in addition other fundamental sectors such as finance, industrial production, labour, science, welfare, health, etc. In short, it affects every area of human activity. In this context, the audio-visual sector (mainly television) is emerging as a key, irreplaceable piece in the game: it is a meeting point for all other communications sectors. Why should the local and regional spaces be democratically or culturally cut off from television, which is the great medium of our times? Why can't television play the same role that the press and radio have played in smaller communication areas?

As mentioned previously, instead of threatening the existence of small-scale television, the rapid changes in communications reinforce its relevance and offer new opportunities for its development. However, this does not mean that the future of regional and local television in the "digital era" is obstacle free.

Our research, with a whole host of data and examples, shows that the decentralisation of television cannot carry on being considered as a secondary phenomenon on the edge of mainstream changes in communications. On the contrary, decentralisation is on the rise – though in different ways and with many variants and versions – in virtually every EU country. Neither can it be described as a "minority" phenomenon, because nowadays the concept of "minority" applied to television audiences is somewhat out of date. In the era of fragmentation, equivalence between television audience and mass groups must be rejected once and for all.

In this new communications ecology, contrary to initial forecasts, demand for "proximity communication" is an emerging reality which provides those television stations supplying it with a competitive potential in new context marked by the multiplication of channels and programmes which are far removed from the concrete experiences of their viewers.

Our research shows the extent to which there are factors that can be considered positive for the consolidation of regional and local television: technology, channel availability, social demand and awareness of public powers all point in that direction. But it also reveals the existence of obstacles and negative factors: higher production costs for certain contents, growing competition among programme suppliers, the poverty of the audio-visual industry in many regions, the persistence of centralist or restrictive regulations... However, everything points towards a potential major obstacle: the absence of democratic communication policies that are capable of grasping the importance of regional and local areas in the Europe of the future.

Bibliography and References

Charon, Jean-Marie (1991): *L'état des medias*. Paris: La Decouverte-Mediaspouvoirs.

Collins, Richard (1994): *Broadcasting and audio-visual policy in the European single market*. London: John Libbey.

Cormack, Mike (1995): "United Kingdom: more centralization than meets the eye", in Moragas, Miquel de and Carmelo Garitaonandía (eds.): *Decentralization in the Global Era*. London: John Libbey.

European Commission (1992): *Green Paper on Media Pluralism and Concentration in the Internal Market*. COM (92) 0480. Luxembourg: Office for Official Publications of the European Communities.

European Commission (1993): *White Paper Growth, Competitiveness, Employment*. Luxembourg: Office for Official Publications of the European Communities.

European Commission (1994): *Possible evolution of consultation about the Green Paper on "Media Pluralism and Concentration in the Internal Market "*. *Evaluation of the need for community action*. COM (94) 353 final. Luxembourg: Office for Official Publications of the European Communities.

European Commission (1997): *Green Paper on the Convergence of Telecommunications,*

Media and Information Technology Sectors. Luxembourg: Office for Official Publications of the European Communities.

Garitaonandía, Carmelo (1993): "Regional Television in Europe", in *European Journal of Communication* 8, 3 (September).

Garitaonandía, Carmelo, S. López, C. Peñafiel and B. Zalbidea (1990): "Políticas de comunicación de las regiones y nacionalidades europeas", in RTVV: *Las radiotelevisiones en el espacio europeo*. Valencia: Ens Públic Radiotelevisió Valenciana.

Jankowski, Nick (1995): "The Netherlands: In search of a niche for regional television", in Moragas, Miquel de and Carmelo Garitaonandía (eds.): *Decentralization in the Global Era*. London: John Libbey.

Jankowski, Nick, Ole Prehn and James Stappers (eds.) (1992): *The people's voice. Local radio and television in Europe*. London: John Libbey.

Kleinsteuber, Hans and Barbara Thomass (1995): "Germany: the initiative in the hands of the *länder*", in Moragas, M. and C. Garitaonandía: *Decentralization in the Global Era*. London: John Libbey.

López, Bernat (1998): *La descentralització dels sistemes televisius als cinc grans estats de l'Europa occidental: Alemanya, França, Espanya, Itàlia i Regne Unit (1945-1996)*. Microfilmed doctoral thesis. Bellaterra: Servei de Publicacions de la Universitat Autònoma de Barcelona.

López, Bernat and Maria Corominas (1995): "Spain: The contradictions of the Autonomous model", in Moragas, Miquel de and Carmelo Garitaonandía (eds.): *Decentralization in the Global Era*. London: John Libbey.

Majó, Joan (1997): *Chips, Cables y Poder*. Barcelona: Planeta.

Miguel, Juan Carlos de (1993): *Los grupos multimedia*. Barcelona: Bosch.

Moragas Spà, Miquel de (1997a): "Las ciencias de la comunicación en la «sociedad de la información»", in *Retos de la sociedad de la información*. Salamanca: Universidad Pontificia de Salamanca.

Moragas Spà, Miquel de (1997b): "Global y local: competitividad y complementariedad en la era digital", in RTVV: *Hacia un nuevo concepto de televisión*. Valencia: Ens Públic Radiotelevisió Valenciana.

Moragas, Miquel de (1988): *Espais de Comunicació*. Barcelona: Edicions 62.

Moragas, Miquel de and Carmelo Garitaonandía (eds.) (1995): *Decentralization in the Global Era*. London: John Libbey.

Musso, Pierre *et al.* (eds.) (1991): *Régions d'Europe et télévisions*. Paris: Miroirs.

Musso, Pierre et al. (eds.) (1993): *Presse écrite et télévision dans les régions d'Europe. Rapport au Conseil de l'Europe. Rapport provisoire*. 1993.

Sánchez Tabernero, Alfonso *et al.* (1994): *Concentración de la comunicación en Europa. Empresa comercial e interés publico*. Barcelona: Centre d'Investigació de la Comunicació.

Vasconcelos, P. A. *et al.* (1994): *Rapport de la cellule de réflexion sur la politique audiovisuelle dans l'Union Européenne*. Luxembourg: Office for Official Publications of the European Communities.

Wolton, Dominique (1989): "La place de la télévision régionale", in Vidéotrame: *Les télévisions communautaires locales et régionales dans la CEE*. Namur: Vidéotrame.

Notes

1 See the European Commission's interpretation of this transformation in the Green Paper on the *Convergence of the Telecommunications, Media and Information Technology Sectors* (COM(97)623). Luxembourg: Office for Official Publications of the European Communities.

2 Including a wide variety of experiences, ranging from the regional centres of the national public broadcasting organizations, like RTP Açores and RTP Madeira in Portugal, or the RAI's regional centres, to the independent television stations of regional coverage, like the Spanish "autonomic" TV stations.

3 Like the ones created by the cable operators (for instance Wien 1, produced by RTV Lower Austria in Wien), or local over-the-air stations as Hamburg 1, Barcelona Televisió or Télé Lyon Métropole.

Austria: A shy and belated regionalization of television

Hans Heinz Fabris, Gabriele Siegert

1. Regional dimension of the State

1.1. General political framework and the role of the regions

Austria, with eight million inhabitants and a surface area of 83.000 km,[?] is a small State in the heart of Europe which came into being as we know it today at the end of the First World War in 1918 and after the downfall of the Austro-Hungarian Empire, which had been one of Europe's major political powers. The Second Republic was founded in 1945 when the country, which had been annexed by Nazi Germany, regained its independence.

Today Austria is a parliamentary democracy with a long tradition of strong parties and so-called "social cooperation". Such cooperation between employers' organisations and trade unions is virtually institutionalised. From 1945 and for over 30 years the country was governed by a "large" coalition of the two major political forces, the social democrats and the conservatives, which gave rise to political stability and consistent electoral behaviour. However, it also produced social immobility and political apathy. Austria's five political parties have only been represented in the Parliament since a few years ago.

From an economic point of view, Austria is currently one of the richest countries in the world. To a large extent, the Austrian economy is characterised by its "passive internationalism", which manifests itself as dependence on capital and technology imports. Its main partner is

Germany, which accounts for 40 per cent of the import/export market. It is still too soon to say whether this situation will change as a result of joining the European Union. However, it can be asserted that since 1989 its peripheral situation with regards to Europe has, indeed, changed. Once again, Austria is at the centre of the continent, and not merely from a geographical point of view. Even though its unemployment rate is lower than most European Union countries, its economic growth in the 1990s has slowed down after a long period of prosperity and the consequences of the "Maastricht criteria" are noticeable everywhere.

Table 1. Basic indicators of the Austrian *länder*

Land	Inhabitants*	Homes (thousands)	Surface Area (km2)	Minorities
Upper Austria	1,294,000	502	11,980	-
Lower Austria	1,426,000	565	19,172	-
Burgenland	267,000	97	3,966	Croatians, Hungarians
Carinthia	542,000	210	9,533	Slovenians
Styria	1,181,000	444	16,387	-
Salzburg	462,000	191	7,154	-
Tyrol	610,000	236	12,647	-
Vienna	1,480,000	765	415	-
Vorarlberg	314,000	121	2,601	-

* 1992 data

Source: *Microzensus 1995*.

1.2. Federalism in theory and practice: "A unified decentralised State"

Together with Germany and Belgium, Austria is one of the EU States that has a federal constitution. However, at the time when the constitution was drafted, federalism was one of the most debated principles. This is a phenomenon that dates back to the 19th century. Whereas a multitude of centralised national States arose in Europe, the territory of the Austro-Hungarian monarchy had a multicultural structure with a delicate balance between regional, language and economic interests, etc., which did not however exclude the centralist component symbolised by Vienna as the capital of the Empire. Austria can be considered as a "tardy nation" in which the nine federal States, the *länder* (Burgenland, Carinthia, Lower Austria, Upper Austria, Salzburg, Styria, Tyrol, Vorarlberg and Vienna), have a much older history and identity.

The previously mentioned political debate was between the right wing who defended strict federalism – since they dominated in the *länder* – and the social democrats, in the centre – whose stronghold was the capital,

Vienna. Hence a compromise was reached regarding the constitutional model, which could be described as a "unified decentralised State" characterised by the following traits:

- Regarding the distribution of powers, the Federation has very clear primacy over the *länder*, to which secondary powers for legislation, administration, finance and education are equally assigned.

- The representative body of the *länder*, the regional chamber or *Bundesrat*, plays a marginal role in the Constitution and in everyday political life: unlike the lower chamber or *Nationalrat* it is not directly elected, but is constituted in accordance with the proportion of forces in the *länder*.

- The supremacy of the Federation is particularly noticeable when it comes to economic issues.

- The *länder* have very limited room for manoeuvre when it comes to foreign affairs.

- The executive is determined by the Federation.

This is what the Constitution sets out. But political reality is much more complex:

- To a large extent, the federal States determine the execution of the State's general budgets and, therefore, the allocation of resources.

- Through private law institutions and informal routes, the federal States have opened up possibilities for themselves to act in almost all areas of political life and even foreign affairs.

So, the real influence of the *länder* does not simply depend on the Constitution. To a large extent it is shaped by people and coalitions in power, as well as the Parliament and the Government. As a result, the president of a *land* may have more political influence than a minister of the federal Government.

The *länder* took advantage of Austria's admission to the EU (1st January, 1995) to demand a distribution of powers that was more beneficial to their interests, though they were not as successful as they expected. In 1997 there was a heated debate about the possibility of reducing the number of *länder* to three larger administrative units on the basis of two arguments: first, that most of them were too small in comparison with other EU member States and, second, that such a reduction would allow cutbacks in public spending to be made. The reactions to this proposal highlighted the fact that the mentality about the uniqueness of the *länder* was still firmly rooted in the Austrians' consciousness. The proposal was rejected.

Tension between centralism and decentralisation has also had repercussions on the media and particularly on the development of

television. Vienna's strong position as the traditional centre of not only the main cultural institutions such as the National Opera, the *Burgtheater* and the Philharmonic Orchestra of Vienna, but also of publishers, newspapers and of course the Austrian public service Radio and Television Network, ORF (Osterreich Rundfunk und Fernsehen), is absolutely clear to see. After 1945 this situation changed in favour of the western *länder* because the allies supported media reconstruction in the areas they occupied resulting from a shift of economic power. This process was marked by numerous conflicts. The situation has changed very little since then, and now the political parties are debating the Federation's and the *länder*'s involvement in the transformation of radio and television society to the *länder*'s benefit. This is the main reason behind the delay in creating cable, local and regional stations which are not dependent on ORF. The coalition of interests represented by regional media, city councils, regional economic powers and other political forces has not attained any of its objectives yet and many experts consider that local cable television will not be a reality until the year 2000.

1.3. Language and cultural minorities

Similar tension is caused by the representation of the cultural and language interests of some *länder*'s minorities. They are relatively small bilingual minorities and are very local, as is the case for Croatians and Hungarians in Burgenland and Slovenians in the south of Carinthia and in Styria. The situation is particularly unfavourable for foreigners who are not citizens of an EU country. In addition to their political rights being extremely restricted, they hardly have any access to the media. In this sense, the only programme aimed at national minorities is *Heimat, fremde Heimat*, broadcast on Sundays with the presence of the director of the Minorities Office. However, even among German-speaking Austrians (Austrian German) there are numerous differences regarding customs and language use, though up to now they have hardly been taken into account despite the ORF's "regionalisation".

2. Television in Austria

2.1. ORF's origins, consolidation and structure

Television broadcasting began in Austria in 1955, coinciding with the State's reconstruction after the Second World War, when the country regained sovereignty by means of the "State Treaty". As from 1945 the allies had organised the *länder*'s stations to fit in with their own distribution patterns: the USSR controlled Radio Wien; the USA controlled the well-known Rot-Weiß-Rot in Upper Austria and Salzburg; Great Britain controlled the Sendergruppe Alpenland station in Styria and Carinthia; and France controlled Sendergruppe West in Tyrol and Vorarlberg.

In 1954, the Constitutional Court resolved the debate about whether or not radio should have a central or federal structure, a debate that dated back to the First Republic. Members of the Supreme Court, who ruled in favour of a central structure, accepted the essence of the Government's arguments which defended this option because it saw radio as an instrument of political integration. The *länder*, on the other hand, wanted autonomous radio stations. The Constitutional Court's ruling considerably delayed the development of radio in the *länder*.

That same year, the first television broadcast was made from a television studio in Vienna. The first channel appeared on the scene in 1955. Two years later it regularly broadcast six days a week. The second channel came ten years later when a group of independent journalists promulgated a reform which gave rise to a new Act (1966) which attempted to remove the Government's influence from television and radio and established a more modern organisation. This is the current situation, although the debate about the creation of a third channel and private television companies periodically arises. Broadcasts from Austrian soil for satellite and cable transmission were not authorised until 1996. Thanks to such authorisation and skilful business policies, ORF has managed to maintain its undeniable leadership on the small screen.

ORF manages three radio stations and two television channels. It recently began broadcasting a special weather channel via satellite. The first channels' broadcasts are centred around programmes for children, sport, films and serials. ORF 2, with news programmes, documentaries and attention to Austrian contents is particularly aimed at adult viewers and people interested in such topics.

ORF currently employs 2,800 people, of which 700 are employed in regional studios, and has numerous outside collaborators. ORF is financed approximately 50/50 by fees and advertising revenue. On average the radio and television licence fee is 235.69 Austrian Schillings per month, of which 148.75 (63.1 per cent) are allocated to ORF. The fee contains a regional tax that varies depending on the *land*.

The supreme broadcasting authority is ORF's Board of Directors, which appoints the general and regional directors. This Board is also responsible for long-term decision making for all programming, technical, financial and human resources issues. Nine of the 35 Board members are appointed by the *länder* (one from each). The financial director acts as the administrator though his powers are limited. An organisation that has no equal on an international scale is the listeners' and viewers' representative body, despite the fact that it has few effective attributions. The five members of the Executive Council have greater decision-making capacity and are appointed by the central Board of Directors.

2.2. Cable and satellite television

The beginnings of cable in Austria date back to 1956. In the 1970s cable was generally installed in the west of the country, especially in Vienna, and in the mid 1980s throughout the rest of country. Several private sector companies and not public services are responsible for introducing cable television in Austria. Initially, only foreign public service channels were authorised, specifically the German ARD and ZDF and the Swiss SRG. Currently, cable television promoters offer products that are very similar to satellite television. The cable television market is dominated by the electronics industry, especially Siemens and Phillips (the latter of the two has sold a portion of its shares in Telekabel Wien to United International Holdings, UIH). This concentration of product supply is reproduced in the *länder*, where regional electricity companies and city councils can be found alongside private sector companies. For a long time the legal basis was established by a 1987 Order (*Fernspruch-Verordnung*) which only authorised the broadcasting of foreign channels, though it did not authorise the companies' own productions ("passive television"). In 1993, cable teletext was authorised, that is, the broadcasting of written messages, and, in 1995, after a ruling made by the Constitutional Court, the companies' own programmes were also permitted.

2.3. Television's legal framework in Austria

The legal basis of cable television in Austria is the 1974 Act which, since it was passed, has undergone several reforms. The most important aspect of the Act is that it establishes radio and television as public-right organisations, stating that "radio and television are public services". In its current version, after the last reform in 1993, the Act of 10th July, 1974, details the duties of Austria's public service Radio and Television Network (ORF) as the only institution authorised to broadcast by cable. Its obligations are:

1. To inform citizens about politics, the economy, culture and sport by: (a) objectively selecting and broadcasting news and reports; (b) reproducing and broadcasting comments, points of view and critical stances essential to the citizens while respecting the diversity of opinions in public life; (c) the service's own comments and analysis, upholding the principle of objectivity.

2. To educate youths and the citizens in general, paying special attention to the promotion of school and adult education, and to encourage awareness of all issues connected with democratic coexistence.

3. To disseminate and promote art and science.

4. To offer morally proper entertainment.

5. To encourage the inhabitants' interest in active sport.

Other duties mentioned are connected with observing the principles of the Austrian Constitution, particularly the federal articulation of the State and the principle of equality of the *länder*, the freedom of art, objectivity and impartiality of information, respect for the diversity of opinion and the balance of programmes. The Act guarantees independence of people and organisations of ORF.

Regarding radio, the Act establishes that one of the stations must operate as a regional station, mostly through windows for each *land*. However, nothing is stated about television, except that programming "must observe the *länder's* interests" (article 3.2), for which the regional studios are responsible.

Of the duties contained in television directives issued by the Council of Europe and the EU, the following have been assumed: respect for human dignity, fundamental human rights of others, the obligation of not inciting hate on grounds of race, culture, religion or nationality, special protection of minors from pornography and violence, and the quota of European productions.

2.3.1. The Cable and Satellite Television Act (1997)

This Act was passed at the beginning of 1997. It regulates the constitution of cable television systems, a possibility introduced by the Supreme Court's ruling, as these stations could not broadcast paid advertising as a result of which their production was seriously restricted.

The new act, however, is very liberal, as it does not provide for any licensing system. All that needs to be done is to inform the regional cable radio and television authority with a week's notice. There are some limitations affecting promoters. For example, the participation of non-EU citizens cannot be greater than 25 per cent and the participation of the press cannot be greater than 26 per cent. On the other hand, authorisation of satellite programme production and broadcasting must be applied for.

The promoters of cable and satellite television must observe certain rules such as "objectivity" and respect for the "diversity of opinions" (article 14.1), although the act is less restrictive in comparison to the one that regulates ORF's programming. It also specifies that local channels must have a "suitable proportion" of local writers (article 14.4). The rules governing advertising and television shopping observe the EU directive concerning television without frontiers.

2.4. The television market in Austria

98 per cent of Austrian homes have a television set. On average, adults watch television two and a quarter hours per day and children one and a quarter. The average daily audience is 77 per cent. Foreign channels can be picked up over the air, by cable or satellite in 78 per cent of Austrian homes. ORF's channels are still the favourites: over 66 per cent of viewers (audience in the

first half of 1997) preferred ORF to foreign German-speaking channels. Occupying first place among the foreign channels is RTL followed by the German Sat 1, PRO 7, ARD and ZDF (accounting for 33 per cent of the audience in the first half of 1997). The market data show that ORF is the EU's most successful public channel. The remaining foreign channels together account for 16 per cent of the share. It should be pointed out that after the last reform ORF has even managed to increase its market leadership.

Graph 1. Television consumption on a national scale. AQH Audience (1996) (population aged over 14 years)

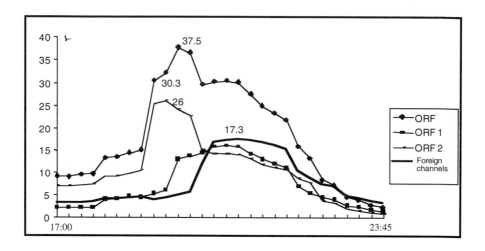

ORF 2 has a larger audience than ORF1. This is due to the fact that the former of the two is the only channel whose programming is clearly Austrian oriented. Its news programmes and documentaries are a considerable source of regional and national information mainly for adult and rural audiences, whereas ORF 1 has – except for the daily news – a USP (unique selling position) profile similar to the German RTL and SAT1, meaning that it has to fight against tough competition.

3. Regional television in Austria

3.1. Regional and local television: stages of a process

In Austria, regional television is understood as consisting of programmes produced by ORF in the *länder's* studios and broadcast throughout the country. Local television is the one that is only broadcast throughout a *land*. From this point of view, the 270 cable channels which, as a general rule, broadcast throughout a territory which does not extend to a whole *land* or which are often restricted to a municipality, should be considered as sub-local.

Table 2. Daily TV Share (1993-1996, in %)

	Adults (over 12 years)								Children (between 3 and 11 years)							
	National				Cable and satellite				National				Cable and satellite			
	93	94	95	96	93	94	95	96	93	94	95	96	93	94	95	96
ORF	66	62	63	62	44	44	47	48	59	52	59	47	26	25	34	29
Foreign	34	38	37	39	56	56	53	52	41	48	41	54	74	76	66	71
ORF 1	36	32	27	25	22	21	20	20	42	36	48	38	17	16	27	22
ORF 2	30	31	36	36	22	23	27	29	17	16	11	9	9	9	8	7
RTL	8	8	7	6	14	12	10	9	9	8	6	6	17	12	9	8
SAT 1	6	6	6	5	10	9	8	7	4	5	4	3	8	7	6	4
PRO7	5	6	5	5	10	9	8	7	11	14	12	11	21	22	19	15
RTL2	2	2	2	3	4	4	3	4	8	11	8	8	14	18	12	11
ARD	3	3	3	3	3	4	4	3	2	2	2	2	2	3	2	2
ARD3	-	-	-	3	-	-	-	3	-	-	-	2	-	-	-	2
ZDF	3	3	3	2	3	4	3	3	1	1	1	1	1	1	1	1
KABEL 1	-	-	1	2	-	-	1	3	-	-	2	3	-	-	3	4
VOX	-	-	-	2	-	-	-	2	-	-	-	1	-	-	-	1
BFS	1	1	1	1	2	2	2	2	1	0	1	1	0	1	1	1
Super RTL	-	-	-	1-	-	-	-	2	-	-	-	12	-	-	-	16
EUROSPORT	1	1	1	1	1	2	2	1	1	1	1	1	1	1	1	1
3SAT	1	1	1	1	2	1	1	1	0	0	0	1	1	1	1	1
DSF	1	1	1	1	1	1	1	1	0	0	1	0	1	1	1	1
DRS	1	1	0	0	1	1	1	1	0	0	0	0	1	1	0	0
MTV	0	0	0	0	0	0	0	0	0	0	1	1	1	1	1	1
VIVA	-	-	-	0	-	-	-	0	-	-	-	0	-	-	-	0
n-TV	-	-	-	0	-	-	-	0	-	-	-	*	-	-	-	0
CNN	0	*	0	0	0	0	0	0	*	*	0	0	0	*	0	0
Others	2	5	6	3	5	6	9	3	4	6	2	1	6	7	9	2
Total TV	100	100	100	100	100	100	100	100	100	100	100	100	100	100	100	100

* = below 0.49

Source: *Teletest* 1993/1994/1995/1996; *ORF-GMF* 1997.

In the same way as for general broadcasting in Austria, the development of regional and local television has taken place in a tug of war between centralising and decentralising forces. This has caused considerable delays when compared to other countries in the European context. The phases into which the set-up and development of regional and local television in Austria can be divided are as follows:

- 1966-1974: resulting from the 1966/67 reform, the *länder*'s studios in Upper Austria, Salzburg and Vorarlberg are extended and programme production in the *länder* begins.

- 1974-1984: this period is characterised by a marked growth of regional studio production. The introduction of regional programmes was declared as ORF's priority objective and the first broadcasts in

windows began (*Österreich-Bild, Club regional*). In 1980, the regionalisation of television officially got underway, which involved the regional studios' full participation and, above all, the growth of independent productions.

• 1984-1994: in the mid 80s, the regional studios produced 20 per cent of ORF programmes. From 1987, their own news programmes lasting half an hour were broadcast daily before the main evening news programme, *Zeit im Bild*. The audience of these news programmes was between 11 per cent and 26 per cent (in Vienna or Salzburg), representing a share between 39 per cent and 80 per cent.

• 1994-1997: currently the debate is centred on the privatisation of at least one of ORF's channels, private television as the television for an urban concentration zone in the Vienna area, increasing the number of existing programmes and the introduction of new programmes such as regional debates.

In the 1980s, a proposal to divide the two channels between the Federation and the *länder* already existed (Haslauer-Niederl Plan). This idea was reintroduced in 1996/97 when, among other issues, the possibility of turning ORF into a private company was debated. So far the Government has been unable to reach an agreement about ORF's privatisation and the regulation of private cable television. Meanwhile, ORF is trying to occupy the market by expanding regional studios' programming which – it must be said – are not producing any losses for the moment. The objective over the coming years is to carry on strengthening regionalisation as well as generating new revenue in the service sector and via new media.

3.2. Regional ORF operation: television as a public service

ORF's regional television is organised through its regional studios. As already indicated, "regional television" is spoken about in Austria when the programmes produced by the regional studios are broadcast throughout the country and "local television" when programmes are produced and broadcast regionally. There are nine regional studios in total, one in each *land*. These studios are run by a regional director who reports to the director general of ORF. The studios are organised into different sections: culture, news programmes, radio serials, etc.

The main activity of regional studios still concentrates on radio. However, their role in the television sector will almost certainly become more important due to the present and future competition of private cable television. This is already patently obvious, for example, from the expansion of evening programming which took place in 1997. The number of employees at regional studios varies between 79 and 110 (1994 data) and they have a very high level technical infrastructure. However, rationalist tendencies, which constitute an important part of ORF's

business policy, have already been felt (such as cutting back on the number of employees).

To a different degree and depending on the *land*, regional studios have managed to play an important role in the politics, economy and culture of their regions, and they have become "institutions" of public life. Access is more direct than to the central corporation of ORF, although the political spectrum of the *land* is inevitably reflected in the composition of the workforce and the programming philosophy.

Of major importance to programme production are the so-called internal Programming Directives which try to translate the legal precepts into day-to-day tasks. Regarding regional interests, these directives state that "as far as television programmes are concerned, article 3.2 of the Broadcasting Act must be taken into account. This article forces the interests of the *länder* to be considered and, therefore, foresees contributions by regional directors. That does not release the director general from ultimate responsibility. The regional director oversees the upholding of the region's rights by means of its own product supply or by means of an invitation from the director general to make us of its attributions".

3.2.1. ORF's regional programming

Regional studios, which were initially limited to radio, have formed part of the successive phases of ORF's modernisation and regionalisation process. Thus, there has been increasingly greater involvement of the regional studios in television programme production, so much so that in 1996 regional programming accounted for 10 per cent of total programming. Regional studios are currently in charge of producing a radio station (Ö2 or Ö Regional), regional sections of national news programmes and a half-hour programme in the afternoon-evening time block, *Bundesland Heute* ("*Land* news"). In 1998, the news and interview programme *Treffpunkt Bundesland* ("The *Land*'s meeting point") was added to the afternoon time block. In the first month of broadcasting, this new programme managed to secure an average share of 7.9 per cent, though with variations in the different Austrian *länder* (fore example: Burgenland, 11.3 per cent; Steiermark, 10.4 per cent; Vorarlberg, 8.5 per cent; Salzburg, 3 per cent; Niederösterreich, 4.7 per cent; and Vienna, 6.3 per cent).

The *länder*'s newsroom, centralised in Vienna, coordinates and produces the national block of local editions of *Bundesland Heute* and also produces *Österreich Heute* ("Austria today") for the whole country at weekends and on public holidays. It also lends logistic support to the regional studios for the production of *Bundesland Heute*, legal advice, archive work, etc.

In 1995, the involvement of local studios in ORF's total news programming was 23 per cent, whose production accounted for 22 per cent of the news programme budget.

Table 3. ORF's regional studios. Broadcasting hours in 1994

	Burgenland	Carinthia	Lower Austria	Upper Austria	Salzburg	Styria	Tyrol	Vorarlberg	Vienna
Total	153	302	193	241	154	154	148	147	139
With own budget	145	212	188	145	139	129	133	119	128

Source: *ORF-Almanach 1995/96*

Bundesland Heute is a 30 programme broadcast in each *land* from Monday to Friday (from 7.00 p.m. to 7.30 p.m.) before the afternoon-evening news, with regional and local information alongside a block of national news. The programmes are called *Kärnten Heute, Salzburg Heute*, etc, and attempt to present the news of each *land* in an entertaining way. Depending on the studio, the information is supplemented with brief surveys about regional and local topics in addition to other news services. Some studios also broadcast this news programme on the radio. The programmes *Bundesland Heute*, which are broadcast on ORF's second channel, have good audiences and excellent shares, even in comparison to ORF's other channel or foreign channels. According to Media Analyse data, the *Bundesland Heute* programme accounts for an average daily audience of 25.7 per cent, whereas ORF 1 accounts for 5.7 per cent and all the foreign channels together account for 4.2 per cent (with a share of 35.6 per cent).

The high share figures go to show just how attractive the programmes are, and they have even gone up in comparison to 1994, when an average 65 per cent of viewers watched the corresponding *Bundesland Heute* programme between 7.00 p.m. and 7.30 p.m. In 1996, the shares for these programmes in the different *länder* were as follows.

Table 4. *Bundesland Heute* Programmes. 1996 Audience Figures (in %)

Land	Share	Total Audience
Upper Austria	21.7	78.2
Lower Austria	20.5	72.7
Burgenland	21.5	79.3
Carinthia	27.3	81.7
Styria	22.5	75.8
Salzburg	22.4	79.2
Tyrol	21.8	78.7
Vienna	17.4	64.9
Vorarlberg	23.5	83.8

Source: *ORF Mediaresearch*.

Graph 2. 1996 Shares (7.00 p.m. to 7.30 p.m. time block)

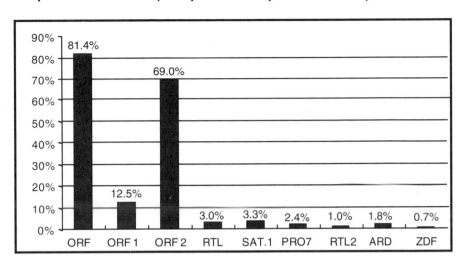

Source: *Teletest* 1996/12+; ORF *Geschäftsbericht* 1996.

Preference for these local programmes is confirmed by other data: in 1996 the *Bundesland Heute* programmes scored an average of 4.17 on a scale from 0 (very bad) to 6 (very good). The fidelity rate of 84.2 indicates that not only do viewers change channels just before the start of the programme but also watch it for virtually the whole broadcast. What's more, in the top-rated programmes in 1996 by viewers over the age of 12, the *Bundesland Heute* programme broadcast on 29th February was in fourth place with an average audience of 28.7 per cent.

Treffpunkt Bundesland is a new format programme which, lasting for 60 minutes, began to be broadcast at the beginning of 1998, from Monday to Friday, at 4.00 p.m. The programme's structure varies depending on the studio, though the main block is reserved for interviews and chats. This block is completed with news and general interest items (health, self-help, esoterics, etc), with telephone competitions or video requests. The aim is guarantee the public's involvement by encouraging them to intervene in debates and taking the cameras out to attractive places, such as shopping centres or fairs. Its budget is 5.5 million Austrian Schillings per studio per annum. In this case however, funding is threatened because the broadcast of local advertising is forbidden. In Austria, public local television channels cannot increase their budgets by local advertising because it is forbidden. This prohibition is very controversial, although it is supported by newspaper editors among others. Some regional studios are experimenting with other formulas for their own programmes. For example, in 1996 Upper Austria broadcast *Mittagsstudio Oberösterreich* ("Upper Austria's Midday Studio") in pilot phase and the regional studio of Styria broadcasts its own special window programmes.

3.3. Regional private television: cable television channels

3.3.1. Private channels in the länder

As a result of the public broadcasting monopoly and the legislation in force, private cable television channels, whether national or regional, have not been allowed to operate until now. Since, on the other hand, Austria and its *länder* represent a relatively small market, neither of the two ORF channels have had any competitors for financial reasons. However, since the beginning of the 1980s, regional cable television companies have gradually been set up and, since the 1997 Act was passed, they have officially been allowed to broadcast their own programmes. Therefore, the situation is characterised by the decentralised television of ORF's regional studios, with their regional and local programmes, and by the presence of the local and sub-local television of cable television companies. On the other hand, some issues that are currently being debated are the appropriateness of privatising or regionalising one of ORF's channels, the possibility of finding a third channel with wide coverage or even a fourth channel for private promoters to cover urban concentration zones.

How can the continuance of ORF's monopoly of cable television be explained? The fact is that the legislators have so far omitted to create the legal basis for other operators' actions despite the constant declarations made by those responsible for communications policies about the need to set up a dual television system in Austria like the one that has recently been introduced for radio. Due to the proximity of Germany, it should be borne in mind that the German television stations' programmes can be picked up over the air virtually throughout the whole of Austria, that most Austrian homes are now equipped with satellite and cable reception systems and that among the political forces there is a great deal of consensus to keep ORF as a solid, public, Austrian organisation in the future. The differences arise for the regional television model.

As private cable television channels have not been authorised for the whole of Austria yet, private local and sub-local television depends on cable television companies who are able to broadcast their own programmes. These broadcasts began in 1996 and were regulated by the 1997 Act. Even though the satellite and cable television Act distinguishes between cable television producers and network managers, both ideas are mixed up in practice. In the Federal Chamber of Commerce's list, under the Communications-Cable Television section, at the end of 1996 there were 273 companies, which did not include those strictly classified as broadcasting companies. It is not clear, then, which and how many of the companies produce their own programmes, buy in programmes and broadcast them or simply make their network available to other companies. Cable television production does not require any licence. All that is needed is a statement made to the corresponding regional authority. As these regulations are relatively recent, no official list of cable television

producers exists yet. To make things even more difficult, since the Act was passed, the panorama of private media is constantly changing, so much so, that it is virtually impossible to describe the short-term situation.

Table 5. Cable television companies in Austria. December 1996

Upper Austria	108
Lower Austria	29
Burgenland	3
Carinthia	7
Styria	41
Salzburg	25
Tyrol	38
Vienna	5
Vorarlberg	17

Source: Berufsgruppe 'Kabel-TV': *Liste der Bundeswirtschaftskammer für den Fachverband für Verkehr.*

The ownership structure of cable television companies is as follows: the smallest local companies mostly belong to private promoters, although there are some mixed companies formed by industrial companies and city councils, as well as the *länder*'s public companies, public institutions, chambers or city councils. In these cases, the *länder*'s electricity companies are responsible for cabling.

Of the 276 registered cable television operators, it is estimated that around 170 have fewer than 500 subscribers. They therefore cover very small local markets. As a whole, these companies have 870,000 customers. Some companies broadcast German-speaking and international radio and television on their networks whereas others offer local and sub-local channel or station programmes. The remainder produce and broadcast local and sub-local programmes. Among these companies there are three large operators: the Telekabel group – in Vienna, Graz, Klagenfurt, Wiener Neustadt and Baden- Kabelsignal – in Linz, Wels, Steyr and southern areas of Vienna – and Telesystem – in Tyrol, Burgenland, Salzburg and Vorarlberg. The large cable operators also offer fast Internet access.

On their television channels the cable operators have "traditional" weekly, monthly and quarterly news programmes about the economy, culture, sports and the weather, and they broadcast them repeatedly on several networks. Very few produce more than an hour of daily news programmes and quality varies greatly. In the long term the large cable network operators will probably be the only ones able to create ambitious local channels. They are mostly financed by advertising – authorised in 1997 – or sponsors. In some city councils, political institutions are involved in

private local television channels, claiming that they provide citizens with information. It remains to be seen to what extent the power groups will instrumentalise these new possibilities to serve their own ends.

3.3.2. Types of cable television in the länder

As is the case for public television, the situation varies greatly from one *land* to another. The panorama is as follows:

Vienna

There are five cable television companies. These include Telekabel Wien, 5 per cent of which is owned by the city council and 95 per cent by United International Holding (UIH). With some 370,000 subscribers, it manages one of the world's largest networks. 68.5 per cent of Vienna's cabled homes subscribe to Telekabel. However, apart from teletext, it does not broadcast its own programmes. Its programming includes 33 international programmes, the *Reuters Junior* financial information system, radio programmes and, since April 1997, Wien 1 municipal television (see section 3.4.). The Kabelsignal firm, owned by Siemens AG Österreich, also operates in Vienna.

Lower Austria

There are 29 cable television companies. The biggest is Kabelsignal with 52,000 subscribers, though it only provides the infrastructure. Kabelsignal broadcasts a total of 38 television and 13 radio channels from seven different satellites. In August 1997 it became the first Internet service provider. Its St. Pölten subsidiary has around 10,000 subscribers. For the moment, besides private national and German programmes, it broadcasts its own teletext and a weekly programme. Other companies have very few subscribers (between 350 and 5,000) and in addition to private national and German programmes, they broadcast their own teletext, cartoons and other video channels. St. Pölten, the *land*'s capital, has its own local programme production company, P3, which reaches 10,000 homes. In the Waldviertel area, W4 TV has operated since March 1997. It produces a one-hour news programme for 4,000 subscribers.

The RTV (Regional Tele Vision) company is the largest cable television broadcaster in Lower Austria and supplies five regions with regional and local television. Since 1995, RTV has produced a one-hour local news programme about city councils and regions, and information about the economy, culture, sport and the weather. This programme is broadcast twenty times between 5.00 a.m. and 1.00 a.m. It also produces teletext with an information service and calendar of events. RTV broadcasts on Kabelsignal and Telekabel networks, among others, and reaches around 60,000 homes. RTV intends to form an association of cable television companies to offer advertising companies a more attractive, larger audience.

Burgenland

Only one of the three cable companies, Burgenländische Kabel-und Fernsehgesellschaft, BKF, broadcasts its own programmes. It has around 34,000 subscribers who are supplied with a one-hour block of news about culture, sport, the economy, tourism, etc, besides weather information and teletext.

Carinthia

There are seven cable television companies, of which four only rebroadcast satellite programming. In Klagenfurt, the *land*'s capital, around 13,800 homes are connected to the Telekabel Klagenfurt network, although its own local programme does not exist yet. The private FKK (Friesacher Kabelkanal) station does not broadcast on the *land*'s capital's network, although the Slovenian channel Slovenija 1 can, for example, be found among the channels it broadcasts. The FKK promoter has joined other promoters to form BTV (Bezirksfernsehen St. Veit/Glan). Its local programme is a two-hour magazine, FKK, which is updated once a week.

Styria

The city councils have major interests in the 41 cable television companies. In total there are currently two large companies offering programmes, Steiermark 1 and Steirer TV, and 12 promoters who do not broadcast own-produced programmes. Steiermark 1, a broadcasting company which does not have any of its own networks, has been in operation since March 1997. In Graz, the *land*'s capital, it reaches 29,000 homes via Telekabel networks and different zones via other networks. In total it can be picked up by 50,000 homes. Steiermark 1 broadcasts the local ORF programme *Steiermark Heute* at different times. In addition, it has magazines, debates and services which are updated weekly. It broadcasts 24 hours a day with repeat programming. Steirer TV also started to broadcast in 1997. It reaches around 47,000 homes via several networks and has a two-hour programme which is updated weekly. In this case too, programming consists of magazines, services, sport and culture. The remaining cable television companies cover small municipalities or supply larger companies with programmes.

Salzburg

In this *land* there are 25 cable operators. The *land*'s largest network belongs to the regional electricity company SAFE. Here, in the Pinzgau region, the first private cable television station Salzburg TV began operating in 1995. Currently, it has three regional channels with a one-hour programme which is updated weekly for the Salzburg, Pinzgau and Pongau/Lungau areas. In the city of Salzburg alone it reaches 10,000 homes via several networks. In the *land* as a whole, Salzburg TV reaches 65,000 homes, which represents 180,000 people. The channel made its first profits in the Pinzgau

area. According to the companies own data, 78 per cent of cable television subscribers watch Salzburg TV, which represents 28 per cent of the population.

Upper Austria

Here the market is very fragmented. A total of 108 cable television companies serve 200,000 homes, and new local channels are popping up every day. In Linz, the *land*'s capital, four companies manage the network and two local channels produce programmes. The OÖ-Vision channel, which can be picked up in other parts of Austria, offers a daily half-hour news programme called *Zoom*. The second local channel, TV3, offers a weekly magazine with very varied contents. It is worth mentioning other programmes such as *Bezirks-TV* in Vöcklabruck, *WT1* in Wels and *Steyr/Ennstal-TV*, which are produced once a week and broadcast repeatedly.

Vorarlberg

The seven largest cable network operators offer multi-channel services to around 17,000 homes, although another ten companies raise this figure to 50,000. Vorarlberg TV reaches all of them, with its local programme *AHA*, a weekly magazine with very varied content.

Tyrol

There are 28 cable television companies. In Innsbruck, not only does Telesystem manage most of the network, but has also produced a local programme called *Tyrol im Bild* since the beginning of 1997. It is a half-hour spot which is first broadcast on Friday and repeated on Saturday and Sunday.

3.4. Urban television

The only local urban television channel is Wien 1, produced by Lower Austria's RTV, which only reaches the 750,000 cabled homes in Vienna. It basically aims to broadcast Viennese information for the Viennese. In mid 1997 it had an average daily audience of 130,000 viewers. The channel, which reached ten hours of programming in 1997, is financed by advertising and sponsors. Its programming is based on the broadcasting of films and municipal, traffic and weather information. The Viennese Institute of Media Studies intends to become involved in an educational programme called Uni-TV.

4. A study of ORF's and cable television's programming

In general, ORF's programming is characterised by an increase in local broadcasts and a high degree of involvement in regional and local productions. So, ORF-2 is becoming more and more regional and federal. This should allow it to cope with growing competition from German

channels. If the surface area and population of the Austrian *länder* are taken into account, they are relatively small when compared to other European States (for example, Vorarlberg "only" has 275,000 inhabitants over the age of 12, and Salzburg 411,000). However, the regional studios have been able to create their own style.

ORF's regional and local programming consists of contributions made by regional studios to global national programming (see section 4.1., about types of programme) and by the regional studios' local television channels, as referred to previously. The proportion of local programming in ORF's schedule as a whole, which was expanded in January 1998 with the new local programme *Treffpunkt Bundesland*, has evolved since 1987 as shown below.

Table 6. ORF broadcasting hours (1987-1996)

	1987	1988	1989	1990	1991	1992	1993	1994	1995	1996
Total	8,667	10,436	10,645	10,918	12,138	12,015	13,078	13,779	17,098	18,630
Regional	21	859	957	956	983	959	1,009	992	1,033	1.946
	0.24%	8.2%	9%	8.8%	8.1%	8.0%	7.7%	7.2%	6%	10.5%

Source: *ORF Mediaresearch.*

The regional studios of Carinthia and Burgenland produce and broadcast special programmes for specific population groups: Croatians, Slovenians and Hungarians. As mentioned previously, there isn't any local or regional advertising in ORF's local programming because it is forbidden.

What cable television offers generally follows the same format: there is a "traditional" programme lasting one hour, which is updated weekly and whose contents consist of local news, sport, services, debates, weather and local advertising. Wien 1 is the only channel that broadcasts a programme with wider and more varied contents.

4.1. Types of programme

4.1.1. News

ORF'S regional studios contribute their contents to the evening news programmes *Zeit im Bild 1* and *Zeit im Bild 2*, the Sunday news programme *Österreich-Bild am Sonntag*, the afternoon news programme *Willkommen Österreich* and to other programmes with scientific or economic contents. Regional studios devote a great deal of time to cultural information and make special contributions to the Monday night cultural programme. They also contribute information to sports programmes and other programmes with political contents like, for example, information about the *länder* parliamentary or municipal elections. A systematic study of cable television channels' regional and local news has yet to be done but, in general, it can be asserted that the news programmes refer to the regions, counties or municipalities depending on their broadcasting scope.

4.1.2. Magazines

Some of ORF's regional studios also produce *magazines* and are involved in other national scale programmes (for example, *Bilder aus Österreich* or *Alpen-Donau-Adria-Magazin*). The cable television channels have placed their bets on *magazine*-type programmes with topics that are attractive to the general public. Wien 1, for example, broadcasts a citizens' forum at 9.45 p.m. every day, including interviews with people affected by various issues, and specific *magazines* for the elderly, children and university students.

4.1.3. Debates and interviews

During *länder* parliamentary elections, ORF's regional studios broadcast debates with the parties' candidates throughout the *land*. For that purpose, the national programme *Die Pressestunde* ("Press time") provides windows on Sunday mornings. In the news programme *Treffpunkt Bundesland,* a large spot is given over to talks and interviews for budgetary reasons. On the other hand, to a lesser or greater extent, all the *länder* include short interviews in the programme *Bundesland Heute*. Cable television programmes also include short interviews. This is the case for Wien 1, which has a daily programme called *Wiener im Gespräch* ("The Viennese talk").

4.1.4. Documentaries

Almost all the regional studios produce documentaries about specific regional events and topics, especially cultural and sporting events (autumn in Styria, Ars Electronica, Salzburg festivals, etc.), which are included in national programming. The cable channel Wien 1 has a specific documentary time block.

4.1.5. Fiction and entertainment

Many of ORF's regional studios produce entertainment programmes with emphasis on music: *Schlagerkarussell* ("Hits carousel"), *Wenn die Musik spielt* ("When the music plays"), *Klingendes Österreich* ("Austrian sounds"). Some are co-produced by more than one *land*, and all of them are broadcast by the national channel. Cable network operators' channels lack their own entertainment programmes, though their news programmes are designed in such a way that one can, and should, speak of "infotainment".

4.1.6. Sports

ORF's regional studios produce sports reports for the programme *Bundesland Heute* and for the national channel. Sports programmes and football in particular also constitute a large proportion of cable television programming because they guarantee the public's fidelity. They mainly report on sub-local or local events and occasionally on large regional events.

5. New problems and prospects

Due to a matter of frequencies there can only be one new national private channel in addition to Vienna's cable channel. In other large cities the only option available is to open new windows in the national channel. In debates, the alternative of three channels in each large urban concentration zone (Vienna, Graz and Linz) is opposed to this model.

In order to neutralise any likely competition, ORF will carry on making efforts to regionalise its channels, so long as it follows strict lines of savings and rationalisation. In the future, this tugging will mark the evolution of public television in Austria.

For the moment, cable television companies are too small to compete with ORF. However, because the new cable and satellite television Act is very liberal, these companies benefit from good start-out conditions and mergers are expected in order to coordinate programmes. In the long term, a process of concentration and cross-ownership will probably arise in the media environment.

5.1. Financial viability

Even though ORF's funding is assured by fees and advertising revenue, in the long term the previously mentioned problem concerning the strain between the drive towards federalisation and localisation will come to the fore, motivated in part by a political expansion of programming budgetary cutback policies.

The prospects for urban cable television must be contemplated with caution. Urban television will probably only be profitable in Vienna, so the local window variant on a private national television channel may prevail. This type of channel must be able to finance itself from advertising revenue (will the same happen on a regional scale?), as this type is only offered so far by ORF in a very limited way, although the need for alternatives is becoming clear.

Cable television broadcasters have allowed advertising markets to be opened up as a result of a decided policy in that direction, and new local markets are sure to open up, too. Despite the fact that Austria has very little experience in this field, cable television channels in the long term may be able to finance themselves satisfactorily by local advertising.

5.2. Cultural synergies

Regional cultural events are covered by regional studios and broadcast on a national scale. So, ORF's regional studios play an essential role in the transferral of each *land*'s specific culture and, consequently, in the cultural integration of Austria. Regional studios have also played an important cultural and economic role in their *länder*, particularly in their capitals, because information about local and regional events makes them popular

and because regional studios are becoming the organisers of this type of event more and more often. In 1996 alone, the Vienna studios organised 200 outdoor activities and the Upper Austria studios organised 300 events, including some very well-known ones like Linzer Klangvolke or Ars Electronica. The Salzburg studios contribute to the conformation of their *land*'s cultural life with events like Goldegger Dialoge, the cabaret forum Salzburger Stier, or Rauriser Literaturtage of a literary nature. The Carinthia studios held the Ingeborg Bachmann Wettbewerb literature contest. Finally, regional studios play an important role as regional buyers, meaning that they are consumers of services, that they need audio-visual material suppliers and, together with other cultural institutions, they cooperate to organise cultural events. The number of people who attend the annual "open days" bears witness to their importance in the life of their *länder*.

5.3. Influence of new communications networks
ORF's regional studios have sites on the Internet which attempt to establish new contacts with the public. Meanwhile, cable television companies are offering increasingly greater access to the Internet via their networks. Similarly, cabled homes have a "pay-per-view" option which is currently limited to foreign channels. Attempts have been made to encourage citizen participation in "municipal" television channels via the cable networks although these experiments are still only occasional and so far no clear lines of progress have been defined for the whole of Austria. In all, an increase in television supply in all fields – including regional and local- can be expected. Reports and news about the environment closest to the citizens enriches the news programmes' menus. This represents a quantitative expansion of the supply despite the fact that it only leads to better quality in some cases.

6. Bibliography and references

Dachs, Herbert (1997): "Bundesländer und Gemeinden", in Dachs, Herbert *et al.* (eds): *Handbuch des politischen Systems Osterreichs: Die Zweite Republik.* Vienna.

Institut für Publizistik -und Kommunikationswissenschaft (ed) (1993): *Massenmedien in Österreich Medienbericht 4.* Wien

Latzer, Michael (1996): "Cable TV in Austria. Between telecommunications and broadcasting", in *Telecommunications Policy*, Vol. 20, No. 4.

ORF (1996): *ORF-Almanach 1995/1996.* Vienna.

ORF (1997): *Geschäftsbericht 1996.* Vienna.

Pürer, Heinz (ed) (1996): *Praktischer Journalismus in Zeitung, Radio und Fernsehen.* Salzburg: Kuratorium für Journalistenausbildung.

Steinmaurer, Thomas (1996): "Das Rundfunksystem Österreichs", in Hans-Bredow-Institut (ed): *Internationales Handbuch für Hörfunk und Fernsehen.* Baden-Baden/Hamburg: Nomos.

Translation: Steve Norris

Belgium: Federalisation of broadcasting and community television

J-M Nobre-Correia, Suzy Collard[1]

1. General political framework and the role of the regions

Belgium is a small country covering slightly more than 30,000 km², and with a population of 10 million inhabitants, has a smaller population than some of the great world and European cities.

As a result of several constitutional reforms in the last 40 years, Belgium has turned into a federalized state, but its regional pattern is very complex, as two structures coexist, each of which has its own powers and institutions: the Communities (Flemish, French-speaking and German-speaking), responsible for all the cultural, communicative and social matters, and the Regions (Flanders, Walloon and Brussels Capital), entitled with competences in the economic area. These two structures don't coincide territorially, as the German-speaking Community is included in the Walloon region, and the Brussels Capital's inhabitants are under the rule of either the Flemish or the French-speaking Communities. The existence of a jealous local control of its important prerogatives, as well as the regional and sub-regional sense of identity, firmly rooted in the mind of the population, all account for the strong decentralized structure of the Belgian State.

One of the consequences of federalisation was that legislation in matters of radio, television and cable broadcasting no longer depended on the central state, but on the Communities. Since 1971, the Flemish Community, the

French Community (and since 1983 the German-speaking Community) have progressively gained powers in the field of regulation of their own respective audiovisual sectors (see below). This has caused some problems in the region of Brussels, the only officially recognised bilingual territory of Belgium.

1.1. Cultural-linguistic dimension

Belgium is a country which lacks its own specific language, sharing those of its neighbours: Dutch (about 58 per cent of the population), French (32 per cent) and some German (about 68,000 people). The Brussels Capital region is officially bilingual, although the population is 80-90 per cent French-speaking.[2] Overall, around 55 per cent of the Belgian population is Dutch-speaking, while 45 per cent is French-speaking.

2. General framework of television: Rampant federalisation

French-speaking and Dutch-speaking public television stations were created under the auspices of the INR-NIR (*Institut National Belge de Radiodiffusion-Nationale Instituut voor Radio*). This Institute came into being under the law passed in 1930, and, whilst overseen by a single governing body, developed two distinct General Directorates: one for the French-speaking part of the country and another for the Dutch-speaking region. Since the birth of television in Belgium, in October 1953, Belgians have had two different national TV channels, one in French and another in Flemish; even the line system they used was different, as the Flemish channel complied with the European 625 lines standard (the one adopted by Dutch television), while its French language counterpart adopted the 825 lines French standard.

In 1960 the INR-NIR was dissolved and its structures changed into three distinct public broadcasting bodies: RTB (Radiodiffusion-Télévision Belge, in French), BRT (Belgische Radio en Televisie, in Dutch) and ISC (Institut des Services Communs). RTB and BRT were each placed under the authority of a board of directors appointed by the national Chamber of Representatives and the Senate. The ISC, constituted by the association of RTB and BRT, was in charge of the management of joint technical services such as the musical and literary libraries, the sound archives and the symphony orchestra, in addition to German language and foreign radio broadcasts (Vertommen, 1980).

The revised constitution of 1970-71 recognised the existence in Belgium of three cultural communities: French, Flemish and German-speaking. Each of these communities was granted its own cultural council, constituted by the members of the two houses of Parliament belonging to their respective linguistic community. Each of these cultural councils was to have authority over the public service radio and television stations within its particular community, as well as the power to legislate in audiovisual matters.

The services guarantied by the ISC were divided up. Moreover, the law passed on 18 February, 1977 dissolved the ISC, transferring its staff and

assets to RTB and BRT (later called RTBF and BRTN, respectively), and created the BRF (Belgisches Rundfunk und Fernsehenzentrum für Deutschsprachige Sendungen), in charge of German language broadcasts.[3] A further move towards splitting up powers in the field of communication between the Communities was the transference to the latter, in 1988, of the competences on advertising regulation. Finally, in January 1989 the control over the radio and TV licence fee was transferred to the Communities.

This overall process has resulted in a complete transfer of powers in the field of the media to the Cultural Communities.

2.1. Public television

At the present time, and following this federal pattern, the Belgian public TV system is clearly divided in two main geographic areas, with fairly parallel TV systems:

- Public television in the French Community of Belgium is managed by RTBF (Radio Télévision Belge de la Communauté Culturelle Française), which operates two TV channels (La Une and La Deux), as well as five radio programmes. La Une is a general interest channel. The second channel, originally called Télé 21, underwent several important changes between 1993 and 1997, when RTBF allocated this network to a sports-oriented channel (Eurosport 21, distributed by cable) in association with Eurosport France (this agreement was broken in February, 1999). The remainder of Télé 21's schedule has been transferred to a new channel, called La Deux. RTFB broadcasts around 120 hours per week programming, of which 50 per cent approx. is own-produced. In 1998, the French Community financed RTBF with the sum of 6,628 million FB (including 157 million aimed to cover RTBF's participation in TV5). The advertising revenues attained 1,806 million (1,317 from television), and sponsorship accounted for 282 million (82 from television). In 1998, RTBF's staff totalled 1,665 permanent and 728 temporarily engaged.

From the very beginning of television in Belgium, a powerful regionalist trend led to the decentralization of the RTBF, which has developed a network of regional production centres for radio and television. They provide the different radio and TV channels with a wide range of programmes, as well as news items and reports. There are three radio and TV regional centres (Brussels, Charleroi and Liège) and two regional radio centres (Hainaut and Namur-Luxembourg-Brabant Walloon), which participate in some degree both in radio and in television. Local and regional programming disconnections are only carried out in radio channels; there are no regional disconnections in TV.

- Similarly, in the Flemish Community public television is managed under VRT (Vlaamse Radio en Televisie, called BRTN until the end of

1997), which operates two TV channels and six radio programmes. TV1 is a general interest channel, carrying some 3,400 hours per year programming, whereas the second channel TV2, inaugurated in 1977, was recently renamed as Ketnet, broadcasting until 8.00 p.m. with a youth oriented schedule; after that time it is named Canvas, and broadcasts a cultural schedule. In 1998, the Flemish Community's subsidy amounted to 7,694 million FB. Advertising revenues (originated only in radio broadcasting) amounted to 1.350 million, while sponsorship (both in radio and in TV) reached 400 million. At the end of 1998, the staff amounted to 1,470 permanent and 740 temporarily engaged. A Decree passed in April 1997 and aimed at coping with the financial crisis of the public broadcaster stipulated that it would change into a Limited Company under public law, wholly owned by the Flemish Community (D'Haenens and Saeys, 1998).

BRTN did not develop such a dense regional network as its French-speaking counterpart, so TV production is centralised in Brussels, and only regional radio centres exist in Flanders.

All of the public Belgian channels, both French and Dutch-speaking, are transmitted throughout the country through the cable system, even though they are aimed at one or other cultural community.

2.2. Private television

The Belgian border areas had for a long time been able to receive hertzian transmissions from neighbouring countries. This meant for instance, that the Walloon region was exposed from the very beginning to strong influence from French television. In 1961 the first cable network was inaugurated at Namur, and from then on, Belgium became the most densely cabled country in the world (at present, approximately 95 per cent of all TV households are connected to a network). This meant that the Belgians were increasingly able to receive the majority of television programmes broadcast by neighbouring countries. As long as commercial TV advertising remained banned in Belgium,

> ...advertisers could reach their audience in the country through foreign stations. The pressure exerted by this phenomenon was felt much more strongly in French-speaking Belgium than in Flanders. In the course of the 1980s, it was to become an important argument in both Communities in favor of lifting the monopoly of public broadcasting organizations and the legalization of advertising on radio and television (d'Haenens and Saeys, 1998).

The French-speaking Community "was the first region in continental Europe to put the phenomenon of multi-choice television to the test on a large scale" (Antoine, 1998), as an outcome of the invasion of foreign channels through the cable systems referred to above. As early as the 1960s

the CLT's channel Télé Luxembourg (renamed later as RTL), transmitted from Luxembourg and broadcast in French, began to address itself increasingly to the Walloon population, carrying even advertising aimed at this market and becoming the main competitor of RTBF. Since 1983 a Hertzian beam authorized by the Belgian government allowed the channel to receive a specific news programme live from Brussels (Antoine, 1998).

This situation of *de facto* competition ended in a *de iure* liberalization of the Walloon audiovisual system in July 1987, when the government of the French community allowed the creation of private channels. As expected, the only licence was awarded to a new consortium under the control of the CLT, which ran the RTL-TVi channel, launched in September 1997. To protect the interests of the print media, the French community forced an alliance of CLT (66 per cent) with the group Audiopresse (34 per cent), a company which includes most of the editors of the French language Belgian daily newspapers. To counter the growing competition in the French-speaking TV market, RTL-TVi launched a second channel in February 1995 (Club RTL), mainly intended for a young and urban audience.

Also addressed to French-speaking Belgium is the coded Canal+ Belgique, which was launched on 27 September 1989, with a programming schedule largely based on films. Canal+ Belgique is controlled by Canal+ France, the remainder of its capital being held by Belgian shareholders, of whom RTBF accounts for 12 per cent and its advertising subsidiary, RMB, a further 13 per cent. The presence of the public channel in this venture was aimed at creating partnership, rather than competition, in the overcrowded audiovisual panorama of the Walloon region.

In May 1998 a new channel joined the French speaking audio-visual panorama in Belgium: the teleshopping channel LTA (La Télé Achat), broadcasting from Charleroi. In January 1999 Event TV was launched, a channel devoted to events, leisure and cultural activities (its Flemish counterpart broadcasts a similar schedule addressed to the Dutch-speaking audience).

In Flanders, competition from foreign channels wasn't so strong as in the Walloon region, although Dutch and British channels were widely watched. Eventually, the Cable Decree of 28 January 1987 meant the end of the public monopoly in this Community and paved the way for creation of a single commercial terrestrial channel broadcasting through the cable network, as well as to local cable channels. The monopoly on commercial television was subsequently granted for 18 years to the consortium Vlaamse Televisie Maatschappij (VTM), which began broadcasting in February 1989. Its shares were distributed among nine publishers of Flemish newspapers and magazines, as a result of a political decision aimed at protecting the interests of the print media in front of the new competitor for advertising revenue. However, at present there are only two

groups involved in VTM's shareholding: De Persgroep (50 per cent) and Roularta (50 per cent).

The setting up in February 1995 of the satellite channel VT4, launched by SBS (a subsidiary of the American ABC Disney) broadcasting from London, broke the monopoly of VTM in the field of TV advertising in Flanders. To counter the new competition, VTM created a second channel, Ka2.

Pay-TV in Flanders began in 1985, when the channel Filmnet was given the permission to launch a pay television service in Flanders. This international channel had different versions for Flanders, the Netherlands, Scandinavia and some Eastern countries. In August 1997, Filmnet was replaced by Canal+ Vlaanderen, a 100 per cent subsidiary of Canal+ France, although its programming differs from that of Canal+ Belgique.

Later on, four new thematic channels have ben launched: TNCC (The Narrowcasting Compagnie, set up in May 1997, but closed down in October 1998), TMF (The Music Factory, launched in October 1998, the Flemish version of the Dutch channel of the same name), Event TV (the Flemish version of the above quoted French speaking channel) and Kanaal Z (set up in February 1999 and devoted to economic and financial information).

Table 1. Television market shares in Flanders since 1992

	1992	1993	1994	1995	1996
BRTN-TV1	25.5	25.0	22.5	17.5	19.3
BRTN-TV2	4.6	4.5	6.4	5.1	5.7
VTM	37.3	38.3	36.4	37.1	32.8
Ka2	-	-	-	3.9	6.5
VT4	-	-	-	6.1	7.9
Netherl.	9.1	9.0	8.7	6.4	5.3

Source: BRTN Research Department, quoted in D'Haenens and Saeys, 1998.

3. Local and community television in Belgium

Federalization of the powers in the field of culture and specially audio-visual in Belgium was carried out at a time when important movements were developing. The social disputes which occurred at the end of the 1960s and the beginning of the 1970s gave way to the discovery of "life in community" and a search for solutions leading to the encouragement of freedom of expression, dialogue and discussion among the members of the community. At the same time, the new lightweight video techniques were becoming popular, allowing them to play the role of catalyst in the community. This was a step which would lead some to attempt to go

beyond the state of a simple tool of action on a microsocial scale to try to reach a wider public, questioning the sacred "monopoly on the air" and thus opening the door to a deregulation movement which would bring about a fundamental change in European audio-visual history (Nobre-Correia, 1992: 285-292).

In the face of Flanders' strong claim of national identity, Belgium's French Community (including the population of the Walloon region and the French-speaking population of Brussels) urgently needed to form their own cultural identity. This separation would, for that matter, be one of the main factors in the development of the audio-visual scenes to the north and the south of the "linguistic boundary".

During the 1970s, the French community of Belgium took Quebec (where community television played an important socio-cultural role) as their model for identity affirmation within a nation-state, whereas Flanders would instead wait until the 1990s to take up the question of regional television. Two different histories which would consequently have two different models: one where the socio-cultural problem remained a predominant factor (Walloon), the other where commercial considerations seem to have taken control (Flanders).

3.1. Local and community television for the French community[4]

3.1.1. Local and community stations: an imported idea

The birth of local and regional television is the result of some subtle alchemy. In this event we find the conjunction of several aims: the search for partnership and collaboration and the wish to democratize the media, fruit of the movements that took place in May 1968, the progress of light weight video techniques, cable's strong incursion and, finally, the settlement of the Quebequois model, that crossed the Atlantic to impress in Belgium both civil associations and some of those in charge of the French Community's Ministry of Culture. Some of these associations soon tried their own initiative ie "wild injections" of cable network broadcasting.

In 1976 a Group for Reflection on Audio-Visual (GRAV) was created by the French Community's Ministry of Culture. Its mission was defined in the following way: ...to study de development and possibilities of the new audio-visual media's exploitation", including "the other television" ("l'autre télévision"), considered a genuine instrument for the local community.

In March 1976, following the GRAV's proposal, various local projects for local television, which would count on a public subsidy to cover its operative and material costs, were selected. However, these would have to fulfill five vital conditions:

1. The project will be in the hands of a non-profit-making and plural association, be representative of the local community;
2. All programmes will be home produced;
3. The broadcasting of advertisements won't be permitted;
4. The radio and television deontology in force will be followed;
5. A four part agreement will be signed, which will arrange relations between the association in charge of the project, the French Community's Ministry of Culture, the cable company or companies and the local administration.

This way, the extent and aims of these television services remain fixed. They're basically private associative structures with public service missions. The associations are entirely responsible for the programming, while the cable operators' task is strictly limited to the transport and broadcast of the contents.

3.1.2. Difficult beginnings
In 1976 two local Walloon television services begin to broadcast specific programming; six other channels soon joined them. They all started broadcasting in black and white with a short schedule, weekly broadcast by a channel which they all share. This channel was awarded primarily to another channel, pushing local programming to low audience slots.

Faithful to their targets, the local stations sought a trade name image, each centering themselves on different aspects. One stood for local information, another for the importance given to participation and freedom of speech, and a third was assigned to permanent training projects.

3.1.3. The initial balance
Although the programmes showed off their creativity, opened doors to free expression and reflected the real socio-economic and cultural panorama of the sub regions, they sometimes proved to be far too narcissistic and, in technical matters, were over ameteurish. Nevertheless, they proved that local television was possible.

However the experimental context, which foresaw the need to renew yearly the local channels' authorization, the weakness of public financing and the scarcity of the material placed these new channels in a vulnerable situation. The years from 1983 to 1988[5] were grim for local channels because of the economic struggles.

The need to unlock resources was an urgent problem, especially from the moment that institutional reform joined small towns into bigger units. This made broadcasting develop at a fast rate. The majority of broadcasting stations requested financial support from other public bodies, such as councils and provinces.

In May 1985, some channels decided to adopt a strong position and defy the advertising ban, with the aim to put pressure on the Ministry that

supervises them and the politicians, all in response to the pressing needs to take side for one of two options:

- Permitting local channels to develop their own resources through the access to commercial advertisements;

- Or increasing significantly the subsidy they receive and review the labour statute of their staff.

Although this last option was the one preferred by local channels, it was finally refused, in a context of public finance crisis.

3.1.4. The beginning of change

The Act of July 1985 marked a real point of inflexion for Walloon's local TV stations. On the one hand, it ended local television's experimental period and gave them full rights status as actors in the French-speaking audio-visual landscape. On the other hand, it obliged cable operators to broadcast all the local station's programmes in specific channels, an essential condition for those to be able to carry out daily programming planning as well as encouraging a larger audience.

In fact, faced with the hard rivalry of the numerous channels distributed throughout the French Community, many local stations adopted successfully the "looped multibroadcast" system, by which viewers could watch local programming depending on their disposable time.[6]

On the other hand, financial means didn't improve substantially, as public subsidy was still insufficient. Commercial advertisements weren't formally banned at this time, but the French Community only had full responsibility on this matter from 1998 onwards. The March 1990 Act authorized local channels to accede to commercial advertising and sponsorship.

Progressively, local television gains a significant audience. It loses its "sociocultural" and occasionally militant markings, and acquires a more professional and journalistic orientation. In fact, information is increasingly important in the daily programming schedule.

3.1.5. The current legal and regulation framework

The acknowledgement of local television in the French Community is linked to the Broadcasting Act of July 1987, modified by the Act of 19 July 1991.

Ten conditions have been fixed for the creation of a local TV station:

1. It must constitute a non-profit-making association, according to 1921's laws, and adapt itself to what 1973's law offered which guaranteed the protection of ideological and philosophic tendencies.
2. Its programming should aim to provide local information and entertainment, cultural development and permanent training. It should include own productions for at least a third of the total broadcasting time, leaving aside repeats.

3. It should broadcast for a specific area.
4. It should adopt an internal regulation about the objectivity in handling information, which the channel should undertake to respect.
5. A programming commission would be formed charged with fixing the proposals of programmes that will be submitted to the association's management board.
6. A professional journalist will be responsible for handling news, according to the law of 30 December 1963 on the acknowledgement and protection of a professional journalist's title.

On the other hand, the Conséil Superieur de l'Audiovisuel (the body which regulates and controls the French-speaking electronic media in Belgium) remains as an advisor to the French Community's government in matters that regard to granting, renewing, postponing or withdrawing local television licences, which will be granted for a renewable nine year period.

The Act contains regulations in relation to the composition of management boards and the programming committee, which state that representatives of public bodies can't occupy more than half of the posts.

Finally, the Act defines the kinds of subsidies which can be awarded to cover operational, staff and equipment costs.

The Government's decision of July 1997 referring to the operating contract for RTBF foresees explicitly the development of synergy with local televisions in matters related to the exchange of images, documentaries, and programmes, the coproduction of magazines, the broadcast of programmes, the technical and service lending, the participation in regional cultural events and the search and broadcast of advertising.

In October 1994, RTBF signed an agreement with every local channel and its federation to seal this alliance. It also signed an agreement with Régie Média Belge (RMB, subsidiary of RTBF for commercial matters) that entrusted RTBF the sale of commercial advertisements for the local television networks, while the management of common non-commercial advertisements has been conferred on the organization that gathers the 12 French-speaking local televisions, called Vidéotrame.

The advertisements broadcast by local television are also regulated by the 1987 Act, which limits the time reserved for advertisements broadcast to a maximum of 20 per cent of each 60 minute period.

In 1999 there were 12 local French-speaking television stations, which since the beginnings of TV Lux (the television station for the Belgian province of Luxembourg) in 1997 cover the French Community's entire territory.

Table 2. Local and Regional Television for Belgium's French-speaking Community

Province	Channel	Head-quarters	Starting date
Brussels-Capital*	Télé Bruxelles	Brussels	1985
Brabant Walloon	TV Com	Ottignies	1979
Hainaut	Antenne Centre	La Louvière	1983
Hainaut	No Télé	Tournai	1977
Hainaut	Télé M/B	Mons	1988
Hainaut	Télésambre	Charleroi	1973
Liège	RTC Télé Liège	Liège	1977
Liège	Télévesdre	Verviers	1989
Namur	Canal C	Namur	1978
Namur	Canal Zoom	Gembloux	1976
Namur	Vidéoscope	Rochefort	1977
Luxembourg	TV Lux	Libramont	1997

* Brussels-Capital Region.

Source: Fédération des TV locales.

3.1.6. Local television's fnancing

According to local television stations yearly balances, their resources were assigned in 1997 as shown in table 3. One can observe that subsidy represented in 1997 an average of 52.82 per cent of all the local channel's total resources. The remaining 47.18 per cent was the sum of their own earnings (advertising and commercial as well as earnings from the participation in coproductions related to the magazines launched and managed by Vidéotrame).

It's relevant to state that Walloon local TV stations count on a complementary means of financing, fruit of a tax cable distributors charge their subscribers. This tax, established by the French Community in 1997, has a fixed cost of 150 Belgian Francs per subscriber, half of which goes to local channels and the other half which cherish a fund to support French-speaking Belgian audio-visual industry. Télé Bruxelles, situated in an area under the rule of both the French and Flemish Communities, can't benefit from these means. However, it receives an important subsidy from the Brussels-Capital Region to make up for it.

3.1.7. Characteristics of French-speaking local channels

As shown by the great importance of own earnings in local TV stations finance structure, all of them have overcome the survival stage and are entering a phase of development. However, this is determined by each

channel's specific implantation and history. In fact, the stations in large cities enjoy a favouring "situation's rent". On the one hand, they find it easier to generate advertising and commercial earnings, and on the other, also due to the area's population density, they receive significant sums from the cable network subscription tax, a whole lot more than those channels in smaller or less populated areas.

Table 3. The French-speaking's Local Television Finance Structure in 1997 (% from the total)

	Subsidies				
	French Community	FBIE*	Other**	Total Subscribers	Own resources
Antenne Centre	19.74	25.56	19.18	64.47	35.63
Canal C	21.80	26.49	22.05	70.33	29.67
Canal Zoom	39.52	23.23	3.95	66.70	33.30
No Télé	15.09	8.14	3.39	26.61	73.39
RTC Télé liège	14.80	11.15	11.50	37.44	62.56
Télé Bruxelles	11.05	9.85	55.04	75.94	24.06
Télé M/B	18.93	17.17	10.88	40.98	53.02
Télésambre	12.62	12.27	2.50	27.40	72.60
Télévesdre	15.74	32.50	2.73	50.97	49.03
TV Com	20.47	17.19	35.35	73.02	26.98
TV Lux	15.39	6.50	33.00	51.89	45.11
Vidéoscope	30.51	26.55	8.48	65.54	34.46
Total	**16.62**	**14.99**	**21.22**	**52.82**	**47.18**

* Fonds Budgétaire Interdépartemental pour l'Emploi.

** Municipalities and Provinces (the Region in the case of Télé Bruxelles).

Source: data from the local TV stations, from Vidéotrame and from the French Community.

Currently, local channels cover 288 towns and their audience target is of over four milion viewers. Depending on their coverage, the following groups can be distinguished:

- Those stations in big cities (Charleroi, Liège and Brussels), with an audience target of between 500,000 and 1,000,000 people (Télé Bruxelles, RTC Télé Liège and Télésambre);

- The stations in medium size cities, which have audience targets of about 200,000 and 270,000 people (Antenne Centre, Canal C, No Télé, Télé Mons Borinage, Télévesdre and TV Com);

- Two TV stations situated in rural or semi-rural areas that broadcast for small audience targets of around 30,000 and 70,000 people (Vidéoscope and Canal Zoom);

- A channel in a rural area that broadcasts to about 250,000 people (TV Lux).

Table 4. French-speaking Local Televisions' Broadcasting Area and Potential Audience

Channel	Municipali-ties covered	Households connected	Potential audience
Antenne Centre	10	76,162	205,637
Canal C	23	109,693	296,063
Canal Zoom	4	10,000	27,000
No Télé	30	100,695	271,877
RTC Télé Liège	58	288,320	778,464
Télé Bruxelles	19	344,842	931,073
Télé M/B	12	80,138	216,373
Télésambre	26	177,341	478,820
Télévesdre	28	80,628	259,356
TV Com	23	94,845	256,082
TV Lux	44	81,149	241,339
Vidéoscope	11	24,501	73,074
Total	**288**	**1,468,274**	**4,035,158**

Source: Fédération des TV locales.

3.1.8. Programming

Unlike in the case of Flemish local TV stations, there isn't any legal boundary to French-speaking local channels' production volume. The only limits are those imposed by each's production capacity.

The 12 French-speaking local TV stations together broadcast an average of around 100 hours of weekly programmes, in their first broadcast (except looped multibroadcast). This programming is made up of more than 90 per cent of own productions, completed with co-produced programmes or exchanges with other channels.

Local channels broadcast daily, mostly during the hours between 6.00p.m. and 12.00p.m. (weekdays). As a novelty, many channels broadcast specific programming on Saturdays and Sundays, which consist of a review of the week's current affairs complemented with different types of magazines and sports programmes.

(a) Programming by genres

An examination of local televisions' schedules show their diversity as well as the uniqueness of each channel. However, it also stands out how local information is the real base of them all. Some have taken even further this approach creating a daily programme open to local correspondents dispersed across the television stations' respective coverage areas. These journalists send their information to the station's headquarters, where a professional team work on the news items that will finally be broadcast.

The news-bulletins are complemented with magazines, documentaries and cultural agendas which cover all local life's activities. The information generally acquires a sensitizing and service-providing dimension, loyal to the calling for the development of permanent training and participation, a far more evident vocation during local television's first days. Some of these gave access to local groups or associations (youth organizations, universities, cultural centres), with which they co-operated in the production of programmes.

Local stations can be divided into two categories, named in a rather simple way as "local news televisions" and "local general televisions". RTC Télé Liège broadcasts daily two editions of the news-bulletin, complemented with the interview of a guest on the set. It would belong to the first category, although at the weekend it broadcasts programmes based more on magazines and debates. The second category applies to Antenne Centre, Canal C, Canal Zoom, No Télé, Télé Bruxelles, Télé Mons-Borinage and Vidéoscope. Télésambre, Télévesdre, TV Lux y TV Com are intermediate types.

Some channels broadcast a magazine where local dialects are given a great deal of space. Sports also occupy an outstanding position on the schedules. On the other hand entertainment, games and variety programmes are quite rare in local TV station's schedules. Children's programmes and contents dedicated to teenagers are also scarce.

(b) Common programming

Vidéotrame promotes and manages joint programmes for the 12 associated channels, and guarantees its financing when looking for partners. The particularity of these programmes is that they achieve scale economies with the production of joint sequences, while they also preserve the specific characteristics of each station by means of a particular, local anchorage. Therefore, the same edition has 12 different versions. Among the magazines produced by the network, a weekly programme on employment and training, and the monthly *Sous votre toit*, based on do-it-yourself and home improvement, are the ones which most stand out.

3.1.9. Videotext-Teletext

All local channels broadcast, before their daily programming, a videotext with cultural and sports announcements, job offers, information about

services and commercial advertisements, which generate considerable earnings.

Several channels also have a selective teletext service broadcast 24 hours a day, containing information on services related to a wide range of activities, selected by the viewer with the remote control.

3.1.10. The audience

The fragmentation of broadcasting areas and the segmentation of local television's audience targets make it both expensive and difficult to measure the audience. To compensate this problem, Vidéotrame has entered into a partnership agreement with Régie Média Belge to regularly carry out audience research for all the associated stations through the specialized institute Sobemap.

The results prove the success of local television. Indeed, in 1997 they obtained 97 per cent of renown and 46 per cent of regular audience between viewers aged 15 or more. This poll showed that viewing periods are mostly during prime time (from 6.00 p.m. to 8.00 p.m.), although the audience also appreciate multibroadcasting.

Therefore, while satellite channels proliferate and digital platforms multiply the programme offer, local television has enriched the audio-visual landscape with its specific approach to communication, which walks in the opposite direction to uniformalizing information.

3.2. Local and community television in Flanders: The endless North-South division

In the decree of 17 July 1987, the legislator decided that it would be desirable to create, along with Community-wide private television, "regional private television" stations. The new legislation stipulated that 11 regions in Flanders would be allocated one local channel each, which couldn't broadcast beyond the borders of the respective area. Further, they couldn't form chains. The new regional stations could only broadcst until 7:30 and for a maximum of 200 hours per year, not including repeats and live coverage of sports and cultural events: "It is clearly the intention therefore that regional stations remain small and complementary fo the public broadcasting organizations" (D'Haenens and Saeys: 1998).

Nonetheless, they began to develop only quite slowly. This challenge of "private regional television" was due to the Flemish community in 1991-93, when the necessary legislation was passed regarding different aspects of regional television, but specially financing. It is true that the situation north of the "linguistic border" was at that time diametrically opposed to that of the south. For many years, the predominant political attitude in Flanders has been to oppose any opening of the TV sector, controlled by the BRTN.

The first opening was put into effect to the benefit of VTM. Its success surpassed all expectations. And, in order to avoid cable penetration from the Netherlands' RTL4 and RTL5, the Flemish community authorized the creation of 11 "regional TV stations". As said above, the French-speaking Community call their television "local", whilst the Dutch-speaking Community call theirs "regional". This is only a difference in terminology, since in reality they are fairly similar in size. Nevertheless, three major differences are found between the southern "community and local television", and the northern "regional television": the southern ones were created by socio-cultural non-profit-making organizations which still control them, and have year after year sought an increase in the zone their station covered, operating mainly from public subsidies. The northern ones, created more recently, even though awarded to non-profit-making organizations, are operated by commercial societies within zones pre-established by the Flemish community and will have to survive mainly by means of advertising and sponsorship, which have to come from the region they broadcast to (although this rule is not respected). There is only one exception to the rule regarding resources: TV Brussel, because of the minority position of the Dutch-speaking population in Brussels and the popularity of its French-speaking counterpart, Télé-Bruxelles, would get subsidies from the Flemish Community (30 million FB in 1993) and the region of Brussels-Capital (40 million). Besides, it is allowed to broadcast around the clock.

As said above, four local stations were authorized in Flanders by the decree of 28 January 1987: AVS, in Eeklo (since 19 February 1981), ATV, in Berchem (since 26 April 1986), RTVO in Courtrai (since 23 March 1987; it became WTV Zuid in 1993), and RTVL in Louvain (since 10 April 1987; it became Rob TV in 1993). As a matter of fact, only AVS was broadcasting one hour on Saturdays and the rest of the time a teletext was shown on the screen. RTVO was only broadcasting teletext. As for the other two, they had no programmes at all. Such a situation looked strangely like fallow land…

The decree of 23 October 1991 by the Flemish community (modified by the decree of May 1992) defined the structure of a new television scene, which legally was not, in truth, different from the one formed by the southern TVLC. In Flanders as well, the TVR's mission was "to guarantee news, animation, training and entertainment programmes in order to promote communication among the population of its broadcasting zone, and to contribute to the social and cultural general development of the region". Also, "the news programmes must follow the usual standards with respect to the journalistic professional codes of ethics, and assure impartiality and editorial independence". Likewise, the cable-casters must carry the TVR's programmes "free of charge, simultaneously and full length, on a specific channel".

On the other hand, the structure of the stations' management is defined in a more precise and restrictive way than in the south. The structure of the general assembly and the consultative committee must comply with "representativeness on the political, social, cultural, philosophical, ethnic and geographic scenes". At the same time the administration council cannot have more than one fifth of its members made up of political representatives, employers' organizations and trade union leaders, mass media, advertising and cable-casting companies' managers, and where legislative or executive public powers' members are completely excluded.

3.2.1. From theory to reality

If at first, from a legal point of view, the northern and southern television scenes had some chance of being more or less equal, the economic and management reality is completely changing this picture. Indeed, whereas in French-speaking Belgium the men and women managing the TVLC come from stations with originally socio-cultural concerns, in Dutch-speaking Belgium we find that professionals coming from the world of media and advertising have taken control of the TVR, in journalistic, technical and commercial aspects.

Under pressure from the political powers of Flanders,[7] groups from the press and northern cable-caster have been actively involved in the inauguration of the new regional TV stations. Behind the non-profit organizations receiving the licence for such creation, there are hidden operating societies with the technical and equipment support assuring the programme production intended for these stations. Operating in societies in which press publishers have made sizeable investments in order to keep their dominant position within the regions where they often enjoy control over the newspaper and/or of the most major free magazines, press publishers have taken control of the TVR's advertising departments, by merging them with the newspaper published in their established zone. This explains why the advertisers are worried, even if advertising and sponsorship must originate from the region.

The programming carried out in TVR, even though designed to "attract audiences", does not really vary from that carried out by the TVLC: the local news bulletins are the main spots of the schedule, and the most popular programmes; other programmes include sports magazines, encounter programmes, and games (Galuszka, 1993; D'Haenens and Saeys, 1998). The original programme production is quite low in quantitative terms, but the "carousel formula" of broadcasting ensures that they are available to viewers throught the entire night

Table 5. Belgium: local and community television in the Dutch-speaking Community

Name	Starting date	Area	Potential audience (15+)	Daily reach November 1996
ATV	15.12.93	Antwerp	712,000	27.4
AVS	01.09.94	Ghent	537,000	33.3
Focus TV	01.09.93	Bruges	404,000	49.5
Kanaal 3	26.09.94	Termonde	523,000	29.7
ROB TV	15.11.93	Louvain	344,000	34.7
Ring TV	1.03.95	Hal-Vilvorde	417,000	30.5
WTV	01.02.93	Kuurne	471,000	43.6
TVL	25.04.94	Hasselt	593,000	35.7
TV Brussels	15.09.93	Brussels	121,000	18.4
RTV Kempen	01.03.94	Turnhout	533,000	34.2
RTV Mechelen	01.05.95	Mechelen	n.a.	n.a.

n.a.: not available.

Source: De Bens, Janssen & Van Landuyt, 1997 & Sobemap, 1996 quoted in D'Haenens and Saeys, 1998.

4. The future of the two models

In addition to the national channels there are, depending on the cable networks, some twenty foreign channels, making a total of approximately 30 national or transnational, general or special interest, free or pay channels. Belgians also enjoy (or soon will enjoy) a "proximate" local or regional television channel (TVLC or TVR). But here, like in many other fields, the audio-visual landscape will be divided by a linguistic boundary, which will involve a deep gap between two models. Two models that are the result of different cultural and political developments, in French Cultural Community and in Flanders. Two models in agreement with the times that saw their origins: the 1970s, on the one hand, when the notion of "public service" was still preponderant and people dreamed about "changing life" and building an "alternative" society based on participation; and the 1990s, on the other, where private sector and advertisers' drive predominate over the European audiovisual landscape. Will these models be able to achieve a solid enough consolidation to resist the invasion of "television without frontiers" coming from abroad?

Bibliography and references

Antoine, Frédéric (1998): "Media politics in French-speaking Belgium: from the origins of deregulation to the impossibility of control", in D'Haenens and Saeys: *Media Dynamics & Regulatory Concerns in the Digital Age*. Berlin: Quintessenz Verlags.

BRTN (1993): *Cahier d'Information* (typed). Brussels: BRTN.

Collard, S. (1994): *Les télévisions de proximité en Communauté française de Belgique.* Namur: Fédération des Télévisions Locales.

Communauté Française de Belgique (1993): *Annuaire de l'audiovisuel 1993.* Brussels: Communauté Française de Belgique.

Conseil Supérieur de l'Audiovisuel (1989-90): *Les avis du Conseil Supérieur de l'Audiovisuel, 1989-90.* Brussels: Direction de l'Audiovisuel.

Conseil Supérieur de l'Audiovisuel (1991): *Les avis du Conseil Supérieur de l'Audiovisuel, 1991.* Brussels: Direction de l'Audiovisuel.

D'Haenens, Leen & Frieda Saeys (1998): "Media polititcs in Dutch-sepaking Belgium: the reluctant mutation from a monopoly to a multi-channel landacape", in *Media Dynamics & Regulatory Concerns in the Digital Age.* Berlin: Quintessenz Verlags.

Galuszka, V. (1993): "Petites, mais ambitieuse", in *Média Marketing,* 86.

Groupe R. Dupuis (1993): *Médiaplan 1993.* Brussels.

Hermanus, A.-M. (1990): *Tempêtes sur l'audiovisuel.* Liège: Editions du Perron.

Jocquet, M. (1981): *Rapport d'évaluation des télévisions locales et communautaires.* Duplicated document.

Jocquet, M. and D. Sotiaux (1981): "Au pays où le câble est roi", in *Pointillés,* 11.

Nobre-Correia, J.-M. (1984): "Rêves et désillusions de l'autre télévision", in *Vidéodoc,* 66.

Nobre-Correia. J.-M. (1992): "Formes et limites du paysage médiatique européen", in Féron, F. and A. Thoraval (dir.): *L'état de l'Europe.* Paris: La Découverte.

RTBF (1992): *Rapport annuel 1991.* Brussels: RTBF.

RTBF (1994): *Rapport annuel 1993.* Brussels: RTBF.

Van Apeldoorn, R. (1994): "Les interrogations du câble belge face au numérique", in *Médiaspouvoirs,* 36.

Vertommen, R. (1980): "Le statut de la radiodiffusion en Belgique, histoire et évolution", in *Etudes de Radio-Télévision,* 27.

Vidéotrame (1983a): *L'avenir des télévisions locales...* Duplicated document. Namur: Fédération des télévisions locales.

Vidéotrame (1983b): *L'information, la diffusion et la publicité non commerciale...* Duplicated document. Namur: Fédération des télévisions locales.

Vidéotrame (1994): *Les televisions locales en Communauté française de Belgique.* Namur: Fédération des télévisions locales.

Wangermée, R. (1993): *Les Carrefours professionnels de l'audiovisuel. Rapport de synthèse.* Brussels.

Notes

1 Editor's note: this chapter is an update of the one J-M Nobre-Correia published in 1995 in the book *Decentralization in the Global Era* (Moragas and Garitaonandía, 1995), undertaken by the same author. Suzy Collard has written part 3.1, and Els De Bens has contributed with information and data to the update of part 3.2. The editors appreciate and thank their cooperation.

2 The official figures are not available... to avoid further problems over the "linguistic conflicts".

3 To date, the BRF provides almost only radio broadcasting.

4 This part has been written by Suzy Collard.

5 Canal Emploi, the only example of a specialized local channel based on employment and training, was set up in 1979 and closed in 1988.

6 This successful system has been imitated by some Flemish regional televisions, as well as by RTBF for the broadcast of the late evening news bulletin.

7 According to statements made by Rilk De Nolf, director of the Groupe Roularta, to *MédiaMarketing*, 90, October 1993: 24

Denmark: New legislation, last-minute rescue?

Thomas Tufte

Introduction

Small-scale television in Denmark has a long tradition, in particular the non-commercial local experiments, seen first in the 1970s and widely carried out in the early 1980s. In 1986/87 local and regional media are for the first time formally included as constituents of the Danish media landscape. This article presents and analyses both the legal scenario and the *de facto* development and current state of local and regional television in Denmark, showing how it becomes an extended dimension of public service broadcasting and simultaneously functions as a dynamic cultural agent rooted in civil society on a community level.

1. The Kingdom of Denmark

Denmark[1] is one of the smallest member states in the European Union (43,000 Km²). It has 5.2 million inhabitants of which 1.4 million live in the capital, Copenhagen, and its suburbs. The second largest city, Århus, has approximately 500,000 inhabitants, including urban peripheries. The average per capita income in Denmark is US$ 28,110.

Denmark is culturally a rather homogeneous nation. Lutheranism is the official religion of the country and the majority of inhabitants (90 per cent) are non-practising Lutherans. Ninety three per cent of the population live in urban settings, having experienced three major periods of substantial migration from rural to urban settings: the late 19th century, and in the 20th century, the 1930s and the 1950s and early 1960s. Today, most Danes have a predominantly urban lifestyle. Five point two per cent of the population

are immigrants or refugees, especially from Turkey, Pakistan, Lebanon, Iran, Iraq and the former Yugoslavia (mainly from Bosnia). There are Palestinian refugees as well (*Politiken*, December 1997).

With regard to its political structure, Denmark is a democratic society with a 179-member parliament representing nine political parties. The government consists of a two-party minority coalition reflecting a classical scenario over the last 25 years of Danish politics. The present coalition government is between the Social Democrats and the centre-party Radikale Venstre.

Denmark is divided into 15 counties – besides the urban centre of Copenhagen and its municipality (Frederiksberg) – and 270 municipalities. Together with the national state administration and regional counties the municipalities share responsibilities for education, health, and, as we shall see, also within media policies and practices. The municipalities in particular hold extensive political and economical autonomy, which is reflected in the municipal media committees that grant concessions.

A significant historical characteristic of Denmark is the level of development and complexity of its civil society. Denmark has a century-long tradition of locally rooted, non-governmental, democratic organisations of all kinds. They vary from the more traditional sports and boy-scouts organisations, political parties and trade union movements to newer social and grassroot organisations such as Greenpeace, Amnesty International, the large Danish environmental organisation Dansk Naturfrednings Forening, organisations for the elderly and a series of church-related organisations. For example, of Denmark's one million people over the age of 60, more than 350,000 are organised in the only 12 year old organisation Ældre Sagen which takes up issues of concern for the elderly.

Both regional TV and the (non-commercial) local media have strong ties to this environment of local organisation and popular participation, to which I shall return.

2. Television in Denmark: History and legal setting

The broadcasting history of Denmark is on the one hand a well-known and characteristic story for many EU-countries: decades of state monopoly on broadcasting, recently having experienced deregulation, commercialisation and internationalisation, moving from a public monopoly towards an increasingly multi-channel and competitive environment. On the other hand, broadcasting history in Denmark shows a slower deregulation process than in most other Western European countries, where the state, despite the many recent changes, continues to possess a high degree of control over electronic media.

Table 1. The Kingdom of Denmark. Basic indicators

Administrative structure (counties)	Area (sq. km) (1994)	Population 1995	Inhabitants per sq. km
København (city of Copenhagen)	88	471,300*	5,340.5
Frederiksberg (municipality of Copenhagen)	9	88,002	10,034.4
Københavns (county of Copenhagen)	526	605,868	1,151.9
Frederiksborg	1,347	350,236	259.9
Roskilde	891	153,199	251.3
Vestsjaelland	2,984	288,221	96.6
Storstrøm	3,398	256,562	75.5
Bornholm	588	44,936	76.4
Fyn	3,486	467,695	134.2
Sønderjylland	3,938	251,992	64.0
Ribe	3,131	221,750	70.8
Vejle	2,997	336,663	112.3
Ringkøbing	4,853	270,128	58.7
Århus	4,561	619,232	135.8
Viborg	4,122	230,778	56.0
Nordjylland	6,173	488,303	79.1
TOTAL	43,094	5,215,718	121.0

*In 1995, the capital, including the municipalities of Copenhagen, Frederiksberg and Gentofte, had 625,810 inhabitants and a overall 1,353,333 inhabitants including the metropolitan area.

Source: Hunter, 1996.

In this recent transition process the local media became important ice-breakers, pointing in new directions. However, to understand the Danish scenario, some historical threads must be spun, in particular regarding the legacy of enlightenment and of public service from which Danish television emerged.

2.1 Public service and the legacy of enlightenment

Television in Denmark is linked to a long tradition of public service broadcasting, originating back to the beginning of radio broadcasting in the 1920s. Danmarks Radio (DR, at the time called Radiosymfonien) was created in 1925 around the time of the passing of the Broadcast Act. One of the fundamental criteria in programme production and selection was that they should be of a "general enlightening and cultural nature". Radio was seen as a disseminator of high quality programmes with educational aims and influence.

When television was introduced by DR in 1951 the above high brow cultural discourse and subsequent distaste for popular culture remained

manifest, despite DR transmitting many popular programmes, including popular music programmes and radio soaps. DR's TV monopoly was kept until the local TV experiments began in 1983.

This organisation of both radio, and later television, as public broadcasting represents a continuation and development of a strong Danish tradition of popular enlightenment dating back to the early 19th century and strongly linked to the social movement and philosophical ideals of that time. These movements and ideas strongly influenced the writing of the first Danish constitution (1848) and was fundamental in the founding of Danish democracy. The founding of public service broadcasting in Denmark constituted an extension of these ideals, at that time reflecting a wish of the political and intellectual élite to promote education for all, to spread information and to "democratise culture".

Rooted in this politically broad Danish legacy of enlightenment is the Social Democratic party. Historically, public service television in Denmark is linked to the Social Democratic dominance in politics, from the pre-war era through the entire post-World War II period and all the way up to the early 1980s. For the Social Democrats throughout this period, television was designed to support the basic principle of socialising and capacitating all Danes to become well informed democratic citizens.

Given this political-ideological context, the mass media had to be public, and all forms of commercialisation of the electronic media, including the use of advertising, was to be avoided. The economic and industrial aspects of this new medium were given scarce consideration. Television was cultural politics, and in order to secure a correctly enlightening use of television, it was established and developed as an organisation under state control.

In the 1950s and 1960s Denmark experienced profound socio-demographic and cultural changes, from being still a highly agricultural and traditional nation to a modern urbanised industrial nation. The welfare state developed, and in the process of social and cultural adaptation to new and modern lifestyles, the national broadcasting monopoly positioned itself as a central instrument in the advancement of a unifying, modern national cultural discourse. Television was seen as a central social agent through which many people obtained access to a social and cultural discourse relevant to, and part of, the process of modernisation.

In the 1970s, maintaining a public broadcasting monopoly became a difficult task. In particular, the increase in programming obligations became difficult to meet. High priority was given to national production of almost everything, linked to the highly valued principle of diversity in serving the Danish public, which, after all, is not so uniform. The oil crisis, setting in from 1973 and creating an economic setback on all fronts, worsened what thus far were only symptoms of a public institution – and an entire welfare

society – and placed them in crisis. Providing the nation with a satisfying programme supply was expensive and too demanding a challenge.

Criticism arose from many sides. The viewers demanded entertainment programmes, praising (and watching!) the growing number of imported programmes such as serials and films. The cultural elite disapproved of the growing influence of foreign (largely American) programmes upon the Danish audience. Legal and institutional rearrangements around DR contributed to, rather than solved, the crisis of the public broadcasting monopoly. Until 1973, parliamentarians, experts and prominent cultural personalities were members of the programme council under the mandate of the Radio Council of DR (The Danish Broadcasting Institution), which was the top political authority of DR. Programme policy was primarily discussed in the programme council, with the Radio Council as a supervising entity. From 1973 the Radio Council merged with the programme council and created a new version of the Radio Council which was both the political head of the institution and functioned as a programme council. This became a dangerous cocktail, mixing political interests with the daily running of a state institution. This politicisation of the day-to-day work of DR received increasing criticism, but it was not until the Broadcast Act of 1987 that parliamentarians were prevented from becoming board members in DR. The new top authority, the DR Board of Governors, was given the overall responsibility for DR, leaving the programme policy to a series of programme councils of DR.

In the 1980s, when television underwent a process of deregulation and internationalisation, its role as a national cultural articulator was highly questioned and debated. In the course of this debate the local and regional media began to gain visibility. Some of the experiments with local media developed new forms of expression, new formats in content, financing and organisation, which decisively paved the way for the breaking of Danmarks Radio's monopoly on radio and television.

Summing up, the trajectory of Danish public service broadcasting demonstrates two particularities which impacted strongly on more recent media developments: (1) the slower deregulation process in Denmark vis-à-vis other EU-countries, explained by the specific political and ideological basis on which television was founded in Denmark; and (2) a strong political influence on Danmarks Radio, in particular from 1973-1987, an influence and political struggle which largely was a power struggle regarding the future of Danish television; what would and should happen once the monopoly fell? Answers to this question came in the course of the 1980s, with small-scale television playing an important role.

2.2 Transition in the 1980s: from monopoly to competition

In 1980 the Danish government set up a Media Commission with the purpose of initiating the political process of revising the legal framework for

Danish broadcasting. It took five years before the final report was published, nonetheless the results (analyses, scenarios and recommendations) were scarcely debated and did not lead to any substantial nor broad political agreement on which to base future media development. The report itself pointed at the difficulty in reaching a consensus on anything more than a general level. The subsequent legislation from 1986/1987 shows this lack of consensus: the law breaking DR's monopoly and establishing TV2, the second national TV broadcaster, was passed by a margin of just one vote!

While most political parties did agree upon the establishment of a second national TV-channel, the principal controversy concerned the organisation and profile of TV2 (ownership, financing, structure and programme content). The compromise became a state-owned autonomous organisation, financed 28 per cent by licence fees and 72 per cent by revenue from commercials (TV2 *Annual Report 1996*). Ten per cent of the programme content could be comprised of by commercials.

One significant innovation was the establishment of regional services, eight independent stations as part of the TV2 system. They offered initially a daily 30 minute regional news bulletin. It was the local television experiments which, already in 1983, broke the public service monopoly of DR and furthermore paved the way for their formal integration in the Danish media landscape from 1986. Based on a political agreement in 1981, a huge amount of experiments were carried out between 1983-1986, totalling 90 local radios and 34 local TV stations (Jauert and Prehn, 1995).

Economically, the experiments proved how difficult it was to run a local TV or radio station. The justification for their whole existence lay in the legacy of public service and enlightenment in Denmark. They became an extension of the public service concept, adding the proximity dimension. The experiments demonstrated that public service small-scale television in practice would be impossible to implement if it was not either secured substantial public support or given the possibility to network and run commercials.

2.2.1. The rise of local television: Kanal 2 and Weekend TV

The first period for temporary experiments with local radio and television was established with the law of 15 June 1973. It established the possibility for local experiments which subsequently were carried out in the period 1974 to 1977, mostly with local radio. After the experimental period ended, a commission under the Ministry of Culture summed up the experience in a report. They concluded that the experiments in this period had been too few and too small to draw substantial and significant conclusions as to the viability of local cable born radio and television in Denmark (Hjarvard & Søndergaard, 1988: 20-21). On this basis the commission recommended the establishment of a new period for temporary experiments which was decided upon in 1981 and carried out between 1983-86.

Experiences of local television in the first part of the 1980s are highlighted by Kanal 2 (1984) and Weekend TV (1984-86). Both were formally local commercial TV stations in Copenhagen, however covering approximately a quarter of Denmark's entire population (greater Copenhagen). Despite operating within the framework of local media, the ambitions were clearly to compete with DR, launching themselves as alternatives to DR. In this competition, they laid heavy weight on films, series and entertainment programmes, constituting 90 per cent of Kanal 2's programming schedule and 80 per cent of Weekend TV's programming schedule (Hjarvard & Søndergaard, 1988). A maximum of 50 per cent of the programming schedule could by law be imported programmes, and this consisted mainly of American programmes. Large parts of the national programmes were to some extent copied from foreign programme concepts (Søndergaard 1996: 26-27).

Kanal 2 was an initiative of two Danish entrepreneurs, and was converted into the first commercial and pay to view television in Denmark. However, one year after its establishment, it was acquired by Esselte FilmNet, a subsidiary of the Swedish multi-national company Esselte. Since then various reorganisation processes have been undertaken. In this way, in 1990, the Scandanavian Broadcasting System (SBS), American owned and with headquarters in Luxembourg, entered to form part of the shareholding of the company of Kanal 2 Prime Time, a production and commercial company that provides an important part of the programming of Kanal 2.

With the establishment of Kanal 2 and Weekend TV Danish people could see television different to what they were used to. It was commercial television with a different programming policy, a new aesthetic and other priorities than those offered by the public state television service. The numerous American series were broadcast in English with subtitles in Danish. Nowadays Kanal 2, as part of the channel Tvd, continues to broadcast a large proportion of foreign programmes – especially from the USA – although many legislative rules exist regulating the mass media in relation to television content.

What Kanal 2 and Weekend TV achieved was to challenge "Big Brother", Danmarks Radio. Their challenge lay on many fronts: being private and commercially driven enterprises; having "free hands" which resulted in a very entertainment-oriented international (American) programming schedule; experimenting with new transmission hours (ie the first to introduce morning television in Denmark); generally introducing a more direct, informal and explicitly entertaining discourse into Danish television, seen for example in how the studio hosts relate to each other and to the audience. The result was a new style of television, not seen before in Denmark, a style which anticipated change in Danish broadcasting. It was based less on a cultural and social ideal of

democratising culture (enlightening the people and providing public service in a serious and diverse programming schedule under public control) and was rather based on a commercial logic where priorities were on strong audience attention, resulting in many of the innovations mentioned above.

2.3. A decisive media agreement

The 1980s were characterised as a process of transition, where the political agenda dealt with how to transcend the era of state monopoly. Many interest groups were concerned about how to position themselves in the competition for the second national television channel. The experiments with local television were important agents and articulators of the more competitive, internationalised and deregulated media landscape.

However, the legislation of 1986/87 became only the first decisive step away from national monopoly. The political message remained unclear: how should public service be seen and understood in the future? Which role should local and regional media play, and on what economic premises? On the one hand the law established regional television linked to the second national TV-channel (TV2) and offered substantial public support. On the other hand the local urban media were formally recognised and integrated into the Danish media landscape, but they were neither permitted networking possibilities nor given any substantial public support. This was politically a very unclear signal regarding local and regional television.

Not until 1996/97 were some of these questions answered in the new media agreement and legislative revisions. 10 May 1996 marks a turning point in Danish media history. The media-political agreement for the 4-year period was signed (1997-2000). The principal objective was to secure for the electronic media in Denmark as free and broad a framework as possible, establishing the conditions for them to meet the growing international competition and the challenges merging from rapid technological development. It was a broad political agreement, decided upon by 8 of the 9 political parties represented in Parliament. It constituted the basis for the Broadcasting Act (Law no. 1208 of 27 December 1996) and for the Departamental Order of 29 January 1997, from the Ministry of Culture. Together they constituted the political, economic and technical mechanisms under which radio and television function in Denmark today.

This recent consensus legal structure merged from the work of the Media Committee set up by Statsminister Poul Nyrup, in 1994, produced three principal reports: *Danish Media Policy* (1995), *The Electronic Media* (1995), and *The Media in Democracy* (1996). The Committee also requested a series of 15 reports, written by Danish academics providing an unprecedented scientific base and contribution on which to establish the political decision process. The Media Committee consisted of 30 people representing a broad

spectrum of interest organisations, public and private media enterprises (both workers and employers side) within the mass media. Three members represented ministries and 11 were nominated in their personal capacity (academics, a writer, media professionals, a priest, etc). Despite a rather large group of personally nominated people, the Committee was considered representative of the different interest groups.

The main legislative changes were as follows:

• DR and TV2 gained increased economic liberty. Now, both TV2 and Danmarks Radio are independent and the Minister of Culture cannot, as before, determine the budget frame within which Danmarks Radio, TV2 and the regional TV2 stations have to operate. This remains now the responsibility of the respective stations. This gives both Danmarks Radio and TV2 full disposition over their shares of the licence fee revenue and TV2 can furthermore, contrary to before, now freely have the disposal of their revenue from commercials.

• DR and TV2 are given the possibility to establish subsidiary companies and to co-operate with other companies. They are also permitted to enter into tele-enterprise.

• Public service obligations were extended ie with increased engagement in Danish film production and increased use of independent producers. The public service obligations are to be accounted for in order to prove fulfilment of the same.

• The permitted share of commercials on TV2's daily programming schedule was increased from 10 per cent to 15 per cent.

• The licence fee increases with 3.3 per cent on a yearly basis, equal to the general development and increase in prices and salaries.

Legislation of particular interest for local and regional television include the following:

• Local commercial television stations were given the right to network, provided they transmit minimum one hour of local programmes per day, and providing they sell the non-commercial TV-stations access ("programme-windows"), three hours a day (9-10 a.m., 5-6 and 11-12 p.m.).

• A permanent pool with 50 million Danish kroner per year was established in order to support non-commercial local radio and television. It is simultaneously permitted to obtain financial support from other sources (though not commercials)

• Two four-year pools are established containing each 5 million Danish kroner per year. They are to support both experiments with local television and tele-enterprise, as well as experiments with media schools.

2.4. The future

The legislation from 1986 through 1996/97 shows a clear political priority in assuring the existence of small-scale television in Denmark, although the premises seem unclear: How should it be organised? How should it be financed? Do we want commercial television and to what extent and on which levels? Obviously, all forms of organisation and financing are given some chance – we can see a complex configuration of the current Danish media landscape which, however, comprises with long-standing principles in Denmark of democracy and diversity. Meanwhile, with competition growing fiercely, the current media policy may seem very broad, spreading public funds among too many institutions, and providing a media institutional supply which may prove too luxurious for so small a country.

Technologically speaking, digitalisation is foreseen, both for DR and for TV2, including the eight regional TV-stations. In addition to the two existing earth-bound analogue TV-channels, a third one, being digital, is planned to be established by the year 2001, thus providing DR and TV2 with the possibility for digital transmission. The governmental Media Committee estimated in 1995 that by the year 2005 approximately 20 per cent of the TV-households will be receiving digital TV (Report No.1300, p. 277). However, the penetration will obviously depend upon digital programme supply.

Part of the future Danish scenario has to do with the status of TV2. Should it continue as a public service channel? Four scenarios have been set up by the Ministry of Culture, varying from a status-quo model of public service television to a 100 per cent privately owned TV-company with no public service obligations. TV2 is currently lobbying for their own alternative, "The 5th model", including mixed private and public financing, maintaining public service obligations and maintaining a close co-operation between the national TV2 and the autonomous regional TV-stations currently belonging to the TV2 family. TV2 and the regional stations have recently anticipated the fulfilment of a political agreement along their own lines of argument, signing a contract for the period 1998-2005, including agreements on programme policy, production and financing. It gives the regional TV-stations an increasing role to play. On the digital TV2 TV-channel, planned to be transmitting from 2001, they should thus have a one-hour daily programme window, parallel with the current obligations on TV2's existing TV-channel. The political decisions regarding TV2's institutional and financial future will be taken in the course of 1998, having been postponed several times already. It is undoubtedly a controversial political issue.

3. Television in Denmark: Current structure, ownership and financing

TV broadcasting in Denmark today is a complex field with many institutions involved. Broadcasting takes place on four principal levels today; local, regional, national and international.

Table 2. TV in Denmark. Structure, ownership and financing

Level	TV-stations	Owner	Financing
Local	43 local TV stations	Private	Public (non commercial)
	(Tvd = cable or satellite)	Private and public	Commercial
Regional	8 regional stations	Public	Public
National	DR1	Public	Public
	DR2 (cable and sat.)	Public	Public
	TV2	Public	Public/private
	TV3 (cable or satellite)	Private	Private
	TV3+ (cable or satellite)	Private	Private
International	Aprox. 70 foreign channels	Publ./priv.	Public/private

(a) International level

The international level refers to broadcasters that include a Danish audience as part of their target group. At present, a little over half the population have either cable or private dishes, thus receiving satellite TV.

(b) National level

It consists of three main groups, with six channels:

(1) DR, with two channels: DR1 is broadcast as a terrestrial station, while DR2 is a satellite station, opened in August 1996.

(2) TV2 possesses one national channel working jointly with eight regional stations.

(3) TV3 (1990) and TV3+ (1995), both owned by the Swedish Kinnevik Corporation and transmitting from London to all of Scandinavia – are considered part of the "national level". They are produced specifically aiming at the national Danish audience, for example talking Danish and using Danish subtitling.

Finally, on the national level, a new sports channel called TVS was launched *and* closed again in 1997. In March 1997 TeleDanmark, the national telecoms operator, opened up TVS with DR and TV2 as joint owners. With the new legislation, operational from 1 January 1997, telecom-companies were allowed to enter other areas of operation. TVS, however, was not able to compete, gaining very little audience support. By the end of 1997 TVS's aim was at least 40,000 subscribers. It had reached only 14,000. To avoid huge continuous investments in the

channel TeleDanmark decided to stop transmission, closing TVS down again by the end of 1997.

(c) Regional level

On a regional level only the 8 regional TV-stations exist. They all form part of the TV2 structure, albeit being autonomous public enterprises. Their existence and survival is however based on their integration into the TV2 structure with the substantial public support this triggers. Of the eight regional TV stations, the oldest is TV SYD, created in 1983 as one of the experiments of the period 1983-1986. It continued to broadcast and became the first of the eight regional TV stations to form the "regional fundament" of TV2. The other seven regional stations were all established between January 1989 and January 1991, and together cover all 15 counties in Denmark.

(d) Local level

On the local level around 60 concessioneers transmit television over 43 existing local TV-stations that operate from 21 different cities in Denmark. About one third of the concessioneers are commercially driven.[2] The concessioneers as a whole represent different organisations, companies and institutions, some of which co-possess the licences/concessions behind a particular station. A third of the concessioneers are gathered on the two TV-stations in Copenhagen. Eight of the commercial TV-stations are linked together in the commercial network TV Danmark (Tv*d*), with the perspective of including another 3 in 1998.

3.1. Financing

Looking at the finances of the Danish TV market, public funds constitute a fundamental impetus. The licence fees paid by everybody with a TV-set in Denmark finances 100 per cent DR's activities and approximately 28 per cent of TV2's activities. The rest of TV2's revenues come basically from commercials. Revenues from licence fees furthermore provide the economic backbone for non-commercial local TV and radio. During the present media-agreement (1997-2000) the public support allocated to local radio and local TV production total 50 million kroner every year (see Tables 3 and 4).

4. Increased complexity and competition

As seen, television in Denmark today reflects an increasingly complex institutional panorama, with a gradual growth in competition. However, public service television remains very strong on the Danish market, even having been extended to include both regional and local television.

Simultaneously, commercial television in Denmark is growing, in suppliers as well as in viewers. TV3, TV3+ and the Tv*d* network are all growing, indicating continuous change. Noteworthy is the minimal success of the

large number of foreign satellite channels. They may be contributing to an increased segmentation of the Danish audience, but they have not gained any significant shares or ratings. Danish viewers clearly prefer Danish programmes.

Table 3. Planned distribution of licence fee revenues 1997-2000 (million Kr)

	1997		1998		1999		2000	
	Millions	%	Millions	%	Millions	%	Millions	%
DR	2,342	88.00	2,406	87.50	2,457	86.50	2,495	85.00
TV2	319	12.00	344	12.50	384	13.50	440	15.00
Total	2,661	100.00	2,750	100.00	2,841	100.00	2,935	100.00

Source: Law n. 1208, 27 December 1996, p.33.

Table 4. Public subsidies to local radio and local TV production (million kr)

	1997	1998	1999	2000
Licence fee	15	15	15	15
The Radio Fund	30	25	20	10
Fee from commercial TV	5	10	15	25
Total	50	50	50	50

In shares of total viewing time, we see TV2 as the most popular channel, with 41 per cent of the total viewing time. TV2 overtook DR1 as the most popular TV-channel only two years after their launching in 1988. Since 1992 TV2's share has been rather constant (around 40-42 per cent).

Among satellite viewers with access to TV3, TV2's share falls to 35 per cent. Among viewers with access to DR2, TV2's share is 34 per cent, still significantly higher than DR's 24 per cent (DR1) + 2 per cent (DR2). Among satellite viewers TV3 have an 18 per cent share, having grown close to DR's total 26 per cent.

The newly established national network Tvd (constituting the predominant part of the category "all local TV" in table 2) seems to be gaining viewers from TV3's share, thus competing mainly with commercial TV and not with TV2, as many predicted.

5. Structure and characteristics of TV in the regions

5.1. Typology

The TV-stations in the Danish regions fall within two typologies. There are some local television stations with a regional outreach, in particular Kanal 2 in Copenhagen. However, regional television in Denmark primarily refers to the eight autonomous regional stations that form part

of the TV2 structure. According to the definition established by Moragas Spà and Garitaonandía (1995: 11ff), they are decentralised TV stations, however with some characteristics of many regional off-the-network TV stations. They each produce 36-37 minutes of daily new bulletins (spread on three time slots) plus a weekly 30 minute programme. They offer regional advertising within their time slots and possess independent production capacity, producing programmes not only for their own programming schedule, but also programmes intended for state-wide transmission.

Table 5. The channels' shares of the viewing-time (per cent)

Channel	1992	1993	1994	1995	1996	1996*
TV2	40	42	41	42	41	34
DR1	35	32	30	28	27	24
DR2	-	-	-	-	-	2
TV3	7	8	10	11	13	18
All local-TV	5	5	6	6	5	7
Others	13	13	13	14	14	15
Total	100	100	100	100	100	100

* Covers the period 30.8.96-31.12.96. Indicates the channels' share among viewers that could see DR2, launched 30.8.96

Source: Gallup, *Annual Report 1996*: The TV-meter study in Denmark.

5.1.1. TV2 Regional Stations

The regional stations linked to the national TV2 channel were legally and formally included into the Danish media landscape with the 1986/87 legislation. The oldest of them, TV SYD dates back to the first experiments with local television from 1983.

Each regional station has between 40-70 employees and cover population areas between 50,000 (the island of Bornholm) and 1.7 million (the population of the greater Copenhagen area), covering between 1 and 4 counties each. Thus, TV2 Lorry, based in Copenhagen, covers 36 per cent of the Danish population. TV SYD is the second biggest covering 1 million Danes (16 per cent) and TV2 Østjylland (East Jutland) is the third biggest with 600.000 (13 per cent).

The average of total viewing for the regional stations was in 1997 20-35 per cent. Their share of viewing is between 65-80 per cent (CIRCOM Website). Compared to the general figures on viewing, this places them very fine in the top part, both on ratings and share.

Financially each regional TV-station is independent. However, being part of the TV2 structure and obliged to fill the above mentioned

programme slots, their finances are tied closely to those of TV2. TV2 supports the running of each regional TV-station with a fixed amount every year, approximately 5 million ECU (36 million DKK) per station.[3] The income generated by regional advertising is initially allotted centrally to TV2, subsequently being redistributed to all of the regional stations.

Table 6. The regional television stations in Denmark

Name	Reach	Staff	Established
TV2 Bornholm	50,000	43	n.a.
TV/Midt Vest	500,000	n.a.	n.a.
TV2/Nord	500,000	55	1.4.89
TV 2/East	520,000	42	n.a.
TV2 Østjylland	600,000	n.a.	1.4.90
TV2/FYN	468,000	52	n.a.
TV2/Lorry	1,700,000	n.a.	n.a.
TV SYD	1,000,000	70	1987 (1983)
TOTAL	5,338,000 *	n.a.	

* Approx. = the overall Danish population.

The financing of TV2 and the regional TV-stations originates 22 per cent from licence fees and 78 per cent from commercials (TV2, 1996). Some fluctuation in the revenue from commercials is expected in the coming years due to increased competition from the local TV-network Tvd and from TV3 and TV3+. Local networking permitted by the new legislation and put into practice with the official establishment of Tvd is, fully built out, estimated to imply a loss for TV2 in income revenue of up to 200 million kroner. These are difficult estimates, however calculated by the governmental Media Commission (Regnegruppen, Medieudvalget 1995). Should the competition lead to serious revenue losses for TV2, they will most probably be granted supplementary public funds, given their status as a national public service channel.

In other words, contrary to commercial local-TV, the regional TV-stations are through their membership of the TV2 family, economically secured, one way or the other. Many local TV-stations find this being unfair competition, giving the regional stations' easier conditions compared to the market-based life conditions of commercial local TV.[4]

In addition to the fixed grant from TV2 to cover running costs, the regional TV-stations generate income by selling productions to TV2 and to others and by renting out facilities and equipment. For example TV SYD received

79 per cent of their 1996-income from TV2 as a fixed grant towards running costs and 21 per cent of the income was generated in other ways (TV SYD, Annual Report 1996). Compared to some of the other regional stations TV SYD's percentage of parallel income is high.

All regional stations are responsible for producing their own programme slots. For example TV SYD has, in co-operation with amateur actors, professional directors and professional local production companies, produced television plays written directly for the local community: *The Finderup Barn Murder, Wild Island Horse, Winners and Losers*. These may often be sold on to TV2. As TV2's director of Information has stated, the regional TV stations may be considered as "really good workshops", a forum where new formats are tried out to a smaller cost, prior to a possible national exposure and further development (Krarup, Interview 1997).

The average TV-viewer on regional TV programmes is generally older than the average viewer profile on the national programming. The director of TV SYD, Tim Johnson, indicates that their main audience profile is the +55 age group, in particular on the 19:30 news bulletin (Johnson, Interview 1997). It is, however, his impression that with the new 22:15 programme slot, initiated early 1997, they are reaching other segments than the 19:30-20:00 slot. Both with the daily slot at 22:15 and the late Monday slot at 10.40 p.m. the regional TV-stations are attempting to conquer shares among the young families with small children, a segment of the population that does not have time to watch television at 19:30. They seem to be having some success.

Roots in the region: Popular support

All eight regional stations are politically and financially independent entities, with their respective Boards of Directors and management. Each station has a council of approximately 70 people representing a wide range of different organisations from the region. These councils every four years elect the Board of Directors. Furthermore, the councils establish the overall programme policy for their respective stations, a policy typically debated and agreed upon at two annual meetings.

Based on the idea of having a solid democratic foundation in the region, with roots among the organisations of civil society of each region, the regional TV-stations are in principle governed each by a sort of public assembly. Each regional council has approximately 70 members (in TV SYD 100 members), representing grassroot organisations, NGOs, sports, youth, church and other organisations from their particular region. From the regional council is elected a Board of Trustees which again appoints the daily management which finally hires the rest of the employees.

In southern Jutland, where TV SYD is based, organisations representing the Danish minority in Northern Germany form part of the council. TV SYD's regional council meets twice a year at one of the local folk high

schools, where they spend a whole day discussing TV SYD's activities. According to director Tim Johnson, the overall programme policy is outlined and decided upon at these day-long gatherings twice a year.

Both Tim Johnson and Anders Krarup, Head of Information at TV2, believe in the true popular participation and its influence on the regional TV-stations. However, on a day to day basis the decisions are taken by the editors in chief and obviously taking TV2's overall programme policy into consideration. Therefore, it is within this more complex panorama of decision-making that the regional councils work to get the TV-stations to reflect the interests and concerns of the people living in the regions.

Community participation in regional TV-broadcasting is also seen in the local support organisation, the strongest being the one supporting TV SYD. 16,000 people in Southern Jutland are members of TV SYD Support Organisation (TV MidtVest's support organisation has approximately 13,000 members). In 1996 TV SYD's local support organisation donated 340,000 DKK (approx 50,000 ECU) to the station.

Yet another aspect of the local community's interest regarding TV SYD is the fact that TV SYD receives over 5,000 visitors every year, people who come and pay to see how the TV-station is run and how a news bulletin is produced. A more recent initiative is to stimulate school classes to come as well. The visitors at TV SYD come at 17:30 and stay through the evening programming until 21:00.

5.1.2. The urban TV-stations
Urban TV-stations in Denmark are spread over 21 cities, although with particular concentration in the three principal cities; Copenhagen, Århus and Odense. Of the approximately 60 concession holders transmitting – or planning to transmit – through 43 different TV-stations many are small civil organisations jointly running small TV-stations and transmitting to very segmented parts of the audience. One local TV-station stands out in particular: Kanal 2, transmitting on channel 60 in Copenhagen. It is the coordinator of Tvd and is the largest local TV-station in Denmark.

However, a *de facto* network Kanal Danmark did actually exist (Prehn & Jauert, 1995). It was established in 1990 between 5 local TV-stations (among them Kanal 2) and gradually expanding to 13 local TV-stations. This "*de facto* network" had as a main aim to co-ordinate the buying of foreign programmes. The programmes were bought and charged to the other participating local TV-stations with the condition that part of the commercial time on these local TV-stations were given to Kanal 2 Prime Time A/S. The revenues earned by Kanal 2 Prime Time A/S for these commercial slots were channelled over to Lifacts Aps.

Given that networking between local TV-stations was forbidden in Denmark until January 1997 the Ministry of Culture already in 1991

investigated the co-operation established within Kanal Danmark, resulting in a continued acceptance of the informal network, where each local TV-station apparently still maintained their autonomy. In 1997, the participating local TV-stations in Kanal Danmark were the same that – once networking was legalised – established the Tvd Network.

Both financially and in terms of ratings, Kanal 2 is by far the biggest local TV-station in Denmark. Of the 1995 advertising turnover for local TV in Denmark (108 mio DKK) 70-80 million DKK are generated in the "greater Copenhagen" area, with Kanal 2 as the principal vehicle (*Media Commission Report* 1995, Annex, p. 283 and 299). I return to Kanal 2 below.

The non-commercial TV-stations are generally owned and run by small non-governmental organisations, private associations with specific interests that see local television as a way to reach their specific target groups. Among these concession holders are, for example, *XTV* transmitting to university students, Vesterbro Lokal TV to one particular section of the city and Iransk TV transmitting to Iranians in Copenhagen. Despite very small and thus non-measurable ratings, they often have reasonable ratings within their particular interest groups. XTV, for example, made a recent survey which indicated that 15 per cent of the university students at Danmarks Tekniske Universitet were occasional or regular viewers of XTV (Lars Birk, 1997). Only the commercially driven Tvd as a network is large enough to be registered in the TvMeter measuring system, indicating an average rating of between 5-7 per cent.

Financially, the non-commercial local TV-stations survive on public support, a situation which was introduced with the new legislation from January 1997. As a result of the media agreement from May 1996, 50 million DDK (approximately 7 million ECU) will, on a permanent basis, annually be invested in local radio and TV production. The first year, 1997, show that 68 per cent of the funds are given to local TV-production (Ministry of Culture, December 1997).

These funds are distributed to 41 different TV-stations, receiving each amounts between 2,000 and 52,000 ECU in 1997. On one hand this secures diversity and breadth in the media landscape. On the other hand, the breadth may be too large, providing too many TV-stations with too few funds. It is still too early to say, but experiences with local television in Denmark in the 1980s showed the high expenses in running a TV-station. The problem may arise again in a near future.

Where the above funds predominantly are destined to support work expenses at the local radio and local TV-stations, an additional 10 million DDK (approximately 1.4 million ECU) are yearly earmarked to support two issues: experiments in local TV and tele-entreprise and experiment in local media schools.

Table 7. TV-stations and transmitters in Denmark

	Tv-stations	Transmitters
København	20	2
Odense	1	1
Århus	1	1
Ålborg	2	1
Svendborg	1	1
Others	14	8
Total	43*	14

* 7 of the 43 TV-stations do not yet transmit (Hartvig, March 1997)

TV Denmark

Tvd is a network of 8 local TV-stations, launched formally on 7 April 1997 as a network with national coverage.[5] Scandinavian Broadcast System (SBS), who is the principal owner of Tvd (delivering the majority of the foreign programmes) is an American Luxembourg-based company. Walt Disney owns 23 per cent of the stock in SBS. SBS' aim is to reach a market share of 20-25 per cent on the commercial Danish TV-market, overtaking TV3's position as the second largest commercial national TV-station/network in Denmark. The current share of these 8 local TV-stations is 13.8 per cent (August 1997), having almost doubled since their beginning in April 1997. In order to pursue their aim, SBS plans to invest 150-200 million DDK in the network (*Politiken*, 8.4.97).

Three criteria that have to be met by the local TV-stations participating in networking are:

(1) They are obliged to transmit at least one hour of locally produced news and current affairs programmes, or other programmes that have their roots in the local society;

(2) A significant part of the programmes must be in Danish or produced for a Danish audience;

(3) Programme time must be reserved for the non-commercial concessioneers covered by the same frequency, which is administered by this one commercial local TV-station.

In the course of the first 6 months of transmission, Tvd has received substantial criticism for not meeting criteria number 2. In the first months of transmission, both the National Consumer Council, the Minister of Culture and media researchers all pointed at the fact that only a very little percentage of the programme offer programmes in Danish or produced for a Danish audience. Soon afterwards, this imbalance was partly adjusted.

However, it remains an open question whether these criteria will be fully reached. Experiences with local television in the 1980s showed a lack of will among local commercial TV-stations to comply fully with such obligations.

Table 8. TVd member stations and their headquarters

TV station	City
TV-Trekanten	Vejle
TV Aalborg	Aalborg
TV-Fynboen	Odense
UTV-Slagelse	Slagelse
TV Herning	Herning
TV Næstved	Næstved
TV Århus	Århus
Kanal 2	Copenaguen

* Future participants expected in the course of 1998: Esbjerg, Randers and Viborg.

Decision-making

Concessions are given for local TV on a 7 year basis. The concessions are approved on a municipal level. However, smaller municipalities main join efforts, setting up Joint Councils for Local Radio and Television covering areas with a total of inhabitants up to 200,000.

Only one commercial TV-station is given a licence in each area of coverage. They are granted only to companies representing a broad range of economic and cultural interests in the community and that comply with a set of criteria regarding locally oriented programming, national production, etc. (I return to this when dealing explicitly with TvDenmark below.) Furthermore, the local commercial stations pay an annual concession fee to the national treasury, which then uses this revenue to support the non-commercial TV-stations.

The case of Copenhagen is a particular case. Here only one Joint Council exists, covering a population of approx. 1.4 million inhabitants, comprising the municipalities of Copenhagen and Frederiksberg plus the municipalities within the county of Copenhagen.

5.2. Conclusion

The regional TV-stations are expanding, and seeking to consolidate their position in their communities, wooing younger audience segments and thus seeking to avoid becoming solely "TV for the elderly". They generally enjoy substantial popular support each in their regions, illustrated best in the many members of the support organisations.

Some jealousy exists between these stations and the member-stations. The regional TV-stations are allowed commercials and furthermore receive substantial public support, while the Tvd– stations receive no public support, compete on market conditions and furthermore have to respond to criteria of local orientation in programming and quota of Danish programmes.

The possibility of networking has, for several of the commercial local TV-stations in Tvd, been seen as a last-minute chance for survival. So far, they have doubled their share of the commercial TV market in Denmark, capturing viewers from TV3, without having influenced on TV2 or DR. It is however too soon to say whether Tvd will manage to survive in its present form on the premises given.

Non-commercial local TV has been provided with an important possibility for continued existence, receiving 50 million Danish Kroner every year, distributed among a large number of TV-stations. The first experiences registered at the Ministry of Culture, who administer the public support, show a large and varied demand. For the size of the country, the degree of sustainability for this large number of local and regional TV-stations could be questioned. However, again it is too early to evaluate how they will perform under the improved economic situation.

Analysing the programme schedules of regional TV in the following will reveal further dimensions and particularities of some of these local cultural agents, thereby providing some indication of which way local and regional television in Denmark is moving.

5.3. Study of regional programming

The regional TV-stations are tied to a fixed programming schedule decided upon in negotiation between the eight regional TV-stations and TV2. At present they transmit 36-37 minutes per day on Sunday-Friday:

(1) a very brief news slot at 18:05;

(2) a 30 minute news bulletin at 19:30;

(3) a 5 minute news bulletin at 22:15.

The news bulletins with clear regional or local profiles cover all issues, be they political, sports, cultural or meteorological stories, or other events of importance for the region. Furthermore, some of the regional TV-stations transmit a one-hour programme in the morning (11-12 a.m.), advertising vacant jobs for the local public employment service.

Since January 1997 they have also transmitted every Monday at 10.40 p.m. It is a 30 minute programme slot, usually dedicated to current affairs programmes and debate programmes (including regional talk shows), but some regional stations have also produced documentaries and fiction. As

we shall see in the case study below, TV SYD has several times used this weekly half hour to screen fiction produced by themselves. This late night slot was in 1997 screened for 32 weeks.

Furthermore, from 1 September 1998 all regional TV-stations will increase their programming schedule with a 15 minute news bulletin on Saturdays, from 19:30 to 19:45, and from 1999 the plan is to be transmitting a morning slot in coordination with the already existing national morning programme with current affairs.

5.3.1. Regional co-operation accross frontiers

In addition to the above weekly programme schedule on TV2, many of the regional TV-stations produce and sell programmes to other TV-stations, most often programmes for national screening on TV2, but they also sell to TV-stations abroad. Furthermore, increased programme co-operation across borders is occurring. It is seen between TV SYD and NDR in Hamburg, Germany, between TV Bornholm and the Baltic countries, and most recently initiated between TV Lorry in Copenhagen and Sydnytt in Malmø, Sweden. From March 1998 Sydnytt (regional TV-station linked to Sverige Television) and TV Lorry will cooperate on their daily news bulletins, and also jointly produce a weekly 15-minute current affairs programme to be screened on Saturdays.

This co-operation, as the one between TV SYD and NDR in Hamburg, is financed partly by the EU Interreg II-programme. The two-year pilot project between TV Lorry and Sydnytt will cost 22 million Kroner (3.2 million ECU), 50 per cent financed by Interreg-II. Part of the funds will finance a satellite link, permitting the two regional stations to exchange features by satellite instead of on videos that have to cross Øresund (the strait between Denmark and Sweden).

The TV Lorry-Sydnytt cooperation should be seen in the perspective of an increased contact within the Øresunds-region, the bi-national urban region including Copenhagen in Denmark and Malmø in Sweden, (totalling 3 million people). A bridge is currently being built across Øresund to link Copenhagen with Malmø (ready in the year 2000), and an increased economic, political and cultural integration is underway between both sides of Øresund. In a couple of years Malmø and Copenhagen will be only a 20-25 minute drive away from each other, with a subsequent increase in mobility. In linguistic terms Danes and Swedes, at least in this region, understand each other. The TV Lorry - Sydnytt cooperation may very well help improve the contact and understanding between these populations.

In general, the regional stations are doing well. After several years on a steady programme schedule of 30 minutes per day, they have in 1997 increased their programme schedule significantly, obviously striking some cultural strings among the viewers making regional programmes a

success. Below, I take a closer look at programme formats and content in the case of TV SYD.

5.3.2. TV SYD

TV SYD covers three councils, Sønderjylland, Vejle and Esbjerg as well as the Northern part of Germany (South Slesvig) where the Danish minority of approximately 30,000 people live (this particular region of Northern Germany was Danish territory until 1920). Geographically TV SYD is the largest regional TV-station in Denmark.

Table 8. TV SYD's total transmission in 1996

Own production	167	hrs (of which 29 hrs were repeats)
Other production	21	hrs (of which 3 hrs were repeats)
Commercials	10	hrs
Job-TV	211	hrs
TOTAL	**409**	**hrs**

Source: TV SYD, Annual Report 1997.

As noted above, TV SYD, together with North German Broadcasting (NDR), which is the largest TV-station in Hamburg, Germany (about the size of the national Danish DR), produces a 10-12 minute programme every fortnight, a programme called *Here*. It is bilingual (German and Danish) covering issues of joint interest. In TV SYD it is transmitted from about 19:50-20:00, within the principal daily news bulletin. It is a combined news/feature programme (light news) and has been developed as an experiment within the Intereg-II of the European Union, thus with substantial financial support from the EU. *Here* was mentioned in very positive terms in EU's 10th General Directorate (DGX) as a good example of bi-national co-operation between regional television stations. DGX encouraged the European Union to screen it on their own satellite-TV-channel, EBS.

As something unusual for Danish regional TV-stations TV SYD has produced fiction and drama with significant success, and intends to continue doing this. Most recently (1996) TVSyd produced *Spillets Regles* ("The rules of the game") a TV series in 6 episodes, each of 30 minutes. It cost approximately 1 million ECU and was co-produced with TV2 and with the local production company Jens Ravn Production, based in the provincial town of Horsens. *Spillets Regles* was screened on the Monday late night slot with fine ratings. Subsequently, it was screened nationally on TV2 Denmark obtaining ratings around 10 (500,000 viewers). Finally it was exported to TV-stations in Norway, Sweden and Finland.

Spillets Regler was a story about young people in the Danish provincial town Horsens in the southern part of Denmark. The focus is on the everyday life of a group of football-players, however covering many issues

relevant for the Danish youth of today. In a Danish context it was new and different, producing fiction on a regional level, having the plot set within a region being one of the most remote, and basing the production on a local producer, and mostly with local non-professional actors. With the success of this programme the possibility of decentralised production of fiction in Denmark was demonstrated. Furthermore, it became a spearhead for TV SYD in their ambition to reach a younger audience than they usually do.

For TV SYD's director, Tim Johnson, it is important that TV SYD maintains a relation to the local and regional production environment as part of the strategy to the TV-station's regional rooting, relevance and profile. TV SYD therefore maintains a close and continuous contact with local production companies in Haderslev, Vejle, Esbjerg and Horsens.

Concerning competition within the region, Tim Johnson does feel some competition from the sole local TV-station in the area, TV Vejle, which is part of the TVd network. However, he also clearly feels that DR is competing (a little on unfair premises he indicates), transmitting game shows and popular consumer information programmes (medical information, garden tips, etc) as a competition to the regional news programmes. Nevertheless, TV SYD succeeds in maintaining high shares and ratings.

The 19:30 news bulletin

The backbone in TV SYD's (and all the other regional stations') programming schedule, is the 19:30-20:00 news bulletin, a programme achieving significant success. Among the continuing programmes on TV2 (news, series, sports, talk and quiz shows, etc) the regional new bulletins are the fifth most viewed programmes. What makes this a success?

The typical programme usually consists of 9-10 news features which usually include: 1-2 sports features relating to sports events of the region, one feature on regional weather, 2-3 features on national politics and their impact on or relation to the region (eg a local MP abusing national funds) and another 2-3 related to important cultural or political events in the region in general (the inauguration of a local airport, the premiere of a new theatre piece, etc). Generally, the features are from 7-8 different geographical spots within the region, mostly from the provincial towns of the region but also rural life is referred to.

These regional news bulletins are thus very different from the national news programmes. They focus on issues that in all terms are much closer to the particular viewer. They operate as a local/regional bard telling other stories and in other ways than the national story-tellers. The whole cultural universe in which they operate is different than that of national TV-channels: the features are often very creative, often humorous, and usually with a different narrative structure to that of the national news. The

narrative is less efficient, longer, often with a slower rhythm, less preoccupied with some official discourse and less controlled by time constraints. They are often very experience-oriented features. Furthermore they show issues of the proximate setting, they speak the dialect of the region and they provide local perspectives on national events. The aesthetics of the studio and of the anchor men and women are more relaxed and the interviews with local authorities are less formal. This creates a pleasant environment which finds high appeal especially among the older viewers.

5.3.3. Conclusion: Reasons to be satisfied

In programme terms, the regional TV-stations are demonstrating success, in quantity, as well as in diversity and quality. They have increased their programme schedule substantially in 1997 with a perspective of continuous increase in 1998 and 1999. They are producing programmes sold nationally and internationally, and are diversifying their programme supply with innovations such as regional fiction series, regional talk shows and, soon, regional morning slots.

Finally, several regional TV-stations are cooperating across borders, thereby strengthening the transnational dimension of regions and challenging the conceptual delimitation of region. Cross-border co-operation among regional TV-stations may prove interesting, strengthening the socio-economic development within transnational, culturally determined regions in Europe. It seems to be a dimension of the European integration process that is growing stronger.

The audience success of regional TV-stations, in particular with their daily new bulletins, can be explained by various factors: they represent a different cultural universe *vis-à-vis* the central-government-like cultural discourse of the national broadcasters. Regional television has other modes of address, and they are particularly oriented towards the individual viewer. Their perspective is clear, representing concerns of the individual citizen of the region. Their stories and people are easier to relate to, recognise and identify with.

6. Small-scale television and democracy

Denmark is a small country, culturally rather homogenous, although differences are seen in dialect and traditions. The mission of regional and local television is mainly of a democratic nature, more than specifically cultural: they play an important role in sustaining a community-based democracy in Denmark. On the one hand they promote participation in the life of local communities, and on the other hand they inform and entertain about relevant issues of concern for the citizen, whether these concerns are political, economic, social or cultural. Especially the regional TV-stations that are heavily subsidised by the state play this role.

The legacy of enlightenment and the strong tradition for community based democracy are the cultural and political matrices of small-scale television in Denmark. They are manifested in the concept of an extended public service broadcasting of which regional and local television can be seen as formally established constituents. Together with the national public service broadcasters they constitute important cultural agents in the Danish democracy. In legal terms these regional and local "pillars of democracy" have been secured.

The regional TV-stations as integral members of the TV2-family are heavily subsidised by the state. Considered along with their viewer success, their substantial local support and their institutional radiation among the community organisations of each their region – considering all these aspects together, the regional TV-stations are successful, in cultural, political and economic terms.

The inter-regional cooperation across borders, as seen between TV SYD and NDR in Germany, between TV Bornholm and their Baltic neighbours and most recently between TV Lorry and their Swedish neighbours, is an interesting advancement in the notion of region and in the development of regional activities. It shows that regional TV-broadcasting transcends geopolitical borderlines and rather follows culturally determined constituencies and rationales.

Local television, both the commercial and the non-commercial, is likewise formally integrated in the Danish media landscape. Non-commercial local TV has been secured financially, however with what could be seen as a problem of spreading the funds over too large a number of concessioneers and TV-stations. Where a more restricted policy would provide a better economy to each supported TV-station, the current policy secures an open and democratic breadth.

While non-commercial local TV is secured this breadth, local commercial TV has "gone national". By having been allowed to network, the local commercial stations have joined forces in Tvd which in practice works as a national network with local windows. One hour a day, in the margins of prime time, they have scheduled local programmes. Despite the networking in Tvd, large investments are required in order to develop under the current conditions prescribed in the law. National production and local production are expensive, although definitely popular. The question is whether Tvd will survive the competition, linked with conditions written into the law? Has the possibility of networking come too late? Is the current commercial investment large enough to secure the survival of these local commercial TV-stations? Finally, with the possibility of networking and with a predominantly non-local programme schedule, how local can these TV-stations claim to be?

The revision of the law in 1996/97 has kept the different agents under the same legal framework, letting public service and the legacy of enlightenment permeate the legislation. Increased competition in recent years could be an argument for a more liberal legislation, giving the local commercial TV-stations less obligations and thus a sharper commercial profile. But then again, nationalism, democratic political principles and the legacy of enlightenment constitute significant characteristics of the legislation, only gradually giving way to increased commercialisation. For example, the permission to network in Tvd was only granted to the local commercial TV-stations due to their own efficient lobbying prior to the finalising of the political decision-making process.

The transition process of the Danish media landscape has far from come to an end. The adaptation to deregulation, internationalisation and commercialisation will continue for a long time yet. Some guidelines and political priorities were established with the 1996 legislation, including several steps to secure an extended public service on the "proximate level", both with the continuous support to the regional TV-stations and with support structures for local television. Especially the support for non-commercial local television is a culture political signal, recognising their cultural significance within a Danish media landscape. Together with the regional TV-stations, non-commercial local television delivers a programme supply which otherwise would not appear, neither on a market driven commercial programme schedule, nor on a national public service programme schedule.

Technologically speaking, funds have been earmarked to initiate digitalisation of the national and regional broadcasters, and allowing local stations to experiment with tele-entreprise. Some questions are still unsolved as to the future structure and ownership of TV2 and likewise with a vacant national radio channel.

What this case study of small-scale television in Denmark tells us, is a story about the Danish democracy in action. This political system is in constant dialogue with civil society on all levels, an often lengthy, dialogical political process resulting in democratic but often very pragmatic decisions. This has been the case with local and regional television in Denmark. The political process is not yet finished, however it has so-far proved its success as a culturally relevant and articulate agent, gaining both popular support and legal rights to secure its future existence.

Bibliography and references

Berlingske Tidende (14-05-97): "Mindre Glamour - mere dansk TV + Amerikanske serier - ikke et folkekrav". Copenhagen: Det Berlingske Hus.

Berlingske Tidende (14-08-97): "TvDanmark mere dansk". Copenhagen: Det Berlingske Hus.

Berlingske Tidende (8-04-97): "Dansk lokal-tv går Anders And". Copenhagen: Det Berlingske Hus.

Bondebjerg, Ib & Francesco Bono (eds) (1996): *Television in Scandinavia*. London: John Libbey.

Carlsson, Ulla & Eva Harrie (eds): *Media Trends 1997 in Denmark, Finland, Iceland, Norway and Sweden*. Göteborg: Nordicom, Göteborg University.

Degn, D. M. y K. T. Larsen (1997): *Statiskik- om de etniske minoriteter i Danmark*. Copenhagen: Mellemfolkeligt Samvirke.

Folketinget (1996): *Lovforslag no. L 84. Lov om ændring af lov om radio- og fjernsynsvirksomhed*. Copenhagen: Folkentinget.

Gallup (1997): *Årsrapport for 1996: TV-meter undersøgelsen i Danmark*. Copenhagen: Gallup.

Hartvig Nielsen, S. (1997): *Radio- tvhåndbogen*, n. 23, March 1997. Randers: Hartvig Media APS.

Hjardvard, S. & H. Søndergaard (1988): *Naersyn paa Fjernsyn- Kanal 2 og Weekend-TV*. Copenhagen: C.A. Reitzels Forlag A/S.

Hunterr, B. (1996): "Denmark", in *The Stateman's Year-Book 1996-1997*. London: MacMillan.

Jauert, P & O. Prehn (1997a): "Danish Mass Media. Recent Developments", in Carlsson, U. & E. Harrie (eds.): *Media Trends 1997* . Göteborg: Nordicom, Göteborg University.

Jauert, P & O. Prehn (1997b). "Ny Lov - Nye Perspektiver? Lokalradio og lokal-tv i Danmark". Paper presented at the "13th Nordic Conference for Mass Communication Research", Jyväskyla, Finland, 9 to 12 august 1997.

Jauert, P. & O. Prehn (1995): *Lokalradio og lokal-tv - nu og i fremtiden*. Copenhagen: Kulturministeriet.

Kulturministeriet (1996): *Betænkning fra Kulturministeriets lokal-tv-udvalg*. Copenhagen: Kulturministeriet.

Kulturministeriet (1997): *Bekendtgørelse nr. 658 af 18 august 1997: Bekendtgørelse om vedtægt for TV2*. Copenhagen: Kulturministeriet.

Kulturministeriet (1997): *Brev af 23.6.97 til de lokale nævn vedr. fordeling af 1.pulje*. Copenhagen: Udvalget vedr. Lokal Radio og TV.

Kulturministeriet (1997): *Lovbekendtgørelse nr. 75 af 29. januar 1997: Bekendtgørelse af lov om radio- og fjernsynsvirksomhed*. Copehagen: Kulturministeriet.

Kulturministeriet (1997): *Redegorelse til de lokale nævn om udvalgets forste fordeling af tilskud fra puljerne. 23. juni 1997*. Copenhagen: Kulturministeriet.

Kulturministeriet (1997): *Retningslinier for fordeling af tilskud til ikke-kommercielle lokale radio- og TV-stationer; Retningslinier for pulje til lokale TV-stationers forsøg med televirksomhed; Retningslinier for pulje til forsøg med medieskoler*. Copenhagen: Kulturministeriet.

"Made in Fagbevaegelsen" and "I Iommen på Disney", in *Politiken*, 14-05-97. Copenhagen.

Medieudvalget (1995): "Betænkning om de elektroniske medier", in *Betænkning Nr. 1300 + Annexes* . Copenhagen: Stasministeriet.

Medieudvalget (1996): *Betænkning om medierne i demokratiet.*. Copenhagen: Statsministeriet.

Ministry of Economical Affairs: *Statistisk Årbog* (1997). Copenhagen: Statens Information.

Petersson, O. (1994): *The Government and Politics of the Nordic Countries*. Stockholm.

Poulsen, J. (1995): "Denmark: From community radio to regional television", in Moragas Spà, M. & C. Garitaonandía (eds.) (1995): *Decentralization in the Global Era*. London: John Libbey.

Poulsen, J. (1996): *At læse avis*. Roskilde: RUC, Kommunikations-uddannelsen.

Sondergaard, Henrik (1994): *DR i TV-konkurrencens tidsalder*. Copenhagen: Samfundslitteratur.

Sondergaard, Henrik (1995): "Public Service i Dansk Fjernsyn - begreber, status og scenarier. Rapport til Statsministeriets Medieudvalg". Copenhagen: Statens Information.

Sondergaard, Henrik (1996): "Fundamentals in the History of Danish Television", in Bondebjerg, Ib & F. Bono (eds.): *Television in Scandinavia*. London: John Libbey.

TV SYD (1997): *Annual Report 1996*. TV SYD

TV2 (1997): *Annual Report 1996*. Copenhaguen: TV2.

TV2 nyt (June 1997).

TV2nyt Special (June 1997): "The 5th Model".

"TvDanmark risikerer lukning", in *Politiken*, 14-05-97. Copenhagen.

Web sites

CIRCOM (16 September 1997): http://www.circom-regio.si/indexstates.html

Danmarks Radio (December 1997): http://www.dr.dk

Video-recordings

Full weekly programmes from TV SYD (6-12 January 1997), TV2 MidtVest (9-15 March 1997) and TV Lorry (9-15 March 1997).

Interviews by Thomas Tufte

Interview with Anders Krarup, Chief of Information, TV2 Denmark, 18-9-1997.

Interview with Tim Johnson, Director of TV SYD, 19-9-1997.

Interview with Lars Birk, XTV, 17-12-1997

Interview with FAEM-Repr. Alexander Krone, 17-12-1997

Interview with KTV-Repr Asger Eduardsen, 17-12-1997

Notes

1 The entire Kingdom of Denmark is huge given that it includes the two selv-governing territories in the North Atlantic Sea: Greenland (2.2 mio square kms/the second largest island in the world/55.000 inhabitants) and the Faroe Islands (17 small islands in the North Sea/ 47.000 inhabitants). However, when not mentioned, the following article excludes these territories and deals in particular with "South Denmark", the territory normally known of as Denmark.

2 In March 1997 there existed 18 registered commercial companies (Hartvig, March 1997). In October 1997 there were 41 non commercial companies registered at the Ministry of Culture, as receivers of a public subsidy.

3 In 1997 each regional tv-station received 36,1 million Kroner from TV2; in 1996 35,4 million Kroner and in 1995 34,7. TV2/Bornholm, being remarkably smaller than the others received a smaller amount in fixed annual support.

4 This was the position for example of Alexander Krone, the coordinator of FAEM, the network of local radio and tv-stations linked to workers movement.

5 The Danish labour movement embarked in the late 1980s in a huge local media
 adventure, wanting to set up their own local radio and television stations many places in
 the country. At least 90 million Danish Kroner was between 1987 and 1990 invested in the
 attempt to set up and run the stations. The attempt failed, it was extremely costly and
 had very limited audience.five of the tv-stations originating from this experiment
 however survived and are today members of the Tvd network.

Finland: Cultural challenges in the digital era

Tapio Varis

1. The State's regional dimensions

Finland has slightly over five million inhabitants even though its territory takes up the considerable area of 338,145 square kilometres. This low population rate explains how Finland has developed a decentralized broadcasting system which covers the country in Finnish, Swedish and Lappish. These are the languages spoken by the different communities that live together in the twelve provinces that administratively divide Finland (see table 1).

Finland has a small Swedish-speaking minority (of approximately 300,000 people) which is widely dispersed along the coastline of the Baltic Sea. Approximately half of them live in the Province of Uusimaa, which lies on the southern coast, and the other half are scattered along the western and south-western coasts, in the Province of Vaas. Swedish is also spoken in the Aland Islands which have a statute of autonomy in the State of Finland.

Although about 93 per cent of the population speak Finnish and only 6 per cent Swedish, the country is officially bilingual (Finnish and Swedish). In addition, the Lapps speak their language in the North of the country and there are also a few Russian speakers (see table 2).

The Swedish language minority, scattered in a country of Finland's dimensions, causes a considerable problem for the country's media system that has to be tackled by the public broadcasting service, as from the

commercial point of view it would be very expensive and unprofitable. Swedish-speakers' rights are guaranteed by the Constitution and in their fight for cultural survival, this minority in Finland has traditionally used and relied very much upon the radio. The research carried out concerning the matter suggests that programming in Swedish helps to reinforce the cultural identity of this linguistic minority (Moring, 1997).

Table 1. Finland's Provinces: Surface and Population

Province	Area sq km	Population	Inhabitants /sq km
Uusimaa	10,404	1,343,039	136
Turku	20,719	703,146	35
Häme	22,248	732,883	38
Kymi	12,824	330,571	31
Mikkeli	21,633	204,194	13
Pohjois-Karjala	21,585	176220	10
Kuopio	19,954	257,742	16
Keski-Suomi	19,388	259,096	16
Vaasa	27,319	446,708	17
Oulu	61,572	452,885	8
Lapland	98,946	200,579	2
Aland Islands	1,552	25,257	17
Total	338,145	5,132,320	17

Sources: *Statistics Finland*, 25/11/1997

Table 2. The Languages Spoken in Finland (1996)

Language	%	Number
Finnish	92.86	4,765,434
Swedish	5.73	294,233
Lappish	0.03	1,712
Russian	0.35	17,861
Other	1.03	53,080

Source: *Statistics Finland*, 25/11/1997

The region occupied by the Lapps includes areas from North Finland, Norway, Sweden and Russia. The majority of Lappish people live in Norway (35,000) and in Sweden (18,0000), while about 5,000 live in Finland and 2,000 in Russia. Later on, we will talk about a radio service that broadcasts from Finland, Norway and Sweden to reach this entire territory.

The area where the Lapps live in Finland has retreated progressively, leaving only the region of Karelia to this settlement. The Lapps' language (of Finno-Ugric origins) and their own cultural traditions have helped to ensure the future of this culture as well as the close links among the Lapps, even as citizens of different States. The most important dialect is North Lappish. It's also known as "Mountain Lappish" and it's the vernacular tongue of about 70 per cent to 80 per cent of the current Lappish-speaking population, many of which are also bilingual or multilingual (Aikio, 1994).

2. Finland's television structure

The current broadcasting system in Finland, based on the Yleisradio Oy Act of January 1994 and reformed in 1997 by the Ministry of Transport and Communications, modified the 1927's Radio Equipment Act and the Cable Transmission Act of 1988. For the moment, television's over-the-air broadcasting licences are granted without restraint on the basis of 1927's Act. On the other hand, those licences related to cable broadcasting are subjected to certain limits and granted following the Cable Transmission Act. The Finnish Broadcasting Company (YLE) is regulated by the Yleisradio Oy Act. Meanwhile, the Ministry is seeking to adapt and coordinate the existent regulation on media with the aim to implement the European Union's television regulations in the Finnish legislation.

Finland's media structure is quite similar to its organisation in other countries in West Europe, specially to the rest of Scandinavia. The main operator is the state-owned broadcasting company YLE, financed by the licence fee and under the Parliament's control, but there are also other private television and radio companies. Finland has the following television channels:

- YLE: TV1, TV2, FST (Swedish-language)
- MTV Finland (MTV3)
- Oy Ruutunelonen Ab (Channel 4 or "Nelonen")

The Swedish channel TV4 reaches 32 per cent of the Finnish population. The viewing of programs broadcasted from Sweden is scarce among the Finnish, although quite considerable in some parts of the western coast of the country, in Ostrobotnia and specially in the Aland Islands. All the public and private Swedish channels can be received in these areas due to spillover but also thanks to some special agreements to rebroadcast them (Moring, 1998).

Televiewing in Finland is increasing. In 1996, the Finnish spent more time exposed to television than to any other type of media: a study carried out by AS to a national extent showed that they spend a daily average of 163 minutes watching television, 155 minutes listening to the radio and 79 minutes reading the press. However, in 1997 the daily average of Finnish televiewing was of two hours and 41 minutes, nearly half an hour less than France and Germany and an hour less than the United Kingdom.

Table 3. Finnish Television Market Share (1997)

MTV3	44%
YLE TV1	26%
YLE TV2	21%
YLE FST	2%
Other*	7%

* Satellite, cable, TV4, spillover viewing.

2.1. The Public Service Television Broadcasting: YLE

The Finnish Broadcasting Company (YLE) is a public limited company which owns the transmission networks. The Administrative Council, controlled by the Finnish Parliament, disposes of the directorship and takes all the vital decisions.

YLE offers the country's viewers news and current affairs as well as a wide range of documentaries, sports and entertainment programming and educational, cultural and children's programmes. YLE channels' programming offer is the following:

 • YLE TV1 is a national full service channel broadcasting from Helsinki. Its programming is based on news, current affairs, culture and entertainment. In-house productions make up 54 per cent of weekly programming (88 hours), while European productions add up to 80 per cent.

 • YLE TV2 broadcasts from Tampere. It's also a national full service channel, although its aim is to reach the family audience offering regional productions as an important part of its programming. In-house productions are 50 per cent and European productions sum up to 77 per cent of the week's programmes (68 hours). Tampere is one of YLE's base locations because it's the city where Finnish television started out, but also because of the wish to decentralize television activities. There are many local studios scattered around the country, although Helsinki and Tampere are YLE's only official broadcasting headquarters.

 • YLE FST is the Swedish-speaking television. YLE FST broadcasts by YLE's transmitters and produces TV1 and TV2's Swedish programmes (some 930 hour per year, including daily news; see Moring, 1998). FST offers 17 hours of weekly in-house productions, mainly programming for children and youngsters, news and current affairs.

Because of the regional legislation to which the Swedish-speaking Aland Islands are submitted to, their own YLE delegation and broadcasting station there, have been transferred, together with the staff, to the isle's new public broadcasting company.

The philosophy of the public corporation remains in the hands of the Yleisradio Oy Act, which fixes the company's assignment: the delivery of complete broadcasting services to all citizens in condition of equal rights. State-owned broadcasting is understood as a public service which guarantees Finns the possibility to inform, educate and entertain themselves as they enjoy new experiences. It's conceived as a programming organism and not as the mere conjunction of independent programmes put together by chance.

YLE's broadcasting network arrives to Finland's entire territory and offers the population a wide variety of programmes. Finnish commercial television companies pay YLE a fee for hiring the channels and using their broadcasting frequencies. The commercial company MTV3's broadcasts cover the same geographical area as YLE, while the new television operator, Oy Ruutunelonen Ab (Channel 4), only covers 70 per cent of the territory.

Finnish culture stands out for its notable presence in television productions. Every year, YLE exhibits practically all Finland's independent producer's feature films and nearly all their shorts and documentaries.

2.1.1. The debate on public television's safeguard as a result of the recent technological developments

The Ministry of Transport and Communications recently asked about 70 companies and organisations their general opinion on the future of television. Among the most important issues were the appliance of Television without Frontiers and the regulation by means of laws on a public service fee and an operating licence fee. YLE points out the need for general regulation on broadcasting, including the respect for public service's basic principles. The company considers that the licence fee will be its future financial basis and finds viable applying an operating licence fee to commercial televisions that would also favour public broadcasting.

As for Finland's broadcasting legislation, a number of reforms were introduced in 1996 concerning the public television service. The first step was the presentation of a provisional report prepared by a committee appointed by the Ministry of Justice to draft a proposal on new legislation related to freedom of expression. In February 1997, the Commission on Freedom of Expression issued its final report which proposed that regulation on freedom of speech in mass communication should be incorporated in a single act and applied to all national broadcasting channels, regardless of the technology employed. The Finnish Government issued its proposal for a new Telecommunications Market Act that defined the line of demarcation between public service broadcasting and telecommunications.

A report assigned by the Ministry of Transport and Communications in 1995 observed that digitalization allows a more efficient use of the frequency band, enabling the multiplication of television channels. It can also improve technical quality and it opens doors to new types of services. The report proposed that Finnish Government could start out by deciding on the digitalization of the country's radio and television networks, although by no means would it involve the investment of state funds. According to the report, the digitalized networks would be set-up by the Finnish Broadcasting Company, in collaboration with the commercial operators.

The report made reference to the mass media's current situation as a period of transition. The following stage will be the digital and network eras. There'll be a great number of channels available. The national media strategy includes two main points. On one hand, the future of Yleisradio Oy is guaranteed, as long as it fulfills its legal task as a public service. On the other, more operating licences for commercial radio and television will be granted.

The Finnish Broadcasting Company is getting ready for the set up of at least two digital television networks. The existing TV1 and TV2 channels will broadcast both in the analogue and digital format and additional services will be offered. YLE also intends to create new programming services specialized in news, sports, current affairs, culture, education and in the Swedish language. Radio channels, teletext and Internet services will form part of the television signal as well.

The Finnish Government decided in 1996 that the digitalization of terrestrial distribution networks would be brought to term and new analogue operating licences were granted to the country's second commercial television, Oy Ruutunelonen Ab (Channel 4), and to the first private national radio. Later on, Finland and Russia signed an agreement on digital radio broadcasting frequencies. The Ministry of Transport and Communications linked digitalization matters to the decisions that should be taken concerning the new television and radio channels, and the country's new private operators felt obliged to collaborate in the set up of the digital networks.

The switch to digital broadcasting will enable a more efficient use of frequencies. It will also increase competition in both national and regional media. The advent of new operators will allow the press to expand its business area to both radio and television, which will also strengthen the competition between the big multimedia groups (YLE, 1997).

2.2. The private channels: MTV3 and Oy Ruutunelonen Ab (Channel 4 or Nelonen)

Finland's first commercial television channel, MTV Finland, was founded in 1957 and named Oy Mainos-TV-Reklam Ab. It first broadcasted that

same year, coinciding with the beginnings of YLE's first channel, which makes it the third oldest commercial television company in Europe. In 1982, the company changed its name to MTV Oy. Since 1993, it broadcasts its own channel, MTV3, from Helsinki to the whole country, following quite commercial programming tendencies. MTV3's share of total viewing time in Finland has always exceeded 40 per cent. In 1996, Finnish productions composed 58 per cent of all of MTV's programming.

Immersed in the generalized process of integrating media communications, in 1997 MTV3 joined Finland's second press publishing company (Aamulehti group) and became one of the largest and most widely diversified communication companies in North Europe. Its main activities are publishing, radio and television broadcasting and printing. The new company also plays a pioneering role in the development of Finland's new media. Taking on base 1996's yearly accounts, the company will soon surpass net sales of 2,600 million FIM (Finnish Marcs) and will count on a staff of 3,800 employees. The Swedish company Marieberg and other Finnish insurance companies are amongst its greatest investors.

MTV's major operating cost factors are the network's leasing charges and the production and purchase of programmes. Over the last years, MTV has paid the Finnish Broadcasting Company the yearly average sum of almost 30 per cent of its net sales (Alma Media Oyj, 6/6-/997) in terms of the broadcasting network's leasing. As a result of the claim put in by MTV in November 1996, The Office of Free Competition considered that this broadcasting charge obstacled free competition and proposed the Ministry of Transport and Communications to undertake the fee's abolishment.

It appears likely that these leasing fees will decrease as there'll be more operators to share basic investment costs with. However, the growing competition will raise the purchase cost of both international programmes and the broadcasting rights for sporting events and independent productions.

In 1996, the MTV3 group's advertising turnover was of 975 million Finnish Marcs (939 million in 995). MTV3's network is divided into 11 regions, all of which can include their own regional commercials. Advertising revenues continued to grow during 1997.

According to the preliminary data for the first quarter of 1997, Finland's advertising revenue declined in the daily press (-5 per cent) and in local radio (-6 per cent), but rose in the magazines (+23 per cent) and in television (+12 per cent). However, the correspondant figures on television must be analysed considering that the beginning of 1996 had been particularly weak for television advertisement. Television advertising composes about 21 per cent of the total contracted by Finnish media, less than Continental Europe's average of 30 per cent.

In June 1997 Finland's second commercial channel, Nelonen (Channel 4), began to broadcast. This channel, which has the intention of covering the

whole country (it currently reaches 70 per cent of the population), belongs to Oy Ruutunelonen Ab, which is owned by the Helsinki Media Company (42.5 per cent), its affiliated company PTV (7.5 per cent), the Danish company Egmont (20 per cent), VBH Television Oy (16 per cent, independent producers) and TS Group (14 per cent, press publishing). According to its operating licence, Oy Ruutunelonen Ab should pay the Finnish Broadcasting Company a public service fee of 0 per cent in 1997's net sales, of 10 per cent in 1998 and of 20 per cent in 1999. From the year 2000 onwards it will have to pay the same quantity as the other operators in the sector.

3. Finland's television programming

3.1. YLE television programming

In 1996, the Finnish Broadcasting Company's (YLE) channels, TV1 and TV2, respectively broadcasted 4,590 hours and 3,518 hours of programming, which meant an increase of 343 hours with regard to the year before. FST's programming in Swedish reached 874 hours (29 hours less than the year before). TV1 has stood out as a news and current affairs channel that also offers a wide dose of culture and entertainment (see table 4). On the other hand, TV2 is rather like a family audience channel with programmes that also reflect views and events outside the capital city.

In 1996, YLE broadcasted 52 per cent of in-house programming from the total programme output, 5 per cent from other northern countries, 19 per cent of European origin, 17 per cent from the United States and 7 per cent from other countries. The country's independent productions represented 13 per cent of the total, while European productions added up to 78 per cent.

YLE's top television programmes in 1996 were the evening's news and weather (20:30), with an average of 43 per cent of the audience, followed by the Independence Day Reception (42 per cent) and the World Ice Hockey Championships (41 per cent).

3.2. MTV3's television programming

MTV3 has maintained its position as Finland's most popular channel, with an average share of about 42 per cent, which makes it one of Europe's most viewed television channels. Up until today, it offers nearly 20 hours of daily programming.

MTV3's programming is the same for the whole country, although the advertisements can be regional. The Finnish have a clear image of MTV3: its an entertaining channel, youthful and versatile. Its standardized programme schedule has been one of the main factors of its success, which was steadily developed in association with other international companies.

The increase of the public's interest was achieved during the weekdays' evening hours (19:30) with in-house comedy series and replays of current affairs programmes started to be broadcasted on weekday mornings.

Table 4. YLE's Television Programming in 1996 (both channels)

Genres	%
News	8
Current affairs	9
Factual	21
Education	5
Children	7
Drama/classical music	3
Fiction series	14
Films	12
Entertainment/light music	8
Sports	12
Other	1
Total	100 (8.108 h.)

Source: YLE, 1997; http//www.yle.fi/fbc

In 1996, Finnish productions made up 58 per cent of all MTV's programming. Independent European producers supplied 20.5 per cent of the programming. Nearly 10 per cent of all MTV's programmes in 1996 were repeats and 0.6 per cent of them were offered with Swedish subtitles. MTV3's top programme in 1996 was *Miss Finland 1996*, with 1,677,000 viewers, which means 38 per cent of the total audience. In addition, MTV also offers teletext services and an information web in Internet (www.mtv3.fi).

4. The media in the lappish region: Sami Radio as the population's own voice

Modern means of communication took considerable time to develop in the Lappish region. The first attempt at creating a newspaper in Lappish was in 1873, but monthly press didn't start up in Sweden and Finland until after the First World War.

The first radio broadcasts in Lappish took place in Norway in 1946. At the present moment there are daily radio broadcasts in Lappish in northern Sweden, Norway and Finland, which basically give the news and current affairs programmes, although one can also find Lappish music, interviews, coverage of local events... On the other hand, there is still very few

television broadcasting in Lappish. Over the last years there have been monthly half-hour programmes in Lappish, and at the moment there are plans in Norway and Finland to launch a new television channel in this language.

Table 5. MTV3's Television Programming in 1996

Genres	Minutes	%
Drama and films	87,993	32.7
Documentaries and current affairs	63,637	23.6
Entertainment	55,043	20.4
Sports	26,885	10.0
News	14,901	5.5
Music	4,672	1.7
Children	12,340	4.6
Religious	226	0.1
Education	3,475	1.3
Continuity	30	0.0

Source: MTV group's *Annual Report, 1996*

In Finland, the first radio programme in Lappish was broadcasted in 1947 from Oulu, in medium-wave. It was a weekly 10 minute news bulletin adapted from the press. The Finnish radio broadcasting headquarters moved to Inari at the beginning of the 1970's. Towards the end of the 1960's the programme *Messages in Lappish (Sami Saga-tark)*, edited by Rovaniemi, was launched: that was the beginning of the authentic communication in Lappish as it regularly included music, interviews and current affairs. In 1977, the new broadcasting facilities in Inari were assigned. At that time, Sami Radio was part of the Finnish Radio Lapland, under Rovaniemi's financial supervision (Juhani Nousuniemi, 1997).

In the mid-1980's the Finnish Broadcasting Company was reorganized, by which Sami Radio separated itself from the main company in 1985. This can be interpreted as a step towards cultural autonomy. From then onwards, decisions on the budget as well as on the production of programmes would take place in Inari.

Also, in the mid-1980's the Ministry of Transport and Communications appointed a commission assigned to study the future of Finnish radio. A radio service in Finnish was set up in answer to the commission's request. It was planned that it would receive public funding similar to that of Swedish television broadcasts, but this support didn't came. The Finnish Broadcasting Company has contributed on its behalf to help pay the radio school's set up and the construction of the building.

There are three Sami Radio stations, which cooperate at all levels. Their programmes are broadcasted in three different dialects: Northern Lappish, Inari Lappish and Koltta Lappish although the majority of programmes are in the most common of these, Northern Lappish.

As well as becoming an independent broadcasting unit, Sami Radio also acquired its own network, built by the Finnish Broadcasting Company (12 transmitters), that covers the areas of Inari, Utsjoki, Enontekiö and Sodankylä/Vuotso in Finland, Karesuando and Kiruna, in Sweden, and Tana and Karasjok, in Norway.

The digital communication technologies are opening new possibilities for Sami Radio, as one of Finland's six forthcoming digital radio channels, which will be received all over the country is planned to be in the Lappish language.

In relation with other neighbouring countries, there are also plans to set up a digital Finnish radio station to broadcast throughout Scandinavia (although whether to include or not the Russian area of Murmansk is still a question mark).

In 1991, programming in Lappish was entirely reformed. With the aim to be aware of the audience's reaction towards these changes, the YLE's research department carried out a survey in April 1992 which revealed, among other things, that Norwegian and Swedish listeners widely follow Sami Radio's programmes from Finland. In the Lappish region, among the over-15 year old Lappish population, Sami Radio has an average daily audience of 58 per cent, about 3,500 listeners. 43 per cent of this audience lives in Finland, and the rest in Sweden and Norway (Ruohomaa, 1992).

Radio listening among the Lapps follows similar patterns to Finland's general audience habits: a considerably important number of people listen to radio (different channels) regularly or on a daily basis (Ruohomaa, 1992).

Regarding the press, written media in Lappish doesn't really exist. In Karasjok (Norway) a weekly newspaper is printed on Fridays, but it doesn't get to Inari until the following Tuesday. Reading and writing in Lappish is a rather recent practise, which gives radio an essential, central role among the Lappish media.

According to Nousuniemi, the Lapps see radio as a useful instrument for the community's development, although television would certainly allow their messages and points of view to reach a great part of the population. Nevertheless, the Lappish community is far too small to sustain television. Only in Norway is television in Lappish more advanced, where there are two production teams already working.

In Karasjok (Norway) there are both radio and television broadcasts in Lappish. According to the editing manager Piera Balto and Magne Ove Varsi, who teaches journalism at Kautokeino's Lappish College, television is important for a number of reasons. In many ways, its a stronger media

than radio, and it reaches more efficiently those who aren't yet very fluent in Lappish. Children's programmes have received a considerable amount of resources, in an aim to strengthen the cultural identity of the future generations (interview 18 July 1995).

For Nousuniemi, "new technology is more a possibility than a danger. The more programmes existing in Lappish, the better. In the information society, the Lappish must use the same means as other communities, with even more efficiency".

The Norwegians have recently published the report *Sami Radio mot ar 2000*, which ponders on the future of Lappish radio and television. Their main target would be to create a Lappish radio and television network, broadcasting throughout Scandinavia.

5. Analysis of new problems and future prospects

Throughout this century, the Finnish Government's attitude towards new technology has been of support and promotion in a country where telecommunications have developed and advanced at an extraordinary rate. Finland is the country which has the highest number of Internet servers per thousand inhabitants in the world: approximately 64 servers per 1,000 inhabitants, while Iceland has 44, Norway 41 and the United States "only" 35 (*New York Times*, 20 January 1997). The Finnish also have the highest number of mobile telephones *per capita* in the world: at the moment, 1.7 million mobile telephones, one for every three Finns, of which the majority are from 18 to 25 years old (*Helsingin Sanomat*, 4 July 1997).

On the other hand, the Finnish broadcast of ABC News (15 May 1997) informed that Finland is the most "connected" nation in the world (at the moment, nearly 76 per cent of Finnish schools are connected to Internet), because a great part of the country's five million inhabitants have access to the Web and mobile telephones are almost as common as the snow there:

> While the rest of the world asks itself how to install a modem to enter Internet, Finland has already been connected for some time. It has twice as many connections as the States; practically all the schools in Finland's capital city, Helsinki, have access to Internet and the rest of schools are estimated to be connected before the year 2000.

In Finland, telecommunications in general have been regulated in a series of stages: in 1997 a new act on telecommunication's market entirely replaced the previous legislation. Now, the lay out for cable television's digitalization is being prepared, impelled mainly by the Finnish broadcasting service, MTV Finland, Helsinki Media Company and Nokia MNT Oy.

In addition to the four national channels (YLE 1 and 2, MTV3 and Oy Ruutunelonen Ab) other experiences are carried out at a smaller scale, although they're turning out to be quite significative, like the local

televisions in Narpio (Swedish-speaking community) and Tornio (a border Finnish town) as well as Radio Robin Hood in Turku for immigrants (www.atlasnet.fi / yritys / robinhood).

Another interesting initiative is the existing cooperation between several Finno-Ugric[1] broadcasting organizations, gathered in Lohusalu (Estonia) in 1994, that have started to carry out joint television projects with the aim to preserve and promote the culture of the Finno-Ugric nations. They're working at present to set up an information network between the different Finno-Ugric television organisations in order to improve future cooperation and exchange news and programmes (Co-operation Agreement 1994).

Other important objectives are also the support to the regular international film and television festivals and the creation of the necessary conditions for the organisation of a film and video market. On the other hand, it's also necessary to promote the professional's theoretical and practical preparation in those television organisations which have the possibility to undertake these tasks, especially to train in the regions that don't have access to educational television programmes.

These efforts are an example of the historical importance and complexity of the initiatives that are being carried out to impulse small-scale television in Northern and Eastern Europe, where there is a large number of ethnic groups and communities that don't count on such services yet. Finland has an obvious position of advantage, as far as the European media panorama is concerned, because it's the leader of the latest technology set up, without forgetting its constant effort to guarantee cultural diversity in future television services.

5.1. The Future of YLE and MTV

It is estimated that there will be about 3,500 satellite channels operating in Europe by the year 2002. However, the choosing possibility will be focused on the main language areas, which are the English, German and French regions. At the beginning of 1998 there were hopes that the Northern countries would be able to receive up to 1,200 channels of digital television. Nevertheless, Finland, as a country with a minority language, won't count on a great deal of satellite channels in Finnish.

Television's digitalization has brought about in Finland the construction of new terrestial broadcasting networks. The immediate objective is to start up two national digital television networks and two other similar networks for radio broadcasting. The switch to digital broadcasting will also mean further investment for the households that will want these services, because the existing analogue radio and television sets are unable to receive digital signals. The first digital television receivers were out on market in 1998.

As to the future of YLE, the preparations in relation to digital television are under way and the first trial broadcasts took place during 1998.

At the moment YLE's structure is being reconsidered and the initial reforms are in progress. Measures are being taken, concerning the establishment of an independent subsidiary company for dealing with all digital distribution matters, and a company to run the existing distribution network.

YLE's main uncertainty are the earnings generated by its network leasing and the public service licence fee, in a moment of increasing competition. Arrangements are being made in case of eventual financial falls a light increase in public service licence fees was proposed at the end of 1998 – YLE states that more operative efficiency is needed, and it aims to achieve it through structural change and by investing in personal training and information technology.

The commercial channel MTV3 also considers that radio and television's digitalization will be the centre of future development in communication. Digitalization is indeed progressing at a rapid rate as far as satellite television broadcasting is concerned. New terrestrial digital broadcasting networks will start to be built between 1998 and 2007. The aim of the MTV group is to guarantee the digital broadcast of its channel MTV3, and obtain the means to carry out a digital expansion in the future.

Bibliography and References

Aikio, Samuli, Ulla Aikio-Puoskari and Johannes Helander (1994): *The Sami Culture in Finland*. Helsinki.

Cooperation Agreement of TV Organisations of Finno-Ugric Countries and Regions. Lohusalu, Estonia, 20 October 1994.

Alma Media Oyj: *Listing Particulars*. Merger Prospectus, 6-6-1997.

Moring, Tom and Jussi Salmi (1997): *Public Service Radio Programming for a Minority Language Audience in a Competitive Market: The Case of the Swedish-Speaking Minority in Finland*. Paper for the XIII Nordic Conference for Mass Communication Research, Jyväskylä 9 to 12 August 1997.

MTV Group (1997): *Annual Report 1996*.

Nousuniemi, Juhani, Head of Regional Service in Inari, Interview 17-7- 1994, and 15-9-1997.

Publications of the Ministry of Transport and Communications (1995): *Yleisradiotoiminnan strategiaselvitys*, n. 45/1995. Helsinki.

Ruohomaa, Erja (1992): *Sami Radio: Audiences in Finland, Sweden and Norway*. Research Report 3/1992. The Finnish Broadcasting Company, Department of Research and Development..

"Samisk radioekspansjon - men når kommer de andre mediene?", in *Nordisk Medie Nyt*, 3/1992 (September).

YLE's Web site (1997): www.yle.fi/fbc

Wiio, Juhani, YLE's Head of Corporate Development (1995): *Flow of Intercultural*

Information via Electronic Media in Scandinavia. Paper presented at the Conference on Intercultural Communication: The last 25 years and the Next. Rochester Institute of Technology, New York, July 13-15,1995. Also interview 15 September 1997.

YLE 1997, Oy Yleisradio Ab. Helsinki.

Yleisradio, Media Development Group/M. Österlund-Karinkanta, June 1997.

Translation: Rhoda Justel

Note

1 Finland, Estonia and Hungary as independent States and the following Russian regions: the Republic of Udmurtia, Republic of Mordovia, Yugoria, Republic of Komi, Republic of Mari, Tjumen and Republic of Karelia.

France: The national players take the local arena

Sylvie Bardou-Boisnier, Isabelle Pailliart

1. Regional dimension of the State

1.1. General political framework and the role of the regions

France has a long history of being a centralised nation. Until the Decentralisation Act was passed in 1982, there were only local institutions which were essentially administrative management units. However, from the 1960s onwards, local and regional movements claiming identities and more modern management of local spaces began to arise. Throughout the 1970s, at the same time as local powers were demanding more autonomy, the State attempted to bring itself up to date by delegating some powers in order to concentrate on functions that were really considered to be the most essential. In this sense, the Decentralisation Act of 1982 responded to the local institutions' desire to be able to take local decisions on matters concerning town or city councils, départements or regions. The Act states that "the rights and freedoms" of town or city councils, *départements* and regions, removes tutelage of the State and transfers executive power to the *Préfet* and the presidents of general councils (of the *départements*) and regional councils. It also reinforces the financial power of town and city councils and, above all, it raises the region to a fully-fledged institutional ranking.

The Act of 2 March 1982 marked the beginning of an important era for town and city councils, *départements* and regions, who could apply an essential principle from then on: the principle of authority and

119

responsibility of local and regional elected positions with subsequent control of their decisions by State representatives. The first elections to regional assemblies by universal suffrage took place in 1986 for a 6-year mandate. Since 1982, the 22 metropolitan regions and the four French overseas communities have had a regional assembly and an executive consisting of a president and several regional councillors. As a result of this Act, the regions have received specific powers. In particular, they are in charge of three main areas:

- Financial development is an important objective for regional assemblies, as asserted in the context of the first reforms in 1972, which mentioned that they should "contribute to the economic, social and cultural development of the region". Regional action in this area manifests itself in two ways: on the one hand, by drawing up regional plans and signing "plan contracts" with the State (setting the targets and funding required to attain them) and, on the other, by granting public subsidies to businesses through regional development agencies. The regions activities are mostly devoted to providing aid for the creation and development of new businesses rather than help for ailing companies.

- Acts 1983 and 1985, which supplement the Decentralisation Act of 1982, have entrusted regional assemblies with major responsibilities for education and training. The powers mostly apply to building, extending and equipping school buildings and specialised education centres (teaching staff and other staff costs are met by the State). They also have powers in the field of job training: a regional apprenticeship and continuing job training programme is established each year in collaboration with the State's services.

- Since 1972, the third area of regional intervention has been territorial organisation. The latest Acts have strengthened their actions in this field. Since 1995, each region has been able to draw up a regional territorial organisation and development plan which includes major targets for the environment, large transportation infrastructures, large facilities and service of regional interest. They are also in charge of programming the development of tourism by drawing up a regional plan for tourism and leisure. Finally, the regions also invest a great deal of money in transport (they organise regular non-urban transport services by road and regional railway links) and telecommunications.

The aim of the 1982 Act was to facilitate the identification and delimitation of powers and intervening sectors of each territorial institution. More than 15 years on, its is difficult to be able to recognise homogenous power "packages" allocated en bloc at similar territorial levels. In fact, in some areas that the decentralisation Act allocated to the regions, State intervention is still quite high (eg, job training and continuing education, housing, aid to businesses and territorial organisation). In fact, in France there is competition between the various different territorial levels: the

municipality, the *département*, the region and the State. This leads to numerous co-funding operations and that is why it is very difficult to establish the efficacy of the investments made by each executive body and clearly mark the boundaries of their responsibilities.

1.2. Language and culture

The Decentralisation Act of 1982 granted the regions powers "to assure the preservation of their identity by respecting integrity, autonomy and the attributions of the *départements* and municipalities". Although the regions frequently appeal to the regional identity, this is difficult to delimit because of the predominant role that the State has historically played in France. So, the legislator has included the notion of regional identity in a context which tends to optimise the State's actions.

In addition, the French territorial division into 22 administrative regions does not correspond to language spaces, old "provinces" or even geographical criteria. It is therefore hard to delimit the identity of French regions, whether culturally or linguistically. However, there are some specific features like minority languages (Occitan, Catalan, Corsican, Alsation, Breton, Basque...). Over the centuries there have also been territorial claims – sometimes very contradictory – against the Jacobin State.

The sociologist Louis Quéré (1978) identified five periods in the evolution of regionalist movements in France. The first was at the beginning of the 19th century and was based on a traditionally inspired literary and language renaissance, mostly counter-revolutionary. The second was at the end of the 19th century and beginning of the 20th. It was characterised by its claims to teach minority languages in schools, by the first criticisms levelled at the centralising State and by the emergence of regionalist socialist thought. The third period was marked by the influence of extreme right-wing ideologies which led to some extremist autonomist movements to commit themselves to Nazism. The fourth period was during the 1960s and was centred around a rebirth of regional claims, first on a financial level and then in the 1970s – and carrying on into the next decade – with the reactivation of regional cultural characteristics in areas of literature, music and theatre. This fifth period, loaded with cultural and financial challenges, is different from the others because of the its desire to assert itself against the State and capitalism. According to Quéré's arguments, it can be said that the 1990s is a period of recognition of regional identity although this notion conceals fairly disparate realities: except for Corsica, the autonomist claims of nationalist minorities are weak, and claims to a regional identity often form part of the regional political powers' communication strategies. These powers thus try to acquire legitimacy over municipalities and *départements*. The rebirth of cultural peculiarities corresponds to a revaluation of local heritage, both rural and industrial, which is part of a general movement of cultural-product industrialisation.

2. Television's legal framework in France

French television was a State monopoly for many years. As from 1982, under a Socialist government, this monopolistic, over-the-air public television company began to compete with other stations and supports (cable and satellite).

According to Jêrome Bourdon (1994), the first newscast was made in 1949, the year when RTF (Radiodiffusion-Télévision Française) was created, under the authority of the Information Minister. In the years after the Liberation, politicians had other priorities to deal with and showed a degree of indifference towards television. In addition, public interest grew slowly, particularly because the technical means of broadcasting were still poor. Television did not take advantage of the drive stemming from the economic reconstruction of France. At that time some authors referred to the delay in audio-visual equipment reaching French homes. In 1960, 64 per cent of American homes were already equipped with television whereas only 13 per cent of French homes had television sets. In the European context, in terms of numbers of television sets, France (1.3 million) at that time was behind Federal Germany and Italy (1.5 million and 4.6 million, respectively).

The definitive drive behind television came in 1958, the time when a new political regime came on to the scene with General de Gaulle's rise to power. This regime made television a real instrument of power. The government, through the Information Minister, directly controlled RTF (he appointed the Director General), set the television fee (done until then by the Parliament) and defined the functions of the public service radio and television network. The SLII (a governmental service) was in charge of censoring all information before being broadcast on the news. So, in 1959, the monopoly was consolidated: the State controlled broadcasting, programming and production. During this period the number of television sets in French homes increased significantly from 13 per cent in 1960 to 70 per cent in 1970.

In the 1960s there were some novel events. In 1964, the second channel began broadcasting – as a State monopoly, of course – and RTF became ORTF under the tutelage of the Information Minister (no longer under his authority). So, in the 1962 and 1965 elections, the political parties of the opposition enjoyed, for the first time ever, the right to express themselves in public audio-visual media.

One of the reforms promulgated by the Information Minister was the creation of regional centres. Between 1963 and 1965, 23 regional stations were created and regional news programmes began to be broadcast in six regions. But even then the regional directors had to observe the channel's national policy. In fact, regionalisation of the programmes was a way of reassessing national political action (or local politicians' actions, provided that they belonged to the political currents prevailing Paris). In 1968, the

first channel began broadcasting commercials before the 8.00 p.m. news. The commercials lasted for two minutes a day. The second channel also gradually incorporated advertising.

1973 was the year when a new channel was born, France Régions 3 (now France 3), with a great deal of resources. Despite its "channel of the regions" status, its structure was heavily centralised. Throughout the 1970s, the three national public channels (Télévision Française 1, Antenne 2 and France Régions 3) were in direct competition. The channel of the regions, created – or so it was asserted – to offset the regional daily press which had become anti-governmental, actually broadcast a very small number of regional programmes (between 2 and 3 per cent of its broadcasting schedule in 1978, according to its director). On the other hand, all three channels simultaneously broadcast (from 7.20 p.m. to 7.40 p.m.) their regional news produced by FR3. This common broadcast continued until 1985. The majority of the directors of regional stations, as well as the journalists recruited, were very close to the ruling political power. Research published in 1977 showed that FR3's journalists, more than those of any other medium, practised self-censorship, and that this channel had the lowest rate of trade union membership. FR3 very soon turned into the channel for representatives of local institutions (mayors, presidents of general councils...), in which controversy, conflict and contradictions were censored. For many years, journalists complained about the centralised management of the channel and its lack of independence.

In the 1980s, the French television panorama underwent major changes. First of all with the new 1982 Act about audio-visual communications authorised private local radio stations, got rid of the programming monopoly and created a new organisation, the Supreme Authority for Communication. Among other things, this organisation was in charge of appointing the directors of public stations.

In 1982, the Council of Ministers adopted the "Cable Plan" which had been put forward by the Directorate General of Telecommunications. This plan foresaw the connection of 50 per cent of French homes to a national network by 1995, providing reception of over 15 television channels and pay-per-view films, as well as access to information about local life through local channels and, on the basis of the initial technological aspirations, interactive communication. Local actors at many different levels had important roles to play: mayors had authority to cable municipalities, local channels began to appear on the scene. However, the aim of creating local channels soon came up against financial obstacles and the interactive possibilities encountered both technical and financial difficulties. A new audio-visual sector Act passed in 1986 basically did away with any chance for local television to develop, as it did not force cable operators to create them. The cable market was very quickly taken

over by three large operators. All of them were involved in areas of urban services – and not communication – and thus formed an oligopoly. The operators were Lyonnaise des Eaux, Compagnie Générale des Eaux and Caisse des Dépôts et Consignations.

As from 1984, private national channels began to appear on the scene. These competed with the public over-the-air channels. The first one was Canal+, a subscription channel (by monthly payments) whose majority shareholder was the Havas media group; in 1985, a fifth and sixth channel began operating. The right-wing government's return to power in 1986 led to the privatisation of the public channel TF1, the channel with the highest viewership in France and the only European case of a public channel's privatisation. The licence to operate it was granted to the construction and civil engineering company Bouygues. The fifth channel (La Cinq) belonged to Silvio Berlusconi, who is also the owner of the biggest private television network in Italy, in association with the French group Chargeurs Réunis. The sixth channel (TV6), a music channel for young people, belongs to a company formed by a private radio station (NRJ), an advertising group (Publicis) and a film production company. In 1989, the CSA appointed a single chairman for the two public channels. This led to the creation of a single company – France Télévision – in 1992 which included the former A2 and FR3 renamed France 2 and France 3, respectively. That same year the fifth channel stopped broadcasting and made way for the French and German cultural channel Arte, which only broadcasts in the evening. In the daytime, La Cinq became an educational and informational channel. TV6 became M6 (Métropole 6) and is owned by CLT (Compagnie Luxembourgeoise de Télévision). Finally, in 1996, digital television appeared on the scene, with the launch of the digital platforms CanalSatellite Numérique (Canal+), TPS (TF1, CLT, M6, FranceTélévision, France Télécom and Lyonnaise Communications) and ABSat (a subsidiary of the company AB Production).

In France, as in many other places, television is in the process of diversification, with a multiplication of over-the-air channels and the arrival of cable and satellite television. The ways they are financed are also being diversified. The compulsory fee paid to the State is but one of several methods of generating revenue: advertising and direct payment to be able to receive multi-channel services, or this station or that programme, etc. Most importantly, together with the multiplication of channels, which does not necessarily imply a greater diversity of programmes, some important financial strategies have been implemented meaning that major communications companies are forced to compete. What is more, the State is no longer the dominant actor. Strong competition between the operators has given rise to a game of alliances and break-ups that does not seem to have stabilised yet. Such a changing situation forces the observer to be wary and to recall the financial weight and relative stability – in terms of audience figures – of national channels (TF1, France 2, France 3, La Cinquième-Arte, M6 and Canal+).

2.1. The CSA

Regarding legal matters, in 1989 the Higher Audio-visual Council (CSA) replaced the National Communication and Freedom Commission (CNLC), which had previously replaced the Supreme Authority for Communication. The aim of this organisation is to break with direct links between political power and the media. The CSA consists of nine members appointed by decree by the President of the Republic on the basis of a proposal put forward by the president of the National Assembly, the president of the Senate and the President of the Republic himself. His or her mandate lasts for six years. The CSA, as a regulatory organisation, has wide-ranging powers to punish violations.

The CSA ensures that anti-concentration rules are applied. In fact, the Act stipulates a certain number of rules to prevent the formation of large groups that could endanger plurality and ethical standards. So, the Act forbids the same person or organisation from owning a national over-the-air television station and a local station. Likewise, it forbids common ownership of several local media (press, radio, television) by the same group. Neither can a group be the owner of local services affecting a population over 6,000,000 inhabitants. As we can see, these provisions impede the formation of local multimedia groups and the creation of local information monopolies.

The CSA also acts as a regulating authority for both the public and private sectors. It appoints the president of France Télévision and sets the private channel's editorial responsibility. It has the authority to sign agreements stipulating the obligations of private channels, like the one signed in July 1996 with TF1 and M6. There are two types of obligation: those concerning the content of programmes (standards for the protection of children and adolescents, the importance of "family" programming, the classification of programmes and information by their degree of violence, ethics and good practices) and those concerning audio-visual production and broadcasting. All television stations that broadcast over the air or via satellite have to comply with obligations concerning their broadcasts: "at least 60 per cent of European films and productions and (...) 40 per cent of films and productions whose original language is French". Likewise, these channels must comply with directives referring to the development of film and audio-visual production and to contribute to the independence of producers from broadcasters. To be more precise, the mechanism consists of deducting a tax from the revenue of private channels (whatever broadcasting system they use) and from the television licence fee and advertising revenue of public channels for the "audio-visual programme industry's maintenance account" and for productions for French channels. Obviously, the CSA ensures that the channels' mission statements are met and can even apply penalties.

The CSA has the power to authorise local television stations and set their obligations. In general, for programming, advertising and sponsorship, the

obligations of a local over-the-air channel are the same as a national over-the-air channel's. However, local channels do not have any obligation as far as production is concerned and they enjoy special conditions in the section referring to the duration of commercial breaks which can, if the CSA so decides, be longer than national television stations' commercial breaks.

All cable television services must sign an agreement with the CSA. Only television activities belonging to the public service are exempted from obtaining this authorisation. These agreements affect advertising, sponsorship, production and broadcasting of films, as well as the penalties that the CSA can apply in the event of violating these obligations.

The same applies to local windows of national over-the-air television stations. This basically affects the national over-the-air channel M6 (originally dedicated to music, aimed at a young audience, which wishes to diversify its actions with "proximate broadcasts"), which has local news windows lasting between six and seven minutes. In 1997, M6 broadcast local news in 10 cities (Bourdeaux, Grenoble, Lyon, Lille, Marseilles, Montpellier, Nancy, Nantes, Rennes and Tours). Local windows are subject to specific rules. In particular, they must not contain advertising or sponsorship messages and their duration cannot be any longer than three hours in total per day. Finally, the national channel has editorial responsibility for the contents broadcast locally.

In general, there have been two types of criticism levelled at the obligations imposed by the CSA on local television stations. The first refers to the lack of specific regulation, given the particular nature of their broadcasting conditions. These channels' finances and the nature of their broadcasts is hardly comparable to those of national television stations. So, their obligations regarding production, advertising broadcasts and sponsorship – which could be a source of income on a local scale – are the same as those applied to national television stations. As a result, the particular character of local television services is not acknowledged. Likewise, the application of exactly the same rules means, for example, that local over-the-air television stations concessions are only granted to companies, whereas civic associations are usually the most important bodies on a local scale and therefore more likely to be the promoters of such initiatives. Faced with these contradictions, the CSA has been forced to display some degree of flexibility towards temporary channels, for example. Perhaps this will soon extend to neighbourhood television stations.

The second criticism was that local television concession procedures set by the CSA are different depending on the system used (over-the-air or cable). These differences make the concession regime more complicated and, above all, prevent an overall, consistent view of the role, the place and the finances of television in a local area. These differences can be explained by

the history of the audio-visual sector in France and the fact that regulations have been made as and when new technologies have appeared on the scene. Now it would be a positive move to harmonise these rules and not have a policy which depends on the channels or the technologies, but on local projection and local interest services.

3. Television's institutional and financial framework[1]

3.1. National public television stations

The two public service channels, France 2 and France 3, have been grouped together in one public company, France Télévision, under the management of a single director for both. France Télévision is a shareholder in the digital platform TPS. France 2 is a general channel that competes with the private station TF1, especially when it comes to variety and news programmes. The frenzied competition between the two channels has led observers to frequently ask themselves about the specific nature of the public service. The public mission of France 2 seems to be disappearing and programming similar to any other national private channel appears to be taking over.

Generally speaking, the public television stations' financial situation got worse in 1996. France 2's turnover for that year was 5,387.2 million Francs but it made a loss of almost 200 million Francs. This was the biggest loss of this decade. The growth in turnover can only come from advertising revenue, as France 2's public resources have gone down slightly. All of that meant that France 2 had to pay particular attention to its viewership in order to increase advertising revenue. This gives rise to growing competition with the private sector and the impression that the viewer only has one television model available. The functions of the public service are in a contradictory situation because of their need to compete with private television stations.

France 3 is in virtually the same situation, although rather less so than France 2. In 1996 it reached a turnover figure of 5,444.8 million Francs, with a 3.2 per cent increase over the previous year. But, as the State places emphasis on funding the channel's "own resources", that is, the resources generated by advertising and sponsorship, France 3 must also pay a great deal of attention to its viewership. The danger – more acute in France 2's case – is that this broadcaster, identified by the viewers as the documentary and cultural broadcast channel, may become too general. This would happen, for example, if it moved its public service broadcasts, which are important for its brand image, to timeblocks that are later on in the day or not within peak viewing hours.

Despite the financial restrictions, France 3 continued with its regional development. So, in 1996 it launched two new news programmes and two departmental news programmes. The local and departmental newscast

volume went up every year as from 1990. In 1996 it reached 528 hours, that is, an increase of 113 hours in comparison to 1995 (+21.4 per cent). Together with these broadcasts, which the channel calls *télévision de proximité*, France 3 produced and broadcast regional programmes whose volume also went up (+13.79 per cent) in comparison to 1995. These regional programmes are sometimes broadcast nationally.

The European cultural channel ARTE merged in 1997 with La Cinquième, the educational and informational channel. Now they have a common president. The programming of these channels is essentially based on documentaries and news programmes. Clearly set within the public service function context, they are gradually finding their niche in the audio-visual market although their viewership is still fairly low.

3.2. Private channels and their digital platforms

TF1 and TPS

TF1 (Télévision Française 1), the oldest French channel, is 39 per cent owned by the Bouygues group and is still the one with the highest audience figures. Its programming is based on variety shows, sport – especially football – and news. In 1994, TF1 began operating the 100 per cent news channel LCI (*La Chaîne d'Information*), which it broadcasts via cable networks.

TF1, together with all the other public and private national channels – except for Canal Plus-, has been involved in the digital platform TPS (*Télévision Par Satellite*) since 1996, which also includes (depending on the options) the following channels: Eurosport France, LCI, Télétoon, RTL9, Série Club, Odyssée, Fun TV, Téva, TV5, Festival, France Supervision, BBC World, BBC Prime, CNN International, VH-1, Cinéstar 1 and 2, Cinétoile and interactive services (France-Courses, Canal Auto, Météo Express), as well as several radio stations. In 1997, TPS had 350,000 subscribers. The company is controlled by TF1 (25 per cent), France Télévision Entreprises (France Télécom and France Télévision, 25 per cent), CLT-UFA (20 per cent), M6 (20 per cent) and Suez-Lyonnaise des Eaux (10 per cent).

Canal Plus and CanalSatellite Numérique

Canal Plus (Canal+), a subscription channel (monthly payments), is 34 per cent owned by Compagnie Générale des Eaux through Havas. Since 1984 it has broadcast encoded programmes with a decoded or "open" section that includes commercials. Canal+'s programming mainly revolves around broadcasting recent films and re-broadcasting sports events. In December 1997 the channel had almost 4,408,000 subscribers. At the end of its first year of operations it only had 186,000. At that time the channel's launch was considered to be a failure. Its turnover in 1996 was 11,628.4 million Francs, some 14.5 per cent higher than the previous year.

Canal Plus implements a major diversification policy. It has launched subscription channels abroad in conjunction with other partners (Canal Plus Spain, Poland and Belgium; Première in Germany). The channel is also a shareholder in numerous satellite or cable channels: Canal J (1986), Planète, TV Sport and Ciné-Cinémas (1988), Canal Jimmy and Ciné-Cinéfil (1991). In 1996 it launched three new thematic channels: Spectacle, a cultural tele-shopping channel; Seasons, a channel devoted to hunting, fishing and nature; and Kiosque, a pay-per-view system for films and sport. Since its beginnings, Canal Plus has undertaken major projects in film and audio-visual production.

In 1996, Canal+ launched the digital satellite platform CanalSatellite Numérique, which includes the following channels: MTV, TMC, Eurosport France, Canal J, CNN International, Bloomberg, LCI, Planète, Paris Première, France Courses, Cartoon Network, Spectacle, La Chaîne Météo, Canal Jimmy, Voyage and MCM. Optionally, the subscriber can access Ciné-Cinémas, Ciné-Cinéphil, Disney Channel, Seasons, Muzzik and Multimusic, as well as C+ software download services. What the channel has to offer is rounded off with general North American channels. In 1997, this digital platform had 757,000 subscribers. Canal+ controls 70 per cent of CanalSatellite's share capital and the remaining 20 per cent is owned by the Pathé company.

ABSat

As far as digital television is concerned, France is in a very peculiar and original situation because viewers can access a third digital platform, ABSat, a subsidiary of the television production company AB Productions. This platform, which was launched in 1996, had 50,000 subscribers in December 1997. In view of the minor profitability of digital platforms, there have been recent talks about a merger between TPS and CanalSatellite.

M6 (Métropole 6)

M6 (Métropole 6) is a national over-the-air music channel aimed at young people. Its programming is mostly based on "stock" programmes, as it gives priority to fiction (especially American serials), music programmes (particularly music videos), documentaries and *magazines*. National news was initially limited to a daily six-minute programme. However, M6 has gradually incorporated news programmes into its national programming at peak viewing times and, above all, it has increased the number of its local windows. In 1996 there were 10 local windows (consisting of daily six-minute programmes put on at 8.35 p.m.), with an estimated coverage of 12 million people and an average share of 35.4 per cent (which is on the up).

3.3. Cable networks

The Cable Plan, which was approved in 1982, foresaw fast, efficient connection of French homes as a result of using fibre-optic technology and

funding by territorial institutions. However, very soon it ran into both technological and financial difficulties. In 1997, the number of subscribing homes in France was way behind the number in Germany, the Netherlands or Belgium, and the growth rate was a long way off the United Kingdom's and Portugal's. In the same year there were 617 registered cable networks, but this figure concealed a great deal of imbalance in terms of their size. In June 1997, 2,234,000 homes had been cabled, whereas the number of homes subscribing was 1,511,000. The penetration rate (number of subscribing homes divided by the number of homes with a television) of cable networks was 22.8 per cent, and the connection rate (number of homes cabled divided by the number of homes with a television), was 33.7 per cent. Since 1995 the growth of numbers of subscribers has been stable at about 15 per cent .

The French situation is characterised by the presence of an operator oligopoly formed by three large groups: Lyonnaise Câble, Compagnie Générale de Vidéocommunication and France Télécom Câble, which in themselves accounted for over 82 per cent of connection points and 81 per cent of subscribers in 1997, although they only exploited about 5 per cent of the networks due to the fact that they were the first to install networks in large urban conglomerations with a high population density. Cable is undergoing a "concentration" movement around these three operators because of its difficult viability. Out of a total of 120 channels approved in May 1997 by the CSA, 83 were French, 33 foreign and four were for digital audio services. The best distributed channels are the French-speaking ones (TV5, Eurosport France, Canal J, RTL 9, Euronews, MCM, Planète, Paris Première, TMC). Among non-French channels, the most popular are RAI 1, MTV and CNN.

3.4. Audience

In 1995, the French watched an average of 179 minutes of television per day. This figure is identical to the 1989 one. But the audience structure has evolved since then. Viewers consume more *magazines* and news than in 1989 to the detriment of entertainment and fiction programmes. In 1995, the average viewer watched an average of 34 minutes per day of news, 20 minutes per day of *magazines* and one hour per day of fiction. Advertising went up from an average of 10 minutes per day to 16 minutes per day in 1995.

The channels' shares have changed since 1990. At that time TF1 was at the top of the list with about 42 per cent. France 2 was in second place with 23 per cent, followed by La Cinq with 11.8 per cent, France3 with 10.8 per cent and M6, at the bottom, with 7 per cent. In 1995, although TF1 was still the leader, it had lost 6 points of the market share (36 per cent), whereas France 2's and France 3's shares were bigger. France 2's was 25 per cent and France 3's, which had steadily progressed, was 18.5 per cent. M6

accounted for about 11 per cent, Canal Plus was stable at 5 per cent and La Cinquième-Arte attained 1 per cent.

It is worth pointing out that the success of France 3's regional broadcasts was due to a real regional audience. The audiences for regional news in the 7.10-7.30 p.m. timeblock and those for local or departmental news have progressively grown. At the end of 1996, the average share in this timeblock was 42 per cent.

Regarding subscribers to new cable or satellite digital channels, the audience is also evolving. In this market, general channels' shares are falling to the benefit of thematic channels. The former account for 63 per cent and the latter 37 per cent. The success of digital television confirms and amplifies the cable audiences characteristics, which had already shown a progressive erosion of large, national general channels' audiences.

3.5. Advertising market

In 1995, the media advertising market was shared as follows: film 0.6 per cent, radio 7 per cent, outdoor advertising 11.6 per cent, television 33.5 per cent and the press 47.3 per cent. The advertising revenue of large media increased by 5 per cent in 1994, 4.1 per cent in 1995 and 3 per cent in 1996 (total revenue: 52,100 million Francs). Television had good results, with an increase in revenue of 4.5 per cent, representing a total of 17,000 million Francs.

As a result of selling advertising slots on over-the-air channels, year after year television is approaching the press, which is still the first medium in terms of advertising investment. The growth of advertising spending on television, after it had slowed down between 1991-1993, recovered and ended up two percentage points above the advertising market as a whole. It is worth pointing out TF1's particular situation. With one quarter of the slots and a third of the audience, since 1990 it has attracted over half of all advertising revenue. However, this market share went down slightly as from 1993 to the benefit of M6 and, in particular, of France 3.

Thematic and local television channels account for a minor market share, with 400 million Francs in 1995, that is, hardly 3 per cent of all advertising investment.

4. Structure and characteristics of television in the regions

4.1. Description of types

Regarding the types of regional television broadcasters included in the book entitled *Decentralization in the Global Era* (Moragas and Garitaonandía, 1995), regional and local television in France fits into three categories:

Decentralised television

This model is the most widespread in France. Regional and local broadcasts by the national public television station (France 3) and the local windows of the national private station M6 belong in this category. France 3 broadcasts 24 regional and 19 local news programmes per day in regional or local windows. The success of these newscasts is encouraging France 3 to extend them to new cities and départements. M6 produces and broadcasts 10 local news programmes. The regional or local windows for both channels are produced by local units whose budgets are independent of the headquarters'. Occasionally, the reports and news items of these newscasts, which mainly consist of news and information about the region, are also broadcast in national news programmes.

Regional television with supraregional, national or international coverage

In France there is only one channel which appears to fit into this category. It is the cable television station Paris Première, which was originally an urban channel broadcast for Paris and the Parisian region. Its coverage has gradually spread and reached a national scale thanks to the high viewership and the use of a combined broadcasting system (cable and satellite). Soon it will be possible to receive this channel abroad. Despite the expansion of its coverage, the channel is interested in preserving slots that specifically deal with life and news in Paris.

Local television with infraregional coverage

In this category we could include the local over-the-air channels called "city television stations" (Télé Lyon Métropole and Télé Toulouse), whose coverage includes the conglomerations of Lyon and Toulouse, respectively. The channels knows as "country television stations", such as Télé 2 Savoies-8 Mont-Blanc (the Savoie and Haute Savoie départements) and Aqui TV (Aquitaine), have greater coverage that extends to one or even two départements. The French overseas domain and territory (DOM-TOM) television stations also fit into this category, as do some cable television stations that usually have coverage that is not limited to a city because they also extend to neighbouring communities. Paris Première is an exception, as it fits into the previously described model. Also included in this category are temporary channels, whose fleeting existence – limited to a few days or months by law – does not allow them to have a strong identity. All of these forms of television differ in the way they are financed, in their development strategies, in the nature of their production and programming and, finally, in the profile of the organisation which holds editorial responsibility (local over-the-air television stations, which must be companies, have an editorial management team which signs the agreement with the CSA; however, cable channels have an editorial management team which can be a cable operator, an association, a SEM or

a town or city council). However, their common feature is the production of specifically local programmes. From time to time they take recourse to other local television stations' programmes to "pad out" their schedules.

4.2. Regional activities of national coverage television stations (decentralised television)

The broadcasting of local and regional windows by a national channel is the most commonplace practice of *télévision de proximité* and the best-known one in France. It was introduced in France quite late on, even though public powers gave FR3 the responsibility to turn itself into an array of information about local life in 1974 and a medium capable of serving regional interests and revaluing the regions' language and cultural peculiarities. In this sense, the Decentralisation Act of 29 July 1982, stipulated the creation of autonomous television companies in the regions. This provision was pending for some time, but as a result of it, France 3 and RFO are now offering local windows and enjoying a great deal of freedom with regard to the definition of its mission statements.

Later on, in 1989, the CSA authorised M6 to launch its first window in Bordeaux. As a result of the success of this experiment, the channel obtained permission to offer windows in another nine French cities. These decentralising practices have continued to proliferate, as France 3's and M6's windows are the object of growing public interest judging by their audiences, which are bigger than those of national programmes. These two television channels, one public and one private, are studied below. Each one constitutes a particular model of decentralised television.

4.2.1. France 3

The general public television station France 3 (formerly FR3) differs from other State channels in its regional and local vocation. According to article 2 of its mission statements,

> ...as one of its general missions, France 3 asserts its particular vocation as a regional and local channel. It prioritises decentralised information and regional events, mostly cultural and sporting ones. It concedes an important position to regional news and *télévision de proximité*. National programming and regional stations' networks are designed to be used as instruments for an audio-visual organisation policy of the territory.

Quantitatively speaking, regional windows were not very important initially. However, the three public channels (TF1, Antenne 2 and FR3) used to broadcast the regional news programmes produced by FR3 simultaneously (TF1 stopped broadcasting these regional programmes in 1985, and Antenne 2 in 1988). For several years there was a regular increase in regional broadcasts of non news programmes on France 3. In 1994, they accounted for 10,387 hours, that is, 49 per cent more than in 1990.

In 1990 on the other hand, France 3 had placed its bets on specifically local information programming. As a result, six-minute long local news bulletins, with an "all picture" format are now broadcast in some cities before the regional news. Currently, 19 local news programmes are broadcast five days a week (seven days a week in some cases) in medium-sized cities (Tours, Nantes, La Rochelle...), in areas defined by communities sharing economic, social and language interests (Tarn, Finistère...) and in large conglomerations or regional capitals (Paris, Lille...). They consist of short reports and interviews with local inhabitants and deal with local life issues. They have audiences that are quite a bit higher than those for national programmes.

In France 3's evolution and the improvement of the public service's image, the role of the channel's former president, Hervé Bourges (who currently presides over the CSA), must be underscored. In 1993 and under his presidency, the company France Télévision was created. This company grouped together France 3 and France 2 (formerly FR3 and Antenne 2, respectively) with the aim of relaunching the public service to compete with the private channel TF1. In this new structure, France 3 has stuck to its policy of developing local and regional information, increasing the number of local news programmes and the presence of regional information in national newscasts. In 1995, four new local windows were created. These were broadcast 5 days a week (France 3 Côte Varoise in Toulon; France 3 Pays Gaudois in Nîmes; France 3 Noï in Ajaccio; and France 3 Quercy-Rouergue in Rodez).

The volume of local windows went up constantly after the first one was launched in 1990. These windows have had excellent audience ratings, thus contributing to France 3's increased audience share, particularly in the 7.00-8.00 p.m. timeblock. The creation of new decentralised delegations in Valence, Vesoul, Chateauroux and Cahors at the end of 1995 allowed the content of local, regional and national newscasts to be enriched.

The decentralised "regional information bureaux" (BRI, regional information services) were created in order to support development of local news programmes (technical support) and to "trim" regional and national news programmes (re-broadcasting of local news in national broadcasts). France 3 carried on creating new regional delegations, a policy that had been based on collaborations with different local and regional actors since 1990, such as territorial institutions (offering premises and materials) and regional press (supplying programmes, promotional campaigns). In April 1998, France 3 had 24 BRIs and 16 local windows within the context of the channel's 13 Regional Directorates.

On similar innovative lines, it should be pointed out that France 3 does not limit its regional broadcasts to France. In 1995, it launched an "all picture" transfrontier news programmes in collaboration with Télévision Suisse Romande (TSR). However, this cooperation was short lived. Relations were broken off at the end of that same year due to differences concerning

the objectives and management of both channels. TSR's management wanted to wanted to broadcast live news about the snow, events, "proximate shopping", etc. France 3's management felt that this formula based on "proximate topics" would quickly run dry. So it decided not to carry on with the cooperation. While it lasted, this transfrontier news programme, which was broadcast from Monday to Friday, dealt with news in the territories on both sides of the French-Swiss border (canton of Geneva and départements of Ain and Haute Savoie). In addition, there were daily departmental newscasts, with or without a presenter, based on the news of one or several départements. These were broadcast in the whole area that they affected.

France 3, as a national television company, has legal authority to broadcast advertising in its local and regional programmes, although resources generated by this method are much lower than the real cost of the windows broadcasts. The content of the latter almost always depends on the strategy defined by the national channel and the financial resources it wants to invest. So, even when they are allocated to local delegations, these delegations are not free to be able to decide on their own programming. Currently, France 3's windows policy is subject to certain conditions; in particular, to carry on developing they must broadcast for a population that is big enough.

On the other hand, France 3, instead of competing with cable networks, has signed agreements with about 15 of them to re-broadcast the State channel's regional, departmental or local programmes. In general, these agreements foresee payment for the latter only if the number of subscribing homes is over 10,000. The annual cost of each of France 3's local news programmes is estimated at about 5 million Francs.

4.2.2. France 3's programming: a case study of France 3 Alsace

France 3 has a varied programming schedule. Although the predominant language in all its programmes is French, it also broadcasts in non French autochthonous languages in some Regional Directorates. In the case of France 3 Alsace, one's attention is drawn to the large volume of broadcasts in Alsatian, with a schedule that is dotted with magazines or news bulletins in that language throughout the day. On Saturday, France 3 Alsace mainly broadcasts programmes in Alsatian. The first magazine, of the day, *Télédisch*, is in Alsatian. It consists of a 26-minute broadcast in which journalists and guests comment on the news (from 11.45 a.m. to 12.15 p.m.). For its part, the weekly 26-minute broadcast *Sür un Siess* consists of comments made by a guest – an Alsatian celebrity – on the Alsatian news by referring to a recipe (5.20 p.m. to 5.46 p.m.). On Saturday afternoon, an adaptation of Tintin cartoons in Alsation is broadcast. In addition, a 6-minute news bulletin is broadcast every day from Monday to Friday. It is called *Rund Um* and contains local information about Strasbourg (from 6.57 p.m. to 7.03 p.m.).

Because of both the times and days of broadcasting, these programmes in Alsatian try to familiarise viewers with the regional language and draw the attention of a family public at peak viewing times.

4.2.3. M6

M6 is the second national coverage television station that currently offers windows. Initially it intended to associate its services with local or regional television projects to make itself stand out a little more from other national over-the-air television stations.[2] This initial proposal led to it being granted a national over-the-air channel status in 1987, by decision 87-13 of 26 February 1987. This rule states that local television services, after the corresponding bid procedure, can be broadcast over the air. However, M6, without going through the bid procedure, experimentally launched a daily 6-minute window from Monday to Friday in Bordeaux. Nine more windows in nine other French cities have been added to the first one. Until the Act of 1st February, 1994, was published, M6 broadcast its local windows outside of the legal framework in force. In principle, this new Act allowed local window broadcasting possibilities to be extended (up to 3 hours a day) without recourse to advertising. This limitation has stopped M6 from extending its windows broadcasting time, despite the channel's firm desire to do so.

As with France 3, M6 broadcasts local windows via cable networks (only on networks in Tours, Nantes and Marseilles, for the moment). In the rest of M6's reception area, it broadcasts short thematic programmes like *Ciné 6, Ecolo 6, Le Mardi c'est permis, Passé simple* and *Capital 6*, produced mostly with the support of regional press (*Ouest France, Sud-Ouest, L'Est Républicain, La Voix du Nord*, etc). Viewership of these windows has been very stable for the last two years and is similar to the viewership of the national broadcast. M6 intends to develop longer local windows (about 20 minutes), but this project comes up against the legislation in force. Article 7 of the Act of 1 February 1994, provides a legal framework for national channels' "open" local windows broadcasts over the air by an agreement regime. These windows must not include commercials or sponsorship. The can only last "for a total of three hours a day, unless otherwise permitted by the Higher Audio-visual Council (CSA)". On 21 July 1995, the channel presented a daily windows project for Lyon. The CSA threw it out on the grounds of the conditions of direct competition with TLM, which is in a very delicate financial situation, and because of the risk of violating the ban on broadcasting commercials and sponsored programmes, as the returns that would be recouped for national programming during local windows broadcasts signified the inclusion of commercials in the latter.

Faced with these legal restrictions that limit the channel's sources of finance, M6 decided to meet the broadcasting and organisational expenses of local programmes. The annual budget of each local news programme is about 5 million Francs.

The main difference between France 3's and M6's local windows is that M6's are only broadcast in urban areas, whereas France 3's can also be picked up in some outlying rural areas. These more highly focussed local news programmes which are much closer to the inhabitants' daily lives are undeniably an essential factor of the growing success of France 3's windows.

Table 1. France 3's and M6's regional and local broadcasts (1997)

Production	Programming	Share	Annual cost of each local news programme
France 3	• 24 daily regional news programmes in two editions (15 minutes for the midday edition and 30 minutes for the evening edition). • A daily summary of the regional evening news (5 minutes "all picture" before the national news at 8.00 p.m.), re-broadcast after the *Soir 3* news. • regional windows in the morning from 11.50 a.m. to 12.20 a.m. on Tuesday after *Soir 3* and on Saturday at midday. • 16 daily local news programmes in 16 French cities.	Local news programmes: between 39.6 per cent and 70 per cent.	5 million Francs
M6	•10 local news programmes, From Monday to Friday from 8.35 p.m. to 8.41 p.m., produced by small units with 7 employees in each.	Group 15-49 years: between 34 per cent and 55 per cent (1996). Group 15 years and over: between 27 per cent and 45 per cent (1996).	5 million Francs

It can be deduced from these experiences that "proximate news" is widely accepted by the public. The broadcast of reports about the area, about old trades and about neighbourhood activities are appreciated by the audience. National channels are extremely interested in this phenomenon (Ohayon, 1994) and have announced that they will introduce more "localism" in their regional news programmes and increase the number of regional and local windows throughout the territory.

4.3. Specifically regional coverage broadcasters: "country television stations" and French overseas domain and territory (DOM-TOM) channels

In France at the moment there are no local over-the-air or cable channels whose coverage is specifically regional (in the sense that their broadcasts

cover a territory of an administrative region). At most, existing television stations cover one or two départements (for example, Télé 2 Savoie-8 Mont Blanc and Aqui TV) and are not culturally representative of a specific region. Télé 2 Savoie-8 Mont-Blanc cannot in fact be considered a regional television station because its broadcasts do not cover any more than two départements (Savoie and Haute Savoie). However, these two channels have been termed "country television stations" ("area television stations"), because their broadcasting area corresponds to a set of medium-sized cities with a population coverage above two million inhabitants. Another feature of both broadcasters is that they belong to local entrepreneurs who are well established in the region.

The overseas television stations, those which broadcast for French overseas domains and territories (DOM-TOM) in the West Indies and the Pacific and Indian oceans (Réunion, Martinique, Guadaloupe, Guyana, New Caledonia, French Polynesia, Saint-Pierre and Miquelon, Mayotte, Wallis and Futuna), also deal with local news. However, their way of operating, their production and their strategies are very different from the local television stations mentioned so far. The overseas territory channels, besides their distinct language and cultural aspects, share the common feature of being islands which are geographically a long way away from France. This has a major influence on their characters.

This category consists of public sector channels (RFO1 and RFO2) and private sector channels. In turn, these consist of eight "open" over-the-air channels (Antenne Réunion, Archipel 4, TCI Guadeloupe, ATV, TV Sud, TV4, TCI Martinique, Antenne Créole Guyane) and five encoded channels. Only RFO (Radio France Outremer) and private television stations "open" channels broadcast local programmes. Going by the name of RFO1, they broadcast nine different channels for each one of the French overseas territories. Encouraged by the CSA, RFO has increased its specific production of local programmes. Since 1996, RFO2 has been broadcasting one hour a day of local service, education and "proximate programmes". Only the overseas domains (DOM) can receive private local "open" channels. These channels differ from French mainland's "télévision de proximité", in that their format is general and their specifically local content is much lower than average. In fact, the local television stations of overseas domains have based their programming schedules on programmes imported from French channels because of their concern for the assurance of "territorial continuity" of news in relation to France.

Réunion has three private local television stations. Each one has specific coverage, but together they cover the whole of the territory. They broadcast five days a week. Sixteen per cent of these three channels' production is their own, and almost 50 per cent of the hours are devoted to first-time broadcasts. Antenne Réunion has local news programmes and often negotiates with TF1 to get supplementary programmes. TV4

broadcasts local productions and programmes in French. Severe financial difficulties and repeated violations caused two of the four television channels in the West Indies to disappear: TCI Martinique and Archipel 4. Guyana, Réunion and the French West Indies also have their own broadcaster. Antenne Créole Guyane has been broadcasting in Guyana since 1994 for the cities of Cayena and Kourou. This channel can be picked up by just over half of the population. It is the most dynamic television station in the overseas domains as far as its own production is concerned, accounting for 4 hours 30 minutes of first-time broadcasts per day. The rest of the programming schedule consists of TF1 and MCM (Société Euromusique) programmes.

Private "open" television channels in the overseas domains are making major losses even though the CSA has given them permission to broadcast commercial advertising. This critical financial situation has three main causes: they bear high financial loads for the supply of programmes (by TF1 in particular), they are forced to finance the high cost of satellite link-ups and over-the-air broadcasting and, finally, the advertising resources available to them are very limited, even after 1994 when local advertising on RFO's second channel was banned. Commercials are mostly broadcast on RFO1 to the private channels' detriment. What's more, private channels rarely benefit from subsidies provided by local institutions.

4.4. Urban television stations

Three types of urban television stations can currently be described: permanent over-the air stations, temporary over-the-air stations and cable stations.

4.4.1.Local over-the-air television stations: TLM and TLT

Unlike the previously described local delegations of national channels, local over-the-air television stations belong to independent operators and broadcast specific programmes. Depending on their status they are either fully-fledged channels authorised to broadcast for a specific length of time (between 4 and 5 years) or temporary television stations with a very short concession period which are usually created for cultural or sporting events in the area.

Since 1996, only two over-the-air television stations have been broadcasting in France. These have been termed "city television stations". Namely they are Télé Lyon Métropole (TLM) in Lyon and Télé Toulouse (TLT) in Toulouse, both of which were created in 1987. These two channels serve the Lyon conglomeration (1,200,000 inhabitants) and the Toulouse conglomeration (650,000 inhabitants) and are controlled by subsidiaries of Compagnie Générale des Eaux (CGE). The two local over-the-air channels' obligations in terms of programming are the same as the national channels', though they are not under any obligation to produce.

The originality of urban over-the-air stations lies in the fact that they produce most of their programmes (between 55 and 92 per cent), which basically include magazines and local-issue news). The rest of the programming schedule consists of documentaries, fiction and cartoons. Rights for these are acquired by the broadcaster and the programmes are broadcast several times throughout the day. These local channels' own production is the end-product of a recent policy (dating from 1993). Before that, their schedule was mostly based on supplementary programmes (taken from the MCM-Musique channel). However, they dropped that formula due its cost and the lack of local character.

In 1995, Télé Toulouse's annual budget was 25 million Francs, whereas TLM's was 21.4 million. TLT currently has 41 employees.

Despite financial support from the majority shareholder (CGE) and an aggressive programming policy, Télé Toulouse is making operating losses. That is why the operators are hoping that the ban on broadcasting advertising in local news programmes will soon be lifted. Local institutions provide funds for the operating budgets of TLM and TLT though they are relatively insignificant: Télé Toulouse receives subsidies from Toulouse City Council and the Conseil Général de Haute-Garonne in exchange for broadcasting institutional programmes about city or departmental life. This source of finance is intermittent, as it is suspended during electoral periods. According to the Electoral Code, "as from the first day of the sixth month before the month when general elections are planned to be held, no advertising promotion of the realisations or management of an institution in the territory can be organised by those organisations with interests in the elections".

Calculating local television stations' audience figures is complicated, given that Médiamétrie, the organisation in charge of their measurement, uses panels that are not representative of small geographical areas. However, it has been found that both channels have a high degree of public acclaim (82 per cent and 94 per cent, respectively).

The broadcasts of urban channels, like the majority of local and regional TV stations, have to find a balance between their own production and supplementary programming. Own production has the advantage of providing a strong identity for the channel, but it is very costly. In order to secure the public's fidelity, local television stations must broadcast a significant number of hours per day. So they are forced to take recourse to supplementary programmes which are less personalised yet less costly.

4.4.2. Temporary television stations: support for events

Temporary over-the-air channels constitute a secondary aspect of local television. Even though the CSA stipulated in 1994 that they could get permission without going through a bid procedure, this form of television

is still marginal. In a period of seven years, only 44 temporary channels have been authorised. Temporary television stations are almost always created to support a local event, meaning that broadcasts do not last any longer than a few days or months (the maximum is six months). They are recognised and supported by local radio and press. These announce their opening. However, they have a limited audience because of the viewers consumption habits and technical difficulties for signal reception. In general, temporary channels are financed to a minor extent by advertising and sponsorship resources (25 per cent) and mostly by subsidies provided by local institutions (municipalities, general councils, regional councils, etc., which usually contribute between 20 and 60 per cent towards the budgets). The rest is met by the channels' developers, who generally call on the "savoir faire" of volunteers and use equipment owned by private individuals to reduce costs.

4.4.3. The rise of local cable television stations

Despite the obstacles that cable technology has come up against in France, today cable television is experiencing a second rise, which is tacit but real. In the period between 1984 and 1988, local broadcasts were considered to be the central feature of cable distribution. The first local services had different fortunes. Some remained in the experimental phase (Isle d'Abeau), some operated for two or three years (Biarritz Télé Câble, GR15 Grenoble) and others became long lasting (Paris, Lille, Marseilles, etc.) As from 1988, the initiative of cable operators in the design and edition of programmes gave rise to thematic channels and not local programmes. It was not until after 1992 that local services were once again given a push forward; between 1992 and 1995, 26 local channels were created as a result of municipal initiatives (not the cable operators'). City councils and semi-municipal organisations took charge of the channels' editorial responsibilities. Local television stations and video services distributed by cable were broadcast in large urban conglomerations, in medium-sized cities and even some small municipalities.

The cable channels' local information is systematic (sport, culture, education, associations). However, each local channel has its peculiarities. According to a CSA survey about *télévision de proximité* in France (1996), three models could be identified. The first included small format services placing emphasis on local information (news and news magazines lasting between 15 minutes and two hours). They had average budgets below one million Francs and were installed in small municipalities (Télévision Thermale in Bourbonne les Bains, 1993; Beffroi Vision in Certeau, 1992). The second cable television model was the "proximate channel" whose programming was more varied. It dealt mainly with local news and differed from the model described previously because it broadcast slots supplied by local outside producers (up to 30 per cent of broadcasting time). On average, these channels had budgets over 3 million Francs

(Canal Marseille, Téléssonne, Images Plus d'Epinal, etc). The third model was local television whose programming schedule included both general and local slots (Angers, Rennes, Villeurbanne). These three forms of television received financial support from the municipalities and operators, and benefited from technological capabilities that allowed them to offer audio-visual services for outside customers.

The financial resources of local cable channels can vary. Initially it appeared that cable operators were going to contribute a great deal to support them in order to attain rapid growth in subscriber numbers. However, they then realised that these experiences were an obvious failure despite their proven local notoriety. Some local institutions with very limited financial resources decided to take over where the cable operators left off. Therefore, cable channels had no other option than to take recourse to sponsorship and advertising. But the advertisers were not convinced about buying slots in these media because of a lack of audience data. In this sense, the CSA report revealed that some local channels had diversified their sources of funding and had become the local correspondents of national coverage television channels (TF1, M6, Canal+, LCI).

Paris Première, the Parisian cable television station, is an atypical case. Initially it was an urban cable channel, but, because of its success, it has gradually turned into a national coverage television station. With the CSA's consent, it has become a thematic channel (the fashionable Parisian channel), with national coverage via satellite and cable. There is perhaps a danger that successful cable channels will systematically turn into thematic channels, and that local content television stations will give way to more attractive – and more lucrative – programming for the operators. However, before describing an overly Manichaean panorama which confronts thematic and local cable channels, one wonders if it would be possible to consider a successful television station that incorporates this dual orientation in some balanced way.

So, local cable television stations, despite the fact that they could take recourse to advertising and sponsorship, had a great deal of trouble in surviving. Such difficulties were mainly due to the fact that cable operators were not satisfied with the number of subscribers and therefore gradually got rid of the channels by handing them over to city councils. The city councils, for their part, had financial resources that were sometimes very limited and did not want to finance these television stations alone. Finally, some local television stations were faced with tough competition from the local news programmes of national channels (M6 and France 3), which were better financed and therefore of better quality. To sum up, there were three factors that put the brakes on the development of local cable television channels:

- Not enough subscribers. This dissuaded advertisers from using these media.

- Lack of interest by cable operators and, to a lesser extent, by local institutions. This was due to poor profitability of the networks for the former and the lack of resources for the latter.

- Direct competition from local windows of national television stations.

However, after the initial failure of local cable television, the situation today is very different. In fact, since 1992, 26 new channels have been created. These new television stations are less ambitious in terms of the number of broadcasting hours and their own production, but they are better suited to the resources they have available. They have learnt the lessons of the past, and their directors now have a number of subscribers which is slowly but surely on the up (Joxe, 1994).

5. Programming analysis: a case study of TLM, Télésonne and Paris Première

In this section we will concentrate on local television stations which are not very numerous in France, though their orientation, broadcasting methods, funding and programming differ greatly from one television station to another. To avoid having to take a look at all of them, we decided to focus our attention on those that we felt to be representative of the local audio-visual panorama. The example of TLM, an urban over-the-air television station, is interesting for two reasons. First of all because it is a channel whose programming is typical and secondly because it has managed to pass the test of time despite financial uncertainties and competition from local cable television stations. Similarly, we will examine the programming schedule of an urban cable channel, Télésonne. Finally, we will analyse Paris Première's programming. This station is an original case because it has gone from being a local television station to a national coverage thematic television channel.

5.1. Téle Lyon Métropole (TLM)

The programming of Télé Lyon Métropole (TLM), which began broadcasting in February 1989, has varied throughout its existence. Such constant evolution is due to a great extent to frequent operator changes and, above all, to a suspension of payments situation in 1993. As from 1994 the channel chose a urban *télévision de proximité* model, based on local interest news programmes and magazines. So, as from that time, TLM stopped broadcasting supplementary programmes (taken from the MCM/Musique channel) and did not take recourse to films, serials or cartoons, for which it had paid large sums of money in broadcasting rights (to minimise these costs, most of the rights purchases were done jointly with Télé Toulouse via Générale d'Images, although that collaboration ended in 1993).

At the beginning TLM only broadcast six and a half hours a day, though later on it gradually expanded its broadcasting volume to 17 hours a day, from Monday to Friday (from 7.15 a.m. to 12.25 a.m.), and 14 hours 35 minutes on Saturday and Sunday (from 9.40 a.m. to 12.15 a.m.). The aim of this change of direction was to make a daily appointment with the 7.30 p.m. news and stimulate "self-service" type access as a result of the high number of news bulletins and re-broadcasts. Thus, different audiences could gain access to the same programme throughout the day. Despite the fact that the law forbids local television stations from taking recourse to advertising and commercials, the channel regularly broadcasts advertisements for the commercial sector. On that basis, the stations' own productions that were broadcast for the first time each day accounted for 2 hours 15 minutes, whereas re-broadcasts accounted for 13 hours. Imported programming only accounted for two hours of the daily schedule.

Since the beginning of 1996, TLM's schedule has offered broadcasts on a range of topics. News occupies an important, fractionated place on the schedule. It consists of a two minute press review at the end of the morning, which is re-broadcast every hour; a two minute "service area" (traffic, stock exchange), five times a day; 10-minute news bulletins every hour; a nine minute news programme at 12.30 p.m. and a 22-minute evening news programme at 7.30 p.m. There are not many debates. In fact there are only a couple of broadcasts of this type: *Jeudi Soir*, a discussion programme between the public and guests lasting for one hour which is re-broadcast seven times throughout the week until the broadcast of the subsequent programme; and a 30-minute weekly slot, *Point de vue*, which consists of a radio or press journalist interviewing a city celebrity (re-broadcast 10 times).

TLM has two weekly sports programmes. One is a general slot, *Lundi Sport*, which is re-broadcast four times a week, and the other is a magazine slot, *Moteur*, which deals with motor vehicle competitions and news (re-broadcast 13 times). TLM only produces two daily programmes in the studio. Both last for 25 minutes. One has a theme that changes depending on the guest's profile and the other deals with education and local job market themes in the company of guests. TLM produces six weekly 13-minute magazines with varying themes. However, they are all related to the activities of the city of Lyon (cinema, cultural news, transport, the life of an entrepreneur, a day in the life of a Lyon celebrity...). It also produces four small six minute magazines about various themes (astrology, local economy, the housing market, edition, cultural events, small ads...), though always within the local milieu. These programmes are re-broadcast several times a day (between 10 and 12 times). It is worth noting that TLT does not broadcast fiction or children's programmes.

This programming schedule, which is full of newscasts, is rounded off with programmes imported from other channels. These programmes are

mainly based on film and television news (programmes from Télé Monte Carlo and from thematic channels like Planète, Ciné Cinéphil and Ciné Cinéma), which are also re-broadcast. Likewise, there is a daily tele-shopping programme produced in collaboration with TF1.

5.2. Télésonne: a small cable channel on the outskirts of Paris

Local cable television channels also have specific features. They obviously do not have identical profiles, but their programming schedules are often designed along the same lines. In this sense we invariably find that there are five broadcast profiles or types. First of all there is local information that deals with the news of a specific territory with bulletins, magazines, news programmes and debates. The variety and consistency of these broadcasts depends on budgets and technical resources available. Magazines and news programmes are based around life in the neighbourhoods and municipalities, and they briefly deal with news of the département and the region. We will now examine the case of Télésonne, a mixed capital company which has been broadcasting 24 hours a day since September 1989 for the city of Massy and associated municipalities (Palaiseau, Bièvres, Chilly, Igny and Les Ulis).

This cable channel benefits from two forms of funding: France Telecom Câble (35 per cent) and associated municipalities (65 per cent). In 1996, Télésonne's own production volume was 120 minutes a day. News programmes are renewed every day, last for 30 minutes and are broadcast five days a week. A journalist presents the news in a studio. The presenter is assisted by guests and short reports. At the weekend a news summary is broadcast. Télésonne broadcasts a magazine once a week. There is also a monthly debate called *Micro Ondes* which takes the shape of a press club in which a newsroom journalist and professional from the collaborating media (the local radio station Sweet FM and *Le Républicain*) interview a guest. Even though emphasis on local news is a general trend, it is not however systematic practice for local cable television channels. For example, Canal Marseille considers that the subscribers' demand for local news is satisfied by broadcasting the local news of France 3 Rhône-Alpes and M6 Marseille on its network. The channel prefers to diversify programmes about more specific themes instead of concentrating on local information.

Besides the news, cable channels also create thematic magazines and documentaries, but hardly ever make fiction or variety shows whose production costs would be far too expensive. The themes that channels deal with depend to a large extent on the cultural and economic activities of the city, and its social and political history. The themes covered most are sport, cinema and culture, even though each channel uses a magazine with a very pronounced character to support its broadcasts (children's programmes, cuisine, education, etc).

Sport, a very important activity in local life, generally receives a great deal of coverage through specialist magazines, reports, interviews and re-broadcasts of events. Similarly, cinema news occupies an important place in programming schedules, though the programmes' quality depends on the financial capacity of the channels and staff involved in them. Sometimes journalists specialising in the seventh art who work for other local media are called in. Finally, local channels broadcast cinema magazines for special events such as festivals.

Local cable channels also deal with other themes such as information about services, heritage, employment and training, legal information and culture. Their level of development depends on the thematic potential and profile chosen by the broadcaster.

Télésonne coproduces programmes with other cable channels or broadcasts programmes lent by specialist producers. This is the case for educational broadcasts created by the Centre National d'Education Pédagogique (CNDP) and produced by the Educable channel. This company is like a television video library with programming on demand. It also offers its services to local channels who want to broadcast specific programmes. In addition, every month Télésonne broadcasts a 26-minute scientific and technical magazine produced by the Cité des Sciences and l'Industrie de la Vilette. The television station of Massy and the associated municipalities organises its programming and broadcasting slots depending on demand and its collaborating partners, which can be the city, a cable operator or a Centre Régional d'Education Pédagogique.

Télésonne also produces a 26-minute monthly magazine consisting of reports by other channels on a common theme in association with other local channels (Image Plus Epinal, TV Cholet, Cannes TV, Cités TV, Canal 8, Télé Val d'Argent and Canal 40). It supplies the production company Cités Télévision with a programme. That company then does the post-production and provides a "Label TV locale" identification label. This label has, for example, been applied to a four minute serial, *Vite vu*, which provides practical advice about different issues. One of Télésonne's first broadcast proposals was *Vite vu transports*. This initiative allows local cable channels to promote their coproductions and to broadcast local programmes at a lower cost and with a common identity. This "programme bank" formula, whose objective is to supply local television stations with supplementary programmes at a lower cost has not, however, been a wholly satisfactory experience judging by the financial uncertainties of cable channels. Télésonne also coproduces the monthly amateur video *Amat'heure* with TV Fil 78, Saint-Quentin-en-Yvelines' cable channel. These videos are recorded by universities, youth centres and cultural associations (local cable channels are offering more and more slots for these institutions' productions).

This presentation of Télésonne's programmes does not include any original experiences of other local cable channels. However, the aim is

show that local television stations do not design their production in an isolated manner. On the contrary, they look for partners to make cheaper coproductions. Occasionally this leads to a cohesion of identity between some local cable channels, the purpose of which is to show experiences of local life in other regions. We would remind the reader that Télésonne is dependent on the same operator (France Télécom) as another five local cable television stations, a situation which forcibly benefits a convergence of financial interests. This initiative does not necessarily create an "area" culture. Instead, it could be described as a "localist" culture.

Additionally, our analysis also shows that some cable channels tend to evolve towards thematic formats and deal with themes that the audience can identify (cinema, education, cuisine, etc), whereas others, like Télésonne for example, make every attempt to hold on to their style as local life information channels.

In all, it can be said that cable channels try to concentrate their activities on local life news. So, local information – in the form of a magazine, a news programme, a short bulletin, an interview or a debate – occupies a predominant place in their programming schedules. This strategy is intended to preserve a proximity dimension in the programming which helps win audiences over, thus assuring the public's fidelity. The main factors which definitively guarantee Télésonne's strong position are the nature of its associations with other local cable television stations for programme coproduction, broadcasting its own productions at peak viewing times and active participation of local organisations in the design of its programmes.

5.3. Paris Première: the transformation of a local channel into an international thematic television station

In 1986, Paris Première, an urban cable television station appeared on the scene. Initially, it intended to employ a series of windows in the Île-de-France region. In 1990, after a few windows tests in Boulogne and Saint-Germain, broadcast of the channel extended to the whole of the Parisian region. The success of this formula encouraged its promoters, who offered the channel to all cable networks at the end of 1992. For that reason, in 1993 the CSA granted it a national vocation channel status. That same year, its inclusion in the CanalSatellite Numérique platform allowed it to extend its coverage a little more. The channel's directors are currently considering several offers to broadcast it overseas. In September 1997, Paris Première reached a total of 1.7 million subscribing homes (1,150,000 via cable and 550,000 via satellite), and had a budget of 100 million Francs resulting from financial support given by numerous shareholders. The most important of these was Lyonnaise Communications. At the beginning of September 1997, Paris Première's share capital was distributed as follows: Lyonnaise Communications (50.5 per cent), Canal+ (15 per cent), Groupe Marie-

Claire (15 per cent), M6 (10 per cent), COM DEV Image (5 per cent) and Paris Câble (4.5 per cent).

That small local cable channel is now a national coverage thematic channel despite the fact that in 1994 its director wanted to preserve the original philosophy of broadcasting an 8-minute news programme at 7.00 p.m. devoted to the capital's daily life, culture and sports. By September 1997, this news programme had disappeared from the programming schedule, though all the broadcasts are still centred around the activities of Parisian life. Rather than an urban cable television station, Paris Première is now a "capital cable television station" based on the cultural activities of Parisian life. This gives rise to programmes about art, museums, cinema, nightlife (clubs, discos, restaurants), the media and its stars. This television station, which places its bets an a modern image, has become the reference channel for Paris art and spectacle within a ten-year period. Although some slots sometimes deal with cultural news beyond the borders of Paris, the metropolis is still the core theme. Each slot, irrespective of the theme being dealt with, draws on cultural activities (eg, *Rive Droite, Rive Gauche*), celebrities (*Paris Première*), fashion (*Paris Modes*) and shows (*Classique*) in Paris. In some ways, it is a reflection of the Parisian monopoly of French artistic life and the centralism of the capital's cultural and intellectual activities. These slots have a standard format (52 minutes or 26 minutes) and variable frequency (daily, weekly fortnightly).

The programmes, except for films, are produced to a large extent by the channel itself. They are well-made, low-cost products that may be of interest to other cable channels with own production problems. In fact, the way Parisian cultural, artistic, intellectual and sports news is dealt with may mean that the programmes are a suitable supplement for the programming schedules of cable televisions on the outskirts of Paris.

So, it can be said that local over-the-air television stations, local cable television stations and national cable televisions stations (thematic) do not necessarily compete with each other because their positions are not the same. On the contrary, there is a tendency for television stations to exchange or buy productions from other television stations to supplement their own production and to make coproductions with other cable channels.

6. New problems and prospects

6.1. Financial viability

The development of local television in France is quite unstable. These channels depend on a range of funding sources: a major operator, aware of the losses or lack of profit in return for its backing; public institutions, whose intervention poses the problem of the channel's political independence; or other types of random and often ambiguous financing (local advertising, sponsorship, commercials, commissions...).

Local television stations' current situation demonstrates just how the legislation that governs the media and the advertising market has interfered with their development. The severe limitations on over-the-air television stations in terms of sponsorship and advertising make their finances suffer. The second penalising factor is the ban on broadcasting advertising for the commercial sector, a market which is enormous.

The CSA, whose report states that it regrets the poor viability of *télévision de proximité*, is not, however, oblivious to the regulatory rigidity that affects their operation. In fact, it was the CSA who subsequently encouraged the promulgation of the Act of 1 February 1994, which legalised M6's and France 3's local windows. It was also the CSA who established the practice of bidding for over-the-air television frequencies, a regime which is not applied to cable television. Thus it is easy to understand why there are so few local over-the-air channels. However, the CSA, aware of the fact that it is "killing the chick before it hatches", suggests that the rules for the broadcast of advertising on local over-the-air channels should be more flexible to allow them to get renewable financial support which is independent of decision strategies of large groups. Another solution proposed by the CSA is more active financial participation of local institutions in the operation of *télévision de proximité*. This somehow reminds us of the origins of local cable channels...

So, the CSA's powers are themselves brought into question, as its report about "télévision de proximité"in France (*Les télévisions de proximité, les études du CSA*, Paris, 1996, page 107 and Appendices) will soon become a working document for the Minister of Culture.

6.2. Cultural synergies

Undoubtedly, local television stations or local and regional windows of national television stations enjoy a great deal of public interest and success. The tendency towards the individualisation of communication practices and the fragmentation of audiences will unquestionably reinforce their position. However, there are several sides to the French situation. There are local and regional windows of national television stations which are incorporated into national programming schedules with the purpose of conquering a market or a supplementary audience and feeding the flow of national programmes. As far as programming is concerned, permanent local over-the-air or cable television stations do not offer an alternative model to general national television, in that the proportion of local or regional production is still low. As far as local news is concerned, it is still very dependent on local institutions (representatives of the State, local political powers...). On the other hand, temporary channels which are often set up on a virtually home-made basis play a dynamic role in rural areas or neighbourhoods that cannot be ignored.

Besides local information, it is clear to see that the essential problem is the existence of local or regional production units. In general, these units are fragile and the broadcasting organisations are not very numerous. Finally, national television stations, and France 3 in particular, are basically the ones that implement the most important production policies for regional broadcasts, taking into consideration the diversity of practices and local cultures. In all, the place for local television stations is well matched to the role generally assigned to things local in a highly centralised political system. They exist, but they are strictly "framed" and supervised by the State.

6.3. Influence of new communications networks

The general spread of information superhighways still isn't a reality if we consider the number of cable and over-the-air channels with their own sites, or those that have designed programmes aimed at interactivity. However, there is a new image market that is rapidly developing. According to some authors (Podguszer, 1997), the convergence between television and the Internet (telecommunications and information technologies) will put an end to analogue and over-the-air broadcasts and benefit digital platforms. This will imply major changes, both technically and otherwise. In fact, we find that the border between the consulted medium (Internet) and the watched medium (television) is becoming less and less clear. Television is becoming interactive as a result of cable technologies, digital and satellite networks, and Web sites are offering better definition and faster images. These are nearby and complementary media. In fact, the Internet can store television programmes on the network. Television stations in the future will have to create new programmes, contents and services adapted to new technological capabilities.

Some experts (see Le Floch-Andersen, 1997) assert that television stations that have opened Web sites are pursuing precise objectives: they are using them either to broadcast institutional information, news and programmes with the aim of reinforcing the company's profile or to broadcast specialist news and information. In the latter case, production costs are higher because of the need to update information. For the time being, most television stations which have Web sites or projects in progress are national television stations (TF1, France 2, France 3, La Cinquième-Arte, M6, Canal+) and thematic channels (LCI, Paris Première...), with the exception of some local cable television stations (eg, TV Metz).

Television stations that administer Web sites either produce the information themselves or contract specialist outside companies to develop them and answer the e-mails sent by users. Canal+ has gone even further and has created interactive thematic games (predicting the results of football matches or Formula 1 races). The encoded channel soon intends to use advertising

banners to finance the Web site. For example, the cost of a banner on TF1 is 10,000 Francs for 15 days and 3,000 Francs for a week. At the moment, mainly commercial television channels (TF1, Canal+) and public channels (France 2, France 3) use the Internet. Their Web sites broadcast information, programmes, games, dossiers, and even tele-shopping promotions. Local cable or over-the-air television stations have yet to become interested in this medium. This is due to the fact that they have to deal with other, more pressing problems, most of which are financial.

Metz's cable television station is an exception. In fact, the city of Metz, in collaboration with France Télécom and the newspaper *Le Républicain Lorrain*, is experimenting with Webcasting via cable. Taking advantage of this experiment, which allows specific results of this technology to be analysed, TF1 will broadcast video films by cable. This is an example of a small-scale experiment done by a local cable channel which serves the interests of a large, national coverage commercial television channel in search of broadcasting networks with better definition (Laubier, 1997). Urban cable networks are the best places to set up a quality Web site, as they can benefit from a technology (cable) that provides them with good picture definition and the opportunity of creating interactive programmes (which a traditional telephone line does not permit). The situation is not the same for over-the-air channels which, for the moment, can only use the telephone network, a technology with limited transmission capacity. The experiment undertaken by the cable television station will not, however, be an isolated case, bearing in mind the interests at stake. In fact, France Télécom, which manages six cable television stations (Télésonne, Canal Avignon, TV Angers, Canal Marseille, TV Rennes and TV Fil 78, in Saint Quentin en Yvelines), has a privileged arena at its disposal to perform this type of test. In this sense, at MIP (Marché International du Programme de télévision), France Télécom demonstrated that the convergence between the Internet and television can also take place alongside computer users connected to the network. Bearing in mind that France Télécom wishes to participate in the new market firstly to develop high-speed multimedia channels (MGV) and fast Internet access thanks to its satellites and cable networks and secondly because it wants to become an editor (doing pilot experiments of Web TV convergence thanks to the thematic channels in which it is a shareholder), it is likely that audio-visual and telecommunications sectors will get closer and closer.

In February 1996 France Télévision launched a number of Web sites. In France 2's, the viewer can watch several broadcasts (*Télématin* and the 8.00 a.m. news). France 3, for it part, has opened a Web site whose editorial line is the same as the channel's: local information, proximity and oddities (http://www.france3.fr). The Web site provides access to local and regional news via its on-line consultation of local news. Up until now it had been impossible to receive a regional programme without being in the broadcasting area. The Internet has changed that situation since the

programmes broadcast on the Internet can be accessed by anyone anywhere in the world. That is how an experiment consisting of broadcasting some "all picture" broadcasts by France 3 on the Internet has allowed the company to establish that 30 per cent of the hits come from overseas. All of these experiments as a whole respond to France 3's desire to make greater proximity efforts by broadcasting regional news beyond the traditional broadcasting areas.

Furthermore, at the end of 1996 France 3 considered the possibility of creating a thematic channel called La Chaîne des Régions, aimed at the TPS platform. The project was suspended because of budgetary limitations imposed by the State (the new channel's annual budget was estimated at 50 million Francs), though it should be given the go ahead in 1998. To mark the launch of this new thematic channel, a Web site will be created.

So, an on-line news, broadcast and film market is emerging. Television stations which already have the proper technology (thematic cable channels), those which have major financial resources (TF1, Canal+, France Télévision...) or those which belong to cable operators wishing to diversify their market (local cable channels), already have, or will soon have, one or more Web sites on the Internet. Local over-the-air channels, on the other hand, find that they are somewhat left out of this new market of vast commercial opportunities.

Bibliography and References

Bourdon, Jêrome (1994): *Haute Fidélité. Pouvoir et télévision (1935-1994)*. Paris: Seuil.

CSA (1996): *Les télévisions de proximité*. Les études du CSA.

CSA (1996): *Les télévisions de proximité. Premier bilan de 140 expériences locales en France*. Paris.

CSA (1997): *Les bilans du CSA, Année 1996*. Paris: Service de Publications du CSA.

Daguerre, A. (1996): "Les télévisions de proximité à débat", en *Légipresse* (July-August).

Garitaonandía, Carmelo (1993): "Regional Television in Europe", in *European Journal of Communication* 8, 3 (September).

Indicateurs statistiques de la publicité 1996. La documentation française, 1997.

Joxe, Cécilia (1994): "Le local... par le câble", in *Dossiers de l'audiovisuel* 57 (September-October). Paris: INA-La documentation française.

Laubier, Charles de (1997): "TF1 se lance dans l'information et le téléshopping sur le net", in *Ecran Total* 19 (September).

Le Floch-Andersen, Lone (1997): "La mode du web" in *Sequentia*, vol. III, no. 10.

"Le serpent de mer des décrochages locaux de M6", in *Legipresse* (April 1996).

Ohayon, Daniel (1994): "Le national à la conquête du local", in *Dossiers de l'audiovisuel* 57 (September-October). Paris: INA-La documentation française.

Podguszer, Franck (1997): "Bernard Stiegler, au coeur de la galaxie numérique", in *Inamag* (September).

Quéré, Louis (1978): *Jeux interdits à la frontière*. Paris: Anthropos.

Various authors (1994): "Les télévisions de proximité", monograph of *Dossiers de l'audiovisuel* 57 (September-October). Paris: INA-La documentation française.

Translation: Steve Norris

Notes

1 The figures appearing in this chapter were taken from *Indicateurs statistiques de la publicité 1996*. Paris: La documentation française, 1997.

2 "Le serpent de mer, des décrochages locaux de M6", in *Légipresse*, April 1996.

Germany: Continuity of the *Länder* system and the rise of urban television

Hans J. Kleinsteuber, Barbara Thomaß

1. The regional dimension of the State

There is a German paradox. It is the country with probably the most extended federal system in Europe which implies the existence of strong regions. At the same time 'region' is not a prominent term in German politics; it certainly shows little indication of repression of minorities and protest movements or the resistance of peripheries to the centre. If it is used, it refers mainly to the administrative dimension of sub-national politics, how to define a regional unit and build a respective administrative infrastructure to serve it. The term 'region' also refers to historical, cultural and folklorist particularities of parts of the country.

The reason for this understanding of 'region' is twofold:

(a) Germany has a very long tradition of extreme political and economic decentralisation, which is reflected today in the federal political system and the fact that there is no economic or cultural centre in the country;

(b) Germany has a rather high cultural homogeneity; with very few exceptions there is only one undisputed language, one accepted culture (regional variations are mainly folklorist) and the strong identification with a region does not clash with the feeling of belonging to the German national state.

Table 1. Socio-economic indicators of the *Länder*, 1996

Land	Population (1,000)	Area (sq. km)	GPD (billion DM)	Unemployment rate (July 1997)	Population (%)	Share of GDP in %
Baden-Württemberg	10,374	35,752	510,500	7.7	12.65	14.4
Bavaria	12,043	70,550	596,500	7.0	14.69	16.8
Berlin	3,459	890	150,500	15.9	4.22	4.3
Brandenburg	2,554	29,478	67,900	17.7	3.11	1.9
Bremen	678	404	39,200	15.4	083	1.1
Hamburg	1,708	755	136,700	11.7	2.08	3.9
Hesse	6,027	21,114	343,500	9.3	7.35	9.7
Mecklenburg-Vorpommern	1,817	23,170	44,400	18.6	2.22	1.3
Lower Saxony	7,815	47,611	315,100	11.5	9.53	8.9
Northrhine-Westphalia	17,948	34,070	788,300	11.2	21.87	22.3
Rhineland Palatinate	4,006	19,846	150,300	9.1	4.89	4.2
Saarland	1,084	2,570	43,800	12.5	1.32	1.2
Saxony	4,546	18,413	116,400	17.1	5.54	3.3
Saxony-Anhalt	2,724	20,446	66,200	20.5	3.32	1.9
Schleswig-Holstein	2,742	15,770	110,700	9.7	3.34	3.1
Thuringia	2,491	16,171	61,000	17.7	3.04	1.7
Total Germany	82,012	357,022	3,541,000	-	100.00	100.0

Source: *Fischer Weltalmanach*, 1998

In the European Union, Germany (perhaps together with Austria) tends to represent the element of decentralisation, it has also introduced the idea of subsidiarity in the European process of integration. The adherence to these principles is not without contradictions: in certain parts of Germany elements of centralisation and strict exclusion of small-scale initiatives may be found.

During the last quarter of a century Germany has also become a country with a high proportion of immigrants; today nearly 10 per cent of the population are "foreigners" (at least this is what they are called). But as they are spread all over the country, the mosaic of ethnic minorities has no dominant regional dimension (Turks, Arabs, Greeks, Spanish, Portuguese, Serb-Croats, etc).

1.1 The general political framework of the State and the role of the regions

Germany happened to be one of the "late" national states in Europe. The Second Reich was founded only in 1871 after a war against France which was seen at that time as the "arch-enemy". Looking back into history we realise that a feeling of belonging to a German culture is much older than any German state. In fact the geographical part of Europe that is called Germany today looked like a patchwork of a large number of mid-sized

kingdoms, small principalities and independent republican cities. They claimed state sovereignty, but were at the same time members in a rather weak old German Empire that finally vanished in 1806. This old Empire covered much larger territories than today's Germany and was at times governed by emperors who were not even of German origin.

The old Germany was based on a clear separation of culture and politics. The Germans were culturally united by the use of their common language. The space, where German is spoken today, was much determined by the use of the German language Bible that goes back to Martin Luther's first translation. Politically, this part of Europe was administered by a combination of rulers from quite different backgrounds. Let us take the example of Hamburg – which will be the prime example in this contribution. This port city itself is an ancient republic, going back to the times of the Hanse, was dominated by a trade aristocracy. The agglomeration Hamburg included more independent towns, one was Altona, governed by the Danish king – like all territories north of Hamburg – until 1864. This decentralisation supported Hamburg in becoming an early media centre, not just because of the port communication lines, but also because the publishers could easily escape censure by moving to one of the neighbouring towns.

For a long time, being German meant that a person identified with cultural achievements like poetry and philosophy, music and science as they had developed around the German language. As a politically united Germany had to be created against the old reigning dynasties, creating a national state was seen as a subversive, politically leftist goal. Unfortunately, the national revolution of 1848-49 failed and the modern German state of 1871, was instituted "from the top": the German Empire was founded by its old crowned leaders and the king of Prussia was chosen as the new emperor. The resulting political structure accepted the realities of existing strong dynastic states. These states survived the revolution of 1918 which ended the monarchy and became *Land* (plural: *Länder*) an integral part of the present federal system. Quite a few important jurisdictions remain with these *Länder*, the most important being that of culture – referring for example to schools, universities – and later to broadcasting.

A special characteristic of the German type of federalism is a unique two-chamber-system: on the national level that includes the usual national parliament (*Bundestag*) and a second body (*Bundesrat*), consisting of representatives of all *Länder*-governments. The *Bundesrat* represents an accumulation of considerable power. Through the *Bundesrat* the *Länder* always share power on the national level; as opposition parties in Bonn (and in the future in the new capital of Berlin) tend to be strong on the *Länder*-level, they are always involved in national politics as well. Due to the federal system, the country is somehow continuously governed by a "Grand Coalition".

The Basic Law of 1949, the present German constitution requires an examination of the existing federal system and redistribution of the *Länder*

territories to move away from artificial borders and introduce a more balanced system in terms of size and population. As consent about the *status quo* is widespread and politicians profit from the existing system, the chances for change are negligible. The *Länder* Brandenburg and Berlin (being an island inside Brandenburg) attempted to merge, but citizens objected and politicians lost a plebiscite so that the *status quo* was maintained.

The *Länder* system is well established and based on a national consensus. This appreciation is enforced by the fact that the last attempt to establish a centralised state – together with a centralised broadcasting structure – was made by the Third Reich. The federal system is well written into the Constitution (Article 20 of the Basic Law), protected by a guarantee that it may not be abolished, not even by the procedure for changing other sections of the constitution (Article 79). The process of unification in 1990 took place after the federal principle was reintroduced in the former GDR, subdividing its territory into the five historical *Länder* that had been taken away by the Communists in 1952. These *Länder* then joined the Federal Republic individually and adopted the Basic Law.

Today's 16 *Länder* see themselves as the main representatives of the regions, and therefore claim exclusive representation in the newly established Council of Regions of the EU. Partly they are historical entities being centuries old, as in the case of the ancient Kingdom of Bavaria, meanwhile, others such as North Rhine-Westphalia, have been artificially created to succeed Prussia after the Second World War. Some of them cover a large territory, like Bavaria that is twice the size of Belgium. Some are densely populated, like North Rhine-Westphalia which has more inhabitants than the Netherlands. Other *Länder* are relatively small, especially as three are city-states (Berlin, Hamburg, Bremen). The smallest of them, Bremen, having less than 700.000 inhabitants (and with Radio Bremen the smallest broadcasting corporation in the country).

In Germany people identify with their local or regional home or native place, for which they use the term *heimat*, where they grew up and developed a strong feeling of belonging. Besides the three city states, most of the *Länder* are too large to be seen as *heimat*. Instead the *Länder* comprise a number of different regions. The Eurostat *Portrait of the Regions of Europe* subdivides Bavaria into seven regions, Lower Saxony into four. The *Land* of Hamburg is seen as one region. Also historical regions like Swebia (in the south) might be administratively divided. Inside the *Länder* a relatively high degree of centralisation may be found, being a cause for complaint: Franconia lost its independence roughly 200 years ago to Bavaria and the people around Nuremberg still feel somehow "colonised" by the Bavarians of Munich.

The concept of a "region" is not clearly defined in Germany. A common definition separates the functional regions – fulfilling economic, planning functions – from the historical and/or political regions. Functional regions

usually reflect the territorial changes that came with the processes of industrialisation, urbanisation, and modernisation. The most often quoted example for a functional region is the Ruhr Valley, one of the large industrial agglomerations in Europe, located inside North Rhine-Westphalia. To cope with common problems of planning, infrastructure, environment etc. the communities involved established a rather powerful and well respected association, called *Kommunalverband Ruhrgebiet*. Functional regions of this type may be found all over the country.

The political region is a territorial authority and characterised by borders. Most definitions see the region in size below the *Länder* but above the level of local communities. The political level above local communities is usually the district (*Kreis*), having an elected parliament and an administrative superstructure. Several districts are bound together and constitute a *regierungsbezirk*, a purely administrative entity. The German understanding of "region" mostly refers to this intermediate level. A different case are the three city-states that in themselves come close to the concept of a region or a very small *Land* like the Saarland.

1.2 The culture-language dimension

Germany has no relevant minorities to speak of. This is mainly the outcome of two wars started and lost by Germany and the resulting re-arrangement of national borders. An established minority is that of a little more than 30,000 Danes in the very north, south of the Danish border, kept together by a Danish language newspaper. Another group are the 40,000 to 60,000 Sorbs in the Lausitz, speaking a Slavic dialect, enjoying some autonomy and again having a newspaper of their own. There are few complaints of their minority rights not being respected.

The area where Sorbs live is covered by two different radio-television corporations, ORD and MDR. This collective is divided into two linguistic groups, one close to Polish and the other one to Czech. While on the radio there are programmes for both communities, there is only a half hour television programme called *Luzyca* which is broadcast every third Saturday at 13:30. It is produced by the Sorbs and is addressed to their community, as well to those interested in their culture and language. For the Danish minority there are no special television programmes and the community is inclined towards Danish television.

A new element in German society are the approximate 7.3 million people, that are legally described as "foreigners", even though they may have lived in the country for more than a quarter of a century. The term "foreigner" refers to the fact that German nationalisation laws make it difficult for these people to gain German citizenship. Culturally they may have already adopted the German way of living. It makes more sense to call them German-Turks, German-Arabs etc. Many of them were invited to come as workers, others came seeking political asylum. For the larger foreign groups,

special editions of domestic papers, modified for the German market, are offered, eg three major Turkish newspapers for Turkish-German citizens.

For many years the fact that Germany is a country with high immigration has been virtually ignored by politicians. With the increase of hostilities against foreigners, often initiated by neo-nazi elements, a discussion of their rights and the way to integrate them into the German society has just begun. As they come from a large variety of ethnic backgrounds and are dispersed over most of the country, their problems are certainly those of minorities, but should not be interpreted in terms of regional politics. So far the German media system has not taken much interest in them. Foreign households have only recently been included into the national TV-rating-system (GfK). In 1998, 440 foreign TV-households are being monitored.

The largest group are about 1.85 million Turks that have established a media network of their own, including newspapers, video libraries and TV-programmes that come via satellite from Turkey and are offered on cable systems. The public broadcasters also offer some TV-programming for the larger migrant groups, including the Turkish, Greek, Spanish, Portuguese and Serbo-Croatian languages. Foreigners especially use the public access channels (see below).

If Germans were asked about the region they live in, they would probably describe their narrow environs, often quoting more than one region they adhere to. For example, many of the people that call themselves Hamburgers actually live in suburbs that belong to neighbouring *Länder* in the North and South (the largest "city" of Schleswig-Holstein is also Hamburg, they say). Politically they might identify with their suburban hometown, belonging to Schleswig-Holstein, they read either a local or a Hamburg newspaper or both, they probably listen to a Hamburg radio station and watch regional TV either from Hamburg or from Kiel (the capital of Schleswig-Holstein). In terms of broadcast ratings they are seen as part of the market of Hamburg. They have a choice between Hamburg and Schleswig-Holstein media and may decide either way. This can be seen as a reflection of the somehow split regional adherence that come with today's multi-spaced living.

The traditional media of the region are the daily newspapers. Newspapers have a high distribution rate; about 90 per cent of them define themselves as being local or regional, and because of this they are called "*heimat*-press". Even a nationally available paper like the tabloid *Bild* is edited in regional editions. National papers also demonstrate their regional affiliation like the *Frankfurter Allgemeine Zeitung* (Frankfurt) or *Süddeutsche Zeitung* (Munich) by referring to the place they come from. This reflects the fact that media activities are not concentrated in one metropolis in Germany. Instead a number of media centres (Hamburg, Munich, Berlin, and Cologne, among others) fiercely compete with each other. The old capital, Bonn, was always a media wasteland, only housing correspondents working outside media.

2. Television's legal setting

2.1. Legal framework of television in Germany

To continue we are going to analyse in detail the *Länder* system, as it is absolutely crucial for the understanding of the German broadcasting system. The constitution renders final authority on all cultural matters to the *Länder* – there is no Ministry of Culture in Bonn – and all questions of broadcasting are legally seen as falling into this category. This interpretation of the Basic Law was upheld in a key decision of the Federal Constitutional Court of 1961 – and repeated several times thereafter – outlawing a commercial TV-company licenced by the Bonn government. The federal government is not totally excluded in intervention in radio-television: one means of influence in broadcasting is the recently privatised company Deutsch Telekom, which handles most of the technical side of broadcasting. Another exception is broadcasting directed towards the rest of the world, Deutsche Welle, a federal institution, which is in charge of this aspect. All other broadcast activities, public or commercial, are based on laws passed by the *Länder* parliaments, or written down in agreements that were signed by some or all of the *Länder*.

2.1.1. Public television

The most common case is that one *Land* established one corporation (*anstalt*) for public service broadcasting (like WDR in North Rhine-Westfalia or BR in Bavaria). In a number of cases several *Länder* agreed to maintain one joint corporation. This last case is represented by NDR for Schleswig-Holstein, Hamburg, Lower Saxony, later incorporating Mecklenburg-Vorpommern. The actual structure is often determined by political events of the past. As such, the French occupation zone still lives on in SWF, covering Rhineland-Palantine and parts of Baden – Württemberg. North Rhine-Westphalia's WDR was cut out from the Hamburg based NWDR (now NDR) by the ruling CDU, party as it was considered as being too close to the rival SPD-party.

The rule is that the *Länder* corporations are under heavy political pressure from the governing party of the respective *Land,* with some proportional representation for the opposition party. This political approach has often been attacked, but it guarantees that the *Länder* Minister Presidents have a stake and vital interest in the well-being of "their" broadcast corporations. After the unification of Germany, three eastern *Länder*, all controlled by the CDU-party, established the new corporation MDR, meanwhile, the SPD-government of Brandenburg founded the small ORB.

Public broadcasters, being a creation of the *Länder*, are required by law to report on the respective *Land*. The statutes of Norddeutscher Rundfunk (NDR) for example require the corporation, to provide "an objective and comprehensive overview of international, national and *Länder*, related

events" and "the regional pattern has to be properly taken into consideration" (*Staatsvertrag über den Norddeutschen Rundfunk 1991*, sections 5.1 and 5.2.)

Table 2. Public Broadcasters of the *Länder* (1994)

Full name	Starting date	Initials	*Länder* covered
Bayerischer Rundfunk	1948	BR	Bavaria
Hessischer Rundfunk	1948	HR	Hesse
Mitteldeutscher Rundfunk	1991	MDR	Saxony, Saxony-Anhalt and Thuringia
Norddeutscher Rundfunk	1955	NDR	Lower Saxony, Hamburg, Schleswig-Holstein and Mecklenburg-Vorpommern
Ostdeutscher Rundfunk Brandenburg	1992	ORB	Brandenburg
Radio Bremen	1948	RB	Bremen
Saarländischer Rundfunk	1957	SR	Saarland
Sender Freies Berlin	1953	SFB	Berlin
Süddeutscher Rundfunk	1950	SDR	North of Baden-Württemberg
Südwestfunk	1950	SWF	Rhineland-Palatinate and south of Baden-Württemberg
Westdeutscher Rundfunk	1955	WDR	Northrhine-Westphalia

Source: ARD.

The public corporations already offered *Länder*-wide radio programmes before the advent of television. In fact there never was significant national public radio in Germany. In 1954 the first TV-channel was started as a joint venture of all existing broadcasters, called ARD (Arbeitsgemeinschaft der öffentlich-rechtlichen Rundfunkanstalten Deutschlands). The federal structure was built into ARD as all *Länder*-corporations offer a fixed share of national TV programmes, based on a quota system. Very little programming (news, sports) was produced jointly, the centre of this decentralised system was established mainly for transmission purposes. This principle is still working with ARD, ensuring that TV-reporting and entertainment is produced in different regions of the country and reflects regional differences. For instance an established detective-series (*Tatort*) is produced by different corporations and uses cities in the different *Länder* as background of its "regionalized" stories.

The second channel ZDF (Zweites Deutsches Fernsehen, "Second German Channel") established in 1961, was legally based on an agreement, signed by all *Länder*. The national headquarters was built in Mainz, the capital of Rhineland-Palantinat and until then was not a place of any media significance. The programme of ZDF is not regionalized, but *Länder* politicians are heavily represented in its supervising TV-council. Also,

beginning in the early 1960s, the *Länder*-broadcasters started to introduce regional Third Channels that today represent the main regional element in television.

For many years the first channel (ARD) carried a "window" (disconnection) for a daily *Länder*-wide regional news and entertainment magazine. This has recently been moved to the Third Channels, to offer ARD as a national advertising medium. The multi-*Länder*-corporation split up their Third Channel to offer regional programming for each *Land*. Public television is rarely regionalized below the *Länder*-level. In some parts of the country, public radio offers special programming for smaller areas, but public local radio is the exception.

2.1.2. Commercial Television

The *Länder* also have final responsibility for commercial broadcasting. For this purpose, 15 new supervisory bodies, *Landesmedienanstalten* were established by the 16 *Länder* (Berlin and Brandenburg maintain one joint body) since the 1980s, that hand out licences and regulate the activities of broadcasters based inside their borders. Referring to more local media such as radio, this form of decentralised supervision makes sense, but obviously television tends to be a national medium. The directors of these supervisory bodies closely co-operate and decide which of them licences national TV-producers. In addition, they forced national broadcasters in a form of bargaining process to offer some *Länder*-wide programming in exchange for the use of (much sought after) terrestrial frequencies. But this worked only in parts of the country and excludes satellite-TV that transmits direct-to-home (which is widely used in East Germany). In Berlin an attractive regional frequency was given in 1993 to an international consortium *IA Brandenburg* (see below).

It has been claimed that this system of 15 supervising bodies, which is unique, is much too fragmented and each body is too weak to check large media companies. The process of licensing also turned out to be heavily politicised, the *Länder*-governments supporting TV-producers according to their political affiliation and those that promise to work out of their *Land*.

2.2. Legislation about regional television

According to the legal basis of public service as well as commercial TV, both are considered regional by principle, meaning their legitimacy rests with *Länder* law. This is of course reflected in the many broadcasting laws that are effective in Germany. The wording of respective laws differs, but in all probability they refer to the *Land* or region and demand special consideration.

As already mentioned NDR is the public broadcaster of the North but the organisation itself is regionalized. The agreement (*Rundfunkstaatsvertrag*)

between four *Länder*, which constitutes this co-oporation, stipulates that there is not just one headquarters in Hamburg. In the capital city of each *Land* there has to be an independent regional station with complete equipment, extensive staff, large studios, production facilities etc called *landesfunkhaus* (*Land* radio-television centres paragraph 2 of *Staatsvertrag über den Norddeutschen Rundfunk*). Another rule demands that the regional differences of the territory shall be considered with due regard (paragraph 5). In the programming produced especially for a *Land*, the *landesfunkhaus* has to especially reflect public activities, political events and cultural life (paragraph 8).

Similar regulations may be found for regional commercial broadcasters. In this case each of the Northern German *Länder* established a separate law. Hamburg again serves as an example, and its law uses a similar structure to the one that affects the public service (cf paragraph 6 of *Hamburgisches Mediengesetz* follows the editing of the paragraph 8 of the aforementioned treaty). A special duty for the *Land* supervisory body (in Hamburg, Hamburgische Anstalt für neue Medien, HAM) is to decide which programmes will be fed into the cable systems of the city (usually owned by Deutsche Telekom). A ranking is prescribed which puts programmes on top which are of a public service nature and legally provide for Hamburg (the NDR); also ranked highly are commercial programmes that have been licenced by the HAM to specifically serve Hamburg and a Public Access Channel (see below). Second ranking are programmes that can be received in Hamburg by terrestrial transmission but come from the outside. The lowest rank is reserved for programmes which are provided by foreign broadcasters (paragraph 44).

Another regional element comes into the composition of the supervisory body. Lets us take the eleven member board of the HAM. The law enumerates organizations in Hamburg that are eligible to propose representatives to the Hamburg parliament. This parliament makes the final selection; among them are Hamburg churches, trade unions, the chamber of commerce, womens' organizations etc (paragraph 55). In fact, it is agreed, that people from Hamburg make the final decisions on broadcasting matters in their respective *Land*.

All this gives the impression of a strong regional element in broadcasting. This is only partially true. First, many regulations do not protect the region as such, but much rather the political majority influence in the respective region. For example, the NDR might be under the influence of one party (the Social Democrats are leading in the North and exert strong influence in NDR). But in one *Land* the Minister President represents the conservative Christian Democratic Party (CDU) and he is allowed to exert pressure upon his respective *Funkhaus*. Secondly, the significance of regional TV is low. Viewers show only limited interest, advertising money is short and because of technical developments a quickly increasing

number of national and international programmes compete with local production (see below). This implies, thirdly, that bodies like the HAM are losing importance, even though they might attempt to protect whatever local TV-production is available. Fourthly, the actors on the regional market my be national media companies that do not show much interest in regional affairs and prefer to market their national programmes.

3. Institutional and business structure of television as a whole

The institutions of public television have been established by the *Länder* and as such "ownership" rests with them. The financing of these corporations is regulated and decided upon by all *Länder* parliaments on the basis of an agreement among them. In 1998 each TV-household in Germany has to pay a monthly fee for public radio and television of DM 28.25 (for television alone it is DM 18.80). This money is first distributed between ARD and ZDF, the ARD money again is re-distributed between the *Länder* according to the size of population.

Some corporations in small *Länder* – this applies especially to Bremen (BR) and Saarland (SR) – have too little support to survive by themselves. They are in need of support. This has been a tough issue of media politics during the last years, because large corporations (like WDR, NDR, and MDR) want to keep all their respective money and demand re-consolidation in larger and financially sounder corporations. But this would mean that regions become larger (NDR provides for four, MDR for three *Länder*) and support for regional particularities withers away. In the small Saarland, for example, the corporation SR maintains the only symphonic orchestra of the *Land*. What happens if SR disappears?

It should be recognised that the monthly fee actually finances some more special interest channels. These are in 1998: ARTE (German-French cultural programme), Kinderkanal (children's programme without advertising), Phoenix (documentaries, parliamentary reports, special events) and 3Sat (German language cultural programmes, managed together with Austrian and Swiss public service corporations).

Commercial television was advocated in the 1970s in order to create much more diversity than offered by public broadcasting. Not much of that intention has survived. Today ownership of most TV-channels rests in the hands of two media conglomerates, being the largest media actors in the country and even beyond. They like to call themselves "sender families". One is the Kirch Group of the ageing film trader Leo Kirch and his son Thomas, including the full programme channels Sat1, Pro7, the secondary channel Kabel and the sports programme DSF. Kirch also controls a decisive share of the largest publishing company Springer (being the largest publishing house in Europe). Bertelsmann is the other conglomerate, actually the largest media company of Europe. In an alliance with the Luxembourg CLT they control all European RTL-channels. In

Germany, their "sender family" includes RTL (the most popular programme in the country), RTL2 and partially SuperRTL and VOX. Both "families" together receive about 90 per cent of all advertising money that flows into commercial TV. Kirch and Bertelsmann/CLT jointly own the only pay-TV venture Premiere and have agreed to develop digital television together, creating a *de facto* monopoly in this future market, but the European Commission finally prohibited this alliance.

The dominance of the two "sender families" is of significance for television in the region. Springer is the leading publisher of regional newspapers (national market share around 24 per cent, and 80 per cent for "boulevard -type" press) and its owners, Kirch among them, prefer to keep TV national so as to limit competition with regionalized newsprint. The same applies to Bertelsmann who also has significant newspaper interests in the region.

4. Structure and characteristics of television in the regions

4.1. Public service regional TV

Until the middle of 1993 the regional TV-programmes of the *Länder* were offered on the first channel (ARD) through disconnections ("windows"). They consisted of a magazine of about 30 minutes reporting on general interest topics like regional politics, economics, culture, and weather but also "soft news" and entertainment with a regional accent. In two respects they played a crucial role in the broadcasting system of Germany. Firstly, the Federal Constitutional Court had demanded that the public broadcasters provide the country with a "basic supply". Therefore, the *Länder* corporations are obliged to offer a comprehensive and integrated programme. This was interpreted as meaning that even minorities of audiences have to be served if that is not done by any other broadcaster, including reporting about the *Länder*. Public broadcasters saw their regional magazines as one of the ways to fulfil this demand.

Secondly, regional programming on the first channel was important for the revenues of the ARD-corporations. They get most of their income from monthly user fees, but about 4 per cent (this share went down because of commercial competition) of all income is derived from around 22 minutes of advertising each weekday (ARD, 1997: 154). These advertising spots are broadcast during intermissions of the programme between 17:00 and 20:00. As regional programming was not as attractive to viewers and advertisers as pure entertainment material, the ARD-corporations decided to move regional programming away from the first to the third channel (which is free of advertising). This move made it possible for the ARD-corporations to offer a comprehensive nation-wide programme and become a national advertising medium. This decision was interpreted as implying a decline in the significance of regional reporting. On the other hand, the third channels of the *Länder* traditionally had audiences mainly interested in culture and

education and their ratings were relatively low. According to recent data though, the audience decline, due to the shift to the third channel, seems to be low.

The presence of regional elements on the first channel is now limited to 10 minutes of regional information as a "window" in an otherwise nation-wide programme at 17:40. Some of the entertainment series however, which harmonised for all *Länder*, fill the programme of the first channel during the time between 17:40 and 20:00, and are produced with a regional background and story in mind.

The second national channel (ZDF) does not offer special programmes for regions or sub-regional territories because of its centralist structure. Nevertheless, it has a few programmes with reports from different regions which are broadcast nation-wide: *Länderspiegel*, *Hallo Deutschland* or *Blickpunkt* (about the *Länder* in the former GDR) are specialised on regional and/or local subjects.

As was pointed out, the third channels were created to serve a *Land* or a combination of several *Länder* with television. Since the middle of 1993 they provide practically all of regional programming, the daily regional magazine being the most important contribution. The third channels start their broadcasting time in the morning with educational programmes and end late at night. WDR started to offer a 24-hour-programme beginning in 1994. News programmes are concentrated in the time before 20:00. Since the beginning of the 1990s the third channels expanded their regional news and magazines considerably. They were at 524 minutes daily on all eight channels in 1992, and increased only until 1994 to 1.041 minutes. This trend is supposed to continue (Brüssau 1997).

4.1.1. Regional programming

Regional TV-magazines

The regional magazines of the third channels mainly cover the news of the *Landër*, although they also include references to national and international news only if they are related to a regional subject. On the other hand, the national news of the first channel is re-broadcast by the third channels in determined time slots.

The landscape of regional TV-magazines is quite diverse. NDR for example broadcasts a magazine of 45 minutes, starting at 18:45, called *DAS!* (*Das Abendstudio*), which contains not only themes from the four *Länder* which NDR has to serve, but also topics of nation-wide interest. The following 30 minutes are dedicated to magazines for each of the four *Länder*, coming from studios out of the *Land*-capital: Hamburg (*Hamburger Journal*), Schleswig-Holstein (*Schleswig-Holstein-Magazin*), Lower Saxony (*Hallo Niedersachsen*) and Mecklenburg-Vorpommern

(*Nordmagazin*). Besides those, there are two time slots of five minutes at 17:25 and 18:35 for regional news.

WDR as another example broadcasts 30 minutes of North Rhine-Westphalia news each day (*NRW am Mittag*), followed by a daily interview of 30 minutes (*NRW im Gespräch*). A general interest magazine of 40 minutes, called *Aktuelle Stunde* about the area also contains sports. Besides this, WDR offers 55 minutes of information in nine "regional windows" to different parts of North Rhine-Westphalia (*Lokalzeit*). They are broadcast in four different time slots between five and 30 minutes. With these programmes the WDR offers the biggest supply of regional information.

To give an example, the *Hamburger Journal* is described in more detail. This 30 minute per weekday programme for the city – *Land* of Hamburg – is produced in a special subsection of NDR, the "Landesfunkhaus Hamburg" which enjoys significant independence from the main NDR organisation. The regional magazine is produced by a staff of approximately 16 fully employed journalists and another 30 freelancers. (Klar 1997: 58) According to NDR sources the average market share of the *Journal* has been 24.3 per cent in the last quarter of 1996 (Klar 1997: 59). Despite the increasing competition in a multi-channel environment this market share has been gradually increasing in the last years. But in the mid-1980s, when the *Journal* had a virtual monopoly and only three public channels were available, the market share reached about 40 per cent. In addition, the *Landesfunkhaus* produces some occasional programming for the Northern German third channel (N3) like *Nordmagazin* or *NordZeit*.

The other three *Landesfunkhäuser* of the four-*Länder*-corporation NDR offer similar services. By far the largest of the four NDR-*Länder* is Lower Saxony, which consists, according to Eurostat, of four regions, Braunschweig, Hannover, Lüneburg and Weser-Ems, and they are only reflected in regional studios contributing to the *Land*-magazine, not in any regional programming. Providing such a large area with a magazine might contribute to the fact, that *Hallo Niedersachsen* has considerably lower ratings than the other *Länder*-magazines.

Other regional programming

Besides these daily magazines, the third channels broadcast other types of more infrequent programming which represent aspects of the region. This includes programmes with typical music, talk shows – in which important people of the region participate – and documentaries on regional culture. Another aspect are special shows that support regional speech, produced for example in Low German (*plattdeutsch*), as is typical for Northern Germany. Many of these programmes with a regional accent reflect somehow a folklorist view of the *Länder*. Their attraction

for audiences and their appeal concerning regional identity is therefore limited.

The news programmes of the third channels put a special emphasis on the internal diversity of the *Landërs,* through the delegations they have in different parts of the country. For example, in Lower Saxony there are delegations in Braunschweig, Oldenburg and Osnabrück. The radio-television of Bavaria, BR, has delegations in Würzburg y Regensburg, that cover the very diverse Mainfranken and eastern Bavaria regions. The third Bavarian channel, broadcasts a special information programme to four different zones of the *Land,* through disconnections that take place twice per week. As the third channel of the NDR is already divided between the *Länder* that constitute it, there is no regionalization below this level. The internal matters of Lower Saxony are reflected in the correspondent information magazine of the *Land*.

A special service of regional information plates is offered by all third channels on teletext (that are called *videotext* in German). NDR's Nordtext on N3 provides some daily information on Northern German politics and the economy, culture (schedule of theatres), the environment (latest data on air pollution) etc. Even the audience ratings of N3 from the day before are presented.

The third channels of WDR (West 3), NDR (N3), MDR (MDR Fernsehen) and BR (BFS) are transmitted via satellite and may be received via cable or satellite antenna in other parts of Germany and Europe. But this has little significance in terms of ratings. It implies however, that people, living elsewhere have the chance to receive some information from their home region, if they should wish to do so.

While the share of audiences of public broadcasting have fallen drastically during the last years, suffering due to competition with commercial TV, the third channels' audiences did not lose to the same extent. While the First (ARD) and Second (ZDF) Channel lost nearly half of their audience, the third channels declined from 11 per cent to 8.3 per cent in 1992 and went up again to 11.5 per cent in 1997. Within the *Länder*-corporations the common third channel of Saxony, Thuringia and Saxony-Anhalt was the most successful in 1996 (see Table 3).

Until the beginning of the 1980s, the *Länder*-corporations offered a comprehensive programme for the *Länder* as such, not considering the regions below that level or local entities. They tended to recognise the so-called "division of power" in the media between public *Länder*-broadcasters and commercial print media which controlled regional and local markets, often as monopolists. The dawning of commercial broadcasting in 1984, with its possibilities of local radio and television, brought an end to this mutually recognised division. It intensified plans within the public broadcasters of moving into smaller regions.

Table 3: Share of audiences of the public regional TV in 1996 (%)

Bayerisches Fernsehen BFS (Bavaria)	9.8
Hessen 3 (Hessia)	10.7
MDR Fernsehen (Saxony, Saxony-Anhalt, Thuringua)	11.6
N3 (Schleswig-Holstein, Bremen, Hamburg, Lower Saxony,Berlin, Mecklenburg-Vorpommern)	10.6
Fernsehen Brandenburg (Brandenburg)	11.4
Südwest 3 (Rhinland Palatinate, Saarland, Baden-Württemberg)	9.9
West 3 (North Rhine-Westphalia)	8.6

Source: *ARD Jahrbuch 1997*: 381.

Offering TV and radio programmes *Länder*-wide was considered as insufficient for the regions. The public broadcasters commissioned a number of studies on how to subdivide their service area, therefore most of the research results on regionalization were produced during the 1980s. As a result, public radio in some parts of the country now offers special programming for smaller areas, but public local radio is the exception.

Providing the same in the TV programmes was estimated to be too expensive. Consequently there is only little regionalized TV offered below the *Länder*-level. WDR in North Rhine-Westphalia, being the most populated *Land*, maintains a number of regional studios which make it possible to offer real regional programmes besides the daily *Land*-magazine. Multi-*Länder*-corporations like NDR and MDR split up their third channel to offer regional programming for each *Land*.

4.2. Private regional TV

Commercial broadcasters in Germany are licenced (with few exceptions) for nation-wide transmission and are interested in serving markets as large as possible. They started out as cable programmers, but as they could not reach enough audiences by cable they sought terrestrial frequencies, which are franchised by the *Länder* supervisory bodies. When RTL and SAT.1, the two main commercial TV-companies in Germany, applied for terrestrial frequencies in the *Länder*, they were asked to offer a regional TV-magazine in return. But following the commercial logic, regional programming was considered by the broadcasters as a burden rather than a chance. It seemed to be too expensive and too unattractive in terms of costs and advertising income. Today we find regional programming by commercial companies only in some *Länder*. Mostly in the attractive markets of densely populated regions, regional "windows" were opened where they report during 30 minutes about current affairs of the region.

These magazines, called *Live aus...* within SAT.1 and *Guten Abend RTL* within RTL emphasise "infotainment" and prefer human interest stories

referring to the region. Again Hamburg is the example: adding all regional magazines up, each weekday, three programmes (by NDR, SAT.1, RTL) are offered besides the urban television channel Hamburg 1 (see below).

SAT.1 has developed a rather dense network of regional magazines. Its *Live aus...* is produced in seven versions (in the beginning of the 1990s this had been nine). In comparison to the former regional magazine *Regional report* which was, for example, started in Hamburg in 1988, the length of *Live aus ...* was reduced from 35 to 30 minutes. Within this half an hour between three and eleven minutes of advertising are broadcast. The seven regional magazines are produced by a staff of 125 fully employed journalists, and they reached an average market share of 11.4 per cent in 1997.

RTL reduced its regional magazines from six to four. Most of them were concentrated in the north: *Nord live* was broadcast for Hamburg, Lower Saxony and Schleswig-Holstein. These three magazines were produced in Hamburg by an independent company, the Kommanditgesellschaft HRB Hamburger Rundfunk Beteiligungsgesellschaft mbh & Co. Started in 1988 and 1989 they reduced their length in the beginning of 1994 from 45 to 30 minutes. Now there are three remaining magazines of 30 minutes called *Guten Abend RTL* each for the north, the west and Hessia. For the rest of Germany a general *Ländermagazin* of the same length is broadcast. Within this half hour, three blocks of advertising are broadcast. The four magazines are produced by a staff of 61 fully employed journalists (North: 30, *Ländermagazin*: 7). They reached an average market share of 15.2 per cent in 1996. RTL is quite unhappy with the necessities of those regional windows, because the advertising income of 15 million DM does not cover, by a long way, the production costs of 50 million DM (*Media Spectrum* 6/1997: 6).

In some areas, eg in the north, the time schedules of all regional magazines are co-ordinated by the supervisory bodies of the *Länder*, so that the companies do not compete during the same time slot for the regional advertising market. Together with the programmes of Schleswig-Holstein, which may be received in Hamburg as well, regional programmes amount to three hours every day. The fact that these regional offerings were forced upon the media companies is outweighed by another advantage. Media companies which exceed a market share of 10 per cent, are obliged to leave broadcasting time to small companies. The regional windows can be taken into account for this duty.

The important media companies more or less ignored the region for a long time as an area for television activities. The main reason is that according to what the companies say, programmes with regional content cater for small audiences, produce only limited advertising revenues and are highly unprofitable. Based on this argument, RTL in Hesse even managed to reduce its time for regional programmes to half an hour, although its licence obliged the broadcaster to offer one hour of programming. They are

considered to be a heritage of media politics of former times which is no longer adequate. On the other hand a new trend of discovering the local advertising market arose.

4.3. A new trend: Urban commercial broadcasters

Since 1994 the situation has changed as new terrestrial frequencies have been made available for local and regional programmes. As a consequence, 10 years after the beginning of commercial broadcasting, the big media companies started a race for licences of regional TV. The most attractive places for regional TV are big cities and regions with a dense population. Until now eight stations have started their programme in such areas: three in Berlin (PulsTV, FAB and the Turkish-German TD 1), one in Hamburg (Hamburg 1), Karlsruhe (TV Baden), Nuremberg (Franken Fernsehen) and two in Munich (TV München, and M 1).

The first regional programme based on this new concept (IA Brandenburg, after a relaunch in May 1996 called PulsTV) started in February 1993 in Berlin and its environs. It had at its disposal the largest budget in comparison with similar stations which followed. But within four years it accumulated losses of 140 million DM. Although the concepts of programming were restructured and three chief managers were dismissed, and it even started with a complete relaunch after three years of existence, it was not accepted either among the audience, with an average audience share of 1.6 per cent and a maximum of 2.5 per cent, or within the advertising market.

The changes in programme strategies were about the degree of local or regional engagement. First it was planned to show a distinct profile by a large amount of local reporting and self-produced programming. In this way regional identification should become possible. Subsequently, purchased programmes, with some few regional elements, seemed to be the adequate concept. With the relaunch of PulsTV the strategy was "totally local", comprising many repeated programmes and magazines with an obvious tabloid standard of journalism. An everyday magazine *Pulsiv* was about "people to be secured" or "victims who need help", but no political reporting was offered.

It was due to the ongoing engagement of the American group CME who held 21.65 per cent and her partner CEDC with the same share (Time Warner and George Soros participated with the same shares) that *PulsTV* continued its activities in spite of the bad results. CME, which is also engaged in urban television in Nuremberg, and in developing similar projects in Leipzig, Dresden and Chemnitz, has a strategic interest in the Berlin station as one step into the German television market.

Munich was the second city to put regional TV on the air. The German TV market was already strongly dominated by the Kirch group, which has a

40 per cent share in TV München. Moreover, it is Thomas Kirch, the son of Leo Kirch, who was interested in the takeover of PulsTV when the licence was offered again. As the Berlin station declared bankruptcy he was freed from the takeover of the losses. His concept for the programme is similar to the one in Munich with a share of fiction films of below 40 per cent and local magazines, sport programmes and news. In this concept PulsTV would be at the end of the row of exploitation of the Kirch's film stock and be able to come across with a yearly budget of 80 million DM. München TV itself is managed with a yearly budget of only 45 million DM and is supposed to reach its break even not before 2000 (Wöste 1997: 343). It has an audience share of 6 per cent.

In Hamburg the invitation to tender for a regional TV-licence attracted 13 applicants. Hamburg 1, with the participation of Time Warner (24 per cent), Springer (24 per cent) DFA (a television news agency, 24 per cent), Frank Otto (successful in radio broadcasting in Hamburg, 24 per cent) and two small share holders, was supposed to start in autumn 1994, but finally did so in September 1995. The concepts of programming were unknown in the beginning, but there was the contradiction of the promises of seven hours of local programmes daily and a very small budget for this purpose. And indeed spending 16 to 18 million DM a year it started with a much smaller budget than PulsTV.

The idea at the beginning that the transmission of these programmes promises to be a lucrative business, and the estimation of media experts that it should be possible for broadcasters in those densely populated areas to gain a share of 10 per cent of national advertising expenditures, seemed to be to optimistic. Although the failure of PulsTV was due mostly to disagreements between the shareholders and high costs, it shows a fundamental difficulty of urban television: the quest for a programme which presents something new within the well established market of nationwide commercial television and the necessity to produce this new concept with an acceptable quality at low costs.

Two eminent requirements for the success of urban television can be seen in a qualitative and a quantitative aspect: On the one hand it is necessary that there is an audience which identifies itself as a homogenous population in the area, so to say with a common interest in reporting on that area. On the other hand for economic reasons there must be an advertising market which is big enough. These two requirements do not necessarily correspond. The Berlin area shows how difficult it is, although there is quite a large advertising market, to integrate in one programme, for example, the preferences of a rural population in the forest of the river Spree and the gay community in the centre is almost impossible. The different mentalities of east and west German populations is an extra specificity of the heterogenic character of the town. That an area produces enough events to be reported, can be considered a third problem.

A sceptical evaluation of the perspective of urban television is also common within the association of supervisory bodies. In their annual report they argued:

> On the one hand the advantage of local issues is not as strong in urban areas as in rural areas. On the other hand audiences in big cities seem to have a higher demand for professionalism in the local TV than can be financed by them. (ALM 1996: 315)

So the viability and future of these regional stations is still unclear. One model sees a network of independent broadcasters, which operate jointly to buy their necessary programmes. Another device proposes a "mantle", regional reporting provided by the local newspapers. New forms of co-operation between public and commercial broadcasters may also develop on the regional level. For example, Bavaria's public corporation (BR) is interested in offering parts of its Third Channel as a "mantle" to future regional commercial stations.

4.4. Public access channels

The introduction of cable TV during the 1980s brought proposals to use this new media not just for professionally produced programmes, but to reserve one channel as a forum for individuals and groups of amateurs to produce and distribute their own programmes. This concept of public access was taken from the US and introduced as "open channel" (*offener kanal*) in Germany. As the public access channel is physically related to local cable systems, all programming is *per se* local and/or regional. In fact, the content of programmes is often concerned with local/regional developments, experiences and problems.

The Minister Presidents of the *Länder* recommended its introduction, and now the laws of 12 of the 16 *Länder* provide for some kind public access channel, although they are not yet operating in all parts of Germany. Usually the *landesmedienanstalt* is also the sponsor for public access channels.

At present, 34 public access channels are run in 8 *Länder* of Germany. They are offered in areas of very different sizes and potential audiences including for instance the new capital and largest city Berlin, Hamburg and small villages like Kirchheimbolanden, in Rhineland-Palatinate. In most cases they serve a local area rather than what we would call a region.

The main idea of the public access channel is to be a medium of non-professional users who contribute to the communication of a municipality or a region. In terms of ratings, the audiences of these channels are microscopic, as they have to compete with many other channels, provided by cable. Nearly half of the cabled households never switch to a public access channel; only one to two per cent can be counted as regular viewers.

Also in relation to the active users, the public access channels seem to disappoint the expectations once created. It was hoped, that politically motivated individuals and groups, especially of lower formal education, would use this "do-it-your-self-television" to promote communication and discussion in a local/regional area. It turns out though, that only 20 to 30 per cent of the programmes include a local or regional aspect. Furthermore, the typical user of the facilities of a public access channel is a young man from 20 to 30 years of age with a high formal education.

5. Study of programming

5.1. The case of Hamburg 1

When the urban television channel Hamburg 1 started in September 1995 the concepts of programming were quite unclear; the contradiction of the promises of seven hours of local programmes daily and a very small budget for those purposes, caused doubts about the possibility to achieve those ambitious goals.

Meanwhile the station has overcome initial difficulties and has established itself as a counting factor on the Hamburg media market. The potential viewer market comprises 3.3 million inhabitants in the area, as the programme is transmitted with the power of 10 kW as well as on cable. But as a maximum, an audience of half a million is watching the channel at least once a day. According to this coverage the manager of Hamburg 1 claims that the channel is the most important medium in the town after the local tabloid *Bildzeitung*, the local daily *Hamburger Abendblatt* and the local commercial radio channel Radio Hamburg.

The audience for special programmes oscillates between 90,000 and 160,000 viewers. Audiences of around 100,000 viewers are already estimated as good results. A strategic decision for augmenting the audience in this sense is the fact that, as part of the screen, the present temperature in the town is to be seen. The audience share of Hamburg 1 in total is not fixed until now as the nationwide system of counting audiences does not comprise these small numbers.

News

Scheduling of the news is an important decision in Germany as the main news programme of the public service television (*Tagesschau* at 20:00) still holds a strong position. Hamburg 1 decided to choose the same time slot from 20:00 to 20:15 for news, called *Hamburg um 8*, which are mainly dedicated to local stories, but also comprise some headlines on national and international events. Further news programmes are given every hour in the evening from 18:00 or in combination with a weather report (18:00 and 22:00) and sports (19:00). At 21:00 a five minute programme of news is given with headlines from national and international events. Half an hour

of local news at 12:00 is offered as a mixture between a news show and a magazine.

In Hamburg 1 there is no special section in the newspaper office for covering local political information, this is done through the area of general information (Donges and Jarren, 1997: 201).

Magazines

An important part of the programming are the magazines. This *Frühcafe* called programme has the biggest market share in the time between 06:00 and 09:00. Important elements are service features as, for example, the information about rush hour and traffic blocks. Another half an hour later in the morning is filled with the repetition of different magazines every day which consist mostly of cultural and entertainment events of the town.

Most of the programming during the day was provided by the fiction channel Super RTL. However, these take-overs ended when Super RTL entered the cable network of Hamburg in July 1997. Hamburg 1 continued another co-operation with RTL, the leading commercial channel, which offers for example a daily cooking programme or a travel magazine twice a day. Again in the evening there are magazines between 22:15 and 23:00 which vary every day and are near to local cultural and entertainment events as for example *Party patrol*, a programme for young people on the different clubs in the town, *St Pauli Report*, which offers reporting on the Hamburg "red light district" to show "soft porno" programmes, and cinema news on new films starting in the town.

Debates

During the elections for the Hamburg senate, Hamburg 1 achieved its break through as a serious programme for political debates as it managed to gather nearly all the top candidates for a electoral debate – a success that was acknowledged by the print media.

The programme was presented by the anchorman who is the head of a talk show called *Schalthoff live*. This weekly programme deals with current local subjects and politics and invites concerned persons and parties, as for example, for a programme about a district of the town with drug problems and present drug politics.

Special attention is given to youth programming, especially the creation of the cult figure *Dieter* who is the star entertainer for young people aged 10 to 18. Another emblematic figure is the caretaker *Rudi* who performs to serve the local ambience through the use of a strong Hamburg accent while talking about everyday life concerns in a humorous way. Both figures play an important role in the marketing strategy of the broadcaster.

Documentaries

The only documentary which has a daily time slot is about divorces. A divorce-case as it is dealt with before trial pretends to be a "documentary" which is commented on by a popular talk show lady host, although the fictional elements dominate.

Fiction

Most of the fiction programmes are shown in the afternoon and in the evening. The fiction time slot between 21:05 and 22:00 was filled with a rather incoherent programme strategy which comprised during this time US-American detective stories as well as comedy and documentaries on nature and animals. It made audience shares go down rather strengthen in comparison with other programmes during the day. A more coherent programming during this time consisting of material of the fiction channel Super RTL, which did not improve this situation very much. After the end of the co-operation with Super RTL this time slot is now filled with a daily soap opera with a regional background. The serial called *Westerdeich* takes place in a small town on the shore of the North Sea and stems from the stocks of the market leader of commercial television (RTL).

Sports

One of the two Hamburg football teams have a time slot of their own of five minutes twice a day. Sports are also included in the 19:00 news, which is repeated in the morning between 10:00 and 11:00.

Children's programmes

Children's programmes do not really exist. Only after noon there is one and a half hours of comic programmes. Marvel comics are taken from RTL and replaced the former Donald Duck cartoons. As it is admitted by the management this change was not relevant to the audience share.

Quiz shows

Local contests are given within the regular quiz show between 20:15 and 21:00. This quiz is repeated every morning. With this programme the manager of Hamburg 1 claims that they are giving nine hours of local orientated programmes daily, an amount which could not be extended any further.

5.2. N 3 Hamburg Journal

The Third channel in the north, called N 3 has to cover quite a large area which consists of five *Länder*, two of them being towns: Hamburg, Bremen, Schleswig-Holstein, Lower Saxony and Mecklenburg-Vorpommern. This area not only covers different regions, they are characterised by enormous socio-cultural differences. The urban centre of Hamburg has to be served

as well as the large rural areas of Lower Saxony and, as Meclenburg-Vorpommern belonged to the former communist GDR and thus both east and west German mentalities have to be taken in to account. Regional programming thus is an important feature for N 3. It is served within N 3 at different time slots. Magazines, news and debates are the main genders in which regional aspects are presented.

NordZeit is a magazine at 15:15 which is broadcast only from Monday to Thursday for 45 minutes. It consists of information about the cultures and societies of different regions in northern Germany as well as features, talk and music. On Friday this time slot is dedicated to a documentary on different regions in Germany.

Regional news are given for five minutes at 17:25. The programme is then split and produced by five different studios of the *Länder* (Hamburg, Bremen, Kiel for Schleswig-Holstein, Hannover for Lower-Saxony and Schwerin for Mecklenburg-Vorpommern). Again at 18:35 this split takes place for 10 minutes, where every Studio *landesfunkhaus* has its own news agenda short programme. The following magazine *DAS!* is given for the whole area, but takes into account subjects and issues from the northern parts of Germany. The main split for regional information is at 19:30, where four different magazines are broadcast (Bremen is then included by Lower Saxony). These magazines are repeated subsequently from Tuesday to Friday in the morning, so that they all can be seen in the whole area of N 3.

Hamburg is again the example to be described in more detail. The *Hamburg Journal* is terrestrially transmitted with the power of 300 kW as well on cable and on satellite. Thus it provides the strongest transmission of all regional channels, which is due to its character as part of the public service channel. The magazine is presented by two anchor people, a man and a woman; it consists of news, reports, features, live transmissions and a nearly regular talk in the studio with a politician. The newsroom with 16 fully employed journalists is divided into the departments of politics, economics, culture, social affairs, issues of the port and features. Two further departments are looking to cover the rest of northern Germany and undertake the planning. Approximately 30 freelancers contribute to the programme.

An analysis of the topics offered during one week in 1996 shows that the *Hamburg Journal* broadcasts more exclusive issues than the competing regional magazines, thus trying to offer a very specific profile. Hard news like politics, social affairs and economics amount to 43 per cent; "soft news" like culture and human interest stories are at 57 per cent with a strong accent on cultural issues. On Friday and Saturday "hard news" are even less important than cultural issues (Klar 1997: 96). The same analysis acknowledges that the *Hamburg Journal* issues are not of the same type as the competitor Hamburg 1, which concern the number of subjects dedicated to the present day. On the other hand the regional context of the

reports and news is far more prominent in *Hamburg Journal* than in any other of the competing magazines.

6. Analysis of new problems and prospects

6.1. Financial viability

The question of the success of regional broadcasting in a competitive market has become, above all, a financial one. But the question is a little bit different for the public service Third Channels. As they are not allowed to broadcast advertising their legitimisation to strengthen regional issues is only based on the demanded "basic supply" and the market share they achieve. Financial considerations are important with regard to the costs they need to pay to obtain these market shares in comparison to other programme providers. Thus the regional programming of the public service channels is dependent on the general financial situation of public broadcasting. This has worsened considerably in Germany in the last years. Declining income from advertising and seriously increased prices for programming force it to cut down expenses with consequences for regional broadcasting. On the other hand the third channels were quite successful in maintaining and even augmenting audience shares so that a rather strong position in defending their production costs can be assumed.

The important, if not the single, source of revenues of private regional TV broadcasting, is advertising. A station which is starting to go for advertising on the local or regional market is bound to get advertisements which had been distributed by other media or has to enlarge the volume of advertising as a whole in order to gain higher advertising revenues. While national advertising of brands is regarded as an attractive means of financing because it has proved to be effective, local and regional advertising is a means of financing which depends on regional advertisers with much less to spend. This difficulty of financial background has been proved especially for regional TV in big cities and regions with a dense population which seemed to be at their dawn the most promising form of commercial regional TV.

However, the financial situation is very different for the varying types of regional television. As was already mentioned above, the new type of urban television seems to have the biggest difficulties. None of these stations reached the break even point until now. The one to be the earliest will probably be Hamburg 1 which claims to do so in 1999. This would come up to four years before the channel will have had a positive income.

An additional important source of income for this urban channel is the production of advertising spots for local clients. They cost between DM 2,000 and 20,000 and are created in an independent profit centre. To improve the financial situation the management plans to take over shares in the downward spiralling Berlin urban television PulsTV. Links between

179

the capital and Hamburg could help to bring synergy effects. PulsTV had to declare bankruptcy in May 1997 and continued to broadcast a very reduced programme until new investors could be found.

The failure of PulsTV is due to the fact, that it was, in spite of the potential for a large audience (4.1 million) and the willingness of investors to wait quite a long time for the break even point, it was not possible to find a coherent concept: "The contradiction between a station of the capital city and broadcasting from a village is obvious" stated one critical observer (*Deutsches Allgemeines Sonntagsblatt* 31 December 1993). To serve the interest of a very heterogeneous audience where it was not satisfied by the nationwide television stations would have required a large creative input which was not achieved. (Wöste 1997: 343).

This is an extreme example of the difficult situation of urban television, while the situation of Hamburg 1 can be considered as typical. A survey which had been undertaken by the German Institute for Economic Research (Deutsches Wirtschaftsforschungsinstitut, DIW) came to the conclusion, that urban television can cover its costs only to 36 per cent by income. Covering of costs by advertising income is only at 25 per cent. With these results this type of commercial television turns out to be the one with the worst economic standing (Wöste 1997: 339).

More than one evaluation in the last two years doubted if urban television has any chance for profitability or, if so, claimed that investors would have to wait up to 10 years until their capital investment would return any profits. Nevertheless there seems to be an ongoing interest in urban television, not for reasons of profitability, but for finding ways into the highly competitive German television market or to secure the already achieved position in the market.

The situation is quite different for strictly local television, as this type is mostly broadcast only between half an hour and a few hours, thus allowing a higher coverage of costs by income than urban television which is broadcasting up to 24 hours. However, in Bavaria and Saxonia where there are most of the local stations, they receive special funding. It comes from the fees for the cable networks (which are supposed to go down in future) or from the payments broadcasters have to give for terrestrial transmission. By these means the local television stations in these two *Länder* can cover 35 per cent of their costs. Forty eight per cent are refunded by incomes from advertising whereas urban television achieves only 25 per cent (Wöste 1997: 344). On the other hand their production costs, with an average of 14 million DM per year, turned out to be seven times as high as those of local television. Calculated per minute, the production costs are only at 145 DM of the average, local TV is at 212 DM/per minute and the competing regional windows within the nation-wide channels is at 414 DM/per minute. So it seems to prove that the very low expenses for production contradict the quest for quality.

Synergism might be achieved if urban television advances in building co-operations and even networks, as can be observed with the plans of TV München taking over PulsTV. On the other hand such a strategy will weaken the local and/or regional links of a channel. In the financial calculation of nationwide commercial broadcasting, regional windows have proved to be held with little esteem. Where legal provisions no longer required them, they were reduced or disappeared altogether.

6.2 Cultural synergies

As was demonstrated, the regional dimension is very much alive in German culture and history; among many other things it may be found in the strong federal state, based on the *Länder* and their dominant role in broadcasting. The *Länder* are leading actors in public service television and some *Länder*-wide television has always been present. In addition, commercial broadcasters offer regional TV in some parts of the country.

Taken the German concept of region, most of the *Länder* include a number of regions. In most cases only the large-scale area of the *Land* is served, not the small-scale regions inside the *Land*. Exceptions are the city-*Länder* (like Hamburg), small *Länder* (like Saarland) and large *Länder* that sub-divide some of their programming (North Rhine-Westphalia). In many cases the structure inside one *Land* can be quite centralist (as in Bavaria or Lower Saxony).

The central idea of German federalism was, and still is, to keep the government as close to the citizens as possible. Culture is seen as the central field in which regional and local identities have to be protected, where diversity has a chance. Therefore "culture" is the most important responsibility of the *Länder*. Economy is often seen as the opposite of culture, it demands large and unified markets, therefore it is (mainly) the responsibility of the central government (and today of the European Union). Seen this way, culture itself is a highly political concept. At least this is the theory and it was often translated into a criticism of European politics. The concentration of bureaucratic "mega-machine" power in Brussels was confronted with the decentralisation and closeness of politics on the local and regional level (Bullmann/Eißel 1994). Because of the German experience, the principle of "subsidiarity" was introduced into the shaping of the European Union and finally embodied into the Maastricht Treaty of 1992. In this context, the *Länder* see themselves as "politics on the third level" (Bullmann 1994). This regional level, being incorporated as *Länder*, has vital interests in the participation in, and influence upon, European politics. One aspect of this policy is that they directly communicate with Brussels, eg they maintain offices (so called "embassies") in the European capital (Hamburg together with other *Länder*).

The *Länder* often feel attacked by German federal politics and fight for what they consider their constitutional privileges. When the central

government in Bonn routinely signed the European TV-directive *Television without Frontiers* of 1989, several *Länder* accused the Bonn government of not having them duly included into the decision making process. They went to the highest authority, to the Federal Constitutional Court, which is the final arbiter in all questions of federal conflicts. The central government accepted the need to respect the rights of the *Länder* and both sides agreed on procedures that make it possible for *Länder* to keep informed and decide on their matters, if negotiated in Brussels. When the European Council of Regions was established, based on the Maastricht Treaty, the *Länder* demanded most of the 24 seats that have been given to Germany; they claimed 21, three more went to local city governments (Hrbek/Weyand 1994: 134ff).

Culture in the *Länder* follows a broad concept. Universities are managed by the *Länder* and schools are under the authority of local governments. Cultural institutions like museums, theatres, opera buildings etc may be either be under the rule of the *Länder* or of local governments.

In particular, public broadcasters work in this framework. It is expected that they use local resources for their work. A typical example is programming with a folklorist touch, eg theatre in the regional dialect or local folklore music. These might be presented over the first ARD channel and because of this, are available to the rest of the country. Theatre performances or TV-series, spoken in regional dialects, can be quite popular nationwide. Or they are just being produced for the Third Channel, appealing to regional audiences only. The same applies to sports events of regional significance.

But it should be emphasised that regional interest in this kind of programming is limited. Asked about the importance of regional programming, people give it very high ranking, but in actual consumption patterns, the interest tends to be low. This is why commercial broadcasters prefer to offer as little regional TV as possible to acquire and keep their licence.

There is another interesting element to the federal pattern. The regional public broadcasters co-operate in many ways and are not required to use regional production facilities only. The oldest evening soap-opera, *Lindenstraße*, claims to play in the city of Munich, but is actually produced in the WDR-studios of Cologne, far away from Bavaria. This was seen to be more cost effective and is not seen as a problem. Another aspect of this principle is that TV-teams from one public corporation may work in other parts of the country and perhaps pick up topics that are not welcome in the political landscape of that respective *Land*. Artists with a regional flavour may be more welcome outside of their region and promoted by outside broadcasters. Let us not forget that the system is highly politicised and culture might have to migrate to another *Land* with a more favourable political climate to be accepted. This openness is seen as a special advantage of the federal principle and makes some of the heavy political control more bearable.

On the federal and *Länder*-level we find significant support for audiovisual production. Public broadcasters are required to invest in German film-making and the same is expected from commercial TV-stations. Several *Länder* offer, as part of their cultural policy, funding and support to film makers if they come and produce (or do at least some shooting) inside their borders. Sometimes projects of cultural significance compete or co-operate between the *Länder* and the central level.

The rule is that public broadcaster's funding goes into the *Land*, the TV-corporation works in. Therefore production centres for TV are located in different parts of the country; large film and TV studios might be found at places like Hamburg, Berlin/Potsdam, Cologne, Mainz and Munich. The public (and therefore non-profit) broadcaster NDR, to give that example, maintains Studio Hamburg, organised as a 'sister' company that may earn profits (and pay it into NDRs casket). Studio Hamburg is a large and highly regarded film and TV production complex that offers its services to all those interested, including commercial broadcasters.

The private TV industry tends to create production facilities at the places where they maintain their headquarters. These are places like Cologne (RTL *et al*), Berlin and Mainz (Sat1), Munich (Pro7 *et al*) or Hamburg (Premiere). The federal situation makes it virtually impossible to concentrate resources at one location and create a kind of German Hollywood. On the other hand, it is obvious, that TV and film businesses are centred in the large cities of the country. Some more deserted regions, especially in the formerly communist East, have little chance to attract many activities in this respect.

6.3. The influence of new integrated communication networks

6.3.1. New media: the significance of cable and satellite

Only 10 years ago, TV-reception was mainly via terrestrial transmission and antennas in Germany. Already in 1996, 44.6 per cent of all households received their TV-image via cable and another 30 per cent via direct broadcasting satellites (DBS). In the beginning of 1998 nearly 80 per cent of all households got their programming either directly or via cable from the system of Astra satellites. More than 30 programmes are being produced in German and for the German market. Most of these national programmes (and public regional third channels as well) are (more or less) available for most Germans in all parts of the country. Whoever is cabled, receives at least 20 German language channels (among these special interest channels for music, news, sports, women etc) and about 10 programmes in foreign languages. They all compete with the regional programming of public (ARD, Third Programmes) and if available commercial broadcasters (window programmes or urban broadcasters). Also, if the image is taken directly from the satellite, viewers might receive the national version of a commercial programme (without the window). And regional broadcasters

are too small to be using satellite transponders; if a viewer only uses a satellite receiver, regional terrestrial TV might virtually be lost for them.

A very special situation arises with regional third channels, most of which are on satellite in 1998. Via satellite and cable it is possible to follow regional reporting in other parts of the country (eg in Bavaria or Northrhine-Westphalia) and via 3Sat in Austria and Switzerland. This offers "expatriates" the chance to follow regional events in his part of the country while living some place else. This lends a new meaning to regional TV.

Another challenge to regional reporting comes from digital TV. Since 1996 digital television is available in Germany, DF 1, offered by the Kirch Group, and it delivers packages of another 30 (or more) pay programmes into the households, that are all of a national nature and further marginalise regional TV. In an environment of multi-channel-TV, regional reporting will have to compete with many more attractive national programming than before. This might also apply to TV-programmes, coming from third countries outside Germany (CNN, MTV, Euronews, Eurosport etc), but interest among the viewers is very low.

6.3.2. Converging media

Expectations for the future are that broadcasting, telecommunications and personal computers will merge into one unified superstructure, sometimes labelled the "information highway". This will make the Deutsche Telekom (the largest service company in Europe), the former state PTT privatised in 1997, a top actor. It already played a role in broadcasting during the last years, controlling nearly all cable systems and most TV and radio transmitters. According to the constitution, the telecom industry is under federal supervision, a new Regulatory Authority (*Regulierungsbehörde*) was established for this purpose, beginning its work in 1998.

With digital convergence gaining in strength, conflicts between the *Länder* and federal authorities will definitely increase. Who will regulate television over the telephone network? How about telephone calls on cable systems? (Kleinsteuber/Rosenbach 1997). If the conflict is not solved, a stalemate between the two poles – *Länder* and central government of the federal system – might occur.

This has some significance for regional TV. Local or regional TV is regulated by *Länder* authority, local on-line activities are supervised by a federal body. Another aspect is, that federal regulation and the leading actor *Deutsche Telekom*, managed as a purely national company, will certainly reflect less regional peculiarities as the broadcasters have done.

Bibliography and References

ALM Arbeitsgemeinschaft der Landesmedienanstalten (1996): *Jahrbuch* 1995/96, München.

ARD (1997): *Jahrbuch*. ARD: Frankfurt.

Brockmeyer (1997): Ungeliebte Bastarde. Regionalfenster sind ein Spielball der Politik aber kein Werberenner in *Media Spectrum* 6, p. 6-8.

Brüssau, Werner (1997): So sehen sie aus: Regionale Informationsprogramme. *Bundeszentrale für politische Bildung*.

Bullmann, Udo (ed) (1994): *Die Politik der dritten Ebene. Regionen im Europa der Union*. Baden-Baden.

Bullmann, Udo/Dieter Eißel (1994): EG-Integration, Politikverflechtung und die demokratische Willensbildung und Mitentscheidung auf dezentraler und regionaler Ebene, in: Hans-Wolfgang Platzer (ed): *Die Region im Europäischen Integrationsprozeß*, Frankfurt, p. 25-43.

Bundeszentrale für politische Bildung (1997): *Profile der Dritten. Die acht regionalen ARD-Fernsehprogramme im Wettbewerb des dualen Systems*. Bonn

Buss, M. (1979): "Regionale Medien und Bürgerinteressen", in *Media Perspektiven* 12.

Darschin, W. and Frank, B. (1993): "Tendenzen im Zuschauerverhalten", in *Media Perspektiven* 3.

Donges, Patrick/Otfried Jarren (1997): Redaktionelle Strukturen und publizistische Qualität. ERgebnisse einer Fallstudie zum Entstehungsprozeß landespolitischer Berichterstattung im Rudnfunk. in *Media Perspektiven* 4, p. 198-205.

EUROSTAT (1993): *Portrait der Regionen. Vol. 1: Deutschland, Benelux, Dänemark*. Luxembourg: EUROSTAT.

Först, W. (ed) (1984): *Rundfunk in der Region. Probleme und Möglichkeiten der Regionalität*. Köln.

Heidinger, V., Schwab, F. and Winterhoff-Spurk, P. (1993): "Offene Kanäle nach der Ausbauphasc", in *Media Perspektiven* 7.

Hinrichs, E. (1987): "Regionalgeschichte", in Carl-Hans Hauptmeyer (ed): *Landesgeschichte heute*. Göttingen.

Hrbek, Rudolf/Sabine Weyand (1994): *Betrifft: Das Europa der Regionen*. München.

Jarren, O. (1989): "Lokaler Rundfunk und politische Kultur. Auswirkungen lokaler elektronischer Medienangebote auf Institutionen und institutionelles Handeln", in *Publizistik* 4.

Jonscher, Norbert (1995): *Lokale Publizistik. Theorie und Praxis der örtlichen Berichterstattung*. Opladen.

Klar, Susanne (1997): *Regionale Berichterstattung im Fernsehen der Hansestdt Hamburg*. Marburg.

Kleinsteuber, Hans J/Marcel Rosenbach (1997): Regulations in the USA - Lessons for Europe, in: *European Communication Council Report 1997: Exploring the Limits. Europe's Changing Communication Environment*. Berlin, p. 229-336.

Lange, K. (1970): "Regionen", in Akademie für Raumforschung und Landesplanung (ed): *Handwörterbuch der Raumforschung und Raumordnung*. Hannover.

Lerg, W. B. (1982): "Regionalität als Programmauftrag?" in *Rundfunk und Fernsehen* 1.

Lindner, J.-U. (1993): "Kampf um die TV-Provinz", epd *Kirche und Rundfunk* 87.

Niemeyer, H.-G. (1979): "Regionale Informationen im Fernsehen", in *Media Perspektiven* 5.

Rühl, M. (1982): "Auf der Suche nach dem systematischen Regionalprogramm", in *Media Perspektiven* 1.

Schuler-Harms, M. (1992): "Das Rundfunksystem der Bundesrepublik Deutschland", in *Internationales Handbuch für Hörfunk und Fernsehen*. Baden-Baden.

Schütte, W. (1971): *Regionalität und Föderalismus im Rundfunk. Die geschichtliche Entwicklung in Deutschland 1923-1945*. Frankfurt.

Teichert, W. (1982): *Die Region als publizistische Aufgabe*. Hamburg.

Walendy, E. (1993): "Offene Kanäle in Deutschland - ein Überblick", in *Media Perspektiven* 7.

Wirth-Patzelt, S. (1986): *Regionale Fernsehberichterstattung in Bayern. Inhaltsanalyse ausgewählter Sendungen des Bayerishen Rundfunks*. Frankfurt.

Wöste, Marlene (1997): Ballungsräume - kein geeignetes Terrain für Fernsehkanäle? in *Media Perspektiven* 6, p. 339-350.

Greece: A numerous but weak sector

Roy Panagiotopoulou*

1. The regional dimension of the state

1.1 Regional policy and local government

The problem of the geographical and administrative division of Greece appears with the constitution of the modern Greek state, in 1828. Previously, the Greek territory was based administratively on communities, that had gained a high level of autonomy from the Ottoman empire. The main political scope of the first government of the new state was to create a centralised administration system in order to establish state intervention.

The basic administrative unit that exists until today remains the department, which includes at the local level all public services in a consistent way (Christofilopoulou, 1996, and Papadimitropoulos, 1998). The governor of the department was appointed by the government and represented the central political authority. His responsibilities included the supervision of the municipalities and the communities, as well as the distribution of the funds for public investments in order to finance the public works and decisions about the development programmes of the department. The Department, as an administrative centre of economic interests, has remained the core for the constitution of the local clientelistic

* I would like to express my gratitude to Katerina Fassouli and Sofiana Milioritsa, who have helped in the preparation and carrying out of the research on regional and local telelvision in Greece.

networks. These structures have been in existence for a long time, and with the exception of two reform attempts, and some minor interventions, remained active until 1984.[1]

In the middle of the 1950s, the regional policy was shaped according to the decisions made by the central state administration which acknowledged the need for decentralisation and regional development based on the development of the region and avoided the extensive concentration of the population in Athens.[2] However, ultimately, it did not succeed in forming important regional centres of development.

The resolution of local problems based upon a clientelistic relationship was reinforced by the extreme centralised system of Greek administration at the local level. As a consequence a great period of inertia concerning the Organizations of local government took place that began before the First World War and ended when Greece entered the European Economic Community.

In 1982 the district councils were created. These councils consisted representatives of the local government, the local authorities and of professional Organizations (l. 1235/82). Their aim was to achieve consent among the persons and institutions involved and, moreover, to change the local personal, clientelistic networks of relations. Law 1416/84 which followed, attempted to strengthen the phenomenon of decentralisation by bringing new institutions that allowed the creation of municipal or community enterprises. Two years later the law 1622/1986 was passed, trying to bring institutional and political change by separating the Greek territory into 13 regions. This law, which defines the region primarily by geographical terms and secondly as an administrative unit (Christofilopoulou, 1996 and Papadimitropoulos, 1998), could never be fully implemented because it did not distinguish between the responsibilities of the central and the regional authorities.

Ten years later, in 1994, in a state of scepticism and unsuccessful legal adjustments, the law 2218/94 (90/13-4-1994) was passed, which introduced the abolition of the department and its substitution by the department of local government. Furthermore, it initiated a change in the system of supervision of the local government with the introduction of the 2nd degree of the local government, the decentralisation of some services and the transfer of main administrative offices to the region. This law tried to set the base for a true reform of the local government; nevertheless, it was met with strong disapproval from the opposition and also from some members of the parliament of the governing party. Within three months the government was forced to pass a second complementary law (l. 2240/94, 113/16-9-1994) that revoked many of the radical adjustments of the former law.

The governors of the districts gradually ceased playing a significant role. The reason was that the European development programmes, which were

their only source of financing the regional projects, were not granted anymore by taking into account the criteria of locality. Instead, they are given according to the sector that belong to. In other words, they are now granted by the central authorities in Athens.

On 16 October 1994, the first representatives were elected for the first and second degree of local authorities and until now the new representatives have been fighting in order to clarify the extent of the orders that they can implement. Nevertheless, despite all of the reactions, the important issue of decentralisation and modernisation of the local government – that caused the country so many problem for more than 100 years – has now entered a new phase in order to solve the main institutional problems of the regions.

Recently, law 2539/97 (vol. 244/4-12-1997) was passed concerning the amalgamation of the municipalities and communities into greater spatial and population units. This move is trying to establish the cornerstone for a more rational planning of the space according to the number, size and area of the local government units, in addition to the augmentation of their administrative responsibilities.

1.2. Demographic and socio-economical characteristics of the regions

One of the main characteristics regarding the evolution of the Greek population was its extensive concentration in Athens, the capital, and the city of Salonica. In 1991, 38.4 per cent of the total population lived in the two cities. (NSSG, *Statistical Yearbook* 1992-93). During the years 1981 to 1991 an increase in population of the less populated regions (Continental Greece, Peloponnese, Ionian Islands, Aegean Islands) took place. In the other regions, the population remains stable at the level of 1981. In 1991, Athens and its surroundings remained one of the most densely populated areas of the European Union, with 6,724 inhabitants per square kilometre.

With the exception of Attica, the islands of Southern Aegean and Central Macedonia, where the city of Salonica influences the percentage, agricultural is the dominant sector in terms of occupation. The average rate of unemployment in Greece in 1996 was 9.7 per cent but now has reached the average percentage of the EU (10.9 per cent). The higher percentages of unemployment are noticed in Western Macedonia (16.3 per cent), Attica (11.9 per cent), Epirus (11.2 per cent) and Continental Greece (10.3 per cent).

Generally, the Greek regions are characterised by large economic inequality. Epirus and the Northern Aegean islands belong among the 10 poorest regions of the EU and have one of the lowest PPS (below the half of the average of the EU countries), whilst another five regions (Western Greece, Ionian Islands, Crete, Thessaly and Eastern Macedonia &Thrace)

are amongst the 25 poorest regions of the EU (European Commission: *First Report on the Economic and Social Cohesion*, 1996).

Table 1. Regional structure of Greece

Regions	Population (1991)	% employed in primary sector (1995)	Unemploy ment rate (1996)	Average monthly family income (1994)	Rate of monthly family income of counrtry (1994)	Purchasing Power Std. (1994)
Eastern Macedonia & Thrace	570,496	43.1	9.6	267,694	82.3	58
Central Macedonia	1,710,513	20.8	8.9	301,573	92.7	65
Western Macedonia	293,015	25.7	16.3	266,072	81.8	59
Thessaly	734,846	39.0	7.6	276,634	85.0	60
Epirus	339,728	32.9	11.2	285,836	87.9	43
Ionian Islands	193,734	29.3	5.5	328,646	101.0	60
Western Greece	707,687	41.9	8.6	296,836	91.2	56
Continental Greece	582,280	31.1	10.3	304,633	93.6	65
Peloponnese	607,428	45.6	6.4	314,590	96.7	57
Attica	3,523,407	1.1	11.9	367,958	113.1	73
Northern Aegean	199,231	27.5	7.1	287,532	88.4	49
Southern Aegean	257,481	9.7	4.9	327,748	100.7	73
Crete	540,054	34.7	3.4	316,112	97.2	70
Greece total	**10,259,900**	**20.4**	**9.7**	**325,283**	**100.0**	**65** (EUR15 =100)

Source: Column 1: NSSG, Population Census 1991; column 2: EUROSTAT, Statistics in Focus, Regions 3/1996, p. 3; column 3: EUROSTAT, Statistics in Focus, Regions 4/1997, p. 3; column 4-5: NSSG, Households Survey 1993-94; column 6: EUROSTAT, Statistics in Focus, Regions 1/1997, pp. 4-5.

Certainly, one must bear in mind that the percentage of the black economy in Greece is very high: it is calculated at 34.6 per cent of the GDP (Kanellopoulos *et. al*, 1992). This situation causes a certain equality in income distribution, without changing the general trend. This factor is very important if one takes into consideration that the revenues of a private TV channel mostly come from the advertising that presupposes wealthy societies with growing consuming needs.

The issues related to the local government, decentralisation and the economic growth of the regions often preoccupy local public opinion. This fact can be explained by the extraordinary growth of the press and the electronic media that operate in the regions. In 1988, from the 1,143 newspapers that were in circulation in Greece, 519 (45 per cent) were published in the county (N. Demertzis, 1996). As for the radio, in 1993, 256 radio stations were active in Attica and almost 1,200 in the whole country (Papathanasopoulos, 1994). In our latest provisional research of the

provincial press, analysing the data offered by the press offices of the regional authorities, we found that in 1998, 440 county newspapers and 367 radio stations operate in the various regions.

Therefore, local advertising in Greece is influenced by several factors: (a) the unobtrusive division between the public and the private sphere,(b) the fast social and economic development of Greek society after the 1960's, (c) the uneven economic and social development of the regions, (d) the expansion of the electronic mass media during the last decade, and (e) the transformation of the cultural values due to the migration of the agricultural population to the urban centres, and due to the creation of antinomies in defying the social identifications and identities (Demertzis, 1996). These factors consist the most important axis according to which the local press and the electronic media choose their topics and their strategy.

2. Television's political and legal framework

It is well known in Greece that all the post-war governments, even within parliamentary rules, used the state run radio and television stations heavily according to their political wishes. Both radio and television began to transmit during periods of dictatorship. From the view of the public, absolute governmental control of the electronic mass media was accepted as the norm. During the period that followed the fall of the dictatorship, in 1974, the electronic media (contrary to what happened to the press) could never ensure their independence which is guaranteed by the constitution, something that the press had already achieved (Alivisatos, 1986). In all the post-war Greek Constitutions, control of the mass media is expressed. The same applies for the most recent Constitution of 1975, where it is noted that "radio and television will be under the direct control of the state" (article 15, paragraph 2). In order to allow the private audiovisual media to exist, a new interpretation was given, which meant that the control by the state did not necessarily mean state monopoly (Dagtoglou, 1989, and Venizelos, 1989).

At the end of the 1980s the political conjuncture favoured the abolition of the state monopoly. The liberation from the state monopoly was the outcome of a number of factors. First, deregulation at the international level imposing its influence over Greece. As a member of the EU the country was obliged to adopt certain legislative adjustments which allowed the activation of private enterprises concerning the electronic media. Secondly, the general ideological trend favouring privatisation of the public enterprises and the decreasing state intervention that dominated in several countries in Europe, was also adopted by the conservative party of New Democracy in Greece. Thirdly, the technology of satellite and cable television facilitated the spreading of the medium, and fourthly, the deregulation has mainly been related to the political crisis of the country (Panagiotopoulou, 1996, and Papathanassopoulos, 1993 and 1994).

The entry of the private business interests in the electronic media sector is observed in a period of a prolonged economic and administrative crisis. The reliability of the parties was wounded, the role of the Parliament had been devalued, and the majority of trade unions were unable to reunite their power in a period that was characterised by a complete lack of a national strategy and of a rational planned restructuring (Panagiotopoulou, 1996).

In 1987 the socialist party (PASOK) tried to control the development of electronic media deregulation and passed the law 1730/87. This law introduced organisational changes in the National Radio and Television corporation (ERT) and also regulated the distribution of the frequencies with respect to the satellite channels. The state television tried to respond to the pressure and to the various initiatives of those who wanted to break-up the state TV monopoly. Moreover, ERT tried to occupy the existing frequencies, forming a third channel in 1988, Ellas Television 3 (ET3), which was established in Salonica as a "regional" channel with national coverage.

The law 1866/1989 was also a haphazard reaction to the events of the day. This law was somewhat of an entry-ticket for the creation and the operation of "non-state" television. This law was completed by the law 1943/91 article 85, paragraph 4, that provides the ability to set up a technical network, to be able to transmit from local to national coverage. During the last two months of 1989, two private TV stations, Mega Channel and Antenna TV, were founded and started to broadcast. After them, many stations with national, but mostly with regional or/and local coverage, started transmitting.

A little later, a number of complementary presidential decrees, orders, etc. followed. These regulations tried to partially correct an already formed unregulated sector.[3] By the stabilisation of the private TV stations, and also by the change of the government after the elections in 1993 (which were won by PASOK), two new laws were passed (2173/1993 and 2328/1995).

According to the law 1866/89 the conditions concern the ownership of TV stations are set down. Firstly, the shares of TV companies are nominal. Every stockholder does not have the right to keep more than 25 per cent of the whole stockholding capital of the company; the same applies for the participation of foreign stocks. The licence to broadcast is not transferable and the stockholders are not allowed to participate in any other TV station. The companies must be financially reliable and the stockholders must not have been sentenced for crimes concerning the press. Finally, among the criteria that are valued for the provision and the renewal of the licence, is the quality of the programme. According to the law, the licences for private television will preferably be given to institutions that already have experience and a tradition concerning the operation of the mass media – especially the press – and the Organizations of local government (article 3,

paragraph (d). It is obvious that the Organizations of local government neither have the required capital, nor the appropriate organisation. Moreover, the local authorities do not provide the necessary knowledge to operate a TV station and to compete as an alternative commercial institution.

The law refers to the Organizations of local government in order to support the ideological spirit of populism that does not take into consideration whether or not the proposed institutions are adequate, or if they have the ability and the know-how to explore the urge and the privileges that are given to them.

According to the same law (article 1, paragraph 8-14), certain conditions of the ownership status are modified, more specifically: (a) licence for a TV station can receive only the companies whose base is located in a state member of the EU, and of course, if they fulfil all the other criteria; (b) individuals can participate in a maximum of two mass media categories; (c) the simultaneous participation in media companies and in companies that are related to public supplies or infrastructure is incompatible. The latter is the most essential change regarding the conditions providing licences. The government, through this regulation, tried to lessen the pressure received from the mass media especially the decisions regarding the major public construction works, and most notably those planned according to the Second Community Frame of Support.[4]

It is worth noting that no law passed from 1989 to 1995 includes any adjustment concerning the regional or local TV stations. In effect, the first distinction concerning their coverage was made by the law 2328/1995. This law classifies three categories of TV stations according to their ability to cover geographical areas: national, regional and local coverage. A map of TV frequencies by ministry decision, was to be drawn. This map would determine the number of stations that would be allowed to transmit according to their category (law 2328/2995 article 1, paragraph 3 and 5). However, this ministerial decision was released two years later.

The policy to form regulatory bodies which are neither fully equipped nor have decisive responsibilities, facilitates state intervention and guarantees that the control of the media remains in the hands of the state. In the broadcasting sector this policy is evident in the case of the National Council for Radio and Television (NCRT). According to the law 1866/89, the NCRT is an independent, consultative body which oversees the broadcasting industry. The NCRT, as other regulatory bodies, are supposed to implement the legislative framework, but due to its lack of decisive powers, has more or less become an "executive arm" of the government. Besides this, the members of NCRT are nominated according to political criteria.[5] This can also be seen in the law 2173/1993, which although brought a few changes concerns NCRT power, its consultative character remained untouched. However, the new law 2328/95 increased NCRT's

responsibilities without altering its consultative role or its political dependence from the government. Four members are elected by the majority party and four members by the opposition; the president is named by the president of the Parliament, guaranteeing the majority of the governing party.

The NCRT is concerned with monitoring the licences of the radio and TV stations, the advertising time and the observance of a code of ethics, concerning mainly the protection of the citizens.

During the New Democracy's administration (1990-1993), it announced many times its intention to grant the licences. From the summer of 1992 until the spring of 1993, the NCRT examined the applications of the stations, and after a period of contradictory discussions and decisions, the regulatory body proposed the granting of licences for nine national and five local stations (three in Athens and two in Salonica). However, only national licences were granted in mid-1994.

The procedure of granting a TV licence has existed since the early days of the entry of private television. With the exception of the national TV stations, no other licences have been granted yet. This is mainly connected with the fact that the licensing procedure has been a part of domestic "hot" politics with the result of non-official licence having been given by the government (Papathanassopoulos, 1997).

Therefore, the publication of an announcement for the provision of licences concerning the three categories of TV stations in September 1997 not only surprised many, but also found most stations unprepared to conform to the rules, although most of them were known for almost two years, since they were mentioned in law 2328/1995.

3. Institutional and business structure of television

Although law 1866/89 included several restrictions referring to the capital composition of the TV stations, it proved to be very favourable to the Greek newspaper owners. It should be mentioned that such favourable treatment for a specific professional group has never before been acknowledged in any other EU country.

Apart from some exceptions, most of the owners respected the first years the restrictions concerning the upper limit of participation at the capital stock of a TV station (the president of the NCRT declared that there were no registers of the nominal stocks and thus it was impossible, at least for the near future, to check the owners and to prove whether there is transparency in the ownership status or not (*Tá Íea*, 3-12-1997)). This decision was a compromise between the imperative demand to reduce the business risk in a new market area and, at the same time, to maintain the balance of power among publishers (Panagiotopoulou, 1996, and Papathanassopoulos, 1997). However, it must be recognised that the main

objective, which was to avoid cross-ownership among different kinds of media, was not achieved. Taking into consideration the fact that satellite and cable television are the most promising enterprising ventures of the near future, it seems likely that the concentration of ownership, as well as, the cross-ownership of various media enterprises would intensify.

The Greek publishers became rapidly involved in the field of private television. The first private television station, Mega Channel is owned by the company Teletypos. The latter is a conglomerate of several Athenian newspaper owners "whose combined assets cover half of the country's written media" (Papathanassopoulos, 1997). The owners of Antenna TV and Sky TV also own a radio station and the owners of Kanali 5, 902 TV, and most recently of SEVEN X are also newspaper owners.

The company Multichoice Hellas was established in 1994. It owns the Pay TV station FilmNet, KTV and Supersport channel and is partly owned by the Dutch company Nethold and Teletypos.

In the beginning of 1998, negotiations have being held between the Nova company, owned by Multichoice, and the Greek government, in order to provide services of a digital satellite package of TV channels in Greece. In the meantime the owners of Antenna TV have also expressed their interest and, in cooperation with Intracom Enterprises. They also seem to be interested in being involved in the production of decoder and corresponding software (*To Vima tis Kyriakis*, 15-2-1998, and *To Paron*, 8-3-1998).

All TV stations use terrestrial, encyphered transmission, with the exception of the encoded pay TV station FilmNet. This channel started its transmission on 15 October 1994 using a terrestrial, codified signal in frequencies that were provided by ERT. On one of the frequencies entertaining film programmes are available, and on another, programmes for children (KTV) are available during the mornings and in the evening programmes about sport events (Supersport) are transmitted. At present there is no cable TV.

The present national channels are: the three state channels (ET1, ET2 and ET3); the state channel of Cyprus (RIK) which is broadcasting through the ERT's frequencies; the private channels, Mega Channel, Antenna TV, Star Channel, Sky TV, New Channel, Seven X, Kanali 5 and TV Macedonia. Most of them are general channels.

Since November 1997 the state television changed the name of ET2 into ET1 and the name of ET1 into NET (New Hellenic Television). At the same time changes were also applied to the entertaining and the informative programmes. ET3 was left as it was. ET1 was given a new, mainly entertaining orientation, focusing on cultural events and information, while NET broadcasts mainly informative programmes and political talk shows.

One of the main problems of Greek TV is that there are too many national TV channels, considering the size of the Greek TV market (10.5 million inhabitants and 3,740,000 television households) a fact that causes serious financial problems.

Advertising expenditure is the main source of income for the private TV stations. Advertising revenues grew considerably during the last ten years. Indeed, the percentage of advertising investment in television related to the total advertising investments has evolved as follows: in 1988 (before deregulation) 44.4 per cent; in 1990 42.1 per cent; in 1992 59.3 per cent; in 1994 66.5 per cent and in 1996 53 per cent (Heretakis,1997). In the last three years the audiotex telephone line services that allow the viewers to participate in programmes or to receive information, have become another important source of income.· These telephone lines are provided by companies that pay 50 per cent of the total cost of the unit to OTE (public company of telecommunications) and 25 per cent of the price to the TV station. Furthermore, it is also true that several regional and local TV stations deliberately avoid paying their copyright royalties to foreign programme companies in an attempt to keep down their costs.

4.Structure and characteristics of the regional and local TV channels

4.1. The granting of TV licences

The TV licences are granted by the Ministries of the Presidency, the Interior and the Transports and Telecommunications. In this procedure the opinion of the NCRT is consultative. Moreover, the law also defines that "the installation of antennas and other equipment for transmission and reception of radio and television broadcasting is allowed within woods or forest areas, if the governor of the department decides so" (article 13). This provision gives the opportunity to a great number of regional and local television stations to receive temporary licence, without prior consent from the local authorities. Several stations transmit with a temporary licence, provided for experimental broadcasting, (according to the law 2075/1992, article 5, paragraph 2). It is estimated that during 1993 about 145 local and regional television stations were broadcasting without a licence and without the status of frequencies having being defined (Papathanassopoulos, 1993).

According to the law 2328/1995 all licences are valid for a period of 4 years, with a possibility of renewal. All TV stations which at that time held a licence, could extend it for an extra year, until the new announcement concerning the new "map" of TV frequencies. A year later, in effect, a little before the 1996 legislative elections a new extension of the time limit (nine-months) was given. Thus, all TV channels continued to broadcast, technically speaking, unofficially. This new deadline has expired, while no announcement of measures was made, in order to define the situation in

the field of television frequencies. That effectively means that since May 1997 all regional and local stations broadcast without official licence.

Finally, in September 1997 by a ministerial decision the "map" of television frequencies was announced. It was also announced that the minimum amount of stock capital that every private, regional and local TV station ought to deposit.[6] Greece is divided into 42 transmission centres. 117 "positions of TV stations" are defined, from which 6 regarding national coverage, 53 regional and 58 local TV stations broadcasting licences (m. d. 15587/E, article 3, paragraph 4). In the Attica region, 4 positions for TV stations of regional coverage have been defined. The announcement of the first proclamation took place at 10 September 1997 and the second and final proclamation was announced on the 4 and 5 February 1998. Finally, according to the announcements of the Ministry of the Press and the Mass Media, 6 national coverage, 51 regional and 57 local coverage broadcasting licences are proclaimed. The main difference between the first and the second proclamation regards the area of the East Aegean, for which the proclamation will be announced later in the future (*Eleftherotypia*, 28-1-1998 and 26-2-1998).

Although it has to be admitted that a little progress has been made regarding the licensing procedure, the government policy has not shown any major signs of change. The licences are still used as a pressure tool upon the regional and local TV stations. This happens just before the campaign of forthcoming local elections which will be held under the new conditions outlined by the law 2539/1997. This means that competition on the local level will be heated up and the local electronic media will be called to play a decisive role in the local politics game. The fact that a significant number of local and regional TV stations will be excluded from the new frequency map (it is estimated that about one forth of the total of TV stations that were recently registered and were broadcasting, should be closed down, as the number of available frequencies in many regions is much smaller than the number of transmitting TV stations) will most probably cause a political furore.

4.2. Typological classification of television in the regions

In order explain the foggy landscape of regional and local TV in Greece, one should attempt to classify them into categories, taking into consideration the ownership status, the power and the coverage of their signal. In the case of Greece these criteria are difficult to define, as until now there has been no attempt by the authorities to register the number of the TV stations, regardless of the fact that they have occupied the frequencies. The geographical particularities of Greece (mountainous, very many islands) poses additional burdens and makes it even more difficult for the stations to fully cover an area with an acceptable quality.

However, besides the lack of information, there are many difficulties, and we will attempt to classify categories according to the scheme proposed by Miquel de Moragas Spà and Carmelo Garitaonandía (1995) for those regional and local TV stations that we are aware that transmit in Greece until March of 1998.

The first category refers to regional production centres which work for a national television company. Into this category falls ET3, a national coverage channel which produces regional programme for Northern Greece.

The second category is that of decentralised television. This includes branches of large private TV stations of Athens, located in other cities of the country. These are mainly small studios or mobile groups of broadcasters which produce regional or local broadcasting programmes, reports and various programmes that are then to be sent to the central studios, in order to be presented in the news or fit within other programmes. The TV stations that have offices, studios and other equipment on a permanent base in cities other than Athens (such as Salonica, Patra, Iraklion) are Mega Channel, Antenna TV, Sky TV and Star TV.

The third and largest category, consists of those TV stations that broadcast as independent companies and their owners are either private persons or the local authorities or even the Church. Most of them are joint stock companies and their transmission signal covers a limited area. The coverage of the local stations does not surpass the limits of the region in which the station functions. As far as the coverage of the regional stations is concerned, this does not surpass the limit of the administrative district in which they belong.

4.3. ET3: State television in the regions

The first "regional" station of Greece was established in 1988 without any kind of economic or/and technical study and without the necessary equipment and material infrastructure. ERT3 (Third Greek Channel of Radio and Television) has the administrative status of a branch of ERT in the Northern Greece. Includes a channel of television (ET3) and three radio stations (two in OM and FM and one on short wave). In spite the rather hasty and deliberated foundation of the station, this was positively exhorted as an answer to the permanent demand of the local authorities and citizens of Macedonia for more information and more attention to issues of great interest for their region.

During the first five years ET3 was broadcasting without following any specific legal remit. Later on, the law 2173/1993 (article 3, paragraph 3-7) put an end to that legal uncertainty and defined general, administrate conditions for ET3 and its connection to ERT, of which it is directly dependent, as far as the budget, the financial management, the administrate organisation and the agenda setting and policy of the news

programmes are concerned.[7] The station is financed, as the other ERT channels, through the licence fee which is included in the electricity bills and is defined as the 10 per cent of the annual budget of ERT (some 4,500 million drachmas annually). The rest of the income of ERT3 come from publicity, sponsorship, the sale of programmes and the provision of technical services.

Even though ERT3 was created like a regional channel of the north of Greece, it has a wide network of transmission, with 17 broadcasting stations and 142 boosters that cover practically all of Greece and 85 per cent of the country's population. In fact, ET3 is a regional channel with national coverage. It emits in the 16:9 format (since 1996 until the first quarter of 1998, 150 hours of programmes were produced in this format and they had broadcast 400 hours in PAL Plus; in 1997, in the framework of the European cultural capital of Salonica, it produced 65 documentaries on cultural and ecological subjects were produced among others), and half of the programming reefers to regional aspects.

During its first years, ET3 used to broadcast for only 7-8 hours a day and for about 12 hours during the weekends. Its entertainment programme was covered with older programmes of ERT and only the sport, news and informative programmes (talk shows, reports about current local events etc) were home-productions (Zacharopoulos and Paraschos, 1993). Actually, it broadcasts 17 hours per day, including three news programmes, three time slots for documentaries, a children's programme, foreign films, as well as other news, sports, entertainment, youth, cultural and music programmes (according to the news bulletin of ERT3, the television programming of ET3 for the period 1997-98 consists of 5 per cent documentaries, 2.5 per cent of classical music, 1.2 per cent of educational programmes, 2.5 per cent of children's programmes, 24.5 per cent of films, 31.5 per cent of entertainment, 26.0 per cent of news and 6.4 per cent sports). In the last years, the entertainment programmes tend to present a higher quality and there is also greater interest in the screening of cultural events.

Table 2 shows that the percentage of ET3 viewers in Greece stays at a very low level. This, from a business point of view can not justify the presence and operation of the station in economic terms. However, the percentage concerning the area of Salonica, has increased during the last two years, a fact that has to be related to the presentation of events and TV celebrations regarding Salonica as a cultural capital of Europe in 1997. The same appears with the most cities of Northern Greece. After a few years of broadcasting ET3 starts playing its role as a regional TV station seriously providing a different profile from that of the two Athenian "sister-channels", as far as the programme is concerned. ET3 has also shown a

constant improvement to attract more advertising during the last three years. Within two years ET3 almost doubled its revenues from advertising, but this does not mean that the progress is satisfactory (*Annual Guide of Communication and Advertising* 1996 and 1997).

Table 2. Percentage of the television audience by day for ET3* by geographic region (1993-1997)**

Areas	1993	1994	1995	1996	1997
Athens	1.1	1.1	0.8	1.3	1.5
Salonica	2.2	1.8	1.8	2.0	3.6
Urban centres 50,000+	0.9	1.0	0.7	0.8	1.2
semi-urban & rural areas	0.8	1.2	1.3	0.9	1.6
Greece total	**1.0**	**1.2**	**1.2**	**1.1**	**1.8**
Continental Greece	0.4	0.6	0.5	0.5	0.9
Thessaly	1.0	1.0	0.7	0.4	2.8
Epirus	0.6	0.9	0.9	0.8	1.2
Macedonia	1.5	1.8	3.4	1.6	2.8
Thrace	1.0	2.4	1.5	1.6	2.2
Peloponnese	0.2	0.9	0.2	0.5	0.2
Crete	0.3	0.5	-	0.3	0.1

*Percentage of viewers (%) who have seen the channel ET3 at least half an hour in the day of the examined period.

** The survey examined the first quarter of the year and included people of 7 to 70 years of age

Source: Bari Report of Focus for the years 1993-997.

Actually, ET3 has two television studios in Salonica and two regional studios in the north of Greece (in the cities of Florina and Komotini) equipped with digital technology. At the beginning of 1998 ET3 announced that it would extend its activities to other regions. Thus, ET3 created a studio in the capital of the island Lesbos, Mitilini, in order to produce programmes with local content and to cover the whole area of the Northern Aegean islands. The transmission centre belongs to the local government of Lesbos, which participates also in the financing of this project. It is hoped that in the near future this will become a modern centre of TV production for the region, giving special attention to the problems of the Aegean islands (*Eleftherotypia*, 26-1-1998).

Finally, ET3 is cooperating with various European television companies, fundamentally regional, in the area of co-production and interchange of programmes, with a special interest in the establishment of co-operation programmes in the Balcans.

4.4. Private TV stations

4.4.1. How many are there?

It is estimated that the total number of the regional and local TV stations fluctuates between 160 and 250 (M.Heretakis, 1997, *To Vima tis Kyriakis*, 5 October 1997). Until now there is non institution that monitors their activities. This, in combination with the fact that most of them broadcast without a licence, makes an accurate estimate concerning their number even more difficult. Additionally, the fact that from an economic point of view, the local channels are not considered to be of great importance, specific measurements regarding their operations (eg ratings, advertising expenses etc) are not being conducted. Only recently the TV journals began to publish the programmes of some of the largest regional TV stations. It would not be an exaggeration, if someone would claim that the number of the Greek regional and local stations remains a puzzle. The granting of the licences in the future will probably help to have a clear view of the existing situation. But this does not necessarily means that many, principally small, local TV stations will not attempt to survive under illegal conditions, as they have done until now.

Table 3. Regional distribution of regional and local TV stations, number of households, average number of members per household and percentage of population by age groups

Regions	Number of TV stations 1998	Number of households 1994	Average n. of members per household 1994	o% of population by age groups 1991 -14	15-64	+65
Eastern Macedonia & Thrace	15	179,452	3.18	19.3	68.0	12.7
Central Macedonia	21	534,447	3.20	19.0	69.5	11.5
Western Macedonia	5	66,342	4.42	20.7	66.2	13.1
Thessaly	8	213,500	3.44	20.1	65.6	14.3
Epirus	11	102,353	3.32	19.2	64.8	16.0
Ionian Islands	7	60,742	3.19	18.4	63.6	18.0
Western Greece	12	196,553	3.60	21.3	64.2	14.5
Continental Greece	7	171,320	3.40	19.5	65.1	15.4
Peloponnese	13	182,506	3.33	18.4	63.5	18.1
Attica	17	1,155,522	3.05	18.5	68.9	12.6
Northern Aegean	8	68,872	2.89	17.6	62.3	20.1
Southern Aegean	13	82,254	3.13	21.1	65.7	13.2
Crete	6	161,790	3.14	21.3	63.6	15.1
Greece total	143	3,203,834	3.20	19.2	67.4	13.7

Source: Column 1, research data 1998; columns 2 and 3, NSSG, households survey 1993-94; columns 4 and 6, NSSG, population census 1991.

The closest estimation of the real number of the TV stations that have been listed within a list[8] is 173, from which 30 stations had stopped transmitting by the end of 1997.[9] The establishment of private TV stations at a regional and local level followed the same course, as for the national coverage private channels, with a delay of two years. Again, in the case of regional and local stations, most of the owners were previously involved in the field of regional or local press or radio activities. According to our research, 14.6 per cent of the TV stations which were transmitting in 1997, were founded during the first two years of the deregulation (1989-1990), 40.7 per cent of the TV stations have started broadcasting (1991-1992), 27.6 per cent between the years 1993 and 1994 and the rest (17.1 per cent) started to transmit from 1995 until 1997.

The total number of the operating regional and local TV stations could be divided into two main categories: The first includes the large, professional stations, mainly of regional coverage that are self-sufficient, as far as the production and the transmission of their programme is concerned (Delta TV (Alexandroupolis), Centre TV (Kavala), TVS (Serres), Castor TV (Kastoria), West Channel (Kozani), TV Macedonia, TV100 (Salonica), IN Channel (Ionnina), Corfu Channel (Corfu), TRT (Larissa and Volos), ASTRA TV (Volos), Star Channel (Lamia), T.D.E. (Messologi), TeleTime, Super B (Patra), Blue Sky, Mad TV, TeleCity, TeleTora and Junior's TV in Attica, TOP Channel (Korinth), Criti TV, Criti 1 and Creta Channel (Iraklion), Kydon TV (Chania), etc). The second category consists of amateur initiatives, usually of local range that are insufficient in the field of production. Their survival in the future seems rather uncertain. These stations could be divided into three sub-categories:

(a) Into those that belong to local, political representatives and are mainly in operation due to the personal interests of their owners (for example members of the Parliament, Organizations of the Local Government, people with strong political ambitions etc). There are also stations owned by building contractors that do business with the public sector and believe that through a TV station they can facilitate their other business interests, or stations owned by businessmen (eg food chain-stores, carpenters etc) that need constant and cheap advertisement in the local market etc.

(b) those stations owned by people involved in relevant, professional activities, such as publishers of local newspapers, owners of radio stations, joint ventures among journalists, owners of photo studios, video-clubs, electrical appliances stores, representative companies for mobile phones, etc.

(c) those owned by amateurs that are only occasionally involved, led by personal interest.

Most of the TV stations are joint stock companies or private limited companies. There are also some stations that operate as municipal enterprises and are financed by the municipal budget.

4.4.2. Financing

The financial situation of the TV stations in the region could not be described as flourishing. The fact that most of them confront serious financial problems explains the frequent changes of their ownership status. The most important changes concern the following stations: Delta TV, Centre TV, IN Channel, TRT, ASTRA TV, TeleTime, Star Channel, Achaia Channel, ERZ, ORT, TV E, West Channel, ECHO TV, TeleKerkyra etc.

The advertising market in the cities of the Greek regions has not yet been efficiently organised. Rather, the opposite happens. The TV station owners thought that through the establishment of a TV channel, they would be able to control advertising expenditure in their respective area. The excess number of channels in every region and their rather limited audiences were the main obstacles in their effort to form and maintain a specific policy in the field of advertising and to keep standard prices for every category of commercials. Their commercial policy was proven to be a trap for all operators. The stations offer advertising packages in very low prices that tend to be non-profitable because: (a) the programme is "loaded" with commercials that are constantly repeated and are provided at very low prices; (b) the advertiser does not gain profits as expected, because of the accumulation of low budget commercials. The viewers are finally bored watching the same material again and again; (c) the production quality of low budget commercials is extremely poor (d) with an exception of a few larger regional stations, no ratings research is conducted.

The telephone lines of audiotex have become an important source of income for the regional and local stations. These lines, provided by several companies, offer the audience the ability to be informed and/or to take part in shows etc. The demand for this kind of service has increased in the last year (1997) mainly because several regional stations facing serious financial difficulties, considered these services as a profitable solution and, secondly, as an easy way to fill their broadcast time in the night hours with cheap programme.

Another negative effect of the prevailing anarchy in the field of regional television is the constant denial or avoidance of some stations in paying their royalties, something that has also caused problems in the relationship among the stations, as well as in the relationship between Greece and other foreign countries, especially the USA. An owner of a regional channel has successfully pointed out that "if it was not for the Video-clubs, there would not be any local television". The video-clubs provide the regional stations with movies for which the stations have not paid the copyrights or they have partly covered the royalties for some of them (Panagiotopoulou, 1988). This

joint venture between Video-clubs and TV stations is now under the examination by the justice department. Due to the protest, continuous control by the NCRT has been conducted, so that the payment of the copyrights can be insured. The NCRT began to impose fines and in certain cases it decided the shut down of the stations for a six-month period. See also *Eleftherotypia*, 17-1-1997, and 26-6-1997, and *Nautemboriki*, 20-3-1998.

Finally, the financial problems of the TV stations are aggravated by the special tax that is imposed upon their advertisement expenses. On the one hand, the stations are obliged to pay taxes for the commercials, as well as a stamp duty. On the other, according to the law 2328/95 (article 9, paragraph b), 30 per cent of the state advertising expenditure should be directed to the regional media. The presidential decree No. 261 that define all the details was issued in 23 September 1997 and thus the total amount of revenues coming from state advertising has not yet been stablished.

4.4.3. The technological background

The technological background of the regional and local TV stations depends upon the motives of their owners. All stations have equipment of former technology, often of the last decade and even more often second-handed. With an exception of the larger stations that use Betacam equipment in combination with Super VHS and have relative well equipped studios (eg cameras, auto-cue devices, lights, sound isolation, air conditioning), as well as mobile teams for outdoor transmissions, most of the rest are using Super VHS or VHS equipment.[10] Most of the stations are using more than one centre of transmission, set in different frequencies, in order to overcome difficulties, due to the geographical particularities of the specific region in which they are located. Except from the amateurs, most stations have studios, efficient enough to provide at least post production of special effects, used in the production process of commercials.

4.4.4. Broadcasting conditions

Apart from their financial difficulties, most of the stations try to remain active, mainly because they are concerned to continuously occupy the frequency of their transmission signal.

The size of the company determines the number of the employees. The amateur stations are basically supported by members of the owner's family. Apart of the owner one or two more people are involved in the station and cover both the journalistic, as well as the technical merit. The programme of these stations is filled by movies provided by the local video-outlet, frequently neglecting to pay the copyrights by the station.

The medium size stations provide their own productions and they occupy an average of eight to 10 employees on a permanent basis, while they also employ temporary workers.

In the larger regional stations there are 25 to 30 specialised employees on a permanent and some others who work on a part time basis.

The duration of the broadcasting time depends on the size, the number of employees and the technical background of every station.[11] Taking the time duration of the programme into consideration, one could distinguish the three following categories of TV stations: (a) those that offer a programme of six to 12 hours daily, from about 12:00 until 21:00; (b) those whose programme lasts approximately 16 hours, from about 9:00 to 24:00; and (c) those that offer their programme on a round the clock basis.

Concerning the national level the prime time is estimated between 19:00 and 23:00. On the contrary, in the regions this time slot is located between 15:00 and 18:30, a fact that is directly related to the working hours in the countryside and the life circle of the local (mainly rural) daily activities.

More specifically as far as the composition of the daily programme is concerned, the larger regional TV stations follow the pattern of national private TV stations.

Regional and local TV stations seem to attract their audience during the afternoon hours presenting their own productions that incorporate news bulletins, entertainment programmes and current issues of local interest. At 20:00, the viewers usually turn to the large, national stations, in order to watch the evening news. The audience turns into the national stations, unless an interesting talk-show about current local affairs or a programme about local sport news is transmitted.

From the view of their audience, the regional and local channels are related to local activities. This fact indicates the importance of these stations in shaping the social and political life in the regions.

The live programmes of these TV stations consist of principally political talk shows programmes, with the participation of several local representatives and secondly of sport programmes (eg transmission of soccer matches between local teams, running commentary of local sport events, etc). The entertaining side of a regional and/or local station programme is fulfilled by TV games with the participation of audience in the studio and by programmes dedicated to the presentation of local habits and customs, (local artists and cultural events), mostly organised by the local cultural institutions. The daily programme output also contains satirical programmes, usually written in the local dialect which attempt to criticise the social and political everyday life of the region. The children programming in the mornings is also part of the entertainment programme.

The local news programmes are classified into two categories: (a) the brief ones that have a duration of five to 15 minutes and are presented in the afternoon between 14:45 and 15:30 hour, as well as later between 17:00 and

18:30; (b) the central TV news bulletins, twice in a day, that last about 30 minutes and are presented before those of the national coverage stations.

The first news telecast is presented at about 20:00 and is partially covered by those of the national stations. The night TV news bulletins lasts also 30 minutes and is usually presented at 23:00 until 23:30. The information programmes (magazines, information programmes, documentaries, etc) are usually presented in the evening time slot, while the talk shows about politics or sports are presented after the evening news.

Apart from some programmes in which the local dialect is used, there are no other programmes, addressed to national, linguistic, religious or other minorities. Also there are no programmes in a language other than Greek. This can possibly be explained by the fact that the Greek population appears to be very homogeneous (Dimitras, 1995) and also by the fact that the only officially recognised minority in Greece is that of the Moslems of Thrace. According to the population census of 1991, 97.3 per cent of the population has Greek citizenship and speaks Greek (*Statistical Yearbook of Greece 1992-1993*, 1995). In Thrace the viewers have the opportunity to watch four Turkish, satellite TV stations that are using frequencies which belong to Greek regional TV stations. The owners of the stations believe that programmes in other languages or programmes addressed to minorities would not attract an important part of the local market and, consequently, this kind of programmes would not be profitable.

4.4.5. Audience

Unfortunately, for most of the Greek regions systematically measurements are not conducted and as a result the rating cannot be measured properly. Nevertheless, there are some measurements[12] at regional level that indicate certain tendencies.

Examining TV viewing of Greece as a whole, the rating of the regional TV stations doubled during the recent decade. There are also some TV stations which attract, on a continuous basis, the preference of the viewers in Athens, in the other bigger urban centres, as well as in the semi-urban and rural areas. This fact reveals the dynamic that the regional and local stations could obtain by offering a qualitative acceptable information concerning events happening at the region. Perhaps the option of the audience towards small stations, is a sign of fatigue of the viewers by the programmes that are transmitted by the national channels. The rating that the local TV stations obtain per geographical area, is increasing for all areas without exception. The regions that show the greatest increase are the ones where big local channels exist and the competition has increased, as for instance Thrace, Crete, Continental Greece, Thessaly, etc.

As previously mentioned, there are two Unions that represent the interests of the local and regional TV stations. 12 regional channels producing their own broadcasting programmes and desiring a certain regulation for the TV

frequencies, were organised under the Union Of Owners of the Regional Television Media of Greece, EIPTME. On the contrary, the owner's of small stations, not producing programmes, would prefer a legislative absence and free action without severe governmental control, organised themselves under the Union of Regional Channels (EPEK). The EPEK was founded in 1995 and in 1997 included 87 members.

Table 4. Percentage of average daily TV viewing* of various channels by areas and geographic regions for the years (1993-1997) (%).

Areas	1993		1994		1995		1996		1997	
	1**	2***	1	2	1	2	1	2	1	2
Athens	78.2	2.8	78.1	6.3	72.3	5.3	77.3	6.2	76.4	8.7
Salonica	73.4	8.5	77.1	12.3	73.6	12.4	79.9	9.6	81.8	10.3
Urban centres 50,000+	79.3	8.5	84.1	13.7	83.3	12.2	83.2	14.6	85.6	16.9
semi-urban & rural areas	79.2	7.1	81.3	10.2	81.2	11.9	83.1	11.9	84.1	14.8
Greece total	78.2	5.5	79.6	8.9	77.1	9.3	80.4	9.4	80.7	11.9
Continental Greece	73.5	3.3	81.6	6.1	77.2	5.3	79.2	6.6	83.9	10.4
Thessaly	80.2	10.3	82.5	14.3	84.7	14.6	85.9	18.5	86.8	21.4
Epirus	73.3	9.2	90.3	17.7	85.5	14.6	85.7	19.5	87.7	18.7
Macedonia	81.0	8.0	76.7	8.9	81.0	12.1	81.8	8.2	80.8	10.3
Thrace	80.3	4.3	85.1	10.7	83.8	16.0	87.1	9.2	82.2	16.1
Peloponnese	82.8	7.9	83.8	10.0	82.6	13.2	87.7	14.0	85.7	15.8
Crete	81.6	7.8	80.5	11.5	79.6	14.6	79.6	20.5	86.6	24.2

*% of viewers who have seen the TV channel at least half hour in the day of the examined period. The survey examine the first trimester of the year and include people of seven to 70 years of age.

**Viewers who have seen any national channel.

*** Viewers who have seen any local channel.

Source: Bari Report of Focus for the years 1993-1997.

Another effort of co-operation based on purely private business criteria was the foundation of the TV NET in 1992, whose founding members were the following TV stations: Delta TV, Centre TV, TV Epsilon, Macedonia TV, Criti TV, TV 7, and Alithia TV. In 1997 some of the founding members left, and today the joint stock company is based on five stockholders: TRT, Teletype, In Channel, Criti TV, Delta TV, and the Metron Media. It also holds a network of 23 local and regional TV station-subscribers throughout the country. It is a network of certain regional channels throughout Greece co-operating with local radios and the private company Metron Media. Their scope is co-production and acquisition of Greek and foreign programmes and common distribution of the advertisement and the promotion of the TV stations.

5. STAR Channel: Structure and functioning of a regional TV station in Continental Greece

The regional TV station STAR Channel was founded in 1993. It belongs together with the homonymous radio station STAR FM (founded in 1988) to the company Radiotelevisional and Publishing Organisation of Central Greece (STAR A.E.). The basic stockholders of the joint stockholding company are journalists, self-employed professionals and entrepreneurs that are active in the area. The station is situated in the city of Lamia, a town of Continental Greece with 44,000 inhabitants. The total number of inhabitants that the station covers is 582,280 (NSSG, population census 1991).

The channel, which should not be mistaken for the national channel Star TV, has transmitted without interruption from the day of its foundation, in 1993, when it applied for a broadcasting licence and the NCRT gave a positive decision. So it is obvious that after a successful five years of operation the owners intend to continue broadcasting and therefore they applied for a new licence.

The station has regional coverage and covers sufficiently all the districts of the region of Continental Greece using a centre of transmission (three frequencies) and eight transmitters. Concerning the TV coverage, the area is difficult to access because off its mountainous environment. That's why the competitive local stations (another six TV stations are broadcasting at the same region) did not succeed to cover with an acceptable quality signal the entire area.

The technical equipment of the station is at a stage of renewal. They use the Betacam system and at the same time the system Super VHS and according to their expansion plans they intend to buy equipment for digital processing in the near future. The channel has two studios, a small studio with one camera and auto cue and a stage with three cameras. As for the needs of the external transmissions there are several teams with portable cameras and also a car (van) is being equipped. The station has six editing sets and a console, which although does not offer digital technology, offers the ability of parallel production and transmission. The building is not sufficient to cover the needs of the station, but they do not intend to improve the existing conditions before the state policy concerning the provision of broadcasting licences is settled. The investments by the end of 1996 were over 650 million drachmas with the perspective that in 1997 they will reach more than 1 billion drachmas.

The administrative division of the station includes the following six sections: news, information, programming, marketing, public relations, advertising, and technical division. Almost 40 people work for the station. Five of them belong to the administrative personnel, five to the sales and the advertising, and fifteen consist the technical personnel. The channel

also includes a journalistic team of fifteen people and co-operates with many external collaborators (correspondents). The educational level and the vocational training of the staff lacks of any specialisation, nevertheless it covers more or less the needs of the station. As for the training and the specialisation of the staff, seminars are organised by the management, inviting various kind of specialists.

The revenues of the station are coming from the advertisements. Unfortunately, we were not able to find out the income of the advertising expenditure in the last economic year. A very significant source of income is the manipulation of the phone information services audiotex in tele games and in "after midnight shows".

As for the local advertisements the conditions are the same with the majority of the regional and local stations. The entrepreneurs of the region, although interested in advertising their activities and products through the regional television, they totally ignore the way that the advertising is produced and operates through the medium. The staff of the station, although not properly trained, have to create and produce advertising spots. It is estimated that almost 80 per cent of the advertising spots come from the local market and only 20 per cent from Athenian companies. Because of the lack of measurements for regional advertisement expenditures, it is not possible to specify the target groups of the consumers, nor to evaluate the results of the advertisements. The station follows a steady financial policy towards all the operators (media shops, advertising companies, local representatives, clients etc) per type of advertisement and per time slot.

The programming of the station follows a general orientation, with information and entertainment transmissions. The "philosophy" of the production of the programmes is made to fit a public that includes, according to the research of the station, 40 per cent rural population, and 60 per cent other occupational activities. Given that the competition towards the national channels is strong and the costs of the programme are high, the programme has focused on the production of transmission that refer to local activities. They pay much attention to the news, the informative transmissions – political and sports events – reportage referring to current local topics, and the entertainment that include participation by the public, such as TV games.

During the period 1997-1998 almost 95 per cent of the broadcast programmes were internal productions of the station. More specifically, the following types of programmes are being produced: a daily informative magazine; an informative transmission every weekend with an overview of the events of the week; three talk shows with guests from the regional political and social life that are scheduled after the evening news; a cultural transmission that present different landscapes and cultural events from Central Greece; an informative transmission exclusively for peasants; a

transmission for the fans of automobiles; two athletic transmissions; a TV game with participation of viewers and a musical transmission presenting Greek and foreign video clips and interviews with artists etc.

There are three news bulletins during the weekdays and four during the weekend. More specifically, the news is transmitted daily between 18:30 and 18:35, in the evening at 21:00 till 21:30 – usually for a half an hour – and at 23:30 until 23:50 as the late night twenty minute news bulletin. During the weekend a five minute news bulletin is added between 15:30 and 15:05.

The station starts transmitting at 9:00 a.m. and stops at 02:00 a.m., depending on the duration of the foreign movie. After that follows the well known "after midnight programme": *pink ads*, fortune-tellers, porno graphic movies etc.

The programming during the week remain stable. The only exception is the midday time slot at the weekend which includes transmissions referring to special categories of viewers as eg rural population, sports fans, automobile fans etc.

The structure of this programming seems to be effective. According the ratings of the Nielsen company in November 1996, 54 per cent of the inhabitants of the Continental Greek region watched this station.[13] The popularity of the station in local society is also visible from the fact that the public turns to STAR to make its beliefs and problems public. The communicational relations with the viewers, which are also supported by the radio station, are the most significant advantage of the station. The station managers believe that this relationship has come true because STAR Channel keeps its independence from political parties and local political authorities and representatives.

The owners of the station are members of the EIPTME and also participate in the TV NET network. Moreover, the station plays a leading part in activities that aim to organise and distribute the advertising at the regional level.

To summarise, STAR Channel is a typical example of a well operated regional station in Greece that acknowledges the general transmitting problems of the regional and local stations. Furthermore, it is characterised by the well-known deficiency in technological support, training and specialisation of the staff, lack of information about the new technological abilities of networking that offers satellite and digital television etc. If finally the broadcasting licences will be provided and the TV business field will be settled, TV channels like STAR Channel will be challenged to make the decisive step that is going to lead them to a modern technological environment with greater abilities of networking and major changes in their programme schedules. Otherwise, in the long-run they are condemned to local isolation and marginalisation.

Table 5. A typical week's programming schedule of the regional TV station STAR Channel of the period 1997-1998.

Time	Monday	Tuesday	Wednesday	Thursday	Friday	Saturday	Sunday
9:00	Cartoons, children's programme						
11:15	Telemarketing						
12:00	Greek movie					Sports show	Cultural show
13:00	Talk show on local affairs (sports, repetitions, documentary)					Peasants hour	
15:00	Local news					5' bulletin Foreign movie	
16:30	Children's series						
17:00	Greek series					Automobile show	
17:30	Music video clip					Greek serial	
18:30	5' news						
18:35	Greek movie						
21:00	News						
21:30	Talk show on current local affairs						
23:00	Foreign movie						
23:30	News						
23:35	Foreign movie (continuing)						
2:00	After midnight show (fortune tellers, pink ads. etc.)						

6. New problems and perspectives

The above presentation shows us that the future of Greek regional and local TV stations, in terms of their economic viability is very fragile and faces many problems. This is not only due to their large number in comparison to the relative small number of households in each region, nor to their old-fashion technical equipment, but also in the human resources and in the incentives which forced the owners to get involved into such business. Their owners do not have the adequate educational background nor sufficient specialisation in the management of electronic media companies.

Furthermore, their information seems to lag with regards to the new technical developments, especially concerning digital and satellite technology applications. The majority of the owners do not receive information about new joint ventures in the audio-visual market. In effect, there is little or no interest in being involved in networks with other regional EU TV stations aiming to exchange programmes.[14]

Among the positive effects which characterise the sector of regional TV enterpreneurialism is the relative high interest of the citizen in issues concerning regional and domestic politics and in promoting local cultural events in which local initiatives or institutions take part. The relationship

211

between regional and local media to the regional or local authorities and institutions has always been very tight because of the mutual benefits. On the one hand, they receive continuous information interesting the population of the area, and, on the other, local activities are made public and therefore gain regional and/or local prestige.

1998 may become the year, during which a form of order will be set up regarding the terrestrial TV frequencies. But it is worth noting that the recent development in digital TV could refute the planning concerning the distribution of frequencies and the licence policy for terrestrial channels. In a period when the majority of EU countries are concerned with planning the next steps in order to face new technological developments, Greece is seeking to find out solutions caused by older technological standards. This indicates not only a serious delay in Greece keeping up with the pace of the new environment, but it would also affect the balance among EU countries as well as among different social groups.

The question that arises is: what will be the future of regional and local TV stations on the new digital era? It is obvious that in such a competitive field only those TV stations which are able to provide a satisfactory technological structure and a considerable share in the regional advertising market will survive. Many production companies or TV stations at an international level will try to "recycle" their programmes using the networking of regional channels. Thus, it may be possible that a parallel circle of TV programmes distribution may be organised. This will address the small, specialised regional channels which will receive an economically profitable programme diet and at the same time would offer an international entertainment programme to its audience. Of significance to the Greek case, and especially the smaller countries of EU, language will cause a serious barrier in the flow of international programmes. Besides this, the low purchasing power of the Greek population in the regions in comparison to its EU counterparts, will provide another barrier.

During the last two years, considering decentralisation and reinforcement of local government, some decisive steps towards the modernisation of the legal framework have been made. These efforts will certainly influence the functioning of regional and local TV stations. New developments in the digital production followed by the intention of the government to regulate the chaotic conditions of TV station practices, will also decisively influence the field in the next years. A new era is coming.

Neither one can foresee how many of the approximate 140 existing regional and local TV applicants for a licence will survive in the near future. This has mainly related to the consideration of whether they will successfully face the conditions of the new competitive environment. What is certain is that the number of regional and local TV stations in Greece will be drastically decreased. However, this new situation may alarm the local TV channels' owners and change their traditional attitudes. Although this

may be difficult, one has also to take into consideration that Greek businessmen and media have been proven to be extremely adaptable to the demands of their time.

Bibliography and References

Alivizatos, N. (1986): *State and Broadcasting. The Regulatory Dimension*. Athens: Sakkoulas (in Greek).

Beriatos, E. (1994): "The Policy of Administrative and Territorial Reorganization of Local Government (1984-1994)", in *Topos. Review of Urban and Regional Studies* 8 (in Greek).

Christofillopoulou, P. (1996): "Field Administration and Local Government in the Greek *Nomos*", in *Greek Political Science Review* 7 (in Greek).

Dagtoglou, P. D. (1989): *Broadcasting and Constitution*. Athens: Sakkoulas (in Greek).

Demertzis, N. (1996): *Local Publicity and Local Press in Greece*. Athens: Agricultural Bank of Greece (in Greek).

Dimitras, P. E. (1995): "Greece: Unbridled deregulation", in Moragas, M. de and Carmelo Garitaonandía (eds.): *Decentralisation in the Global Era*. London: John Libbey.

Hadjimichalis, C. (1987): *Uneven Development and Regionalism. State, Territory and Class in Southern Europe*. London: Croom Helm Ltd.

Heretakis, M. (1997): "Trends in Mass Media. An exclusively quantitative analysis", in *Notes on Communication*. Athens: Institute of Audio-visual Studies, no. 1 (in Greek).

Kanellopoulos, K. *et al.* (1992): *Shadow Economy and Tax Evasion: Calculations and Economic Results*. Athens: KEPE Publications (in Greek).

Katsoudas, D. (1985): "Greece: A Politically Controlled State Monopoly Broadcasting System", in *West European Politics*.

Moragas Spà, M. de and C. Garitaonandía (1995): "Television in the Regions and the European Audio-visual Space", in *Decentralisation in the Global Era*. London: John Libbey.

Panagiotopoulou, R. (1988): "Changes in the Behavior of People Through New Ways of Spending Leisure: The Use of Video in a Small Town", in *Review of Social Research* 71 (in Greek).

Panagiotopoulou, R. (1996): "From the State Monopoly to the Private Duopoly and From the Citizen to the Viewers: Recent Development in the Mass Media", in *Limits and Relations Between Public and Private Sphere*. Athens: Sakis Karagiorgas Foundation (in Greek).

Papadimitropoulos, D. (1998): "The Re-organisation of the Regional State Administration (law 2503/1997)", in *Administration Review* 10 (in Greek).

Papathanassopoulos, S. (1993): *Deregulating Television*. Athens: Kastaniotis (in Greek).

Papathanassopoulos, S. (1994): *Television in the World*. Athens: Papazissis (in Greek).

Papathanassopoulos, S. (1997): "The Politics and the Effects of the Deregulation of Greek Television", in *European Journal of Communication*, vol. 12, no. 3.

Pesmazoglou, S. (1993): "The 1980s in the Looking-Glass: PASOK and the Media", in Clogg, Richard (ed): *Greece, 1981-89. The Populist Decade*. London: The Macmillan Press.

Venizelos, E. (1989): *The Broadcasting Explosion: Constitutional Framework and Regulatory Choices*. Thessaloniki (in Greek).

Zacharopoulos T. and M. E. Paraschos, (1993): *Mass Media in Greece. Power, Politics and Privatization*. Westport CT: Praeger Publishers.

Notes

1 The historical evolution of the local government is divided into four periods: (a) 1828-1887, institutional establishment of local government (Capodistrias, Othon); (b) 1887-1927 the reforms (H. Tricoupis and E.Venizelos); (c) 1927-1984 inactivity, and d) 1984-1997 the latest reforms and the restructuring of the Local Administration Units. See also E. Beriatos, 1994.

2 In 1951 in the Greater Athens area lived 18 per cent of the total population, in 1961 22 per cent, 1971 29 per cent, 1981 31,1 per cent and in 1991 29.6 per cent. See also Special Annual Edition, The Greek Economy 1997- The Greek Departments, Epilogi, 2nd volume, Athens, 1997. The concentration of the population is followed by a strong concentration of industrial activities. See also C. Hadjimichalis (1987).

3 Exempt from the those two laws that are mentioned, several laws have also passed 1941/91, 1943/91 and 2173/93, they have been published the following presidential decrees 25/1988, 572/1989, 236/1992 and ministry decisions 22255/2/1990 and 187118/23.7.1993.

4 During 1993-94 most of the stockholders of TV companies tried to expand in other activities, especially in the constructing sector in order to ensure in their favor the big public construction works that were offered by the Second Community Frame of Support. It is worthy to mention that construction works are mostly bought by the public sector (90%). Therefore, it is obvious how profit-bearing can the combination between the construction enterprises and the media be. The same occurs with other enterprising activities, for example, the commercial marine, the energy sector, the telecommunications etc., where the state is one of the greater clients, and also the necessary regulator of the interests. See also Panagiotopoulou, 1996.

5 See also, law 1866/89 article 2, par. 2, and its alteration to the law 2173/93 208/16.12.1993 articles 1 and 2, Presidential Decree 213/1995 that define the organization and function of the NCRT and the law 2328/1995 articles 17 and 18.

6 Ministerial decision number 15587/E, 785/1.9.1997 and 813/9.9.1997. The capital stock varies according to the size of population and the region covered by the station.

7 ET3, as well as ERT, is suffering under the pressure of problems that derive from an inefficient management (too many employees, high costs etc). See also Eleftherotypia, 14-12-1989 and Zacharopoulos and Paraschos, 1993.

8 The first indication about the number of the regional and local TV stations is included in a list edited by the Ministry of the Press and the Mass Media in 1993. According to this list the total number of stations was 152. Other sources that were used during the research to enrich this information were: (a) the catalogue of the members and the associates of TV NET; (b) the edition Annual Guide of Communication for the years 1996 and 1997; (c) the edition Economic Guide of ICAP for the years 1992-1998; and (d) the catalogs about local media available by the press offices of the Regional Authorities of Greece.

9 Using a standardized questionnaire, data about the main characteristics of 126 TV station were collected, while another 17 TV stations were located but refused to give information about their activities.

10 From the total number of the stations which answered the question about their technological equipment, 12.1 per cent is using Betacam equipment, 21.0 per cent is using Betacam in combination to Super VHS equipment, 39.5 per cent is using exclusively Super VHS, 21.0 per cent uses both Super VHS and VHS type and finally, 5.6 per cent is using VHS equipment.

11 According to the research data, from the total number of the stations that answered the question about the duration of their daily broadcasting 21 (17.3 per cent) are broadcasting for less than 10 hours a day, 31 (25.6 per cent) are broadcasting up to 15 hours daily, 20 (16.5 per cent) reach the 20 hours of broadcasting during the day and 49 (40.6 per cent) are broadcasting in a round the clock basis.

12 The measurements are referring to the BARI Research that is held from FOCUS company in trimesters, using a quota sample by sex, age (people 7-70 years old) that live in urban, semi-urban and rural areas. The viewership that concerns the TV viewing of the previous day. Unfortunately the sample that the research used does not include the inhabitants of the islands with the exemption of Crete and the geographical distribution does not follow the existing administrative division for each region of the country.

13 The measurement concern the TV viewing of the previous day and indicates the TV spectators of the department of Fthiotida and Biotia that watched this channel for at least five minutes.

14 From a number of TV stations examined during the research project, only the owner of one TV station, that of Kriti TV, declared that he participates in an international network initiated by the Japanese Yamagata Broadcasting Co. Ltd. The scope of this network is to exchange TV programmes dealing with cultural issues and events. The members of the network named YBC Sister-Station Network are beside Japan and Greece the regional stations of KCNC (Denver, Colorado), Andong MBC in Korea, PTV in Poland and SCN in Germany.

Ireland: Competitive challenges for television[1]

Ellen Hazelkorn

A palpable sense of prosperity is creeping over the country. Ireland has its first generation of homegrown millionaires. (*Time Magazine*, 11-12-1995, quoted in O'Grada, 1997)

Ireland's transformation is so dazzling. One of the most remarkable economic transformations of recent times: from basket case to 'emerald tiger' in 10 years. ('Europe's Shining Light', *The Economist*, 17-5-1997, quoted Sweeney, 1997)

1. Ireland's economy and society: overcoming peripherality?

Over the past few years, dramatic changes in the performance of the Irish economy and rises in living standards, reflected in the palpable buoyancy of the population as it partakes in a widening range of consumer products, outlets and opportunities, have set commentators reeling. The term "Celtic tiger", deliberately used to trade on the experience of the "tiger" economies of Southeast Asia, has achieved public currency as the description for this remarkable turn-about in economic fortunes. Contemporary writers focus almost exclusively on optimistic economic forecasts, predicting that per capita income, if calculated as a per cent of GNP, is already overtaking that of its former "colonial master", the United Kingdom, and EU norms. Thus making Ireland ineligible for future consideration for the structural and cohesion funds partially responsible for the "take-off" (Stephen Collins, "Ireland's new wealth to affect EU funding", *The Sunday Tribune*, 15 February 1998). In contrast, publication titles of a decade ago abounded with the words "crisis" or "challenge" (See

inter alia: Crotty (1986); O'Malley, (1989); and Keane (1993). Cf. Sweeney, 1997: 207). Their writers referred to Ireland as a peripheral late-developing society, with associated difficulties of little indigenous manufacturing, virtually no commercial exploitation of national resources, small-scale and inefficient agriculture, poor dispersal of resources and a weak infrastructure. Ireland was described by this author as a "labour exporting economy" with a "culture of migration" provoked by persistent unemployment and poor economic prospects (Hazelkorn, 1992: 193).

Irish economic development has, as O'Grada (1997: 34) comments, been "closely bound up with those of the United Kingdom. Geography and politics [has] determined both fluctuations and trends". As the small island neighbour of a more economically and politically powerful empire, there was a certain inevitability that competitive advantage during (and indeed, after) the rise of industrial capitalism lay where the concentration and scale of burgeoning manufacturing, resources and trade, and proximity to large markets would prove most profitable. In contrast, Ireland's competence arguably lay with pasture agriculture; traditional practices had, however, favoured tillage on ever decreasing plots of land, a perch which proved too precarious to withstand the onslaught of famine and relative over-population in the mid-19th century (Cullen, 1972, and O'Malley, 1989).

Political nationalism seized upon the human and economic misery of these imbalances, and proffered a view that an independent Ireland would have "averted the decline which was otherwise inevitable" (Connolly, 1973: 32). However, following independence in 1921, the government (was led by Cumann na Gaedheal, the predecessor of the current Fine Gael party) chose a policy that preserved Ireland's political and economic "dominion" status. Within a decade, a matrix of global and national economic, ideological and cultural factors forced the jettisoning of that policy. The victory of Fianna Fáil, the more nationalist party, led by Eamon de Valera, applauded protectionism, exclusion of foreign capital, indigenous manufacturing, and tillage farming based on small family farms.

The aftermath of World War II (a period known as "the crisis" in "neutral" Ireland), saw the ground laid for yet another policy reversal, this time emphasizing the liberalisation of trade, incentives to foreign capital, and capital-intensive export-oriented production, a strategy that has remained at the heart of industrial policy eversince. Within two decades, Ireland was transformed from a traditional agricultural society with a class structure based on family property to an urban industrial society with a class structure based on skill and educational opportunity. The road to economic growth has not, however, been steady; the economic boom of the 1960s ran into difficulties after the oil crisis of 1973 and a risqué political strategy employed by Fianna Fail in late 1977 in a blatant effort to win votes. The 1980s were bleak: poor economic performance, declining incomes, numbers at work in 1991 lower than in 1926, and emigration at

the exceptionally high level of earlier decades (over 40,000 chose to seek employment elsewhere in 1989). Per capita income was 40 per cent below the EU average, the unemployment record the second worst in the OECD, long-term unemployed comprising 67.2 per cent of the total out of work, and approximately one-third of the population surviving solely on state subsidy (ee Hazelkorn, 1992: 180-200). Various reports (most notably the Telesis Report), questioned a government strategy that was based largely on "import innovation" (Telesis Consultancy Group, 1982, and Wickham, in *Irish Times*, 26-2-1993) or "economic development off-the-peg" (O'Toole, in *Irish Times*, 3-3-1993), warning that Ireland was in danger of becoming a labour-intensive, low-cost, low-wage production centre.

In a strenuous effort to overcome the legacy of late-industrialisation, Irish policy makers identified and targeted first the electronics industry, and more recently, information and communications technologies, with a particular emphasis on information distribution and cultural content products, as a mechanism for "jump-starting" Irish economic growth. Strategists of all the main political parties have deliberately chosen to eschew traditional links and dependence on Britain and sterling, and entered the EMU on 1 January 1999. Combined with massive state transfers through access to EU funds, these initiatives have, inter alia, enabled Ireland to arguably become one of the fastest growing economies in the world by the latter 1990s, albeit it remains plagued by stubbornly high long-term unemployment, widespread poverty, and over-reliance on multinationals (Sweeney, 1997: 4-5, 130, 155, 164) (see Table 1). This is a remarkable turn-about by almost every measurement, albeit storm clouds are already gathering (Suiter, in *The Irish Times*, 13 June 1998). The electronic and print media, film, music, publishing, and multimedia – the cultural industries – lie increasingly at the heart of this strategy.

Fianna Fáil has dominated political power in Ireland since 1932, whether in or out of government; it has, with variations, successfully constructed its hegemony on an alliance of petit-bourgeois economic nationalism, state interventionism and popular social reform. Despite occasional electoral hic-ups when Fine Gael governed with the support of Labour and a combination of various smaller parties, the party system was long portrayed in the academic literature as a stable two and a half party system (Bew, Hazelkorn and Patterson, 1989; O'Leary, 1979). The impact of the fiscal, political and social crisis of the 1980s combined with a weakening of nationalist objectives, and contributed to the steady decomposition of Fianna Fáil, and the emergence of two "radical" parties, on either end of the political spectrum. The Workers' Party (transformed into Democratic Left in 1992) surged ahead dramatically in 1989, challenging Labour for the working class agenda. In contrast, 1986 saw the Progressive Democrats break away from FF because of deep ideological divisions over economic strategy. While arguably both parties have helped shape public policy and social values, the latter has been to the fore in helping forge a growing

public and popular consensus around the neo-liberal agenda; thus, the creeping global acceptance of neo-classicism as formidably espoused by the UK's Margaret Thatcher found ready followers in the Ireland of the 1980s: fiscal rectitude and severe cut-backs in public expenditure, the importance of the market, attacks on "welfare dependency", and the de-regulation, sale and commercialisation of public enterprise.

Table 1. Characteristics of the "Irish Economic Miracle"

- Over 50,000 net new jobs created per year in the mid-1990s
- 216,000 additional jobs created – a 20% increase since 1987
- Growth rates highest in the world, running at 7.5% per year in the late 1990s
- Low inflation
- Low nominal interest rates
- Large balance of payments surplus
- Net immigration
- Current budget surplus
- National debt dramatically reduced to 69% of GNP in 1997
- Few industrial disputes; conflict replaced by partnership in the better enterprises
- Profits booming
- Incomes growing in real terms every year
- Fall-off in the dependency ratio
- Irish living standards will soon equal the EU average
- Future looks good!

But:
- Unemployment remains high compared to most countries – 10.3% in 1997
- 58% of the unemployed have been without a job for more than a year
- One-third of the population is classified as poor
- By 2000, the foreign MNC sector will be the biggest employer

Source: Sweeney, 1997: 4-5.

Today, the Irish political landscape is complex and fragmented.[2] Since 1987, minority or coalition government has become the norm; various government combinations and titles ("partnership", "coalition" and "rainbow") signal the extent to which political parties are able to (re)define themselves, constructing and re-constructing myriad cross-class alliances. The 1997 election acutely measures the extent of this convergence on the centre, not least in the manner by which the political extremes (right as well as left) had been marginalized (Hazelkorn, 1997a). Thus, predictions that modernisation and European integration would prompt a political realignment along a more "European" left-right divide have proved premature.

The most striking fact about life in modern Ireland is the rapidity of change from a society dominated by a traditional, agricultural and nationalist petit-bourgeoisie to one dominated by a modern, commercial

and professional Europeanised bourgeoisie. There is little doubt that internationalisation of the economy, enhanced employment opportunities, travel, telecommunications, and rising living standards have led to a "sustained and increasing internal assault" on the traditional values of women and the family, religion, sexual conservatism, and "rural fundamentalism" (Fennell, quoted in *The Irish Times*, 6 December 1967; Commish, 1986: 52). Still a society with an overwhelming Roman Catholic majority (92 per cent), the main tenets of the liberal agenda have been won contraception, divorce, abortion information and, arguably, limited abortion are available,[3] and the decriminalisation of homosexuality and the lowering of the age of consent have been attained. The once omnipotent Roman Church is imploding, racked by sex scandals and allegations of hypocrisy: priests fathering children and the sexual abuse of children in their care. Surveys show a steady decline in religious devotion, attendance at Mass, and "loyalty" to priests (see Table 2) (MRBI/RTE *Primetime* Survey on "Religious Practice", February 3, 1998; see also *The Irish Times*/MRBISurvey on "Changing Religious Attitudes", 16 December 1996). The fall in numbers entering religious life, once one of the sureties of "employment" has further undermined the church's influential position in society through their pre-eminent role in education, health and social care.

The advent of this café society has presented other challenges to the once monolithic society. A few years ago, one could still speak of a society on the periphery of Europe untouched by the recent waves of migration. This is no longer the case; rapid economic expansion has given rise to a labour shortage attracting many from elsewhere in Europe and further afield. Political and economic refugees from eastern Europe have also been attracted by a society described as the most dynamic in Europe. For a society that had (perhaps falsely) prided itself on being the land of *céad mile fáilte* (a hundred thousand welcomes), racism has raised its head.[4] The general election of 1997 saw the issue of illegal immigrants become a heated political one, with various politicians expressing concern that Irish society and its way of life was under threat.

Table 2. The "Millennium Generation" (18-34 year olds)

- 89% say its acceptable for couples to live together before marriage
- 71% are in favour of legalized divorce
- 64% believe abortion should be legalized in certain or all circumstances
- 88% say the church is of less importance to them than their parents

Source: Landsdowne Market Research/*The Sunday Press* Survey, 26-2-1995.

While affiliation to traditional nationalist objectives as expressed in a desire for a "united Ireland" has weakened so considerably that it is no longer on the political agenda (a factor arguably evident in the exceptionally high level of support for the "Good Friday Agreement" among citizens of the Republic), the current wave of economic success has

been interwoven with the emergence of a new nationalism, described by some authors as a "postnationalist" nationalism (Kearney, 1997). "Irishness" in this context has been aided very definitely by success whether in the economy, in sport or in the arts. It is confidently expressed; no longer worn as the cultural flag of an un(der)developed society forced to export its surplus labour and from which young people couldn't wait to leave, Ireland is increasingly the location of choice for today's young and the country to which over five million tourists eagerly flock. Indeed, Dublin is one of the top destinations for weekend visitors from the UK and the European continent. The transformation from an isolated conservative backwater of Europe to an outward-looking society sharing similar values and lifestyles with the rest of the developed world has been strongly welcomed. This confidence is expressed in an Irish culture influenced by tradition but not hide-bound by it; traditional musicians happily play along side blues, rock and country musicians while Irish dancing uses the techniques of modern dance and ballet (The most successful exponent of this phenomenon was Riverdance, a musical-dance routine)· The success of, inter alia, Clannad, Enya and Hot House Flowers with songs in Irish, of the Irish football team, especially under Jack Charlton (1986-1995), and the Irish film industry with its many Oscar nominations and trophies, are examples of a national culture commodified and marketed, an "entrepreneurial nationalism".[5] The Irish language still primarily associated with the west of the country, an area known as the Gaeltacht, is increasingly spoken with pride.

2. Television's legal setting

Ireland has followed its European partners in attempting to establish a dual system of private and public television services by making legal provisions for private (terrestrial) commercial television (Brants and Siune, 1992). RTE (Radio Teilifís Éireann) has been the sole broadcaster operating within the state of Ireland although not on the island of Ireland. Despite its troubled history, it is now certain that TV3, the first private-commercial television station will begin broadcasting in autumn 1998, thereby offering direct competition to the public broadcaster.

RTE provides two national television channels, RTE 1 and Network 2, broadcasting an average of 200 hours service per week. Half of its total output is home produced. RTE is also responsible for several public radio stations: Radio 1, 2FM (a 24-hour popular music station), FM3 (a classical music station), Raidio na Gaeltachta (an Irish-language station) and Radio Cork (a local station in the second main city). RTE also has an interest in Atlantic 252, a commercial popular music station financed by British advertising and broadcasting to the UK on long wave, and a UK cable television company, Tara Television.[6] RTE provides a range of services by satellite, shortwave, Internet and telephone for Irish people living abroad, and contributes to the 24-hour English language channel which is co-

ordinated by the World Radio Network on behalf of a number of international public services broadcasters on the Intelsat and Asiasat satellites (www.rte.ie/aboutrte/overseas.html). Extracts of RTE programmes are available on the US east coast via cable. RTE has also been the primary national music provider, responsible for the National Symphony Orchestra, Concert Band, and various choirs and ensembles.

Teilifís na Gaeilge, the Irish language television station, began broadcasting in October 1996 with four hours programming per day; operating as a publisher-broadcaster, it is located in the Gaeltacht but provides a national as distinct from a regional or local service (see below for an in-depth discussion). There are no other regional or local television services in Ireland, except for the occasional campus television of a Dublin university and local cable television programmes run by the cable TV company in Cork, Ireland's second largest city. During 1994, the Minister for Communications permitted eighteen limited experiments in cable community television.

Irish broadcasting began in 1926 with radio. Modeled on John Reith's formula for public service broadcasting as represented by the BBC (Reith was a member of the initial interview board), 2RN (later Radio Éireann) was erected under the watchful eye of the Irish civil service as a vehicle for promoting national sovereignty and cultural/religious identity. Most programmes were home-produced and any material that affronted Catholic principles was self-censored. Both this conservative interpretation of "public service" and an appreciation of the wider economic realities encouraged early exclusion of commercial interests. The most notable of these was the obvious difficulties presented by a small population (3.5m) and an undeveloped economy. This forced government to – somewhat reluctantly – take a formidable role in broadcasting, both radio and later television, and to rely on a combination of licence fees and advertising revenues for funding. Such tight financial margins necessitated increasingly heavy reliance on American and British programmes, and prohibited any private commercial radio or television service operating, until recently.

Radio Teilifís Éireann (RTE - Irish television) began broadcasting in 1960, coinciding with and responding to the phenomenal rate of economic and social change. Over the decades it has powerfully challenged traditional cultural forms and vented the aspirations of an emergent urban bourgeoisie, whose allegiances have increasingly been tuned to continental Europe. While RTE has enjoyed a monopoly position within the state, its proximity to the UK, has meant that it has operated in the most competitive broadcasting environment in Europe; indeed, with the move to digital broadcasting, that situation will become even more significant and present RTE with its greatest challenges to date. To complement the existing single channel service and to strengthen home-

produced television against the competition from British channels, a second RTE television channel was established in 1978, known initially as RTE2 and now as Network 2. This popularly endorsed strong public service remit has come increasingly, however, under attack since the 1980s; then, a deepening domestic fiscal crisis began to undermine hitherto unquestioned loyalty and subsidization across a range of public services.

Beginning in 1988, the Irish government introduced a series of legislative and policy changes designed to deregulate ("emancipate") the broadcasting and telecommunications environment, to restrict the public broadcaster's entrance into satellite broadcasting (DBS), to increase opportunities for private ownership and independent production, and to suggest that the licence fee should be shared.[7] The then Minister for Communications argued that it "was not the function of the state to provide the new broadcasting services (...) [but] merely to provide the framework and opportunity to allow the public to decide what they wanted to see and hear" (Hall, 1993: 183). Despite confirming a commitment to public service broadcasting and adopting the language of "cultural autonomy", two recent policy proposals (Department of Arts, Culture and the Gaeltacht, 1995 and 1997), suggest threats to RTE's status.

Three main Acts[8] regulate Irish television broadcasting: the Broadcasting Authority Acts 1960-1993, which regulate the public broadcaster RTE; the Radio and Television Act 1988 which contains the regulations applicable to private commercial broadcasting; and the Broadcasting Act 1990, which, inter alia, facilitates the implementation of the EU Directive on Television Broadcasting. Additional "regulations" for the private (radio) broadcasters are contained in the broadcasting contracts signed between individual stations and the Independent Radio and Television Commission (IRTC), the government-appointed regulatory body for private broadcasters. Several policy initiatives, 1995 and 1997, have been published, suggesting dramatic changes in the regulatory structure for broadcasting and the ownership of transmission network, although no legislation has appeared. The government to which the minister responsible for these initiatives belonged has since fallen, and it is likely that the new minister has indicated that she will be bringing forward new legislation during her term of office. Cable Television is governed by the Wireless Telegraphy (Wired Broadcast Relay Licence) Regulations 1974, as amended in 1988; the Multipoint Microwave Distribution System (MMDS) is subject to the Wireless Telegraphy (Television Programme Retransmissions) Regulations 1989. Apart from these specific Acts and Regulations, other statutes such as Contempt of Court, Censorship, Defamation, Copyright, Official Secrets Act, Public Order, etc. also apply to broadcasting (see Truetzschler, 1991, and Hall, 1993, for a detailed discussion of Irish Media Law).

The Acts contain detailed and explicit regulations for private and public broadcasters. Programmes broadcast are subject to impartiality, fairness

and objectivity clauses. Thus, programmes must not offend against good taste and decency; they must not incite to crime or undermine the authority of the state. The laws also enable censorship by the government in relation to "The Troubles" in Northern Ireland. In this way, the Minister for Communications may direct broadcasters to refrain from broadcasting interviews or reports of interviews, with spokespersons of prohibited organisations, such as the IRA, under Section 31 of the Broadcasting Act, 1960 and 1976.[9] This ban was annually renewed from 1978-1994, until, against the background of the British-Irish *Joint Declaration for Peace and Reconciliation in Northern Ireland*, the cabinet agreed in January 1994 to allow Section 31 to lapse.[10] In its place, RTE and the IRTC introduced new guidelines under Section 18, and with due regard to Sections 9(1) (a) and (b), of the same legislation to curb the broadcasting of any material deleterious to the "authority of the state".[11] In its programming, the public broadcaster and any future private television service has the duty to be responsive to the interests and culture of the whole community, and to be mindful of the need for peace within the whole island of Ireland. It must have special regard for the Irish language and for promoting understanding of other countries, especially those in the EU. This duty does not apply to the private radio broadcasting services; instead private radio is subject to the requirement to ensure that 20 per cent of transmission time consists of news and current affairs.

The Radio and Telegraphy Act, 1988, established the Independent Radio and Television Commission (IRTC) with authority to licence national, local and community radio stations, and one national television station.[12] The Commission was appointed in November 1993 for five years by the then Labour Party Minister for Arts, Culture and the Gaeltacht, Michael D. Higgins (IRTC, 1995). The IRTC enters into an unspecified number of contracts with "sound broadcasting contractors" and with a "television programme service contractor". The Act specifies that the stations are to be solely commercial enterprises not in receipt of public funding. Each operator is required to pay a 3 per cent levy, amounting to between IR£600,000 and IR£650,000, in order to fund the Commission. The IRTC's role is to ensure the creation, operation and development of independent broadcasting in Ireland, and to ensure that independent radio and television contractors comply with the terms of their broadcasting contracts (IRTC, 1998). In 1994, the incoming IRTC board announced a broadening of its policy objectives to include "a developmental role, with a long-term view to consolidating and strengthening the independent broadcasting sector in general and helping to improve the standards of presentation, programming and, in some areas, management".

By law, programming quotas were established: 20 per cent news and current affairs and 30 per cent music; as evidence of deviation from the original intent of the 1960 legislation, there is no specific quota for Irish language programming. Advertising is limited to ten minutes per hour.

Each station is visited by the Commission at least once a year to review financial, programming, technical and other station operations.

The Broadcasting Authority (Amendment) Act 1993 overturned that part of the Broadcasting Act 1990 that sought to limit, or cap, the amount of advertising revenue, RTE could earn. Although the RTE Authority may, subject to the approval of the Minister, determine the total daily times and the maximum time in any one hour for broadcast advertisements, this is fixed at seven and a half minutes, significantly less than its competitors, a costly remnant of the intent behind the earlier legislation.[13] The cap had been introduced in order to divert advertising revenue away from the public service broadcaster and to assist (favour) private radio broadcasters and the proposed private television service. A political outcry followed what was alleged to be the Minister's blatant attack on RTE, not least because the "cap" arguably led to severe cutbacks in its operations. This first onslaught on RTE's revenue generating powers had been anticipated in light of the government's determination to de-regulate the sector; further manoeuvres attacking RTE's "monopolist" and anti-competitive position have been mooted.

The 1993 Act, following similar developments in the UK, marks government determination to force the creation of an independent film and broadcasting sector. Under the legislation, RTE is required to make specific amounts of money available in each financial year for programmes commissioned from the independent sector: from IR£5.0 million in 1994 to 20 per cent of television programme expenditure or IR£12.5 million (whichever is greater) by 1999. Independent television producers are very clearly defined in the Bill, thereby ensuring that RTE or any other existing broadcaster is prevented from allocating the money to any subsidiary company. RTE has established the Independent Production Unit (IPU) to liaise with independent producers and commission such programming.

The Government Green Paper (Department of Culture, Arts and the Gaeltacht, 1995), provided one of the most thought-provoking discussion papers on broadcasting and related issues ever in Ireland. Clearly influenced by international academic debate, the paper addressed, by way of a series of questions to which it sought a public response, concerns about globalization and its effect on national culture, and the impact of broadcasting on national identity, issues particularly pertinent to a peripheral society, often described as the United States' 51st state or a colony of the UK. Issues of a "super-authority" to regulate broadcasting in Ireland, whether public service or commercial, the privatization of the transmission network (currently under RTE's control), the concept of public interest and accountability, and the importance of public broadcasting were all addressed. That debate was followed two years later by legislative proposals, *Clear Focus* (Department of Culture, Arts and the Gaeltacht, 1997), whose main proposals included, *inter alia*, endorsement

of mixed broadcasting environment; proposals to establish a single regulatory and policy-making authority, Irish Broadcasting Commission, to oversee the broadcasting sector – including local and community services on cable, MMDS, educational television, Irish language television, etc – and conversion of the RTE Authority into a statutory broadcasting corporation. The present government, which in opposition opposed key aspects of that document, will introduce further legislation in 1998 (Foley, in *The Irish Times*, January 1997).

Irish national broadcasting policy is fairly consistent with European tendencies and generally there is much emphasis on the economic and financial benefits of European membership for Ireland. As mentioned above, the licensing of private broadcasting operations and the regulation/deregulation of broadcasting in Ireland reflect current European trends, such as abolition of state monopolies, privatization of state enterprises, and commercialization of broadcasting. Irish media law is broadly in line with the EU *Directive on Television Broadcasting* and the Council of Europe Convention on *Transfrontier Television*. In fact it can be argued that Ireland has simply copied its European partners and has privatized the airwaves, without developing a specifically thoughtout policy appropriate to a small state like Ireland, albeit the 1995 Green Paper on broadcasting did hint that this was about to change.

3. Institutional and business structure of television in Ireland

Economic factors have played an important role in public policy towards broadcasting communications in Ireland since radio began in 1926. Given the absence of a vibrant, private entrepreneurial class, broadcasting policy has mimicked economic policy generally, with the state filling the vacuum, promoting, regulating, deregulating and, arguably, re-regulating sections of the economy for pragmatic but not ideological reasons. Today, little has changed except the intensity of that project.

Since the mid-1980s, numerous political and financial initiatives have sought to de-regulate and re-construct the broadcasting and tele-communications environment based on an increasing realization that information distribution and cultural products can be a significant player in the national economy.

Most recently, the government has indicated that it intends to deregulate the telecommunications sector by 1 January 1999, a year ahead of schedule, and to force the sale of Cablelink, jointly owned by Telecom Éireann and RTE. Other semi-state companies are also being readied for a "sustained programme of privatisation" (Coleman, in *The Sunday Tribune*, 24 May 1998).The view that the government would be better off regulating rather than owning various key utilities is now broadly accepted by most political parties, this shift towards commercialization and privatization is now accepted as ideologically non-contentious (For a full discussion of

how the state has sought to kick-start an audiovisual industry in Ireland, see Hazelkorn, 1997b: 235-260).

Early in the 1980s, a consultant report had recommended a reformation of RTE's corporate organization and strategy: transformation from producer to publisher, externalization of programme-making through active commissioning and purchasing of independent productions, and changes in heretofore restrictive work practices and conditions of employment (SKC, 1985). The 1988 RTE management strategy, *Competing in the New Environment - Our Strategy for Survival*, accepted the need for technological innovation and deployment of new media technologies, emphasizing flexibility, efficiency and lower costs in the changed media environment (For a full discussion of changes within RTE, see Hazelkorn, 1996: 28-38).

According to what was said in 1996 concerning the changes inside RTE:

> We must produce and transmit more and better programmes at lower cost and with fewer staff. This is the essence of the challenge that we face and must overcome. If we fail to do so now we risk getting into a spiral of decline that will become impossible to halt and which would undoubtedly have disastrous consequences for RTE and RTE staff... Multiskilling must become the norm, and while preserving how [sic] essential production and operational core skills and maintaining programme quality and output standards, staff in general will need to cover a range of duties for which they are competent or for which they can, with limited effort, be trained and scheduled to work as a team (...) reasonable flexibility within a team concept has to be the norm.[14]

By the end of the 1980s, these changes were seen as insufficient to meet the challenges posed by other television broadcasters who had embraced new technology with low operating and cost structures. Like other large broadcasters, RTE sought to rapidly downsize and casualize. The most dramatic changes have been: a continuing decline in full-time employment; a move towards casualisation of employment through a shift towards short term contracts lasting either for several months or a series' duration (see Table 3), slimmed-down production teams (including camera crews, but also the elimination of sound and video operators, etc.), and the contracting of programming and/or skills from independent production and facilities houses. During 1997, RTE, following trends elsewhere, introduced the position of multi-skilled "technical operator" (for a discussion of the implications of these changes in broadcasting for issues of gender see, Hazelkorn, 1998, and RTE, 1998).

Despite this restructuring and some improvement *vis-à-vis* its competitors, RTE is in a very difficult (financial) position. Its programme schedule on both television and radio looks tired, production and labour costs are still considered too high, the station is committed by legislation to fund one-hour per day of Teilifís na Gaeilge's programming, competition is

intensifying at home and abroad threatening audience fragmentation, advertising income is stagnant, there is a threat to the licence fee, and there is a "fear that the organization is being starved of vital political support at a time when it needs all the help it can get" ("RTE: Trouble Ahead", in *Business and Finance*, 12 June 1997). To meet some of these challenges, RTE is continuing a programme of internal reform, not least in its management structure which underwent a significant re-definition following the recent appointment of a new Director-General, Bob Collins, who carries a strong commitment to public broadcasting. Following an intensive six-month review, the RTE Authority and senior management issued a blueprint for the future, *Review of Structures and Operations*; in anticipation, the trade union group within RTE published their own review, *Towards a Shared Vision*. Initiatives are likely to include the introduction of new system of total programme costing and internal bidding for programmes (pitching RTE programme makers against independent producers), continuing flexibility in work practices, reduction in numbers employed (particularly permanent staff), and programme innovation including the merger of news and current affairs into one department.[16]

Table 3. RTE labour force, 1988 and 1998

Year	Total Employed	Permanent	Non-permanent	% Non-permanent
1988	2,146	1,867	99	4.6
1998	2,100	1,399	761	36.2

Source: RTE[15]

In 1996, RTE's accounts showed a modest profit of only IR£2.557m (anticipated to rise to IR£5m in 1997 but a fall from IR£14.538m in 1995). However, maintaining the trend over the last number of years, RTE continues to record a loss of IR£2.106m on its core broadcasting business. Its profit is due to strong showings by RTE Commercial Enterprises (a subsidiary set up to tap revenue from programme sales, publications, merchandising of products and consultancy services), income and investment from Atlantic 252, advertising revenue (which continue to show buoyancy, reflecting the current economic boom) and the licence fee, RTE's funding mainstay, static since March 1986 but which was increased albeit marginally by the government in September 1996 (the licence fee is IR£52 and IR£70 for a black and white, and colour television licence, respectively; this is an increase from IR£44 and IR£62. The government, however, reversed a decision to index the licence fee against inflation - see Table 4). Some of RTE's loss can be explained by the rise in the cost of imported programmes (although this is likely to increase as competition between various broadcasters forces up the price) and the annual cost of providing 365 hours of programming plus services to Teilifís na Gaeilge (IR£3.9m in 1996 and anticipated to rise to almost IR£5.6m in 1997). Requirements that RTE commit 20 per cent of its annual television or IR£12.5m (whichever was

greater) to independent commissioning has also further exacerbated its financial difficulties, forcing it seek some redress by reducing programming costs and staff numbers (Linehan, in The Irish Times, 18 April 1998).While explanations abound, it is increasingly clear that mounting global pressures on the small, peripheral state broadcaster will continue to make its life difficult. As an editorial in *The Irish Times* (10 January 1997) stated "the glory days of State broadcasting are gone – if indeed they ever existed in reality".

Table 4. Selected RTE financial statistics, 1987 and 1996 (IR£000s)

	1996	1987
Revenue	**159,418**	**136,412**
TV Licence Fee	55,408	53,053
Advertising (TV/Radio)	81,811	59,076
Other broadcasting income	5,607	10,773
RTE Commercial Enterprises	16,592	0
Long wave radio	0	0
Cable Television	0	13,412
Expenditure	**159,099**	**126,917**
Broadcasting Services	142,518	115,453
RTE Commercial Enterprises	12,980	0
Teilifís na Gaeilge	3,980	-
Long wave radio	0	0
Cable Television	0	11,464
Operating surplus	**319**	**9,495**
Surplus attributable to RTE Group	**2,557**	**8,924**
Net assets	**90,237**	**31,757**
Non-repayable Exchequer advances	**-16,427**	**0**

Source: RTE, 1996 and 1991.

With an increasing need to develop new revenue-generating possibilities, programme sponsorship is being significantly investigated, particularly in the area of sports, arts and culture, although one of its most noteworthy – and perhaps controversial examples – is a police-crime programme sponsored by a major insurance company (see Amanda Dunne). RTE has also sought to develop programming with an appeal beyond the traditional Irish market. It provides radio material on the Astra satellite, and through its recent involvement in Tara TV, it now claims several hundred thousand UK subscribers.

In recognition of the need for independence from government and the civil service, RTE policy is decided by a nine-person RTE Authority; members

are appointed by the Minister for a period not exceeding five years, while the chairperson is appointed by the Government. The Director General, appointed through public competition by the Authority for a seven-year term runs RTE on a day-to-day basis. Significant powers are, however, reserved to the Minister, especially, the right to issue directives in regard to broadcast matters.

4. Programming and audience issues: RTE and TV3

Given the small geographic size (70,283 km^2), population (3.6 million and 1,133,000 private homes with television) and the historic relative poverty of the Irish state, it is probably inevitable that RTE has been both the primary and only broadcasting provider, a factor that accounts for the absence of commercial broadcasting until lately. The recent arrival of local, community and special interest radio stations, and Teilifís na Gaeilge (which began broadcasting in October 1996) has begun to challenge RTE's prominence and to diversify the broadcasting landscape. The advent of TV3 in autumn 1998 will further change that environment. Nevertheless, all three television broadcasters maintain that they are (or will be) providing a national not a regional service, even Teilifís na Gaeilge, despite its location in the Gaeltacht with the largest Irish language speaking community. In this respect, the lack of an emphasis on regional television follows the absence of an institutionalised regional political structure in Ireland; the local government sub-structure is very much subservient to national government with legal but not constitutional recognition.

Given this scenario, this section will look at programming and audience issues for RTE and TV3, while the next section will contain a similar examination of Teilifís na Gaeilge.

4.1. RTE

RTE has been the sole television broadcaster within the state until recently; TV3, with its long and often troubled history, began broadcasting in autumn 1998. At that point, RTE faced its first domestic competition. But, the station is already feeling the wind of change: forthcoming audience figures suggest that British programmes, especially British soaps, are capturing an increasing lion's share of Irish audiences, with RTE's two flagship programmes not even being included among the top three. Equally concerning, RTE's peak-market share which had stood at 50 per cent in the early 1990s has fallen to about 45 per cent in 1998, even though one-third of Irish homes receive only the two RTE channels! (Murphy, in *The Sunday Times*, 15 February 1998). These problems are likely to mount for the public broadcaster: the multiplicity of viewing choices available to the Irish public, the more aggressive approach taken by UTV,[17] possible competition for the licence fee, the arrival of TV3, financial obligations to Teilifís na Gaeilge, and the advent of terrestrial digital broadcasting

initially from the UK. Competition is also forcing up the cost of purchasing ready-made programmes and live-events, especially international sporting events.[18] While Irish audiences may have access to a wider variety of international choices – provided they are willing to pay – its own deteriorating financial position could jeopardize its ability to continue to capture Irish audiences, and hence advertising revenue. Hence, the present situation could rapidly become a downward spiral. Set against a background of an ideological undermining (or at best questioning) of public confidence and support for state institutions, it seems clear that RTE will be operating in a less favourable political and public atmosphere in the future.

The relatively limited RTE service and proximity to the UK multi-channel service has meant there has been a continual demand for access to the latter. Today, 70 per cent of the Irish television audience have access to four British terrestrial television channels, while some can receive Channel 5 (the UK's newest channel). The establishment of Network 2 in 1978 had come as a result of people living in single channel areas demanding access to more television services as per elsewhere in the country. That decision did not, however, satisfy those demands, as people wanted access to British channels not just an additional Irish channel. Consequently, people turned increasingly to illegal "deflector" systems.[19] In 1989, the government awarded 29 licences to install and operate a network of multipoint microwave (television retransmissions) distribution systems (MMDS) in those parts of the country where viewers were unable to receive cable.[20] Today, 36 per cent of television homes have access to cable, 5 per cent to MMDS, and 5 per cent to satellite dish reception.[21] Most of these households can receive at least twelve satellite TV programmes.

RTE has faced competition to its radio service since 1989 with many local stations consistently outperforming the national broadcaster – its individual stations but not its collective listenership – at peak times (see Table 5). The national picture is quite different: the collapse of the first private national radio franchise, Century Radio, in 1991, was followed by a second equally beleaguered, Radio Ireland, until relaunched as a popular-music channel, Today FM.

Table 5. Percentage of listeners: RTE vs. local radio, 1997

RTE Radio 1	32%
RTE 2FM	22%
Any Local Radio	46%

Source: JNLR, 1997

In interesting contrast, RTE television has been able to maintain its dominant position due to skilful in programme scheduling, (see Table 6). While almost "60 per cent of prime time programming watched by Irish

viewers ... [was] still on the two national stations despite the constant erosion of viewership figures by foreign stations, especially UTV"[22] in 1996, this figure has slipped to just over fifty per cent in recent years.

Table 6. Market shares of television channels in Ireland (1996 and 1998)

Channel	1996	1998
RTE 1 and Network 2	59	59
BBC 1 and BBC 2	15	15
UTV(ITV)[23]/Channel 4	16	16
Satellite Channels	10	10

Source: A. C. Nielson RTE, December 1996, quoted in Kelly and Truetschler, 1997: 124.

Table 7. Market Shares (%) of Television Channels in Ireland (1996 and 1998)

Channel	1996	1998
RTE 1 and Network 2	59	51.6
BBC 1 and BBC 2	15	14.3
UTV(ITV)/Channel 4	16	15.7
Satellite Channels	10	16.1*
TnaG	-	0.8
TV3**	-	1.6

* For 1998, the figure includes stations received by either dish or cable.

** Annualised figures for TV3 are misleading as the station only began transmission in September 1998; see further discussion on TV3 later in this chapter.

Source: A. C. Nielson, 1996 (data taken from Kelly and Truetzschler, 1997: 124) and 1998

Current scheduling policy exhibits a strong emphasis on news and current affairs programming. Until the recent introduction of a syndicated news service for private radio, and TV3's proposal to supply its own news service, RTE was the only provider of broadcast news in the country. Drama production centres on the production of two soap operas: a weekly rural-based and long-running popular series and a more recent urban soap opera. Daytime programmes broadcast between 10a.m. and 1p.m. were first introduced on RTE 1 in 1992. This strand which is independently commissioned includes phone-in and access programmes, and advice slots on domestic, legal and current affairs. RTE produces its own daytime programming for the afternoon schedule with a similar mix of talk and advice aimed at an older audience. The bulk of young people's programmes are broadcast on RTE's second channel, Network 2, relaunched and formatted as a "lifestyle" channel in 1988, and redesigned within the last year as a youth channel (clearly under the influence of MTV). In an effort to "overcome the accident of history that placed the bulk of RTE's production capacity in Dublin", the station has begun producing some "regional" programming under the title *Nationwide*, and will develop Cork as a production centre, will encourage both community-

access programmes and independent productions from outside Dublin ("RTE Trouble Ahead", in *Business and Finance*, 12 June 1997).

To-date, RTE has successfully fended off UK and satellite competition with a strong programming mix of factual, entertainment and educational programmes typical of public service broadcasting organisations. Like such organisations, RTE has retained popular support by a combination of high ratings entertainment programming, thereby ensuring its advertising revenue base, and a range of "public service" programming in minority interest areas, eg Irish language, religious affairs, culture, the arts and educational programming. Significantly for RTE, home produced programmes do enjoy high levels of audience loyalty. *The Late Late Show*, for example, enjoys the highest loyalty factor of 67 per cent. *Kenny Live*, the Saturday chat show equivalent, also enjoys a very high loyalty figures of 60 per cent as does the popular rural soap series *Glenroe*. Weekday magazine programmes all have a 40 per cent loyalty (Fahy, 1992). Increased competition and costs of production do, however, pose threats to its continued ability to retain and extend quality broadcasting. Effects of these pressures are evident throughout the schedule. There has, for example, continuously been criticism of RTE's failure to encourage new talent in writing or acting, or to innovate with new drama production (Sheehan, 1987). More recent high profile (co-)productions have attempted to redress this situation including specially commissioned scripts featuring prominent acting/writing talent. For example, *Fair City*, the urban soap, has – after a lucklustre start – been particularly successful in transforming the fortunes of tv drama for RTE; this has been followed by *Making the Cut*, a serialised thriller; *Family*, a gritty urban drama written by Roddy Doyle – one of Ireland's foremost contemporary authors; and most recently, the drama adaptation of John McGahern's *Amongst Women*, in co-production with BBC Northern Ireland. There has also been a noticeable reorganisation in high-cost current affairs programming, preferencing the studio-based discussion and talk-radio programming format; this formula continues to provide crucial anchor points in the schedule while enhancing home-produced programming, thus reducing reliance on acquired programming from 65 per cent in 1984 to 50 per cent today.

While this programming has long been favoured by Irish audiences, much of it has remained lacklustre, dull and timid, continuously drawing upon a small pool of "experts": "Many of the new programmes introduced are modeled too closely on existing radio successes, which may not necessarily transfer properly to television" (Cooper, in *The Sunday Tribune*, 12 January 1997).

Irish language programming has tended to occupy a marginalised location in the schedule and often on the second channel – the subject of continuing criticism that RTE is not wholly committed to the language. Opposing

demands and changing attitudes towards the Irish language and Irish language broadcasting ultimately led to the government's decision in 1993 to establish Teilifís na Gaeilge (see below).

A management shake-up and with other changes signaled have followed the recent appointment of a new Director-General; such moves are clearly a direct result of repeated public comment, and growing concern within the RTE Authority and among senior management about increasing competitive and financial pressures on the station. Television and radio programming is being subjected to closer scrutiny. Already, Network 2 has been relaunched as a youth channel, and several daytime programmes on RTE 1 have been replaced. As per instructions under the Broadcasting Authority (Amendment) Act 1990 and popular support for home-produced programmes, RTE aims to produce itself or to commission approximately 50 per cent of its programming requirements.

The greatest change (and challenge) in television provision, and consequently to RTE, will be the introduction of digital television. Both cable and MMDS suppliers are also actively pursuing the development of digital television, with the capacity to carry 450 channels by the end of 1998 depending upon the "creation by the government of a supporting financial and political climate to attract the very significant capital investment that will be required" (Deloitte and Touche, 1998). Cable companies are not alone in these plans. RTE has submitted its own plans for the provision of digital television, for which it is actively canvassing government permission to develop a strategic partnership at a cost of around £40m; it aims to start with between thirty to forty-channel digital broadcasts by 2000, and desiring to maintain analogue broadcasts only for another ten years, five years less than previously expected. RTE also argues that DTT would enable it to develop local/regional broadcasting, which heretofore has been too expensive to consider. Telecom Éireann (TE), the primary provider of internet connections, has no input into broadcasting other than in the provision of certain technical facilities and its ownership of 80 per cent of the shares in Cablelink (RTE owns the other 20 per cent), Ireland's largest cable television operator, a situation which will change dramatically with the scheduled sell-off aforementioned.

4.2. TV3

It has taken the consortium proposing to establish Ireland's first commercial national television station almost 10 years, from initially securing the franchise to preparing for broadcast in autumn 1998. Headed by James Morris, Chairman of Windmill Lane, a Dublin production facilities company, the franchise was awarded by the Independent Radio and Television Commission in April 1989, just shortly after the enabling legislation was passed (the Radio and Television Act, 1988). It had intended to be on air by November 1991. However, failure to convince the

IRTC that TV3 had sufficient financial backing for the venture has continually dogged the negotiations.[25] The former had stated that the consortium would need to show it had access to almost IR£50m during the first three years of operation; an initial IR£20-25m would be required to cover the start-up period and a further IR£8m would be required annually in the first three years ("Commision concerned on TV3 package", in Business and Finance, 30 May 1991). In October 1991, the IRTC decided that the consortium had missed its deadline and withdrew the licence. A judicial review was sought and in 1994, the High Court found in TV3's favour. The IRTC appealed to the Supreme Court but the latter upheld the High Court's decision. The licence was restored and negotiations between the IRTC and TV3 began again.

Funding has again proved to be a difficulty. Initially UTV, a UK channel broadcasting in Northern Ireland, expressed interest in investing in the new station. An agreement between TV3 and UTV was being brokered whereby the latter would withdraw their services from cable and MMDS systems in the Republic so that it would not be in competition with itself, and thus, TV3 could secure that audience. Meanwhile, the IRTC was also concerned about who would control the station:

> As negotiations developed, conflicts between UTV's position as an existing broadcaster and its desire to become involved in TV3 became more apparent. Unfortunately, as a result, it was not possible to agree terms that were satisfactory to both the IRTC and UTV. (Foley, in *The Irish Times*, 19 September 1996)

The deal fell apart in September 1996 when UTV withdrew. In April 1997, CanWest Global,[26] Canada's most profitable broadcaster, took over the 45 per cent ownership previously controlled by UTV, leaving twenty percent owned by the original consortium, and the remaining 35 per cent available to third-party investors. CanWest Global has subsequently taken an increasing share in UTV (rising from 2.7 per cent to 7.4 per cent to 12.1 per cent to 29.9 per cent), making no secret of its desire to increase further, opening up the possibility of a serious all-Ireland competitor in the future. This represents the first significant non-Irish involvement in the media in Ireland (This does not include control of the Independent group of newspapers, part of a major global media empire owned by Irishman Tony O'Reilly).

TV3 will operate as a publisher-broadcaster, like CanWest Global, with its own national news service. It will be a general entertainment channel, catering for the high-spending 15-44 year old market, which accounts for approximately half of Irish television audiences; 85 per cent of Ireland's 1.13m million homes will be able to access it. Claiming that it aims to provide "as much home-produced programming as possible" (it has given a commitment that initially 15 per cent of its total output would be home-produced, comprising 30 per cent of prime-time broadcasting, which would rise to 25 per cent over five years), much of its programming will be

of US and UK origin. There will be eight hours per week of prime-time movies, and significant sport coverage, exemplified by TV3 purchase of the rights to all of Ireland's away matches for the 2000 European Championship qualifying games and to all other games in the group. Children's programming will aim at the "tweens", the 8-14 year-old age group. Thus, the marriage with CanWest, the biggest purchaser of American TV-output outside the US, and a major funder of co-productions, offers TV3 the benefit of CanWest's buying power and its enormous programming library. TV3 will pay an annual rent to RTE for transmission. It is entitled to broadcast up to nine minutes of advertising per hour. Initially start-up costs are likely to be around IR£20m, breaking even within two years, and employing about 160 people, operating from a Dublin suburb. TV3's sums are based on attracting 6 per cent of the TV audience, translating into approximately 18 per cent of the estimated £100m annual Irish advertising revenue (Taylor, in *The Irish Times*, 26 June 1998).

Six months since first transmission, TV3 has cornered six per cent of the television viewer market. Depending on the source, this is either a good first return or evidence of its inability to challenge/counter RTE; although it is fair to say that there was never any suggestion that the new station would seek to displace RTE, rather that it would develop a sizeable market in its own right. The hope that the station would introduce new, innovative programming has not, however, (yet?) materialised. Not surprisingly, given Can West's involvement, there has been a strong dependence on 'cheap and cheerful' 'north American' series, viewed primarily by an audience closer to 20years than the desired under-40s – a strategy firmly endorsed by TV3's director of sales, Pat Kiely: "We were never in the business of re-inventing TV. We are here to provide entertainment". Nevertheless, while competing head-on with RTE has proved difficult – the station has decided against developing an independent news division, for example – it is still early days, and no one really believes that TV3 will go bust.

The market in which TV3 is operating is very different from that it initially sought to enter in 1989. Fierce competition for audience and advertising share, particularly with the arrival of digital television on the horizon, will make the ask even harder. Tight financial margins, with an operating budget of around IR£6m, suggest a greater use of imported programming than originally (or publicly) stated, with great deal of organizational emphasis given to overall programming and labour costs, flexibility in work practices, and the use of new technology. The size of the advertising market in Ireland, relatively small in comparison to other European countries, and the fact that all media in Ireland, including public television, are commercial in the sense that they all rely on advertising revenue, has to date prevented the operation of a private commercial television service. While advertisers keenly desire additional advertising

time, they share a concern that the arrival of TV3 could endanger RTE, already under financial pressure. Both the government and the IRTC are anxious to see TV3 successfully on the air. Given difficulties with the franchise for the national radio stations – the collapse of Century Radio, followed by the ignominious launch of Radio Ireland and its recently forced re-launch as Today FM – the entire policy of de-regulation and commercialisation is under the spot-light.

5. Programming and audience issues: Teilifís na Gaeilge (TnaG)

Irish language programming has been controversial since the station's inception in 1926 as 2RN, with a cacophony of complaints about poor programming, lack of adequate finance, marginal scheduling, low audiences and a lack of commitment by both government and RTE. After RTE began broadcasting in 1960, critics drew attention to the fact that Irish language programmes represented a declining portion of the total radio and television schedule, falling from a peak of 11.3 per cent of broadcast time in 1945 (radio) to only 2 per cent in 1995 (television) (Watson, 1995; Gorham, 1967: 139; for an overall analysis of TV programmes, see Quill, 1993). Critics also pointed to the displacement of Irish-made television programming by "cheaper" American programmes, and to their marginalization within the television schedule. Iarfhlaith Watson stated in 1996 that:

> ...because of the neglect from which Irish language programmes have suffered for years, Irish-speaking directors in the station do not wish to be associated with them. Whoever is in charge of an Irish programme understands that it will be broadcast at an unfavourable time and that the facilities and finances available to a comparable English language programme will not be made available to it. (Whatson, 1996: 263)

Concern was also expressed with the legislation, which the critics claimed failed to fully promote and protect the language, thus demonstrating the government's fading commitment; the Broadcasting Amendment Act, 1976 merely noted that RTE should "have special regard for the Irish language" but did not impose any particular requirements on the station.

The announcement in November 1993 that Teilifís na Gaeilge was to be established followed years of campaigning by Irish language organisations – led by Conradh na Gaeilge (the Gaelic League) – and an Feachtas Náisiúnta Teilifíse – the national television campaign – for a designated television station.[27] It also followed directly upon advice contained in a 1988 Udarás na Gaeltachta (the Gaeltacht Authority) commissioned feasibility study on an Irish language/Gaeltacht television service broadcasting nation-wide (Stokes Kennedy Crowley, 1989). That report recommended that "an Irish language television service was necessary for the survival and extended use of the language". Based in the Gaeltacht,

such a service could cater for 31.6 per cent of the population, it would need to broadcast a minimum of two hours high quality programming daily (730 hours per annum) to be built up progressively over time, the service would stimulate significant job creation in the area, the annual running costs would be approximately IR£9.6m, and it would be necessary to establish a new low cost UHF transmission network. Start-up costs were estimated to be in the region of IR£5m, but it noted that TnaG was likely to remain dependent upon the state for a long time with additional resources being derived from advertising.

The government's intentions were initially signalled in the *Programme for a Partnership Government*, 1992, jointly written by Fianna Fail and the Labour Party. In the section titled "Fostering our Language, Culture and Heritage", it stated: (1) that it was essential to establish a television service in Irish for Irish speakers and the people of the Gaeltacht and (2) that the government was committed to the establishment of such a service as a third channel with limited broadcasting hours. The proposals provided that Teilifís na Gaeilge would broadcast nation-wide, including Northern Ireland, for three hours per day beginning April 1996. One hour of programming per day would be provided free-of-charge by RTE as part of its public service remit; indeed, RTE would also still be required to broadcast Irish-language programmes on its own two channels as part of the same remit. TnaG would operate as a publisher-broadcaster, with most of its programmes commissioned from independent producers or bought in and dubbed (mainly from languages other than English, and particularly from lesser-used languages). At least one of the three hours would be for children's programming. The start-up costs were designated to come from a combination of advertising revenue (amounting to IR£17.35m) accumulated by RTE under restrictions imposed in the Broadcasting Act 1990. Running-costs were estimated at IR£15-20m per year.

Teilifís na Gaeilge began broadcasting in October 1996. It broadcasts a comprehensive schedule – originally for four hours per day increasing to a current schedule of eight hours – with an emphasis on original material, including the provision of its own news service. Transmission is provided nation-wide from its headquarters in the Baile na hAbhann in Connemara, Co. Galway, over the UHF network; it is also available on all cable services operating in the Republic. Subtitles are available on all programmes, either as open subtitles or on teletext. The station is a publisher-broadcaster model, with its programmes coming from the independent production sector, and RTE. The policy has been to commission drama from new Irish talent, in particular Irish writers and young directors. Establishing transmission and network links cost IR£16.1m, funded directly from the Exchequer; running costs are approximately IR£10.2m also funded directly. TnaG receives over 365 hours of programming from RTE annually at no cost to the former; it also sells advertising time, and is involved in

programme sponsorship. It has a core staff of thirty people, who perform administrative, commissioning and acquisition functions in addition to providing technical and presentation skills.

Administered by RTE, there is a nine member advisory committee (Comhairle Theilifís na Gaeilge) appointed by the RTE Authority under Section 21 of the Broadcasting Act, 1960. Seirbhísí Theilifís na Gaeilge Teo was established to ensure that TnaG would be able to operate as much as possible as a stand-alone unit under the aegis of RTE, but also to prepare for eventual operation as an autonomous organisation. Indeed, *Clear Focus*, which contain the former government's proposals for an Irish Broadcasting Commission, envisaged that TnaG would come directly under the latter's remit.

Some programming on TnaG has been remarkable for its vibrancy, youthful enthusiasm, innovation, and commitment to contemporise Irish programming. In addition to a traditional programming schedule that includes drama, comedy, music, documentaries, travel, fashion, young people's and pre-school, and animation, TnaG has broadcast some noteworthy highlights: interactive children's entertainment, foreign-language drama shown first with Irish sub-titles and then followed by English, *C.U. Burn* "arguably the finest black comedy ever produced in Ireland", *Síbín* – a light entertainment magazine – and *Hollywood Anocht*, a "frothy review of the world of film"(Mac Dubhghaill, in *The Irish Times*, 18 February 1988). One of the biggest undertakings is *Ros na Rún*, a daily drama series set in the Connemara Gaeltacht, broadcast fifteen minutes per day, four times a week. In addition to Irish language programming, TnaG also carries coverage from Dáil Éireann (the Irish Parliament), *EuroNews* and *All Ireland Gold* (a sports programme).

A typical broadcasting day carries a variety of both specially commissioned home-produced programming or programmes re-broadcast from RTE or other broadcasters. Yet, while the station has been praised for its creativity and energy, the over-all programming schedule remains fairly limited, repetitive and routine, an eclectic mix of children's programming, MTV look-alike, "international" documentaries and sports; thus, it would be difficult to ascribe a particular programming genre. There is little doubt that the financial mechanisms for TnaG, in which it has been tied to RTE, has restricted both its own and RTE's development. Thus, very recent proposals to formally separate the two stations, and grant some financial autonomy to TnaG albeit making it more dependent on direct government funding, may prove helpful but may also prove to be a double-edged sword. A key issue will always remain TnaG's potential to develop a significant and consistent audience that will prove attractive to advertisers and to long-term exchequer funding. Much of this depends on its programming.

Table 8. Typical Teilifís na Gaeilge programming day (based on Sunday, 22 June 1998)

Time	Programme	Translation/Type
12:00	RnaG	Simultaneous broadcast from Radio na Gaeltachta
17:25	Bouli	Children's Animation
17:30	Cabúm	Children's Programming
17:35	Lulu	Children's Animation
18:00	Art O Ruairc	Children's Animation
18:30	Pop TV an tSamhraidh	Chart music /music video magazine programme
19:28	An Aimsir Laithreach	Weather
19:30	Sportiris ar an Lathair. Clare v Cork	Sport
20:30	Na Cruicha Diamhra	"Mystic Lands", documentary on foreign countries
20:58	An Aimsir Laithreach	Weather
21:00	John Huston an tEireannach	Documentary
22:00	Nuacht TnaG; An Aimsir	News/Weather
22:20	History Written in Stone	Documentary
22:50	Waterways	Documentary
23:17	Barabbas	Comedy
23:18	An Aimsir Laithreach	Weather
23:20	Deireadh Crolta	Close

As a national broadcaster, albeit broadcasting primarily in Irish, TnaG aims to ensure that it provides as attractive a schedule as possible in order to appeal to a wider audience than Irish speakers. In this respect, TnaG is not simply an Irish language station but arguably another national television channel broadcasting to the entire country; thus many of its programmes carry English-language subtitles. Indeed, most recently, the station has adopted a policy of screening popular English-language films.

> We are a television service and we regard the whole ... island as our viewers, it happens that the programmes will be broadcast in Irish, of course it also happens that subtitles in English will be available on teletext for all recorded programmes, therefore we are not ... restricting ourselves to those who speak and understand the Irish language. (Padhraic O Ciardha,quoted in Watson, 1997: 223)

Such a balance is crucial to enable the station to draw in sufficient advertising revenue to provide a degree of financial viability. But this balance has also been the subject of continuing criticism, suggesting that perhaps the stations is suffering from a "crisis of identity". Critics ask if TnaG can successfully serve a national audience, most of whom do not speak Irish in their daily lives, while meeting the needs of the small Irish-speaking minority, many of whom actually live in the Gaeltacht region in which the station is actually located. Indeed, there is a perception that:

...people from Leitir Mealláin (or other areas where the language is still spoken with a rich blas) are at a disadvantage when it comes to looking for work from TnaG, on the grounds that their Irish is too difficult for the rest of the country to understand. (Mac Dubhghaill, in *The Irish Times*, 18-2-1988)

Indeed, the controversy has led to renewed calls for a community-based Gaeltacht television service, a proposal firmly rejected when TnaG was established.

Controversy has also surrounded all discussion about the potential and actual audiences and listenership for Irish language programming on either/both radio and television. The problem has been aggravated by the fact that much of the data (especially prior to the establishment of TnaG) was produced by advocates of the service who often drew a casual relationship between speakers and viewers/listeners. The 1986 Census of Population revealed that over one million people (or approximately 30 per cent of the population) speak some Irish. These figures were supported by a report by the Institiúid Teangeolaíochta Éireann (ITÉ) in 1993 which indicated that a high proportion of the national population has some speaking or reading ability, with those claiming the highest level of fluency or competence in Gaeltacht areas: (1) 2 per cent native speaker ability (approximately 70,000 people); (2) 9 per cent capable of most conversation (approximately 315,000 people); (3) 22 per cent capable of some conversation (approximately 770,000 people) (Ó Riagáin and Ó Gliasáin, 1994). An initial feasibility report by SKC, using various television and radio measurement surveys, suggested that such figures could be translated into a potential audience for an Irish language television service representing approximately 14 per cent of the population (Stokes Kennedy Crowley, 1989: 20).

Conversion of potential audiences for Irish language programmes needs, however, to be seen in the context of competition from multi-channel television, and the fact that Irish speakers, like their English-language counter-parts, will not watch Irish language programmes simply because they are in Irish; hence, debate has equally focused on issues such as programming and scheduling. An ITÉ report revealed some of the difficulties: in 1983, 72 per cent of the population viewed Irish language programmes at least occasionally, but by 1993, this figure had declined sharply to 40 per cent . Ó Riagáin and Ó Gliasáin in 1993 suggested there is a strong relationship between viewership and the availability of Irish language programming on television and radio; when RTE 1 carried a number of Irish language or bilingual programmes they were fairly popular with viewers, however once these programmes were relegated to the less popular Network 2, the audience fell (Ó Ríagáin and Ó Gliasáin, 1994: 12-13). Other data suggested there was a high core audience for programming aimed at children and young people, leading Watson to ask

if RTE has "fully tapped into the potential audience for Irish language programmes" (Watson, 1997: 221). In response, RTE has argued that:

> ...while the Survey figures quoted in the Green Paper may indeed indicate a growth in favour of the language and, out of that, a perceived growth in the need for more and better programmes in Irish, the fact is that this does not translate into any growth in audiences for such programmes when they are transmitted. (RTE, 1995: 28)

As the sole national broadcaster, with no complementary regional public or private stations, facing strong competition from UK stations, the demands on RTE have been particularly onerous: (1) need to attract adequate advertising; (2) the needs of the majority English-speaking audience in an increasingly competitive market; (3) the scattered linguistic minority with widely varying competence in the language despite it being taught throughout the educational system; (4) the ideological shifts of State policy towards the language; and (5) the conflicting demands of the various components of the Irish language lobby (Quill, 1993: 46). Within such political and financial/commercial constraints, it has argued that it is difficult to provide the type of service demanded by some Irish language proponents.

The establishment of TnaG has not tempered that debate. Since October 1996, it has shown a steady but not strong rise in audience numbers. It started from a particularly low base of 0.22 per cent of the national TV audience (or 5,800 viewers) during its first month. A situation aggravated by the fact that 40 per cent of the population could not tune into the station on the UHF frequency but did little to reassure advertisers ("TV Turkey", in *Business and Finance*, 6 February 1997). By summer 1997, however, TnaG had a nightly audience of 250,000 viewers, climbing to a peak of 400,000 during Christmas 1997, before falling back to its present level of 320,000 viewers. A Landsdowne survey, commissioned by TnaG in December 1996, suggested that 24 per cent of all adults watched TnaG occasionally or regularly, while their average viewing time had increased to 1.5 hours per week; interestingly, 70 per cent of that audience did not have good Irish language ability. Not surprisingly, a survey by Envision revealed that 55 per cent of the Gaeltacht population watched regularly (Mac Dubhghaill, in *The Irish Times*, 18 February 1988). If these figures can be sustained, then TnaG has reached the initial hopes of its chief executive, Cathal Goan, who hoped to attract up to 120,000 viewers on a regular basis from a possible audience of 500,000 ("Teilifis na Gaeilge prepares for opening", in *The Irish Times*, 5 February 1996).Perhaps more important than numbers is the buying-power of the viewer. The Landsdowne survey also revealed that TnaG had the greatest appeal among the "upmarket, educated with school-going children" (quoted in Watson, 1997: 225).

The arrival of TnaG can not be isolated from either the revival of cultural nationalism (see above) and the strong belief that its establishment as a

publisher-broadcaster could play a significant role in (re)generating economic growth in what had traditionally been a high unemployment region. The launch of the station coincided with a growing realization that the cultural industries could make a strong contribution to wealth and job creation, effectively helping to "jump-start" Irish economic growth (Coopers and Lydbrand Corporate Finance, 1994). Since the early 1990s, Irish development policy has focussed increasingly on cultural "high technology" audiovisual and design/image utilizing new digital technologies. Almost two dozen reports have been drafted by government or state agencies drawing attention to the significance of this sector; these reports have been backed-up by a noticeable change in government attitude towards RTE, with an increasing emphasis on deregulation, competition and commercialization. The decision to establish TnaG as a non-producing broadcaster, and to locate it in the Gaeltacht, are clearly related to this strategy. Thus while the station employs only thirty people, there are approximately forty independent companies (having grown from an initial twenty) employing upwards of 250 people competing for TnaG's budget of IR£15m. The station has also been working with Forbairt, one of the state's job creation agencies, to assist small companies in the creative, marketing and business development areas.

6. Analysis of new problems and prospects

The Irish broadcasting environment is in a state of flux; government policy shifts between registering (rhetorical) protest against media predators and the political-economy of globalisation (for instance, the government has announced its intention to introduce legislation prohibiting broadcasters' purchase of exclusive rights to key events), and policies which effectively serve to further deregulate the Irish media (broadcasting, film, internet, e-commerce) market. New policy decisions likely to affect broadcasting in Ireland are to unveiled sometime during 1998, although an outline of some possible directions were signalled in earlier legislative proposals (Department of Arts, Culture and the Gaeltacht, 1995 and 1997) drafted by the previous government and in recent comments by the current Minister. It had been proposed that an Irish Broadcasting Commission would be established as an over-arching regulatory framework, over-seeing both public and private broadcasting. It would control broadcasting policy, content and possibly transmission; it would also effectively remove the Minister from potential interference. Its real significance lay in its replacement or at best authority over the RTE Authority; the former could, according to those proposals, consider RTE's structure, organization, financial decisions, and programming. It could "investigate RTE's commercial practices and require changes to be made if it considers them detrimental to the development of or the provision of [read: competitive] broadcasting services in Ireland". There were also suggestions that the licence fee could be re-apportioned by the Commission, who could also

"instruct RTE how to spend the licence fee revenue". Recent ministerial statements suggest that the Commission is unlikely to have such extreme powers, leaving the RTE Authority in tact as the national broadcaster's governing body. Nevertheless, there is unlikely to be much assistance to RTE, whose request to index-link the licence fee and introduce a generous early-retirement scheme have both been rejected.

TnaG's survival is likely to be enhanced, and its future on an equal statutory footing with RTE, guaranteed, albeit there is no suggestion of additional or independent funding (the government will merely take the place of RTE as the base creditor for the station) thus creating a future exchequer difficulty. The arrival of Teilifís na Gaeilge may have helped generate employment in the surrounding area, but it is clear that the new channel faces continuing difficulties despite some innovative programming. Its ability to attract an audience rests on providing programming for a population with widely differing linguistic competencies in the Irish language in the face of heavy competition from other channels. Effectively it must become a broadcaster, viable because of its programming and audience, in spite of rather than because of the language. Continuing concern about its ability to survive without substantial and permanent funding remains. From the beginning, it had been proposed that TnaG would raise additional revenue by selling spare frequency to companies broadcasting "compatible material" such as distance learning, Irish and EU parliamentary broadcasting and foreign language programming (Foley, in *The Irish Times*, 19 April 1997). The former has not materialised despite direct intervention by the former Minister's Advisor, while some frequency time has been sold to QVC (shopping television) and Olé, Olé (Spanish football). Critics still argue that given the difficult financial environment (and threats to RTE's future) it would have made more sense to simply increase the amount of Irish-language programming on RTE. Nevertheless, given the station's clear cultural-national remit and the sensitivity with which that issue has been handled or dodged over the years, no government is likely to question the station's continued existence.

Clear Focus proposes institutional change, in a mixture of what one commentator called "old-fashioned socialist authoritarianism, poor thinking about broadcasting and busy-bodying" (Mac Conghail, in *The Irish Times*, 13 January 1997). Its intent resides uncomfortably beside the government green paper, *Active or passive? Broadcasting in the future tense*, which, through a series of commentary and open questions, sought to raise the level of public debate about broadcasting in small peripheral societies, the need to protect the cultural integrity of Irish society and culture, and to guarantee the future of public service broadcasting in the face of threats from global competition and trans-frontier broadcasting.

National sovereignty is becoming a leaky vessel for political autonomy. Cultural industries, including broadcasting, are undergoing deep

change under the influence of forces that go beyond the policy-making of national governments. New technologies are crucial to this process of globalisation. (Department of Arts, Culture and the Gaeltacht, 1995)

Yet, neither the previous nor the current government has developed any policy framework in which to actually meet those challenges. Instead, the subsequent legislative framework appears to have been drafted on the premise those countries, and particularly small countries like Ireland, can regulate their broadcasting environment. Additionally, it could be strongly argued that the effect of consistent government policy to create a more multi-faceted and competitive media environment threatens to undermine the very goals it sought to defend.

This contradiction is particularly evident in that the anticipated arrival of TV3 has opened the door to the first significant non-Irish involvement in the media in Ireland. More prophetic, TV3's association with CanWest Global, which has simultaneously increased its share holding in UTV so significantly and so quickly, presents RTE with its first serious all-Ireland competitor. The newly formed conglomerate of TV3/CanWest Global/UTV is clearly readying itself to compete head-on with RTE for advertising, purchasing/commissioning and programming. Heretofore the Irish television market had appeared too small and insignificant to attract investors, either domestic or international; those days, however, are at an end. CanWest's 29.9 per cent holding of UTV and 45 per cent holding in TV3 makes CanWest the most significant and serious media player in Ireland; in turn, TV3's partnership with CanWest Global makes RTE, in global terms, a "minnow, and CanWest, the shark" (O'Kane, in *The Sunday Tribune*, 1 March 1998).

RTE has begun a tactical repositioning in anticipation of the launch of TV3; its refiguring of Network 2 towards a younger audience, 16-39 year age group (the demographic group on which CanWest has built its own profit base), seems to have been done with that in mind. RTE has, also, sought permission to enter a strategic partnership with the private sector to develop digital terrestrial television (DTT, estimated to cost approximately IR£50m), a strategy, it argues, which would enable Ireland to continue to exercise a "degree of control over broadcasting" and bring in key funding for development. However, thus far, government has rejected that strategy. [28]

Domestic broadcasting policy has increasingly been influenced by domestic economic strategic concerns. Consecutive governments, regardless of hue, have applauded the need to deregulate the sector – a view traditionally associated with the political right but now equally embraced by social democracy – as a means of "jump-starting" economic growth. Given Ireland's history of late-industrialization, the new information revolution/society has presented a mechanism for entering the industrialized world having missed the industrial revolution. Thus, since the mid-1980s, government policy has actively sought to create a

"competitive liberalized market" with "low taxes on profit" and to restructure the media environment in terms increasingly attractive to private interests, a policy of "managed privatization". Such attention is particularly noticeable in the number of (government, agency and consultant) reports published in the last few years highlighting the potential strength of the sector.[29]

Piggy-backing on the rise of a new and vibrant Irish cultural nationalism, various statist efforts have been introduced to privatize the airwaves, to establish a commercial national television broadcaster, and to force RTE to operate in a more commercial and efficient manner. In line with EU and other nation-state policy initiatives, the Irish state has used an arsenal of structural, financial and cultural-ideological mechanisms – eg agencies, commissions, corporations, tax incentives, low-interest loans, and national-identity – to promote and support the growth of an independent, commercial audio-visual/cultural content production industry. That such activity fits into a wider strategy can partially be gauged by a 1994 study which claimed that 20,000 full-time equivalent jobs, producing a net value return of IR£387m, had been created in the "cultural industries" sector. This figure has been expanded in a more recent report, which, using the slightly broader conglomeration of the "content sector" (including those companies/businesses that "aggregate music, audio-visual and information/data services (...) using digital delivery technology and skills"), pointed to 30,000 people producing an output of IR£1b annually. Thus, there is increasing evidence that the potential contribution of the cultural industries heretofore dismissed as the cultural icing on the economic cake, to the national and urban (city-state) economy may be greater than that of the financial sector. In turn, planners have deliberately courted small cultural/design innovators recognizing that the shift to post-fordist models of vertical disintegration and flexible-specialization particularly suit the audio-visual and image industries; the result has been the spear-heading of localized networks of small units at the forefront of urban and economic development. Dublin has followed the path of Glasgow, Barcelona and others as the "culture capital" of Europe (Hazelkorn, 1997). On this basis, studies strongly agree that "the cultural industries are a significant employer relative to other industrial sectors" or as Morley and Robbins (1997: 37) argue, "the arts and culture industries [have successfully] been drawn into the heart of (...) [the] entrepreneurial initiative".

As the sole broadcaster and primary producer and trainer[30] of all audio-visual products in Ireland, RTE has heretofore constituted the "backbone" of the media industry. Today, its position and status is being challenged by an increasingly multifaceted audio-visual industry, locked into and targeting a competitive global economy. While the establishment of TnaG represents a serious cultural-nationalist intervention, it will do little to either defend or strengthen the Irish

state's ability to control or regulate the media environment. Deregulation of the domestic and global markets aided by technological developments have effectively ensured that both RTE and TnaG will become increasingly smaller players.

Selected Bibliography and References

AGB TAM (1993): *A Report on Television Trends in Ireland 1990-1992*. Dublin: AGB TAM.

Bew, P., E. Hazelkorn and H. Patterson (1989): *The Dynamics of Irish Politics*. London: Lawrence and Wishart.

Brants, K. and K. Siune (1992): "Public Broadcasting in a State of Flux", in K. Siune and W. Truetzschler (eds): *Dynamics of Media Politics*. London: Sage.

Campbell, J. J. (1961): *Television in Ireland*. Dublin: M. H. Gill & Son Ltd.

Coopers and Lybrand Corporate Finance (1994): *The Employment and Economic Significance of the Cultural Industries in Ireland*. Dublin: Temple Bar Properties.

Deloitte and Touche (1998): *A Strategy for Digital Television and Broadband Communications Services*. Dublin.

Department of Arts, Culture and the Gaeltacht (1995): *Active or Passive? Broadcasting in the future tense*. Dublin.

Department of Arts, Culture and the Gaeltacht (1997): *Clear Focus. The Government's Proposals for Broadcasting Legislation*. Dublin.

Doolan, L., J. Dowling and B. Quinn (1969): *Sit Down and Be Counted*. Dublin: Wellington Publishers Ltd.

Fahy, T. (1992): "Audience Research in RTE", in *Irish Communications Review*, vol. 2.

Farrell, B.(ed) (1984): *Communications and Community*. Dublin: RTE/Mercier.

Fisher, D. (1978): *Broadcasting in Ireland*. London: Routledge and Kegan Paul, Ltd.

French, N., E. Hazelkorn and W. Truetzschler (eds) (1990-): *Irish Communications Review*. Dublin: Dublin Institute of Technology.

Gorham, M. (1966): *Forty Years of Irish Broadcasting*. Dublin: RTE.

Hall, E. (1993): *The Electronic Age. Telecommunication in Ireland*. Dublin: Oak Tree Press.

Hazelkorn, E. (1992): "'We can't all live on a small island': The political economy of migration", in P. O'Sullivan (ed): *The Irish in the New Communities*. Leicester: University Press: 180-200.

Hazelkorn, E. and P. Smyth (eds) (1993): *Let in the Light. Censorship, Secrecy and Democracy*. Dingle: Brandon Books.

Hazelkorn, Ellen (1995): "Ireland: from nation building to economic priorities", in *Decentralization in the Global Era. Television in the Regions, Nationalities and Small Countries of the European Union*. London: John Libbey.

Hazelkorn, Ellen (1996): "Technology and Labour Restructuring in Public Broadcasting: the case of Ireland's RTE", in *Irish Communications Review*, vol. 6: 28-38.

Hazelkorn, Ellen (1997): "Arise and Follow Charlie?", in *Fortnight*, September.

Hazelkorn, Ellen (1997): "New digital technologies, work practices and cultural production in Ireland", in*The Economic and Social Review*m 28,3: 235-260.

Irish Broadcasting Review (1978-1983). Dublin: RTE.

Kelly, Mary and Barbara O'Connor (eds) (1997) *Media Audiences in Ireland*. Dublin: University of Dublin Press.

Kelly, Mary and Wolfgang Truetzschler (1992): "Ireland", in Euromedia Research Group: *The Media in Western Europe*. London: Sage.

Kelly, Mary and Wolfgang Truetzschler (1997): "Ireland", in Euro-media Research Group: *The Media in Western Europe*. London: Sage.

McLoone, M. and J. MacMahon (eds) (1984): *Television and Irish Society*. Dublin: RTE/IFI.

Ó Riagáin, P. and M. Ó Gliasáin (1994): *National Survey on Languages 1993: Preliminary Report* [Research Report 18]. Dublin: Institúid Teangeolaíochta Éireann.

O'Grada, Cormac (1997): *The Irish Economy Since the 1920s*. Manchester: Manchester University Press.

Quill, T. (1993): *From Restoration to Consumerism: Directions in Irish Language Television Broadcasting*. MA, Dublin City University.

"RTE" (1967), in *Administration*, 15, 3. Dublin: Institute of Public Administration.

RTE (1995): *Response to the Government's Green Paper on Broadcasting*. Dublin.

RTE (1998): *Equality Report*. Dublin.

RTE (1998): *Review of Structures and Operations*. Dublin.

RTE Group of Unions (1998): *Towards a Shared Vision*. Dublin.

Sheehan, H. (1987): *Irish Television Drama*. Dublin: RTE.

Siune, Karen and Wolfgang Truetzschler (eds.) (1992): *Dynamics of Media Politics*. London: Sage.

Stokes Kennedy Crowley (SKC) (1989): *Staidéur Indéunlachla. Seirbhís Teilifíse Gaeilge. Údaras na Gaeltachta*.

Sweeney, Paul (1997): *The Celtic Tiger. Ireland's Economic Miracle Explained*. Dublin: Oak Tree Press.

Telesis Consultancy Group (1982): *A Review of Industrial Policy*. Dublin: NESC.

Truetzschler, W. (1991a): "Foreign Investment in the Media in Ireland", in *Irish Communications Review*, 1, 1.

Truetzschler, W. (1991b): "Broadcasting Law and Broadcasting Policy in Ireland", in *Irish Communications Review*, 1, 1.

Watson, Iarfhlaith (1996): "The Irish language and television: national identity, preservation, restoration and minority rights", in *British Journal of Sociology*, 47, 2 (June): 255-274.

Watson, Iarfhlaith (1997): "A History of Irish Language Broadcasting: National Ideology, Commercial Interest and Minority Rights", in Mary J. Kelly and Barbara O'Connor (eds.): *Media Audiences in Ireland*. Dublin: UCD Press.

Notes

1 I am grateful for comments on an earlier draft of this paper from Wolfgang Truetzschler, Brian O'Neill and Tom Gormley, and for research conducted by Amanda Dunne. All errors and omissions are my own.

2 Among the minoritarian organizations, the Green Party, Sinn Fein, and various permutations of the "religious right" show varying levels of support; the former two currently have representation in the Dáil (Irish parliament) and at local government level.

3 The 8th amendment to the Constitution (1984) granted equal rights of the mother and the "unborn", however, following a public outcry after the rape of a 13 year old known as the X-case, the 12th and 13th amendments (1992) permitted the distribution of abortion information and freedom to travel outside the country for an abortion. A reading of the judge's decision in the X-case suggests that limited abortion is available.

4 Micháel MacGreil's study, (1991) verified a high level of religious intolerance and suspicion towards "minority" beliefs: 51 per cent would not marry or welcome a Methodist into their families; 60 per cent likewise a Jew; 69 per cent likewise an agnostic; 71 per cent likewise an atheist; 79 per cent likewise a Muslim; and 87 per cent likewise a Hare Krishna. See also Micheál MacGreil, 1996.

5 I am grateful to James Wickham for this concept. The Irish music industry was the fifth highest provider of international hit records in 1995; see Kelly and Truetzschler, 1997: 112.

6 Atlantic 252 has maintained its position as the UK's largest commercial station, broadcasting from Trim, co. Meath, Ireland. Its frequency is issued by the Irish Department of Communications, and is jointly owned by the Luxembourg media company, CLT, and RTE. See Michael Foley, in *The Irish Times*, 15 May 1997; Re. Tara Television, see Barry O'Keeffe, in *The Irish Times*, 19 June 1996.

7 Many of the decisions by the then Minister for Communications, Mr Ray Burke, T.D., were highly controversial at the times, with allegations of political and financial favouratism. These allegations were given substantial weight during 1997, when the same individual was forced out of office, then Minister for Foreign Affairs, after allegations of interference in the planning process. More recently, renewed allegations about the allocation of the MMDS licences has come to light. See Geraldine Kennedy, in *The Irish Times*, 6 June 1998.

8 The following is a list of key legislation effecting broadcasting in Ireland: Wireless Telegraphy Act 45, 1926; Broadcasting Authority Act 10, 1960; Broadcasting Authority (Amendment) Act 4, 1964; Broadcasting Authority (Amendment) Act 7, 1966; Broadcasting Authority (Offenses) Act 35; 1968; Broadcasting Authority (Amendment) Act 2, 1971; Broadcasting Authority (Amendment) Act 1, 1973; Broadcasting Authority (Amendment) Act 33, 1974; Broadcasting Authority (Amendment) Act 37, 1976; Broadcasting and Wireless Telegraphy Act, 1979; Radio and Television Act, 1988; Broadcasting Act, 1990; Broadcasting (Amendment) Act, 1993.

9 Throughout the 1960s, RTE had a stormy relationship with the Government; in one of the most notable speeches on the issue, the then Taoiseach, Séan Lemass, stated: "Radio Telefís Éireann was set up by legislation as an instrument of public policy and as such is responsible to the government... The government reject the view that Radio Telefís Éireann should be, either generally or in regard to its current affairs and news programmes, completely independent ot government supervision." The rise in political unrest in Northern Ireland in the early 1970s further increased tensions between the government and RTE especially following a directive that RTE was to: "refrain from broadcasting any matter that could be calculated to promote the aims or activities of any organization which engaged in, promotes, encourages or advocates the attaining of any political objective by violent means." When an interview in 1972 with a senior member of the IRA was not followed by an apology, the Minister dismissed the RTE Authority. The Broadcasting Authority Amendment Act, 1976 curtailed some of the Minister's power in this regard; thus, the Minister can only dispense with the services of one or all members of the Authority following passage of a parliamentary resolution.

10 There had been only token public or indeed broadcasting protest at this gross interference in broadcasting by the State although a recent report by the UN's Human Rights Committee obliged its replacement. In 1993, the Supreme Court determined that RTE's implementation of the Ministerial Directive had been too rigidly applied.

11 See Broadcasting Authority Acts, 1960-1993 - Section 18(1) Guidelines (Dublin: RTE , 20 January 1994) and "Interim Guidelines for IRTC Sound Broadcasting Services", (Dublin: IRTC, 20 January 1994). For further discussion of these issues, see E. Hazelkorn and P. Smyth (eds), 1993.

12 There were five bidders for the national radio licence in 1996; the franchise was awarded to Radio Ireland whose proposed schedule was a mixture of current affairs, talk radio and music similar to that of RTE Radio 1. Poor listenership ratings, internal personnel

problems, and poor advertising revenues forced Radio Ireland to relaunch itself just six months after starting up; its new format is music driven, dramatically different from the revamped proposal submitted and approved by the IRTC. The station's blatant disregard for the authority of the Commission raises fundamental questions as to whether the IRTC is in any position to actually enforce its authority.

13 Advertising is restricted to 10 per cent of total programming time on RTE television and five per cent on RTE radio; private broadcasters may broadcast double that amount. See Kelly and Truetzschler, 1997: 116.

14 RTE, 1988: 2, 6. The RTE approach was remarkably similar in tone to the *UK Broadcasting in the '90s: Competition, Choice and Quality - The Government's Plans for Broadcasting* (Home Office, 1988, paras 10.2-10.4, p41).

15 I am grateful to Tom Gormley, RTE, for the 1998 data.

16 RTE's review points to a range of problem areas, inter alia: the lack of a business ethos; the need to focus on providing value for money; lack of clarity in managerial roles and responsibilities; lack of trust between management, staff and unions; no shared vision of how RTE should face competition, and poor preparation for change and a resistance to change. See Matt Cooper, "Reports of RTE's demise exaggerated", *The Sunday Tribune*, 28 June 1998; Michael Foley, "RTE report proposes changes for future," *The Irish Times*, 26 June 1998.

17 Ironically, UTV's assault on the Republic's audience was assisted by the government "cap" on advertising revenue which effectively forced advertisers to seek alternative platforms.

18 Indeed, the 1995 Annual Report noted that RTE was unable for the first time to purchase some major sporting events.

19 The status of the deflector system became a heated political issue during the 1997 general election; several candidates contested election to parliament urging its legalization. That Mr Tom Gildea won a seat in a Donegal constituency, considered one of the most "nationalist" constituencies in the state, illustrates the irony of that issue.

20 Licences for MMDS were awarded by the Minister for Communications in accordance with the "MMDS Frequency Plan" drawn up by that Department. The plan divides the state into 29 "cells" for purposes of MMDS, and the exclusive licences awarded relate to the retransmissions of television services within these cells. There are seven companies or "MMDS franchises" each of which has been awarded exclusive licences for MMDS in a number of these cells.

21 A. C. Nielson Establishment Survey, May 1997; there are 450,000 cable subscribers supplied by three companies. See *Sunday Business Post*, January 12, 1997. The franchise for the Irish direct broadcasting by satellite (DBS) service was awarded in 1985 to "Atlantic Satellites", a company which was originally owned by the Irish entrepreneur James Stafford. It was then sold to the US company Hughes Communications subsequent to the awarding of the franchise. None of the plans of Atlantic Satellites ever materialised and in 1992 the company was sold back to its original owners.

22 Matt Cooper, "Time for RTE to tackle opposition", *The Sunday Tribune*, 12 January 1997.

23 The UK channel, ITV (Independent Television) is broadcast via Northern Ireland as UTV (Ulster Television); BBC has regional programming emanating from Northern Ireland and is known as BBC NI.

24 Cutbacks in RTE (due ironically to the introduction of the "cap" on advertising revenue) affected Windmill Lane's own financial contribution.

25 CanWest Global owns and operates Canada's largest private-sector broadcasting network while in New Zealand and Australia it owns majority stakes in two independent television stations.

26 For a detailed history of the campaign to established an Irish language television station, see Hazelkorn, 1995; Watson, 1996: 255-274, and Watson, 1997: 212-230.

27 The former Minister has viewed such proposals as providing entry to private exploitation of the transmission network, which he equates with a "national asset ... belong[ing] to the people and must not be sold off". Michael D. Higgins, T.D., speaking before a Dáil Committee on the Irish Language, quoted in *The Irish Times*, 25 February 1988.

28 Within the last several years, almost two dozen government or consultant reports have been published identifying this significance. See inter alia, Coopers & Lybrand, 1992; Colin McIver Associates 1994; Simpson Xavier Howarth, 1994; Kennedy, 1994; Coopers &

Lybrand, 1994; INDECON, 1995; IBEC, 1995; FAS, 1995; Coopers & Lybrand, 1995; Competition Authority, 1995; Music Industry Group, IBEC, 1995; Marketing Partners in Dublin/Coopers & Lybrand, 1995; Government Publications, 1996; Statcom/Film Makers Ireland, 1996; Forbairt, 1996; Report of Ireland's Information Society Steering Committee/Forfas, 1996; IBEC, 1996; Forte Commission Report to the Minister for Arts, Culture and the Gaeltacht, 1997; Department of Arts, Culture and the Gaeltacht, 1997; Deloitte and Touche, 1998; Arts Council, 1998. In addition, several responses to the Government Green Paper were published: IBEC, 1995; Combat Poverty Agency, 1995; and by the IRTC, RTE, and the RTE Group of Unions. Fianna Fail, when in opposition, published a discussion document: Planning for the Film and Television Industry (1996), and within the first year of government, the Minister for Art, the Gaeltacht, Heritage and the Islands, Ms Sile de Valera, T.D., established a Film Commission and a Think Tank on Film.

29 A historic "Memorandum of Agreement" has been signed between RTE and the Dublin Institute of Technology, a pioneer in media education, to provide a series of Masters programmes in Broadcasting.

Italy: Big archipelago of small TV stations

Renato Porro, Giuseppe Richeri

1. General political framework of the State and the role of the regions

Italy has 56 million inhabitants and is administratively organised into 8,000 municipalities, 94 provinces and 20 regions. Italian regions are generally grouped into three large geographical areas:

- The north, formed by Liguria, Piedmont, Valle d'Aosta, Lombardy, Veneto, Trentino-Alto Adige, Friuli-Venezia Giulia and Emilia-Romagna;

- The centre, formed by Tuscany, Marche, Umbria, Lazio, Abruzzo and Molise;

- The south, formed by Campania, Apulia, Basilicata, Calabria, Sicily and Sardinia.

The north is the richest part of the country. It is where the industrial revolution began (Liguria, Piedmont and Lombardy) and where an extensive fabric of small and medium-sized industries and cooperatives developed after the Second World War (Veneto and Emilia-Romagna). Lombardy's capital, Milan, is considered to be Italy's economic and financial capital. It is home to the largest banks and the Stock Exchange. Industrialisation of the centre of Italy is more recent. It mainly consists of small and medium-sized business (Marche, Tuscany, Lazio) though agriculture is still present. The south is the country's least developed area

where agriculture predominates. Industrial activity is not very developed and is concentrated in a few areas. Unemployment is high and people are forced to go north or emigrate to find work.

In general, every Italian region is characterised by its own history, local culture and language: Italian is the most widely spoken, with various specific dialects, but other languages are also spoken in some regions. This is the case, for example, of German in Alto Adige, French in Valle d'Aosta, Slovenian in Trieste and Gorizia and Ladino in some valleys of Alto Adige. Throughout Italian territory there are several autochthonous communities of Albanian, Greek and Serbo-Croat speakers.

The Italian constitution states that "the Republic, whole and indivisible, recognises and promotes local autonomous communities; for services which depend on the State, it applies the highest degree of administrative decentralisation; it adapts the principles and methods of its legislation to the requirements of autonomy and decentralisation" (article 5). "The Republic is divided into Regions, Provinces and Municipalities" (article 114); "The Regions will be constituted as autonomous bodies with their own powers and functions" (article 115). Despite the fact that the Italian constitution dates from 1948, regional reorganisation of Italy did not begin until 1971.

Of the 20 regions that the Italian State is divided into, five have special statutes. These are stipulated in the constitution because of their greater degree of differentiation: Valle d'Aosta, Trentino-Alto Adige, Sicily, Sardinia and Friuli-Venezia Giulia. The others have ordinary statutes. The difference between the two types of region lies in the fact that powers are distributed by a statute of autonomy in the special regions and directly by the constitution for the rest (with a closed, limited list). The autonomous opportunities of the former are therefore quite good (Fossas, 1990). Regional powers include areas such as health and social services, agriculture, job training, the environment, etc. In addition, the regions have the power to intervene in many other sectors such as culture, sport and recreation, industry and transportation. The regional authorities are the regional Council, elected by universal suffrage, the regional Board, elected by the Council, and the regional President, elected by the Board.

Regarding cultural issues, the Italian constitution does not contain any explicit distribution of powers. So, in principle, no public institution is excluded from cultural promotion or tutelage. The only explicit mention of cultural power delegation to the regions appears in article 117, which grants regions with ordinary statutes legislative powers for "museums and libraries of local bodies". Despite this undefined and relatively limited constitutional framework, all Italian regions have adopted programming rules in their statutes which provide for the region's promotional intervention in the cultural sector, among others. It should be pointed out that the Italian legal system does not contemplate any type of regional power as far as the media are concerned.

Evolution of the Italian political-territorial structure is uncertain, especially when taking into account the growing influence of federalist demands, whose proposals come up against the unitarianism of most political forces.

2. Television's legal framework

The main legal text of a general nature for radio and television is Act 223 of 9 August 1990, promulgated after numerous rulings by the Constitutional Court and a whole host of court interventions which had in fact liberalised radio and television activities in Italy (cf. Richeri, 1995: from page 220). This gave rise to a mixed public and private system, which is effectively represented by a public service (RAI) and local television. Through a process of buy-outs and mergers, the national private television system came into being. So, the 1990 Act served mainly as recognition of an existing reality rather than a means of regulating it. Despite that, the Act includes novel elements connected with the objectives and prospects of televisual communication.

First of all, recognition of the existence of a competitive "public-private" system meant that the constitutional rule (article 43) had been surpassed. This rule defined broadcasting as a national public service and therefore limited to the State. As from the 1990s, broadcasting was understood as a general-interest service which had to be regulated by a licensing regime open to private actors with commercial and business goals. From that time on, calls for the impartiality, integrity and objectivity of information turned into a statement of general intentions. The *de facto* situation that had been created between 1970-90 meant that a balance between rights and interests had to be found. On the one hand, those aimed at assuring the condition of plurality understood as being the need to guarantee the expression of opinions and access to information and, on the other, those aimed at assuring entrepreneurial liberty as the basis of any free economy. Secondly, the nature of the public service was progressively defined. It had to change to a company structure which, instead of being totally and exclusively publicly owned, had to have a general interest character (Act 206 of 25 June 1993). This process culminated in the 1995 referendum, which approved the participation of private companies in the RAI's share capital as an essential requirement for public service broadcasting activities (yet to be applied). In fact, recognition of the existence of a competitive "public-private" system meant looking for different objectives, underscoring the difference between the roles of public service and private broadcasting. It is the former's job to express the political, cultural and social orientations and opinions existing in the country, whereas the latter should guarantee the right to information through a variety of competing voices. Private broadcasting, and local broadcasting in particular, is thus attributed a subjective role to guarantee what the Constitutional Court defined as "external plurality".

In a very short space of time, the idea of different roles being played by the national public system and the private system had in fact become a duopoly. The public and private systems, rather than performing different communicative functions, developed a relationship of pure competition regarding audience figures, access and distribution of advertising resources and, at the same time, a virtually perfect match regarding programming options and strategies. These were the premises of a closed system, at least until Act 249 of July 1997 was passed, which aimed to create the right conditions to assure the presence of other private editors in the future by limiting the number of networks that each licence-holder could control, for example. The construction of a rigid, closed system has led to absolute marginalisation of local broadcasting, relegating it to a secondary role until virtually becoming irrelevant. The latter, in terms of financial resources, can only draw on no more than 500,000 million Lira per annum, that is, about nine per cent of the total advertising budget for the television system.

The general principles and targets set at the beginning of the 1990s for television broadcasting took on a special meaning for the local system. As already mentioned, this system had to express and guarantee the conditions of plurality. This mission turned its involvement in the nascent processes of globalisation, "proximate communication" strategies, and the cultural and economic features of the various communities into something substantially secondary and ignored. As a private body, local television is therefore defined "by scale" within the national setting. This is reflected by the requirements (share capital, frequency allocation, constraints on the broadcasting of commercials, administrative permits, etc) and obligations imposed (quotas for a station's own productions, daily information, etc) as provided for in the different Acts. In this scenario, its is clear to see that demands are being made on local television stations for general programming commitments which are not at all different. These can be summed up as follows: a licence-holder must broadcast at least one daily new programme with no fewer than four hours a week dedicated to news and social problems of local interest. If at least one hour of news produced by the station itself is broadcast per day, it has the right to apply for financial incentives and benefits provided for by the law (electricity and phone bills, subscriptions to news agencies, etc). Secondly, every television station must broadcast programmes for at least eigth hours a day and 64 hours a week as a requirement that has to be met to be recognised as an active company and editor. Finally, local television stations have an advertising ceiling of 35 per cent of daily programming time and 20 per cent per hour. Regarding the last issue, and since the end of 1992 at least, the situation has become somewhat confusing because of the particular definition of sponsorship which tended to describe it as a secondary category of commercial advertising. This means that it has contributed to a partial

increase in the percentage figures mentioned. A proper distinction between sponsorship and telepromotion understood as being messages aimed at stimulating and explicitly suggesting that products and services should be bought or hired has put an end to this state of uncertainty by placing the latter in the same category as commercial advertising.

To sum up, the fact that local television's framework is considered to be "public-private" and "by scale" within the national setting means that it has been defined as a system which ought to be homogenous and unanimous as far as functions and communicative options are concerned. In fact, the law does not provide for any possibility of recognising or encouraging different, specific editorial vocations.[1] Thus, territorial peculiarities do not have any form of expression other than information and news programming.

The television system that now exists in Italy only consists of frequencies that can be received over the air. RAI has recently announced and launched three free thematic channels by satellite. Some private national and local channels have adopted the same solution. It is, however, an option that can be considered as a supplement to and not as a replacement for the land-based system. This is demonstrated by the fact that few Italian families have satellite antennas.[2] These are installed to receive foreign channels and in some particular areas where national channels cannot be picked up because of geographical conditions. Legally, cable and satellite broadcasting is defined by the adaptation of the European Union's directives. The use of cable and satellite is seen as a compulsory solution only for codified channels and pay TV.

As far as guarantees are concerned, television has shifted from the phase aimed at tutelage of all sociocultural instances and representation of various group interests to one that favours recognition of citizens' rights. So, the traditional *Garante per l'Editoria* institution (Communication Ombudsman/Watchdog), introduced into national legislation in 1981, has been modified to respond to the "public-private" system. The *Garante* had three areas of tutelage and control of market mechanisms assigned to it in order to prevent concentration and to support the weakest editorial actors. Consequently, its intermediary was the Parliament and not the citizen. In 1990 the functions of the *Garante* were redefined in accordance with the logic of independent authorities aimed at assuring guarantee conditions for all citizens and intervention, if necessary, in the relationship existing between the citizens and the mass media. In this sense, conditions that can jeopardise or impede personal development, full realisation of citizens' rights, conditions of equality and parity became controlled matters. That way, attention is paid to ethical and social values as the basis for legitimising a set of limits imposed on radio and television advertising and programming. Even though it is true to say that the actions of the *Garante* have only been

expressed in terms of bureaucratic and administrative control, it is a model which has redefined the relationship between the State and the citizen, and is a stimulus for the media system to produce quality television. So, the *Garante* had to develop a function of promotion and mediation, freeing the institutional apparatus and the anonymous mass of citizens from a task which, for instrumental reasons, they cannot undertake. But the issue of quality has been completely or almost completely ignored in Italy, whereas it has been dealt with in a decisive manner in other countries by large institutions, starting with the Parliament and, on an operative scale, through independent authorities. In the United States, the Communications Decency Act was promulgated. It contains seven articles. The fifth is explicitly dedicated to matters of obscenity and violence in any television programme. Various standards have been defined in other countries to regulate programming so that it meets requirements for respect towards values shared by the community and positively promotes the potential of communications technology.

3. Television's institutional structure and organisation

The Italian television system is nationally divided into the following categories:

(a) free television (over the air);
(b) pay TV (over the air);
(c) free digital channels;
(d) pay TV and a pay-per-view services via satellite.

There are nine free television channels over the air with coverage between 70 and 90 per cent of the territory:

• three channels belong to RAI Radiotelevisione Italiana, the public service radio and television network;
• three channels belong to Mediaset, a company controlled by the Fininvest group, which has the majority shareholding and also includes some foreign shareholders;
• the company TeleMonteCarlo owns two channels and is controlled in turn by the Cecchi-Gori group, the Italian film industry's main producer and distributor.
• the company Rete A, controlled by the editorial group Peruzzo, owns one channel.

The two over-the-air pay TV channels are managed by the company Telepiù, controlled by the French company Canal+. Fininvest has a minority shareholding (10 per cent) in it. Free digital television via satellite is managed by RAI and it currently has three thematic channels. Digital pay TV is managed by Telepiù and consists of some basic and some pay channels for sporting events and films.

Table 1. TV viewing share in Italy (end of 1997) (%)

RAI	49.7
RAI 1	24.2
RAI 2	15.4
RAI 3	10.1
Mediaset	40.4
Canale 5	21.4
Italia 1	10.1
Rete 4	8.8
Telemontecarlo	2.3
Others (Rete A and local TV)	7.5

The television market is an oligopoly. Two groups with three channels control 90 per cent of the viewership. In fact, competition is highly defective because, on the one hand, RAI has more legislative obligations and connections than Mediaset, as well as series of political connections whose effect (either positive or negative) on the company's behaviour is not quantifiable. On the other hand, RAI is the only organisation that receives resources from the television licence fee. In 1997, free television in Italy accounted for 8,500 billion Lira, distributed as shown in table 2.

Table 2. Origin of television's financial resources in Italy, 1997 (figures in billions of Lira)

National TV advertising	5,244*
Local TV advertising	500
Licence fee	2,450
Others (commercial activities)	250

* Equivalent to 57% of total advertising spending.

So, RAI controls just over 50 per cent of the total resources available for free television, whereas Mediaset controls just over 26 per cent.

As far as pay TV is concerned, it is a sector that still has not reached a point of financial balance: the analogue over-the-air channels now have just over 800,000 subscribers, whereas the digital television stations already have over 150,000 subscribers despite being in operation for only a year.

The Italian national television situation is one of uncertainty. Legislative and business decisions are awaited, and these could provoke some alterations. Some of the main ones refer to:

- the reorganisation of one of RAI's channels which intends to exclude advertising altogether and offer more cultural and regional contents;

- transferring one of Mediaset's over-the-air channels to a satellite channel;
- attempts to create a single digital platform which, besides Telepiù, will include RAI, Mediaset, Telemontecarlo and Telecom Italia.

In this last case, it was a complex transformation, which could have been successful when creating a powerful national initiative in the area of digital television. The failure lead to the creation of Stream – around Telecom Italy – which has converted into the digital television offering an alternative to the one actually managed by Telepiù. At the end of 1998, it had 440,000 subscribers.

4. Television's structure and characteristics in the regions

4.1. Types of television stations broadcasting in the regions

In comparison to the types of regional television broadcasts defined in *Decentralization in the global era*, the Italian reality has endless, deep-rooted elements that characterise it. First of all, "productive television delegated to the region" is unheard of. One experience that is partially comparable to this type is perhaps the one stemming from the recent agreement between the regions and RAI, which involved producing a 15-minute information programme called *TGR Regione Italia*, broadcast every two weeks on a regional scale and three times on a national scale. It was broadcast for a total of nine hours in 1997. The regions participate in and contribute to the choice of contents that should be covered, even though journalistic responsibility belongs to RAI, as do production costs. The topics covered are very varied and include areas of regional interest. Despite this recent experience, today's local television panorama is divided into two subsystems: RAI, with its decentralised centres, and private local television. Both of these are dealt with later, though here it should be pointed out that the panorama is likely to change in the near future.

In the summer of 1997, Act 249 of 31 July was passed, which claimed to be a global regulatory instrument. In this sense, it contemplated the prospect of media and telecommunications integration, and created the Authority for communications guarantees. This Authority acts as a third party as far as the market and political and parliamentary systems are concerned, and has executive powers to control and guarantee the whole of the communications system. There was a long, wide-ranging debate about its intervention centred around two themes: the maximum number of channels that each licence-holder could manage and, as mentioned previously, turning one of RAI's channels into a territorial station. The latter of the two themes had several repercussions on the regional television system. The original idea consisted of promoting a channel organised on a federal basis like that of the German *länder*. That way, a "federal television" reality could have materialised in Italy. As it was impossible to set up this federal-type institutional reality and due to the

high level of financial resources required, the need to rethink the idea soon became clear. So, it appeared to be more feasible to think about the existence of other local centres by financial competition between the regions and the cultural (associations, universities, museums, etc) and financial actors (insurance, banking, etc) in order to guarantee national and regional programming. This would have involved a proliferation of managerial and administrative structures on a territorial scale (boards of directors, management committees, etc). The legislative solution favours and suggests a different panorama. RAI ought to create a channel free from advertising that can only access financial resources from the licence fee. Respecting the unity of the public service, a national channel is designed to reflect the diversity and specific nature of the territories. At the same time, it should broadcast local "windows" whose number and duration must be appropriate. That way, a situation would materialise that is at least partially comparable to the type defined as "regional window television", with a feature allowing each territorial reality to have its own programme (culture, sport, entertainment, etc), besides journalistic information and newscasts.

4.2. Description of RAI's regional model

While waiting for this transformation to take place – which should be implemented before the new millennium-, the local television system in Italy is based on "decentralised television" (RAI) and "regional coverage local television" (local television channels).

Regional television broadcasts in Italy began in 1978 with the creation of RAI's third channel. The implementation of regional television was expedited by the creation of a new network of land-based stations that could broadcast a single national programme or different programmes for each region. In addition, a RAI delegation was created in each region and equipped with the necessary professional and technical capabilities to manage the design, production and broadcast on a regional scale of information, entertainment, sports and other types of television programme. The regional centres do not just produce and operate for local broadcast. They also contribute to the third channel's broadcasts on a national scale. The original model estimated that at least 60 per cent of programmes broadcast by the third channel on a national scale should consist of programmes created and produced by the regional delegations. However, this model only worked in the first phase. In the first half of the 80s, the idea gradually eroded until it was reduced to the regional part of producing and broadcasting a daily information programme (*TG regionale*).

A completely new phenomenon in Europe began to materialise in Italy in the second half of the 1970s: the birth of private television stations over the air. They were stations that covered territorial areas of variable dimensions: coverage was metropolitan, provincial, interprovincial or regional. These

stations were legalised by a Constitutional Court ruling in 1976 (no. 202) and, in the course of years to follow, gave rise to two different "formats": most of them carried on operating in a basically independent way whereas some turned into the first networks. Then a certain number of national private networks arose out of these in a situation of regulatory absence which lasted until the 1990s.

RAI's regional structure has been consolidated for some time. Being part of the third channel's (Raitre) organisation, in 1995 it had 84 stations and 1,491 boosters, to which structures (7 and 101, respectively) dedicated to broadcasting programmes aimed at ethnic and language minorities (Valle d'Aosta, Friuli-Venezia Giulia and Trentino-Alto Adige) were added. Its coverage of national territory is, therefore, as good as Raiuno (94 stations and 1,659 boosters, respectively) or Raidue (78 and 1,622, respectively). In fact, regional broadcasts by the public service can be received by 94 per cent of the population. From another viewpoint, RAI's decentralisation is also apparent in the staffing domain. More than 5,000 employees work in the productive structures operating in the territory, though in reality these structures are mainly devoted to national network programming. As far as television channels are concerned, RAI's decentralisation in practice signifies the production of regional information (RAI, 1997). The decentralised structure of the public service can be assessed by broadcasting stations and staff employed on the one hand, and by the programmes it offers on the other. The first piece of information refers to annual broadcasting hours. In 1993 and 1994, the number of hours went down, albeit slightly, in absolute terms (from 5,928 to 5,850), in a context of constant total broadcasting hours (26,020 and 26,010 hours per annum, respectively). This reduction that did not affect the broadcasting of programmes for language and ethnic minorities which, on the contrary, registered a slight increase (from 626 to 641 hours). If we take the last decade into consideration, the reduction takes on proportions that are clearly appreciable.

Currently, RAI's regional broadcasting model is basically limited to four regional broadcasts of a news programme which is broadcast separately for each region at the end of third channel's same number of national newscasts. Regional news programmes are made under the responsibility of a central national director. Each delegation has studios and fixed and mobile audio-visual equipment. Besides the regional news, the delegations have the job of covering regional events of national interest for national news programmes broadcast by RAI's three channels.

The regional delegations' activity does not usually generate specific resources: RAI, like other television companies operating on a national scale, cannot broadcast regional or local advertising due to a regulation that aims to protect the resources potentially devoted to private local television. Only in a few cases have there been specific agreements

between regional public institutions which have generated specific resources for RAI's regional delegations.

Table 3. Evolution of RAI's regional and local broadcasting hours, 1985-1994

	1985	1986	1987	1988	1989	1990	1991	1992	1993	1994
Total hours	7,234	7,343	6,659	6,311	6,642	6,599	6,496	6,156	5,928	5,850
Index	100	101.5	92.0	87.2	91.8	91.2	89.8	85.1	81.9	80.8

Source: RAI, 1997 and own work.

Confirmation of this trend is provided by average daily broadcasting hours, which went down from 19,49 in 1985 to 16,02 in 1994.

The delegations' activity exclusively depends on the company's decisions, though each region has *Comitati Regionali per i servizi radiotelevisivi*, appointed by each regional parliament. Among other powers, they can put forward suggestions and proposals for RAI's regional activity.

Here it is impossible to describe the audience figures of RAI's regional broadcasts in detail. It is a phenomenon that varies according to each region which depends on the internal factors of regional delegations and the context of private local television stations. In general, it can be asserted that RAI's regional news have high ratings which the company considers to be good.

Previously mentioned data concerning staffing in the regional delegations indicates that journalists are the category which accounts for the highest proportion of employees. This is confirmed by the types of programme broadcast at local level. Basically we come across an information/news "monopoly" (5,262 hours in 1993, 88.76 per cent, and 5,190 hours in 1994, 88.71 per cent), thus relegating entertainment and cultural programmes to a completely marginal position (11.24 per cent and 11.29 per cent, respectively). On the whole, this means a regional daily average of almost 1,600 news units (Rizza, 1997). TG3's national newsroom and regional newsrooms also produce other information programmes accounting for some 188 hours per annum.[3] Between October 1996 and September 1997, the third channel made 51 "extra" broadcasts aimed basically at electoral campaigns and results, with an annual total of 33 hours. Mention has already been made of the programme *TGR Regione Italia*. Finally, the regional delegations produce single-topic news programmes which are summarised in Table 4.

4.3. Local television

The second aspect that characterises the Italian reality is local television. The first difficulty for defining this reality is the uncertainty of its quantification. Several annual guides state that in Italy there are 1.059 local television and almost 3,000 local radio stations. There is a clear and

sometimes gross overestimate of the phenomenon. In fact, at least 10 per cent of these stations have been formally created but have never operated; associations between several stations have not been taken into account; it ignores ownership changes that have taken place and activity cessation; it ignores that fact that some stations have been "relegated" to the role of boosters for other stations' programmes. Therefore, the only option is to refer to official data about licences granted. On 25 October, 1995, there were 714 local television stations in operation in Italy. 81 permits issued by the Regional Administrative Tribunals (TAR) at different times have to be added to the first figure. So, in theory, the total is 795 television stations. In reality, if we consider the previously mentioned elements of selection and simplification of the system, we estimate that there are only 550-580 television companies effectively in operation, less than 60 per cent of the initial figure. So, it can be concluded that in less than a decade, the local system has decreased by almost 2/5ths in comparison to its initial figure.

Table 4. Specialised, regionally-produced news programmes

	Science[1]	The Economy[2]	Environment/ Culture[3]	Europe[4]	Others[5]
Annual Total	31' 17"	24' 02"	55' 58"	14' 18"	6' 35"

1 TGR Leonardo, since 1996.
2 TGR Economia, since 1996 and TGR Metropoli, since 1997.
3 TGR Ambiente, since 1996; TGR Fratelli d'Italia, since 1997; TGR Mediterraneo and TGR Bellitalia, since 1996.
4 TGR in Europa, since 1996 and TGR Eurozoom, only scheduled in 1996.
5 TGR Da Costa a Costa, since 1997.

As far as this first definition is concerned, the existence of an obvious territorial imbalance must be emphasised. A large majority of stations are in the south of the country. Almost half of them are in Sicily, Calabria, Campania and Apulia (43.2 per cent). That creates an imbalance in comparison to other media like newspapers, for example. So much so that it indicates a virtually "vicarious" presence of television in relation to the others (see table 5). The limited average potential audience is equally as worrying: just over 40,000 people in Sicily in comparison to 175,000 in Lombardy, for a national average of 80,000. The table is complete if we consider territorial diversity in terms of gross domestic product and, therefore, local advertising resources available for regional broadcasts. A second element of evaluation is represented by those stations defined by Act 223/90 as community stations, in other words, non-profit making organisations which are expressions of particular social and cultural realities. According to official data, these total 228, to which 19 authorised by the TARs have to be added: a total of 247 companies theoretically in operation. It is impossible to suggest elements of evaluation, even general ones, to define how many of them are effectively in operation because of their

fragmentation and the difficulties connected with obtaining formal proof about their operation. However, their presence confirms and aggravates the situation of territorial imbalance as described. In Sicily there would be 42 community stations, 25 (out of 39) in Calabria, 22 in Apulia and 39 in Campania, a total of 51.8 per cent. This data is hard to interpret with regard to the nature of community stations, as it would indicate little presence of associative, cultural and social actors in other regions of the country.

Table 5. Local television broadcasts: the first defining elements

Regions	Regional distribution %		Proportion TV/Newspapers	Average population for a TV station
	TV	Radio		
Sicily	15.7	11.9	28.1	44,144
Campania	13.5	6.5	24.1	56,906
Lazio	10.5	7.9	3.1	67,570
Apulia	9.5	10.3	11.1	56,941
Lombardy	7.1	10.8	2.1	174,352
Tuscany	6.0	5.6	9.1	83,279
Piedmont	4.9	6.6	6.1	127,971
National Total	714	2.107	6.1	83,413

Source: Calculated using data provided by the Ufficio del Garante.

We previously mentioned a "natural" selection and simplification mechanism for the system which has led to a 2/5ths reduction of it. What are the reasons behind this process? It goes without saying that there are many, though there are two that stand out in particular. The first is of a political and regulatory nature. The inability to regulate the system with Act 223/90 meant that no types of selection criteria were adopted when recognising the station. These, as expected, could not simply be financial and business criteria. They also needed to include elements for evaluating the real availability of frequencies, system development possibilities, editorial powers and global communications demands of a territory. Deciding how to recognise what exists meant accepting the fact that almost 1,000 local television stations are operating in Italy and that there enough editorial powers and an enormous network of companies with adequate financial capacities. Secondly, it was thought that the market was going to react quickly in this context of regulation and rationalisation. In reality, the market has tolerated a whole host of survival phenomena and has actually favoured conditions that make "everyone poorer". It is difficult to trust market mechanisms when the market, if it exists, is very limited, not very dynamic and endowed with few or zero development prospects.

For some time, the number of local television stations in Italy was the same as in the United States, which has around 250 million inhabitants and a system, as a whole, in which 53 billion Lira is invested in advertising, in comparison to the 5.5 billion in Italy. This leads us to remind the reader of the fact that local television currently has a little under half a million Lira and, as shown by the FRT survey (May 1997), advertising revenue represents 91.14 per cent of total income. We are faced, then, with a system that depends almost entirely on advertisers and that only marginally gets significant financial resources from "other activities" (the sale of products and services, for example). A few data can better illustrate the reality of local stations from a business point of view. The Ufficio del Garante's last report (1996) shows that local stations have a percentage distribution depending on declared net capital as shown in Table 6.

Table 6. Percentage distribution of local television, by declared net capital

Categories	%
Up to 0.3 billion Lira	43
From 0.3 to 1 billion Lira	34
From 1 to 2 billion Lira	10
Over 2 billion Lira	13
Total	**100**

A situation of little operability which appears to be confirmed by the most recent FRT survey concerning capital companies, which highlights a worrying, progressive deterioration of the situation (with 57.1 per cent in the first category, 30.9 per cent in the second and 6 per cent in the third and fourth). The second piece of information refers to television companies' turnover figures, which do not exceed an average of 1.1 billion Lira, with only one third of them above the one billion threshold. So, it is not surprising that only 21.62 per cent declared profits for the 1995 financial year, whereas the system as a whole registered a negative balance of almost 60 billion Lira. So, a considerable proportion of the stations could be considered as being financially non-viable according to the Ufficio del Garante's definition, which situates the minimum threshold to be considered as a company at a minimum of one billion Lira for annual turnover. It is perhaps even more worrying to find that television station owners are becoming more and more involved in other financial activities outside the communications system in the widest sense. This highlights the supplementary nature, not to say marginal nature, of the television editor's role. So, it is not surprising to find a quantitatively high presence of individual companies in general, and not only among community stations.

The system's fragility is confirmed by analysing the workforce figures. In this case, an estimate is made on the basis of the business balances and

FRT's proposals, identifying the number on the basis of an annual cost per capita set at 45 million Lira. This is clearly on overestimate, as it is hard to suggest that this amount could be considered as sufficient to sustain expenses corresponding to journalists, the station's director or the commercial department. Whatever the case, we find that local stations employ an average of just over seven people, accounting for almost one third of total income. Even in this case, as to be expected by now, we are faced with a highly diversified reality on a territorial scale: in Campania the average number of employees is just over 5; in Lombardy it is almost 19. In Apulia and Piedmont staff costs do not even reach 20 per cent, whereas in Lombardy and Sicily they represent one third of total income. The similarity between the last two probably reflects a different reality: in the first case it is due to a modest availability of resources, in the second it is determined by the high number of employees and, therefore, by a complex business and productive structure.

Table 7. Local television stations' staff

Regions	Average number of employees	Staff costs over revenue (%)
Sicily	5.9	34.01
Campania	5.2	31.46
Lazio	5.6	27.36
Apulia	6.0	19.61
Lombardy	18.9	34.29
Tuscany	6.2	31.39
Piedmont	5.0	16.64
National Total	7.5	30.51

Source: Calculated using data provided by FRT, 1997.

Finally, it is interesting to define some general elements relating to local television programming. We would first of all refer to the levels of stations' own productions. According to what the television stations declare (Barca and Novella, 1997), the stations broadcast a daily average of 4.8 hours of programmes they produce themselves, accounting for 24 per cent of total programming. We can consider this data, irrespective of the fact that it may be overestimated, as acceptable and significant. In reality, the smallest companies with the most limited business capacity are the ones that pay greater attention to their own productions.

It is possible to deduce from this that the programmes, to a large extent, are of modest quality and that the choice to do their own production is governed by the fact that it is not possible to access the market and not because of editorial reasons. Consequently, we cannot identify this element as a specific factor of local television or as an expression of looking for ways of "proximate communication".

Table 8. Local television stations' own productions

	Medium-Large stations (turnover > 2 billion)	Small-Medium stations (500 million-2 billion)	Small stations (< 500 million)
Own production	4.1 hours (18%)	4.6 hours (22%)	5.7 hours (33%)

As far as types of information programme are concerned, the data given in table 11 show that there is considerable activity regarding information (news programmes and magazines), service and sports programmes. Regarding news programmes, it is worth remembering that almost half of the television stations studied[4] broadcast more than five daily editions, including repeats (See Table 9).

Table 9. Local television station distribution, by number of daily news editions

Number of daily editions	1-2	3-4	5-6	7-10	More than 10
% of station	19.8	34.0	28.6	5.5	12.1

A considerable editorial effort that is limited, however, by the journalistic capacity available, yet further confirmation of the fact that modest financial resources limit editorial possibilities and abilities.

As far as information is concerned, mention should be made of a phenomenon that is so recent that it still has not been consolidated. RAI's regional newsrooms, because of a major drop in viewing figures particularly in the southern regions of the country, have considered the problem of greater proximity to the territory, of a redefinition of daily information localisation levels. In this sense, they have suggested working in collaboration with local television stations whose eventual results will be available for evaluation in the future.

5. Analysis of local television programming: Rete 7's case

We have taken Rete 7's case as the object of our analysis of regional and local programming. Rete 7 is the biggest private television station in the Emilia-Romagna region and operates on an interprovincial scale. It is a television company that belonged to a cooperative society for a very long time and has recently been bought out by a businessman who also owns the Bologna football team, one of the region's most important ones (it plays in the national league).

We felt that it would be useful to analyse local origin programmes in particular, highlighting the organisational and content aspects in order to offer some useful elements for the evaluation of "local" television programming potential and grounds on which future comparisons can be based.

Table 10. Information resources available to local television stations

	Archive access	News agency connection	Internet connection	Videotext connection	Teletext connection
Yes	22.6%	48.9%	40%	41.8%	23.2%
No	77.4%	51.1%	60%	51.2%	76.2%

Table 11. Weekly time dedicated to some types of television programme

Daily information		Service programmes		Sport	
Up to 8 hours	19.7	Up to 1 hour	27.3	Up to 10 hours	22.5
From 8 to 14 hours	21.1	Up to 1 hours	27.3	Up to 4 hours	26.2
From 14 to 18hours	18.3	Up to 2 hours	18.2	From 4 to 8 hours	22.5
From 18 to 27 hours	21.2	More than 2 hours	27.2	More than 8 hours	28.8
28 hours or more	19.7				

Source: Co.Re.Rat survey on a sample of 176 television stations in 10 different regions (Lombardy, Trentino, Veneto, Friuli-Venezia Giulia, Emilia-Romagna, Tuscany, Umbria, Apulia, Sicily and Sardinia) in 1997.

The programmes that Rete 7 produces and broadcasts are the following:
* *TG7*: news.
* *Buongiorno Emilia-Romagna*: information and entertainment.
* *Parliamone con...*: information (supplement of *Buongiorno Emilia Romagna*).
* *Ultimo minuto*: sport.
* *Basket time*: sport (basketball).
* *Il pallone nel 7*: sport (football).
* *A tamburo battente*: talk show.

TG7

There are seven editions of the news, of which there are only three main ones (13:45, 19:28, 23:00). The others are repeats of previous editions (15:00, 23:59, 1:00, 2:45).

The length of the news programme, the headlines and the speaker's presence are some of the elements that define the importance of each edition. In this sense, the main TG is on at 19:28. This edition opens with the headlines, which the speaker reads out over images of the news announced. The headlines, separated by each section's logo, are followed by the news programme's opening initials. The speaker is in a studio with a very uncomplicated set. The duration of this "orthodox" news is about 30 minutes with a total of 15 news items. Each one lasts for between one and two and a half minutes depending on the importance of the event or simply because it has good audio-visual material. Most of the news items

have images and often include interviews with the protagonists of the event.

References to national issues are quite frequent in this edition, although the various news items are presented from the point of view of the consequences and effects they will have locally: for example, the debate about the national law to reduce the working week to 35 hours was dealt with in a news programme to assess the effects and consequences that such a decision would have on local businesses.

Local political news are the most important and generally appear at the beginning, either in the headlines or in presentations. Then there is news about local events, particularly social and legal ones. A lot of time is dedicated to sport (football and basketball), with news and interviews with the star players of the local teams playing in the respective national championships. News relating to other cities in the region and "stop-press" items occupy a different slot at the end of the TG. This is clearly distinguished because it comes after a commercial break. Small news items and ones without images are not read out by the speaker, but by a journalist who intervenes from the newsroom.

The 13:15 edition is the first one of the day. It does not open with the headlines, but directly with the speaker in the studio. The number of news items is quite small (between eight and ten), as is the total duration of the TG (approximately 10 minutes). Almost half the news items have images, whereas the rest are read out by the speaker without any images. This edition of the news favours local news items, especially events (society and others). For that reason there are few references to the national context. This alters the traditional hierarchy of journalistic forms (which is well observed in the 19:28 edition of the TG), in which political news items have a much better chance of appearing at the beginning. This edition is often opened with news about events and sports information about local teams. It is rebroadcast at 15:00.

The 23:00 edition is different from the other two. First of all it does not have a speaker, but a series of videos with voice-overs and the occasional interview. It lasts for about seven minutes. The number of news items is reduced to between 5 and 7 and each one lasts for between one and two minutes. Here too, all the news items presented are local and rarely refer to national events. This edition is repeated at 23:59, 1:00, and 2:45.

Buongiorno Emilia-Romagna

This is an information and entertainment programme which is broadcast in the morning from Monday to Friday, from 7:00 to 9:30.

The broadcast is run from a studio by two speakers, a man and a woman, and is divided into two parts: the first part consists of a series of news items whose format and sometimes even contents are repeated, whereas

the second part, *Parliamone con...*, is given over to in-depth interviews with guests in the studio.

The broadcast has a "radio" style, as it places greater importance on the spoken word than on images: there are not many videos, and few images are used to illustrate the news. The two hosts present the broadcast in a familiar, relaxed manner. The programme, because of the timeblock and the way the contents are presented, is basically aimed at two target audiences: housewives and people getting ready to go out. In other words, audiences who cannot dedicate their full attention to what is on the screen. This gives rise to a programme style that includes fast and often repeated news items. However, constant attempts are made to attract the viewer's attention by using several strategies: the newsroom's telephone number is repeated a lot so that viewers can leave messages on an answering machine; emphasis is placed on the fact that viewers themselves can "contribute" to the programme's contents (by sending in recipes, for example, which are then read out live); news items from national news programmes, for example, are viewed on a screen next to the host, who watches them with the viewers.

In the first part, news items are generally presented in the following order:

- Weather: weather forecasts in the region.

- Press review: the speaker reads out the headlines on the covers of the main national and local newspapers; more attention is paid to local news, by reading not only the headlines but also extracts from the most important articles.

- A special slot is dedicated to news items from the region's main cities (Reggio Emilia, Modena, Ravenna, Rimini); sometimes, when special-interest events occur, the news is supplemented by connections to outside broadcasts and the newsroom.

- The headlines of the morning editions of the two main national news programmes are displayed on a screen next to the speaker (RAI's TG1 and Canale 5's TG5).

- Horoscope.

- The local and regional transport situation: information is provided during the broadcast about the road traffic, railway and tram situation in the city of Bologna and the region as a whole. The information is periodically updated by telephone connection with the managers of the various transport networks.

- TG7 news: of all types (politics, society, sport...), referring to the local area. Sometimes the video broadcast is directly connected with news item read out when going through the press. Videos last for about one minute and are often supplemented with interviews.

• Miscellaneous news: between one news item and another, and for fill-in, the speaker reads out a curious piece of news, a recipe or advice about how to solve minor daily problems.

The series of news items last for about 15 minutes. There are 5 minutes of commercials between them. The second part of the programme lasts for about an hour. It consists of a series of daily and local-life slots. Each one last for about 10 minutes and deals with the topic in question with a guest in the studio (usually an expert in the topic being dealt with, a lecturer or a doctor) or with the aid of an outside broadcast. The topics are varied, but each day of the week has a fixed slot (cinema on Wednesday, for example). In this case a great deal of attention is also paid to the local dimension of the topic: the guests are from Bologna, and references are often made to the local context (during the cinema slot, for example, besides reviewing the film in question, explicit reference is made to the theatre where it is on by using images).

Parliamone con...

This programme uses the same structure as the second part of *Buongiorno Emilia-Romagna* with its slots and studio guests. It is broadcast from Monday to Friday, from 20:00 to 21:00. The speakers talk to the guests about very general, local-interest topics (eg health, housework, the job market, everyday problems). Viewers can phone in to ask their questions live. They can also participate in the debate with guests. Each day of the week the first slot consists of a documentary lasting for 10 minutes. These are long videos that deal with general-interest topics (Thursday is dedicated to Emilia-Romagna's artistic cities, for example).

Ultimo minuto

This is a weekly sports information *magazine* which is broadcast every Sunday at 21:00 (and repeated at 1.40 a.m.). The broadcast, which lasts for 30 minutes, deals mainly with football, paying special attention to Bologna's team. The journalist, who is well known by the viewers, hosts the programme in a very familiar way. He gets personally involved in much the same way as a die-hard team supporter. So, he does not conceal his enthusiasm or disappointment in his comments and appraisal of the Sunday match, depending on how well Bologna did.

Besides the speaker, a guest intervenes in the studio (a sports journalist or a football player), called in to comment on the matches and to give his opinion about the players, about tactics or about the coach's work.

As a Sunday programme, *Ultimo minuto* obviously talks about the results of the Italian first and second division matches. Tables and classifications appear several times throughout the broadcast. However, most of the time

(about 20 minutes) is dedicated to the match played by Bologna. A fairly long and detailed summary of it is given, with images of the first and second halves. A long telephone connection with a journalist who watched the match acts as a live witness to the emotion experienced during the match. The rest of the broadcast is dedicated to other sports of interest to the capital city and bordering provinces: rugby or rhythmic gymnastics championships are talked about. This corresponds to the target set by the broadcast which, according to the speaker himself, is aimed at "athletes".

Basket Time

Basket Time is broadcast every Sunday at 21:30 It is a weekly magazine specialising in basketball and created by an independent producer in cooperation with Rete 7. The broadcast lasts for almost an hour and deals with the Italian basketball first and second division leagues, other minor leagues and international championships (Euroleague).

A specialised journalist presents the programme. He is accompanied by two or three guests (other journalists or players in local teams). After a review of the scores for the different matches and the classifications of the different leagues, attention is concentrated on local teams. A complete report about the matches is not given. Instead, there are just a few images (when a guest is talking, for example), because a repeat of one of the matches played on Sunday is put on at 22:30 on Monday.

To respect the majority tendencies of the Emilia-Romagna viewers, the guests are divided into two boxes: one for Virtus supporters and one for Fortitudo supporters (Bologna's two traditional rival teams). The corresponding flag appears behind each team's box in an attempt to simulate the atmosphere of a sports hall. Anyone in the audience can participate in the programme, and seats can be reserved by phoning a number that the speaker repeats several times throughout the broadcast.

The audience's role, both in the studio and at home, is a core feature. A novel characteristic of the programme is its clear desire to interact as much as possible with the viewer. The studio audience is directly encouraged to participate by the speaker, who asks for opinions about the best players, about the team's situation and about the future development of the championship. There is also a slot, *100 secondi*, which is offered by the sponsor of one of the teams, dedicated to questions posed by the studio audience. The goal is to unleash a mini-debate between live supporters and protagonists.

Another element of public involvement is the quiz about the history of Bologna's two basketball teams: twice in the course of the broadcast a couple of questions are asked for viewers to answer. Besides chatting with guests in the studio, the programme also has telephone connections with the stars of the matches played, videos about famous players and a slot for local teams of minor leagues, called *BasketBOL*.

Il Pallone nel 7

This sports programme is broadcast every Monday from 21:00 to 22:30 and is hosted by two speakers, a man and a woman. The studio is designed like a living room. In the background there is an outline of a crowd of supporters, as if they were in a stadium, waving scarves and flags.

On this occasion it is not a matter of informing the public about match scores, but about a time for comment and discussion. That's why the programme is devoted to discussing the situations and problems of Bologna's team with guests who intervene in the studio. Generally they are journalists, players or former players of the local team. The two speakers suggest discussion topics to the guests, who can refer to the latest game played, to the schemes adopted by the coach, to the players' performance, etc. At the beginning the speakers do an audience survey about a topic of interest for the team and, during the course of the broadcast, they report on its progress. Viewers are invited to express their opinions by phoning in. The final results of the survey are presented at the end of the programme.

In the studio debate, slots and videos produced by the newsroom are alternated: *L'opinione* (opinion about the Sunday game), *Rossi e blu* (the players' statements), *La tattica* (the team's tactics on the pitch), and interviews with the coach and players after the match.

A tamburo battente

This is a talk show which is broadcast at prime time on Fridays, from 21:00 to 22:00 approximately. It is a regional programme produced by Rete 7 made by an outside organisation which is based in Ravenna, one of Emilia-Romagna's provincial capitals. Regional figures from the world of politics, culture and showbusiness are involved in it. The programme's speaker suggests themes for conversation to them. There isn't any fixed topic for each programme. Instead, the guests talk about their work, their daily concerns, social or political problems. The guests' local origin is often underscored by the fact that many do not conceal their markedly different local accents and often use words and idioms that are typical of the dialect.

The studio audience can intervene to ask the guests questions and to express their own opinions about the topic in hand. Sometimes a member of the audience is asked to present his or her particular activity (exhibition organisation, civic activities...) or to tell his or her story. A band (Judy Testa Band) plays musical intervals before commercial breaks (every 15-20 minutes) and livens up the broadcast with musical numbers that the audience sometimes gets involved in.

Rete 7's annual balance is 5,400 million Liras, obtained from advertising revenue, studio presentations and sponsorship. Some of the main advertisers are businesses selling consumer goods in the regional territory, particularly the distribution network of consumption co-operatives, which

are very powerful and well-established in Emilia-Romagna. The main products advertised are foodstuffs, and home and clothes cleaning products. 50 per cent of the resources are absorbed by programme production, which covers 35 per cent of total programming. To be more specific, the "news programme" item accounts for 1,500 million Lira per annum and the "entertainment and talk show" item accounts for 1,200 million Lira. 30 per cent of the resources are used for bought-in programmes, which mainly include television fiction, documentaries and children's programmes. 20 per cent of the resources are used for infrastructure costs, technical production, broadcasting equipment and organisational costs.

6. Analysis of new problems and prospects

6.1. Financial viability

The financial situation of regional and local television stations in Italy is precarious in most cases, with little room for growth in the current situation of saturation, unequalled by any other European country. The first problem is posed by the excessive number of stations in relation to available resources. The regional and local advertising market is not very developed and, what's more, it is overly competitive. The reasons behind such little local advertising development are mainly the old-fashioned commercial distribution structure and a population which is too widely spread out over the territory.

Most shops in Italy are still family run, with an area of influence that hardly goes any further than the street or neighbourhood. They are, therefore, businesses with limited dimensions, without any financial capacity to sustain a strategy of expansion, with a minimal trading culture which stops them from considering advertising as a necessary investment to ensure fidelity among their current clientele and to expand it. In most trading activities, as well as in businesses that offer services (insurance, banking, the self-employed), it is found that the best means of promotion is at the point of sale, by taking special care over personal relations with customers. Actions aimed at reinforcing product recognition are placed in the hands of producers and promoters on a national scale through national advertising media. In addition, regarding services, Italy has only recently begun to come out of a static situation in which insurance, banking, etc, has never had to deal with problems of competition and, therefore, of promotion of the image of the activity itself.

Large distribution, supermarkets and hypermarkets are a recent phenomenon in comparison to other European countries. They are therefore not in a position, for the moment at least, to generate major advertising resources, and less so for television. Added to this is the fact that over half of all Italian families live in municipalities with populations

no higher than 30.000 inhabitants. This means that in most cases locating shops in the territory is a strong monopolistic factor benefiting the closest trader. Advertising broadcast on local television basically promotes goods that are only purchased now and again and justify a trip into a larger neighbouring town to look for better offers. So, local television stations often broadcast advertising for businesses selling furs, cars, clothes, and electrical appliances, among others.

The second element that limits advertising on local television is connected with a high degree of competition between stations and the fragmentation of audiences. On the one hand, the wide-ranging presence of stations experiencing marginal financial situations sinks advertising rates and the overall image that investors and the public get of local television (programmes which are announced but not broadcast or broadcast at another time, the staff's low professional level, poor signal quality, etc.). On the other, the power of national channels leaves a very small proportion of potential viewers for local television. In third place, the excessive number of stations and the fragmentation of the viewership on many channels means that audience measurement for local channels is impracticable because of the high cost. But without the necessary data about the quantity and quality of the audience, it is fairly difficult to maintain a stable, quality relationship with the advertisers.

So, local television stations are caught up in a vicious circle that they can only break out of by taking brave but essential decisions to substantially reduce the number of stations and allow between 10 and 20 per cent of the channels to become consolidated. These would be the ones that have already reached a business dimension that is sufficiently well consolidated to pay market prices for production factors and to invest in the development of structures and programming. Besides this option, there does not appear to be any other way of creating favourable conditions for the growth of total resources aimed at this sector in Italy. A proposal to fund local television with public resources or compulsory transfers from the national sector's resources to the local sector must be considered as being inappropriate and counterproductive, both socioculturally and financially.

Local television stations have a great deal of financial potential when compared to national television stations because they have a large potential viewership for programming inspired on local news and cultural aspects. The problem here is that it would be necessary to recognise that television activity cannot be a means of entertainment, a pastime or parasitic or marginal activity based on low salaries, the black market and obsolete equipment. The presence of a large number of local television businesses experiencing precarious or marginal situations confuses the market and creates difficulties for all of the sector's operators. The only way to readjust the relationship between local television and the necessary

resources to develop a financially viable business is to base it on entrepreneurial initiative, in a business directed by people capable of investing and managing the company in a dynamic way or by proposing a group interest service, the need for which is recognised by potential users by directly paying a fee.

6.2. Cultural synergies

The synergies between local television and civil and cultural institutions up to now have been somewhat limited. Among other things, this is because the number of stations is clearly much higher than the number of institutions potentially interested in activating such synergies. In addition, for reasons of balance, public institutions have difficulties working with some stations to the exclusion of others.

Some examples that we can give refer mainly to political institutions. In some cases, the city councils, provinces or regions strike up agreements with some stations which match some pre-defined conditions (territorial coverage, the ability to insert some specific products into the programming, etc) connected with the production and broadcasting of programmes about the institutions with the goal of informing citizens about their activities, initiatives or projects. A second example refers to stations that strike up agreements with trade union or professional organisations in order to publicise their activities and points of view. There are also cases of some stations establishing relationships with theatres, concert organisations, museums, etc., although relations are not systematic and are often connected with specific events.

6.3. Influence of new integrated communications networks

At the moment the development of new services connected with information highways is too limited to predict what the influence will be. The clearest and most widespread example is the use some local stations make of the Internet to interact with the public and to create ways of access and direct involvement in some specific programmes, as is the case for Rete 7.

In reality, the opportunities that are beginning to open up with the development of digital broadcasting technologies do not, for several reasons, appear to be likely to hold any particularly favourable prospects for local television stations. First of all, digital broadcasts that offer viewers some advantages from the point of view of image quantity and interactive services such as Web-TV will be developed via satellite, and we can expect even national over-the-air channels to progressively change from analogue to digital broadcasting. This means that viewers will gradually get used to the quality and services that the new standard offers, the cost of which can be easily offset by a large number of users. In other words, the changeover from analogue to digital in terms of production, broadcasting and new services represents a very high cost for the budgets of the huge majority of

local television stations and does not bring any substantial competitive advantage with it in comparison to national channels. It is true to say that no local or national television stations will be able to carry on producing and broadcasting using the analogue standard, but the cost-benefit ratio for local television stations will be clearly unfavourable.

The only opportunity that is open to them in this process of transition is to offer a series of new local services connected with local television programming, which could strengthen the attractiveness of local products, but this will require a lot of initiative, creativity and marketing ability, which currently appear to be completely lacking in almost all local television stations. So, there is a new gap to be filled that requires a great deal of investment capability for technological adaptation and an extensive revision of the organisational, operational and commercial structures of local television stations.

Bibliography and References

RAI (1997): *Annuario 1995-1996*. Milan: ERI.

Fossas, E. (1990): *Regions i sector cultural a Europa. Estudi comparat.* Barcelona: Institut d'Estudis Autonòmics.

Rizza, Nora (1997): *I TG regionali della Rai: contenuti formati produttivi; stili di comunicazione*. Rome: VQPT.

FRT (1997): *Studio economico del settore televisivo locale*. Rome.

Ufficio del Garante per la Radiodiffusione e l'Editoria (1996): *Relazione annuale al Parlamento per la radiodiffusione*. Rome.

Barca, F. and P. Novella (1997): *TV locali in Italia. Organizzacione e Programmi*. Rome: ERI.

Richeri, Giuseppe (1995): "Italy: regional television without regional vocation", in Moragas, Miquel de and Carmelo Garitaonandía: *Decentralization in the global era*. London: John Libbey.

Translation: Steve Norris

Notes

1 Act 249 of 31 July 1997, already considered them, as it provides for the existence of community or "non profit" making stations, stations that choose to restrict themselves to information and, finally, commercial stations in the local television system. Regarding the first of these three, they are stations promoted by foundations and associations to express particular social, cultural, political, ethnic or religious instances. This type of station cannot access financial resources from advertising. However, they are guaranteed a frequency reserve, a special taxation regimen and a simplification of administrative procedures. This was the first ever description of types which needs to be defined much more precisely.

2 In order to encourage the public to buy satellite antennas, the Act mentioned in the previous note considers the application of a lower VAT rate, thus bringing the price of them down by about 16 per cent.

3 Calculated on the basis of information provided by the Director of Testata Giornalistica Regionale, Nino Rizzo Nervo. We would like to thank him for his cooperation.

4 Here we are referring to the research commissioned by the Comitati Regionali per i Servizi Radiotelevisivi (Co.Re.Rat) in some regions (See table 5), which gathered information about the business structures, the technical systems adopted for broadcasting, and the editorial and programming choices of local television.

The Netherlands: Regional television comes of age

Nicholas W. Jankowski, Monique K.H. Schoorlemmer

1. Introduction

Regional television in the Netherlands has experienced major growth in the past few years, largely because of national government intervention during a period when efforts to initiate a far-reaching co-operative plan between national broadcasting Organizations and the regional stations terminated in stalemate. Rather than let public service broadcasting whither and probably extinguish at this level, the national government proposed a "deal which could not be refused", and since that moment nearly all provinces in the country have established regional stations. In addition, the private sector has also entered the arena and established a much smaller number of commercially-oriented stations. Perhaps the only remaining serious issue is whether the public service variant can maintain its own in the same "neighbourhood" as the commercial stations, or whether some form of cooperative venture may yet develop.

Regional television has become, within the short span of half a decade, an established and appreciated mode of broadcasting in the Netherlands.[1] Since distribution of the first regional television programmes in September 1992, the number of stations has exploded to a total of 14 situated around the country.[2] Most of the provinces in the Netherlands have a public service-oriented station, and some of these in the more populated provinces and metropolitan areas are, in part, commercially-funded. Although a point of saturation is approaching, further growth is still

expected regarding the establishment of public service regional stations in two provinces. New commercially-oriented stations are also anticipated, and this development constitutes the primary source of concern regarding the future character of this form of broadcasting in the country.

Regional television is a very recent phenomenon in the Netherlands and should be seen in the context of other small scale electronic media (at both the regional and local level) which have a much longer history. Regional television is, in fact, emerging from a rich heritage dominated until recently by experience with regional radio and with concern for the preservation of cultural and linguistic heritage. These themes are considered in the first section of this chapter, along with a brief overview of the Dutch electronic media system. The second section reviews the issues and statements related to formulation of government policy regarding regional broadcasting. Special attention is paid to initiatives designed to generate forms of cooperation between regional stations and those operating at the national and local levels.

In the third section, aspects of the organisation and structure of regional television are sketched, and an overview and profiles of stations are presented. The fourth section provides insight into both the nature of regional programming, and audience attention and appreciation of this material. The fifth and final section reflects on a number of the central developments, and addresses the most important problems and prospects for regional television in the Netherlands.

2. Electronic media in the Netherlands

The Netherlands, with its 41,000 square kilometres and 15-million-plus population, is one of the smallest and most densely populated countries in Europe. It is divided into 12 provinces, with quite diverse sizes and population densities. The provinces housing the cities of Rotterdam, The Hague and Amsterdam (Noord-Holland and Zuid-Holland) are the most populated and essentially constitute one continuous megalopolis. Provinces to the east and south, bordering Germany and Belgium, are the least populated (see Table 1).

It is also a country which has attracted a large number of immigrants, mainly from Morocco and Turkey; some 5 per cent of the total population is, in fact, non-Dutch (Brants & McQuail, 1997: 153). And, although Dutch is the primary language spoken throughout the country, a small minority in the north speaks and reads the second official language, Frisian which is spoken in only Friesland by a little more than half a million people. Dialects are much more common, and scores of dialects are in active use around the country.

Language and cultural diversity, then, are to a greater degree core characteristics of the Netherlands than some of the stereotypical images

commonly associated with this people and country may suggest. This diversity finds expression in a number of ways, including the structure of the electronic media. Because of constraints in space, no more than a superficial overview of the electronic media operating in the country is given in this chapter.[3] Emphasis is, understandably, placed on small scale media, particularly regional and local broadcasting.

The Netherlands is one of the richest countries in Europe with a Gross National Product (1996 figures) of Dfl. 663.8 bn. Compared to the average index for countries of the European Union the Netherlands scored 114.6 and the EU countries 108.7 (figures for 1990 are indexed at 100). On the same index, scores for Japan and the United States are, respectively, 1,016.7 and 112.

The communication infrastructure in the country is well developed. Telephone connections have reached the point of saturation with essentially everyone (96 per cent) having household access. There are 8 national and some 45 regional newspapers in the country. Taken as a whole, some 74 newspapers are distributed for every 100 households, and readers spend approximately 2 hours per week reading newspapers. The availability of magazines in the country is substantially greater than that of newspapers. Some 8,000 Dutch language magazine titles have niche markets covering virtually every interest group. Dutch book publisher release some 7,000 new titles per year with ratio of 60/40 for fiction/non-fiction (see further Bakker & Scholten, 1998).

Table 1. Dutch population statistics

Province	Population	%	pop /km²
Groningen	558,100	3.6	238
Friesland	615,000	4.0	183
Drenthe	460,800	3.0	174
Overijssel	1,057,900	6.8	317
Flevoland	281,000	1.8	198
Gelderland	1,886,100	12.1	378
Utrecht	1,079,400	6.9	795
Noord-Holland	2,474,800	15.9	931
Zuid-Holland	3,344,700	21.5	1,167
Zeeland	368,400	2.4	206
Noord-Brabant	2,304,100	14.8	467
Limburg	1,136,200	7.3	524
Total	**15,567,100**	**100**	**459**

Source: CBS (1998: 54)

2.1.National level

Foreign observers (eg Emery, 1969; Smith, 1976) have often been struck by the diversity of groups which are allowed to produce programming for the national radio and television channels. The electronic media in the Netherlands have, in fact, been noted for their openness and allegiance to the principle of access. To begin with the matter of openness, a total of 31 national Organizations are licenced to broadcast programming in the Netherlands: political parties, religious and educational organizations... More than 90 per cent of broadcasting time on the five radio and three television channels public, however, is taken up by eight broadcasting associations and the Netherlands Broadcasting Corporation (NOS).

Most of these associations have roots which can be traced back to the early days of radio when religious and social groups founded five broadcasting associations in order to reach their respective followings. By the late 1960s this so-called "pillar system" had been opened up to allow other broadcasting associations which did not have such grounding in religious or ideological currents, so that the electronic media adequately reflected the cultural, political and social diversity evident in the country.

Although the legislation resulting in the Broadcasting Act of 1967 was intended to promote such openness and diversity in the electronic media, the policies of the new broadcasting associations tended to increase the predominance of entertainment-driven programming. Some of the entrants to the group of broadcasting associations emphasised amusement programming in spite of regulations specifying a mixture of entertainment, culture, information and education.

The most sweeping disruption to the public service broadcasting system, however, came from outside the system. In 1989 a commercial television station based in Luxembourg began transmitting programming via satellite to Dutch cable systems. This station, RTL4, with programming in the Dutch language, aimed at Dutch viewers and largely produced by Dutch production companies, was an immediate success. Its formula of soaps, and game and talk shows presented by popular Dutch hosts had captured nearly a third of the viewing market by the early 1990s. In 1993 a second commercial channel, RTL5, was launched by the same consortium. This last commercial initiative has not acquired the initially anticipated audience share and various plans have been presented to revamp the programming formula and even to disband the station. Further, the European Commission recently ruled that this station must limit its programming to news and weather information in order to curb formation of a media monopoly.

All programming from the nationally-oriented public service electronic media is distributed via seven over-the-air transmitters located in such a manner that the signals can be received anywhere in the country. In addition to ether transmission, programming is also distributed via the

extensive cable television systems in the country. As compared to other countries, the Netherlands has one of the highest percentages of household connections to cable systems. Nation-wide, more than 85 per cent of the households are "on the cable"; in Amsterdam, close to 95 per cent of the residents are connected to the cable.

Cable, then, provides an important secondary distribution system for national radio and television programming; a "must carry" regulation ensures availability of national, regional and local public service programming to viewers and listeners who rely entirely on the cable for reception. The cable is also the primary mode of reception for satellite-delivered programming. Some 25 to 30 television channels are available on a typical cable system, and anywhere between 10 and 20 satellite-delivered television programmes are relayed to subscribers. The remaining capacity of the cable is used for distribution of thematic music radio channels (national and satellite), programming of local origination, and various subscription channels.

National public broadcasting is financed primarily from a licence fee levied on owners of radio and television sets. Advertising accounts for a little more than a third of the broadcasting revenue, and membership dues to the broadcasting Organizations constitutes a small percentage of the total (generally enough to cover organisational overhead and publication of programme listings). The appearance of RTL4 resulted in competition between the public service broadcasting Organizations and this commercial station for advertising revenue. Development of programming strategies designed to hold the audience has since become a central concern of the national broadcasting Organizations.

Of lesser concern is attention to development of additional cable-delivered services such as teletext, videotext, cable newspapers, pay television, interactive television, and Internet-based services. About 55 per cent of the television sets are equipped to receive teletext, and viewer attention amounts to about 10 minutes per day.

So-called cable newspapers (textual services illustrated with graphics and non-moving pictures) were introduced in 1984 to provide newspaper publishers with access to the electronic media. Some 60-plus cable newspapers operate on cable systems and can be seen by about 70 per cent of the country's population. Of those persons able to receive cable text programming, about a fifth on average actually use it.

Interest in interactive cable-delivered services has been present since the early 1980s, and several small scale experiments have been held (see eg Stappers, Jankowski & Olderaan, 1989), often with substantial governmental funding. These efforts generally failed to produce commercially viable services and interest waned. National broadcasting Organizations remain concerned as to how best to incorporate the "new

media" into their domain of activity (see eg Van Stavoren, 1997), but most follow a conservative, defensive strategy. Concern for Internet-based services (from electronic information depots to channel for programme distribution) is evident at all levels of broadcasting.

2.2. Regional level*

Public regional radio stations have been operational in the Netherlands since the end of World War II. In 1945 two stations were established to provide radio service to outlying regions of the country (to the south in the province of Limburg, and to the north and east in the provinces of Groningen, Friesland and Drenthe). These stations were established to both support cultural life in these areas, and to assist in integrating these economically poor and politically isolated regions into the national "fabric".

From these modest beginnings the number of regional radio stations slowly expanded to the present 13; their service areas roughly corresponding to the 12 provincial divisions of the country (One province, Zuid Holland, containing the metropolitan regions of The Hague and Rotterdam, have two regional stations). This regional-provincial criteria for determination of the station service area has been a point of dispute for nearly two decades. The ROOS, the coordinating organisation of the regional stations, argued in 1980 for gradual development of a network of 23 stations. This plan was declared financially impracticable, however. In its place, "editions", programming targeted at smaller geographic areas within the provinces, developed. Presently, the 13 regional radio stations collectively produce 22 editions of regional radio programming, with emphasis on news broadcast during peak listening periods.

The 13 regional radio stations are primarily involved in ether transmission of radio programming. Produced from a professional journalistic approach, the radio programming generally tends to emphasise events within the respective broadcasting region of each station. News and information, music, cultural and social activities dominate the programming formula. Much of the programming is also service-oriented toward promotion of activities such as sporting, cultural and tourist events. Governmental regulation requires that at least 50 per cent of the programming be informational, cultural and educational in nature, and that at least 50 per cent of the programming be related to residents in the region or province in which the station operates.

Regional stations are financed through a portion of the licence fee collected from households with radio and television receivers. Together with a contribution from the national government, the funds are distributed among the 13 regional radio stations. At least NLG 4.5 million was available for each station in 1997. This funding can, since 1992, be supplemented by advertising revenue. At the present time, most regional

radio stations secure, in this manner, about 40 per cent of their operating budget from advertising revenue.

The funding made available was originally based on three hours programming per day, and most stations in the early years limited transmission periods to peak listening times during the day. Since enactment of the Media Law in 1988, however, stations increased the number of programming hours to the current average of 15 per day. Some stations exceed this average considerably and transmit 24 hours a day.

The regional radio stations are pleased with the attention listeners in most provinces pay to the programming. Listening figures in the first years of the 1990s increased substantially. Considering the average of all 13 stations, the market share for regional stations was just under 25 per cent of the population per week in 1997. Since 1992, the market share of regional stations has surpassed that held by two of the national radio stations (the news-oriented station Radio 1, together with the information and light music channel Radio 2). The regional stations with the strongest cultural identity tend to command the largest share of the listenership within their respective markets. In regions where popular music commercial stations have been developed, regional station listenership figures are generally lower. Nevertheless, audience statistics support the proposition that regional stations are serious competitors for national stations and the radio market generally in the country.

As mentioned, regional broadcasting has been synonymous with regional radio until the last few years. The first regional television programming commenced in 1992, and by the end of 1998, 14 stations were providing a number of hours of television programming on a daily basis, distributed mainly by cable but also in some cases over-the-air. The rationale initially given for this venture is that television has come to be the primary source of international and national news for most people. It is believed regional television could fulfil that same role for news and information at the provincial level. Another prominent reason for this development had to do with national government concern to preserve facets of public service broadcasting during an era of increasing commercial dominance of the electronic media. This development and rationale are elaborated in more detail later in this chapter.

2.3. Local level

Although a national experiment was held with cable-delivered local radio and television programming in the mid-1970s, it was not until 1984 that government regulation permitted further development of local stations.[5] In the past 10 year period the number of such stations has grown almost exponentially: from the six experimental stations in the late 1970s to 355 stations in 1997. They are situated in almost 500 municipalities around the country, from major cities to rural towns and villages. The less populated

provinces, as would be expected, have fewer stations than provinces with a large degree of urban development. Given the number of stations and municipalities served, however, more than 95 per cent of the country's population can receive local programming.

Unlike the experimental stations which were primarily producing television programming, the present local stations are mainly involved in radio production. Since 1988 stations have been able to legally acquire low power transmitters for over-the-air programme distribution. Almost all of the stations now distribute programming both over-the-air and via the cable.

Most stations distribute less than 40 hours of radio programming per week, although about 40 stations are "on the cable" more than 100 hours a week. Only a few stations provide programming around the clock, and these stations tend to make use of specially packaged programming. The majority of the other local stations have an agreement with the regional stations in their area whereby some of their programmes are retransmitted as a "window" in the regional station programming block.

About a third of all the local stations produce television programming, usually cablecast on a weekly or monthly basis. Only a handful of stations, situated in major cities in the country, have daily television programming. This reversal in programming accent, from television during the experimental period in the 1970s to radio in the 1980s and 1990s, is largely a consequence of limited funding: radio production is less expensive than that of television. Another aspect reflecting limited funding is that most stations are staffed by volunteers. About a fourth of the stations have one or more paid personnel in service, usually responsible for programme coordination and technical support. In total, some 500 persons were employed by local stations in 1997. The local stations are financed primarily through subsidies granted by their respective local governments: municipalities can levy up to NLG 2 per cable subscribing household per year to fund local public service stations. Since 1992, advertising is permissible and this source of financing compensates, to a degree, the public funds. Finally, commercial local stations are now allowed to operate, and a number of the present public service stations are considering this organisational alternative.

3. Media policy for the regional level

During the 1960s several ministerial white papers and drafts for legislation were produced in preparation of a new broadcasting law, finally enacted in 1967. Regional broadcasting occupied a minor, but explicit place in several of these documents. Initially, regional broadcasting was defined as a service intended for residents in outlying regions or provinces of the country. By 1966, this definition had been extended to include cities, and referred to both radio and television. Regional broadcasting slowly came to

be seen, then, not merely as a medium for promotion of folk culture in rural and provincial areas, but also as a service for urban residents.

One of the critical issues during this period was which organisational entity was to be responsible for the regional stations: the Netherlands Broadcasting Corporation (NOS) or the regional stations themselves. Both organisational forms were included in the Broadcasting Law of 1967. This situation remained intact until 1989 when NOS responsibility for regional broadcasting was formally terminated.

Whatever their organisational form, however, regional stations were intended to fulfil a public service as opposed to a commercial objective. Even with this restriction there was much interest in launching regional stations in the early 1970s. In order to determine how policy should develop the government initiated a regional radio experiment in 1976.[6] Two stations were involved in this experiment: Radio STAD, in Amsterdam, and SROB, in the province Noord-Brabant. This experiment with over-the-air regional programming eventually contributed to approval of other regional initiatives. By 1990 the present 13 regional radio stations were in operation.

In addition to the organisational form, station objectives occupied a central place in political debates on media policy. During the mid-1970s the government minister responsible for broadcasting suggested that local and regional broadcasting should be cast in the framework of community welfare and development. The stations, however, argued for a more journalistic objective: providing news and information to the metropolitan regions and provinces which they served. One of the underlying reasons the government wished to see regional broadcasting as an instrument for community development was because the stations would then fall under welfare services, and the funding for such services was being transferred, as part of a general decentralisation trend, from the national level to the regional and local levels. With assignment of such a welfare function the national government could absolve itself from further funding of the stations.

This national government strategy eventually failed, and by the late 1970s the Ministry of Culture had come to recognise regional radio stations as more than instruments of community welfare. And, in order that the journalistic function of providing independent news and information could be fulfilled with some independence of regional government, an "organisational buffer" to which the stations are accountable was established.

By 1988, regional broadcasting had come of age, in terms of acceptance in policy statements. In the Media Law enacted that year a description and prescription of regional and local broadcasting is provided. Regarding regional stations, they are, in the first place, to produce programming intended primarily for the province or a portion of that geographic area.

Secondly, the programming is to be relevant and related to social, cultural and religious life in the province. Finally, the programming in its entirety is to serve the general interest of the province or section thereof. Although tones of community welfare and development are clearly present in these formulations, regional broadcasting had, by the time of the enactment of the Media Law, been accepted as a professional journalistic enterprise.

Given the historical reservation regarding advertising in electronic media generally in the Netherlands, it is not surprisingly that this aspect is also highly regulated for regional broadcasting. In the first years of experimental operation, it was prohibited entirely. Since 1991, however, advertising is allowed, providing stations adhere to regulations which are also applicable to the national public service broadcasting stations. First, the amount of advertising must not exceed 6.5 per cent of the total time allotted for programming; second, a maximum of 12 minutes per hour can be devoted to such commercial messages; and third, programmes may not be interrupted with ads unless there is a "natural division" in the programmes (eg intermission in a sporting event or drama production). And, in order to ensure that pluriformity in the overall regional media landscape would not be disturbed by advertising on regional television, it was required that the regional newspaper publishers be allowed to participate in a commission to determine advertising policy for regional electronic media. This last requirement, which understandably resulted in substantial conflicts between publishers and stations, was discarded in 1996 when publishers were permitted to own and operate electronic media.

As for programming, the Media Law stipulates that 50 per cent of both regional radio and television programming must be informational, cultural and/or educational in nature. Further, stations may not transmit outside the geographical region for which they have authorisation. Strictly speaking regional television stations may not broadcast programming during the prime-time viewing period 19:00 to 23:00, without approval from the national television Organizations. In practice, however, no objections are made and the regional television stations can transmit any period of the 24-hour day.

As of 1993 regional television stations were allowed to transmit programming via the ether in addition to cable distribution. Although this extension in transmission opportunities has advantages, there is also a major difficulty. In some provinces it is difficult to achieve full territorial coverage with ether transmission, in part because of the prohibitive expense in constructing additional relay transmitters and antenna towers. For this reason, only seven regional television stations have invested in antennas for ether transmission and, as of 1997, no serious plans have been made for expansion of this option.

Regional broadcasting stations could consider distribution of television programming once the Commissariat for the Media approved the formal

request. One of the conditions for approval was that the provincial government would provide financial guarantees for the operation. And, until 1996, it was also necessary to achieve arrangements with newspaper publishers operating in the region regarding exploitation of the advertising. Since that year, however, print publishers have been able to become involved in locally and regionally-oriented electronic media, and several major publishing houses now own shares in regional television initiatives. For example, the publisher VNU and the newspaper *De Telegraaf* launched TV8 in the southern provinces of Noord-Brabant and Limburg in 1997, and other publishers are involved in the operation of a so-called "public-private" station in the metropolitan areas of Rotterdam, The Hague and Amsterdam.

Although regional and local broadcasting are indeed anchored in the Media Law, it has taken years of debate and lobbying to secure that anchorage. In the first half of 1993 the Ministry of Culture, which was then responsible for broadcasting policy, issued a document which strongly questioned the viability of three levels of broadcasting (national, regional, and local) in a country the size of the Netherlands. The Minister proposed dissolving the level of local stations and encouraging mergers between local and regional stations in situations where feasible. The remaining local stations, generally found in small communities, would be degraded to occasional social and cultural "happenings" on the cable. Several reasons were elaborated for this fusion, but one dominant consideration was the need to secure frequencies for commercial stations to operate at the local or regional level, to conform with European Union media regulations.

This particular threat was politically dismantled, and the three levels of broadcasting now have adequate support in both the regulatory and political spheres to curb any similar future action. Still, the topic of cooperation between levels of broadcasting has remained very much on the agenda. One of the more intensive efforts at developing a form of cooperation between the national and regional stations involved extended development of a "window" in the national programming schedule which could be filled by regional stations. In 1993 discussions began between the NOS and the regional broadcasting organ ROOS regarding possibilities for combining the strengths of national and regional broadcasting. A proposal was launched whereby a so-called "window" on one of the national channels would be filled by regional television stations, and the programming in that "window" would be transmitted to the viewers in the respective provinces of the regional stations.

The regional governments were invited to consider the plan and, in particular, provide part of the required funding for this initiative. Although all provincial governments saw value in a national network of regional television stations which would make use of the national television infrastructure, there was less unanimity regarding how that network

should be financed. Some of the provincial governments were particularly hesitant to levy an additional fee or tax for this project.

In spite of such complications, a business plan was developed and presented to the responsible national ministry in early 1996. By the end of that year the first provincially-oriented television stations were to be operational in this national broadcasting "window" for regional television. The initial idea was to produce a 45-minute regional news programme which would be broadcast before the evening national news programme. This plan was also linked to arrangements whereby other programming could be distributed by cable, for which both cable companies and newspaper publishers could be involved.

Despite extensive preparation, the plan ultimately met with opposition from the Netherlands Broadcasting Corporation (NOS). The NOS, after reassessing its financial position, did not feel it could participate to the degree originally agreed. Two of the 13 provinces were also unwilling to generate new funds or reallocate existing resources for this regional television plan. In August 1996 the national government came to the conclusion that this plan for cooperation failed to meet the basic criteria for its support.

This impasse provided opportunity for the State Secretary responsible for media policy to propose a matching funds construction whereby the money generated by provincial governments would be matched on a "50/50" basis from the national government. An important condition for receiving matching funds was far-reaching cooperation between the regional and national public service stations in the areas of programming and recruitment of advertising. Yet another condition was enforcement of a strict division between the radio and television divisions of the regional stations. Finally, the provincial governments would be allowed to levy an additional fee to a maximum of NLG 10 over and above the already existing fee collected at the provincial level for regional broadcasting.

This national government proposal saved, in fact, regional public service television from being reduced to a insignificant position in an arena increasingly being confiscated by commercially-driven players. Liberalisation of the Media Law was designed to allow commercial broadcasting, and by September 1996 the first regional television station was launched by a publishing concern in the southern provinces of Limburg and Noord-Brabant. It was in this domain, then, that the two conflicting national policies found expression: support and protection of public service broadcasting and, at the same time, liberalisation of media policy to allow involvement by commercially-driven players.

The immediate result of this policy development was a literal explosion of plans to establish regional television stations in the provinces. This development, combined with so-called public/private and strictly

commercial initiatives, has resulted in 14 regional television stations in operation by 1997. Further growth is anticipated by the commercially-driven stations, and the viability of this expansion is considered in the following sections of the chapter.

4. Organisation and structure of regional stations

The 14 regional television stations in operation as of 1997 can be categorised according to public service task and mode of financing. Here, regional stations are distinguished as public, public-private and commercial Organizations. Table 1 provides an overview regarding organisational structural, starting date, and form of signal distribution. Table 2 indicates the various sources of financial support stations receive. Extended profiles are also sketched for two stations, Omrop Fryslân and TV Oost, both of which illustrate particular features of the public service type regional television station.

Regional stations are legally required to restrict area of coverage to the province (or municipality in the case of local stations) covered in the licence of operation. The exceptions to this restriction concern cable-delivered signals on cable systems which cross municipal boundaries. More fundamentally, Omrop Fryslân recently gained approval to broadcast outside the province because of the fact Friesian is the second official language in the country.

The majority of regional television stations in the Netherlands can be considered public service stations, meaning that they broadcast under a public service licence and are financed from public funds. The public service stations are: TV Noord, TV Drenthe, Omrop Fryslân TV, TV Oost, TV Gelderland, Omroep Flevoland TV, TV Zeeland, TV Brabant en TV Limburg. All of these stations have their origins in already established regional radio Organizations. Because of their public status these station must abide by government regulations regarding content of programming whereby at least 50 per cent must contain informational, cultural and educational elements. At least 50 per cent of the programmes must relate to topics in some way relevant to the broadcasting region. Although a strict division of financing of the radio and television divisions is mandated by the government, many regional broadcasting Organizations are developing extensive forms of cooperation, if not integration, of the radio and television divisions. Finally, the amount of advertising is restricted inasmuch as these stations are financed from public funds.

There are three public-private stations in the country (AT5, TV West and TV Rijnmond) which broadcast under a public service licence and therefore must abide by the public service broadcasting regulations mentioned above. The main part of the financial resources for these stations, however, does not come from public funds, but primarily from private resources. Moreover, the commercial partners active in these

stations are not allowed to influence programming content; a strict division exists between the programming department and the rest of the organisation. There is little to no evidence of cooperative undertakings between these public-private stations and the regional radio stations which formally hold the government broadcasting licences.

To complete the typology of station types, commercial stations are not bound by specific governmental regulations regarding programming content or advertising. These stations are funded by commercial Organizations such as publishers and cable companies.

Most of the stations have a very short history with a formal starting date in 1997 (see Table 2). At the same time, these stations have built on broadcasting expertise developed over decades of experience with regional radio and, in some cases, through previous experimentation with regional television. The recent growth in stations is largely accounted for by changes in regulations regarding governmental support, outlined in the previous section. The majority of the stations were launched just after the protracted discussions regarding a "national window" for regional television were abandoned. Then, matching funds were requested (and in most cases secured) from the provincial governments. In two cases where the provincial governments expressed reluctance to provide this funding the regional radio stations reached agreement with publishers and cable television companies to establish so-called "public-private" regional television stations.

Stations in other provinces also sought alliances with private companies, but in most cases the negotiations did not result in the "private-public" organisational structure. In two provinces, however, the governments unsuccessfully urged the public initiatives to reach a form of cooperative arrangement with the already operating commercial regional television stations. The current, less-than-satisfactory arrangement involves the two stations sharing a single cable channel on which their programming is separated by an hour without any programming whatsoever. In two other provinces where the regional government required extensive co-operation between the public broadcasters and private initiatives, no agreement could be reached. Regional television in these two provinces, Utrecht and North Holland, has as a consequence not been established.

The central player behind these commercial stations is the VNU, a major publisher in the Netherlands which has been involved in various electronic media ventures in past years, became quite interested in development of regional television stations once government regulations allowed such as of early 1997. One of the strategic considerations of this publisher was to establish stations quickly so as to diffuse competition, and to link the programming in order to generate a potential viewership attractive to advertisers. In September 1997 VNU launched the stations TV8 in the provinces of Brabant and Limburg.

Other publishers attempted to establish regional stations, but found the costs prohibitive. A few publishers did succeed in producing brief, five-minute news bulletins and cable text programmes incorporating moving images. There are also a few initiatives aimed at producing longer news programmes which do not include cable text. Various commercial players are seriously considering following these initiatives, but because they do not involve complete programming schedules they are not dealt with in further detail here.

Table 2. Regional TV stations in The Netherlands

Station	Starting date	Initiating body	Type of station
Omrop Fryslân TV	Feb. 1994	Omrop Fryslân	public service (cable & ether)
TV Noord	April 1995	Radio Noord	public service (cable & ether)
TV Drenthe	April 1995	Radio Drenthe	public service (cable & ether)
TV Oost	Sept. 1992	Radio Oost	public service (cable & ether*)
TV Gelderland	Nov. 1996	Omroep Gelderland	public service (cable & ether*)
Omroep Flevoland TV	Oct. 1997	Omroep Flevoland	public service (cable & ether)
Omroep Zeeland TV	Oct. 1997	Omroep Zeeland	public service (cable & ether)
Omroep Brabant TV	Sept. 1997	Omroep Brabant	public service (cable)
Omroep Limburg TV	Sept. 1997	Omroep Limburg	public service (cable)
AT5	Sept. 1992	SALTO, PCM publishers	public/private (cable)
TV West	Nov. 1996	Radio West, Casema, PCM	public/private (cable)
TV Rijnmond	Feb. 1997	Radio Rijnmond, PCM publishers, Eneco	public/private (cable)
TV 8 Brabant	Sept. 1996	VNU	commercial (cable)
TV 8 Limburg	Jan. 1997	VNU, Mega Limburg, Telegraaf	commercial (cable)

*scheduled to commence in 1999 with distribution of programming both via the ether and by cable

Table 2 shows the list of regional TV stations including the starting date, the initiating body and the kind of station (public service/private, plus broadcasting system). There are five stations transmitting both via cable and ether (TV Noord, TV Drenthe, Omrop Fryslân, Omroep Flevolant, Omroep Zeeland, to which RTV Oost y Omroep Gelderland plan to join in 1999), while five do only cable broadcasts (AT5, TV West, TV Rijnmond, TV Brabant and TV Limburg). None of these stations broadcast only via ether.

Table 3 provides an overview of the sources of funding available for the regional stations. Public stations receive income from the licence fee for regional television and from advertising and sponsorship, according to the established regulations for these activities. The funds which Amsterdam, The Hague and Rotterdam have allocated to their respective stations are not matched by national funding inasmuch as provincial support is not involved. This exception to the usual funding construction can be partially explained by the historically grounded position of local and regional electronic media in these municipalities.

The public-private stations were initially financed to a large degree by private parties, although the city governments in Rotterdam and Amsterdam also contributed to the budgets of their respective stations. In the first years these two cities financially supported the local stations (Stads TV Rotterdam and SALTO in Amsterdam) from which the regional stations later emerged, TV Rijnmond for Rotterdam, and AT5, for Amsterdam. This exceptional situation can be understood from the historically grounded position taken in these cities regarding the wider metropolitan function it was believed electronic media could fulfil. Since 1998 the provincial government of South Holland has also decided to financially support the regional television stations TV West and TV Rijnmond. Since 1998 the provincial government of South Holland has also decided to financially support the regional television stations TV West and TV Rijnmond.

Commercial stations are funded by the publishers who established the stations, along with modest funding derived from advertising and programming sponsorship. Given the limitations of the regionally-based advertising market, these commercial stations are operating at a financial loss. It is anticipated that this situation will only change should a network of stations be developed which can offer prospective advertisers a larger viewer market.

Compared to stations in other European countries, stations in the Netherlands have relatively limited financial resources at their disposal. Nevertheless, these stations generally succeed in producing high quality programmes, although feature-length documentaries and on-site productions are understandably beyond the budgetary means of regional stations.

4.1. Forms of co-operation

The public and private/public stations strive to co-operate as much as possible, without losing their respective regional identities. Co-operative arrangements involve exchange of programme material, co-production of cultural events, and acquiring broadcasting rights for sporting events. These undertakings are frequently coordinated through the regional broadcasting foundation ROOS.[7]

The public service regional stations also cooperate with other public service stations at the local and national levels. Regarding the national level, cooperation with the NOS mainly consists of broadcasting the daily news programmes, exchanging news items, and benefiting from the respective expertise of stations at each level. Some regional stations exchange programming material with local stations and organise training courses for the volunteer staff of these stations.

At yet another level, the regional stations cooperate with Radio Netherlands World Service which produces a weekly programme,

containing an overview of news and background information from all of the public service regional stations. This programme is broadcast by satellite to the rest of Europe. Most of the regional stations also include this programme in their weekend programming schedules.

Table 3. Financial Sources for Regional Television Stations (NLG)

Station	Provincial	Provincial licence fee*	Matching gov.nat.	Local gov.*	Other gov.	Advertising sources income
Omrop Fryslân TV	10	—	10	—	—	yes
TV Noord	10	—	10	—	—	yes
TV Drenthe	10	—	10	—	—	yes
TV Oost	10	—	10	—	—	yes
TV Gelderland	6.90	—	6.90	—	—	yes
Omroep Flevoland TV	10	—	10	—	—	yes
Omroep Zeeland TV	10	—	10	—	—	yes
Omroep Brabant TV**	—	4 mln	4 mln	—	—	no
Omroep Limburg TV	6.75	—	6.75	—	—	no
AT5	—	—	—	2.5 mln	PCM	yes
TV West	—	—	0.6mln	1.2 mln	Casema, PCM, Wegener	yes
TV Rijnmond	—	—	—	1.2 mln	PCM, Eneco	yes
TV 8 Brabant	—				VNU	yes
TV 8 Limburg	—				VNU	yes

* Per household per year.

** The province of Brabant has chosen not to levy its citizens, but to finance the station with some NLG 4 mln from other provincial funds. The national government matches this amount, for a total of NLG 8 mln.

The Dutch regional stations seldom collaborate with sister stations in neighbouring countries. There has been consideration of exchanging experiences with foreign stations, but only Omrop Fryslân has engaged in regular exchanges, and then only with foreign stations operating in areas with a strong minority language.

4.2. Programming distribution and characteristics

Regional Television programming is distributed by both cable and over-the-air transmission. In 1993 over-the-air transmission was made legally possible. Because of the high costs involved in constructing transmission towers, however, not all stations have been able to take advantage of this change in regulations. To date, only seven stations have invested in the equipment to transmit via the ether. Given the "must carry" regulation in operation for cable companies, however, most households can receive regional television programming in the country.

Although there is a large range in the time duration of the original programming among stations, the core content of nearly all regional television programmes is identical: emphasis on regional news and background information, complemented by programming dealing with sports, cultural events, politics, economics and the province itself. Public service regional television stations are not permitted to broadcast solely entertainment programming because their programming schedule is intended to complement that of the national public service broadcasting stations. The commercial stations, in contrast, devote a considerable portion of their programming time to such fare. As for self-produced fiction, there is very little experience and no particular plans in that direction, largely because regional programming is intended to compliment that already provide at the national level, and fictional programming at the national level is substantial.

Programming in the weekend differs substantially from that broadcast during the rest of the week. Then, many stations provide overview programmes of regional news. Programming related to sporting events is particularly important in the weekend schedule of regional stations. In some cases, however, there are stations which only transmit cable text during the weekend.

Throughout the week, general policy is to repeat blocks of programming at other time slots. Although the majority of stations still include the national evening news programme in their scheduling, the present trend is to cease with this re-broadcast. Most stations also broadcast cable text when their own programming is not being transmitted.

Viewer use and appreciation of this programming has not been, until quite recently (June 1998), subject to reliable audience research. The initial survey findings, however, suggest the public regional stations reach a weekly average of 40 per cent of the possible viewers in their respective geographic service areas. The regional news programmes generally receive the highest audience appreciation ratings.

4.3. Profile of two regional stations

4.3.1. Omrop Fryslân

This station is one of the oldest regional stations operating in the Netherlands, dating from just after World War II when radio station RON (Regionale Omroep Noord) was established. Then, RON provided regional radio broadcasts for the northern provinces of Friesland, Groningen and Drenthe. During the 1950s a specific programme was developed for Frisian speaking listeners. The rationale for this move was that the Frisian language had acquired the status of second national language in the Netherlands and, as such, merited access to the electronic media.[8] Total broadcasting time in that period was no more than a few hours per week, and cultural events, documentaries, and drama productions dominated the programming formula.

In 1968 a studio was constructed in Leeuwarden, the capital of the Frisian province, and a decade later a separate broadcasting organisation for the province had been created. With these developments, the number of programming hours also increased over the years, and by 1992 radio programming was being broadcast an average of 11 hours daily.

Omrop Fryslân has been involved in the production of television programming since 1979 when the station was allocated time from the Netherlands Broadcasting Corporation (NOS) for production of televised instructional materials. The primary reason Omrop Fryslân, along with the provincial government and political parties active in the province, pressed for access to the national television channel in the late 1970s was to strengthen ties of residents with Frisian language and culture.[9] Then, it was only possible to produce Frisian television programmes via the national network; co-operation with the NOS, in other words, was the only option available at the time. Agreement was reached with the NOS after experimentation with a so-called "teleboard", initiated in 1973. With assistance from a special pen and electronic tablet, drawings and messages could be transmitted through the ether to television receivers. This equipment was used to supplement Frisian language lessons in schools around the province.

By the end of the 1970s this "teleboard" equipment was replaced with television equipment and, from 1979, Omrop Fryslân received an annual allotment of transmission hours from the NOS. About a third of the allotted time was devoted to programming intended to supplement classroom instruction. The remainder of the programming time is used for general informational programming (documentaries, discussions, and current events). Virtually all of the programming was broadcast in the Frisian language, as was also customary on radio. Since 1992, however, subtitles have been provided in order to make the television programming accessible to viewers who do not understand spoken Frisian.[10]

For several years Omrop Fryslân has wanted to increase the number of broadcast hours allotted by the NOS, but requests were denied. The station then decided to develop its own regional television. And since early 1994 Omrop Fryslân has also been producing television independent of the arrangement with the NOS. Programming is distributed via the cable systems in the province and transmitted over-the-air. The "regional division" began with funding from a special national government subsidy programme for economically depressed regions, from the province of Friesland, and from the European Union. These funds were intended to assist development of this division of the station during a three year experimental period. In addition, advertising and programme sponsorship further supported the regional television division.

In this manner Omrop Fryslân has two television divisions within the same organisation: a regional division and a national one. There is a strict division as far as financing and programming are concerned. Since 1997

the regional division is financed from the provincial licence fee for regional television and from advertising. The national division is entirely financed by the NOS and has much more funding available for programme development than the regional division.

The programmes – mainly documentaries – of the national division of Omrop Fryslân are broadcast on one of the national channels on Sunday morning and last 30 minutes. The educational programmes last 20 minutes and are broadcast twice a week. The documentary is repeated on the regional channel on Tuesday evenings.

The regional programmes are broadcast on weekdays from 18:55 to 20:00, and the programming schedule[11] is as shown below:

 18:55 - 19:00 children's programme
 19:00 - 19:15 regional news
 19:15 - 19:30 informational programme
 19:30 - 20:00 Monday: sports
 Tuesday: documentary
 Wednesday: informational programme
 Thursday: human interest
 Friday: culture
 Saturday: summary of the week

This hour-long block, is repeated (with the exception of the children's programme) three times during the evening, beginning at 20:00, 21:00 and 22:00. During the evening the regional news (15 minutes) is repeated on the hour. And during time slots between programmes a cable text service is transmitted. At 9:00 the following day the entire block is once again repeated. Thereafter, the cable text service is transmitted.

The national and regional divisions are separated within the station, but do cooperate when appropriate. Co-operative arrangements are made, for example, regarding use of production facilities and performance of some editorial tasks. But given the strict separation between the two divisions, fees are paid from one division to the other for services rendered.

4.3.2. TV Oost

Interest in establishing regional television in the province of Overijssel can be traced to discussions held in the late 1980s. Then, Radio Oost was becoming increasingly concerned about competition from commercial stations. Two strategies were proposed, intended to counteract this encroachment. First, it was deemed important to increase the amount of the station's own radio programming. Second, it was proposed to explore initiation of regional television. Such a development could provide not only a new television service for the region, but also increase public awareness and use of Radio Oost programming through both announcements and programmatic linkage between the two media.

Another concern during this period was the diminishing number of media "voices" in the province. Press mergers reduced these such that only one publisher is presently responsible for all of the daily newspapers in the region. It was believed that electronic media, particularly television, could provide additional pluriformity in the media at the regional level.

Within a relatively short time, both strategies became policy. Radio station programming was increased from eight hours per day in 1957, to 12 per day in 1989, to 14 in 1993. Since 1997 programming is provided around-the-clock. Radio Oost was able, much like Omrop Fryslân, to build upon experience with radio programming initiated after World War II. During those first decades of operation, the station provided programming for several provinces in the eastern section of the country. Since 1985, however, the station has been producing radio programming specifically for the province of Overijssel.

For the regional television division, a new "sister" organisation was established which began producing weekly television programming in September 1992. The initial television programming was limited to a few hours in weekend in order to let residents taste the service. This plan was soon seen as inadequate, and the period was extended to three months. Inasmuch as the television programming was to be distributed via the cable systems in the province (no ether transmission was available at the time), special government permission was required. National regulation only allowed cable distribution of television programming for local stations, and such programming was to be restricted to the municipality where originated. In 1992 an amendment to the regulations was proposed and passed by the national parliament which allowed for experimental distribution of regional television programming via the cable. Such experiments could be conducted for up to three years. These initially modest plans noted above were then transformed into a proposal confirming to the experimental conditions, and in September 1992 the first regional television programming for the province was broadcast. Soon thereafter, however, the service was extended to one hour per day in 1994, and in 1997 to the present three hours of original programming per day.

For years the programming format has remained relatively unchanged since the first broadcast. Transmission begins just a few minutes before the 18:00 national news programme. The highlights of the regional news are briefly presented then. After the 15-minute national news-programme, a regional news show is provided which lasts another 15 minutes. Then an informational programme is broadcast. This generally lasts around 15 minutes, but can be, when necessary, extended to as much as 30 minutes. The programme, in other words, varies from 45 to 60 minutes and is repeated several times during the course of the evening.

Initially, a single weekly programme was produced and repeated later in the week. In 1993 two programmes per week were produced, and in early

1994 a programming schedule was planned for five days per week, Monday through Friday. The schedule mentioned above served as an example for almost all the other regional television stations in the country, and most still follow this programming format.

In 1995 the length of the programme was doubled from one to two hours of news and background information, sports and cultural programming, repeated twice. In 1997 this was extended to three hours of original programming per day with one repeat. In 1998 limited financial resources caused reduction in this amount to two hours per day and the national evening news is no longer included in the programming schema.

The weekday programming format is as follows:

> 17:55-18:00 children's programme
> 18:00-18:21 regional news, sports, weather
> 18:21-18:54 background programmes (sports, culture, provincial affairs)
> 18:54-19:00 travel programme
> 19:00-19:21 regional news, sports, weather
> 19:21-19:39 background programmes, (politics, economics)
> 19:39-20:00 documentaries, youth programmes

This programme is repeated during the following period: 20:00-22:00, 1:00-3:00, 5:00-7:00, 11:00-15:00. During the other time segments a cable text programme is transmitted. In the weekend TV Oost programming begins at 21:00 with an overview of the previous week, historical documentaries, sports and a weekly journal composed of material from the other public and public-private regional stations.

One of the central concerns of TV Oost since inception was to secure an adequate and stable financial base. In the very beginning the station has operated entirely from advertising revenue and donations from regional businesses. In 1995 a more structural source of funding was arranged through a levy of NLG 0.50 per household per year. This arrangement was expanded to include the regional stations in the neighbouring provinces of Groningen and Drenthe. Moreover, the cable company operating in the three provinces, EDON, cooperated through securing advertising and provision of production facilities.

Since 1997, however, the provincial government has authorised a levy of NLG 10 per household per year, which now accounts for a largest part of the budget of TV Oost. Also, the cooperation with the cable company EDON was ruled in violation of regulations prohibiting financial gain involving a third part, and was consequently terminated.

Approximately 80 per cent of the residents in the province are connected to one of the cable television systems used for distribution of TV Oost programming. Although the station wishes to transmit over-the-air, a number of municipalities have hesitated to issue the required permits for

construction of transmission towers. Audience research indicates that some 40 per cent of cable subscribers capable of receiving TV Oost watch its programmes at least once per week. The news, sports and youth programmes are particularly appreciated by viewers.

The available financial resources are considered inadequate to continue programming at the same level as in previous years. Income from advertising has remained less than initially anticipated, largely because of the large number of persons unable to receive TV Oost programming and because of the absence of a nation-wide network of publicly-oriented regional television stations.

5. Concluding remarks

Since the initial initiatives in the first half of the decade to develop a regional level of television broadcasting in the Netherlands, an almost continuous public debate has taken place regarding the cultural need and economic viability of yet another tier of broadcasting in a country already abundantly rich in electronic media. Some of the interest groups in this debate have argued that the "need" for regional television can primarily be found in the preservation of regionally-grounded cultural heritage - sometimes formulated in terms of language and sometimes in terms of folk expression. This need is, in part, the basis for public service broadcasting at whatever geographic level, and various divisions within Dutch governments through the years have considered this an important component of media policy. It is generally agreed that regional broadcasting contributes to a more pluralistic media environment, particularly in those provinces dominated by large publishers.

At the same time, the hard economic reality of media production, television in particular, is that this need is expensive to satisfy. For the past three decades, national Dutch governments have been engaged in distancing themselves from the financial responsibilities of broadcasting at all levels: national, regional and local. Sometimes policy actions were directed at shifting this responsibility to either the provincial or municipal governments; sometimes actions were undertaken to integrate or fuse levels; sometimes liberal wings of government would argue for and achieve policy formulations encouraging market-driven and exploited electronic media.

These two domains, preservation and promotion of cultural heritage, on the one hand, and liberalisation of media policy, on the other, have been in continuous tension at least since the 1960s, and most vividly since the development of local and regional electronic media. The development of regional television is the most recent arena where this tension has been manifested and, interestingly, in the case of regional television the advocates of a market solution to the issue cannot claim to have won the day. On the contrary, regional television has expanded largely through the willingness of

national and provincial governments to search for non-market solutions to the financial consequences of such a decision. Through government interventions in 1996 the way was paved for regional television initiatives to secure funding through an increase in the annual fee levied on owners of radio and televisions sets. The result, as shown in this chapter, was an explosion in regional television stations around the country.

At the same time, these initiatives were encouraged and required to develop forms of cooperation with national broadcasting units, and were allowed to consider co-operative constructions with commercial enterprises. These aspects explain the appearance of so-called public/private regional stations on the media landscape. It can be argued that this construction is not particularly stable and some of these stations may eventually undergo re-organisation; still, this development strongly indicates the types of cooperation being encouraged and initiated between public and private concerns. And, although these players are also engaged in cooperative ventures on the different geographically-based levels of broadcasting (local, regional, national), such cooperation seems to be strengthening the integrity of these levels. It must be acknowledged, however, that commercial influences on public service broadcasting have made these players much more market oriented.

Finally, commercial ventures were allowed to develop electronic media independent of the public service stations, resulting in two regional television stations in Dutch provinces with plans (yet-to-be operationalized) for development of a network of such stations. Such a network may increase the chance of achieving financial solvency - a state of financial affairs very difficult to attain for a single station given the limited advertising potential in most sections of the country.

Whether this expansion of commercial regional television stations in the form of a network will emerge is difficult to predict. Yet another, equally plausible, scenario is emergence of a level of stations designed to achieve a niche in the advertising and audience markets between the municipal or local level and the much larger provincial geographic unit. Given the limited financial potential in these regions as well as the costs involved in producing television, is it improbable that such a network will every cover the entire country.

A complementary consequence of this development is that the public service emphasis on attention to cultural "need" as sketched above will increasingly be operationalized in terms of economically attractive entertainment-oriented programming. Such a development seems likely in the programming formulas of regional television stations with a significant commercial component.

And, in terms of research data, indicators for cultural "need" are at best derived from conventional instruments for measuring audience size and

programming appreciation. These instruments are, in fact, no more than crude research tools for collecting data demanded by advertisers interested in regional stations as conduits for their economic interests. It is a sham to promote these data as the empirical base justifying the attention of a regional station to the cultural and language grounding of the region or province.

Other research findings than such market figures, however, do not exist. Since the previous study of regional television in the Netherlands from which this review stems (Jankowski, 1995), there has been no extensive empirical investigation of regional television, and particularly of audience use and appreciation of this medium. At best, a few student initiated policy investigations have been conducted (eg Jansen, 1998). However valuable these studies may be, they do not contribute to empirically assessing the place of regional television stations in the life and culture of the localities or regions which they are designed to serve. There is, in other words, a lack of empirically-based evidence as to whether the so-called cultural "need" is being attended to by regional television (public service, public/private or commercial) in form.

Suggestions for a research agenda directed at regional television stations were made in the previously published version of this chapter (Jankowski, 1995: 156-158), and those suggestions remain equally relevant today, four years later. As stated then, it is only possible to determine the cultural value of particular media through long-term holistic investigations exploring the environment, organisation, content and audience of these media. Such an undertaking still remains the necessary and challenging task of communication scholars concerned with regional television in the Netherlands.

Bibliography and References

Bakker, P. and Scholten, O (1998): *Communicatiekaart van Nederland*. Houten: Bohn Stafleu Van Loghum.

Bardoel, J. and Bierhoff, J. (eds) (1997): *Media in Nederland; Feiten en Structuren*. Groningen: Wolters-Noordhoff.

Brants, K. & N. Jankowski (1985): "Cable television in the Netherlands", in R. Negrine (ed): *Cable television and the future of broadcasting*. London: Croom Helm.

Brants, K. & D. McQuail (1997): "The Netherlands", in B.S. Ostergaard (ed): *The media in Western Europe: The Euromedia handbook*. London: Sage.

Browne, D.R. (1989): *Comparing broadcast systems. The experiences of six industralized nations*. Ames, Iowa: Iowa State Univ. Press.

CBS (1998): *Statistisch Jaarboek 1998*. Voorburg: Central Bureau voor de Statistek

Emery, W. (1969): *National and international systems of broadcasting*. Lansing: State University Press.

Haak, K. van der (1977): *Broadcasting in the Netherlands*. London: Routledge.

Hemels, J. (1977): "regionale omroep in het medialandschap", in *Massacommunicatie* 5, 2.

Hollander, E. (1997): "Strijd om de regio; de herontdekking van de kleinschalige mediamarkt", in J. Bardoel and J. Bierhoff (eds): *Media in Nederland; Feiten en Structuren*. Groningen: Wolters-Noordhoff.

Jankowski, N.W. (1988):*Community television in Amsterdam: Access to, participation in and use of the "Lokale Omroep Bijlmermeer"*. Dissertation. Amsterdam: Univ. of Amsterdam.

Jankowski, N. (1995): "The Netherlands: In search of a niche for regional television", in Moragas, M. de and C. Garitaonandía (eds): *Decentralisation in the Global Era*. London: John Libbey.

Jansen, O. (1998): *De niet-landelijke omroep tussen overheid en markt. Een onderzoek naar knelpunten en mate van consistentie in het overheidsbeleid aangaande lokale en regionale omroep*. Thesis, University of Nijmegen, Dept. of Communication.

Kuypers, P. (1977): "Regionale omroep en regionalisatie", in *Massacommunicatie* 5, 2.

Linden, C. van der & E. Hollander (1993): *Media in stad en streek*. Amsterdam: Cramwinckel.

Olderaan, F. & N. Jankowski (1989): "The Netherlands: The cable replaces the antenna", in L.B. Becker & K. Schoenbach (eds.): *Audience responses to media diversification: Coping with plenty*. Hillsdale, NJ: Erlbaum.

Smith, A. (1976): *The shadow in the cave. The broadcaster, the audience and the state*. London: Quartet Books.

Stappers, J., N. Jankowski & F. J. Olderaan (1989): *Interactief op inactief. Een onderzoek naar de ontwikkeling van experimen met het kabelnet in het kader van het kabelkommunikatieproject in Zaltbommel*. Nijmegen: Institute for Mass Communication.

Stappers, J., F. Onderaan, & P. de Wit (1992): "The Netherlands: Emergence of a new medium", in N. Jankowski, O. Prehn, & J. Stappers (eds): *The people's voice: Local radio and television in Europe*. London: John Libbey, 90-103.

Staveren, E. van (1998): "De publieke omroep als brede media-onderneming?" Master's thesis. Nijmegen: Dept. of Communication, University of Nijmegen.

Notes

1 This chapter is a revised and expanded version of a previously published work (Jankowski, 1995). An earlier draft of the chapter was presented at the conference of the International Association of Media and Communication Research in Glasgow, Scotland (July 1998). We are appreciative of the comments and suggestions made on an earlier draft by several of our colleagues: Carlo Hagemann, Ed Hollander, Robert Zaal,Leo van Snippenburg and Coen van der Linden.

2 The total number of regional stations is a function of how "region" is defined. For the purpose of this chapter we are using a broad conceptualization of the term, and have included the station AT5, located in Amsterdam, but which serves a much larger area than the city of Amsterdam.

3 An excellent and recent encyclopedic reference is Brants & McQuail (1997). Other readily available English language publications which sometimes emphasize different aspects include Brants & Jankowski (1985), Van der Haak (1977), Olderaan & Jankowski (1988), Browne (1991), and Stappers, Olderaan & de Wit (1992).

4 Much of the information for this section comes from documentation produced by the coordinating body for regional stations, ROOS (Regionale Omroep Overleg en Samenwerking). In addition, reports from symposia on regional broadcasting, held nearly two decades ago, provided valuable background information, especially Hemels (1977) and Kuypers (1977). Van der Linden and Hollander (1993) compiled an extensive

overview of both regional and local media, and Hollander (1997) has updated this review within the context of media developments in the Netherlands (Bardoel & Bierhoff, 1997). Finally, Jansen (1998) has produced perhaps the most extensive treatment of policy development currently available regarding regional broadcasting in the Netherlands.

5 Regulations came, in large measure, in an effort to curb the growing position of pirate radio and television stations operating in major cities around the countries in the early 1980s. Estimates are rough, but observers speak of "thousands" of radio pirates broadcasting during this period (Brants & McQuail, 1997:161).

6 This experiment was separate from the already-existing regional radio stations, ROZ and RONO, which operated under the jurisdiction of the national broadcasting organization NOS.

7 ROOS is the umbrella organisation created for all of the regional stations with a public service objective. ROOS attends to regional station interests regarding government policy and other third-party concerns of benefit to all stations. Special meetings are organized and publications produced for representatives of regional stations in order to further their collective concerns.

8 Discussions in the national Parliament during the mid-1950s, related to allowing education in the Frisian language, contributed both to acknowledging Fries as the official second language in the Netherlands and to promoting Frisian programming on national radio and television.

9 One of the central arguments in this development was that Fries is the official second language in the Netherlands.

10 Within the province of Friesland only about 6 per cent of the residents do not understand spoken Fries. The NOS Frisian programme, however, reaches a national audience which is almost entirely unable to understand Fries.

11 This schedule and that of most of the other regional stations can be found on the following website: http://www.omroep.nl/regio

Portugal: Analysis and perspectives of regional television

Francisco Rui Cádima, Pedro Jorge Braumann

1. Regional dimension of the State

1.1. General political framework

According to the Republic's Constitution, Portugal is a democratic, rule-of-law State. It is based on sovereignty of the people, plurality, democratic political organisation and respect towards, and assurance of fundamental rights and freedoms and the separation of powers. The purpose is to attain an economic, social, cultural and participative democracy. Geographically speaking, Portugal includes the territory of continental Europe and that of the archipelagos of the Azores and Madeira.

The State is unitary. In its organisation and operation, it respects the autonomous regime of the islands and the principles of subsidiarity, of autonomy of local bodies and of democratic decentralisation of public authorities. The archipelagos of the Azores and Madeira are autonomous regions with their own political and administrative statutes and their respective organs of government. On 8 November 1998, a referendum for the division of the country was celebrated in 8 administrative regions as an initiative of the government of Antonio Guterres (Socialist party), which was rejected by the 64 per cent of the participants.

Regarding specific legislation for television, the public service radio and television network RTP (Radiotelevisão Portuguesa, SA), according to the

public service concession granted to it, broadcasts open channels on a national and international scale. It also broadcasts programmes and regional news for the autonomous regions of the Azores and Madeira through the activities of its regional delegations.

The transformation of RTP's public corporation status into a private company (Act 21/92 of 14 August) signified the repeal of legislation that gave regional governments the power to veto the directors appointed by RTP's administration to manage RTP Açores and RTP Madeira.

1.2. Language and cultural realities

The language and cultural realities of the Azores and Madeira are very much the same as the one on the continent. On the basis of a common language, Portuguese, both communities have built their own autonomous communities. This became much apparent after "The Revolution of the Carnations" (25 April 1974).

The political and administrative regime particular to the archipelagos of the Azores and Madeira is based on their geographical, economic, social and cultural characteristics, and on the historic aspiration for autonomy of the islands' inhabitants. It is worth pointing out that regional political and administrative autonomy does not affect the integrity of the State's sovereignty, which is exercised in compliance with the provisions contained in the Republic's Constitution.

The so-called island costs have been reflected in the last few decades in several ways in both regions. On the one hand, by encouraging immigration, of which the South African and Venezuelan communities in Madeira and the North American communities in the Azores are proof. On the other hand, by contributing to the constitution of solid cultural communities in the fields of art, culture and politics on the continent.

Regional broadcast programming for the Azores and Madeira is not really a reflection of autochthonous cultural features since, on the one hand, own-produced programmes are very few and, on the other, these features cannot be clearly distinguished from continental culture, unlike those regions which have different language and cultural realities.

2. Television's evolution in Portugal

The year 1993, when private channels began operating, marked the end of a long period a State monopoly of television. The State began broadcasting in 1957 after creating Radiotelevisão Portuguesa (RTP), the public service television licence-holder, whose director was appointed by the Government. Despite that, the Portuguese State only owned one third of the corporation's capital: the other two thirds belonged to private broadcasters and even private shareholders.

By the mid 1960s, the first channel was still not broadcast nationally. RTP 2, the second channel, was created on 25th December, 1968. Some important dates in this historic overview concern the commencement of regular broadcasts from the regional centres of RTP-Madeira on 6th August, 1972, and RTP-Açores on 10 August 1975.

Table 1. Portugal's main socio-economic indicators, by regions

Indicators	North	Centre	Lisbon and Tagus Valley	Alentejo	Algarve	The Azores	Madeira	Total
Population 1996	3,544,780	1,710,070	3,313,450	519,040	346,110	242,620	258,040	9,934,110
% of total population	35.7	17.2	33.4	5.2	3.5	2.4	2.6	100
GDP at market prices (1993, in millions of Escudos)	4,125,500	1,822,656	5,680,878	573,095	489,921	229,755	269,772	13,209,560
% national GDP (1993)	31,2	13,8	43,0	4,3	3,7	1,7	2,0	100,0
GDP per capita (1993)	1,161	1,064	1,721	1,071	1,428	963	1,060	1,337
1995 Purchasing power index (mean = 100)	81.9	71.6	144.6	69.3	100.4	64.5	59.7	100

Source: Instituto Nacional de Estadística de Portugal (http://infoline.ine.pt).

After "The Revolution of the Carnations", RTP was nationalised and turned into a public corporation. In the two decades of the II Republic, it is worth pointing out the commencement of colour broadcasts (7 March 1980) and RTP Internacional's launch (10 July 1992), which was globalised as from March 1995 with non-stop broadcasting. In October 1992, as already mentioned, the first private television operator in Portugal – SIC, Sociedade Independente de Comunicação- began broadcasting. This project was headed by the former Prime Minister Francisco Pinto Balsemão. On 20 February 1993, it was followed by TVI (Televisão Independente), run by the former Minister of Education Roberto Carneiro and owned mainly by organisations of the Portuguese Catholic church. In January 1998, RTP África began broadcasting to former Portuguese colonies on that continent.

Even more important was the signature of a public service television concession agreement in March 1993 between RTP and the Government. This document forced RTP to fulfil the specific attributes of public service television, already foreseen by the Television Act of September 1990, particularly with regard to the payment of subsidies obtained from the Portuguese State's budgets and granted to RTP for its specific activity as a public service television licence-holder. Among these attributes, the Government referred to the costs of satellite broadcasting of RTP 1's and

RTP2's programming for the autonomous regions of Madeira and the Azores; to the running costs of the respective regional centres; to the costs of RTP Internacional; to co-operation with the POLAC (Portuguese Official Language African Countries); to the maintenance and conservation of audio-visual archives; and, finally, to the expenses incurred by allocating air time to political parties.

Since then, a new concession agreement has been signed (31/12/96), under the new Socialist Government which, to a certain extent, generalises the public service concept to all television activities.

The balance between the press and television in the advertising market has changed substantially in recent years. In the first four months of 1992, the press took a 51 per cent slice of the advertising cake, accounting for 11,300 million Escudos, whereas television took 10,900 million. However, in 1993, television advertising investment went up to 56.1 per cent of the total (15,800 million) and press advertising investment went down to 43.9 per cent (12,400 million). In 1994, television obtained a market share of 56 per cent of advertising contracts, accounting for about 45,000 million of gross revenue. Deducting the commission charged by agencies and buying and "dumping" centres, the net revenue for the television sector reached almost 33,500 million Escudos.

SIC was the market's leading operator for the first time in 1995, with a 41.3 per cent share, whereas RTP1 attained a 38.5 per cent, RTP2 a 6.4 per cent and TVI a 13.9 per cent share in the same year.

The 1996 results confirmed that SIC was the market leader, with a share slightly under 50 per cent, though with a gross advertising share of approximately 51 per cent (RTP 38 per cent; TVI 11 per cent). As far as national audiences are concerned – only on the continent – 1996 ended with the following shares: SIC 48.6 per cent; RTP1 32.6 per cent; TVI 12.3 per cent; and RTP2 6.5 per cent. In 1997, RTP1's share grew very slightly to around 33 per cent; RTP2's fell to 5.6 per cent; SIC's was almost 50 per cent (49.3 per cent) and TVI's, despite the channels strategic redefinition, only obtained 12 per cent.

The Spanish autonomous channels – Televisión de Galicia and Canal Sur- and broadcasts from TVE's territorial centres can especially be picked up in bordering areas of the north and south of Portugal by conventional over-the-air antennas. It is estimated that in these areas the Spanish channels have between 2 and 10 per cent share penetration.

3. Television's legal framework

For over 30 years, the television sector in Portugal was a public monopoly. The Portuguese Republic's Constitution today, which was reformed in 1997, guarantees the freedom of the press and social media. Article 38 stipulates that "the State guarantees the freedom and independence of

social media organs from political and economic powers. It imposes the principle of uniqueness of the companies owning general information organs, treating them and providing them with support indiscriminately and preventing their concentration, particularly through multiple or cross shareholdings".

This article also states that "the State assures the existence and operation of public service radio and television. The structure and operation of the public sector's social media must safeguard their independence from the Government, the Administration and other public powers. It must also assure free speech and diversity of opinion. Radio and television broadcasters can only operate with a licence granted by public tender under the terms and conditions laid down by the law".

Article 39 of the Constitution also foresees the existence of a "Supreme Authority for the Media":

> The right to information, the freedom of the press and the independence of the social media from political and economic powers, as well as the possibility of expressing and confronting the diversity of opinion and exercising air-time rights for political debate are assured by the Supreme Authority for the Social Media.

The Supreme Authority is an independent organ which, according to Act 15/90 of 30 June is formed by the following members: a magistrate, appointed by the Higher Magistrates' Council, who acts as the chairman; five members chosen by the Republic's Assembly by a system of proportional representation and Hondt's law's highest mean method; three members appointed by the Government and four people representing public opinion, communication and culture, elected by the other members.

The Supreme Authority for Social Media is involved in the process of granting licences to radio and television broadcasters in compliance with the provisions laid down by law, and the appointment and removal of directors to and from public social media organs. It controls and audits the social media's contents, as it has been invested with the powers to assure the right to information and the freedom of the press, to oversee the independence of social media organs, to safeguard the existence of different opinions and to guarantee air time for debate (Article 3 of Act 15/90 of 30 June). The Supreme Authority's deliberations are forcibly disseminated by social media organs.

Article 40 of the Constitution also regulates the right to political access and reply. Before the 1989 constitutional reform, which made the existence of private channels possible, only the State could have television channels. Act 58/90 of 7 September, partially reformed by Act 95/97 of 23 August, 1997, is today's principle point of reference for television's legal framework. The new text stipulates that:

- public service television will be granted to an exclusively or mostly public operator, whose statute is approved by Decree-Law (Article 3) for a period of 15 years (Article 5).
- television activities cannot be carried on or financed by political parties, associations, trade unions', employers' or professional organisations, or local bodies or associations, either directly or indirectly through bodies in which they are shareholders (Article 3).
- television's coverage area may be general or regional (Article 4).
- pornographic programmes or ones inciting violence are forbidden; restrictions are established regarding not broadcasting any programmes that may be injurious or damaging to children or adolescents before 10.00 p.m.
- RTP must broadcast messages from public powers and grant air time to institutions, religious confessions, political parties and other types of social organisations (Articles 24, 25 and 32).

As far as programming shares are concerned, Act 58/90 provides for the defence of the Portuguese language (television operators must respect a programming share of 10 per cent of their own productions and 40 per cent of programming in Portuguese, 30 per cent of which must be national). These shares are compulsory for both public and private channels, and it seems as though they were observed in 1996. The most serious infringements were committed by TVI, though SIC also committed similar violations.

Furthermore, Directive 89/552/EEC (*Television without Frontiers*) has been incorporated with regard to setting aside 50 per cent of broadcasting time for European productions, whenever possible, and 10 per cent of broadcasting time for works by independent producers.

Decree-Law 401/90 of 20 December approved the allocation of frequencies for television and granted broadcasting network exploitation rights to a company with a majority public shareholding, Teledifusora de Portugal, EP. Subsequently, the Government reallocated public ownership of Teledifusora de Portugal to Portugal Telecom. In compliance with Act 58/90, the public service television concession affects the broadcasting of general coverage networks (RTP1 and RTP2), the broadcasting of international programmes (RTPi, RTP África), regional broadcasts (RTP-Açores and RTP-Madeira), regional windows in the continental part of the country and the broadcasting of RTP1 in the regional autonomous communities of Madeira and the Azores.

The Council of Ministers' Resolution 49/90 of 31 December, set the terms and conditions for the public tenders for concessions of channels 3 and 4, which were allocated in February 1992 to Sociedade Independente de Comunicação, SA (SIC) and Televisão Independente, SA (TVI).

Decree-Law 292/91 of 13 August organised the activities of public-use cable television network operators. This decree only regulated "passive cable", something that was subsequently altered by Act 95/97 of 23 August, 1997,

thus permitting cable broadcasting of own productions, remitting its final regulation to a standard that was approved in the course of 1998.

Decree-Law 120/96 of 7 August regulated the regime for accessing and carrying on television-via-satellite activities.

Act 21/92 of 14 August transformed the public corporation (RTP) into a company whose share capital was exclusively public and approved its status as public service television licence-holder, by defining the objectives and principles of its subsidy allocation, mainly for the costs resulting from the existence of the regional channels for Madeira and the Azores.

On 31 December, 1996 a new public service concession agreement was signed for 15 years, which substantially increased the public subsidies for RTP.

RTP's statutes (Act 21/92) provide for the constitution of an "Opinion Board" formed by 35 members which, among other duties, should establish the activity plans, the budgets, reports, accounts, general programming rules, investment projects, etc. This Board also gives its opinion about the agreement signed by the State as far as the definition of public service functions are concerned.

Act 31/96 of 14 August imposed the compulsory nature of public service distribution (RTP's channel 1) in the autonomous regions of Madeira and Azores.

On 3 July 1997, the Portuguese government altered its previous strategy regarding RTP by publishing an order which established the conversion of RTP into a business group with a holding company structure whose core objective was to "comply with contents of the concession agreement, trying to give the business structure a model which, on the one hand, would significantly reduce the tax-payers resources which are annually allocated to the company through the State Budget and, on the other, would allow the right organisational conditions to be created in various specific areas so that RTP could compete in the market in such a way as to increase its revenue".

According to the Portuguese Government's provision, RTP's Board of Directors had, in a period of 90 days, to present a project for a business group structure as a holding company with the following components:

(a) a company, with exclusively public share capital, aimed at providing a public television service through RTP 1 and RTP 2;
(b) a company, with exclusively public share capital, for the broadcast of RTPi, RTP África and RTP Brasil;
(c) a mixed capital company aimed at broadcasting RTP Madeira;
(d) a mixed capital company aimed at broadcasting RTP Açores;
(e) the transformation of RTP Porto into an independent business aimed at regional television activities or a production centre.

(f) a company, with majority public share capital, aimed at selling advertising space and developing the holding's merchandising on the basis of the current RTC;

(g) a company, open to private share capital, aimed at producing and creating programmes based on the resources that currently depend on RTP;

(h) one or more mixed capital companies, aimed at marketing archives, launching thematic and general channels, and research into and development of new technologies.

(i) a company, with mixed capital, whose objective is to exploit publications referring to television programming, which especially includes *TV-Guia*".

Consequently, RTP could create a new regional channel in Oporto and have different structures for RTP Madeira and RTP Açores, since new shareholders could join these new companies that could be created in the new RTP holding.

New Decree-Law 241/97 of 18 September substantially altered some aspects referring to cable distribution networks, liberalising the distribution system and the service market, mainly of an interactive nature, such as the Internet and à-la-carte television. The most relevant aspect of this new decree-law for regional television stations was, however, Article 16 (Number 2, Section j), which stipulated that cable distribution network operators "must set aside up to three channels on the respective network for the distribution of regional or local coverage open-broadcast television duly authorised within the framework of applicable legislation, the distribution of video and audio provided by non-profit making organisations concentrating mainly on local news, experimenting with new products or services and the broadcast of educational and cultural activities".

The new Television Act, which the Government presented to the Republic's Assembly in March 1998, introduced several important changes in the Portuguese television system. In the main, these are the apparition of coded and thematic channels; Article 6, concerning areas of television coverage, is very important for the development of regional and local television:

1. Television channels can have national, regional or local coverage, depending on whether they reach:
 (a) all national territory;
 (b) a region;
 (c) a municipality, part of a municipality, or a group of neighbouring municipalities.

2. The geographical area assigned to each channel must be covered with the same consigned programme and frequency, unless there is authorisation to the contrary from the Supreme Authority for Social Media.

The conditions for carrying on television activities with regional or national coverage will be defined by decree-law.

Therefore, all of this indicates that 1998 is the year when the operation of regional and local television in Portugal really comes into effect (excluding the regions of Madeira and the Azores, where it already exists). RTP will expand its six regional windows (from 15 to 25 minutes per day) and there will be greater expansion of cable television networks and new channels on them.

The tendency towards greater importance being placed on regional and local television will be emphasised even more if there is an effective political regionalisation of the country after the national referendum on this issue in 1998.

3.1. Television's institutional and business structure

The importance of analysing the economic and financial situation of the different companies that run television channels (the public operator RTP and private operators SIC and TVI) has often been ignored despite the fact that many of their current strategies are very much conditioned by the extremely bad results obtained in recent years.

RTP's and TVI's current financial situation, as shown in Table 2, has progressed negatively.

Table 2. Overall financial situation of television operators (1992-1996) (current prices in thousands of millions of Escudos)

	Net assets				Liabilities				Loss for the financial year				
	1992	1993	1994	1995	1992	1993	1994	1995	1992	1993	1994	1995	1996
RTP	42,263	39,418	33,738	56,078	30,817	37,860	41,809	51,809	-4,109	-7,833	-19,558	-26,581	-18,512
SIC	10,944	11,621	11,055	12,592	5,645	8,319	6,716	8,099	-0,691	-5,997	-1.962	0,154	1,905
TVI	6,448	8,078	17,936	15,545	4,895	8,557	9,667	12,129	-0,911	-5,479	-4,971	-4,852	-6,100
Total									-5,711	-19,309	-26,491	-31,279	-22,707

Source: Annual reports of RTP, SIC and TVI (1992, 1993, 1994, 1995 and 1996).

This table highlights the worsening situation of the public television company (RTP), which had a technical bankruptcy situation in 1994 (the liabilities were greater than net assets by 8,071 million Escudos, that is, the capital itself was negative). This situation apparently improved in 1995 (the assets are greater than the liabilities by 4,794 million Escudos and therefore the capital was positive). However, in practice this can be explained above all by the increase in assets of 26,569 million Escudos and the increase in capital of 12,800 million Escudos.

The current financial situation of the different television operators is partly due to competition between channels and the scarcity of the advertising market. However, the bad results can also be explained by the increases in programming costs and the low prices charged for advertisements, although management and strategy mistakes – which some of these operators did not manage to avoid- cannot be ignored.

So, it is not surprising to find that private television companies have had more or less important losses in the first few years of operation, though it is worth pointing out the speed with which SIC began to lead the field in terms of audience and current net profits within the European panorama. What appears to be even more exceptional is the progressive worsening of RTP's financial situation and net results without the State, its only shareholder, taking any significant measures not only to sort the financial situation out but also to consider an alternative strategy to the current model, for which there does not seem to be any outlet.

It should be pointed out that in the last five years, between 1992 and 1996, even with public subsidies of around 7,000 million Escudos per year (in 1996 public subsidies were increased to 14,500 million), RTP accumulated losses of over 76,500 million Escudos (an average of 15,300 million per year); TVI, with losses over 22,300 million Escudos (an average of 4,500 million per year) and SIC almost 6,500 million Escudos (an annual average of 1,300 million, despite the fact that finally in 1995 and 1996 it made a profit).

The total losses of the three operators were 105,000 million Escudos over a five-year period, that is, a mean loss of almost 21,100 million per year.

Although SIC's economic and financial situation is on the right track, the same cannot be said for the other operators. If SIC continues to be the leading channel in terms of viewership and advertising revenue, mainly due to the exclusivity of the Brazilian Rede Globo's programmes, its viability appears to be assured. However, as far TVI and RTP are concerned, only a change in strategy and a diversification of its sources of finance -not restricted simply to advertising- will guarantee their ability to survive.

TVI has made some attempts to adapt to today's market situation, but its deficit went up by 25 per cent between 1995 and 1996. Now it is in a situation of technical bankruptcy and changes have been made in the management. RTP recovered a little, as it reduced its annual deficit by 40 per cent, due mainly to an increase in operating subsidies granted by the State (more than twice the amount in 1996 than in the previous year). Without the extra injection of public money, RTP's deficit in 1996 would have been around 23,900 million, meaning that between 1995 and 1996 the annual deficit would have only fallen by approximately 10 per cent. In fact, this demonstrates that the public operator had hardly recovered at all.

The apparition of two private television operators in 1992, though positive in many respects, seemed to ignore Portugal's television advertising market's capacity to bear the costs of four general channels with no fee charged for the public service (in 1997 the current Government decided to completely remove advertising from RTP2 and cut it back on RTP1).

The advertising market's progress over the last few years and the trends mentioned do not give much hope about the possibility of advertising revenue being sufficient in the medium term to cover the financial needs of television operators in Portugal.

Table 3. Advertising market progress and prospects in Portugal (values in thousands of millions of Escudos)

	Television (1)	Other Media (2)	Gross advertising market = (1)+(2)	Net advertising market (only TV)**	Net advertising market growth rate (%)	TV market discount structure% ***
1995	79.6	64.5	144.1	35.6	—	55.3
1996	85.5	64.5	150.0	36.5	2.5	57.3
1997*	93.7	67.8	161.5	40.3	10.4	57.0
1998*	96.8	70.0	166.8	41.6	3.2	57.0

* Forecast

** Estimate of the net value of television advertising after discounts, campaigns, agency commission and average retention.

*** Estimate of the percentage of discounts on television advertising after discounts, campaigns, agency commission and average retention.

Source: Calculated on the basis of Sabatina, RTP's 1996 Annual Report and Plan and RTP's Budgets for 1997 and 1998.

Table 3 shows that the estimated value of net advertising revenue for the four channels was around 36,500 million Escudos in 1996, when the total costs in themselves of RTP in that year were around 49,384 million Escudos.

Faced with this situation, it isn't hard to predict that the Portuguese television market, far from having reached a more or less stable position, will have to make major changes in the coming years.

4. What national channels have to offer

Through the cable operator TV Cabo, and partially through over-the-air broadcasting too, the inhabitants of the Azores and Madeira have access to national channels. A brief description of their characteristics is given below:

RTP

Before the competition came into the arena, RTP had a very easy life. But since 1994, it has recorded annual losses of around 20,000 million Escudos. RTP1 and RTP2 then operated as alternatives to each other. This option was made explicit in the organisational restructuring in 1989: the second channel was "for qualified minorities". But this design was abandoned a short time after granting licences to private operators. Not much publicity was given to RTP2 and no longer was it an autonomous project. It turned

into a subsidiary of RTP1 in the audience war, in which RTP1 opted for an aggressive commercial strategy. In the meantime, the private television operators (SIC and TVI) adopted a clear position against this strategy and against State support of public television. Francisco Pinto Balsemão, leader of the SIC project, criticised the State's excessive power in the Portuguese company. As an example of this he referred to – and rightly so – public television support, and asked for RTP's subsidies to be cancelled in accordance with the rules about competition contained in the EU Treaty. This request was rejected once again by the European Commission. This position was reinforced by the approval of the appendix to the Amsterdam Treaty, which allows member States of the European Union to carry on financing public television channels.

In the meantime, in 1997 the government approved the removal of advertising from RTP2 and a reduction of advertising on RTP1 as way of putting order and balance into the market, and the goal of solving the problem of disloyal competition and programming quality of public channels.

In 1998, RTP received 23,800 million Escudos from the State's budget as a subsidy for providing the public television service (RTP's activity as a whole, unlike what was stipulated in the previous concession agreement between RTP and the State). However, the situation in 1996 was one of "technical bankruptcy", with losses of 18,500 million Escudos and negative capital.

For 1998 there are plans to turn RTP into a holding company. In this instance, the Lisbon and Oporto production centres could become autonomous and the latter, in the framework of the country's regionalisation, would become an autonomous channel of the North region. With political regionalisation there are also plans to transfer responsibility for RTP Madeira and RTP Açores to the regional governments (a possibility mentioned in 1996 RTP's restructuring project), admitting private capital at some time in the future, as already accepted by RTP's Board of Directors in the case of some participated companies. The recent Order of 3 July reinforces the probability of some of the changes becoming a reality.

RTP Internacional is the Portuguese public television's international channel which broadcasts to all five continents via various satellites and cable networks all over the world. RTP África is RTP's specific channel for Africa, aimed mainly at Portuguese-speaking countries (Cabo Verde, Guinea-Bissau, São Tomé e Principe, Angola and Mozambique). As far as contents are concerned, RTP Internacional broadcasts general programmes with contents from RTP's two channels. RTP África broadcasts a selection of the two channels' programmes, though it also has specific programmes produced by television stations in the different Portuguese-speaking African countries or co-productions with RTP.

SIC

Francisco Pinto Balsemão is the majority shareholder of IMPRESA, a holding company whose participation is concentrated on two main companies: SIC-Sociedade Independente de Comunicação, the licence-holder for the television channel that is top in Portugal's audience figures, with a share of almost 50 per cent (IMPRESA, through control over the company SOINCON, is the main shareholder); and Controljornal-Sociedade Gestora de Participações Sociais, in which IMPRESA holds most of the share capital, which essentially deals with press activities.

In 1996 SIC closed the year with profits of 1,900 million Escudos, a 48.6 per cent share and command of the advertising market (51 per cent) – equivalent to net revenue of 26,400 million Escudos – and turnover of 300 million Escudos in telesales, telephone information services and programme sales.

SIC has a traditional commercial schedule in which Rede Globo's serials occupy and dominate prime-time blocks. At these times it reaches viewing figures of over 60 per cent of the total. Its programmers have placed their bets heavily on international formats already tried and tested in Europe, taking recourse to programmes made by the Dutch production company Endemol. Portuguese production is mainly centred on sit-coms, comedies and reality-shows.

TVI

With estimated profits for 1997 of around 2,000 million Escudos, TVI was struggling with accumulated liabilities of around 17,750 million Escudos and a situation of technical bankruptcy.

So, the prospects for renegotiating the long-term debts depended on the company's recovery plan which, at the beginning of 1998, the legal administrator for the judges presented at the creditors' meeting (formed by CGD, BPSM, Banco Cisf, Portugal Telecom, the Lusomundo group and Stanley Ho, among others). Headed until May 1998 by the Portuguese editorial group SOCI, the Scandinavian Broadcasting System and Rádio Renascença – with the majority of TVI's share capital (over 60 per cent) in the hands of foreign investors (including Fidelity) – at the beginning of June 1998, following a court decision, a consortium of companies formed by the Portuguese groups Sonae and Lusomundo, as well as the Venezuelan Cisneros, finally took control of TVI.[1] Finally, in November the same year the portuguese group Media Capital bought 94 per cent of TVI's shares. Until then, TVI's programming was centred on North American fiction and Brazilian and Latin American serials. It achieved the highest audience figures with exclusive rights over Spanish and Italian football leagues.

5. Television's structure and characteristics in the regions

5.1. RTP's regional structure

5.1.1 The Azores

In 1994, the inhabitants of the Azores finally had access to more than one channel thanks to the implantation of TV Cabo despite the restrictions placed on it, particularly in terms of territorial coverage (See Table 4).

Table 4. Cable television distribution (Third quarter of 1997)

	Thousands of homes	Growth (%)	
		Quarter	Last year
North	357	9	57
Centre	114	1	21
Lisbon and Tagus Valley	745	12	84
Alentejo and Algarve	62	7	82
Madeira and The Azores	80	7	33
Total	1,358	10	65

Source: ICP.

In the Azores, RTP1 has reached Ponta Delgada since October 1996 over the air. An estimate at that time forecast complete coverage of the archipelago by this channel's signal by 1997. With an overall investment of 500 million Escudos (250 million in Madeira's case), Portugal Telecom was in charge of installing the signal's distribution network. However, the public channel with the highest viewership still does not cover all nine of the archipelago's islands, although this may be achieved in the course of 1998. As far RTP2 is concerned, many of its contents are broadcast through selected programming by RTP Açores. The same scheme is repeated in Madeira.

RTP Açores

RTP Açores' programming mostly consists of programmes already broadcast by RTP, with a hybrid schedule which takes recourse to RTP1's and RTP2's archives (that's why it is usually called the "repeater") and some programmes simultaneously broadcast by RTP1, mainly football and news. The quality of its own productions is generally poor and of minor import in the schedule. In 1996, RTP Açores programmed around 273 hours of its own productions (4.2 per cent of total broadcasting time). They mainly consisted of the following programme types: music and education, variety, fiction, documentaries and cultural dissemination, religion and access rights, daily news and sports news (see Tables 5 and 6).

Table 5. RTP Açores. Distribution of broadcasting time, by programme type (1994-96)

Programme type	1996 Time	%	1995 Time	%	1994 Time	%
Daily news	1,243' 11"	19.3	1,238' 40"	19.2	793' 22"	13.5
News (not daily)	153' 42"	2.4	187' 39"	2.9	137' 22"	2.3
Sports news	606' 42"	9.4	506' 16"	7.8	416' 20"	7.1
Documentaries	320' 3"	4.9	368' 40"	5.7	293' 17"	5
Culture	9' 9"	0.1	2,134' 39"	33	2,088' 55"	35.5
Fiction	1,917' 9"	29.7	679' 11"	10.5	730' 42"	12.4
Children and young people	583' 6"	9	817' 8"	12.7	880' 52"	15
Light entertainment and music	1,029' 30"	15.9	21' 48"	0.3	8' 57"	0.2
Institutional	165' 22"	2.7	160' 38"	2.5	159' 11"	2.7
Advertising	73' 31"	1.1	57' 48"	0.9	54' 2"	0.9
Continuity	352' 5"	5.5	289' 47"	4.5	317' 48"	5.4
Total	6,453' 35"	100	6,464' 19"	100	5,880' 52"	100

Source: RTP's data processing centre.

With the Socialists already governing the country, in January 1996 the Social Democrats, recently dislodged from power, put forward a proposal to turn RTP's regional centres into private companies depending on the autonomous government – while maintaining the public service status – to the Assembly of the Republic.

At the end of 1997, RTP Açores' director announced that the channel's objective, from her point of view, was to prepare for the "autonomisation" of the television service it provided. It was, in fact, a reply by a director faced with a possible loss of RTP Açores' personality caused by the arrival of the main public channel RTP1's broadcasts to the archipelago. Emphasis is currently placed on major reports and fiction serials, which RTP Açores had already shown signs of being capable of producing in a very competitive way (See the example of fiction serials such as *Xailes Negros* and *Mau Tempo no Canal*, directed by José Medeiros).

No regular audience research is done in the autonomous regions, although a purely indicative study carried out by the University of the Azores into clients of the TV Cabo dos Açores network (in July 1994, before the inclusion of RTP1 and RTP2), indicated that RTP Açores was watched by 33 per cent of those interviewed, whereas 27.5 per cent watched TVI. However, 31.8 per cent preferred TVI and only 14.6 per cent preferred RTP Açores. This is a significant indicator.

Table 6. RTP Madeira's and RTP Açores' own productions (1996)

	RTP Madeira	RTP Açores
Children and young people	5' 41"	-
Music and culture	3' 54"	3' 32"
Variety	137' 46"	4' 41"
Theatre	1' 2"	-
Documentaries	31' 21"	18' 49"
Continuity	129' 7"	49"
Religion	3' 39"	11' 10"
Daily news	126' 7"	149' 37"
News (not daily)	35' 43"	46' 23"
Sports news	60' 2"	34' 45"
Fiction	-	2' 34"

Source: RTP's data processing centre.

5.1.2. Madeira

RTP Madeira

Twenty-five years after the start of regional broadcasting on the island of Madeira, RTP Madeira is still the only Portuguese-language broadcast that covers the whole of the archipelago. The first broadcasts of four hours of daily programming sent by plane from Lisbon are now in the distant past.

Now, RTP Madeira's new strategy is essentially to promote its own production. This applies to documentaries, entertainment, cultural and news programmes. Since the summer of 1997, RTP Madeira has broadcast a news programme dedicated exclusively to regional news (*Jornal RTP:M*, on Saturday and Sunday at 7.30 p.m. before broadcasting the national *Telejornal*, and weekdays at 9.00 p.m.) as well as sports programmes (eg, *Estádio RTP:M*, on Sunday from 12.00 noon to 1.00 p.m. and the rest of week from 1.40 p.m. to 2.00 p.m.).

Regarding culture, there are magazines like *Madeira Artes e Letras* (Thursday, from 9.30 p.m. to 10.00 p.m.) and some slots for a local selection of films. The rest of the schedule is a mixture of programmes and live rebroadcasts (mainly news and sports) of RTP1 and RTP2 .

According to the new director of RTP Madeira, Carlos Alberto Fernandes (see *Público*, 10 August 97), non-daily news programmes are being prepared, as is a children's programme and a range of documentaries about themes ranging from regional flora to regional ethnography. Music, entertainment and drama programmes can also be found among the new bets "on a new RTP Madeira".

This strategy stems above all from the fact that a new media reality in the archipelago is getting closer and closer: coverage of the national channel RTP1, which began in October 1996 and is already a partial reality via cable broadcasting, should also fully materialise over the air in stages throughout 1998.

RTP Madeira's programmes produced in 1996 in the regional centre reached a total of around 8.3 per cent of the channel's total broadcasting time. In other words, around 534 hours of its own productions divided into the following programme types: for children and adolescents, theatre, music and education, variety, fiction, documentaries and cultural dissemination, religion and access rights, daily news, non-daily news, sports news and continuity (see Tables 6 and 7).

5.1.3. RTP Açores' and RTP Madeira's programming

To sum up, it can be said that in 1996, as in previous years, RTP Açores and RTP Madeira presented a total of programming hours which was even higher than RTP2 and slightly lower than RTP1. More specifically, RTP Açores broadcast 6,453 hours, RTP Madeira 6,386 hours, RTP1 7,200 hours and RTP2 4,703 hours.

In RTP Açores, the daily news category, with 1,243 hours accounting for 19.3 per cent of the channel's total programming time, includes the *Notícias/Açores* and *Sinais dos Açores* block, accounting for 47 hours. In turn, this block represents the majority of local programming and 3.8 per cent of total daily news time.

In RTP Madeira, the daily news category, with 880 hours accounting for 13.8 per cent of the channel's total programming time, includes the *Notícias/Madeira* block, accounting for 157 hours. In turn this block virtually represents an absolute majority of local programming and 17.9 per cent of total daily news time.

Own programming in Madeira and the Azores is dominated by daily news, non-daily news and sport news. These news programmes attempt to reflect the local and regional reality and therefore constitute an important contrast to national news programmes broadcast by RTP 1, SIC and TVI.

Regarding fiction, production is virtually non-existent in Madeira. However, in 1996, a reasonable investment in entertainment programmes was registered (including light music), particularly in Madeira. In this category, a considerable number of variety programmes were produced under the theme of "Madeira nights", and some popular celebrations, local folklore festivals and new talent programmes, etc. were even broadcast. The programme type with the highest production investment besides light music was informative documentaries – mainly *Letra Dura e Arte Fina* and *Vamos ao Cinema*.

Table 7. RTP Madeira. Distribution of broadcasting time, by programme type (1994-96)

Programme type	1996 Time	%	1995 Time	%	1994 Time	%
Daily news	880' 24"	13.8	877' 25"	14.6	623' 34"	10.7
News (not daily)	100' 51"	1.6	112' 36"	1.9	82' 42"	1.4
Sports news	588' 52"	9.2	499' 31"	8.3	487' 52"	8.4
Documentaries	413' 19"	6.5	287' 10"	4.8	289' 25"	5
Fiction (theatre)	5' 43"	0.1	6' 50"	0.1	6' 13"	0.1
Fiction (films and serials)	1' 2"	29.7	2,140'	35.6	2,473' 20"	42.6
Children and young people	2.187' 41"	34.3	631' 37"	10.5	550' 15"	9.5
Light entertainment and music	559' 25"	8.7	970' 8"	16.1	771' 46"	13.3
Culture	1,125' 16"	17.6	8' 31"	0.1	19h	0.3
Institutional	127' 41"	2	120' 41"	2	126' 20"	2.2
Advertising	50' 13"	0.8	50' 12"	0.8	54' 53"	1
Continuity	345' 26"	5.4	313' 8"	5.2	318' 24"	5.5
Total	**6,386' 1"**	**100**	**6,017' 18"**	**100**	**5,803' 50"**	**100**

Source: RTP's data processing centre.

In the Azores in 1996, unlike in 1997, there was a lot of investment in fiction (mainly the television films *Viagem* and *Passaporte de Emigrante*) and in informative documentaries, such as the programmes *Magazine Tauromáquico* and *Espaço Vital*. In addition, these were the two slots with the highest investment after the daily news, non-daily news and sports news.

5.1.4. RTP's regional broadcasts on the continent

In April 1997, RTP1 began a process of news regionalisation with the daily prime-time broadcast of 15 minutes of regional information through a system of regional windows, reinforcing the current delegations of Bragança, Coimbra, Évora and Faro, as well as developing regional windows in Lisbon and Oporto (six windows in total). The aim of creating these regional windows was to provide more specific and local news coverage in several regions of the country, thus increasing its broadcasts on the continent.

The regional news programmes are broadcast before the national news at 8.00 p.m. in the regions defined according to RTP's map of stations and boosters, as political-administrative regions do not exist yet in Portugal. To

produce them (15 minutes of daily broadcasting from Monday to Friday), RTP created teams formed by journalists, reporters' units and technical managers (10 people on average in each centre) in its regional delegations on continental territory.

RTP1 plans to increase these regional news windows up to 25 minutes per day in 1998.

The pressure to create a regional channel in Oporto is quite high, and this year there are even plans to broadcast a channel via a cable television network, although it would be a thematic and not a regional channel. This new channel will probably be able to use RTP's studios in Oporto for part of its production. The Oporto production centre already has some degree of autonomy even though it is relatively minor and is currently a very heavy financial burden for RTP in need of urgent restructuring. In view of RTP's reorganisation, there are plans to partially privatise a programme production company which will be created within the holding company. This will involve reusing the Oporto production centre, although no decisions have yet been taken on this matter.

5.2. Cable television in the autonomous regions

Both the Azores and Madeira have their own cable television networks. This has allowed the number of channels that can be received in these regions to be increased. However, the scope of all the channels is either national (Portuguese) or international.

Cabo TV Açoriana

Founded in 1992, this company distributes television via cable in the Azores, where RTP Açores programmes are the only general over-the-air access ones. With 5,000 clients at the end of 1995, at the end of the second quarter of 1996, Cabo TV Açoriana had almost half of the subscribers of the areas covered (16,000 clients). At the end of 1997, it was estimated that Cabo TV Açoriana had reached 20,000 subscribers, with coverage of over 40,000 homes (a penetration rate higher than 50 per cent, surpassing the company's initial forecasts) distributed through Ponta Delgada, Lagoa, Ribeira Grande and Rabo de Peixe (São Miguel), Angra do Heroísmo and Praia da Vitória (Terceira) and Horta (Faial). With a total of 19 channels, including the four Portuguese ones, in 1998 Cabo TV Açoriana provides a basic package of 24 channels, four of which are "premium" which use a Pay TV or pay-per-view system.

Cabo TV Madeira

On 9 April 1991 the cable operator Cabo TV Madeira was created. At the end of 1995 it had almost 15,000 subscribers. One year later the number

of subscribers rose to 18,600, for a total of 39,340 connected homes. The penetration rate was almost 43 per cent.

At the end of 1997 the company reached 25,000 subscribers, with a coverage of almost 50,000 homes (50 per cent penetration rate). The number of channels distributed in 1998 – the same as in the Azores- is 24 (20 included in the basic package and 4 pay channels).

Cabo TV Madeira was also the pioneering company for the launch of television microwave distribution technology in Portugal (MMDS, Multipoint Microwave Distribution System), allowing total coverage of the autonomous region of Madeira. The system was launched at the end of 1996 in the Câmara de Lobos region on 20 December. Now, MMDS is used for all zones outside the city of Funchal and in distribution to the island of Porto Santo.

In Madeira and the Azores as a whole, the distribution of television by cable had 40,000 subscribers at the end of the third quarter of 1997, that is, almost 13 per cent of the national total.

6. New problems and prospects

6.1 Financial viability
RTP Madeira's and RTP Açores' financial situation is summarised in tables 8 and 9.

As shown, the regional channels of Madeira and the Azores make considerable losses: in 1996 RTP Madeira cost 2,105 million Escudos and RTP Açores cost 2,651 million. As RTP Madeira and RTP Açores are an integral part of RTP, they are subject to decisions stemming from the financial criteria of austerity applied to RTP as a whole.

Besides the differences in cost accounting, there is a reduction in the losses in the annual accounts which gave rise to foreseeable losses in 1997 of 1,126 million Escudos for RTP Madeira and 1,481 million Escudos for RTP Açores. In 1998 RTP predicts losses for RTP Madeira which are virtually the same as in 1997 (1,200 million Escudos) and a major increase in RTP Açores losses (1,835 million Escudos).

The operation of regional centres, which is reasonably significant, could be an indicator as to interest in regional audiences and the considerable role they play in national cohesion.

In 1998, RTP Madeira and RTP Açores must widen their own productive capacities. Production choices are the responsibility of regional managers, particularly as far as coverage of regional institutional events are concerned (religious, political and social), for which there are plans to increase local production hours to over 18 per cent in RTP Açores and 15 per cent in RTP Madeira.

Table 8. RTP Madeira's financial data (values in millions of Portuguese Escudos)

	1994	1995	1996	1997*	1998*
Revenue					
Advertising	363	268	218	232	115
Others	13	2	8	3	4
Total revenue (1)	**381**	**270**	**226**	**235**	**119**
Costs					
Own-produced programmes	130	135	139	120	150
Staff costs	473	491	506	480	++
National programmes	925	960	990	++	++
Satellite costs	169	141	117	++	++
Broadcasting costs	204	122	126	++	++
Other costs	423	439	453	++	++
Total costs (2)	**2,324**	**2,288**	**2,331**	**1,361**	**1,319**
Operating results (1)-(2)	**-1,943**	**-2,018**	**-2,105**	**-1,126**	**-1,200**

*Estimate

++ Not available

Source: RTP's Annual Reports and Accounts and RTP's Budgets for 1997 and 1998

Table 9. RTP Açores' financial data (values in millions of Portuguese Escudos)

	1994	1995	1996	1997*	1998*
Revenue					
Advertising	329	248	209	190	172
Others	54	28	30	19	16
Total revenue (1)	**383**	**276**	**239**	**209**	**188**
Costs					
Own-produced programmes	184	135	197	80	150
Staff costs	563	585	603	546	++
National programmes	945	980	1.011	++	++
Satellite costs	215	185	165	++	++
Broadcasting costs	522	257	259	++	++
Other costs	615	694	655	++	++
Total costs (2)	**3,044**	**2,836**	**2,890**	**1,690**	**2,023**
Operating results (1)-(2)	**-2,661**	**-2,418**	**-2,651**	**-1,481**	**-1,835**

*Estimate ++ Not available

Source: RTP's Annual Reports and Accounts and RTP's Budgets for 1997 and 1998

It should be pointed out that in 1998, RTP plans to widen the role of regional centres in RTP's programming, broadcasting some of the most

successful regional productions on national channels, particularly in the categories of fiction and documentaries.

As far as the creation of regional windows on the continent are concerned, the increase in costs stemming from this activity (programme production and over-the-air broadcasting to the delegations of Bragança, Coimbra, Évora and Faro) can be estimated at about 550 million Escudos in 1997.

The new Television Act approved by the Assembly of the Republic in March 1998 envisages the rise of new regional and local over-the-air channels, something that was also foreseen in Decree-Act 241/97 of 18 September referring to cable television networks.

Given the small size of the Portuguese advertising market for the needs of general over-the-air channels and the non-existence of regions on continental territory, the financial viability of future regional and local channels appears to be difficult, particularly in the less developed regions of the country, though a future political setting of new administrative regions could substantially modify the current situation.

6.2. Cultural synergies

Not very much is worth mentioning about cultural synergies between the regional centres of the Azores and Madeira and society: the broadcast of political programmes (air rights) in electoral periods in the Azores and Madeira stems from the obligation contained in the Republic's Constitution and, in particular, in the Television Act referring to television's public service throughout national territory.

In RTP Madeira's case, there are some programmes in which the local communities get involved to a limited extent (for example, the children's song contest, folklore festivals, popular celebrations, *Estrelinhas da Escola*), etc.

In RTP Açores' case, besides the big annual television festival MAT (*Mostra Atlântica de Televisão* – Atlantic Television Show), in which programmes from many different stations of regional and national television participate, it is worth mentioning the production of a children's song contest, the transmission of ethnographic parades, popular celebrations and traditional local religious festivals.

6.3 Influence of new integrated communications networks

The technological transformation that is taking place is not only reflected in over-the-air television (high-definition and digital television), but also in the development of new supports (satellites, cable, video, etc).

The changes in the Portuguese television market in the coming years will not be restricted to competition between the four over-the-air channels that currently exist in the continental part of the country. They will also depend

on new over-the-air channels (local and regional) and new broadcasting supports which are on the increase, such as cable and satellite. However, the spread of new "information superhighway" coverage will still be somewhat slow, and it is possible to think that it will take at least a decade to cover most of the country's territories.

Regarding audiovisuals, particularly referring to local and regional structures, a multiplication of product supply is foreseeable, favoured by technological evolution (new media). There is much more concern about product provision, since the market will be clearly orientated towards the final product and financed more and more directly by the consumer. Software, the product, will take on a fundamental role as the main element in the strategies of businesses involved in the new multimedia context.

Although the broadcasting network is technologically stable, Portugal Telecom, the national telecommunications operator, plans to set up a digital broadcasting network in 1998-99 for DVD. This indicates that the new digital broadcasting network, with new broadcasters and rebroadcasters, will replace the current analogue system.

By means of a single frequency network, digital broadcasting provides access to a greater number of channels in UHF bands IV and V. The expansion of the digital network will last for 15 to 20 years, and both networks are planned (analogue and digital) to simultaneously broadcast the same programme until the process is complete.

The growing use and broadcast of television by cable signifies that today it is no longer possible to ignore its dimension and importance in the Portuguese audio-visual panorama.

The tendency towards liberalising the Portuguese audio-visual market and financial and technological progress, following the example of other European Union countries, allows us to predict:

- the apparition of new competitors in the audio-visual market and the search for new market segments, eg, at regional and local television level;
- the development of the Internet and new interactive channels using this technological support;
- the growing use of fibre-optics and multimedia terminals;
- legislative deregulation, which will give rise to new, different audio-visual experiences combining telecommunications;
- the development of new thematic channels;
- the accentuated growth of digital television networks, whether over the air, by cable or via satellite;
- the synergies stemming from taking advantage of all the new services and competition between the regional channels and the new systems.

The defence of plurality and diversification of information sources in a multimedia society will be fundamental to avoid cultural homogenisation and to develop originality and diversity, thus creating the right conditions

for different local and regional cultures to interact and create synergies for development.

Access to infrastructures and the global information society is a planetary issue which should not leave any human community out, not even in any developing region. If such exclusion is not addressed, the gap in development levels runs the risk of getting wider, because the assimilation of new information and communications technologies in local, regional and national financial and social systems will not be possible.

Bibliography and References

RTP: Anuarios, 1994-1996.

Braumann, Pedro Jorge (1997): "O Mercado Audiovisual em Portugal e os Possíveis Cenários para a Evolução da RTP", inTendências XXI, 2 (September).

Braumann, Pedro Jorge (1996): "Evolução do Mercado e Perspectivas da Televisão em Portugal", in Tendências XXI, 1 (March).

Cádima, F. Rui (1997): "A Situação da Televisão e do Mercado da Publicidade em Portugal", in Estratégias e Discursos da Publicidade. Lisbon: Vega.

Cádima, F. Rui (1996): "Balanço e prospectiva do Audiovisual em Portugal", in Tendências XXI, 1 (March).

The Portuguese Republic's Constitution (revised version, 1997).

Diário da República

European Commission (1993): White Paper for Entry to the 21st Century - Employment, Growth and Competition . Luxembourg: Office of Official Publications of the European Communities.

Ministerio da Cultura (1997): Relatório da Comissão inter-ministerial para o audiovisual, Ministério da Cultura. Lisbon.

Relatórios e contas de RTP, SIC and TVI (1994-1996).

Presidência do Conselho de Ministros (1996): Relatório final da Comissão de reflexão sobre o futuro da televisão. Lisbon.

Media Business School (1993): Télévisions publiques en Europe: quel avenir? Madrid.

Statistics from INE (Instituto Nacional de Estatística), 1997 (

http://infoline.ine.pt/prodserv/indicchave2.html

Statistics from Instituto de Comunicações de Portugal (ICP), 1997.

http://www.icp.pt/publicacoes/manuais/estcom/tvc3_97.html.

Statistics from RTP provided at the researchers' request.

Translation: Steve Norris

Note

1 The Sonae group, managed by entrepreneur Belmiro de Azevedo, owns the newspaper *Público*. Lusomundo controls the newspapers *Diario de Notícias* and *Jornal de Notícias*, besides having businesses involved in film distribution (*El País*, 4 June, 1998, page 30.)

Spain: Consolidation of the *autonomic* system in the multichannel era

Bernat López, Jaume Risquete, Enric Castelló

1. Regional dimension of the State

1.1. Political framework and the role of the regions

The Spanish Constitution of 1978, whose second article "recognises and guarantees the right to autonomy of the nationalities and regions that go to form Spain", established a framework for decentralisation which was characterised by a great deal of flexibility, heterogeneity and progressiveness. The initial differentiation of "fast lane" autonomous communities (Catalonia, the Basque Country, Galicia and Andalusia) and "slow lane" autonomous communities (the remaining 13) emerged from this "à la carte" autonomy system. In April 1983, all territory under Spanish sovereignty, except Ceuta and Melilla, was organised into 17 autonomous communities whose size and population are very diverse (See table 1).[1] Despite the initial distinction between different degrees of autonomy, virtually all of the autonomous communities now have the same powers even though the Basque Country and Catalonia[2] are still one step ahead in terms of power concession.

Likewise, the Constitution partially granted representation of the autonomous communities in the Senate though it cannot be considered as

a real territorial chamber. This has provoked an important political debate in recent years concerning its function.

Table 1. Classification of autonomous communities by surface area, population and GDP

Surface area (km2)		Population (1996)		GDP (1996) (millions of Pesetas)	
1. Castilla y León	94,193	Andalusia	7,234,873	Catalonia	14,148,554
2. Andalusia	87,268	Catalonia	6,090,040	Madrid	12,252,539
3. Castilla-La Mancha	79,230	Madrid	5,022,289	Andalusia	9,606,998
4. Aragon	47,650	Valencian Community*	4,009,329	Valencian Community*	7,378,456
5. Extremadura	41,602	Galicia	2,742,622	Castilla y León	4,440,898
6. Catalonia	31,930	Castilla y León	2,508,496	Basque Country	4,374,958
7. Galicia	29,434	Basque Country	2,098,055	Galicia	4,270,960
8. Valencian Community*	23,305	Castilla-La Mancha	1,712,529	Canary Islands	2,954,971
9. Region of Murcia	11,317	Canary Islands	1,606,534	Castilla-La Mancha	2,709,588
10. Principality of Asturias	10,565	Aragon	1,187,546	Aragon	2,398,419
11. Comunidad Foral de Navarra	10,421	Region of Murcia	1,097,249	Balearic Islands	2,100,655
12. Madrid	7,995	Principality of Asturias	1,087,885	Principality of Asturias	1,749,996
13. Basque Country	7,261	Extremadura	1,070,244	Murcia	1,614,026
14. Canary Islands	7,212	Balearic Islands	760,379	Extremadura	1,434,315
15. Cantabria	5,289	Cantabria	527,437	Comunidad Foral de Navarra	1,151,116
16. La Rioja	5,034	Comunidad Foral de Navarra	520,574	Cantabria	900,730
17. Balearic Islands	5,014	La Rioja	264,941	La Rioja	591,485

* Valencian Community is the official name stated in this region's Statute of Autonomy, although it has historically been known as the Valencian Country. In this article we will give preference to the use of the second denomination, whereas the first will only be used for references in "formal" contexts.

Source: Instituto Nacional de Estadística (INE), compiled in *Anuario El País 1998*.

All autonomous communities are institutionally organised in the same way: a regional parliament, which is elected by direct universal suffrage under a system of proportional representation, and an executive led by a president, appointed by the chamber, which is supported by a dense administrative structure that has tended to create "scale" reproductions of the State's administration.

The overall result of this process is that central State institutions still play a dominant role in the Spanish political system, which is reflected by the control that central government has exercised at all times over the pace and scope of decentralising advances. However, a considerable level of regionalisation has been attained, so much so that Spain, from the outside, is considered to be a quasi-federal regime (see, for example, Elazar, 1991). Thus, autonomous communities enjoy wide-ranging powers in almost all fields, except defence, foreign affairs and the constitutional system. This process has not been exempt from a remarkable degree of conflict between the central and the regional governments, though the tendency is towards a progressive stabilisation of the system and even further decentralisation.[3]

1.2. Language and culture

Several native languages co-exist in Spain: Spanish (or Castilian), which is the State's official language and spoken all over the country and exclusively in a large part of it; Catalan, the language of Catalonia and the Balearic Islands, most of the territory of the Valencian Country[4] and a small part of Aragon; Galician, the language of Galicia and a small part of the province of León; and Basque, the language of the Basque Country and a large part of Navarra.[5] Whereas Spanish has been the prevalent language in the administration, the army and high culture since the end of the Middle Ages, the other languages have suffered from gradual setbacks in terms of their knowledge and use. This reached the most critical stage during Franco's regime.

With the return of democracy, language diversity was recognised in the 1978 Constitution. Consequently, Article 3 of the Constitution declared Castilian as the "official Spanish language". It also stated that "the other Spanish languages will also be official in the respective Autonomous Communities in accordance with their Statutes". The Carta Magna neither specified which languages could be declared as "also (...) official" nor in which territories. Eight autonomous communities have created legal instruments to defend and promote the respective native languages, including provisions that apply to the media. These language policy measures have contributed to a significant recovery of the "peripheral" languages in terms of the number of speakers and public presence.

Table 2. "Minority" languages in Spain

Language	Approx. no. of speakers	Areas where spoken
Aragonese	30,000	Pyrenean valleys of Aragon (r)
Bable	450,000	Asturias (r)
Catalan	10,000,000	Catalonia (o), Balearic Community (o), Valencian Country (o) and eastern Aragon (r)
Basque	560,000	Basque Country (o), Navarra (o)
Galician	2,500,000	Galicia (o), northern León
Aranese (Occitan)	4,000	Valle de Arán (northern Catalonia) (r)

(r): recognised. (o): official.

Source: Information drawn from European Bureau for Lesser Used Languages, 1993.

Despite the advances, it cannot be said that the situation of these languages is excellent. So, their future is still uncertain. The co-existence of four territorial language communities has given rise to a complex situation because the language frontiers do not match the political and administrative boundaries separating the autonomous communities. Consequently, communities of same-language speakers are subject to different regional jurisdictions (and even to different State jurisdictions in the cases of Catalan and Basque).

2. Television's legal framework: powers of the autonomous communities in the field of broadcasting media

The current distribution of powers between the State and the autonomous communities on broadcasting matters is a fairly faithful reproduction of the general decentralising process and its results. Since the 1978 Constitution, the situation has changed from a completely centralised audio-visual system monopolised by Radiotelevisión Española to one in which the autonomous communities now have very wide-ranging powers on such matters. Basically, they have the ability to create and manage their own public service radio and television networks. On the other hand, the "autonomic" broadcasting model is wholly coherent with the general dynamics of the reorganisation of the Spanish communications system, characterised by a lack of planning, coherence and consensus; a model which has "gradually taken shape as a result of the political decisions taken as and when the facts of social reality have imposed themselves" (Carreras, 1996: 217).

The complex power framework of the autonomous communities in the field of electronic media is shaped at four legal levels:[6]

1. Constitution. Article 149.1 states that it is the State's responsibility to set the basic norms on media matters, and the autonomous communities' responsibility to develop and execute these basic norms, depending on the provisions contained in the respective Statutes of Autonomy.

2. Statutes of Autonomy, through which autonomous communities formally assume powers. Up to the beginning of the 1990s, there were major differences between statutes regarding radio and television; the "fast lane communities" theoretically had more powers on these matters than the rest. But since the "autonomic pact" between the Partido Popular (PP, centre-to-right wing) and PSOE (Spanish Socialist Party) in 1992, these powers have become virtually the same in all autonomous communities. This means that now they can all formally create and manage their own radio and television stations even though, as we shall see further on, only six of them have done so far.

3. Spanish Parliament Acts. Since the promulgation of the Radio and Television Statute (ERTV, 1980), State legislation on broadcasting matters has evolved from clearly restrictive positions for regions – even openly contradicting the Statutes of Autonomy, as could be seen in the first period between 1980 and 1988 – towards greater recognition and respect for the autonomous communities' powers, as could be seen in the period between 1993 and 1998. The tangle of restrictions and obstacles contained especially in the previously mentioned Statute and the Third Channel Act (1983) was overcome on several occasions by the daring actions of the Basque and Catalan autonomous governments.

As a result of the new political scenario, Acts passed after 1993 gave authorisation to the autonomous communities to create cable and satellite channels and granted them wide-ranging powers on local over-the-air and cable television.

4. Acts of the autonomous communities. They establish the legal framework for broadcasting at autonomous communities' level, copying almost literally what the ERTV states for Radiotelevisión Española (RTVE), and develop some aspects of regional power contained in the national Acts for cable telecommunications, satellite television and local over-the-air television.

The Partido Popular came into power after their victory in the Spanish general elections of 1996 at the same time as digital satellite television began to be implanted. It seems that this marked the beginning of a new period in the definition of the power framework of autonomous communities on broadcasting matters. In reality, the advance of deregulation and the multiplication of channels is "deflating" the centre-periphery conflict originated in the "broadcasting era". In 1997 and 1998, the regional public broadcasting corporations created around 10 satellite channels (see section 7.2.1) and a further two terrestrial channels (the second channels of Televisió Valenciana and Televisión de Andalucía).

3. Television's institutional and business structure in Spain

The Spanish television system has four levels that are clearly very different: State public service television (Televisión Española, TVE), National private television (Tele Cinco, Antena 3 TV and Canal Plus), regional television (10 "autonomic" channels belonging to six corporations) and local television (between 850 and 900 stations) (the last two are dealt with in detail in sections 4.3 and 4.4).

TVE is the oldest television corporation in Spain (it was launched on 28 October 1956). It is a public corporation included in the Grupo RTVE, the country's biggest audio-visual company, which also includes Radio Nacional de España (RNE), TVE Temática and TVE Internacional. The overall budget of the Grupo RTVE for 1999 is 266,269 million Pesetas (236,794 in 1998), of which public subsidies only cover 11,043 million. In Spain there isn't a licence fee system, so public television at both national and regional levels is financed by public subsidies and commercial revenue, mainly from advertising. Consequently, TVE is yet another actor in the advertising market, which has earned it a great deal of criticism from its competitors. On the one hand, private television companies accuse it of dual funding and unfair competition, whereas other sectors of society consider that this dependence on commercial funding jeopardises the quality of its programming and is detrimental to its function as a public service. In this sense, in 1998 the European Union ruled against TVE's – and the "autonomic" channels – "unfair competition" in relation to

National private networks; in December of the same year the European Commission had planned to start violation proceedings as a consequence of State subsidisation of TVE. In the mid 1980s, at the peak of TVE's monopoly, TVE's advertising revenue managed to cover the whole operating budget and even the budgets of the other companies belonging to the RTVE corporation. But with the advent of private television networks in 1990, this revenue began to shrink while TVE's indebtedness expanded. Now, RTVE sources put the accumulative debt figure at the sum of 765,243 million Pesetas (see www.rtve.es).

The main Act that regulates the existence and operation of TVE is the Radio and Television Statute (ERTV). It establishes an organisational model that favours political control over it by the government through the appointment of its Director General. This control, and its effects on programming (especially on the news), together with its indebtedness, have been the cause of political disputes over the last 10 years. TVE has two national over-the-air channels, TVE-1 (La Primera) and TVE-2 (La 2, launched in 1966), and 17 regional centres, one in each autonomous community, which produce and broadcast regional programmes (See section 4.2.1).

Private national television comprises three companies which broadcast one channel each, as stipulated by the 1988 Private Television Act. The Act contains various anti-concentration provisions meaning that each shareholder can only hold a maximum of 25 per cent of the company's share capital and participation in more than one company is forbidden (central government reformed the Act in November 1998 and raised the shareholding ceiling to 49 per cent). In addition, the Act includes obligations connected with programming and commercial advertising, which were adapted in 1994 to the stipulations contained in the Television Without Frontiers Directive.[7]

The three private channels began broadcasting between the end of 1989 and the beginning of 1990. They are Antena 3 TV, currently controlled by Telefónica, Banco de Santander and the press company Recoletos (whose main shareholder is the British group Pearson); Telecinco, whose reference shareholders are Mediaset-Fininvest (Italy), the Kirch group (Germany), the press company Correo (leader of the Spanish regional press market) and the publishing group Planeta; and Canal Plus, the only over-the-air Pay-TV, controlled by Canal Plus France and by the PRISA group (publisher of the newspaper El País, among other media). In 1993, the two uncoded private channels began to challenge the audience leadership and advertising revenue of TVE's La Primera.

In a very short space of time, Telecinco and Antena 3 TV have had quite a turbulent history of shareholding changes, including irregularities and major losses in the first few years. This was particularly so in the case of Telecinco, which had to incorporate image and programming changes as a result of dwindling audience figures and criticism of their entertainment-

based content (game shows, magazines, reality shows and talk shows). In 1997, after the changes, this channel had a net turnover figure of 54,330 million Pesetas – with 53,635 million in advertising revenue and 9,000 million in profit – and had become one of the most profitable private television networks in Europe. Antena 3 TV's turnover figure was 63,054 million Pesetas (equivalent to total commercial revenue). The number of employees in 1997 were 273 in Telecinco and 1,673 in Antena 3 TV,[8] respectively. In 1998 and according to Sofres data, TVE's La Primera was the audience leader in Spain (Mainland and Balearic Islands), with a 25.5 per cent share (La 2 reached 8.8 per cent, so together they accounted for 34,3 per cent), whereas Antena 3 TV reached 22.8 per cent and Telecinco accounted for 20.4.

From the outset Canal+ opted for a completely different strategy, which has proved to be highly profitable. It was formed as a Pay-TV – without any competition in Spain – with a programming schedule based on films and football. Despite the fact that its audiences are very small in terms of its share, the channel had over a million and a half subscribers in 1997 and had a net turnover figure of 70,762 million Pesetas, of which only 3,628 million came from advertising, and operating profits of 13,371 million Pesetas. In 1997 the company had 744 employees.[9] In 1998 its mean share was 2.4 per cent.

Both TVE and the three private channels offer satellite television. Antena 3 and Telecinco offer versions of their programming on their respective channels which are broadcast by various satellite systems, in both analogue and digital versions, with coverage in Europe and Latin America. TVE is a shareholder in the digital television platform Distribuidora de Televisión Digital-Vía Digital (whose majority shareholder is Telefónica). For its part, Sogecable-Canal Plus owns 80 per cent of the shares in the digital television platform Canal Satélite Digital. A subsidiary of TVE, TVE Temática, produces six specialized channels for Vía Digital, whereas Sogecable-Canal Plus provides Canal Satélite Digital with ten channels. At the end of 1998, Vía Digital had 300,000 subscribers whereas Canal Satélite Digital had 600,000.

4. Structure and characteristics of television in the regions

4.1. Introduction: a rich, complex scenario

The transformation that the Spanish television system has undergone in terms of its territorialisation in the last 15 years can indeed be described as spectacular: it has gone from being a rigidly centralised system, with just one national actor, to a situation where the regional and local levels are well represented and constitute an inevitable reference. The different types of regional television proposed by Moragas and Garitaonandía in *Decentralization in the Global Era* (1995) can be found in Spain: "decentralised television" (most regional centres of TVE), "regional off-

the-network television" (TVE Catalunya or TVE Canarias), "independently managed television" (autonomic channels), "regional television with supra-regional, national or international coverage" (once again, all "autonomic" channels, as they are broadcast also by satellite) and "local television with regional outreach" (Telenova in Palma de Mallorca and Canal 4 in Pamplona, for example).

Of all these experiences, the most important one is undoubtedly the "autonomic" public service channels, whose era began in 1982 when Euskal Telebista was created. With a joint share at the end of the 1990s between 15 per cent and 17 per cent of television audiences in Spain and a total turnover figure of almost 120,000 million Pesetas (all the budgets of the six regional broadcasting corporations in 1995, including both radio and television, combined), these television stations broadcast a total of 10 regional over-the-air channels and the same number of satellite channels. To give some idea of the importance of "autonomic" channels within the Spanish television system, it is worth pointing out that they (together with Canal Plus) have purchased exclusive broadcasting rights for the Spanish professional football league for the 1989-2003 period (here it should be borne in mind that football is the country's number one audio-visual resource as far as audience ratings are concerned). The Federación de Organismos de Radio and Televisión Autonómicos (FORTA) is the umbrella organisation for these broadcasters. (See section 4.3.3.).

4.2. Regional structure of national television stations

4.2.1. State public service television (TVE)

The decentralised organisation of TVE can be traced back to the regional centres of Barcelona (1959) and the Canary Islands (1964), though it did not become the object of a systematic initiative until the early 1970s. Between 1969 and 1971, TVE implemented a regional centre creation plan which included the centres of Seville, Valencia, Bilbao, Oviedo and Santiago de Compostela. Shortly after, in 1973-74, the transmitter network was technically modified to allow for off-the-network broadcasts from these centres besides those that were already being broadcast from pre-existing centres (Barcelona and the Canary Islands). In 1974 the first regional news programmes were broadcast on weekdays. TVE's initial division of Spanish territory had very little to do with the cultural, language and historic divisions of the country (Sampedro, 1997), and basically responded to geographical and technical criteria (the regional stations' coverage).

With the return of democracy and the implantation of "the State of autonomous communities" came TVE's adaptation to the new regional reality through the Radio and Television Statute, which established that public service television would create "specific radio and television

programming for broadcasts in the territorial area of the corresponding nationality or region" (Article 130) even though this programming would have to be "additional to the national programming broadcast by the two existing channels" (Fourth Additional Provision). The new political scenario coincided with the corporation's "Golden Age", marking the start of a period of expansion and consolidation of TVE's regional structure which lasted up to 1988. By that time the public corporation had completed its map of regional delegations and enabled the network to broadcast regional windows in all autonomous communities (basically regional news programmes and magazines for one and a half hours a day from Monday to Friday, in two different timeblocks). Parallel to this, the new headquarters of TVE Catalunya were opened in Sant Cugat near Barcelona in 1983. With 50,000 metres square of floor space, it was the second largest TVE complex, the first one being the central headquarters in Madrid.

In 1984 TVE began to broadcast off-the-network advertising in all the regional centres. In 1988 it raised 16,800 million Pesetas in regional advertising revenue, a figure that went up to 23,000 million in 1989. But, from that time on, competition from the new private and "autonomic" channels sparked off a constant drop in advertising revenue (See Table 3).

Some authors have suggested that RTVE's interest in regional centres in the 1980s was motivated in part by a desire to compete with "autonomic" channels on their home ground (Maneiro, 1989: 153) for political reasons.

In fact, as from 1988 and coinciding with the consolidation of the "autonomic" channels, TVE's regional policy lost its drive. Regional disconnections were concentrated on the second channel whose audience was much smaller. As from 1993 there was a general reduction in the activities of TVE's regional centres, according to the corporation's cutback strategy to cope with the severe financial crisis it was going through, which stemmed from the strong competition of the new private channels. On the other hand, a situation of political conflict between the State and the three autonomous communities which had pioneered the creation of regional channels (Basque Country, Catalonia and Galicia) was followed by a situation of more "fluid" relations between PSOE in power and the nationalist political forces governing in Catalonia and the Basque Country after the socialists lost its absolute majority in the Madrid parliament in the general elections of June 1993.

On the other hand, the regional television scenario changed substantially with the creation of channels in three autonomous communities (Madrid, Valencian Country and Andalusia) governed at that time by PSOE, thus creating a transitory situation of "political equilibrium" in this field. Therefore, all of this meant that the open confrontation strategy between TVE and the "autonomic" channels, which was characteristic of the 1982-1986 period, progressively turned into a new, more co-operative scenario.

In this context, between 1992 and 1995, there was a debate about the possibility of using TVE's second channel and its regional centres as the basis for future "autonomic" channels in those communities that still had not created one although they were indeed interested in doing so: Murcia, Aragon and the Canary Islands, mainly, but also Asturias, Cantabria, the Balearic Islands and Navarra. The possibility of joining forces and sharing expenses in the field of regional television was as attractive to these autonomous communities as it was to TVE. However, there wasn't any agreement on any issue between RTVE's Director General and the representatives of the previously mentioned autonomous communities during the Socialist mandate, which ended in 1996, because of the legal and political obstacles that riddled the operation. In 1998, under the Partido Popular government, conversations were resumed and, so far, have already led to the signature of an agreement between TVE and the governments of the Balearic Islands and Navarra, which were of the same political ilk as the Madrid government.

TVE's regional organisation

As described, TVE has regional centres in the 17 capitals of the autonomous communities, which in turn manage an extensive network of delegations of a provincial scope. Each centre is headed by a "territorial delegate" who is responsible for the delegations of both TVE and RNE. This position is usually held by the television centre's director. Each centre has between 40 and 50 permanent employees, which include journalists, technicians, administrative staff and service staff. The centres of Catalonia and the Canary Islands have bigger workforces and carry on many more activities than the rest of the regional centres, as described below.

Each regional parliament appoints an advisory board, who theoretically represents the people of the corresponding autonomous community, to "control" the activities of the respective TVE's regional centre, though his powers are merely consultative. The mechanism for electing these boards has given rise to a high degree of politicisation of the same.

Regional centres are funded by means of annual allocations from the TVE's general budget. The revenue generated by off-the-network advertising is centralised in Madrid. So, the delegations participation in them is indirect. Table 3 shows the evolution of this revenue, whose drop is partially due to competition from the new national channels and mostly due to the consolidation of "autonomic" channels, which are much more competitive when it comes to securing regional advertising.

Table 3. Advertising revenue of TVE's regional centres (in millions of Pesetas)

1988	1989	1991	1994	1995	1996
16,781	23,000	17,000	10,218	9,545	6,740

Source: *Anuarios RTVE*. 1996 figures: Infoadex. Does not include TVE Canarias.

TVE's regional programmes' audience[10]

In general, TVE's regional broadcasts, and newscasts in particular, are well received by viewers, especially, as one would expect, in those communities without "autonomic" channels where the regional midday news was top in audience ratings in that timeblock in 1997, except in Aragon and the Balearic Islands where it was surpassed by Antena 3 TV's regional newscast (See table 4).

The regional newscasts' shares varied between 26 per cent in the Balearic Islands and 64 per cent in La Rioja, the mean being 39 per cent, which is certainly significant in the multichannel, ultra-competitive television scenario in Spain. This confirms that local and regional information is one of the contents that viewers demand most.

The future of TVE's regional centres

Given the failure of the attempts to turn some regional centres into the future basis for "autonomic" channels in those communities that did not have one, the future of TVE's regional structure was marked by uncertainty up to the beginning of 1998. In the first year of PP's government (1996-1997), the corporation's management looked into the possibility of closing them or transferring them to the private sector or to autonomous communities, but this plan did not come to fruition. So, TVE's regional structure continues to survive with scarce activity (except, as always, TVE Catalunya and TVE Canarias). However, at the beginning of 1998 RTVE announced a regional programme expansion plan in some autonomous communities in co-operation with the respective regional governments, which contributed to the project's funding. The first firm sign of this plan's implementation was the signature of an agreement between TVE Baleares and the autonomous government of that community in January 1998. By way of this agreement, the autonomous government contributed 250 million Pesetas per year to increase the regional disconnections of TVE Baleares up to 13 hours a week, with own-produced programmes about issues in the archipelago. TVE signed a similar agreement with the government of Navarra for an identical sum. In 1999, TVE plans to generate a revenue of 1,300 million Pesetas through agreements of this type (source: www.rtve.es).

4.2.2. Regional activities of national private television stations

Private television was not legalised in Spain until 1988, and in 1989 the three companies that had been granted governmental licences began broadcasting. Private television, by legal obligation – the licence conditions specify that coverage of new channels must be national – and financial reasons in particular, broadcast nationally. However, the Private Television Act allows for the possibility of regionalising the broadcasts in 10 different areas, of which only five coincide with the territorial boundaries of a single

autonomous community. This is due to the fact that the territory had been divided on purely technical criteria which didn't take the political and language frontiers between communities into account. Despite that, the reality of the situation has ended imposing the existing borders of the autonomous communities to the private channels' disconnections. Some private urban television stations deserve special mention, as these have extended their coverage beyond the limits of the city or metropolitan area that they initially broadcast in, and have in fact become regional-scale channels (See section 4.4).

Table 4. Audience for TVE's regional newscasts in 1997 (timeblock 2.00 p.m. to 2.30 p.m., Monday to Friday)

	Mean audience	Mean share (%)	Ranking
Aragon	84,000	27.2	2
Asturias	104,000	49.2	1
Balearic Islands	55,000	26.1	2
Cantabria	50,000	36.7	1
Castilla y León	243,000	39.8	1
Castilla-La Mancha	158,000	38.5	1
Extremadura	94,000	38.6	1
La Rioja	48,000	63.8	1
Murcia	78,000	34.1	1
Navarra	37,000	40.4	1

Source: Servicio de Comunicación de RTVE.

Of the three national private Spanish channels, the most active in terms of regionalisation has been Antena 3 TV, which has created delegations in the country's principal capitals and cities (Seville, Malaga, Saragossa, Palma de Mallorca, Bilbao, Santa Cruz de Tenerife, Las Palmas de Gran Canaria, Oviedo, Santiago de Compostela and Valencia), and a second headquarters in Barcelona which has a major programme production potential. As in the case of national public television, the initial function of these delegations was to act as agencies for the national channel. However, some of these centres soon began broadcasting off-the-network programmes. So, since 1993, Antena 3 TV has regularly broadcast disconnected programmes in Catalonia, Aragon, the Valencian Country, Galicia, the Balearic Islands and the Canary Islands. In the 1997-98 period, in Aragon, the Balearic Islands and the Canary Islands, these regional windows mainly consisted of a regional 30-minute newscast at midday from Monday to Friday,[11] supplemented by the regional current affairs programme *A fondo* at midday on Saturdays. In Catalonia, Galicia and the Valencian Country, this weekly programme

was broadcast on a discontinuous basis. Taking advantage of its decentralised structure, Antena 3 broadcasts several daily blocks of regional advertising in the autonomous communities where it has the infrastructure allowing it to do so. In March 1999, the network's News director, Ernesto Sáenz de Buruaga, announced the setting up of daily regional news disconnections in Catalonia, the Basque Country, the Valencian Country, Andalusia and Castilla y León, from 2.00 p.m. to 2.30 p.m. (*La Razón*, 9-3-1999).

The Antena 3 TV delegation in the Balearic Islands has the distinguishing feature of being owned by an "associate centre", in other words, a company whose majority shareholder is Grupo Serra (a Balearic multimedia conglomerate), which has a collaboration contract with Antena 3 TV according to which the Palma de Mallorca centre produces and broadcasts a 30-minute regional news programme (*Noticias*, from 2.00 p.m. to 2.30 p.m.) and a weekly magazine called *Tiempo de ocio*. It also acts as a news agency for Antena 3 TV. In exchange, it exploits five daily advertising disconnections.

So, Antena 3 TV's regional strategy copies TVE's two-capital feature, with a structure based in the Madrid headquarters and a production centre in Barcelona, and provides daily regional windows in those autonomous communities that do not have their own channel. Antena 3 TV's regional broadcasts are based on regional news programmes, though the channel has had some experience with other kinds of disconnected programmes, like electoral programmes during regional elections and live broadcasts of national cultural or sporting events, especially football matches, with specific commentating in Catalan for Catalonia.

Telecinco's regional experiences are much more recent. By 1998, this channel had set up news agencies in principal Spanish cities and had broadcast some films in Catalan via the dual system (a technique also used by Canal Plus). At the beginning of 1998, Telecinco created a subsidiary company called Atlas which, in co-operation with local partners, began to implant a network of regional associate centres and started broadcasting regional news programmes from 8.00 a.m. to 8.15 a.m. on weekdays in Catalonia (in association with the newspaper *La Vanguardia*), in Galicia (in association with the Grupo Voz) and in the Basque Country (in association with the Grupo Correo). Besides producing regional broadcasts, these delegations act as the channel's news agencies. Later on, Telecinco launched daily regional off-the-network newscasts in the Valencian Country, Madrid and Andalusia. It is worth pointing out that on Saturdays Telecinco broadcasts Basque pelota from 6.00 p.m. to 7.30 p.m., off-the-network for the Basque Country, Navarra and La Rioja.

In short, until 1997 it could be said that the national private TV networks hadn't yet considered exploiting the potential of small scale television in any great depth, but the high interest showed by Antena 3 TV and Telecinco for regional disconnections in 1998 y 1999 seems to indicate that

they have realized the high efficiency of this kind of programming in order to increase and keep the audiencies.

4.3. Specifically regional coverage broadcasters: "autonomic" channels

The advent of "autonomic" television in Spain, with ETB's first broadcast in the evening of 31 December 1982, signified a transcendental mutation of the television scenario because it broke TVE's monopoly, in force since 1956. Furthermore, the creation of the first regional broadcasting corporations (Euskal Irrati Telebista in the Basque Country and Corporació Catalana de Ràdio i Televisió in Catalonia) caused major political commotion throughout the country because it signified an "audio-visual secession with a strong symbolic content" (Sampedro, 1997).

4.3.1. Three stages

The implantation of "autonomic" television took place in three stages. The first one involved the creation of corporations in the Basque Country (Euskal Irrati Telebista, EITB, 1982), in Catalonia (Corporació Catalana de Ràdio i Televisió, 1983) and in Galicia (Compañía de Radio y Televisión de Galicia, 1985). All three communities share the fact that they are historic nationalities with a different native their own language and culture, and the fact that the autonomous governments were controlled by political forces other than the one in office since 1982 at national level (PSOE). Such cultural and political tension between the centre and periphery goes to explain, to a large extent, the early creation of these three "autonomic" channels, as well as the recovery process of the native languages in these nationalities, in which radio and television obviously played a key role.

Euskal Irrati Telebista

The Act creating the public corporation Euskal Irrati Telebista (Basque Radio and Television, EITB) was promulgated by the Basque parliament (the Partido Nacionalista Vasco having the majority) on 20 May 1982. The channel Euskal Telebista ("Basque Television", ETB1 as from 1986) started broadcasting regularly on 2 February 1983. Consequently it is the oldest "autonomic" channel. The main objective, which was explicitly recognised by ETB, was the normalisation of the Basque language and culture, as the Act creating it stipulated. To fulfil that mission, ETB's programming was broadcast mainly in Basque, and even programmes bought in were dubbed. This language option meant that the new channel's degree of penetration was very low because of the limited knowledge of the Basque language by the Basque population (only about 25 per cent of it understands and speaks it fluently). That led EITB to create a second regional channel in 1986 (Garitaonandía et al., 1989: 252), which basically broadcasts in Spanish with the aim of shattering the social isolation of the

first channel and reaching the Basque audience as a whole. However, ETB2 was created by flouting all the established legal instruments and provoked acute conflict between the Basque government and central government which, in the end, accepted it as something already done. This strategy has proven to be very well thought out in the long term, as ETB's annual share of the Basque television market has gone up. In 1993 ETB's two channels accounted for a joint share of 16.2 per cent whereas in 1998 it had reached 23.2 per cent. That same year, ETB1 broadcast 7,500 hours of programming and ETB2 some 6,800 hours (GECA, 1999). EITB's budget for 1998 was 14,538 million Pesetas and it had some 700 employees.

Corporació Catalana de Ràdio i Televisió

In May 1983, the Catalan parliament, with a nationalist coalition majority (Convergència i Unió), promulgated the Act creating Corporació Catalana de Ràdio i Televisió (CCRTV), and regular broadcasts by the Catalan television station (TV3) began in January 1984. The cultural and language issue was also a key element in its origins, as they had been the subject of claims from pro-Catalan positions (Parés, Baget and Berrio, 1981). That's why a strictly single-language (Catalan) programming strategy was chosen for TV3, and even programmes bought in were dubbed. Following on in the footsteps of Basque television, and in view of the imminent controlled liberalisation of the Spanish television market, in 1989 CCRTV created a second channel for Cataluña, Canal 33, with a specialised profile (sport, music, culture...) wholly in Catalan, too. To do this, the autonomous government chose to take the route of consumed facts, just like the Basque case, therefore flouting all the legal instruments in force and doing so against central government's will. Both channels belong to a single business and organisation structure, Televisió de Catalunya. TV3's and Canal 33's implantation has been very successful thanks to its innovative and ambitious programming strategy based on regional information, football live broadcasts and, since 1994, home produced soap operas. It should also be borne in mind that over 95 per cent of the population of Catalonia understands Catalan. In 1998 TVC headed the television audience ratings in Catalonia (taking the sum of both channels), with a 29.3 per cent share. CCRTV's budget in 1998 was 36,000 million Pesetas. It has 1,500 employees.

Compañía de Radio y Televisión de Galicia

The Act creating Compañía de Radio y Televisión de Galicia (CRTVG) was promulgated in June 1984, and the Televisión de Galicia (TVG) channel started broadcasting regularly at the beginning of 1986. The Galician television experience is somehow different from the experience of its Basque and Catalan predecessors. Although it shares the objective of contributing to Galician language and culture standardisation with the other two, it is not a nationalistic project, since the political force behind it

was the Partido Popular, a party of national scope. On the other hand, Galicia is an autonomous community with less financial capacity than Catalonia or the Basque Country which, as we shall see later on, is reflected in its television. In 1998 CRTVG had a budget of 12,000 million Pesetas and it employed 600 people. In 1998 TVG reached a mean share of 18.1 per cent. in the Galician TV market.

Second Stage

The second stage of "autonomic" television history is the 1986-89 period, which was characterised by the consolidation of the scenario of this type of television, and momentary political re-equilibrium between the "old" and "new" regional broadcasters. In fact, in a context marked by the launch of the second Basque and Catalan channels, PSOE decided to create regional broadcasting corporations (and the corresponding "autonomic" channels) in three communities it governed: Andalusia, Madrid and the Valencian Country. Of the three new channels, only the Valencian one has a specific language mission, as the other two are broadcast in Spanish-speaking only communities, although all of them have a regional scope and mission.

Radio y Televisión de Andalucía

In December 1987 the Andalusian parliament promulgated, almost unanimously, the Act creating the public corporation called Empresa Pública de la Radio y Televisión de Andalucía. Canal Sur started broadcasting on 27 February de 1989. Very soon it reached a 20 per cent market share in Andalusia, but in mid-1993 it suffered a drop in audience figures and advertising revenue which led RTVA to a major identity crisis, which was made worse by the political instability of the regional institutions. Following the 1996 regional election, a coalition government was formed between PSOE and Parido Andalucista which cleared the outlook for the Andalusian television which, in 1997 and 1998, expanded its activities by creating a second over-the-air channel (Canal 2 Andalucía, which came into operation in June 1998). Since the new management team's arrival, Canal Sur's audience figures in Andalusia have made a major recovery, and even reached 19.5 per cent of the TV market share in 1998. The key to this recovery was the reorientation of programming towards regional contents. A good example of this was the 1997 launch of news disconnections in each of the eight andalusian provinces, where Canal Sur has permanent delegations. RTVA's budget in 1998 was 23,159 million Pesetas and it had 1,100 employees.

Radiotelevisión Madrid

In 1984 the parliament of the Community of Madrid passed an Act creating the public corporation called Radiotelevisión Madrid (RTVM). Telemadrid's first broadcasts took place in May 1989 in the midst of controversy between those who considered that an "autonomic" channel

in a community without a different language or a marked historic or cultural personality was not very justifiable and those who postulated that Madrid was a metropolis-region with different specific characteristics and problems, and a highly concentrated potential audience that could benefit the channel's advertising profitability. Audience data appear to support the second argument: in 1998 Telemadrid recorded a significant 20.6 per cent share in the autonomous community of Madrid, the second higest share of an "autonomic" channel after TV3.

Two facts marked Telemadrid's beginnings and evolution: tough competition from the television market of the country's capital, the headquarters of the five national channels, and the political instability of the regional institutions. The latter of these two meant that RTVM did not receive any subsidies from the Community of Madrid in the initial years of its existence and that it had to develop at the expense of becoming severely indebted (debts calculated at over 27,000 million Pesetas in 1997). This financial instability was the main reason why RTVM did not have its own facilities until the beginning of 1997, when its various offices, which until then were spread out in several rented buildings, were transferred to facilities belonging to it in the "audio-visual park" of the Ciudad de la Imagen (near Madrid). RTVM employs 650 people and its budget for 1998 was 14,690 million Pesetas.

Since the Partido Popular came into power at central government and regional (Madrid) level, one of the hottest questions about Telemadrid's future was the possibility of it being privatised, as proposed by PP in its 1996 manifesto. However, the legal obstacles in the way of this initiative (the 1983 Third Channel Act forbids privatisation of "autonomic" channels, although it can obviously be modified) and the "cooling" of the privatisation projects have delayed its application.

Radiotelevisió Valenciana

In December 1987, the Valencian parliament, with a PSPV-PSOE majority, approved an Act creating the public corporation called Radiotelevisió Valenciana (RTVV). The first Valencian channel, Canal 9, started broadcasting in October 1989. The birth of this new station should be interpreted in a context of conflict generated by the fact that the Catalan television station (TV3) could be picked up in the Valencian Country as from 1987 as a result of civilian initiatives. Reactions to this, both positive and negative, helped spread an awareness that it was possible to "create an "autonomic" channel for Valencians in Valencian" (Xambó, 1996).

One of the objectives that justified Canal 9's creation, according to its backers, was the standardisation of the Valencian language and culture. However, this mission has become somewhat complicated due the Valencian Country's complex language situation in which two different language communities co-exist: a Spanish-speaking one and a majority

Valencian-speaking one. On the other hand, the language identity of the latter gave rise to a conflict that confronted those party to the idea of considering Valencian as a different language and those who believed that it was a variant of the same language as the one spoken in Catalonia and the Balearic Islands. This complex reality is reflected in the channel's language option, which broadcasts many of its first channel programmes in Spanish and the rest in a Valencian that does not always respond to the "standardised" version of that language. The channel's language ambiguity became more acute since the PP came into power in the autonomous government in 1995 with the support of Unió Valenciana, as this political formation supports the idea of Valencian and Catalan being separate languages.

One of the main initiatives of the new regional government concerning television was the launching of the second "autonomic" channel, Notícies 9, in October 1997, with an annual budget of 2,000 million Pesetas. (In late April 1999 Televisió Valenciana announced that its second channel would be renamed as Punt Dos). The new channel was created in order to diversify what Televisió Valenciana could offer in terms of programming, to raise the number of hours of broadcasting in Valencian (the new channel's majority language) and to reinforce aspects of public service and attention to the community itself that the Act creating Radiotelevisió Valenciana imposed. So, regional news became Valencian television's major strategic bet to compete in the multichannel future and, at the same time, fulfil its public service duties. In 1998 RTVV's budget was 18,500 million Pesetas and it had 1,000 employees. That same year Canal 9 reached a 18.2 per cent market share, while Notícies 9 recorded a 0.9 per cent market share.

Third Stage

After the stabilisation of the "autonomic" television scenario, as from 1996 a third stage in the evolution of these channels appeared to open up, coinciding with the boom of digital satellite television. That gave rise to two parallel and apparently contradictory phenomena: growing deregulation and privatisation pressure on the television system, and the creation of channels for new digital platforms by the "autonomic" channels. The first sign of change came in 1994 with the inclusion of a declaration in favour of privatising public service television networks in the PP's manifesto at a time when PSOE exerted influence over the two national public channels and three "autonomic" channels. However, as soon as they came to power, PP postponed the application of privatising proposals and wholly involved the "autonomic" channels it controlled in the digital television battle which was initially impregnated with a strong political content. In reality, as we shall see section 7.2.1., all the regional broadcasting corporations have created satellite channels for one of the two Spanish digital platforms (or both), and some for analogue distribution in Europe (Astra satellite) and America (Galeusca channel).

4.3.2. Structure and organisation of "autonomic" channels

According to the Radio and Television Statute Act, all the Acts creating regional broadcasting corporations had to reproduce RTVE's organisational and control structure, and that is in fact what has happened: the organisational chart of the regional corporations includes a Director General, appointed by the regional government,[12] who has wide-ranging administrative and managerial powers; a board of directors (generally 12 members), appointed by the regional parliament which has powers to set the general budgetary, programming and advertising criteria, and to control the Director General's activities; and an advisory board, representing the corporation's employees and representative organisations of the general public, which only has consultative powers. Each corporation generally owns two or more independent companies, whose capital is wholly public, which are in charge of the different radio and television stations. Their directors are appointed or dismissed by the Director General. Within these companies, the structure once again is vertical, as the Director appoints the management staff and, in particular, the news director, so it can be asserted that the autonomous government's influence can be direct and transversal in this organisation.

4.3.3. Federación de Organismos de Radio y Televisión Autonómicos (FORTA)[13]

In order to cope better with the new competitive situation unleashed by the emergence of private channels, in 1989 the six regional broadcasting corporations formed an umbrella organisation called FORTA (Federación de Organismos de Radio y Televisión Autonómicos), which took over from ORTA (Organización de Radiotelevisiones Autonómicas), created in 1986 by the public service networks of Catalonia, the Basque Country and Galicia. One of FORTA's priority objectives was to build a buying group that would allow the channels involved to access the national and international audio-visual rights' markets with more competitive purchasing power, and to create a stable framework to close co-production agreements. As far as rights buying is concerned, the most noteworthy operation was an exclusive contract for the broadcasting rights of the Spanish professional football league matches for the period 1989-1997, together with Canal Plus, for a total sum of 54,500 million Pesetas. In 1997 FORTA once again bought the broadcasting rights for football up to the year 2003 by means of a contract signed with Audiovisual Sport, the company which owns the rights and has Sogecable (Canal Plus), Antena 3 TV and Televisió de Catalunya as its shareholders. The strategic importance of this operation is very clear to see if we consider that football regularly heads the lists of the most-watched programmes. As a result, the "autonomic" channels assured their access to a valuable support in order to capture audiences and advertising revenue. To avoid conflicts with RTVE (the Third Channel Act reserves preferential rights for it when it comes to buying

broadcasting rights of national sporting events), FORTA agreed to cede the signal of matches to TVE so that it could broadcast them in autonomous communities that did not have their own television stations.

Table 5. Dates when Acts creating regional broadcasting corporations were passed and channels came into operation

Autonomous community	Public corporation / Channels	Act passed	Broadcast start date
Basque Country	Euskal Irrati-Telebista	5-1982	
	• ETB 1		12-1982
	• ETB 2		5-1986
Catalonia	Corporació Catalana de Ràdio i Televisió	5-1983	
	• TV 3		9-1983
	• Canal 33		4-1989
Galicia	Compañía de Radio y Televisión de Galicia	6-1984	
	• TVG		7-1985
Madrid	Radiotelevisión de Madrid	6-1984	
	• Telemadrid		5-1989
Andalusia	Radiotelevisión de Andalucía	12-1987	
	• Canal Sur		10-1989
	• Canal 2 Andalucía		2-1998
Valencian Community	Radiotelevisió Valenciana	12-1987	
	• Canal 9		2-1989
	• Notícies 9 / Punt Dos		10-1997

As far as rights buying is concerned, the purchase of film and series packages from North American majors should also be mentioned. Likewise, there have been several programme co-production initiates, like *El joven Picasso*, which was recorded in 1990 and received an award at the New York television festival in 1994. In other cases, news and entertainment programmes have been subcontracted to private production companies for joint broadcast by several "autonomic" channels. However, co-production activity cannot be considered to be anywhere near as important as the purchase of television rights. On the other hand, images exchanges have indeed been an important initiative, especially for news programmes. So, FORTA has created a daily image exchange similar to Eurovision that all associate "autonomic" channels take part in.

FORTA's third main objective was to get "autonomic" channels to join the EBU as full members so that they could benefit from the image and programme exchanges that it organises. However, central government and RTVE have repeatedly put obstacles in the way of this operation Consequently, Spanish "autonomic" channels are the only public broadcasters in Europe that do not yet belong to the EBU. Interest among them in joining has however dwindled because they have been able to access the desired exchanges by means of bilateral agreements with the organisation.

4.3.4. Audience[14]

The "autonomic" channels' total audience has remained very stable within the Spanish multichannel scenario. Between 1990 and 1996, the "autonomic" channels' share (annual mean) in Spain as a whole only fell by one percentage point (from 16.4 per cent to 15.4 per cent) in a context marked by the unstoppable rise of the private channels Telecinco and Antena 3 TV at the virtually total expense of TVE's two channels. The latters' share fell from 76.6 per cent in 1990 to 34 per cent in 1997 (See Table 6). The audience figures for "autonomic" channels in 1997 were especially positive, because they gained almost two percentage points of the share, situating them at 17.4 per cent. This is an extraordinary figure if we consider the growing competitiveness of the Spanish television market, which has been much tougher since the digital platforms came into operation in 1997 and 1998. However, in 1998 "autonomic" channels' audience figures dropped 0.8 per cent, situating their share at 16.6 per cent. It should be pointed out that TV3 was the Spanish channel that grew most in 1998 (+1.06 per cent), situating its share at 23.6 per cent in Catalonia (Canal 33's share was 5.7 per cent).

Table 6. 1990-1998 Share evolution in Spain, by television channel (Mainland and the Balearic Islands, in %)

	1990	1991	1992	1993	1994	1995	1996	1997	1998
TVE1	52.4	43	32.6	29.8	27.6	27.6	26.9	25.1	25.5
La 2	20.2	14.2	12.9	9.6	9.8	9.2	9.0	8.9	8.8
Telecinco	6.5	15.9	20.8	21.4	19.0	18.5	20.2	21.5	20.3
Antena 3	3.7	10.1	14.7	21.1	25.7	26.0	25.0	22.7	22.8
Canal+	0.3	0.9	1.7	1.9	1.9	2.3	2.2	2.5	2.3
Autonomic	16.4	15.5	16.5	15.6	15.2	15.4	15.4	17.4	17.1
Others	0.5	0.4	0.8	0.6	0.8	1.0	1.3	1.8	3.4

Source: Sofres, 1998.

It should be pointed out that the shares in Table 6 refer to Spain as a whole and, therefore, do not reflect "autonomic" channels' penetration in their

respective broadcasting territories. Due to the fact that "autonomic" channels as a whole do not cover 100 per cent of the Spanish population, the audience figures for each one in their respective official reception areas should be analysed individually.

Within the "autonomic" channel group, those with the lowest share in their own autonomous community are the first Basque channel (with a 6.7 per cent share in 1998), the second Catalan channel (5.7 per cent) and the second Valencian channel (0.9 per cent). In the first two cases, this low penetration rate can be explained by the specialist, minority character of their programming which, in ETB1's case, is due to the use of the Basque language. It is worth pointing out the positive evolution of audience figures for ETB1 and Canal 33 between 1993 and 1997. Notícies 9/Punt DO3 low implantation level is due to the fact that it has been created only recently (by the end of 1997).

Table 7. 1994-1997 Television audiences, by autonomous community (% share)

	Andalusia				Catalonia				Galicia				Madrid			
	1995	1996	1997	1998	1995	1996	1997	1998	1995	1996	1997	1998	1995	1996	1997	1998
TVE	34.3	33.5	32.3	33.2	29.1	28.1	25.1	25.2	37.4	36.3	35.0	36.0	32.7	32.4	30.4	31.3
TVE1	26.1	25.6	24.1	24.9	21.6	21.0	18.5	18.5	28.8	27.8	26.5	27.9	23.4	22.9	21.3	22.1
La 2	8.2	7.9	8.2	8.3	7.5	7.1	6.6	6.7	8.6	8.5	8.5	8.2	9.3	9.5	9.1	9.3
Auton.	16.4	16.3	19.5	19.6	25.9	26.1	29.3	29.4	15.4	16.5	18.5	18.1	20.0	19.0	20.3	20.6
C Sur	16.4	16.3	19.5	19.5	-	-	-	-	-	-	-	-	-	-	-	-
TV3	-	-	-	-	21.4	19.1	22.0	23.6	-	-	-	-	-	-	-	-
Canal 33	-	-	-	-	4.3	6.9	7.1	5.7	-	-	-	-	-	-	-	-
TVG	-	-	-	-	-	-	-	-	15.4	16.5	18.5	18.1	-	-	-	-
TM	-	-	-	-	-	-	-	-	-	-	-	-	20.0	19.0	20.3	20.6
Canal 9	-	-	-	0.0	0.2	0.1	0.3	0.2	-	-	-	-	-	-	-	-
ETB-1	-	-	-	-	-	-	-	-	-	-	-	-	-	-	-	-
ETB-2	-	-	-	-	-	-	-	-	-	-	-	-	-	-	-	-
Private	46.6	47.1	44.3	-	44.4	45.2	45.1	-	46.7	46.5	45.6	-	47.0	48.1	48.2	-
Others	2.7	3.1	3.9	41.9	0.6	0.6	0.5	43.6	0.5	0.7	0.8	43.9	0.3	0.5	1.1	44.5
				5.4				1.8				2.0				3.6

Shares for the other channels in 1998 varied between a minimum of 16.5 per cent for ETB2 and a maximum of 23.6 per cent for TV3. The latter of these two figures is the highest reached by TV3 in the nineties, and is particularly commendable given the competition that Televisió de Catalunya "creates for itself" with Canal 33. So, if the shares of both channels are added together, Televisió de Catalunya was the most-watched television network in Catalonia (29.3 per cent). ETB, for its part, recorded a spectacular increase in its audience ratings, as the share of 13.8 per cent in 1992 (both channels) went up to 23.2 per cent in 1998.

Table 7 (continued)

	Valencian Community				Basque Country				Other regions (less Canarias)				Mainland and Balearic Islands			
	1995	1996	1997	1998	1995	1996	1997	1998	1995	1996	1997	1998	1995	1996	1997	1998
TVE	32.6	31.2	28.9	29.5	36.2	34.7	31.3	31.1	46.5	46.3	44.2	43.5	36.8	35.9	34	34.3
TVE1	24.2	23.1	21.2	21.7	26.7	25.2	22.4	22.3	35.4	35.1	33.2	33.0	27.6	26.9	25.1	25.5
La 2	8.4	8.1	7.8	7.8	9.5	9.5	8.8	8.8	11.1	11.2	11	10.5	9.2	9	8.9	8.8
Auton.	19.6	18.4	21.9	20.6	20.7	22.8	24.7	23.2	3.9	3.7	4.4	4.1	15.4	15.4	17.4	17.1
C Sur	-	1		0.0	-				-	-	-	-	-	-	-	-
TV3	1.1	0.1	0.9	1.0	-	-			-	-	-	-	-	-	-	-
Canal 33	-	-	0.4	0.4	-	-			-	-	-	-	-	-	-	-
TVG	-	-		-	-	-			-	-	-	-	-	-	-	-
TM	-	-		-	-	-			-	-	-	-	-	-	-	-
Canal 9	18.5	17.3	20.6	18.2	-	-			-	-	-	-	-	-	-	-
Not. 9	-	-	-	0.9	-	-	-		-	-	-	-	-	-	-	-
ETB-1	-			0.9	5.9	6.7	7.5	-	-	-	-	-	-	-	-	-
ETB-2	-			-	14.8	16.1	17.2	6.7	-	-	-	-	-	-	-	-
Private	46.9	49.2	47.6	-	42.6	41.8	43.1	16.5	48.8	48.8	49.4	-	46.8	47.4	46.8	-
Others	0.9	1.2	1.5	47.4	0.5	0.7	0.9	43.6	0.8	1.2	1.9	48.6	1	1.3	1.8	45.2
				2.6				2.0				3.7				3.4

Source: Sofres, 1996, 1997, 1998 and 1999.

Another channel with a considerable rate of penetration which has remained more or less stable, with an upward tendency, is Telemadrid. Its share went up from 18.8 per cent in 1993 to 20.6 per cent in 1998. These figures are commendable because Telemadrid competes in the toughest television market in Spain, that is, the television market of the country's capital. What's more, it does not have the advantage of broadcasting in a language specific to an autonomous community (for the purposes of product differentiation). The Galician channel, which had a lower share than the "autonomic" system as a whole in 1993 (15.5 per cent), experienced a significant three-percentage-point rise between that year and 1997. Canal Sur's and Canal 9's shares, which had recorded a drop between 1993 and 1996, recovered spectacularly in 1997: 19.5 per cent for Canal Sur and 20.6 per cent for Canal 9. However, in 1998, the latter's share was of 18.2 per cent.

4.3.5. "autonomic" channels' funding

According to the Third Channel Act, "autonomic" channels can be funded by subsidies from the corresponding regional governments, by product sales and by participating in the advertising market. Consequently, they have adopted a conduct similar to TVE's, that is, they take recourse to advertising as a primary source of funding, though most of the resources

in all cases are provided by the respective regional governments. Table 8 shows that five of the eight autonomic channels broadcast over 25,000 minutes of advertising in 1997, whereas TVE1 broadcast over 46,000 minutes and La 2 some 30,000 minutes.

Table 8. 1994-1997 Evolution of commercial advertising time, by television channels (in minutes)

	1994	1995	1996	1997	Daily mean, 1997
National					
TVE1	28,961	30,297	38,119	46,456	127
La 2	21,028	20,238	22,127	29,860	82
Telecinco	57,363	55,317	58,573	62,459	171
Antena 3	59,291	53,043	55,836	66,419	182
Canal Plus	4,140	3,820	4,437	6,449	18
Regional					
Canal Sur	22,433	21,123	23,979	29,849	82
TV3	18,671	22,574	21,803	26,143	72
Canal 33	3,191	3,743	6,784	10,148	28
ETB 1	9,285	11,691	8,610	11,014	30
ETB 2	20,403	22,322	17,467	23,097	63
TVG	22,381	25,433	25,278	30,782	84
TVM	35,796	34,618	34,228	38,969	107
Canal 9	26,495	28,708	27,636	31,712	87
Total	329,438	332,927	344,877	413,357	

Source: Sofres, 1995, 1996 and 1997.

These figures, which are relatively moderate in the Spanish television context, can be explained by two main factors: the smaller number of broadcasting hours of "autonomic" channels and the fact that their small markets are less attractive to advertisers. Obviously, those autonomous communities with smaller populations (Basque Country) and/or a lower per capita purchasing power (Galicia) offer less attractive advertising markets than those with a bigger population (Catalonia, Madrid, Andalusia and the Valencian Country). This is reflected in the absolute advertising revenue of the respective broadcasters (See table 9).

The advertising revenue of Televisió de Catalunya stands out. In 1997 it was almost twice the amount of its closest second, Telemadrid. The lowest income produced by advertising corresponds to TVG and ETB's two channels.

Table 9. Advertising revenue, by "autonomic" channel

	1994	1995	1996	1997
TVC (TV3+C33)	10,572	13,645	14,353	14,460
Telemadrid	6,675	7,046	7,215	7,713
Canal Sur	4,040	4,405	4,038	5,088
Canal 9	3,699	4,576	4,050	4,368
TVG	2,250	2,337	2,385	2,440
ETB (1 and 2)	2,143	2,503	2,533	2,717
Total	29,379	34,512	34,574	36,786

Source: Infoadex and Sofres, quoted in Díaz Nosty, 1995 and 1996. *Noticias de la Comunicación*, several 1998 issues.

Table 10 shows the budgets for these regional broadcasting corporations for 1998 and their television advertising revenue in 1997. With all due care when commenting on figures that can be interpreted in several different ways, it can be asserted that CCRTV is the largest regional system, with an annual budget that is much higher than the others. Advertising revenue is more or less proportionate to the corporations' overall budgets and, in 1995, it accounted for 32.5 per cent of the CCRTV budget, 30.5 per cent of the RTVA budget, 14.3 per cent of the CRTVG budget, 30.6 per cent of the RTVM budget, 15.3 per cent of the EITB budget and 29.8 per cent of the RTVV budget (it should be borne in mind that the overall budget refers to all of the corporation's activities, including both radio and television). The budgetary differences are covered by subsidies. It was found that the Galician and Basque corporations' ability to finance themselves is much less than the ability of other regional systems. In any event, the "autonomic" channels' remarkable dependence on public funds is very clear to see.

4.3.6. "autonomic" television projects that have not materialised

Mention was made earlier of the issue concerning projects to "federalise" TVE's second channel, whose objective was to offer those communities that did not have their own television stations at the beginning of the 1990s the opportunity to have their own programming. The main obstacle in the way of these communities having access to their own channels was financial, bearing in mind the high costs that creating and running a television station involve. A further obstacle, sometimes even greater, was the lack of political stability in some regional governments which prevented medium and long-term projects in the audio-visual field from being pursued.

Three communities stood out in terms of looking to have their own channels: Murcia, Aragon and the Canary Islands. The parliament of Murcia passed an Act creating the public corporation called Radiotelevisión Murciana (RTVMur) in November 1988, and then asked central government to grant it a frequency for the corresponding channel.

But that frequency was never granted and the Murcian television never materialised. This was also due in part to the enormous financial effort that it would have involved for the small community of Murcia. However, it did create the radio station Onda Regional. In 1994 the Murcian parliament annulled the public corporation RTVMur, though the radio station has continued broadcasting as a public company.

Table 10. Budgets, advertising revenue (in millions of Pesetas) and number of employees, by regional broadcasting corporation

	Budget 1998	Ad. revenue 1997	Employees
Corp. Catalana de Ràdio i Televisió	36,000	14,460	1,500
Radiotelevisión de Andalucía	23,159	5,088	1,100
Radiotelevisió Valenciana	18,500	4,368	1,000
Radio y Televisión de Madrid	14,690	7,713	650
Euskal Irrati Telebista	14,538	2,717	700
Com. Radio y Televisión de Galicia	12.000	2.440	600

The community of the Canary Islands passed an Act creating a public broadcasting corporation in 1984. Since then the issue of having its own television station has been high on the political agenda of the archipelago. In the early 90s, the autonomous government offered a 1,500 million-Peseta subsidy to any national television network, whether public or private, which was prepared to create a major regional window for the islands. One of the ideas that had been worked on in the 1980s and most of the 1990s was conceding TVE Canarias' facilities and staff from the autonomous community to turn it into an "autonomic" channel. However, this project did not come to fruition because of high operating costs and disagreements between the insular government (headed by Coalición Canaria-Partido Popular) and the Madrid government (PSOE). The 1996 national elections brought this matter up again, as Coalición Canaria, PP's partner in the insular government, demanded the creation of an "autonomic" channel as one of the conditions for lending its support to PP in the central parliament. The formula chosen by the Canarian government was that of granting the task to a private company, something which the Third Channel Act expressly prohibited, and which the central government opposed. After much controversy, in November 1998 the Spanish Ministry of Trade and Industry granted a licence to set up Canarian television on condition that the corporation's model was public (public funding and parliamentary control). At the end of 1998, the Canarian government approved the television station's budget for the next seven years (a total of 17,550 million Pesetas)[15] and programming was awarded to Productora Canaria de Televisión, which is 40 per cent owned by Sogecable (a subsidiary of Grupo PRISA). RTVC plans to start broadcasting sometime in 1999.

Aragon is another community which lacks its own channel. However, it was the one which came closest to having one. In 1984 the Aragonese government asked the central executive to grant it a television frequency even before the Act regulating the broadcasting corporation was passed in the regional parliament. The Act was passed in April 1987 and, one month later, the Aragonese government presented an "autonomic" channel project. But a short while after, PSOE lost the regional elections in Aragon and the project entered into a phase of uncertainty. In 1990 an agreement was reached in the regional parliament and negotiations started for the creation of Aragonese television. But central government did not grant the corresponding frequency and political disputes ended up with the project being frozen at the beginning of 1993, when the premises for the channel's headquarters had already been built and fitted out. To salvage the situation, in 1993 the regional government signed an agreement with Antena 3 TV by which the private channel committed itself to producing and broadcasting specific off-the-network programming for Aragon, with a total of 780 hours per year, in exchange for a payment of 1,300 million Pesetas from the autonomous government. The demise of the government lead to the annulment of the agreement with Antena 3 TV. The new socialist cabinet entered into negotiations with TVE to expand disconnections from the regional centre of Saragossa despite the fact that all the other political forces opposed this action. Finally, with the demise of this government, the project was definitively abandoned.

4.4. Local television

Spain is one of the EU countries with the richest and most varied experience in local television matters. This dates back to the creation of Televisió de Cardedeu in Catalonia in 1981. The enormous diversity of the local audio-visual landscape, its instability and the absence of a legal framework for this sector until 1996 have marked its evolution and hindered its quantification and analysis.

The most realistic estimates show that there are between 850 and 900 local television stations[16] in Spain, whose activities range from sporadic broadcasts coinciding with special events in the locality to round-the-clock broadcasting (like Barcelona Televisió or Canal 4 in Pamplona). It is estimated, however, that there are only about 100 stations of a reasonable size with stable activities. Most of the programmes, or at least those broadcast in prime time, are produced by the stations themselves and are fundamentally news based. Most of them broadcast over the air because of the minimal development of cable in Spain, though with the recent proliferation of cable networks, channels broadcasting via this medium are on the increase. The autonomous communities with the highest number of stations in operation in 1996 were Andalusia (300 stations), Catalonia (140 stations) and the Valencian Community (114 stations). About 20 local stations are operating in Galicia (Ledo, 1998). According to the Estudio

General de Medios, in 1997 some 550,000 people watched on a daily basis these channels' broadcasts.[17]

A study on the sector's situation in Catalonia commissioned in 1997 by Barcelona Provincial Council revealed that of the 140 odd local television stations in Catalonia, 49 per cent were municipally owned, 32.2 per cent belonged to private not-for-profit organisation and 11.7 per cent were commercial. Most of them operate in localities with fewer than 15,000 inhabitants and only nine broadcast in cities with over 60,000 inhabitants. Ninety percent of these television stations have regular programming, whether weekly or daily (Proelsa, 1997). It should be pointed out that in October 1998 the Canal Local Català consortium was created. It is a company formed by 11 local television stations in Catalonia and two on the Balearic Islands broadcasting in Catalan (TV Eivissa and Canal 4 Mallorca) which have begun to broadcast the same programmes in prime time (9.30 p.m. to 10.30 p.m.) from Monday to Friday.[18] This initiative welcomes new local television partners in the Catalan language area.

However, the development of urban or local television stations has been restrained or limited by the influence of "autonomic" channels in the audio-visual arena. In many cases, the latter have filled the space of new demands for metropolitan communication by covering the needs of big cities like Barcelona, Madrid, Seville, Malaga, Bilbao, San Sebastian, Valencia, La Coruña, Santiago de Compostela, etc.

Another serious obstacle in the way of local television development in Spain was the absence of regulation for this sector. It was not until December 1995 that the Spanish parliament passed the Local Television Act, which was very controversial – it was accused of being too restrictive – and, furthermore, it has not been fully developed yet. This Act stipulates that in principle there can only be one local station in each municipality and that the corresponding town/city council has priority over its management. The autonomous government can grant a second licence in those places where a municipally managed television station has been created. It also stipulates that broadcasts must initially be limited to the main urban nucleus of the population. The granting of broadcasting frequencies remains in the hands of central government. Currently there are two prevailing tendencies in the sector: the formation of local multimedia groups and the association of stations to create wider-ranging networks.[19]

Of the existing stations, it is worth highlighting those that can be considered as local-regional television stations because their programmes are broadcast beyond a purely urban environment. Among the most important ones are BTV (Barcelona), Valencia TeVe, Canal 4 (Pamplona), Televisión de Castilla y León, and Telenova (Palma de Mallorca). In some cases, like Canal 4, Telenova and Televisión de Castilla y León, for example, the absence of an "autonomic" channel in the autonomous community

where the urban channel is located has stimulated that expansion, which occasionally has a political undercurrent (besides a purely commercial one). Political conflict can be considered in all cases, as regional coverage of an urban channel is not provided for in the Local Television Act and even violates the terms of the Third Channel Act.

Telenova is one of the two television stations in the city of Palma, on the island of Majorca (together with Canal 4), but its coverage extends to the whole of the island. This channel, which is owned by the principal communications group on the Balearic Islands (Grupo Serra), started broadcasting in November 1996, mostly in Catalan. Between 9.00 a.m. and 4.00 p.m. it rebroadcasts the international music channel MTV, and from 4.00 p.m. to 12.00 midnight it broadcasts a general programme schedule consisting mainly of own-produced programmes, based on Majorcan current affairs. It is basically funded by advertising and is currently making losses.

Canal 4 came into operation in 1997 as Pamplona's "local" television, but since July 1998 its programming began to be broadcast throughout the autonomous community of Navarra and it could be picked up in bordering areas on the communities of La Rioja and Aragon. In fact, this channel, which has 70 employees,[20] presents itself as "the television of Navarra". It is a completely private initiative led by Navarran entrepreneurs which has round-the-clock broadcasting (it produces 6 hours a day itself) on a frequency that the community of Navarra had set aside for a hypothetical "autonomic" channel. The consent of the Navarran executive – Unión del Pueblo Navarro government in coalition with PP – and the central government to Canal 4's activities gave rise to a political interpretation that maintained that it was an initiative that attempted to counterbalance the penetration of the "autonomic" Basque channel ETB2 in the community of Navarra.[21] However, in March 1999 the Spanish Government closed down three broadcasting stations outside Pamplona which were transmitting Canal 4 to other parts of Navarra.

Barcelona Televisió (BTV) is the only Spanish case of a public television station that broadcasts in a big city. This channel, created by Barcelona City Council in 1985, can be picked up in Barcelona and its metropolitan area. In September 1997 it abandoned the format it had been using since its creation and launched a new programming model which is managed by a private company. Multiprogramming and multibroadcasting are the key features of this new television format: programming is divided into microspaces devoted to thematic areas like sport, music, art, film, town planning, etc. It is an urban, specialised television model in which the magazine format plays a major role. Ten "neighbourhood stations" feed the channel with images and news of their respective areas. BTV has an annual budget of 600 million Pesetas, which it mostly gets from subsidies from Barcelona City Council (advertising revenue is very low). In

September 1998 it had reached a daily mean of 180,000 viewers according to the station's own sources.

Another outstanding example is Televisión de Castilla y León. It is a company that was created at the beginning of 1998 by a consortium of local television stations from that autonomous community, headed by Canal 29 from Valladolid. At the end of 1998 its associates included local television stations (over-the-air and cable) and other audio-visual companies in the cities of Valladolid, Salamanca, León, Burgos, Zamora, Ávila, Soria, Segovia, Ponferrada, Palencia, Miranda de Ebro and Medina del Campo. Televisión de Castilla y León distributes two hours of daily programming centred on the autonomous community itself to its associates. These two hours of programming are produced by the different television stations that go to make up the consortium. This mini-schedule includes news and sports programmes, debates and documentaries.

One final example is the city of Valencia's television, Valencia TeVe, which started broadcasting in February 1997 with over seven hours of daily programming. It is a general television station in Spanish which can be picked up in the whole of Valencia's metropolitan area. It is promoted by the regional newspaper *Las Provincias*. In November 1997 this channel had a mean daily audience of 144,000 spectators, according to Sofres data. In autumn 1998 it was broadcasting 10 news programmes live on the hour (lasting between five and 15 minutes), a local newscast from 2.00 p.m. to 3.30 p.m., sport, a history programme (*Recuerdos de Valencia*, from 7.45 p.m. to 8.00 p.m.), interviews (*La hora de Julio Tormo*, from 8.05 p.m. to 10.00 p.m.), a reports programme (*La Crónica*) and films. In the first half of 1998 it did live broadcasts of important events in the city of Valencia, like the parade of the Three Wise Men and the "Fallas" (traditional festivals).

5. Programming analysis

5.1. General characteristics of television programming in Spain in the 1990s

In general, the Spanish over-the-air channels' television programming responds to a general, "popular" model except in the cases of La 2, Canal Plus and Canal 33.[22] The multiplication of channels that came with the advent of "autonomic" and private television did not produce any specialisation of television contents (Prado, 1993). In the past RTVE had two channels on the air whose programming corresponded to the European public service model (a general first channel, TVE1, and a second channel, TVE2, with minority contents). The shattering of the public television monopoly meant a dramatic rise of the programme offer, though the structural and organisational copies of TVE made by the new "autonomic" channels, and the general vocation of the new private channels Antena 3 TV and Telecinco, have led to an absolute prevalence of

programming structures of this type. Although the advent of "autonomic" channels signified an increase in "proximate programming", the private networks accentuated the commercial nature of their television contents by increasing the number of imported series and studio entertainment programmes (talk shows and variety magazines, infotainment...).

Since 1995, programming strategies in Spain have evolved along the same lines as the general trends in Europe, with a consolidation of the channels' own production of series, a slight decline in large format shows (as well as reality shows) and an increase in factual programming. As far as small-scale television is concerned, a consolidation of contents of this type has been found, especially of regional news. The programmes with the biggest audiences in Spain are still football live broadcasts and American films, although in house made series have had a major impact on audience ratings, especially on private channels (*Farmacia de Guardia*, on Antena 3 TV; *Médico de familia*, on Telecinco) and some "autonomic" channels (*Nissaga de Poder*, on TV3; *Goenkale*, on ETB).

The evolution and distribution of television consumption by channel shows that in 1998 less television was watched in general in Spain as a whole (210 minutes per day), and that "autonomic" channels have maintained its TV market share around 17 per cent. This suggests that the Spanish public watches less television but spends proportionally more time watching "autonomic" channels.

In November 1998, the audience for conventional television (general national public and private networks and "autonomic" stations) was 96.7 per cent in Spain as a whole. The audience for non-conventional television was 3.3 per cent, a percentage that was distributed as follows: 43.5 per cent for the two digital platforms, 29.5 per cent for foreign satellite channels and 26.4 per cent for local television stations.[23]

5.2. Televisión Española's (TVE's) regional offer

In 1992 each regional centre of TVE, except Catalonia and the Canary Islands, broadcast a mean of 239 hours of disconnected programming consisting basically of a 30-minute daily news programme from Monday to Friday and a magazine of the same duration and periodicity. Both were broadcast between 1.00 p.m. and 3.00 p.m. In 1996 the regional centres broadcast a mean of 277 hours of disconnected programming consisting generally of two daily news programmes which, in some cases, were supplemented by weekly news programmes and occasional live broadcasts coinciding with cultural, sporting or electoral events in corresponding the autonomous community. Sixty-nine percent of regional broadcasts as a whole – excluding Catalonia and the Canary Islands – consisted of news programmes, 14 per cent of various types of programmes, generally magazines or weekly reports, and 14.5 per cent of regional advertising.

Disconnections were broadcast in low-audience timeblocks (between 1.30 p.m. and 2.30 p.m. and before evening prime time) and were very dependent on national programming strategies. So, unplanned live broadcasts, especially of sporting events, shifted or even eliminated the regional windows. On the other hand, with the exception of the Catalan centre, regional centres have very little involvement in production for national broadcasts. This is basically limited to the contribution of news and images to national newscasts and sports programmes.

Table 10. TVE's regional disconnections (1996)

| | Total hours | News | Percentage of total | | | |
			Other progs.	Adverts	Electoral progs.	Total 1992
Andalusia	250	69.2	-	24.2	6.4	229
Aragon	263	58.6	20.8	18.7	1.7	247
Asturias (Principality of)	286	66.9	22.0	10.9	-	227
Balearic Islands	341	60.0	10.8	28.7	-	239
Canary Islands	n.a.	n.a.	n.a.	n.a.	n.a.	1,309*
Cantabria	239	78.7	11.0	10.6	-	215
Castilla-La Mancha	274	72.9	23.0	4.2	-	201
Castilla y León	271	70.8	0.5	28.3	-	203
Catalonia	2,006	n.a.	n.a.	n.a.	n.a.	1,148
Extremadura	218	88.9	0.7	10.2	-	**
Galicia	306	64.4	25.9	9.5	-	232
Madrid	215	83.0	3.9	8.4	-	274
Murcia (Region of)	237	79.0	-	12.3	8.7	254
Navarra (Comunidad Foral)	354	55.0	34.0	11.0	-	241
Basque Country	308	58.6	26.5	11.2	1.9	312
La Rioja	304	63.8	27.4	8.9	-	226
Valencian Community	297	64.6	2.0	20.0	1.8	251
Mean excl. Cat. & Canaries	277	69.0	14.0	14.5	1.4	239

* 1993 data.

** Joint broadcast with Castilla-La Mancha.

Source: Servicio de Comunicación de RTVE and RTVE yearbooks.

The production and programming activities of the TVE centres in Catalonia and the Canary Islands are much greater than in the rest of the regional centres. As mentioned previously, the first "decentralisation" of TVE took place in Barcelona and the Canary Islands (which can't be covered with an over-the-air signal from mainland Spain). This difference is reflected in the names of the delegations in Catalonia and the Canary Islands which, officially, are "programme production centres", whereas the

rest are simply "territorial centres". However, this title is only fitting in Catalonia's case, as it is the only one in Spain that has always had a remarkable degree of production activity for national broadcasts. On the other hand, TVE Cataluña and TVE Canarias are similar in terms of regional programming as they broadcast an annual total of disconnected programmes that is much higher than TVE's other regional centres.

In 1973 TVE Catalunya tentatively started regular off-the-network broadcasting, and this centre's production and programming have had their ups and downs. TVE Catalunya's changes can, to a large extent, be explained in political terms. In the 1980s, central public service television was under a Socialist influence, whereas the nationalist coalition CiU governed in the community of Catalonia. Financial factors also influenced TVE Catalunya's evolution, especially from the early 1990s when the financial crisis that lashed national public television could be felt in regional centres. In just a few years, TVE Catalunya's workforce went down from 1,300 to 750 employees. This gave rise to a strategic redefinition of the Catalan centre, which went from trying to compete directly with TV3 to strengthening its contributions to national programming (Giró, 1993). So, since the beginning TVE Catalunya has been providing TVE's two channels with a wide range of programmes (sports, game shows, serials, music, children's programmes, news programmes, debates, magazines...), establishing itself as TVE's second production centre, the first being Prado del Rey in Madrid. Likewise, some regional programmes that are successful in Catalonia jump into national programming. This is the case for the report and investigation programme *Línea 900*.

In 1992, TVE Catalunya produced 965 hours of programmes for the two State channels and broadcast 1,148 hours of disconnected programmes, a daily mean that is just over 3 hours, consisting mainly of newscasts and news programmes in Catalan. TVE Catalunya's change of direction in 1996 meant strengthening its own programming, especially news. So, in 1997 the Catalan centre broadcast a record figure of 2,003 hours of regional programming (of which 1,387 or 69 per cent were in Catalan). Most of these disconnections (73 per cent) were broadcast on La 2. However, the number of hours contributed to national broadcasts (961 in 1997) remained stable in comparison to 1992 figures.

Very few data relating to audiences for TVE Catalunya's regional programming have been made public. Those available indicate that most of the programmes have a modest following, with the exception of news programmes. In any event, competition provided by Televisió de Catalunya's two channels in the regional television market stops TVE Catalunya's programmes from having high audience figures. Of programming in Catalan on La Primera, the newscast from 2.00 p.m. to 3.p.m. should be highlighted (weekdays). This is cut back to 30 minutes (2.00 p.m. to 2.30 p.m.) at weekends. On La 2, a news programme is

broadcast from Monday to Friday from 8.00 p.m. to 8.30 p.m. Several talk shows have been broadcast on the second channel in prime time, such as *L'ou o la gallina* on Saturday evenings. At the end of 1998 a documentary series called *Història del Barça* was broadcast on Mondays (8.30 p.m. to 9.00 p.m.) to commemorate F.C. Barcelona's centennial, and a Catalan current affairs report programme called *Gran angular* on Wednesdays from 8.30 p.m. to 9.00 p.m. along the lines of those that TVE Catalunya has been producing since the end of the 1970s, with special attention being paid to social and cultural issues and which, as in the case of *Giravolt,* have been kept on the screen for years though in a somewhat irregular fashion (the first period from 1973 to 1978 and the second period from 1994 onwards). Once a week *135 escons* is broadcast. This programme is about the activities of the members of the Parliament of Catalonia and, in spite of being considered "minority viewing", in 1998 it had been on the air for 13 seasons.[24] Since November 1998, *Seqüències,* a single theme debate preceded by a film has been broadcast on Saturday nights. Likewise, *Xifres i lletres,* a game show on every day from Monday to Thursday (7.30 p.m. to 8.00 p.m.) was launched in December 1998.

For its part, TVE Canarias broadcast 1,309 hours of regional programmes in 1993, a mean of three and a half hours a day, including newscasts (lunchtime and evening), magazines, debates, current affairs programmes, sport... The greater autonomy of the centre on the Canary Islands is explained by its peripheral, distant location in relation to mainland Spain. Unlike TVE Catalunya, the Canary Islands centre plays a very minor production role for the State channels.

5.3. "autonomic" channels

Analysis of the "autonomic" channels' programming schedules shows that they are general and similar in terms of genre composition to those of national television networks, both public and private (See Table 11).

According to Sofres data, the "autonomic" channels as a whole devoted a mean of 28.9 per cent of their programming schedules in 1998 to fiction. This proportion is similar to TVE's for the same year (30.8 per cent) and is a long way off the figure corresponding to private channels (49.7 per cent). The Valencian television station Canal 9 has the highest percentage (44.6 per cent) of fiction in its programming schedule, whereas TVG (17.5) and Notícies 9/Punt 2 (12.1 per cent) have the lowest.

What differentiates "autonomic" channels from national or international ones is, undoubtedly and yet again, their proximity, whose main form of expression is the news. According to an internal report by the Institut de la Comunicació (InCom) at the Autonomous University of Barcelona about "proximate programming" in Spain[25] which analysed a sample of the regional programming schedules for 1997, approximately one third of total programming on Spanish "autonomic" television is based on "proximate

contents", and newscasts were the predominant programme type within that proportion. As a programming strategy, "autonomic" channels devote an average 16.7 per cent of their programming schedules to news, whose contents mostly deal with current affairs of the respective region, although the main editions have a more global vision, in other words, they aim to recount national and international current affairs, too. On the other hand, despite it occupying pride of place in most programming schedules, fiction still has little "proximate contents", as imported products, especially from North America, predominate.

Table 11. Different channels' programming composition, by programme type (1998)

	national					"Autonomic"									Auton. mean	TVE mean	Priv. mean
	TVE1	La 2	Tele5	Ant.3	C+	CST	TV3	C33	ETB1	ETB2	TVG	TVM	C9	N9			
Fiction	38.0	23.6	49.8	45.2	54.3	26.1	39.6	25.0	24.2	45.2	17.5	26.3	44.6	12.1	28.9	30.8	49.7
Misc.	11.6	14.9	16.2	25.9	9.4	25.3	34.4	15.2	13.1	10.3	29.5	17.4	24.7	13.7	20.4	13.2	16.8
News	23.9	7.4	21.5	12.3	5.0	22.3	14.3	4.2	10.6	13.9	24.1	23.4	14.3	23.6	16.7	15.6	12.9
Culture	9.9	27.3	2.0	0.2	8.6	6.5	1.1	23.6	23.7	14.0	7.3	15.1	1.8	17.0	12.2	18.6	5.4
Game shows	4.5	2.6	2.5	5.3	0.0	4.9	3.7	0.0	4.7	3.6	4.5	0.9	2.6	5.2	3.3	3.5	2.6
Sport	4.0	16.4	0.9	0.6	17.6	5.5	3.6	13.1	16.4	2.8	9.5	5.0	2.7	15.4	8.2	10.2	6.3
Infoshow	5.3	0.8	4.1	1.3	0.0	3.0	3.2	1.3	2.8	8.7	1.7	10.0	6.5	0.0	4.1	6.6	1.8
Music	2.1	4.0	0.3	0.7	5.0	2.0	0.1	16.6	3.3	1.0	4.8	0.4	1.6	12.5	4.7	3.0	1.9
Religion	0.0	1.9	0.0	0.0	0.0	1.3	0.0	0.9	1.0	0.3	1.0	0.0	0.1	0.1	0.5	0.9	0.0
Bullfights	0.6	0.3	0.0	0.0	0 1	1 7	0.0	0.0	0.3	0.1	0.0	0.4	1.1	0.1	0.4	0.4	0.0
Telesales	0.0	0.0	2.7	8.6	0.0	1.4	0.0	0.0	0.0	0.1	0.0	0.0	0.0	0.0	0.0	0.0	3.7
Other	0.0	1.0	0.0	0.0	0.0	0.2	0.0	0.0	0.1	0.0	0.0	1.3	0.0	0.0	0.1	0.5	0.0

Does not include self-promotion, programming trailers, test charts, regional programming or advertising inserted between programmes.

Source: Sofres, 1998.

Despite that, since 1994 own-produced series have become one of the major trends of Spanish television. This trend has also been followed by "autonomic" channels with a great deal of success in terms of audience ratings. In fact, after Antena 3 TV, Televisió de Cataluña and Euskal Telebista were the pioneers of this trend, and "autonomic" channels are the ones which have invested most in their own series, with successful co-productions. Since 1994 TVC has produced and broadcast a dozen series which are generally well received by viewers. Several experiments have been done with sub-types, though soap opera is the predominating genre. ETB has broadcast several own-produced series, such as *Goenkale*, a series about daily life in an imaginary Basque village. In 1997 TVG broadcast the own-produced sitcom *Pratos Combinados* and Canal 9 began to broadcast the in house made series *A flor de pell* in the same year after having broadcast *Herència de sang*. In contrast, Canal Sur and Telemadrid's punctual home-produced fiction experiences have been unsuccessful, at least until September 1998, when Canal Sur launched

the home-produced soap *Plaza Alta,* with a remarkable audience acceptance.

Even though the "autonomic" channels have important programming trumps other than sports, in the following section we shall see that in recent years the audience figures have made it absolutely clear that football is undoubtedly the out and out star of national and "autonomic" programming schedules. With the purchase of broadcasting rights for Spanish professional sports league matches up to the year 2003, the "autonomic" channels have assured their livelihood in the battle for audience ratings. Regarding the proximity component, it is worth pointing out that matches involving teams from the autonomous community where the channel opertes are not always the ones with the highest ratings. Instead, encounters involving FC Barcelona or Real Madrid – and especially those involving both – are the ones at the top of audience ratings as the most-watched programmes in all Autonomous Communities.

So, three basic programming features of "autonomic" channels in Spain come to the fore: newscasts, soap operas – now produced more often by the television stations themselves – and sport, basically live broadcasts of Spanish football league matches.

In 1998 **Euskal Telebista** broadcast a total of 7,500 hours on the first channel (single-language channel in Basque), and 6,800 hours on the second (mostly in Spanish). The composition of the programming schedule for both of EITB's channels responds to a general model, although there is a degree of specialisation: ETB1 mostly broadcasts sports, music and children's programmes, whereas ETB2 broadcasts fiction (almost twice the amount) and news.

Given that recovery of the Basque language and culture is ETB's priority, its programming strategy is aimed at channelling the audience towards the first channel, which broadcasts programmes that attract large audiences and do not require any great degree of language ability, such as sport (especially football), in order to get Spanish speakers used to Basque. For that reason, ETB has fought to get exclusive rights for football, the Giro de Italia and the Vuelta al País Vasco, Basque pelota, Basque team basketball matches, etc. Likewise, big social and cultural events are broadcast live on the first channel for the same reason: to take advantage of an important event to attract the public. Along the same lines, ETB 1 mostly broadcasts children's programmes in Basque to attract and stimulate the youngest speakers. The second channel is understood as being an instrument used to secure the majority of the Basque audience's "fidelity" and to get them used to Basque by means of an occasional presence of this language in its broadcasts like, for example, in Basque language courses.

In spite of the efforts made to channel the audience towards the first channel, ETB2's share in 1998 was 16.5 per cent, that is, twice ETB1's. This

is basically due to the difficulties that the majority of the Basque population has in understanding Basque, though the improved language skills of the new generations may modify that reality over the coming years. Currently, 26 per cent of the Basque Country's population speaks Basque and a further 20 per cent can understand it.

Analysis of ETB1's programming schedule for the week from 3 to 9 November, 1997, reveals that "proximate programmes" accounted for almost half of this channel's contents. With this high percentage, ETB1 is the "autonomic" channel that offers the highest amount of this type of programming (excluding the second Valencian channel). On the other hand, ETB2's "proximate programmes" only accounted for a quarter of its programming schedule. Advertising is almost exclusively broadcast in Basque on ETB1; the station itself assumes the dubbing costs.

Along the general lines of all "autonomic" channels, ETB has also placed its bets on "proximate news". In 1997 it launched local disconnections in the news programme *Euskadi hoy*, from Monday to Friday (2.00 p.m. to 2.30 p.m.), on ETB2 for the provinces of Álava, Biscay and Guipúzcoa. Similarly, since 1998 the sports programme *El derby* (sundays, 9.30 p.m.) is broadcast in different versions for the three Basque provinces and Navarra (data from EITB, 1998).

ETB broadcasts as well a news programme aimed at the Basque-speaking zone beyond the French-Spanish border, called *Iparraldearen Orena*, although this is not a disconnection (it can be received throughout the whole transmission area of ETB). It is broadcast during the French *pre prime time*, at 1.00 and 7.00 p.m, lasting for 7 minutes.

Regular disconnections for Navarra (a 30-minute news programme on ETB2) were created in 1998, after ETB's coverage, at the initiative of private individuals, had "spontaneously" spread to that community, which is united by cultural and language links to the Basque Country (Basque is spoken in the north of Navarra). This regional window is an exception on the "autonomic" television scene and has the Navarran government's consent.

Regarding own-produced fiction, the daily series *Goenkale* should be mentioned. It is set in a fictitious village and stars a Basque family. *Goenkale* has become a social phenomenon and is highly successful with the audience since it started being broadcast in October 1994.[26] Within the same programme type there is a daily broadcast on ETB1 of the own-produced series *Benta Berri*, a sitcom about the owners of a Basque farm which has been turned into a rural tourism centre. A weekly series called *Jaun eta Jabe* was launched in March 1996 and narrates the life of a cook who becomes the *lehendakari* (president of the Basque Country). A 50-minute weekly series called *Maité* has been broadcast on ETB2 in Spanish, which is a romantic yet humorous story.

Televisió de Catalunya's (TVC's) model responds to the traditional dual public service television system: the first channel is general (TV3), with a predominantly popular programming schedule and most of the newscasts, and a second more specialised channel (Canal 33) aimed at satisfying minority tastes. Its target audience is younger and the types of programmes are mainly documentaries, cultural, music and sports programmes. In this sense, Canal 33's programming schedule in 1998 was clearly dominated by cultural programmes (23.6 per cent), music programmes (16.6 per cent) and sports programmes (13.1 per cent). In TV3's case, the prevalence of fiction (39.6 per cent) and news programmes is confirmed (22.3 per cent). The cultural and language issues are undoubtedly key components of Catalan television. Both channels only broadcast in Catalan and one of the main objectives of its programming is the normalisation of that language.

In the 1980s, Televisió de Catalunya set up a network of agencies in the capital cities of the four Catalan provinces, to which agencies in the cities of Valencia, Palma de Mallorca, Madrid, Bilbao and Perpignan (in the Catalan-speaking territory of south-western France) have been added. It also has delegations in several foreign cities (Paris, Brussels and Washington). The structure of regional centres in Catalonia supports the broadcast of TVC's news programmes in windows for each Catalan province. The programme is called *Telenotícies Catalunya*, and four separate editions of it are broadcast from 2.00 p.m. to 2.30 p.m.. In the first eight months of 1998, this programme had a 30.5 per cent share in Catalonia. TV3 also takes advantage of this structure to broadcast disconnected advertising. Since 1990 in the small Pyrenean territory of Vall d'Aran, TVC has produced and broadcast off-the-network a daily news programme in Aranese language.

"Proximate contents" accounted for over one third of TV3's programming in the week from 3 to 9 November, 1997. However, programmes of this type only accounted for one sixth of Canal 33's programming schedule. Like the rest of the "autonomic" channels, TV3 has a "universal" news programmes, the *Telenotícies*, which deal with regional, national and international news from a Catalan angle. Four editions are broadcast every day and are highly successful with the audience.

Also successful factual programmes have come out of TVC's factories. These include programmes like *El Cangur*, in which a group of children interview a famous Catalan person; *Vides Privades* (portraits of the daily lives of significant collectives); *Un tomb per la vida* (an in-depth exploratory of a famous person's life), etc. Another success is the weekly current affairs reports programme *30 minuts*, containing a high percentage of information about Catalan reality. This programme has won several national and international awards.

Regarding own-produced fiction, TVC began to experiment on a small scale in 1989. After the failure of *Quan es fa fosc*, a television series co-

produced with the North-american Lorimar, fiction with Catalan references produced in house has had a starring role in its programming schedules since the mid 90s. In 1994 the first of its own-produced soap operas called *Poblenou* was broadcast. It was highly successful with the audience (with a daily mean of 743,000 viewers). This was followed by *Estació d'enllaç, Secrets de família* (mean daily audience: 681,000 viewers), *Rosa, Sitges, Nissaga de poder* (734,000 viewers per day) and *Laberint d'Ombres* (500,000 viewers per day).

Likewise, TVC has produced and broadcast several television films which have achieved disparate ratings. In the last two years, some magazines with humorous tones and Catalan references have been highly successful with the audience: *Persones humanes, Sense Títol s/n, Força Barça, Ja hi som!* and *Malalts de Tele*.

The importance of programmes devoted to sport, and football in particular, on TVC should be pointed out. This includes the broadcast of first, second and even third division matches, though special emphasis is placed on the football, basketball and handball sections of F.C. Barcelona, without of course forgetting about other clubs in Catalonia and even the Balearic Islands.

Debate and interview programmes are usually broadcast on Canal 33 (*Paral.lel, Millennium*), as are cultural and music programmes (*Avisa'ns quan arribi el 2000, Sputnik*). On TV3, after the success of *Vostè jutja* (1985), talk shows like *La vida en un xip* (1989) and *Vox Populi* (1994) have been broadcast. Their generally good audience ratings have assured their prime-time broadcasting slots in the 1990s.

Some other strategic lines of TV3's programming over the last few years have included prime-time broadcasting of own-produced programmes with historic or geographical interest about Catalonia with a remarkable audience success (*Te'n recordes, Aquell 98, Catalunya des de l'aire...*). In January 1999, TVC launched the first docu-soap on television in Spain called *Bellvitge Hospital*.

Televisión de Galicia has one channel, TVG, which broadcasts almost exclusively in Galician. It has a general profile (based on news, accounting for 24.1 per cent of programming, and fiction, accounting for 17.5 per cent). TVG's limited budget (the lowest of all "autonomic" channels at 12,000 million Pesetas in 1998) may explain why there is a high percentage (29.5 per cent) of programmes that correspond to the "miscellaneous" section whose production is cheaper. In the week from 3rd to 9th November, 1997, "proximate programmes" accounted for over one third of the channel's programming. The volume of TVG's own productions in 1998 reached 75.2 per cent of the schedule, which amounted – including the Galicia TV satellite channel – to 14,095 hours, of which 7,330 corresponded to the over-the-air channel (GECA, 1999).

Lately, TVG's programming has tended towards entertainment – with numerous comedy, music and variety programmes – news and specialised programmes about Galician social and cultural reality. Of the programmes produced by TVG itself, it is worth highlighting the various editions of the news (*Telexornal Galicia*, at lunchtime; *Telexornal mediodía*, early afternoon; and *Telexornal serán*, early evening) and the highly successful children's/young people's programme *Xabarín club*, as well as specialised programmes like *A Saúde* (health matters), *O tempo* (weather reports), *O Agro* (agriculture), which are broadcast alongside the news. Other programmes that should be pointed out are *Galicia enteira* (featuring cultural events and customs of Galician cities and villages) and the weekluy current affairs programme*O semanal*. Among the light humour programmes, mention should be made of *A Repanocha* and the candid camera programme *Con perdón*. Debates are represented by *A Chave* and *Bis a vis*. The programme *Galeguidade* attempts to reunite people who, for various reasons, have not seen each other for years.

In the field of news, in 1997 TVG offered disconnections for different areas of Galicia (*Informativos locais*) in addition to *Telexornal Galicia*, a one hour newscast exclusively centred on Galician current affairs. In March 1998 *Galicia directo* started being broadcast. It is a news programme broadcast from Monday to Friday at 8.00 p.m. with general news about Galicia and local programming for different areas. The information is different for the "counties" of A Coruña-Ferrol, Santiago, Lugo, Ourense and Vigo-Pontevedra.

Regarding own-produced fiction, since 1995 TVG has broadcast the successful series *Pratos Combinados*, a sitcom about a family of Galician emigrants who return from Switzerland and open up a restaurant in a Galician city. By November 1998, 104 episodes of this series had been broadcast and TVG had plans to continue with it. The second in house produced sitcom was launched in 1996. It is called *A familia Pita* and is about the daily life of an unusual Galician family. The third own-produced fiction series called *Mareas vivas* started being broadcast in 1999.

Some other important "proximate programmes" that stood out in the 1997-98 programming schedule were the music programme *Luar* – aimed at promoting Galician singers/musicians and TVG's second most successful programme in the 1997-98 period with a means share of 29.8 per cent – , the weekly report programme *Reporteiros* or the programme *Labranza*, devoted to news about the agricultural sector.

Televisió Valenciana has two channels, Canal 9 and Notícies 9. The first one was created in 1989 and is a bilingual channel that broadcasts in Valencian and Spanish. It is a general model dominated by fiction (44.6 per cent of total programming in 1998) and news (14.3 per cent). From the very outset Canal 9 placed its bets on "popular" programming in an attempt to improve its audience figures. This is reflected, for example, by the importance that fiction and infoshows have in its programming schedule,

whereas cultural programmes are really very scarce (1.8 per cent). In 1998 the channel's share was of 18.2 per cent in the Valencian Country (a drop of more than two percent points compared with the previous year, althoug this has been partly compensated with the 0.9 per cent share reached by the new Notícies 9 channel). According to the report presented by TVV's Director General, the 3,869 hours of own-productions broadcast in 1994 went up to 5,201 hours in 1998.[27] In contrast, in the week from 3 to 9 November, 1997, Canal 9 devoted one of the lowest percentages of any "autonomic" channel to "proximate programming", although Notícies 9 filled almost 100 per cent of its programming schedule with programmes of this type, in accordance with the criteria announced by RTVVs' Director General, Josep Vicent Villaescusa.

Radiotelevisió Valenciana brought the latter channel into operation on 9 October 1997. This experience arose in order to better satisfy the public service obligations of Valencian television, which was brought into question by Canal 9's programming practise. That is why it is devoted to "proximate programmes", with basically a news vocation – including the daily newscast *Informatiu Metropolità*, and two short news programmes for the deaf. The new channel's penetration is very slow: as said before, in 1998 it reached a share of 0.9 per cent of the Valencian TV market.

In 1997 the Valencian television network broadcast the own-produced soap opera *A flor de pell*. It starred a family from a city in the Valencian Country devoted to the shoe business. This series was removed because of the low audience response and then put back on in 1998, this time on Notícies 9. Some of the "proximate programmes" worthy of note on the Valencian television network are the current affairs *Dossiers* and *Crònica* – the latter is now being broadcast on Notícies 9 – consisting of reports produced by its newsroom. However, the most successful own-produced programmes belong to the talk-show type (*Parle vosté, calle vosté* and *Tómbola*). In November 1998, from Monday to Friday, Canal 9 broadcast the daily moring children's programme *Babalà*, the morning chat show *A primera hora*, the news programme *Notícies 9* (with lunchtime and evening editions), and the afternoon magazine *Benvinguts* (4.30 p.m. to 5.45 p.m.). At the beginning of 1999 Canal 9 started broadcasting *Com a casa*, a daily morning magazine transmitted each day from a different part of the Valencian Country. In the 1997-98 schedule, it is worth mentioning the live retransmission of the *fallas* festival, which reached a 26.4 per cent share.

Telemadrid is also a general channel which broadcasts wholly in Spanish for the Community of Madrid. Its programming is comparable to the Valencian channel's. Since the very beginning it has placed its bets on a "popular" strategy. This is reflected in its programming schedule: in 1998, there was a predominance of fiction (26.3 per cent of total programming) followed be news (23.4 per cent). In the week from 2 to 7 November 1997, almost half of Telemadrid's programming schedule was made of

"proximate programmes", but the programmes with the biggest audiences were, once again, live broadcasts of football matches and North American films. Virtually all the fiction broadcast by this channel is bought in (mostly from the United States).

Telemadrid's schedule is based on news programmes, of which we could highlight the evening programme *Madrid directo*, the infotainment programme *Sucedió en Madrid*, as well as three editions of the news called *Telenoticias* (morning, lunchtime and evening), and the morning news programme *Buenos días, Madrid*. In July 1997 the late night own-produced programme *Sola en la ciudad* was launched. The programme is conducted by a host to whom viewers make live calls. It is a one-hour long television version of a very popular radiophonic genre. The programme has a "surgery" of sociologists and psychologists who try to answer the public's calls.

Telemadrid has talk shows (*Tómbola*) and sports programmes. In the afternoon it broadcasts the magazines *Con T de Tarde* and *La hora de Mari Pau*. The lunchtime programme *Cyberclub* is very successful among the younger viewers.

Televisión de Andalucía has two channels: Canal Sur and Canal 2 Andalucía. The first one has a general profile and was launched in 1989. Its programming is headed by bought in fiction (26.1 per cent of the programming schedule in 1998). News accounts for 22.3 per cent of the programming, whereas infoshows account for 3 per cent. Like Telemadrid and Canal 9, Canal Sur is one of the "autonomic" channels that has placed its bets on more "popular" programme types, paying less attention to the production of more expensive programme types such as soap operas. The second channel came into operation in June 1998 with an initial nine hours of programming per day.

In the week from 3 to 9 November 1997, "proximate contents" accounted for almost one third of total programming. Of these, we would highlight the programme dedicated to reports called *Los reporteros*, and the mini-series of documentaries in the cultural field called *Las Andalucías*. In September 1998 Canal Sur launched the own produced soap opera *Plaza Alta* (weekdays in the afternoon). It narrates the ups and downs of two rich wine-producing families. Before that, the Andalusian channel had broadcast some other own-produced series (*El Séneca, Pensión El Patio, Vidas cruzadas*), though they were not very successful.

Canal Sur has placed particular emphasis on programmes to recover historic memory. So, it has broadcast *Andalucía, un siglo de fascinación* – a seven-episode series about the last 100 years of Andalusian history, directed by the prestigious film maker Basilio Martín Patino – as well as *Conventos de Andalucía, Parques naturales de Andalucía* and *Fiestas de Andalucía*. Among Canal Sur's "proximate programmes" it is worth

mentioning the live programme *Tal como somos*, which has brought most of Andalusia's 801 municipalities into the studios of Canal Sur. Also worth of mention is the daily educational magazine *El club de las ideas*, which in early 1999 reached a mean market share of 20 per cent.

6. "Autonomic" channels as seen by their directors[28]

Autonomic channels form part of a rich, complex scenario which has become a mirror of the country's different feelings (cultural tastes, identity affinities, social habits, etc). They are helping to bring the autonomous communities' specific realities closer to the public, especially through "proximate programming" (news, home produced soap operas, history and cultural programmes, event broadcast, etc) and the use of vernacular languages.

Language is the factor that directors of ETB, TVC, TVV and TVG consider to be the main feature that makes their channels different. The other component that they highlight is "proximate information", and the news in particular, which has attained shares of approximately 30 per cent. In the "autonomic" channels of Madrid (Telemadrid) and Andalusia (Televisión de Andalucía), news and current affairs programmes, together with specific programmes that stimulate a regional awareness, act as a mirror of their realities. In this sense, Canal Sur's daily programme *Tal como somos* has pursued better knowledge of Andalusians by the daily presence of an Andalusian village in the studios. According to Santiago Sánchez Tráver, Canal Sur's Director, that responds to the need to "provide the backbone of Andalusia through the media" because, until then, their had never been a mass medium aimed at the whole of Andalusia's eight provinces.

In the Valencian Country's case neither had there been any media that reflected Valencia's overall reality until Canal 9 arrived on the scene. Its directors refer to the difficulties existing in this community that make it hard to reflect all Valencians, particularly because of the fact that there are areas which are populated by a majority of Spanish speakers and because of the traditional scarce identification with the provinces of Alicante and Castellón with the capital, Valencia. To sort this problem out, attempts have been made to introduce programmes which avoid rejection of the Alicante and Castellón audiences. For example, programmes set in areas of Alicante have been produced. In addition, news referring to Spanish-speaking areas are broadcast in Spanish as part of newscasts in Valencian.

Telemadrid is the paradigm of a medium which came into being in order to reflect a community which, historically, has had not much feeling of being different. To talk about the Community of Madrid is to talk above all about the capital of Spain, a big city which is the inevitable reference of all the inhabitants of the autonomous community. That has its advantages, like the fact that the television station does not have to worry about criticism being levelled against it for being centralist or the fact that vast

geographical deployment is not necessary to cover the territory, as it is in Andalusia and the Valencian Country, for example.

In this sense, Canal Sur broadcasts two daily disconnections for each of the eight Andalusian provinces in the two main news programmes (lunchtime and evening), including off-the-network advertising, which also help to "provide the backbone of the economic sector" according to Sánchez Tráver. These windows try to avoid the centralism of Seville, though Sánchez Tráver points out that decentralisation is conceptually contradictory in terms of providing the backbone of Andalusia, so a balance between the two needs to be sought.

For their part, the managers of Telemadrid explain that this channel came into being with the disadvantage of having to make itself needed and wanted, as it did not count on the complicity that other television stations enjoyed, like ETB and TVC which, from the very beginning, had a faithful public because of the use of a native language which had been forbidden in large media during Franco's dictatorship. For that reason, Telemadrid has found it hard to make itself stand out from national public and private channels. It is worth mentioning that these channels' soap operas, for example, usually situate their stories in the city of Madrid in order to avoid any type of rejection from the different regional audiences. Oleguer Sarsanedas, former Director of TVC's programming, reminds us that sociocultural tastes are different in each region and that "autonomic" channels like TVC have created "a field of reference in the public". This means that each television channel has a defined audience with a certain degree of fidelity. However, for Albert Rubio (TVC), according to the latest studies, people who watch Catalan "autonomic" television no longer do so for reasons of language fidelity, as that does not stop this channel's public from openly rejecting television formats that are indeed accepted on other channels. In fact, according to Rubio the same people who watch reality shows or talk shows with a sensationalist profile would not accept them being broadcast by TVC because they consider it to be of higher quality.

The managers of Telemadrid have tried to make it close to the inhabitants of Madrid through news programmes (newscasts and report programmes), a strategy that has earned the fidelity of a public in search of information about Madrid on the "autonomic" channel. Around 60-65 per cent of the news that this channel's newscasts offer are of a regional nature. Along these lines, the programme *Madrid directo*, a formula copied by other regional and national channels, has always gone in search of information in the streets since it started (September 1993), with special attention being paid to live features. Another of Telemadrid's trumps, shared by the other "autonomic" channels, is sport, and football in particular, with a major deployment of resources and special programmes that are very successful with the audience.

A strategic sector of programming in recent years has been the exploitation of the cultural realities of each autonomous community. Every year, the

April fairs, the Rocío and Virgen de la Cabeza pilgrimates, the Cadiz carnival celebrations and the Holy Week parades in Andalusia are broadcast live, as are the *Fallas, Fogueres,* and Moors and Christians celebrations in Valencia; Basque pelota matches and the *Sanfermines* of Pamplona in the Basque Country; and *Castellers* (human towers) in Catalonia. The latter are covered by a TVC team responsible for sports live broadcasts.

In recent years, the tendency to "bring villages" into the studio has reversed and the directors have discovered opportunities to do live broadcasts of cultural events. It is a matter of taking the cameras out into the streets and getting people to experience events that they are the stars of through their "autonomic" channels. Telemadrid has played the trump of turning some local sporting events into major audience successes, such as the Real Madrid-Atlético de Madrid football match, with a macro-programme of continuity before and after the match. When Real Madrid won the 1996-97 league, Telemadrid attained a 44.8 per cent share with the live broadcast of the celebrations. On ETB, live broadcast of events like the opening of the Guggenheim Museum and the Bilbao Metro were highly successful with the audiences.

The main feature common to all "autonomic" channels is the news, whose wide acceptance has meant that in recent years the length of newscasts has been extended to up to one hour or one and a half hours, with special sections about the sea, agriculture, the weather, etc, which place emphasis on things proximate. National private television stations have begun to compete in this field with off-the-network news. The success of "autonomic" channels has attracted attention from national channels and become a self-referential area in which some channels look for the formulas of success in others. This has happened with formats like afternoon magazines, the presentation of news and the phenomenon of children's clubs. Examples of the latter are *Xabarín club* (TVG), *Club Super 3* (TVC), *Babalà Club* (TVV), *La banda del sur* (Canal Sur), *Superbat* (ETB) and *Cyberclub* (Telemadrid), which are very successful with children. In the first two of those cases, they have become the clubs with the largest number of members in the communities of Galicia and Catalonia. The success of this formula has led the directors of private channels like Telecinco and Antena 3 TV to copy it on a national scale.

It is easy to understand why "autonomic" channels watch each other: they are competing for different territorial markets which are, however, very similar demographically, and against national channels. In this sense, it is becoming more and more commonplace for a programme broadcast by an "autonomic" station to be adapted to another, even though the audience figures vary from one channel to another. This shows the existence of different feelings and tastes from one region to the next. Take, for example, TV3's magazine called *Malalts de Tele*, which has reached a 31.3 per cent

share in Catalonia. The version of it that started being broadcast on Telemadrid in October 1998 called *Los reyes del mando* only reached 10 per cent and was removed a few weeks later. Likewise, TVC's own-produced soap opera called *Poblenou* failed when Telemadrid broadcast it dubbed into Spanish. According to the managers of Telemadrid's programmes, this was due to the fact that Madrid is now a homogenous and basically urban community, a capital aspect that often goes to explain the programming differences between "autonomic" channels: the fact that social reality and demographic structure are more urban and centralised (like in Madrid and Catalonia) than in the Valencian Country or Andalusia is reflected in their programming.

Tastes also vary depending on the cultural realities of the regions, and this is reflected in the programming. So, bullfights, which cannot be found in the programming schedules of TVG, ETB or TVC, can indeed be found on Canal 9, Telemadrid and particularly on Canal Sur, in that part of Spain with the strongest bullfighting tradition. Canal Sur broadcasts live some 35 bullfights a year, especially from Andalusian bull rings. In 1997 it had the only television programme specialising in bullfights in Spain.

Despite being very rooted to local reality, "autonomic" channels have not fallen into the trap of the model proposed at the beginning of the 1980s by the then Director of RTVE, José María Calviño, who suggested that new regional channels should be "anthropological television stations", with emphasis being placed on folklore. So, and this is common to all "autonomic" channels, newscasts prioritise news by taking their informative importance into account. In this process, proximity is one element among many, and it is not, therefore, the main one. Likewise, the "autonomic" channels' newscasts place a lot of importance on international events. For example, during the conflicts in former Yugoslavia many of them have sent reporters to the area.

On occasions the "autonomic" channels' programming has modified the daily habits of viewers, even on national scale. Take, for example, the broadcast of late shows and night-time news which have gradually created a real late night prime time block. They have also been the seedbed of new formats which have subsequently become usual on all channels (regional or national), as is the case for ETB's cookery programmes. As far as TVC is concerned, it placed its bets on placing factual programmes that it produced itself (*Ciutadans*, *Vides privades*, *Te'n recordes...*) in the late evening prime time-block, something which, according to TVC journalist Francesc Escribano, shows that "television can create habits, and modify and improve people's tastes".

One factor that reflects the differences between "autonomic" channels is their approach to territorial reference boundaries (beyond accidental hertzian overspill), which do not always coincide with the official geographical borders of the respective autonomous communities. TVC's

and ETB's approaches respond to a deliberate strategy of including all territories considered to be Catalan-speaking and Basque-speaking, respectively, irrespective of the audience levels in other communities. In their reference frameworks, ETB incorporates the neighbouring territories of Navarra and the French Basque Country, and TVC incorporates the Valencian Country, Catalan-speaking eastern Aragon, Catalan-speaking areas in southern France and the Balearic Islands (together known as *Països Catalans*). Albert Rubio (TVC) explains that attempts are made to include different dialectal variants of Catalan in different programmes: "We want this concept to be normal. For us, this is the public television of the *Països Catalans*". However, this does not imply that TVC is competing for viewers against TVV in the Valencian Country. In this sense, TVC's audience in this community has considerably decreased since TVV came into operation and shares have only gone above 2 per cent on very few occasions (although in 1998 TV3's share in the Valencian Country was of 1.4 per cent, highger that Notícies 9's). The reference framework approach is also reflected by the agencies opened by ETB and TVC, which are located in the capital cities of their respective language territories. TVG, having found that it has a certain degree of following in northern Portugal, has created a news agency in the city of Oporto.

In the remaining "autonomic" channels, the emergence of reference frameworks that go beyond the official territory of the communities is basically explained by a desire to provide a service to bordering audiences, which it reaches as a result of hertzian signal overspill. In TVG's case, according to its directors, the weather map – which includes neighbouring areas of Portugal, Castilla y León and Asturias – simply responds to audience criteria, given that the channel has a following in those areas. The same thing happens with TVV (whose weather map includes the south of the Catalan province of Tarragona, the community of Murcia, adjacent areas of Castilla and the Balearic Islands) and Telemadrid (the Community of Madrid is surrounded by bordering provinces in the weather map), in response to the audience in those areas. Canal Sur does not include bordering provinces in its weather map despite the fact that this channel has an important following in areas like Badajoz, Ceuta and Melilla.

This "overspill" practice has caused some conflicts between communities, especially between the Basque Country and Navarra on the one hand, and Catalonia and the Valencian Country on the other. However, in Andalusia the complaints have come from the Andalusians themselves. When Canal Sur broadcast the programme *Tal como somos*, some villages of Portugal, Murcia, Castilla-la Mancha and Extremadura appeared on it before some of the 801 Andalusian localities did. This gave rise to protests, especially after the appearance of the Badajoz locality of Zafra.

However, problems arising from extra-territorial over-the-air broadcasts have been surpassed since all the "autonomic" channels' satellite channels

came into operation. TVG's directors explained that during some live programmes, like game shows, they receive more and more calls from outside Galicia, particularly from León, Asturias, the Basque Country and northern Portugal. Broadcasts outside Spain are well received by the emigrant communities, and they are making it possible for many of the two million Spanish people living outside Spain (890,000 in Europe and 1.3 million in Latin America, of which 525,000 are Galician, 253,000 are Andalusian and 164,000 are Catalan) to watch the channels of their communities of origin. For broadcasts of TVG's satellite channel, Galicia TV, the slogan ("from Galicia to the world") is the same as the one for Canal Sur's satellite channel, Andalucía Televisión ("from Andalusia to the world"). For Canal Sur's directors, this channel aims to reach the Andalusian community outside Andalusia, and particularly the one million Andalusians living in Catalonia and the Valencian Country.

The "autonomic" television channel's directors also emphasise their importance as cultural institutions in their respective regions. In Catalonia, the Basque Country and Galicia, "autonomic" channels were assigned a core role in the native language and culture normalisation strategies from the very beginning: TVC broadcasts wholly in Catalan on both its channels, TVG only broadcasts in Galician and ETB has one channel which broadcasts only in Basque (the other is mostly in Spanish). But support for the native language is not the only factor that helps reinforce the culture itself (in fact, they may only be dubbed foreign programmes). More important than this is these stations' task of acting as a window on all sorts of musical, artistic and folkloric manifestations, festivals, crafts, popular sports, the environment, associations and tourism in their respective communities. This task is shared by the channels of other autonomous communities without a native language different of Spanish (Andalusia, Madrid), or with less emphasis on it (the Valencian Country).

Beyond their very nature as cultural institutions, "autonomic" channels have created cooperative links with a whole host of cultural and media institutions, among which the audio-visual industry stands out. The creation of regional channels has been fundamental for the development of audio-visual production companies in the respective territories, and particularly so in those autonomous communities where this type of activity hardly existed (Galicia, the Basque Country, the Valencian Country and Andalusia), as they had been historically centred in Madrid and Barcelona. As the production budgets of the "autonomic" television channels have grown, a certain proportion of them has been allocated to commissioning programmes and subcontracting them to local production companies. The new channels have also become stable clients of the film industry, which has also become a co-producer through cooperation agreements. On the other hand, the new leading role of own produced soap operas has indirectly given theatre a big push forward, as the series have made local actors and actresses popular, creating a "local star system"

which has had favourable repercussions on the number of people attending plays that these people appear in.

Autonomic channels have also signed a wide variety of cooperation agreements with theatres, actors' organisations, museums, city councils, trade unions, religious faiths, fairs and other civic and cultural organisations, always with the aim of providing them with coverage. The managers of "autonomic" television channels that have embarked on the production of soap operas (mainly TVC and ETB) also remark on the positive influence that getting away from symbolic centralism has had when locating some of the stories in rural areas and small cities.

So, it can be asserted that "autonomic" channels have undertaken the essential task of forming the backbone of their respective communities. This can be seen from their programming schedules, which include programmes dealing with a wide range of different aspects of social and cultural life in these regions, which are often highly successful with the audience. This is what we have termed as "proximate programming", self-referential and, at the same time, dynamic and innovative. After centuries of peripherality in relation to Madrid and even mutual unawareness among citizens of the same region, some of these channels have become the main producers, broadcasters and promoters of the symbolic reality of the autonomous communities. Parallel to this, "autonomic" televisions stations are behaving like cultural institutions, acting as the motor behind the development of other areas such as film and theatre.

7. New problems and prospects

7.1. Financial viability

From a strictly financial point of view, local and regional TV stations in Spain are mostly loss making, that is, with very few exceptions they do not manage to cover the expenditure they incur by commercial revenue (advertising, sponsorship, programme sales and service rendering). However, that does not mean that they are not viable, since they are backed by public institutions (by means of stable subsidises) and society in general.

Regarding financial matters, it is worth making the distinction between "autonomic" and local television stations. The former are large audio-visual companies with multi-million-Peseta budgets, facilities equipped with the most advanced technology and workforces of over 600 employees thanks to the support they receive from the respective autonomous governments. They are television stations that aim to compete directly with national channels. On the other hand, local television is a small, much weaker and more disperse sector. Television stations rarely have annual budgets over 100 million Pesetas and the vast majority are small stations with domestic equipment, amateur staff and sporadic programming. Local television stations are not generally set up

as large audio-visual companies, as most of them emerge from not-for-profit civic or municipal initiatives.

Corporació Catalana de Ràdio i Televisió is the regional public service corporation with the highest budget: 36,000 million Pesetas in 1998. This figure makes it the fifth largest audio-visual company in Spain after the national television networks (TVE and the three private channels). The other corporations are situated between this figure and the 12,000-million-Peseta budget of Compañía de Radio y Televisión de Galicia. It can be asserted that "autonomic" channels are medium-sized audio-visual companies comparable to the public or private television stations of many small countries in the European Union. For example, the Swedish public service television network had a turnover figure in 1997 of 3,338 million Coronas (some 66,000 million Pesetas), whereas TV4, the only private over-the-air channel in Sweden, had a revenue of 1,692 million Coronas (some 34,000 million Pesetas).

So, self-financing capability (percentage of the budget covered by commercial revenue) did not exceed 30-35 per cent in the Catalan broadcasting corporation's case. Commercial revenue for the "autonomic" channels as a whole was 53,264 million Pesetas in 1995, whereas public subsidies totalled 62,230 million Pesetas. This highlights the importance of public funding for these channels' existence. The positive aspect of this dependency is these television stations' financial stability, guaranteeing their existence in the medium and long terms irrespective of any market fluctuations; however, the money they receive from regional governments makes them more vulnerable to political influence by the latter.

Autonomic channels are powerful communications actors in their respective regional markets. Their future is guaranteed thanks to a general consensus among political parties and the general public.

The financial situation and prospects for local television stations are much less uniform, as one would expect from such a diverse sector. In general, it can be asserted that finance is the major weakness of these stations, with the exception of a few large private companies operating in metropolitan areas with high populations. So, according to Infoadex data, Spanish urban television stations as a whole had an advertising revenue of just 792 million Pesetas in 1996. However, the strong presence of the public sector – as shown by the data for Catalonia, where almost half the urban televisions stations are municipal – once again points towards the sector's survival. If left to market forces only, there would probably be a lot fewer.

7.2. Information and communication technologies and television decentralisation in Spain

Up to 1996, decentralisation of television in Spain had been almost exclusively connected with "traditional" technologies, basically over-the-air broadcasting.

So, the emergence of "autonomic" channels and, in many cases, of urban television stations has had a major component of "conquering the air" to the detriment of national exclusivity. The autonomous governments of Catalonia and the Basque Country chose to set up their own networks of over-the-air broadcasting stations and boosters which, in many cases, ran parallel to RTVE's, to prevent the State-owned public corporation's monopoly of the network from delaying or impeding the development of the respective "autonomic" channels. As far as local television is concerned, over-the-air broadcasting was claimed as a right and cable broadcasting was expressly rejected because it was felt that it did not guarantee universal coverage.

By the end of the 1980s, friction between the State and the autonomous communities over access to hertzian frequencies had calmed down, but a new dispute emerged: access to satellite broadcasts. The 1992 Satellite Television Act set up a *de facto* monopoly over this mode of television broadcasting from Spain, which was in the hands of the Hispasat consortium controlled by the government. So, TVG's, TVC's and Canal Sur's first satellite broadcasts caused renewed unease at central government level. However, European directives forced this sector to be liberalised, and this was included in the new Satellite Television Act of December 1995. Since then, all "autonomic" channels have created permanent satellite channels. These channels are exclusively made up of own-produced programmes because the television networks that produce them do not have international broadcasting rights on programmes purchased for over-the-air channels and also because the objective of these programming schedules is to act as windows on the respective communities for the rest of the world.

At the beginning of the so-called "digital era", the "autonomic" channels got ready to use their potential and their audio-visual archives to create channels and specialised or multimedia services. So, Telemadrid and TVC have started producing specialised channels. They are *Ella* (for women) and *Tribunal TV* (specialising in court cases), produced by Telemadrid for Vía Digital, and *Canal Meteo* (specialising in weather), produced by TVC for the same platform through the private-sector company Media Park in which TVC is a shareholder.

Unlike the satellite experience, so far the "autonomic" channels' Internet experience is very limited in its scope. It consists of the production of "presentation" Web sites, containing information about activities and programming. The most advanced Web site belongs to TVC's sister company Catalunya Ràdio, which offers on-line broadcasting (live and *à-la-carte*) from Catalunya Ràdio and Catalunya Informació.[30] Besides this initiative, Webcasting experiments are almost non-existent. Similarly, the "autonomic" channels' participation in the cable sector is almost nil, though the Cable Telecommunications Act (1995) does include a "must carry" rule, which guarantees the broadcasting of "autonomic" channels by all networks in the respective communities.

7.2.1. "autonomic" channels and satellite broadcasting

As seen previously, access to satellite broadcasts has been one of the "autonomic" channels' most recent and important advances. Televisión de Galicia put the first satellite broadcasting experience into operation in 1995. Since then, Televisió de Catalunya, Euskal Telebista, Canal Sur, Canal 9 and Telemadrid have done the same, initially on an occasional basis and then, from 1996 onwards, on a regular basis. In January of this year the satellite channel Galeusca started broadcasting to America. As the name suggests, it was initially a joint initiative of the Galician, Basque and Catalan "autonomic" channels, who contributed equal amounts of programming contents. However, a short time after broadcasting started, the Galician television station stood down from the initiative. In 1997, within the context of FORTA, agreements were reached to incorporate programmes from all the other "autonomic" channels into Galeusca's programming schedule. However, in September 1998, the two stations that had promoted the initiative (ETB and TVC) decided to cancel it and replace it with their respective channels ETB Sat and TVC Internacional.

Regarding digital satellite television, the "autonomic" channels were not left out of the two business initiatives launched in Spain in 1997: Canal Satélite Digital and Vía Digital. All the television stations forming part of FORTA reached an agreement to jointly produce an "all news" channel called *Telenoticias*, which was broadcast via the digital platform Vía Digital and intended to take advantage of FORTA's enormous potential to generate news items. However, it stopped broadcasting at the end of July 1998. Televisió Valenciana produces and broadcasts Canal Comunitat Valenciana, which is wholly in Valencian, via this platform. Canal Sur produces the channel Andalucía Televisión for both Spanish digital platforms. Its programming is exclusively produced by the channel itself and consists of programmes that are broadcast by the over-the-air channel and a great deal of archive programmes. In addition, in 1997 it reached an agreement with Antena 3 TV to broadcast one hour a day of its own programming on the American satellite channel *Telenoticias*, which this network produces.

Euskal Telebista produces the channel ETB Sat for both platforms. It wholly consists of own-produced programmes broadcast on the first and second over-the-air channels. As from 1996 Televisión de Galicia produced the channel Galicia TV, which was broadcast via satellite to Latin America and Europe. Since September 1997 it has been broadcast via the platform Vía Digital and wholly consists of own-produced programmes. Since September 1997 Televisió de Catalunya has produced the channel TVC Sat for Vía Digital; it is also in charge of TVC Internacional, which is broadcast by the Astra satellite and is included in the platforms Canal Satélite Digital (Spain), Kirch (Germany) and Canal Satellite (France). Both channels wholly consist of own-produced programmes lasting for 10 hours a day, some of which are simultaneously broadcast by the over-the-air channels

and others are rescheduled. Telemadrid produces a channel of the same name (with programmes from the over-the-air channel plus archive programmes) for the platform Vía Digital.

Bibliography and References

Baget, Josep Maria (1993): *Historia de la televisión en España (1956-1975)*. Barcelona: Feed-Back.

Baget, Josep Maria (1994): *Història de la televisió a Catalunya*. Barcelona: Centre d'Investigació de la Comunicació.

Carreras, Lluís de (1996): *Régimen jurídico de la información. Periodistas y medios de comunicación*. Barcelona: Ariel.

Chinchilla, Carmen (1987): "Les competències de les comunitats autònomes en matèria de televisió", in *Autonomies. Revista Catalana de Dret Públic*, 8.

Corominas, Maria and Bernat López (1995): "Access to and participation in television in Spain", in *Gazette*, 57. Amsterdam: Kluwer.

Cuchillo, Montserrat (1993): "The autonomous communities as the Spanish meso", in L. J. Sharpe (ed): *The rise of meso-government in Europe*. London: Sage.

Elazar, Daniel (ed) (1991): *Federal systems of the world*. Harlow: Longman.

European Bureau for Lesser Used Languages (1993): *Mini-guide to the lesser used languages of the EC*. Leaflet.

Fernández Farreres, Germán (1997): *El paisaje televisivo en España*. Pamplona: Aranzadi.

Fundesco:*Comunicación social/Tendencias*, 1990, 1991, 1992, 1993. Madrid: Fundesco.

Garitaonandía, Carmelo *et al.* (1989): "Estructura y Política de Comunicación en Euskadi", in VVAA: *La Comunicación en las Naciones sin Estado*. Bilbao: UPV-EHU.

GECA (1999): *El anuario de la televisión 1999*. Madrid: GECA Consultores.

Giró, Xavier (1993): "TVE-Sant Cugat: deu anys trampejant", in *Capçalera*, 46 (October). Barcelona: Col·legi de Periodistes de Catalunya.

Ledo, Margarita (1998) (dir): *Televisión e interculturalidade en Bretaña, Galicia e País de Gales*. Santiago de Compostela.

López, Bernat and Maria Corominas (1995): "Spain: the contradictions of the "autonomous model", in Moragas, M. de and C. Garitaonandía (eds): *Decentralization in the global era*. London: John Libbey.

Maneiro Vila, Arturo (1989): *Funcións da TV autonómica galega e do centro rexional de TVE en Galicia*. Santiago de Compostela: Conselleria da presidencia e administración pública.

Moragas, Miquel de (1988): *Espais de Comunicació*. Barcelona: Edicions 62.

Parés, Manuel, Josep Maria Baget and Jordi Berrio (eds) (1981): *La televisió a la Catalunya autònoma*. Barcelona: Edicions 62.

Prado, Emili (1993): "La Spagna", in Baldi, Paolo: *La programmazione televisiva in Europa (1990-1992)*. Rome: RAI-VQPT.

Proelsa (1997): *Anàlisi de les televisions locals a Catalunya*. A report produced for Barcelona Provincial Council.

RTVE (1977): *Nuestro libro del año 1976*. Madrid: RTVE.

RTVE (1979): *Informe 1978*. Madrid: RTVE.

RTVE (1984): *Anuario 1983-84*. Madrid: RTVE.

RTVE (1986): *Anuario RTVE 1986*. Madrid: RTVE.

RTVE (1990): *Anuario RTVE 1989*. Madrid: RTVE.

RTVE (1992): Memoria de RTVE 1992. Madrid: RTVE.

RTVV (1990): *Las radiotelevisiones en el espacio europeo*. Valencia: RTVV.

RTVV (1991): *Financiación y publicidad de las Radiotelevisiones públicas y privadas*. Valencia: RTVV.

Sampedro, Víctor (1997): "Regiones audiovisuales: comunidades y marcos políticos". Presentation given at "Primer Congreso internacional sobre comunicación audio-visual y desarrollo de las regiones". Salamanca: Pontificia University.

Sofres (1994): *Anuario de audiencias de televisión 1993*. Madrid: Sofres.

Sofres (1995): *Anuario de audiencias de televisión 1994*. Madrid: Sofres.

Sofres (1996): *Anuario de audiencias de televisión 1995*. Madrid: Sofres.

Sofres (1997): *Anuario de audiencias de televisión 1996*. Madrid: Sofres.

Sofres (1998): *Anuario de audiencias de televisión 1997*. Madrid: Sofres.

Xambó, Rafael (1996): *El sistema comunicatiu valencià*. Doctoral thesis. Valencia: University of Valencia.

Translation: Steve Norris

Notes

1 The cities of Ceuta and Melilla, which are Spanish enclaves in Africa (Morocco), resorted to the Fifth Provision of Title X of the Spanish Constitution ("Constitutional Reform") to turn themselves into autonomous communities. So, the Statute of Autonomy was approved in Ceuta in March 1995, whereas Melilla's was approved in September of the same year. Officially, both Ceuta and Melilla have become "Autonomous Cities", though they do not enjoy the same legislative or juridical power as the other autonomous communities. The transfer of the first power package, which included broadcasting, took place in October 1996. That same year Ceuta had 68,796 inhabitants (19km^2) and Melilla had 59,576 (13km^2).

2 To which Navarra could be added, as it enjoys a similar level of autonomy as the Basque Country and has its own fiscal system.

3 Since 1993, electoral equilibrium has led to the main nationalist parties of Catalonia, the Basque Country and the Canary Islands lending their support to the governing parties in the central parliament in exchange for accelerated power transfers to the regions.

4 The variant of Catalan spoken in the Valencian Country is given the official name of "Valencian" here. The dialectal differences between Catalan of Catalonia and Valencian have given rise to a opinion movement that claims that the latter is a different language, a position which goes against the most authoritative scientific opinion.

5 Basque and Catalan are also spoken in small parts of French territory. In addition, Catalan is the official language of the State of Andorra.

6 For a detailed analysis see Carreras, 1996.

7 Both the anti-concentration measures and the rules pertaining to programming and advertising have been repeatedly violated without any apparent damage for the violating television stations.

8 Source: *Noticias de la Comunicación*, several 1998 issues.

9 Source: *Noticias de la Comunicación*, several 1998 issues.

10 TVE's regional programming is analysed in section 5.

11 With the exception of Radiotelevisió Valenciana and Euskal Irrati Telebista, whose Director Generals are appointed by the Corporation's Board of Directors and the Basque Parliament, respectively.

12 See www.forta.es

13 The autonomic television stations' programming is analysed in section 5.

14 *El País*, 29 October 1998.

15 According to data from the Asociación para la Investigación de Medios de Comunicación – EGM, in January 1996 there were 881 local stations in Spain. This figure is flexible, since the sector is fairly unstable.

16 InterMedios, Monograph, issue 2 March 1998.

17 *Avui*, 17-10-1998.

18 *InterMedios*, Monograph, issue 2 March 1998.

19 See www.canal4.es

20 *El País*, 12-10-1998.

21 TV2 and Canal 33 (the second channels of RTVE and the autonomic network Televisió de Catalunya, respectively) have been operating as channels with a certain degree of specialisation within a general orientation, with contents aimed at a "minority" public: documentary programmes, music, minority sports, specialised news... Canal Plus, the only over-the-air Pay-TV in Spain, placed its bets on a programming schedule based on film and sport (especially football) right from the very outset.

22 Media Planning data supplied by Europa Press (28 November 1998).

23 In February 1998 the programme Parlament about the activities of the Parliament of Catalonia started being broadcast on TV3 at lunchtime on Saturdays.

24 Castelló, Enric (1998): "Programació de proximitat a les televisions autonòmiques de l'Estat espanyol", an InCom working document. Bellaterra: UAB.

25 Goenkale has become the oldest own-produced series still on air in the Spanish TV market (GECA, 1999).

26 *Las Provincias*, 2 December 1998.

27 This section summarises the opinions that directors and managers of the six autonomic television stations expressed in interviews conducted by the authors of this report between December 1997 and February 1998. In alphabetical order of their surnames, they are: Salvador Alsius (Journalist, Televisió de Catalunya), Andoni Aramburu (Director of the Galeusca channel for Euskal Telebista), Carlos Carballo (Programming and Broadcasts Director, Televisión de Galicia), Paloma Carballo (Head of the Programming Department, Telemadrid), Pablo Carrasco (Audience Control and Research Director, Canal Sur), Juan María Casado (Educational and Cultural Programme Director, Canal Sur), Manu Castilla (Media Director, Euskal Telebista), Ferran Estellés (Scriptwriter, Televisió Valenciana), José Antonio Gurriarán (Head of News, Canal Sur), Jordi Hidalgo (Audience Director, Televisió Valenciana), Maite Iturbe (Director of Euskal Telebista's own productions), Margarita Ledo (Lecturer in the Faculty of Media Studies, Santiago University), Josep Llago (External Relations Director and former Head of News, Televisió Valenciana), Ricardo Llorca (Programme Director, Canal Sur), Ricardo Medina (Deputy Sports Director, Telemadrid), Toni Mollà (Head of the Surveys and Prospects Unit, Radiotelevisió Valenciana), Antonio Muñoz (Deputy News Director, Telemadrid), José María Otermin (Programming Director, Euskal Telebista), Anxo Quintanilla (Director of Televisión de Galicia), Elena Sánchez (Deputy Programming Director, Telemadrid), Santiago Sánchez Tráver (Director of Canal Sur), Oleguer Sarsanedas (Publishing Director, Planeta, former Programming Director, Televisió de Catalunya), Vicent Suberviola (External Fiction and Dubbing Director, Televisió Valenciana), Imma Tubella (Head of External Relations and Surveys Unit, CCRTV), Mikel Urretabizkaia (Head of News, Euskal Telebista).

28 See www.catradio.es

Sweden: Decentralization as part of the public service's mission

Peter Arvidson, Bernat López

1. Regional dimension of Sweden[1]

Looking at Sweden from a European perspective there are several points about the country, its history and its people that should be stressed in order to fully understand the possible place and function of local and regional television in it. Therefore the first few paragraphs are dedicated to those aspects.

1.1. Sweden's location, climate and size

Sweden is one of five Nordic countries situated in the very northern part of Europe. In fact it is one of the countries located furthest from the Equator. It is on roughly the same latitude as Alaska, and for those more familiar with the southern hemisphere of our globe, if it were located there, it would be placed south of Cap Horn, the southernmost tip of South America. Thanks to the Gulf Stream it is not as cold and icy as those other places. But for long periods in the past ice covered the land, which made it unsuitable for human population until rather late in the history of the Earth, about 10,000 years ago.

As a nation, though, Sweden must be looked upon as rather old. A nation began to take shape about 1,000 years ago and Sweden became a centralized state in the modern sense of the word by the 16th century under the king Gustav Vasa.

The size of Sweden has changed over the centuries, if you take into account what could be called its "provinces". But Sweden itself has been as it is

today for more than 300 years. In the 17th century Sweden was one of the major powers in Europe, both in size and in political importance, but since then it has step by step left that position as evidenced by leaving conquered land. For short periods of time Sweden not only had provinces on the southern and eastern shores of the Baltic, but even colonies in North America and the West Indies. But those were given up a long time ago. The more long lasting non Swedish parts of the kingdom have been Finland, a part of Sweden for around 700 years until taken by Russia in 1809, and Norway which in 1905, after a near century-old union with Sweden, became a state of its own. That leaves the country as it is today with unchanged borders since 1912. Another stabilising factor comes from the fact that the country has been spared from war since 1814 and blessed with a period of almost 200 years of peace. This makes Sweden a rare case in Europe and probably in the whole world.

The size of Sweden is almost 500,000 km^2, more than ten times as large as its neighbour Denmark, or about the size of Spain. To this should be added a marked characteristic of Sweden: its sheer length, being even longer than Italy but having less than one seventh of Italy's population.

1.2. Population, religion, ethnics and language

Measured in population figures Sweden is a medium sized European country with a little less than nine million people. In terms of households, the number is 3.4 million.

Having fewer than or around one million inhabitants in the 16th and 17th centuries, the peaceful 19th century allowed the Swedish population to grow rapidly. This started large waves of migration, one within the country from rural to urban areas but also to the still today sparsely populated parts in the north, the other abroad mostly to North America, especially the state of Minnesota and the city of Chicago. As in most countries, at least in the Western world, the migrations within the country have gradually made for larger cities and towns, and a more sparsely populated countryside. The southern third of the country includes the three largest cities, Stockholm (the capital), Göteborg and Malmö and also more than half of the Swedish population. North of Stockholm the largest parts of the population are found in the cities on the Baltic Sea with rather few people living in the inland of the northern half of Sweden. This makes transportation and services a problem in that part of the country.

Ethnically Sweden has traditionally been a very homogenous country as evidenced by Swedish, a Germanic language, being the mother tongue of nearly the entire population. Since World War II this pattern has changed and today roughly 13 per cent of Swedish residents are foreign-born or have at least one non-native parent. Traditionally most immigrants have come from the Nordic countries, more or less as a natural flow of people between neighbours across borders. But increasing numbers have come

from other parts of Europe, the Middle East, South America and the more distant parts of Asia. In the 1950s and 1960s what could be called "labour immigrants" from Yugoslavia and Italy constituted the major part of the immigration. In the 1970srefugees increased in number, mainly from South America, followed by the those coming from the Middle East in the 1980s, and from Bosnia and Iraq in the 1990s.

The comparatively large immigration in the last decades has introduced new cultures, languages and religions in Sweden. But the largest minority language is still Finnish, as it has been for several hundred years, with a number of more than 200,000 speakers. Large groups of Finnish speaking people have traditionally lived in the far north, but are now also spread all over the country. A distinct language community, the "meänkieli" (speaking a dialect of Finnish and amounting to between 50,000 and 60,000) live in the North (Moring, 1998). About 100,000 citizens stem from the Scandinavian neighbours and speak either Norwegian or Danish, but those two languages are very close to Swedish, so there is really no language barrier here or cultural basis for special media in those two languages. Around 60,000 citizens speak one or more of the languages of the former Yugoslavia. The original natives of the Nordic countries, the Sami (Lapps) number around 15,000. They not only speak their own language, very different from Swedish, but many of them lead their own way of life, although no longer as nomads, centered around a reindeer herding system in the very northern part of Sweden.

The Swedes have been Christians since the year 1000, and turned Lutheran in the 16th century. More than nine out of 10 native Swedes have belonged, and still do, to the Lutheran Church, the State Church of Sweden (but in the year 2000 Sweden will no longer have a state church). The Roman Catholic congregation numbers around 150,000 and the Islamic followers are almost as many.

1.3. The state model of Sweden and Sweden as nation

Sweden is a constitutional monarchy. Its Government is based on a majority of the Parliament approving the selection of a Prime Minister, who forms the Cabinet of a dozen or so ministries. For the last 70 years the social democrats have, with the exception for a period in the 1970sand one in the 1990s, governed the country, sometimes in cooperation with one or two smaller parties.

If you ask a Swede to describe their roots they would depict themselves as Swedish, and probably add that she comes from one of the 24 provinces (*landskap*) in which the country is divided. The meaning and importance of the provinces are related to dialects and, to a lesser degree, with the different characteristics of the people. Hardly any would seriously put forward an idea that their province, or other kind of region, should be in any degree independent or self governed. The only division talked about, mainly in jokes

but also more seriously as will be seen below, is the one between the capital and the rest of the country. But even that is more a reflection of the fact that Sweden is a small country and therefore has little room for more than one administrative structure no matter what kind, and that is usually, but not exclusively, located in the capital, Stockholm. So the divisions of the country described in the next paragraph should be seen as purely administrative and not in the very heart of people, with the already mentioned exceptions.

Sweden is administratively divided into three types of regions, every division resulting in a little more than 20 examples. One is made up of counties (*län*), each one headed by a Cabinet appointed Governor. A second type is the regionally elected county councils (*landsting*) responsible for medical care, transportation and in a minor way education and culture. The third type of region is the province (*landskap*) mentioned earlier, which has no political dimension, but has, as explained, some degree of importance for people's sense of identity and roots.

Since none of the different types of regions carry the combined strength of political representativeness and popular allegiance in the minds and lifes of people there is actually, beside the nation of Sweden as a whole, only the very local government (*kommunen*), in many but not all cases centered around a city or town, to reckon with. The local government is exercised by 288 municipalities. They have their own powers of taxation to use for their main responsibilities, which include education (below the university and college level which is a matter for the state), social welfare, child care, fire protection, recreation and culture.

1.4. Summary: the potentials for regional and local media

Sweden has a well established parliamentary democracy, with a monarch as a symbolic head of state, built on a system of relatively weak regions giving almost all the political power to either the central government and the local municipalities. The regions, or perhaps small "kingdoms" that preceded the birth of Sweden as a nation and country have been long buried and forgotten, if indeed they ever existed.

Sweden's inhabitants are Swedes, speaking Swedish, a Germanic language, with a little more than one tenth of its population being first or second generation immigrants mainly from the other Nordic countries, but also from more distant parts of Europe, South America and Asia.

Although the recent immigrants are comparatively small in numbers they form clear minorities in the Swedish society for several reasons. Many of them have arrived at the same time in large groups, many live together especially in certain suburbs to the three largest cities, many bring a new language and a new religion to the country, and some groups can easily be identified by their, in comparison with the blond and pale white swedes, contrasting looks with black hair and yellow, brown or black skin.

These characteristics of today's Sweden potentially shape many, but rather small, different media publics willing to make use of new and more diversified media, although these do not come from any specific regional dimensions of the country. In other words, the concept of region is a quite weak basis for any kind of modern mass medium compared to other European countries. That leaves the factor of proximity almost the only one to build regional television on in Sweden, being the local ambit the more suitable one for such proximity factor. The case against it, however, is the small scale of market, or public, where other means of communication may be stronger and more viable than television. The resulting landscape of regional and local TV broadcasts is one in which public support is fundamental to its continuing existence.

2. Television in Sweden: legislation, financing and organization[2]

In this chapter we will describe the state of and circumstances for Swedish television. A short history is followed by an overview the national TV channels in Sweden today. After that an overview of the laws and regulations for Swedish television is given. Finally we look into ownership, aspects of control and distribution ending with some rules for programming.

2.1. Swedish television - historical overview

The Swedish electronic media landscape (and the one of the media in general) has been a very stable one until the late 1980s, when it began a pace of slow but deep change which seems far from being stabilized. Radio and television developed in Sweden, as in the majority of its European counterparts, in the framework of a public monopoly, financed through the licence fee and rooted in the principles of the social responsibility of these powerful media. Furthermore, the electronic media policy in Sweden was put in the framework (and in a prominent position) of the ambitious social and cultural policies proper of a whole period of the Swedish history (Weibull and Gustafsson, 1997).

The first Swedish television trial transmissions started in 1949, but it was five years before regular transmissions were established. In the early 1960s TV became a national concern symbolized by a classic radio program, *Hyland's Corner,* changing medium and moving into television. In 1969 a second channel was launched and a very expansive period in Swedish television was to follow. In the years to come several organizational changes were made, one of the most important taking place in 1987, when the first channel focused on Stockholm-made programmes and the second on material made in the regions, although it still was transmitted nationally. This development reflects the ambition to lessen the division between the capital and the rest of the country, and even more of that is to follow, as a general principle for media regulation.

In the same year of 1987, the first Swedish commercial TV channel, TV3, started, transmitting by satellite in Swedish from London. TV3 became a comparatively successful channel, reaching a third of Swedish households in 1990. The second Swedish commercial channel, TV4, started in 1990, also transmitted by satellite. After a couple of years it turned into a terrestrial channel, thus reaching almost all Swedes. In the 1990s some more Swedish language satellite channels have been set up.

Table 1. Main Swedish national TV channels in 1998

Channel	Ownership	Status	Distribution	Financing	Population coverage %
SVT-TV1	State	Public service	Terrestrial	Licence fee	100
SVT-TV2	State	Public service	Terrestrial	Licence fee	100
TV4	Private	Public service	Terrestrial	Commercial	98
TV3	Private	Commercial	Satellite-Cable	Commercial	59
Kanal 5	Private	Commercial	Satellite-Cable	Commercial	51
ZTV	Private	Commercial	Satellite-Cable	Commercial	37
TV6	Private	Commercial	Satellite-Cable	Commercial	37
TV21	Private	Commercial	Cable	Commercial	18

As can be seen in table 1 there are three channels that reach almost all Swedes. They have all public service obligations. Then there are five more channels, all commercial with no public service obligations. These five channels have somewhat different profiles. TV3 is primarily entertainment; Kanal 5 broadcasts mainly movies and TV-series; ZTV addresses young people with a musical schedule; TV6 has the same owner as TV3 but since TV3 mainly attracts men TV6 tries to catch the women audience, but also broadcasts sports (again attracting men!) on week ends; TV21 is a game channel.

2.2. Television's legal framework

Sweden's first law for freedom of expression was issued more than 200 years ago, in 1766. It prevented censorship, but still included some limitations, for instance when it came to criticism of the Church and the king. The freedom of expression law in force at present is dated 1949, but it maintains the same main principles as its older versions without the limitations mentioned. The current legal setting of the Swedish televisive system stems from the constitutional text of 1975, which enshrines freedom of expression in the press and in broadcasting.

Today media legislation consists of four laws/regulations:

1. The law for freedom of expression, updated in 1992, including radio, TV and other modern media. Its main contents are as follows:

- Liberalization of cable broadcasting: everyone has the right to transmit radio and TV programmes by cable (with the only restrictions concerning pornographic and violent material).

- Freedom for messenger/source: people who give information to the media are protected as sources. The State, and other governing structures, are forbidden to search for the identity of informers.

- Responsible editor: it is mandatory to appoint one person responsible in the judicial sense for a newspaper edition, a radio programme, etc. It is the responsible editor, not the single journalist, who should be responsible in a court of law for the contents of the medium (there is no place at all for censorship).

- Special trial regulations: The trial has its special rules with a jury, which is unique in Swedish law.

There are exceptions to this freedom of expression, mainly concerning the safety of the country and the demeaning of individuals.

2. The radio and TV law, which contains the basic rules for radio and TV in Sweden, except for the private local radio, which has its own regulations. The law sets that licences for national radio and TV stations are awarded by the government. The programmes must be impartial and truthful with regards to content and should be characterised by the basic ideas of democracy, all humans being of equal value and the individual's freedom and dignity. Realistic reporting of violence and pornographic pictures must not take place at times when there is a considerable risk that children can watch.

A large part of the law regulates commercials and sponsoring, eg stating that news programmes cannot be sponsored. For TV at least half of the programmes should be European in origin (in accordance with EU rules).

The Swedish Broadcasting Commission (see below) has the task of looking at the different programmes, once broadcast, to see whether rules are complied with. If and when it does have objections the concerned radio or TV channel must send a message from the Commission stating them.

3. The law for private local radio could have been a part of the radio and TV law, but as the authorities were at the time (1992) expecting changing conditions for private local radio and wanted to be able to change the law accordingly, they felt that this would be more easily done in a separate law. It regulates who has the right to send, saying that those owning a newspaper cannot be a majority owner of a local radio company. When it comes to content, private local radio does not have to comply with the impartiality and truthfulness obligations mentioned above. But at least a third of the programming time must be produced by the station itself. The parts regulating commercials are much the same as in the radio and TV law.

4. The licences and rules for senders specify the framework for the organization of national radio and TV. They detail, for each medium and company given a licence, what has been said in general in the radio and TV law. A licence consists of four parts: general rules, rules for the contents, rules for corrections and retort, and conditions for commercials and sponsoring. They state that programming should be diversified, of high quality and characterized by ambitions of educating people. This ambition should be understood as a part of something very specific in Sweden, where a certain model of education outside of the general school system has been widespread and used for more than 100 years. These rules also state that the distribution service must be bought from the state company Teracom.

There are two media regulatory bodies in Sweden: the Swedish Broadcasting Commission (Granskningsnämnden för Radio och TV) and the Swedish Radio and Television Authority (Radio-och TV-Verket), whose members are appointed by the Government. The first one is a governmental agency in charge of awarding licences for national terrestrial transmission, and to control the contents of programming transmitted by all the Swedish radio and TV companies that broadcast to the public, specially in those matters concerning advertising and sponsorship rules and the right to reply. The Radio-och TV-Verket, set up in 1994, is in charge of licensing local and community radio, authorizing non-commercial local television stations and registering satellite television broadcasters.

2.3. Ownership and organization, forms of control and distribution

2.3.1 SVT (the Television Company of Sweden)

Starting with what could be labeled as "State television" it should be stressed that this label could be misleading. The owner of the national public service channels in both radio and television has always been freed and separated from the State. People have, however, probably felt that it is and has been a State organization, mainly because of the licence fee financing system, which could be seen as just another tax. The public service character of those media and their, at least up until the start of the second TV channel in 1969, rather formal and "obedient" atmosphere, are factors that would underline the misconception of "State media".

Indeed, radio and TV in Sweden have always been separated from the State using different models of organization through the years. With the advent of television in the 1950s the historically important Social Movements became a major owner.

Something should be said about the Swedish Social Movements (a better name for them could have been Folk Movements or Popular Movements, but both of them carry some connotations that are not quite what we want). Many of them started more than 100 years ago, all of them

characterized by having one central idea (or goal), many followers, a democratic organization and a volunteer basis. The main streams in those first Social Movements were the "teetotaling" movement (abstaining from drinking alcohol), the workers' movement, the free church movement, the sports movement and, to name one of the most recent examples, the environmental movement. So wherever a strong idea comes up, the Swedish way of handling it is to try to make it into a Social Movement thereby gaining power and space in Swedish society giving the idea its best chance of fulfillment.

Some of the largest movements, like the workers' one, have at the same time grown very large and specialized, and divided the main and common idea into separate branches, like the workers' political branch (the Social Democratic Party), the workers' union branch (the Labour Union), the workers' educational branch (the ABF, Workers' Educational Organization) and several others.

Getting back to the media organization the owner group of Swedish public radio and television was made up of the following shareholders from 1966 to 1993: social movements 60 per cent, the press 20 per cent, free enterprise companies 20 per cent. In 1993 a major reorganization was made still keeping the established principles of ownership. The form for ownership changed into Foundations and the existing common company for radio and television, Sveriges Radio (SR), was split into three so-called "programme companies": Sveriges Radio (The Radio Company of Sweden), Sveriges Television (The Television Company of Sweden), and Sveriges Utbildningsradio (The Educational Radio Company of Sweden, for the production of educational programmes).

Sveriges Television (SVT) is by far the largest of the three, with a staff of 3,450 and an annual budget of around 3,309 million Kroner (1995). Its activities are almost entirely financed through the licence fee. It carries two channels, SVT1 and SVT2, the first one centralized and the other carrying the disconnections made by SVT's regional centres, although it remains a nationwide channel. The idea of decentralization is kept through the construction of five main regional organizations: South, West, Stockholm, Middle Sweden and North. Each of these units includes one or more regional centres (see below).

In 1997, after several years of liberalization of the Swedish broadcasting system, the two SVT channels retained around 50 per cent of the TV viewing market in Sweden. About 75 per cent of the programmes are in house made or acquired in the domestic market. In 1995 SVT1 broadcasted a weekly average of 70 hours, while SVT2 transmitted 79 hours. Since December 1997 SVT produces a digital satellite channel, SVT Europe, directed to the European households with Swedish ties and featuring a selection of the terrestrial Swedish-made programmes in SVT1 and SVT2 (data from Carlsson and Harrie, 1997).

Table 2. Television market shares in Sweden, 1995

Channel	%
SVT1	25
SVT2	26
TV3	9
TV4	28
Kanal 5	4

Source: Carlsson and Harrie, 1997.

2.3.2 Commercial Television: TV4

Satellite and cable reception, expanding steadily through the 1980s, would pave the way to the de facto breaking of SR monopoly, with the creation of TV3, a satellite channel based in London. This stimulated the demands for a Swedish, commercially financed, private channel. In autumn 1990 Nordisk Television launched the satellite channel TV4, which was to become the main Swedish commercial channel. It was owned by the Swedish media mogul, Jan Stenbeck (Kinnevik Ltd) together with one of the most influential families in Sweden, Wallenbergs (Investor Ltd), The Farmers' Corporation (LRF), a book publishing company (Natur och Kultur Ltd) and an insurance company (SPP). In 1997 the largest newspaper owner, Marieberg Ltd, bought the SPP part of 15 per cent of the shares, a change that was debated since it led to a concentration of media ownership. In 1998, another major shareholder entered the consortium, the Finnish Alma Media Oyj.

In 1991, TV4 was awarded a terrestrial frequency by the Government and started officially its terrestrial transmissions in March 1992. It is financed by commercials and it pays an annual fee to the State in exchange of the licence, proportional to its commercial incomes. The rules say that commercials can be no more than 10 per cent of the total broadcasting time and must be put in between programmes. Even at prime time commercials must be limited to 10 per cent of the time. Other rules say that commercials must not be directed towards children under 12, and must not advertise alcohol, tobacco nor prescribed medicine.

TV4 is a "conventional" channel, broadcasting an encompassing schedule ranging from news and current affairs to entertainment and feature film (total broadcasting time in 1996: 6,246 hours or on average 120 hours per week). It is a "publisher broadcaster", as it commissions most of the programming to the Swedish independent industry or purchases it in the international market (mainly in the US market). Only the news and current affairs programmes are made in house. About half of the programming is nonetheless of Swedish origin. It has been the most watched channel in Sweden since late 1994 (share autumn 1994: 29.6 per cent; share 1997: 27.6 per cent), but the combined audience of the two SVT channels are by large

ahead in the ranking (share SVT1+SVT2 in 1997: 49 per cent). TV4 is entirely financed through commercials and sponsorship (income 1994: 12 billion kronor).

TV4 operates according to the publisher-broadcaster model, with a rather small staff of 250 employees and a virtual monopoly on national TV advertising. The channel has a centralized structure, with its headquarters being located in Stockholm, but has developed a network of 16 local TV stations which broadcast programmes and advertising locally, off-the-network in the TV4 frequency. At the same time they act as local news correspondents for the national channel (see below).

According to some concrete obligations of the TV4 licence, the channel must broadcast:

- at least 50 hours of programmes per week;

- daily news programmes, which in winter time must be 10 hours or more per week;

- at least 40 hours Swedish or Nordic TV-drama per year;

- 15 hours or more Swedish production per week;

- daily programmes for children under 12.

When TV4 was to receive their second licence, for the years 1997-2001, there was some discussion about TV4's failure to comply with some of the points above, especially programmes for children and the local offices. But a new contract was signed with more general statements than those in the first contract. TV4 has expanded into other media by delivering news to private local radio stations.

2.3.3. Commercial television – Satellite and cable companies

No operating licence is required to transmit by cable nor satellite, unlike ether transmission, which is submitted to public service franchise awarded by the government (Robillard, 1995).

Current legislation includes a "must-carry" principle, stating that any cable network of more than 10 households must forward all programmes from SVT and TV4. This gives a kind of "normality" to cable television making it look like any TV distribution system, although offering many more choices, thanks to the distribution of satellite TV (local cable television is dealt with in chapter 3.2).

Through the use of dishes satellite TV has become commercially successful, as the Swedish examples of TV3, Channel 5, ZTV and TV6 show (see table 1).

The most successful commercial television channels using cable are ZTV, which also broadcasts by satellite, and TV21 The Commercial Channel.

3. Regional and local television in Sweden

Early this decade, Weibull and Anshelm (1991) wrote, concerning the decentralization level of the Swedish media system, that "the expansion of Swedish media in the 1980s in terms of output has, to a large extent, taken place on a local and regional level". These authors argue that, even though these tendencies should not be exaggerated, "it is quite clear that political decisions of the late 1970s and mid-1980s (…) basically changed the traditional pattern of the Swedish media system. The periphery has grown, but what is more interesting is that this, to a large extent, has been at the expense of the national centre" (Weibull and Anshelm, 1991: 43).

Nonetheless, this process should be seen as one of relaxation of a quite tight centralism in the media system, based until then in the overwhelming dominance of the capital over the rest of the country, rather than one of emergence of a powerful regional/local media system. In other words, the population and industrialization pattern (relatively low overall population: less than Belgium; low population density, large parts of the territory almost desert; concentration of inhabitants and economic activity in the southern third of the country...) and the lack of powerful native minorities has meant that the overall centralism of the media remains, despite moves towards decentralization in the last 20 years.

Thus, in the audio-visual media, decentralization has meant the birth of local and regional TV stations, the main ones yet in the framework of nation-wide networks (SVT and TV4), being local cable television still a media activity of little significance in the Swedish media landscape. One explanation for that could be that the only really viable reason for local media is the distance from Stockholm to some parts of the country. From the commercial point of view, the "market" often becomes very small and therefore risky for private media and not very worth while for nationwide media. Any other ideas for local media must be based on either the fact that in some suburbs to the three large cities (and only one of them has more than one million inhabitants) there are strong and large enough groups of immigrants to carry a local TV station, on a very low budget at that. Or if the local medium really centers around some very special interests that can be linked to living in a certain village or town, like interest in the local sports club, a local free church or so.

To summarise, the nation still is the main reference framework of the media system, and this is very likely to continue unchanged. The transnational (foreign or pan-European channels by satellite) and regional-local levels are equally likely to further expand in the future, though with no serious challenge to the centralist pattern.

3.1. Regional activity of the nationwide channels

3.1.1. SVT's regional activity
Despite being a central institution, the Swedish public broadcasting system

has undergone a steady move towards decentralization in the last 20 years. It began in the early 1970s, when the demand for more local and regional influence on central institutions attained national radio and television (Hultén, 1996). Between 1975 and 1979, legal and factual developments led to the setting up of a network of 24 regional public radio stations, organized within the monopoly, and to the proliferation of local, non-commercial public access stations. The first regional TV broadcasts were introduced in three regions as early as 1972. SVT's regional structure received its present shape between 1980 and 1987.

The regional activity of Sveriges Television is quite loosely referred to in its licence agreement ("The charter for television broadcasting services in Sweden 1996"), granted in 1996. According to this agreement, the two channels of the public corporation are to have a "nationwide" scope, but nation-wide transmission "includes the right to segment transmission into regional services". Their programmes should "by virtue of their accessibility and diversity, cater for differing interests and needs of the population" (§ 6); "events should not be assessed and reported from the Stockholm horizon only" (§10). "Programmes originating in SVTs district offices should reflect the characteristics of the respective regions and more generally contribute to the range and diversity of programme output" (§ 16). Thus, beyond the general statements rejecting centralism and praising diversity, no explicit mandate seems to stem from this charter concerning regional activity and broadcasting in SVT, which are referred to as a given reality. No further detail is provided in the radio and TV law of the same year 1996, in which it is stated that the licences granted by the government to television companies may relate to the transmission of programmes "throughout Sweden or to a certain part of Sweden" (chapter 3, section 2, #1), and to "regionally transmit and produce programmes" (*idem*, #14). No obligation is directly contained in those provisions.

The fact that the regional structure is not clearly inscribed in the regulatory framework doesn't hinder, according to Olof Hultén, head of corporate development at SVT, the existence of a broadly shared and rooted conviction in the corporation and in the Swedish society that public television and the institutions in general should be as decentralized as possible.

Indeed, Swedish public television has developed a completely decentralised structure, giving birth to some regional activity. According to Weibull and Anshelm (1991: 44), "it is quite clear that the typical feature of the 1980s is the regionalization of public service broadcasting in terms of transmission, based on the decentralization of the production starting in the 1970s".

SVT's bid for decentralization is illustrated by the fact that the cutbacks of 11 per cent in the budget from 1996 to 1998 imposed by the Parliament have been concentrated mainly in Stockholm: "cutbacks in the regional offices were ruled out in view of our ambition to increase the volume of production originating outside Stockholm" (SVT, 1997).

At present, SVT's regional structure is formed by four big units outside Stockholm, gathering together 10 regional centres.

Table 3. SVT's regional structure

Main unit	Regional centre
SVT Region South	SVT Malmö
	SVT Växjö
SVT Region West	SVT Göteborg
SVT Central Region	SVT Norrköping
	SVT Falun
	SVT Örebro
	SVT Karlstad
SVT Region North	SVT Luleå
	SVT Umeå
	SVT Sundsvall

Source: SVT.

In the period from 1988 to 1996, the two channels were managed separately and even in competition, although a certain specialization was imposed upon them: SVT1 would broadcast mainly programmes made in Stockholm, and SVT2 would transmit regional productions only. Today, this competitive structure has been substituted by a co-operative one, due to the liberalization of the Swedish broadcasting system, even if the regional remit of the second channel is somewhat still alive in the fact that it carries the majority of the regional disconnections.

The activity of the regional centres is mainly devoted to the production of the regional news, broadcast every day on SVT2 in morning, afternoon and late evening slots. In 1996 regional news were transmitted for the first time on Sundays, the 17:00 time slot for regional news was expanded on weekdays and a new window for a 30 minutes regional magazine was introduced on Mondays evening alternative weeks. In a normal weekday, an average Swedish viewer can watch up to 44 minutes of (almost exclusively) regional news. The scheduling of the regional disconnections in 1997 is shown in table 4.

In 1997, regional transmissions amounted to 1,658 hours (including 67 hours of repeats), 31.9 hours per week (all the centres combined), against 8,560 hours (164,6 hours per week) of national transmissions in the two channels combined. Table 5 shows that there has been a steep and progressive increase in the amount of regional broadcasts since 1992. In 1997 the regional broadcasts amounted to 223 per cent more than five years ago, while the amount of nationwide broadcasts only rose by 28 per cent in the same period (the increase consisting largely of repeats). Nonetheless, the average hours per regional centre remains low, about 160 hours per

year in 1996 (see table 6). Furthermore, the figures for 1997 are particularly high due to the fact that an experimental regional magazine was broadcast this year, in addition to the news, but it has been dropped off in 1998 due to the overheads which it caused to the regional budgets

Table 4. Scheduling of SVT's regional disconnections in 1997

Weekdays	
6:57	3 min.
7:57	3 min.
8:57	3 min.
17:00	5 min.
19:10	20 min.
22:00	10 min.
Sundays	
19:25	5 min.
21:45	5 min.

Source: SVT, 1998b.

Table 5. Evolution of SVT's nationwide and regional broadcasts, 1992-1996

	1992		1993		1994		1995		1996		1997		1992-1996	
	Hours	%	Hours	%	Hours	%	Hours	%	Hours	%	Hours	%	Hours	%
Nationwide	6,668	93	7,664	92	7,856	90	7,768	86	8,244	85	8,560	84	+1,892	28
Regional	514	7	625	8	890	10	1,280	14	1,494	15	1,658	16	+1,144	223
Total	7,182	100	8,289	100	8,746	100	9,048	100	9,738	100	10,218	100	+3,036	42

Source: SVT, 1997 and 1998.

Table 6. Hours of regional transmissions by regional centre, 1996

Malmö	165.3
Göteborg	165.3
Växjö	165.3
Norrköping	165.3
Örebro	107.7
Karlstad	60.6
Falun	165.4
Sundsvall	165.3
Umeå	67.8
Luleå	99.6
Total	1,493.5

Source: SVT, 1997.

The regional production for national transmission has also growth in the last years, in order to comply with the governmental requirements of 55 per cent of national programming being originated outside Stockholm. In 1996, this percentage was 57 per cent (see table 7), an increase of 14 per cent compared to 1992 figures. According to Weibull and Anshelm (1991), this is a "long term trend" in public service broadcasting, going back to the 60s, when regional production units for radio were established, and somewhat later for television.

Table 7. Evolution of the share of general production in and outside Stockholm

	1992		1993		1994		1995		1996		1992-1997	
	Hours	%	Hours	%	Hours	%	Hours	%	Hours	%	Hours	%
Stockholm	910	47	1,209	53	1,180	53	1,009	47	883	43	-27	-3
"District offices"	1,011	53	625	47	1,045	47	1,149	53	1,155	47	+144	14

Source: SVT, 1997.

With the reorganization of the two channels in 1996, regional centres were given new production mandates in such areas as medicine (SVT Karlstad), science (SVT Norrköping) and the environment (SVT Sundsvall).

3.1.2. TV4's regional activity

As early as 1992 the company began to get involved with local television, through its participation in a network of local stations throughout Sweden, much of them purpose-made for the new channel. The creation of a decentralized structure was actually a requirement set in the licence granted by the government, following the own proposals of the channel in its application. At first, the majority of the stations were truly independent, with the channel only owning a minority stake in a few of them. Only the stations in the main cities (Stockholm, Göteborg and Malmö) where created as 100 per cent subsidiaries of TV4.

It may seem that the bid for local television was actually a wink to the government in order to get the licence, and that it would be abandoned as soon as possible when confronted with the heavy losses the sector would generate (as it actually did: in 1995, they amounted to 63 million kronor). Through the years, though, not only the structure has remained active, but TV4 has endeavoured in a progressive increase of its shareholding in almost all of the local stations, so that in late 1997 it owned a majority stake in 11 local stations. According to Weibull and Gustafsson (1997) this is due to the poor financial situation of these stations, which has forced TV4 "to go in as a co-owner".

The purpose of this network is double (though in the final analysis both are one and the same): (1) to approach the channel as much as possible to the

audience, through the off-the-network transmissions of the local companies ("as locally-based as possible"; TV4, 1995) and the production of programmes outside Stockholm (47 per cent of the overall production in 1994), (2) and to contribute to the commercial income of the company through local advertising. In short, the overall aim is to strengthen the position of TV4 in the Swedish TV market thanks to its closeness to the viewers.

Local stations' entrepreneurial structure and financing

In 1997 TV4 owned the majority or all of the shares in 11 local TV stations, having increased during this year the average stake in them to 59 per cent. The participation of the company in the local station's shareholdings is shown in table 8. The other shareholders are mainly companies and organizations working in the respective area, and people who work for the companies (which as a whole amounted to 340 in 1997).

The local TV stations are financed through advertising and sponsoring of programmes broadcast off-the-network to each area on the TV4 frequency. The existence of these disconnections was the direct reason for a relaxation in 1996 of the limits to advertising time between 7:00 pm and midnight imposed by the government to TV4. Indeed, thanks to the conclusion of a new agreement between TV4 and the local stations the maximum permissible advertising time was increased from 6 to 10 minutes in the indicated period of time, amounting to a total of 20 extra minutes of advertising. The channel used this to increase the advertising time during the local conventional disconnections (accompanying local programmes), but also to broadcast new slots of specific local advertising.

One of the channel's main commercial strategies aims at developing the market for TV retail advertising, up to now mainly in the hands of the local press and worth in the region of 500-1,000 million kroner per year, according to the company. In autumn 1997 the network was adapted to broadcast different advertising to 25 regions simultaneously (since some local stations can split transmissions within their area), in order to offer the advertisers the possibility of "highly tailored campaigns" (TV4, 1998). According to company sources, "TV4 sees local TV as a strategically important resource now that the TV medium has reached maturity and is moving more towards local news and the concept of big city TV. Digital television will create potential for local TV to further develop its broadcasting in terms of time and content" (TV4, 1998).

In 1997 the commercial income of the local companies was worth 139 million kroner, a rise of 58 per cent against the previous year. The global turnover of the 15 companies amounted to 206 million kroner (154 in 1996). In the first half of 1998, the sales of the local stations increased in 73 per cent, thanks mainly to the retail advertising market. These figures seem to confirm the validity of TV4's strategic analysis concerning local TV.

Nonetheless, during the first half of 1998 the local stations continued to cause losses to the company amounting to 41.2 million kroner, compared to the 27.4 million in the same period of the previous year.

Table 8. Participation of TV4 in the local station's shareholding, 1997

Station	City	%
TV4 Sundsvall	Sundsvall	100
TV4 Göteborg	Göteborg	100
TV4 Sydost	Växjö	100
TV4 Skåne	Malmö	88.9
TV4 Halland	Halmstad	68.9
TV4 Värmland	Karlstad	66.6
TV4 Stockholm	Stockholm	65.5
TV4 Skaraborg	Skövde	60.1
TV4 Öst	Linköping	60
TV4 Jämtland	Östersund	49
TV4 Jönköping/Borås	Jönköping	33.7
TV4 Uppland	Uppsala	27
TV4 Norrbotten	Luleå	26.6
TV4 Bergslagen	Västerås	25
TV4 Botnia	Umeå	-
TV4 Fyrstad	Fyrstad	na

na: not available.

Source: TV4, 1998.

Production, programming and audience

The 16 local TV stations mainly produce local news, sports coverage, weather reports and some entertainment, for local broadcasting mainly. They also contribute to the national schedule occasionally, mainly through reports to the national news and sports programmes. Only the stations in Stockholm, Göteborg and Malmö contribute to the national output with whole programmes.

The disconnections are broadcast in 16 areas[3] four times each weekday, and a local news magazine is broadcast on Saturdays morning. In 1995, the average broadcasting per station was 281 hours. In late 1998 a new time slot at 10:00 p.m. was created for local news. According to data from Sifo/Temo, between 500,000 and one million viewers watch local broadcasts daily (TV4, 1996a).

3.2. Local cable television

The first legislation intended to regulate the cable TV networks was passed by the Parliament in 1986. Cable was then seen by politicians as an

opportunity to develop local non-commercial television; nonetheless, despite government support to local programme origination in the late 80s, and, later on, the proliferation of local cable TV as a result of the new legislation, cable distribution has to do mainly with international satellite channels. The subsequent 1992 law meant the full liberalization of broadcasting through cable, as any citizen or organization willing so can build and operate a cable network, or use one to broadcast radio or TV programmes with the only requirement of reporting to the Radio and Television Authority about their activities. Furthermore, governmental regulation forces the network owners to reserve one channel for community or local television activities. In addition, they can act themselves as local programme producers. The programming of local non-profit stations should be characterized by the "widest possible freedom of speech and information", allowing for sponsoring but no commercials.

Sweden is a highly wired country, as more than 40 per cent of the population is subscribed to a cable TV network. In 1997 not less than 106 cable companies operated in the country, but the dominant cable operator is Telia Kabel-TV, a subsidiary of Telia, which connects about 1.3 million households. The four main cable operators account for 95 per cent of all cabled households in Sweden (Weibull and Gustafsson, 1997).

The non-profit stations (see table 9) are supported by different civil society organizations, even at an individual level, and are funded through non-governmental, local funds raised from different sources. As the activity level of these stations is usually quite low (most of them produce few hours of programming per week), their staff is mainly made of volunteers, and are equipped with inexpensive facilities, their financial requirements are low. Programming is based on local news, which constitute the main spot of the schedule. They are usually produced by volunteer journalists, and account to 15 to 20 minutes on a daily basis (weekdays only). Other programmes can include debates, current affairs, documentaries... During the rest of the day, the channels go to a blank screen, or to different solutions based on fix images (pictures, drawings, text information...).

Open channels in Sweden

Inside this non-profit category one can distinguish the local channels at Stockholm, Göteborg, Malmö, Lund and Västerås, all of them belonging to the "open channel" model. It is based in the "access" principle, ie, any civil society organization of the city in which the channel operates can have access to airtime in it.

In Stockholm, not less than 40 member organizations can broadcast their programmes in the corresponding channel. In addition, the station broadcasts on their own initiative in the occasion of local events, like Stockholm's summer Water Festival. In 1997 the transmissions amounted to 2,358 hours, of which 1,230 hours were made by local TV associations.

Table 9. Swedish local cable TV stations licenced by the Radio-och TV-Verket (June 1997)

City	TV station
Alingsås	ATV
Berg	TV Berg
Eskilstuna	Eskilstuna Television
Falun	Falu närradio- och TV-förening
Gävle	Fria Kanalen
Göteborg	Öppna Kanalen i Göteborg
Helsingsborg	Helsingsborg Vision
Järfälla	Järfälla Lokal-TV Förening
Jönköpings	Jönköpings Lokal-TV Förening
Karlstad/Hammarö	Öppna Kanalen
Luleå	Luleå När-TV
Lund	Öppna Kanalen
Malmö	TV Malmö/Öppna Kanalen
Motala	TV Motala
Nacka	Nacka TV
Norrköping	Norrköping lokal TV-förening
Piteå	Piteå Lokal-TV
Sandviken	Sandviken Television
Skellefteå	Active Television
Skövde	Skövde Lokal-TV
Sollentuna	Sollentuna Lokal-TV
Stockholm	Öppna Kanalen i Stockholm
Sölvesborg	Sölve Kanal
Trollhättans	Trollhättans Kanal
Uddevalla	Uddevalla TV (UTV)
Uppsala	TV Uppsala
Värnamo	TV Värnamo
Västerås	Öppna Kanalen Västerås
Örebro	När-TV Ideell Förening

Source: www.openchannel.se

The programming philosophy of these stations is summarized in the following text, taken from the Open Channels' organization web site:

> Open Channel is free television as programmes are not confined to the rules governing the national public service television or the private commercial channels. Open Channel is dedicated to the fight for the

freedom of speech offering citizens to produce programmes and run a local TV station on their own terms. Open Channels in Sweden will be a dynamic part of the growing multicultural society offering especially young people a cultural and political arena as well as finding new means and ways to make television. (www.openchannel.se)

Open channels are funded by membership and transmission fees as well as project grants and sponsorship. Advertising is not allowed. For example, Open Channel Stockholm, created in 1992, has sponsored since 1993 by the City Council and the Swedish telecom operator Telia. 340,000 households in the capital city have access to it.

Open Channel in Göteborg started broadcasting in 1995, and reaches 80 per cent of the city inhabitants (190,000 households). Some 47 organizations participate in the channel's broadcasts, which are on around the clock. When programmes are not broadcast the channel carries an information loop and local audio access for musicians and composers from the Göteborg region.

The three main open channels (Stockholm, Göteborg and Malmö) are linked together in a network, with a potential audience of 1.3 million viewers, which allow them to share programmes and resources. This cooperation has given birth to common live broadcasts of the Swedish and European parliaments sessions.

4. Technological developments

To date, local independent television has been a matter of cable, while local and regional off-the-network television has been transmitted over the air, using the national frequencies of TV4 or SVT. With the introduction of digital terrestrial television (DTT), which was decided by the Government in December 1996, things may change.

According to Olof Hultén (1998), present plans for digitalization of terrestrial broadcasting in Sweden include the setting up of DTT in five regions of the country, together covering about 50 per cent of the population. In these regions, two digital frequencies (multiplexes) will be available, totaling six national TV channels and two regional. Furthermore, the government has proposed that the 8 channels will offer a mix of national and regional services from several broadcasters. In the case of regional broadcasts, joint channels between different programme providers will be accepted. SVT has announced that one of the four DTT channels it has applied for will be a regional channel, broadcasting to two of the five areas. "An innovation for SVT is the fact that this regional service is planned to be a joint effort with regional, not-for-profit content providers" (Hultén, 1998).

5. Conclusion and outlook for the future

Despite Sweden being a big, sparsely populated country in geographical terms, the low density of population, the lack of significant minorities, the

relative cultural homogeneity of the population and the concentration of people in a few metropolitan areas don't contribute to set the basis for a huge and complex local and regional electronic media system. Certainly, market conditions don't favour the setting up of significant commercial ventures at this level. Thus, local and regional television has recently flourished to a certain extent in Sweden as the result of continuing public support and funding, be it in the form of Governmental regulations (TV4's licence requirements, "must carry" obligations for cable operators to the benefit of local non-profit TV channels. SVT active involvement in regional broadcasting...) or as municipal or civil society non-profit initiatives. This public support seems to be matched by popular acceptance of the role of local and regional TV.

Given this scenario, it seems that the future of local and regional television in the multichannel and digital environment is not threatened, although viewing figures will have to be shared with the growing satellite and niche offers. New forms of support and involvement could be tried, however, such as allotting a part of the licence fee to local non-profit TV initiatives (for instance, open channels), like in other neighbouring countries. The regional and local windows in the national channels could also be expanded, allowing for more regional production capacity, which in turn could gain more room in the national schedules.

Bibliography and References

Hadenius, Stig and Lennart Weibull (1997): *Massmedier. Press, Radio & TV i förvandling*.

Hultén, Olof (1996): "Digital television broadcasting – implications for national media policy. Some notes on the case of Sweden". Paper presented at the IAMCR Conference, Sydney, August 18-22,1996.

Hultén, Olof (1998): "Digitalization of Swedish TV distribution". Unpublished.

Moring, Tom (1998): "Better served or better hidden? Digital radio and television services for three minorities in the Nordic countries: a preliminary assessment", in *Nordicom*, vol. 19, n. 2.

Robillard, Serge (1995): *Television in Europe: Regulatory bodies*. London: John Libbey.

SVT (1997): *Pieces for everybody - Annual report 1996*. Stockholm: Sveriges Television.

SVT (1998a): *Annual report 1997*. Stockholm: Sveriges Television.

SVT (1998b): *Sveriges Television - Public Service -uppföljning 1997*. Stockholm: Sveriges Television.

TV4 (1995): *Annual report 1994*. Stockholm: TV4.

TV4 (1996a): *We provide TV for the whole of Sweden*. Stockholm: TV4.

TV4 (1998): *Annual report 1998*. Stockholm: TV4.

Weibull, Lennart & Karl Erik Gustafsson (1997): "The Swedish media landscape in transition", in Carlsson, Ulla & Eva Harrie (eds): *Media

trends 1997 in Denmark, Finland, Iceland, Norway amd Sweden. Göteborg: Nordicom.

Notes

1 Most of the facts about the country of Sweden, that is most facts in chapter 1, have been taken from Fact Sheets on Sweden published by the Swedish Institute, which describes itself as "a government-financed foundation established to disseminate knowledge about Sweden abroad" (April 1997).

2 For this chapter, scores of sources could be, and have been, used. However, the bulk of the pertinent information is already summarized in the eminent standard work on the Swedish mass media, *Massmedier. Press, Radio & TV i förvandling* ("The Mass Media. The Press, Radio and TV in change") coauthored by Professors Stig Hadenius and Lennart Weibull. Its first edition came in 1978 and the current edition, number six, was published in 1997. So many references in chapter 2 have been taken from this encompassing book.

3 TV4 Sundsvall and TV4 Botnia operate under a single corporate umbrella with joint administration but saparate news desks.

United Kingdom: Political devolution and TV decentralization

Mike Cormack

1. The regional dimension of the State

1.1. The general political framework

The United Kingdom[1] is a plurinational state consisting of England, Scotland, Wales and Northern Ireland. In addition to these the Isle of Man and the Channel Islands have their own parliaments, and have the status of being dependencies of the British Crown. In the cases of both Scotland and Wales there is general recognition of their status as nations within the British state, distinct from England. Northern Ireland is a more complex case, with its nationality in dispute between those (described as "nationalists" within Northern Ireland and largely consisting of the Catholic community) who see it as a region of the Irish nation and those (described as "loyalists" and largely consisting of the Protestant community) who see it as a region of the United Kingdom. In terms of population, England is by far the largest. According to the most recent official census (1991), the population of England is 49,890,000, the population of Scotland is 4,999,000 and the population of Wales is 2,812,000.

Following its massive electoral victory in May 1997, which changed the party of government for the first time since the Conservatives under Mrs Thatcher had won in 1979, the Labour Government headed by Tony Blair promised a comprehensive set of proposals for constitutional reform. Heading this was a programme granting varying degrees of self-government to Scotland and Wales.

The proposals for Scotland ("Scotland's Parliament") recommended a Scottish Parliament based in Edinburgh with 129 members, with power over all the areas which the Scottish Office formerly controlled - in fact power over everything except constitutional change, foreign policy, defence, international relations, major aspects of the economy, and certain areas of social policy and transport regulation. The proposals also included the power to vary income tax by a small amount. Scotland would continue to send Members of Parliament to the House of Commons in London, but these would be reduced from the current number of 72. In September 1997 these proposals were put to a referendum in Scotland in which 74.3 per cent voted in favour of the proposals for a Scottish Parliament and on the separate question of whether it should have tax-varying powers, those in favour were 63.5 per cent.

The proposals for Wales were for an Assembly of 60 members, with substantially less powers than the Scottish Parliament would have, in particular having no tax-varying powers. The reason for the differences between the Scottish and Welsh proposals is that there had been less pressure for change in Wales which, despite having a strongly surviving language of its own, has been historically much more closely integrated into the English legal, educational and political systems. The vote, held a week after the Scottish referendum, was much closer, with 50.3 per cent in favour of the proposals, a majority in actual numbers of only 6,000 votes. Following these referendums, the government introduced the appropriate legislation to Parliament in December 1997, with the aim of making the new Scottish Parliament and Welsh Assembly functional by the year 2000. During the referendum debates, there was reference to the possibility of elected assemblies being created for the English regions, but so far there has only been a little interest shown in this. However, in May 1998 the government intends to hold a referendum in London to decide whether it should have its own unitary local government, headed by a directly-elected Mayor and a local assembly formed by 25 members, which was approved by a majority (72 per cent), although only a third of the people of London with voting rights participated. The situation in Northern Ireland has also experienced an important change caused by the referendum in April 1998 about the multiple-part *(between multiple parties or parts)* peace agreement that was supported by the 71 per cent of voters. Between the proposals of the plan, the creation of an assembly in Northern Ireland formed by 108 members, which will assume all the competencies that until now the government departments for Northern Ireland had assigned, is included. The effects of these changes can be deep because United Kingdom is moving away from the traditional centralised model towards a federal model.

Local government in Britain is based on relatively small areas. These have recently been reorganised. England is in the process (due to be completed during 1998) of changing to a system of 46 unitary local authorities (having

been formerly divided into 45 counties and 32 London Boroughs). Wales consists of 22 local authorities and Scotland is divided into 32 (both Wales and Scotland changed to this structure in 1996). All of these local authorities are run by elected officials. The only elected local government organisations in Northern Ireland are 26 Districts with very restricted powers. Other services are provided by non-elected Area Boards and by central government.

1.2. The culture-language dimension

Linguistic variation in Britain is most obvious in relation to the Celtic languages. The best surviving is Welsh, spoken today by 18.7 per cent of the Welsh population, that is, about 500,000 people. This figure – from the 1991 census – was a decrease of 0.3 per cent since the 1981 census, but the percentage of speakers in the age range 3-15 was significantly up (from 17.6 per cent to 24.3 per cent), suggesting that the future of the language is secure.

Gaelic is spoken by about 65,000 people in Scotland, mainly living in the Western Isles and adjacent coastal areas, although there are significant numbers of speakers scattered throughout Scotland, particularly in Glasgow. This number is 1.4 per cent of the Scottish population (a decrease from 1.6 per cent in 1981). However it has been argued that the low point for the language was in the mid 1980s and, with the development of Gaelic schools and pre-school groups, the figure should increase in the future. Gaelic and Welsh speakers are all bilingual with English.

Since the Welsh Language Act of 1967, Welsh has had a degree of official recognition within Wales. However Gaelic has no official status in Scotland and native Gaelic speakers – who can all also speak English – are not allowed such basic rights as speaking in their own language in law courts or getting official forms in Gaelic. Even within the Gaelic speaking areas in the Western Isles and the Highlands, it is only within the last twenty years that bilingual road signs have been erected. In 1974 the Western Isles local authority (calling itself "Comhairle nan Eilean", Council of the Isles) began its own bilingual policy, concentrating particularly on education.

In Northern Ireland, Irish Gaelic (a language closely related to, but distinct from, Scottish Gaelic) is an important symbol of cultural identity for the nationalist community. According to the 1991 Census there were 142,000 people in Northern Ireland who claimed to be able to speak some Irish, but very few of these would be native speakers who habitually spoke the language.

In addition to the remaining Celtic languages, there are now significant communities of speakers of Asian languages in Britain, particularly the languages of the Indian sub-continent (Hindi, Urdu, Punjabi, Gujerati and Bengali). According to the 1991 Census there were 1,479,645 people claiming South Asian ethnic origin in Britain, 44 per cent of whom were

British born. Although they are spread throughout the United Kingdom, they are found particularly in the larger industrial cities. Punjabi is commonly spoken by up to 400,000 people in Bradford, Leeds, Birmingham and in the London Borough of Southall; Gujerati is spoken by around 300,000 people in Leicester, Coventry and in the London Boroughs of Brent and Harrow; and Bengali is common in the London Borough of Tower Hamlets, and with around 100,000 speakers is the largest single linguistic minority within London. Numbers for Hindu and Urdu are difficult to estimate but both are common as second or third languages for other speakers of Asian languages. There are also significant numbers of Chinese-speakers, particularly in central London (all figures from Alladina and Edwards, 1991).

These different languages overlap in complex ways with the organisation of regional and local television. The simplest case is Wales. With Welsh speakers spread throughout Wales and being a sizable minority, it is easy for there to be a match between Welsh-language television and the regional broadcasters for Wales (BBC Wales and HTV). Scotland is more complicated with a much smaller number of Gaelic speakers, and many of these distributed over a large, sparsely populated area, split between two commercial television broadcasters: Scottish Television and Grampian Television. In Northern Ireland, the broadcasting area covers the whole of the region and is served by BBC Northern Ireland and Ulster TV. Thus Irish language broadcasts can be transmitted easily throughout the region (and can also be picked up by Irish speakers across the border in the Irish Republic). With speakers of Asian languages concentrated in relatively small areas (much smaller than the television regions), their main source for non-English programming is the satellite channel Zee TV which broadcasts programmes made in India, many of which are in Asian languages such as Hindi, Urdu, Punjabi, Bengali and Tamil. Zee TV is a wholly-owned subsidiary of the Indian company Zee Telefilms Ltd, based in Bombay, and took over from its predecessor Asia TV in March 1995.

In addition to these various languages, it is also worth mentioning the question of dialect, particularly those forms of speaking which are on the boundary between dialect and language. There are a number of strong dialects of English within the United Kingdom but special mention must be made of Scots, traditionally the language of most of lowland Scotland. This developed from the same source as English, namely Anglo-Saxon, but had a separate linguistic and literary history, with a particularly rich period in the the fifteenth and sixteenth centuries. From the eighteenth century onwards, however, Scots has been gradually spoken by less people and has also moved closer to Standard English. In 1996 it was estimated that about 1,500,000 people still spoke some form of it, and most Scots would understand it, at least in its less rural forms. Like Gaelic, it is seen by many as one of Scotland's national languages, although its closeness to English and its association with both rural areas and lower social classes mean that

its status is much more controversial than that of Gaelic. It has only a minimal presence in the media (see Cormack, 1997 for further discussion of this).

2. The legal setting for television

The legal framework for British television is given by the BBC's Charter and by the various Acts of Parliament which govern commercial television. The BBC was incorporated as a public body in 1927. It is governed by a Royal Charter and a Licence and Agreement which together set out its powers and functions. Although strictly speaking coming from the crown, in fact the Charter is granted by the government and is regularly renewed (the most recent renewal being in 1996 for 10 years). The BBC is a public service broadcaster financed almost entirely by a licence fee payable by all television owners. It is required to submit its *Annual Report and Accounts* each year to the Secretary of State for Culture, Media and Sport (before the 1997 change of government the Department of Culture, Media and Sport was called the Department of National Heritage). As well as the main BBC television channel (BBC 1), which began broadcasting in 1936 but was closed down between 1939 and 1946, there is also a second channel (BBC 2), which was started in 1964 and is aimed less at the large popular audience than the first channel.

Commercial television was introduced to Britain by the Television Act of 1954 which permitted privately-owned television companies, financed by advertising and regulated by the Independent Television Authority (ITA). From the beginning, commercial television (which, calling itself Independent Television, became known as ITV) was organised on a regional basis with companies being granted licences to broadcast in specific areas for specific periods of time. Later legislation has developed this sector, most notably the Sound Broadcasting Act of 1972 which legalised commercial radio and changed the ITA into the Independent Broadcasting Authority (IBA), and the Broadcasting Act of 1980 which set up a second commercial channel (Channel 4 which began broadcasting in 1982) organised as a single national channel. In Wales the Channel 4 frequencies are used by Sianel Pedwar Cymru (S4C), the Welsh Fourth Channel Authority, to broadcast programmes in Welsh as well as many of Channel 4's English-language programmes.

More recent broadcasting developments have followed from the Broadcasting Acts of 1990 and 1996. The former changed the IBA into the Independent Television Commission (ITC) and created a separate Radio Authority to oversee commercial radio. It also changed the basis for awarding the regional television licences. Whereas under previous Acts the ITA/IBA was free to select whichever application it preferred, under the 1990 Act the ITC was required to award the licence to the applicant who offered the highest annual "cash bid" to the government (creating what

became known as the "franchise auction"), with the only discretion available to the ITC being that all applicants must first pass a "quality hurdle", that is, an assessment to ensure that the quality of their proposed programming passed a basic minimum level, and that in undefined exceptional circumstances a lower bidder might be accepted.

These new regulations came into play in 1991 when new licences were announced, to run for ten years from January 1993. The 1990 Act also allowed takeovers and mergers amongst the ITV regional companies and between them and other non-British EU companies. As far as the general public was concerned, however, the 1990 Act's most obvious result was the creation of a fifth television channel, in addition to the two national BBC channels, the ITV network (which the 1990 Act renamed Channel 3) and Channel 4. This was to be a national commercial channel, without regional variations, but which (because of technological limitations) would only reach about 70 per cent of the UK population. There was some delay in the starting of this channel due to uncertainties about its economic viability, with the ITC refusing to grant the licence after the first round of applications. However when the franchise was subsequently re-advertised, there were three applicants and the franchise was granted in October 1995. Channel 5 finally began broadcasting in March 1997. It is wholly financed by advertising.

There were also changes in the 1990 Act affecting broadcasting in Welsh and Gaelic. Before 1990, S4C's finance had come from a subscription paid by each regional ITV company, the precise amount based on the company's advertising revenue. Since the Act, S4C has been financed by the payment of a percentage (currently 3.2 per cent) of the total advertising revenue earned by terrestrial television in Britain, thus breaking the direct link between the finances of individual regional companies and S4C. The 1990 Broadcasting Act also set up a Gaelic Television Committee (Comataidh Telebhisein Gàidhlig or CTG). This committee is awarded a sum of money, the Gaelic Television Fund, from central government, with the precise amount being decided by the Secretary of State for Scotland. The CTG's role is to commission Gaelic television programmes which are then broadcast by either BBC Scotland or the Scottish regional ITV companies.

The Broadcasting Act of 1996, apart from its relaxation of the rules for cross-media ownership, was notable for setting up the legal framework for digital television. The Act specified three levels of service: (a) the broadcast service providers (that is, the programme providers); (b) the operators of the digital multiplexes (that is, the channel organisers); and (c) the providers of conditional access systems (that is, the subscription service providers). The first two were to be licenced separately by the ITC. The third, on the other hand, was to be controlled by OFTEL, the government department which regulates telecommunications. The Act allows a maximum of three multiplex licences to any one organisation. In addition

to these major provisions the 1996 Act also changed the CTG into the Comataidh Craoladh Gàidhlig (CCG, the Gaelic Broadcasting Committe) and gave it the power to commission Gaelic radio programming as well as television programming.

The legal framework for cable and satellite television in Britain was created by the Cable and Broadcasting Act of 1984. This created a Cable Authority to award licences for cable television in specific areas, and to oversee the functioning of these cable operators. However the 1990 Broadcasting Act abolished the Cable Authority, giving its powers to the ITC. The 1984 Cable and Broadcasting Act also set the scene for the development of satellite broadcasting, giving the IBA the power to award licences for satellite channels.

There are no legal requirements for UK broadcasters relating to access and participation. Legislation does no more than ask the broadcasters to carry out research into audience reactions. Thus the 1990 Broadcasting Act asks the ITC to carry out research to find out "the state of public opinion concerning programmes", as well as the effects of such programmes on audiences. The BBC regularly holds public meetings but these are seen by many as being motivated more by public relations reasons than by any real desire to let the public participate. It is not going too far to say that television broadcasting in the United Kingdom is marked by a lack of concern for the views of the general public and a valorisation of professionalism for its own sake. For most television producers the opinions of colleagues and other media professionals are far more important than the reactions of viewers. Actual viewing figures are, of course, important for economic reasons, but qualitative research concerning the needs and desires of viewers is of only minor concern to broadcasters and indeed very little of this type of research is done by the broadcasters themselves (despite the legal provisions noted above).

Programming requirements are fairly basic. Typical are those given for the ITV companies in the 1990 Act (and in this it is simply repeating and developing the provisions of earlier Acts). Each ITV company has to ensure:

> ... (a) that nothing is included in its programmes which offends against good taste or decency or is likely to encourage or incite to crime or to lead to disorder or to be offensive to public feeling; (b) that any any news given (in whatever form) in its programmes is presented with due accuracy and impartiality; (c) that due impartiality is preserved on the parts of the person providing the service as respects matters of political or industrial controversy or relating to current public policy; (d) that due responsibility is exercised with respect to the content of any of its programmes which are religious programmes, and that in particular any such programmes do not involve (i) any improper exploitation of any susceptibilities of those watching the programmes,

419

or (ii) any abusive treatment of religious views and beliefs of those belonging to a particular religion or religious denomination; (e) that its programmes do not include any technical device which, by using images of very brief duration or by any other means, expoits the possibility of conveying a message to, or otherwise influencing the mind of, persons watching the programmes without their being aware, or fully aware, of what has occurred. (Broadcasting Act 1990, p. 6)

In addition the ITV is asked by the Act to draw up a code of practice for the guidance of the broadcasters in relation to these provisions, and also a general code covering the depiction of violence and other matters relating to ethical standards. Later in the 1990 Act, in a provision governing both the Channel 3 companies and Channel 5, licence holders are required to broadcast "news programmes of high quality dealing with national and international matters". In relation to educational programmes the 1990 Act simply says that the ITV must "do all that they can do to secure that a suitable proportion of the programmes which are included in Channel 3 services and Channels 4 and 5 (taken as a whole) are schools programmes". The Act also lists restrictions which apply to all broadcasters concerning obscenity, racially inflammatory material and libellous material.

In addition to the legal provisions noted above, broadcasting is also regulated by a statutory body called the Broadcasting Standards Commission, whose remit covers radio and all forms of television, including cable and satellite. This organisation was created by the Broadcasting Act of 1996 by amalgamating two previously existing bodies. One was the Broadcasting Complaints Commission, which dealt with public complaints about unfair treatment and invasion of privacy by broadcasters. The other was the Broadcasting Standards Council, which dealt with matters of "taste and decency", which in effect usually meant matters concerning the protrayal of sex and violence on television. Despite being set up by an Act of Parliament, however, the Broadcasting Standards Commission does not have much power at its command. It can publish reports and can order the relevant broadcasters to publish these in any way, but it has no other legal sanctions at its disposal. As a result of this, and the fact that the examination of a complaint from a member of the public can result in protracted proceedings, the BSC is not seen by the public in general as a particularly important organisation, nor is it an organisation which gives the broadcasters anything to worry about.

Local, non-cable, broadcast television has been slow to develop in Britain and so far the demand for local television, such that it is, has been answered by the provision of cable television. There has, however been a small but determined campaign for local broadcasting. The Institute of Local Television, based in Edinburgh (which, despite its impressive name, is a very small organisation, largely dependent on the energies of one man) has since its foundation in 1989 regularly contributed to debates about

such initiatives, in particular arguing that the new fifth channel should be a network of local channels, rather than the one nationally undifferentiated channel which it eventually became.

The Government's proposals for broadcasting changes published in 1988 (*Broadcasting in the '90s: Competition, Choice and Quality*) included a suggestion for developing local television stations through multipoint video distribution systems (MVDS), using microwave technology. This would have provided stations which (given the planned restrictions on usable frequencies) would have had a transmission area of only about one and a half miles and be dependent on line of sight for reception (the quality of the signal was also affected negatively by rainfall). The overall effect of these limitations meant that the MVDS was not economically viable when compared with cable. By the time this proposed legislation had become law in the 1990 Broadcasting Act, MVDS was not mentioned explicitly at all. Instead the Act simply established a legal framework for the provision of "local delivery services", which covered any type television transmission, as well as radio. The term "local" was only defined in the most minimal way as the "simultaneous reception in two or more dwelling-houses", and with no upper size limit stated. During the early 1990s a number of cable operators were awarded such licences, but it was not until the 1996 Broadcasting Act that local non-cable services begin to look like a real, economically viable possibility. This later Act allowed for the creation of what were called "local restricted services". These were defined as "the broadcasting of television programmes for a particular establishment or other defined location, or a particular event". Event-based licences were temporary (up to 56 days) to provide television coverage of a particular event. Location-based licences were for a two-year period (but were renewable) to broadcast to an identifiable geographical area, typically a city. These restricted service licences (RSL's) were advertised in June 1997 and by the deadline of 30 September 1997, 31 applications had been received, all for location-based licences. Most of these were proposals for services in cities such as Bristol, Birmingham, Oxford, Leeds, Liverpool, Manchester, Newcastle, Cardiff, Edinburgh and Glasgow.

The overall system in the UK is marked by a heavily centralised structure in which local and regional elements have so far had little role to play. The ITV companies (Channel 3) are essentially organisations to deliver networked programming to very large areas, with little geographical logic, detemined more by the exigencies of terrestrial broadcasting technology. The cable companies are mainly providing international programming of various kinds. Channels 4 and 5 are national channels (apart from S4C in Wales), and the BBC, for all its regional structure, is an organisation in which the central decisions are taken in the London base. It is likely that there is a direct link between this traditional, centralised structure, and the lack of access, participation and serious consideration of the audience.

Similarly the lack of vociferous demand for local television is partly explained by the fact that television within the United Kingdom (unlike radio or newspapers) has always meant a London-based service. Audiences simply do not think of television as having a local dimension.

3. Institutional and business structure of television in the United Kingdom

Terrestrial television

The BBC is still a centrally-financed broadcaster, with the vast majority of its income coming from the licence fee which all television owners must pay. However in recent years it has been pushed by government more and more towards developing its commercial income through programme sales and associated commercial activities. The ITV companies, on the other hand, are privately owned and since the 1990 Act have been allowed to merge so that now the original 15 regional companies are dominated by four large groupings (although the regional companies still exist as separate organisations, simply merged at the level of overall ownership). In 1992 Tyne Tees (the north-east of England broadcaster) was taken over Yorkshire Television. Then, at the end of 1993, more mergers took place. Carlton (the London weekday broadcaster) merged with Central (the Central England broadcaster based in Birmingham) and then also took over the small South-West England company Westcountry. Granada (based in Manchester) bought London Weekend Television, and Meridian (the South of England broadcaster based in Southampton) bought Anglia, and later took over HTV as well. Thus of the ten purely English regional companies, there are now four large merged organisations and only one surviving independent company (Channel Television, broadcasting to the Channel Islands). The strength of these merged companies can be seen by noting that the Carlton/Central combine, broadcasting to the large urban areas of London and Birmingham, has within its area 35 per cent of all UK television viewers. In 1997 Scottish Television merged with Grampian Television (the north of Scotland broadcaster) and also increased its holdings in Ulster Television (broadcasting in Northern Ireland). The companies which now own these broadcasters are typical cross-media companies, with holdings in the press and other areas. For example, the Scottish ITV stations are owned by the Scottish Media Group, which also owns *The Herald* newspaper (one of only three national daily newspapers in Scotland). The Meridian/Anglia/HTV combine is owned by United News and Media which also owns the Express group of national newspapers (including *The Daily Express*, *The Scottish Daily Express* and the *Sunday Express*), as well as having a 29 per cent stake in Channel 5.

Cable television[2]

Following the 1984 Cable and Broadcasting Act, the first cable stations began in 1985. By the middle of 1996 there were 49 areas in Britain with

cable operators. The total number of subscribers was about 2.24 million.This represented an overall cable penetration level in Britain of 10 per cent (which rises to 22.4 per cent within the cabled areas). By the end of the century it is not expected that the overall figure will have passed 3 million. In their applications for franchises, cable operators are required to make provision for local programming. However when financial problems have arisen, local programmes have usually been the first to suffer. This is not surprising, especially considering that most cable operators in Britain (such as Telewest Communications, Nynex, Comcast Cable, CableTel and Bell Cablemedia), are parts of large North American communications companies.

Satellite television

In 1986 British Satellite Broadcasting (BSB) was awarded the IBA satellite contract and began broadcasting in April 1990. However in February 1989 Rupert Murdoch's Sky Television had begun broadcasting to Britain as a rival satellite service (based in Luxembourg but aimed at the English-speaking audience). The fourteen-month advantage proved to be crucial and in November 1990 Murdoch took over BSB, creating a single satellite service called BSkyB. Initially satellite services were financed partly by advertising but since September 1993 BSkyB has been almost entirely subscription based. By mid 1996, the number of satellite subscribers in Britain was 3.79 million, and satellite and cable together accounted for 10.2 per cent of the total television audience in the United Kingdom. The strength of Rupert Murdoch in this field can be seen by the fact that 70 per cent of all viewing of cable and satellite was for channels provided by BSkyB, especially its various film and sports channels. Of the 3.79 million satellite subscribers, 3.3 million were for BSkyB.

Digital television

The advent of digital television will initially make only a marginal difference to the established ownership structures of British television. In 1997 the ITC awarded the licences for digital television. Two multiplexes went to the BBC – who will also be a programme provider for the commercial multiplexes – two went to Digital 3 and 4 Ltd to provide digital versions of Channel 3, Channel 4 and teletext services. Three were awarded to British Digital Broadcasting (formed by the television companies Carlton and Granada). One multiplex went to S4C Digital Network to provide Channel 5, S4C and some prime-time Gaelic programming. The first digital television services are expected to be available during the second half of 1998. The multiplexes so far awarded are merely the tip of the iceberg. Once digital satellite broadcasting develops (and BSkyB is planning on launching its digital services before the summer of 1998), there will be a rapid expansion in the number of channels available. With this development will also come interactive

television. Thus the overall structure of British television will be transformed fairly rapidly in the years to come as far as the viewer is concerned, although the key players in the market are likely to remain the same, with the strong positions of BSkyB and the larger ITV companies being enhanced. The BBC, on the other hand, will have to fight to retain its position, since the development of digital services is being financed from its existing finances, not from additional funds. BSkyB's position is particularly strong since it has entered into an agreement with the suppliers of digital encryption services (News Datacom) which effectively means that BSky B has control of the access to satellite services for the majority of British satellite subscribers (See Cowie (1997) for a discussion of the implications of this).

3.1. Audience

The relative position of the different broadcasters can be seen from the following figures.

Table 1. Average audience share across the different channels (Autumn season of 1997 in %)

BBC1	30.1
BBC2	10.9
ITV	33.1
Channel 4	10.4
Channel 5	3.5
Cable and satellite	12.1

Source: Broadcast, *9 January 1998*

An important feature to note in these figures is that the ITV share has been steadily falling, being most vulnerable to Channel 5 and increased cable and satellite shares. Overall the television audience is not growing, merely redistributing itself: "there is a limit to how much TV a nation can watch" (*BFI Film and Television Handbook 1998*, 1997, p46). This factor has important implications when the expansion of the number of television channels is being considered.

4. Structure and characteristics of television in the regions

4.1. Typological description

In the terms proposed in *Decentralization in the Global Era*, the BBC is an example of category *"Regional off-the-network television"*, containing regional off-the-network television stations, with centres such as BBC Scotland, BBC Wales, BBC Northern Ireland (all termed "national regions"

by the BBC), as well as the English regions such as BBC South and BBC North, providing some regional programming and a little programming which is networked throughout the country. The Channel 3 ITV network is an example of category *"Federated television"*, although the amount of difference between the regional companies is much the same as with the BBC, with national network provision (organised from the ITV Network Centre in London) dominating the schedules. Channel 4 and Channel 5 have no regional variations at all. Overlapping with these structures are the Welsh and Gaelic language broadcasters. S4C is an example of *"Independently managed station"*, broadcasting partly in Welsh to Wales only. However Welsh-language programming is only about one third of the output, the rest being English-language programmes broadcast elsewhere on the Channel 4 schedules. Since the CCG, which commissions Gaelic broadcasting in Scotland, is not a broadcaster as such, it does not fall into any of these categories, instead providing a specific type of programming for the Scottish parts of the ITV federation, as well as contributing to BBC Scotland's Gaelic output.

4.2 Regional models of state-wide television

The basic pattern of regional programming is very similar on both the BBC and the ITV network. A central network schedule is worked out in London, allowing regional programmers some room to insert locally-made material, most of which is news or news-related. This pattern is strongest in the BBC but also exists in the ITV network, despite its seemingly federal structure. The larger ITV companies make most of the networked material, with the smallest companies doing little more than producing local news programmes, inserted into the national network. In earlier years, the ITV network was dominated by programmes made by the five biggest companies (all in England). More recently the other companies have gained more access to the network with their own programmes and since the 1990 reorganisation under the ITC, the ITV Network Centre was created to oversee the networking of the programmes. Even more recently, of course, (as noted above in section 3) mergers have reduced the number of independent companies so that the ITV network is still dominated but a small number of large companies.

There are currently fourteen ITV regions, one of which (London) has two companies, one for weekend television (Friday evening to Sunday evening) and one for weekday television (Monday morning to Friday afternoon). Ten of these broadcast entirely within England, two broadcast entirely within Scotland, one broadcasts to Wales and to parts of the west of England, one to the border area across the north-west of England and south-east of Scotland, and one broadcasts to Northern Ireland. There is also a separate early morning broadcaster on the ITV network. This provides one service for the whole network, with opt-outs for regional news headlines. The amounts of regional programming broadcast in each

region during 1996 are given en el cuadro 2. Thus most are broadcasting between one and two-and-a-half hours each day of locally-made programmes for their region. Most of this consists of regional news, current affairs and sport.

Table 2. Regional programming broadcast by the ITV companies in 1996

Company	Region	Weekly average
Anglia	East Anglia	10hrs 29 min
Border	South-West Scotland and Cumbria	5hrs 54min
Carlton	London (weekdays)	9hrs 50min
Central	English Midlands	19hrs 10min
Channel	Channel Islands	6hrs 6min
Grampian	North Scotland	8hrs 48min
Granada	North-West England	9hrs
HTV	Wales and West England	11hrs 43min
LWT	London (weekends)	4hrs 43min
Meridian	Southern England	6hrs 2min
Scottish	Central Scotland	18hrs 15min
Tynes Tees	North-East England	10hrs 10min
UTV	Northern Ireland	12hrs 29min
Westcountry	South-West England	12hrs 2min
Yorksire	Yorkshire	14hrs 57min

Source: *ITC Annual report*, 1996.

As part of its public service obligations, the BBC is required to provide a certain amount of regional broadcasting. It does this through six subdivisions: three regions in England (Midlands and East, based in Birmingham; South, based in Bristol; and North, based in Manchester) and three national regions (Scotland, based in Glasgow; Wales, based in Cardiff; and Northern Ireland, based in Belfast). These regions make both radio and television programmes for their own areas as well as for the national network. Part of the BBC South region is London and the south-east, although this area is normally regarded as the core, rather than as a region. In overall charge of these regional centres is a Director of Regional Broadcasting, based in London. The Charter instructs that the BBC shall appoint a National Governor for each of the national regions and that these individuals will be members of the BBC's Board of Governors, the topmost level in the organisation. The Charter also instructs that National Broadcasting Councils shall be set up in Scotland, Wales and Northern Ireland with the primary function of "controlling the policy and content" of BBC programmes in their respective countries. Despite this seemingly powerful remit, the National Broadcasting Councils tend to be organisations for passing on advice to the central BBC organisation. Their

existence is not well-known within their respective countries and it would be very unusual to find anyone who could name their country's National Governor. In each of the English regions, the Charter sets up a Regional Advisory Council but here their role is quite explicitly limited to advice on programmes and policy. Like the National Councils, their existence is not particularly well-known. It is worth noting that the BBC's Board of Management, the principal committee in charge of the day-to-day running of the Corporation, includes the London-based Managing Director of Regional Broadcasting, but does not include any representatives of the BBC's Regions or National Regions.

4.3. Regional Television Stations: S4C

S4C was set up by UK government under the 1980 and 1981 Broadcasting Acts, with the first Chairman appointed in January 1981, and broadcasting began in November 1982. It functions as the fourth channel broadcaster in Wales. It is run by the Welsh Channel Authority, known legally now, since the 1990 Act, by its Welsh name – Sianel Pedwar Cymru (S4C). This is an independent authority responsible to the government, thus it is not responsible to the Independent Television Commission, nor is it part of Channel 4. It comes under the control of the Secretary of State for Culture, Media and Sport, not the Welsh Office. It is not linked institutionally to the BBC, although the BBC does make programmes for it.

The Authority consists of a Chairman and between four and eight members (usually six), all appointed by the government. Members tend to be eminent academic, professional and cultural figures with previous involvement in Welsh public organisations. The Authority itself appoints a Chief Executive who is reponsible for the day-to-day running of S4C. It delivers an *Annual Report and Statement of Accounts* to the government. Under the plans for a Welsh Assembly, responsibility for Welsh language development will pass to the new assembly, but broadcasting will remain as a responsibility of the Department of Culture, Media and Sport in London, thus making a rather anomolous situation even stranger. The only mention of broadcasting in the government's plans for a Welsh Assembly is when it is noted that the Secretary of State for Culture, Media and Sport "will consult the Assembly regularly about broadcasting matters as they relate to Wales, including appointments of the BBC National Governor for Wales and the Board of Sianel Pedwar Cymru (S4C)" (*A Voice for Wales*, p. 21).

S4C is in a rather unique position in British broadcasting, combining public funding with commercial aspects (carrying advertising). Originally its finances were based on a percentage on the other ITV companies' advertising income, paid by these companies to the Independent Broadcasting Authority who passed it on to S4C (Channel 4 was also financed in this way). Since the 1990 Broadcasting Act it is now financed by a single sum paid to S4C by the Home Secretary based on 3.2 per cent of

the total ITV advertising income and is thus removed from the links with specific companies. S4C is now in charge of its own advertising time and gets income from that. In 1996 its income from the Department of National Heritage (as the Department of Culture, Media and Sport was then called) was £68.4 million. In addition its own commercial income (advertising and sales) was £7.8 million. With this income S4C to broadcast 1,677 hours of Welsh-language programming in 1996, that is, a weekly average of 32 hours, and a daily average of four-and-a-half.

S4C has no direct links with Welsh politicians or governing bodies. In effect it functions as an independent television station, but with cultural and linguistic aims. However the government has ultimate control over both the members of the Welsh Authority and the finance (the 3.2 per cent figure is mentioned in the 1990 Act but could be changed).

S4C is structured on the same model as Channel 4. It commissions programmes but does not make them itself. The programmes are commissioned from BBC Wales (just over a third of programmes were commissioned from the BBC in 1996), HTV (the ITV company in Wales) and directly from independent producers. Before S4C began there were only two independant producers in Wales. By the end of 1982 there were 35. S4C has developed many foreign sales, with the cartoon *Superted*, for example, being sold to 43 countries within the first five years of the channel. During 1996, S4C sold programmes to 55 different countries. Of the Welsh language programming, approximately one and a half hours per week are dubbed into Welsh from other languages. S4C has used teletext for English since May 1987. It aims to provide English subtitles on teletext for 75 per cent of programmes. It also provides some Welsh subtitles on teletext for learners of the language.

In terms of the audience, S4C currently gets an audience of less than 20 per cent of all Welsh speakers. In 1995 its audience share was 18.8 per cent. In 1996 it had risen slightly to 19.9 per cent. In terms of the weekly audience reach, it gets figures of over 80 per cent of Welsh speakers watching Welsh programmes at some point: 85 per cent in 1995, and 82 per cent in 1996. In terms of actual numbers the most popular Welsh language programmes seldom get above 200,000. In 1996 only two programmes passed this figure - one was about Cardiff Arms Park, the home of the Wesh national rugby team, and the other was an international football match featuring Wales. Of the more regular programming, the most popular is the drama series *Pobol y Cwm* (People of the Valley) which reached audiences up to a maximum of 183,000. In contrast to this, the English Channel 4 drama series *Brookside*, broadcast by S4C during its non-Welsh hours, reached a maximum audience of 287,000.

4.4. Urban television
Although, as stated earlier, there are currently plans to develop conventionally broadcast local services, at the moment the only urban

television in the United Kingdom is provided by cable. Most cable operations in the United Kingdom are owned by a relatively small number of companies, now known as multiple system operators. Within Scotland, for example, eight cable stations are owned by TeleWest Communications (Scotland), a subsidiary of the US-owned TeleWest Communications, and five are owned by CableTel Glasgow, a subsidiary of International CableTel. This leaves only one independent cable operator. It is not particularly surprising, then, that there is little sign of regional or local differentiation on cable. Almost all cable provision consists of themed channels of the kind familiar internationally from satellite television, and dominated by film and sport channels, along with those channels which re-broadcast terrestrial television programming. The award of a cable franchise does take into consideration plans for local programming, but these have seldom amounted to much. As one writer has said, describing the situation in 1990, "From the current levels of investment in local services throughout UK cable, it is evident the Cable Authority have expected little concrete commitment towards local provisions. The cable contractors have all failed to deliver the local commitments proposed and budgeted in their franchise applications" (Rushton, 1992).

5. Programming

En este apartado se aborda el caso de S4C (Wales), the nearest that there is to an independent regional broadcaster in the UK, and, as examples of the BBC and ITV networks, BBC Scotland and Scottish Television. The Scottish areas of these two networks have slightly more distinctiveness than the English regions and so these examples will show the strongest regional variations within the UK networks. Some comments on English regional programming are also included. Although a rather different type of structure, Gaelic language programming will also be considered since it is of relevance when considering regional variation.

5.1 S4C

Programming on S4C is heavily marked by public service principles. The overall aim has been stated as to give "a sufficiently wide spectrum of viewing to present the viewer with a comprehensive view of contemporary life" (S4C, 1987). The overall selection of programming can be seen by the following figures, covering Welsh-language broadcast output (1996) se refleja en el cuadro 3.

A sense of the pattern of broadcasting on S4C can be given be considering a typical day. The transmissions would begin at 6 a.m. and broadcasts would be of English-language Channel 4 programmes during the morning. There would be 30 minutes of Welsh-language programmes for pre-school children at 1 p.m., then English programmes until 5 when there would be 30 minutes of programmes for older children. After another half hour of

English, programmes in the evening would be in Welsh from 6p.m. until some point between 9 and 10.30 p.m., followed by more English programmes until close-down at some point after midnight.

Table 3. Welsh language programming in S4C (1996)

Type	Hours	%
News and current affairs	527	36.6
Children's programmes	192	13.3
Drama	181	12.6
Light entertainment	175	12.1
Sport	159	11.0
Music and arts	117	8.1
Educational programmes	55	3.8
Religion	35	2.4

More specific examples of programming include the daily soap opera, *Pobol y Cwm* ("People of the Valley"), made by BBC Wales and broadcast each night at 7 p.m., which S4C claims is the only regular television drama series in the world which is rehearsed, recorded and transmitted all in the same week. There have been a number of other drama series which, S4C claims in its web site (http://www.s4c.co.uk), "look at contemporary issues through the lens of popular drama". Classic Welsh literature has also been adapted for television. Light entertainment programmes include comedy series, quiz shows and game shows. Alongside the twice nightly news broadcasts (at 6p.m. for 10 minutes and at 8.30p.m. for 30 minutes), there are current affairs series provided both by BBC Wales and HTV. Particularly popular is the nightly early evening magazine programme *Heno* ("Tonight"). The school-age children's programmes broadcast at 5 p.m. (in a slot called *Pump* ("Five") includes a range of programmes, from news to drama series, all aimed at children and very much modelled on the pattern of English-language children's programming seen elsewhere in the United Kingdom on both BBC and ITV.

It will be clear from these examples that S4C is essentially providing what most other broadcasters provide: a mixture of current affairs, factual programmes, drama, light entertainment and children's programming. There is little that is specifically to do with traditional Welsh culture (although there is extensive coverage of, for example, the Eisteddfod, the annual Welsh literary and cultural festival), with the use of the language and the geographical setting usually being the only notable indicators of Welshness. In this, of course, S4C is like most other minority language television stations in Europe.

5.2 BBC Scotland

In the BBC's "Statement of Promises" (BBC, 1997) the aims of its regional services for Scotland are made explicit. They are: (1) "to provide a

comprehensive news and current affairs service which records, analyses and reflects issues of significance to people throughout Scotland"; (2) "to continue to provide a broad range of general programming on television and radio, which reflects the interests and cultural diversity of Scottish audiences"; and (3) "to develop programme ideas in reponse to developments on devolution in Scotland".

The same set of aims with appropriate adjustments is given for BBC Wales and, with a few more amendments, for BBC Northern Ireland. When output is examined, however, the limitations of these aims become clear. As noted earlier, most of BBC Scotland's output is the same as for other parts of the United Kingdom. In an average week, however, there are a number of opt-outs. Most are for news broadcasts. From Monday to Friday there is a lunchtime 10 minute news programme and an evening 30 minute programme of Scottish news. During the early morning news programme there are four five-minute slots for Scottish news. In addition to these there are usually about six brief Scottish news updates during the day on either BBC1 or BBC2. Weekend regional news is limited to 10 minutes on each of Saturday and Sunday.

In the 1996-97 season, BBC Scotland broadcast 276 hours of news and news related programmes, along with with 32 hours of broadcasts from the Houses of Parliament in London which were of Scottish affairs and only broadcast in Scotland. There are also usually two Scottish sports programmes each week (30 minutes on a Friday evening and 70 minutes on Saturday evening). Beyond these regular programmes, there are occasional series, such as *Frontline Scotland*, a 30 programme of investigative journalism, and *Ex-S* covering culture and the arts. In the Autumn 1997 season, these regional programmes averaged around 11 hours per week (at a time when both BBC channels were broadcasting for 24 hours per day, although the night-time service on BBC1 was taken from the BBC's new 24 hour news service, and on BBC2 it consisted of educational programmes). It will be seen from this that for the BBC, regional programming essentially means regional news and sport, with only occasional examples of other genres (see 5.6. for BBC Scotland's Gaelic programmes).

5.3 Scottish Television

Despite its "federated" structure, specifically regional broadcasting on the ITV in Central Scotland is very similar to the one of the BBC, although recently Scottish Television (the ITV company for the Glasgow and Edinburgh areas) has gradually been increasing its regional output and now regularly broadcasts significantly more of such material than BBC Scotland.

Like BBC Scotland, news and sport make up a significant portion of regional programming. In the Autumn 1997 season, Scottish Television, the

ITV broadcaster to Central Scotland, which includes both Glasgow and Edinburgh, was broadcasting its news programme, *Scotland Today*, for 25 minutes in the middle of the day, 30 minutes in the early evening and 20 minutes in the late evening. This was in addition to several shorter news updates. Sports broadcasts usually consisted of a 30 minute programme on Friday evenings, and a live football match on Sunday afternoon. Beyond these, however, Scottish Television included its own 30 minute weekly drama series *High Road* (which is set near Loch Lomond on the boundary between the highlands and the lowlands, and was also taken by other stations in the ITV network) and a number of other programmes covering topics such as the arts, travel and religion, as well as quiz shows. When Gaelic programmes are added, Scottish Television can be seen to be broadcasting about 22 hours per week of specifically regional programming, covering news, sport, drama, the arts and religion, as well as more general light entertainment formats. Around four or five of these hours were repeat broadcasts transmitted in the middle of the night. Prime-time transmissions were usually limited to 30 minutes of early evening news and 30 minutes of more popular programming (drama, sport or light entertainment).

5.4 English regional television

In neither the English BBC regions, nor in the English ITV regional companies, is there much local programming. In its "Statement of Principles" of 1997 the BBC gives as the aims of regional English television services simply "to provide a daily news service on television from each of our ten regional news centres across England [and] current affairs, political and leisure programming for our English regional audiences" (BBC, 1997). When the schedules are examined, it is clear what these vague aims mean. The BBC regions have their own 30 minute early evening news programmes at the same time as that of BBC Scotland, and have brief regional news headlines during the day, but there is virtually no other regional programming. Sport programmes are the same for all of England. The English ITV companies operate in a similar way, with networked programmes (whether locally made or imported) filling the schedules. Like the BBC, they have their own early evening regional news programmes, as well as regional news updates (and in some regions there are several different versions of the regional news, catering for subdivisions within the area), but there is little else of a specifically regional nature. Thus the range of programming on these stations is a mix of popular commercial programming of the usual kinds, and programming which answers to the public services demands which are put on these stations (such as news and current affairs).

5.5 Northern Ireland

Although BCC speaks about Northern Ireland as one of the "national regions", the programming for Northern Ireland follows the same model

as the one broadcast in the English regions. This is for BBC-Northern Ireland and for the commercial broadcast-station UTV. In a normal week, BBC-Northern Ireland broadcasts a half an hour regional information programme after the afternoon-evening national news during the week, as well as regional bulletins throughout the day. Moreover, it broadcasts current events' programmes. At the moment of writing this text (May 1998), for example, two weekly programmes of 30 minutes were broadcast, one about research and the other about political actuality. There are also two occasional programmes, including a monthly magazine of general current events on Irish. So we can say that regional programming of BBC-Northern Ireland consists, fundamentally, of news and current events' programmes. Even sports programmes are the same for England and Wales.

The regional programming of UTV is slightly broader: its evening regional news programme is daily broadcast during an hour, in addition to brief bulletins along the day, and has also a general current events' programme. Moreover, it normally broadcasts sports programmes and other items of regional interest (at beginning of 1998, a programme of competition between scholar chorus). Therefore, UTV not only broadcasts more regional programmes than BBC, but also has a broader variety of subjects.

Until now, the Irish language has had no a lot of presence in the television programming for Northern Ireland. As pointed out before, Irish is a political symbol in Northern Ireland, so its use has a polemical component. However, popular support can force a change in this situation. Amongst the parts less known in the peace agreement, not only the support of Irish language is taken into account, but also more concretely to the Irish broadcast station (those speaking in Irish). The agreement points out that "all the participants recognise the importance of the respect, the understanding and tolerance in relation to linguistic diversity, including, in Northern Ireland, the Irish, the Scots of Ulster and the languages of various ethnical communities which are part of the cultural richness of the island of Ireland. (*The Agreement*, p. 19). On the next page, it is included as an objective "to explore urgently close to the relevant British authorities the possibility of achieving a bigger reception of Telifis na Gaeilge [the television channel in Irish language in the Irish Republic](1) in Northern Ireland" and "look for more effective ways to encourage and provide economic support for the production of films and television in Irish in Northern Ireland" (*The Agreement*, p.20),. Obviously, to make all these wishes reality, the success of the agreement and of the Assembly will be necessary, to which this will give occasion.

5.6 Gaelic Programmes
The aim of the Comataidh Craoladh Gàidhlig is to provide a full range of Gaelic programmes for Gaelic viewers. For the 1996-97 season, the

433

government award to the Comataidh Telebhisein Gàidhlig (as the CCG was called at that time) was £8.9 million. Of programmes aided by the fund in that year, around 14 per cent of programme-hours were made each by BBC Scotland and Scottish Television. Grampian Television made 42 per cent (Grampian makes the daily and weekly news programmes) and the remaining 30 per cent were made by independent producers (most of which was made by just five companies). The CTG's *Annual Report and Accounts 1996-97* provides the following statistics. During 1996-97, the Committee funded just over 160 hours of programming, distributed as table 4 shows.

Table 4. Type of programmes financed by CTG in 1996-97

Type	Hours	%
News	67.5	42.1
Children's programmes	38.6	24.1
Arts and light entertainment	20.3	12.8
Drama	12.4	7.7
Current affairs	11.0	6.9
Religion	5.2	3.2
Schools programmes	4.2	2.6
Documentary	1.0	0.6

Source: CTG, 1997.

These programmes were broadcast either by BBC Scotland or by one or both of the main Scottish ITV companies – Scottish Television and Grampian Television (Border Television does not take Gaelic programming). BBC Scotland broadcasts Gaelic programmes as part of their public service remit and, as well as CCG funded programmes, still broadcast programmes funded through the BBC's own licence fee income. BBC Gaelic programmes have traditionally included the bulk of Gaelic children's programmes and in their other programmes have tended to concentrate on current affairs, arts and music, and more serious documentary series. Most recently however their programming has included lighter strains, currently exemplified by the magazine-style series *Tele nan Gaidheal* which includes light-hearted studio discussions and items of general interest.

Grampian Television's main contribution to Gaelic programming has been its news service. This consists of two short daily broadcasts, a mid-day one transmitted by Scottish Television as well as Grampian, and an early evening one transmitted only by Grampian. In addition there is a weekly 30 minute news magazine made by Grampian and transmitted by both stations. Grampian has also made religious programmes and programmes for children.

Scottish Television's main contribution to Gaelic programming has been the weekly 30 minute drama series *Machair* (set in the Gaelic-speaking area of

the Western Isles). Independent producers have tended to concentrate on light entertainment programmes of various kinds (including music programmes) and children's programmes, although a range of other genres have been made over the years. The independents' programmes are broadcast on Scottish Television and / or Grampian Television. It will be seen from this that Gaelic programming is now covering a reasonable spread of television genres, although in any specific week the total amount of Gaelic television is not large, usually averaging around 5 hours, but sometimes as low as 2 hours (compare S4C above, averaging 32 hours per week).

5.7 Local Programming on Cable

Dave Rushton (1990) has summarised the experiences of local programnming in several of the earlier cable companies. He noted that by 1989, of the eleven cable operators then functioning, only five offered any locally-made programming. In four of these, between 6 and 10 hours per week was being broadcast on a separate local channel (the fifth had markedly less and did not have a dedicated channel). By the mid 1990s, the situation had not improved much despite the increase in the number of cable operations. The ITC's *Annual Report and Accounts* for 1996 admitted that "the provision of locally originated and centred television programme services has been slower to develop than the ITC would have wished" despite the fact that "the reactions of viewers to local television is positive". This has led the ITC to say that it is "encouraging the further development of local programming". (ITC, 1997). The *Annual Report* notes the four main types of local programming on cable stations. One consists of "local programmes made principally by volunteers with a small in-house support staff". Another consists of "professionally produced in-house early evening news programmes and sports magazines". The third type consists of weekly magazine programmes commissioned from independent producers. Finally, there are the city-based channels provided in various locations by two companies: Channel One (with channels in London, Bristol and Liverpool) and Live TV (with channels in Westminster, Birmingham and Liverpool). These channels form the major innovation in local cable programming provision in the 1990s and seem to be the most likely way forward for the future (and it is worth noting that both are owned by national newspaper companies: Channel One by the owners of the *Daily Mail*, and Live TV by the owners of the *Daily Mirror*.

6. New problems and prospects

6.1 Financial viability

The situation of regional broadcasting within the United Kingdom will be clear from the preceding pages. Apart from the example of S4C (and even it can only be regarded as a semi-regional station since much of its output is taken from Channel 4's national schedule) and the limited autonomy

within Scotland, regional television, as a service specifically catering for a regional audience, hardly exists. In the future, however, several forces will exert increasing, although often conflictive, pressures. These are: (a) the effect of mergers between television companies, combined with the increasing cross-ownership amongst media companies; (b) the expansion of the number of available television channels, particularly as digital television services develop; and (c) the changing government structures in Scotland and Wales. The combined impact of these will have major implications for the future financial viability of regional and local television in the United Kingdom.

The changing pattern of ownership within the media will have a major effect on the finances of regional broadcasting. Regional and local television companies, whether transmitting traditionally or by cable, are becoming parts of larger organisations whose corporate interests have little to do with catering for relatively small audiences. Economies of scale are likely to push programming further and further away from specifically local concerns. Such large companies have been defended as the only means of withstanding the international pressures with an organisation such as BSkyB can exert on the television marketplace. Thus the creation of the Scottish Media Group, covering Scottish Television and Grampian Television, as well as newspaper interests, has resulted in a strong media conglomerate which can withstand pressure from other companies. However there is a real danger here that there will be a resultant loss of diversity, both culturally and politically, which this centralisation may lead to. Within England, the mergers of regional companies have meant that former regional distinctions are rapidly becoming obscured. Part of the problem for the ITV network is that since the transmission regions tend not to coincide with traditional geographical or political regions, the coherence of most of the ITV regions is relatively weak.

The expansion of television channels is likely to have a contradictory effect on the viability of regional broadcasting. On the one hand, digital television will make channel scarcity a thing of the past. There will be room for specialised channels aimed at very specific audiences. Already (as noted at the end of section 3 above) more Welsh and Gaelic programmes are being planned for the first batch of digital channels. However these channels will gain audiences by fragmenting the audiences for current channels. This will have a major effect on the financial viability of each part of the overall system. Similarly as digital satellite services become available and the major expansion of channels occurs, the finances of the entire broadcasting system will become extremely unstable. In this context the profits involved in catering for regional and local audiences are unlikely to be attractive enough for the broadcasters. Importing programming and making new programmes for as large as possible a market are always going to appear financially more secure strategies than making programmes which only appeal to specific regional audiences. The best

way forward for regional broadcasters is likely to be selective co-operation with other similar regions. Some Scottish Gaelic programmes, for example, have been co-produced with the new Irish-language station Teilifís na Gaeilge, and Scottish Television's Gaelic soap opera *Machair* has been broadcast there.

It was noted earlier that by the year 2000 there will be a fully-functioning Scottish Parliament and Welsh Assembly. Although broadcasting regulation is being kept as a preserve of the central government in London, there is already a debate developing reagrding the future of broadcasting in relation to these new institutions. The Scottish National Party had already, before the end of 1997, stated that it believed that broadcasting should be included in the Scottish Parliament's remit. Although this will not happen, both BBC Scotland and Scottish Television (particularly since the latter's takeover of Grampian Television) regard themselves as national broadcasters within Scotland and for both organisations the existence of a Scottish Parliament, and therefore a Scottish political system far more acutely differentiated from that based in London, has major implications. Currently the ITV network controllers insist on all Channel 3 companies taking the later evening news programme *News at Ten* complete, and at the same time. Scottish Television, however, is already lobbying to be allowed to make its own, separate news programme, for Scotland only. It has been building up its provision of news (notably by the extension of the late night Scottish news bulletin into a 20 minute programme). More generally it has been asking re-negotiate its relationship with the rest of the ITV network, to achieve some sort of "affiliate" status.

It is at the BBC, however, that greater pressure is being felt. For many, the logic of political devolution suggests much greater devolution within the BBC as well, with BBC Scotland and BBC Wales being given much more control over resources and decision-making, and a greater degree of programme autonomy. So far, however, the BBC in London is resisting such pressure, although it is likely to steadily increase as the plans for devolution develop. However the Scottish broadcasters are clear of the need for change. In BBC Scotland's *Annual Review 1996-97*, the Controller of BBC Scotland, John McCormick, wrote that the referendum result would mean BBC Scotland "examining the possibility of the realignment of our daily news, current affairs and political programming, to reflect the shift in the agenda brought about by the creation of the Parliament". There would also be consequences for other types of programming. McCormick noted the "clear demand for more programmes for Scotland and from Scotland for the rest of the UK" (BBC Scotland, 1997). Devolution, then, is likely to exert a pressure in favour of more regional broadcasting in Scotland and Wales, and even within the English regions as the overall political structure of the United Kingdom changes.

Overall, then, the financial viability of regional and local television in the United Kingdom is uncertain, as broadcasting begins a period of

instability. Despite the social and cultural effects of political devolution, and the possibilities opened up by digital television, the economics of broadcasting is likely (as always) to push towards less, rather than more, regional and local programming.

6.2 Cultural synergies

The links between television companies and cultural and civic institutions are not great within the United Kingdom. Cultural institutions such as museums, theatres, and music organisations, have had only the most occasional and informal links with broadcasters, and even these have usually operated at a national level (such as the BBC's support of the series of summer concerts held in the Royal Albert Hall in London, known as the "Sir Henry Wood Promenade Concerts", all of which are broadcast on radio and some of which are televised nationally). The most important regional musical links have been the BBC's support of regional orchestras – the BBC Scottish Symphony Orchestra and the BBC National Orchestra of Wales. Similarly, political parties and pressure groups of other kinds, although frequently concerned with television output, do not have formal links with the broadcasters.

One area, however, in which some television companies are linked to outside interests is at the level of the committees which oversee public bodies. The Broadcasting Council for Scotland, which advises the BBC on programmes and services, consists of 12 members and includes representatives from business, local government, school and higher education, the legal profession and the Church of Scotland. Similarly, when the Comataidh Telebhisein Gàidhlig was first set up in 1992, it consisted of eight people. The Chairman was the Secretary General of COSLA (Council of Scottish Local Authorities). The others were a solicitor, a college lecturer, an accountant, a school headmaster, two local councillors who were both former school teachers and the Director of an island local authority enterprise board. Thus the strongest links were with local authorities and with the education system. The committee which runs S4C typically includes academics and professionals who have demonstrated a commitment to the Welsh language by previous involvement in public bodies (see section 4.3 above). It is important to note, however, that such links are informal in that individuals are appointed to these bodies as individuals, not as representatives of other organisations.

Television's external links are strongest in relation to the film industry. Since its beginning in 1982, Channel 4 has had an important role to play in the film industry, to such an extent that some have argued that the renaissance in British film during the 1980s was solely due to that company's investments. Some of this investment has been made into regional film-making, with such Scottish films as *Trainspotting* (directed by Danny Boyle, 1996) and the bilingual Gaelic/English film *As an Eilein/From*

the Island (directed by Mike Alexander, 1993) benefitting from this financial source, as did the award-winning Welsh-language film *Hedd Wyn* (directed by Paul Turner, 1993). The BBC has also made contributions to regional film-making with, a recent example being the Scottish film *Small Faces* (directed by Gillies MacKinnon, 1995).

More recently, and very much a part of the developing political and media situation in Scotland, there has been the creation in April 1997 of Scottish Screen, an organisation created out of an amalgamation of various groups (the Scottish Film Council, the Scottish Film Production Fund, Scottish Broadcast and Film Training, Scottish Screen Locations) and which describes itself as "a film and television agency (...) combining culture and industry". Apart from its general role of providing training for both film and television, Scottish Screen administers four short film schemes to encourage new talent and which involve television companies: Tartan Shorts is a collaboration with BBC Scotland and the Scottish Arts Council to support the making of films of up to 15 minutes length; Prime Cuts is a collaboration with British Screen and Scottish Television for even shorter films (5 minutes); First Reels is a collaboration with Scottish Television and allows small grants to be made to people with limited production experience; and Geur Ghearr is a collaboration with the Gaelic Broadcasting Committee and BBC Scotland and is aimed at giving Gaelic-speaking media professionals experience in Gaelic drama production.

A similar organisation to Scottish Screen exists in Wales, called Sgrin (The Media Agency for Wales). It was created in 1997 out of two earlier bodies (the Wales Film Council and Screen Wales) and its aim is to offer "a co-ordinated vision for all aspects, cultural and industrial, of film, television and related media in Wales" (BFI , 1997).

It will be obvious from the foregoing that television in the United Kingdom, whether at national, regional or local level, has not developed strong links with civic and cultural institutions. The strongest links are with other areas of the media industries and are largely driven by economic pressures.

6.3 The Influence of new integrated communications networks

Interactions between television services and communications networks have begun in several ways. Already some cable television companies are providing telephone services in competition with British Telecom, and telephone lines are being adapted to be used as Integrated Services Digital Network (ISDN) lines, down which digital services ranging from television to the Internet will be provided. The current competition is for the position of provider of the networks, with both cable companies and telephone operators looking to doing this. With the future seeming to be a situation in which the same network structure will be used for telephone, computer and digital television services, the rivalry is intense. The telephone

networks have the advantage of already using computerised switching devices which are essential for the new networks. In a country such as Britain, where cable is still relatively uncommon but the vast majority of homes have telephones, the telephone providers have an in-built advantage. Access to the Internet is already well advanced in Britain and the government has made 1998 "UK Net Year" with the aim of getting half of all British schools linked to the Internet by the end of the year (having earlier in 1997 made one of its election promises that all schools would be linked). The cost was to come from private companies involved in the new communications technology and both local and national education authorities.

The effect of new communications is already being felt by broadcasters. John Wyver, a television producer, has described how, when making a BBC television series about the Internet, more and more use was made of computerised communications. Interviews from the series were put on the web site and e-mail was used to conduct a dialogue with the audience after each programme. The experience led him to conclude as follows. "It is increasingly possible to present your own vision of the world to an audience through the Web, using video pieces that you make with your camcorder or with digital animations and so forth. You can genuinely find an international audience through this very egalitarian distribution structure" (as quoted by Patricia Holland, 1997). To the current Internet user, however, the most obvious link is the fact that television stations have developed their own web sites, although at present they are used as little more than advertising for the stations and their programmes.

At present, the future links between television and the information superhighway are little more than guesses. Whether or not a world is reached in which the delivery of a multiplicity of interactive television services via the Internet becomes a reality will depend, as always, on economic factors, specifically, how much customers are willing to pay for the new services. Such developments clearly have the potential to transform regional and local media provision across Europe, and are particularly important for remote areas. Within the United Kingdom, the Highlands and Islands of Scotland is one such area and there are currently plans to convert a number of further education colleges in that area into a multi-campus university, dependent on the new communications technologies. The proposed University of the Highlands and Islands (UHI) has already been granted substantial development money from the government and its planners hope that it will be granted full university status early in the next century. UHI stands as a symbol of the transforming potential of the new communications technologies, with geographical location becoming essentially irrelevant. If that is so, then the definition of what is a region and what is local may need to be re-examined. For the present, however, it is important to bear in mind that the communications ideals presented by proponents of the new technology may not be borne

out. As one recent writer has put it, "market driven development and commercial media systems by themselves are incapable of fostering democratic communication systems or assuring universal access to telecommunications for diverse people and ideas" (Fred Johnson in Jon Dovey, 1997). If the new communications technologies are to be used to benefit regional and local communities, and to allow television to develop in ways which enhance local cultures, rather than simply reinforcing the power of international conglomerates and state institutions, then political commitment in the regions must take precedence over economic pressures. This is certainly true within the context of the United Kingdom.

Bibliography and References

A Voice for Wales: The Government's Proposals for a Welsh Assembly. Cm 3718. London: The Stationary Office.

Alladina, S. and V. Edwards (eds) (1991): *Multilingualism in the British Isles*. London: Longman.

BBC (1997): *Our Commitment to You: BBC Statement of Promises to Viewers and Listeners*. London: BBC.

BBC Scotland (1997): *Annual Review 1996-97*. Glasgow: BBC Scotland.

Bradbury, J. and J. Mawson (eds) (1997): *British Regionalism and Devolution: the Challenges of State Reform and European Integration*. London: Jessica Kingsley.

British Film Institute (1997): *The BFI Film and Television Handbook 1998*. London: BFI.

Broadcasting Act 1990. London: HMSO, 1990.

Broadcasting Act 1996. London: HMSO, 1996.

Cormack, M (1997): "Spoken Scots in the Media", in *Scottish Affairs* 21, Winter.

Cowie, C (1997): "Competition Problems in the Transition to Digital Television in the UK Market Place", in *Media, Culture and Society* 19, 4 (October).

CTG (1997): *Annual Report and Accounts, 1996-97*. Stornoway: CTG.

Dovey, J. (ed) (1996): *Fractal Dreams: New Media in Social Context*. London: Lawrence & Wishart.

Dunleavy, P. et al. (eds) (1997): *Developments in British Politics, 5*. London: Macmillan.

Holland, P. (1997):*The Television Handbook*. London: Routledge.

Home Office (1988): *Broadcasting in the '90s: Competition, Choice and Quality*. Cm 517. London: HMSO.

ITC (1997): *Annual Report and Accounts 1996-97*. London: ITC.

Marwick, A. (1996): *British Society since 1945*. Third edition. Harmondsworth: Penguin Books.

Rushton, D. (1990): *Noisy Channels: A Local Government Report on Cable, the Local Economy and Local Television*. Edinburgh: Institute of Local Television.

Rushton, D. (1992): *Local Television and Democracy: Essays on Cable and Local Television 1982-1991*. Edinburgh: Institute of Local Television.

S4C (9187): *S4C 1982-87*. Cardiff: S4C.

The Agreement: Agreement Reached in the Multi-Party Negotiations. Belfast, 1998.

The Scottish Office (1997): *Scotland's Parliament*. Cm 3658. Edinburgh: The Stationary Office.

Notes

1 For general reading on the United Kingdom, see *British Society since 1945* by Arthur Marwick which, in its third edition (1996), has been updated to include the first half of the 1990s. For a good discussion of contemporary British politics, see *Developments in British Politics*, 5, edited by P. Dunleavy *et al.* (19979. On the specific question of the regions within the United Kingdom, see *British Regionalism and Devolution: the Challenges of State Reform and European Integration*, edited by J. Bradbury and J. Mawson (1997).

2 Figures in this and the following two parts ('Satellite television' and 'Digital television') taken from the *BFI Film and Television Handbook 1998*.

The Authors

Peter Arvidson is Senior Lecturer in Media and Communication Studies at Lund University, Sweden. Some of his publications on the mass media are the following: *The Barsebäck "Panic": A fictional news cast and its effects*, Liber, 1974 (in Swedish), together with K.E. Rosengren and D. Sturesson; "The Barsebäck "Panic": A Radio Programme as a Negative Summary Event", in *Acta sociologica*, Vol. 18, N. 4, 1975; Deviance and the mass media, in C. Winick (ed.), *SAGE Annual Reviews of Deviance*, Vol 2, 1978, together with K.E. Rosengren and D. Sturesson; *The Credibility of the Mass Media*, Dissertation, 1981 (in Swedish); "Massmedia Credibility", in *Psychological Defense*, N. 81, 1977; "Credibility and Confidence, Accuracy and Believability", in *Psychological Defense*, N. 103, 1980; "Do we believe in our Mass Media?", in *Psychological Defense*, N. 109, 1981. He has published as well in the fields of sociology of leisure, sports, music and the arts, as well as on symbolic interactions, the makings of executives and scientific method.

Sylvie Bardou-Boisnier is a Doctor in Media Studies and a Researcher for GRESEC (Groupe de Recherche sur les Enjeux de la Communication) at Stendhal-Grenoble 3 University. She specialises in the study of information and communication technologies and their effects on territorial organisation. She is also interested in regional communication policies in Europe.

Pedro Jorge Braumann, economist, postgraduated in Regional and Urban Planning, equivalent to the Degree in Communications. Lecturer at the Department of Communication Sciences of the Universidade Nova de Lisboa and assimilated to Assistant Professor of the Escuela Superior de Comunicação Social (Instituto Politécnico de Lisboa). Member of the editorial boards of several Portuguese and Brazilian magazines (*Comunicação e Linguagens, Tendências XXI, Comunicação Empresarial* e *INTERCOM*). Member of the Advisory Board of Radiotelevisão Portuguesa (RTP). President of the Committee for the Assessment of the Costs of Public Interest Remits of LUSA (Agência de Notícias de Portugal),

443

appointed by the State. Member of the board of SOPCOM (Associação Portuguesa de Ciências da Comunicação). Member of the board of LUSOCOM (Federação Lusófona de Ciências da Comunicação). Deputy chairman of the booard of MEIOS.COM-Instituto de Comunicação e Multimédia. Associated member of ORBICOM (Network of UNESCO Chairs in Communication), of IDATE (Francia) and of the Associação Portuguesa para o Desenvolvimento das Comunicações (APDC). Member of the board of the Centro de Estudos de Comunicação e Linguagens (CECL). He was a consultant of the Ministry of Culture in the areas of Audiovisual and Multimedia, and a consultant of the Secretary of State for Communications of the Portuguese Government in the area of economy and financing.

Enric Castelló Cogollos, Degree in Information Sciences, cooperates with the Institut de la Comunicació (InCom) of the Universitat Autònoma de Barcelona (UAB). He is preparing his doctoral thesis in the Department of Journalism (UAB) on fiction production and programming in the Spanish "autonomic" television stations. He works in the Universitat Oberta de Catalunya (Open University of Catalonia), which has pioneered the use of Internet and new technologies in higher education in Spain. He has been a fellow student and collaborator of the Department of Journalism of the UAB. He contributed a paper in the "IV Jornadas Internacionales de Jóvenes Investigadores en Comunicación" (UAB, 1997).

Suzy Collard, Degree in Urban and Communications Sociology from the Université de Louvain (Belgium). She was a teacher and a journalist between 1977 and 1988. From 1984 to 1988 she whas the programming director of the local TV Canal C (Namur). Since 1989 she is the Director of the Belgian Fédération des TV Locales Francophones. Since 1994 she is a member of the Belgian Conseil Supérieur de l'Audiovisuel.

Mike Cormack is Professor and Director of the Department of Film and Media Studies, Stirling University, and member of the Stirling Media Research Institute. He is author of *Ideology* (London, 1992) and *Ideology and Cinematography in Hollywood, 1930-39* (London, 1994). His main research area is related to linguistic minorities and cultural identity. He has published many articles on this subject and he is working at present on a book about language, mass media and culture in Scotland.

Hans Heinz Fabris is a Professor in the Department of Journalism and Media at the University of Salzburg (Austria), where he runs the Applied Media Research section. His main areas of academic and research interest are information policy, international media, journalism and interpersonal communication. He is a member of the Euromedia Research Group, the International Association for Mass Communication Research and the German Society of Journalism and Media. He is the author of numerous books and articles.

Carmelo Garitaonandía is a Professor in Journalism at the University of the Basque Country. He graduated in Law from the Universidad Complutense de Madrid, was awarded a Masters Degree in Audio-visual Communication by the University of Paris VIII and has a Ph.D. in Political Sciences. He was a member of the founding Board of Directors of the Basque Public Service Radio and Television Corporation (1982-84) and a visiting lecturer at the School of Communication & Theatre in Philadelphia, where he researched into cable television and radio in the United States (1992-1993). He is currently the Director of ZER. *Revista de Estudios de Comunicación* and a member of the International Association for Mass Communication Research. Professor Garitaonandía is the author, co-author and, on occasions, also the editor of over twenty books and numerous articles published in scientific journals. His most important projects are the book entitled *Decentralisation in the Global Era* (John Libbey, London 1995), four working papers for the European Parliament entitled *The Role of Regional Television in Europe* (1994, translated into all nine community languages, and the articles "Regional Television in Europe" and "Media Use and Relationships of Children and Teenagers with Their Peer Groups" (*European Journal of Communication*, September 1993 and December 1998, respectively), "Las televisiones regionales en el marco europeo" (*Telos*, 45, March-May 1996), "La presse quotidienne en Espagne" (*Communication*, vol. 17, issue 1, 1996) and "Las relaciones de los niños y los jóvenes con las viejas y nuevas tecnologías de la información" (*ZER*, 4, May 1998). Some of his best-known books are *La radio en España* (1989), *Las empresas informativas en la Europa sin fronteras* (1992) and *Imágenes recíprocas en los medios de comunicación social. Francia-España. Aquitania-País Vasco* (1993).

Ellen Hazelkorn, is Director of the Faculty of Applied Arts (Dublin Institute of Technology). Ellen Hazelkorn has been author and co-author of many articles and books on politics and society in Ireland, digital technologies, gender, work practises and culture industries, as well as on the relationship between mass media and State, including liberalisation, information freedom and censorship. She is member of the editorial committee of the journal *Science and Society* (New York) and co-editor of *Irish Communications Review* (Dublin Institute of Technology), vice-president of CITE (Committee on Information Technology and Education), a consortium of Europan academic and industrial institutions that develop new technologies for mass media and a Board Member of the Contemporary Music Centre, Dublin. She was an advisor to the Government on issues concerning broadcasting, Official Secrets and Freedom of Information (1994-1997). Amongst her publications, are the books *The Dynamics of Irish Politics* (with P. Bew and H. Patterson, 1989), *Let in the Light. Censorship, Secrecy and Democracy* (with P. Smyth, eds.,1993) and *A Guide to Irish Politics* (with T. Murray, 1995), as well as the articles and books' chapters "Ireland: from nation building to economic priorities", in

Moragas and Garitaonandía (eds.), *Decentralization in the Global Era* (1995); "Gendered practices in media production? a case study of Irish broadcasting and film", in *Medienjournal , Journal of the Austrian Society of Communications*, (Salzburg, vol. 2, 1995): and "New digital technologies, work practices and cultural production in Ireland", in *Economic and Social Review*(vol. 28, 1997).

Nicholas W. Jankowski is Associate Professor at the Department of Communication, University of Nijmegen, The Netherlands. Jankowski has published extensively in the areas of research methodology (co-editor of *Handbook for Qualitative Methodologies in Mass Communication Research*, Routledge, 1992) and small-scale media (co-editor of *The People's Voice; Local Radio and Television in Europe*, Libbey, 1992). He is currently preparing a sequel to *The People's Voice* and a textbook on researching new media. Jankowski is Associate Editor of *Communications; The European Journal of Communication Research* and Co-editor of the recently launched Sage journal *New Media & Society*. He is presently serving as President of the Community Communication Section (formerly Local Radio and Television) of the International Association for Media and Communication Research (IAMCR).

Hans J. Kleinsteuber, born in 1943, from 1976 to 1989 was professor of Political Science at the University of Hamburg and from 1989 at the Institute of Journalism. He created the Research Group on Media and Politics, and is the German correspondent of the Euromedia Research Group. From 1996 he is an expert consultant of the Enquete Kommission des Deutschen Bundestages zu Zukunft der Medien. Main interest areas: comparative analysis of media systems, policy, economy and technology in Germany, North America and Western Europe. He has researched and taught in the universities of Tokyo (1994), Bloomington, Indiana (1995), Montreal (1997) and Canberra (1998). Recent publications: *Information Highway-Exit Hamburg?* (Hamburg, 1997, ed.); *Reisejournalismus. Ein Einführung* (Opladen, 1997); *Information Superhighway* (Opladen, 1997, ed.); *Europa als Kommunikationsraum* (with Torsten Rossmann, Opladen, 1994).

Bernat López, Doctor in Communication Sciences, is assitant professor at the Departament de Periodisme i Ciències de la Comunicació of the Universitat Autònoma de Barcelona and academic secretary of the Institut de la Comunicació at the same University. Its research areas are communication policies and decentralization of television. He has published several articles and monograph chapters, namely "Televisión Regional en la Europa de las Identidades" (in *Chasqui. Revista Latinoamericana de Comunicación*, n. 47, 1993), "Minority cultures and audiovisual policy of the EC" (in *Mercator Media Forum*, vol. 1, 1994), "Spain: the Contradictions of the 'Autonomous Model'" (in Moragas, M. & Garitaonandía, C. (eds): *Decentralisation in the Global Era*, 1995, together with M. Corominas), "La 'societé de l'information': promesse de futur ou

rêve néoliberal?" (in *Médiaspouvoirs*, 43-44, 1997), and "Política lingüística i política de comunicació davant dels reptes de la globalització" (in Mollà, Toni (ed): *La política lingüística a la societat de la informació* , 1998).

Miquel de Moragas Spà, Professor of Communications at the Universitat Autònoma de Barcelona (UAB). Former Dean of the Facultat de Ciències de la Comunicació of the UAB (1978-1980 and 1982-1984) and Vice-rector of the same University (1985-1989). He is the founder and director of the Institut de la Comunicació and the Centre d'Estudis Olímpics i de l'Esport (UAB). Its main publications are *Semiótica y comunicación de masas* (1976), *Teorías de la comunicación* (1982), *Sociología de la comunicación de masas* (1984), *Espais de comunicació* (1988), *Los Juegos de la Comunicación* (1992), *Cultura, símbols i Jocs Olímpics. La mediació de la comunicació* (1992), *The Keys to Success. The Social, Sporting, Economic and Communications Impact of Barcelona'92* (1994, edited with Miquel Botella), *Television in the Olympics* (1995) and *Decentralization in the Global Era* (1995, edited with Carmelo Garitaonandía).

J.-M. Nobre-Correia is Professor of Information and Communication at the Université Libre de Bruxelles (ULB) and at Universidade de Coimbra, director of the Observatoire des Médias en Europe at ULB and member of the scientific council of the European Institute for the Media, in Düsseldorf. He was the chairman of the Communication, Information and Journalism Section at the ULB. He is former director of the montly *Média Magazine* (Brussels), and former collaborator of several publications (*Pub*, *Trends Tendances* and *Le Vif-l'Express*, in Belgium, and *Público*, in Portugal). At present, he writes weekly about media in the Portuguese newspaper *Expresso* and is european editor of french review *Médiapouvoirs*. He is author of *A Cidade dos Media* (Porto: Campo das Letras), and co author of several collective books, as *L'État de l'Europe* (Paris: La Découverte), *L'État de l'Allemagne* (Paris: La Découverte), *Le Désarroi démocratique* (Brussels: Labor), *The Media in Western Europe* (London: Sage).

Isabelle Pailliart is a Media Studies Lecturer and Assistant Director of GRESEC (Groupe de Recherche sur les Enjeux de la Communication) at Stendhal-Grenoble 3 University. Her fields of interest include the media and new information technologies in local ambits, the communications policies of local and regional institutions and the social application of communications technologies.

Roy Panagiotopoulou studied sociology, political science and economics at Heidelberg University, and was where he gained his doctorate. She is associate professor of the Communication and Media Department of the Athens University. She has also worked as a researcher in the National Centre of Sociological Research of Greece (1985-97) and as professor at the Heidelberg University. She has published numerous works on sociology, political attitudes and social changes in Greek and international newspapers. Her last books are about organisational communication

447

(Kritiki, Athens, 1997), and about the mass media and the "construction" of reality (ed. Alexandria, Athens, 1998). She is at present finishing a book on regional television in Greece (Kastaniotis, in press).

Renato Porro, born in Tradate (VA) the 13th February 1946 and deceased in Trento the 6 December 1998. Degree in sociology at the Libera Università degli Studi di Trento (1971-1972) with the highest qualification and honour mention. He was professor of Theory and Technique of Mass Communications at the Faculty of Sociology of the Università degli Studi di Trento. Between 1993 and 1995 he was the Secretary of the Associazione Italiana di Sociologia (AIS). Since 1994 he was the Chairman of the Coordinamento Nazionale dei Comitati Regionali per i Servizi Radiotelevisivi (National Coordinating Body of the Ragional Committees for Broadcasting Services). Its main publications include the following: "Dall'incapacità al disinteresse" and "La selezione oculta: Verso un destino disuguale", in M. Livolsi (ed): *La macchina del vuoto*. Bologna, 1974; "Selezione palese e oculte: un parametro di valutazione delle esperienze scolastiche innovative" and "Scuola e territorio: alcune ipostesi di programmazione educativa", in M. Livosi (ed): *Per una nuova scuola dell'obbligo*. Bologna, 1980; "Le agenzie di socializzacione: i mass-media", in M. Livolsi (ed): *Sociologia*. Milano, 1981; *Il mercato televisivo e alcuni suoi orientamenti futuri*. Roma, 1984; *Infanzia e mass-media*. Milano, 1984; "I consumi culturali in Italia", in M. Morcellini (ed): *Lo spettacolo del consumo*. Milano, 1986; (ed): *Media planning: problemi e prospettive*. Trento, 1987; "La pubblicità televisiva: forme e contenuti", in M. Livolsi (ed): *E comprano felici e contenti*. Milano, 1987; "Scuola e mass-media in età infantile. Contrapposizione, concorrenzialità o continuità", in G. Petter-F. Tessari (ed): *I valori e i linguaggi*. Firenze, 1990; "Soggetti e domanda di consumo culturale", in A. Ardigò-E. Minardi (ed): *Ricerca soziale e politiche culturali*. Milano, 1991; "Mass-media e tipologie", in N. Livolsi (cd): *I pubblici dei media*. Firenze: La NIS, 1992; *Preaddolescenti e mass-media*. Roma (to be published); *Bambini e media*. Bologna (to be published).

Giuseppe Richeri teaches Media Strategy at the Università della Svizzera Italiana (Lugano). He is the scientific director of the Istituto di Economia dei Media (Milan). He has taught in several European universities, namely the Universitat Autònoma di Barcelona (UNESCO chair), the École Nationale d'Administration (Paris) and the Università di Bologna (Italy), and has developed research and consulting activities for several organisations and institutions, among which UNESCO, the European Union, the European Broadcasting Union and the Inter American Development Bank. He is one of the most international of the Italian media scholars, as his books have been published in 20 countries. His main recent books are *La transición de la televisión* (Bosch, Barcelona, 1994), *Telecommunication. New Dynamics and Driving Forces* (IOS Press, Oxford, 1996, co-editor), *Televisione e qualità* (Rai-Eri, Roma, 1997, together with C. Lasagni) and *L'industria dei media in italia* (Baskerville, Bologna, 1999, together with A. Pilati).

Jaume Risquete, Degree in Information Sciences (Journalism) and Magister in Journalism from the Universitat Autònoma de Barcelona (UAB). He has been a research fellow of the Departament de Periodisme i Ciències de la Comunicació (UAB); in 1997 he joined the European research network EMTEL (European Media, Technology and Everyday Life), where he developed a research on the elderly and the mass media. He is a collaborator of the Institut de la Comunicació of the UAB. He has worked as a journalist in several newspapers and magazines, as well as in the press agency EFE. He has published *Les noves tecnologies i la comunicació audiovisual,* bibliography and summary of the papers presented at the international symposium "The New Technologies and Audiovisual Communication" (Bellaterra, 1993), and "La política dels intel.lectuals", in *Actes del II Congrés Català de Sociologia* (Societat Catalana de Sociologia: Barcelona, 1996).

Francisco Rui Cádima, Doctor in Communications at the Faculty of Social and Human Sciences of the Universidade Nova de Lisboa (1993). Assitant Professor and responsible for the area of Audiovisual and Interactive Media at the Department of Communication Sciences of the Faculty of Social and Human Sciences (Universidade Nova de Lisboa). He co-ordiates as well the Television Studio of the same Department, of which he was once the co-ordinator. He is a researcher and consultant in the area of Audiovisual and Interactive Media. He was a member of the Think-Tank on the Future of Television, appointed by the presidency of the Government (1996), and cooperated in the edition of the Green Paper on the Information Society (Ministry of Science and Technology, 1997). He is Deputy Director of the magazine *Tendências XXI* (APDC), and has authored the following books: *Os Desafios dos Novos Media* (Lisboa: Notícias, 1999); *Estratégias e Discursos da Publicidade* (Lisboa: Vega, 1997); *História e Crítica da Comunicação* (Lisboa: Editora Século XXI, 1996); *Salazar, Caetano e a Televisão Portuguesa* (Lisboa: Presença, 1996); *O Fenómeno Televisivo* (Lisboa: Círculo de Leitores, 1995).

Monique K. H. Schoorlemmer is staffmember of Stichting ROOS, the umbrella-organisation of all public regional stations in the Netherlands. In 1994 she received her Mastersdegree at the department of Communication, University of Nijmegen, The Netherlands.

Gabriele Siegert is an Assistant Lecturer in the Department of Journalism and Media at the University of Salzburg (Austria). Her teaching and research interests are centred around two main areas: information economics and empirical research into communication, including the theoretical and practical aspects of media economics and politics in Austria, media planning and research and communication effectiveness methodology (projects in progress). Some of her most recent publications are: *Marktmacht Medienforschung – Die Bedeutung der empirischen Medien- und Publikumsforschung im Medienwettbewerbssystem* ("The sense of audience

research in marketing", Munich, 1993), *Kommunikationswelten* ("The world of communication", Innsbruck-Vienna, 1997, published with Rudi Renger) and "Medienkonzentration und Medienpolitik" ("Media concentration and policy", in *Medien Journal* 2/1997, published with Manfred Knoche).

Barbara Thomaß, born in 1957 in Bremen, Germany. She studied communications, political science and economy in Berlin and Grenoble (France). She was the editor of a woman's magazine and a scientific magazine. From 1991 se does research in the fields of journalism, media policies in Europe, comparative ethics of European journalism, the media in France and the United Kingdom and regional communication. Publications: *Arbeit im Kommerziellen Fernsehen* (Münster, 1993); *Journalistische Ethik* (Opladen, 1998).

Thomas Tufte, Cultural sociologist (1989), PhD in communication (1995). Assistant research professor at the University of Copenhagen. Current research: (1) Media, regional cultural identity and everyday life (case study from Brazil). (2) Proximity television in Denmark. Posts held: Associate member of UNESCO's global communication network, ORBICOM; Co-editor of the Danish Journal of Communication (*Mediekultur*); International correspondent for Estudios sobre las Culturas Contemporaneas, Colima, Mexico; Member of the advisory panels of the Brazilian journal *Intercom* and of the Brazilian Internet journal *Intexto*; Co-ordinator of the European-South American communication research network COMSUR. Recent publications include: *Living with the Rubbish Queen - a media ethnography about telenovelas in everyday life of Brazilian women.* University of Luton Press (forthcoming); "The Popular Forms of Hope – TV-fiction, audience consumption and social change in Brazil: a media ethnographical perspective", in Ingunn Hagen and Janet Vasco: *Consuming Audiences.* Hampton Press (forthcoming); "Television, modernity and everyday life - discussing Roger Silverstone's work *vis-à-vis* different cultural contexts", in Spanish in *Comunicación y Sociedad*, vol. 31. Guadalajara, Mexico, 1998; Co-author with Nilda Jacks: "Televisão, Identidade e Cotidiano", in *Annual COMPOS Research Journal* 1997, Brazil 1998 (forthcoming); "Pesquisa em comunicação de massa na Dinamarca", in Maria Immacolata V. de Lopes (ed):*Temas Contemporaneas em Comunicação*, INTERCOM/EDICON, São Paulo, Brazil, 1997.

Tapio Varis, Professor and Chair in Media Culture and Communication Education at the University of Tampere, Finland. He teaches and researches on peace and communication, having been the author of more than 200 cientific publications, including *The Media of the Knowledge Age* (in Finnish, Helsinki 1995, and in Galician, Santiago de Compostela 1998), *International Flow of Television Programmes* (UNESCO, 1995), etc. He has been the Rector of the University for Peace (Costa Rica), UNESCO Chair in Communications at the Autonomous University of Barcelona (Spain) and Director of the Tampere Peace Research Institute and the Centre of

Continuing Education of the University of Art and Design Helsinki. He has been visiting professor in several countries in Europe and North and South America.